HISTORY OF
MODERN ART

PAINTING SCULPTURE ARCHITECTURE PHOTOGRAPHY

VOLUME I

SEVENTH EDITION

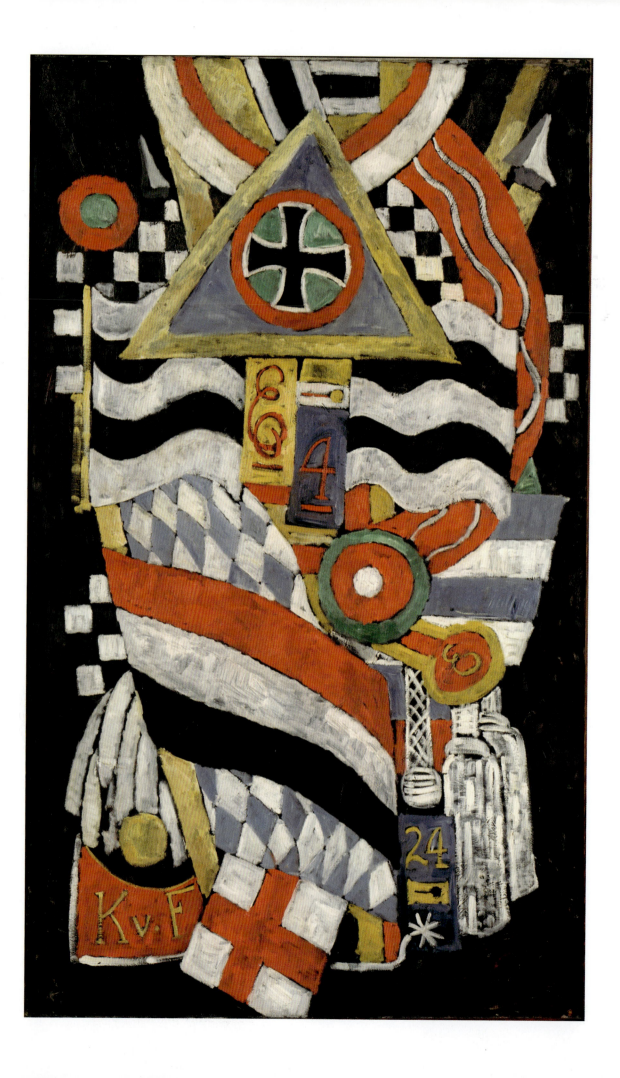

HISTORY OF MODERN ART

PAINTING SCULPTURE ARCHITECTURE PHOTOGRAPHY

VOLUME I

SEVENTH EDITION

H.H. ARNASON

ELIZABETH C. MANSFIELD
National Humanities Center

PEARSON

Boston Columbus Indianapolis New York San Francisco Upper Saddle River
Amsterdam Cape Town Dubai London Madrid Milan Munich Paris Montréal Toronto
Delhi Mexico City São Paulo Sydney Hong Kong Seoul Singapore Taipei Tokyo

Editorial Director: Craig Campanella
Editor-in-Chief: Sarah Touborg
Senior Sponsoring Editor: Helen Ronan
Editorial Assistant: Victoria Engros
Vice President, Director of Marketing: Brandy Dawson
Executive Marketing Manager: Kate Mitchell
Editorial Project Manager: David Nitti
Production Liaison: Barbara Cappuccio
Managing Editor: Melissa Feimer
Senior Operations Supervisor: Mary Fischer
Operations Specialist: Diane Peirano
Senior Digital Media Editor: David Alick
Media Project Manager: Rich Barnes

This book was designed and produced by Laurence King Publishing Ltd, London
www.laurenceking.com

Production Manager: Simon Walsh
Page Design: Robin Farrow
Photo Researcher: Emma Brown
Copy Editor: Lis Ingles

Cover photo: Pablo Picasso, *Painter and Model*, 1928 (detail). Oil on canvas, 51⅛ × 64¼" (130 × 163.2 cm). The Museum of Modern Art, New York.

page 2: Marsden Hartley, *Portrait of a German Officer*, 1914. Oil on canvas, 68¼" × 41⅜" (173.3 × 105.1 cm). The Metropolitan Museum of Art, New York.

Credits and acknowledgments borrowed from other sources and reproduced, with permission, in this textbook appear on the appropriate page within text or in the picture credits on pages 420–24.

Library of Congress Cataloging-in-Publication Data

Arnason, H. Harvard, author.
 History of modern art : painting, sculpture, architecture, photography
/ H.H. Arnason, Elizabeth C. Mansfield, National Humanities
Center. --
Seventh Edition.
 pages cm
Includes bibliographical references and index.
ISBN-13: 978-0-205-25947-2 (pbk.)
ISBN-10: 0-205-25947-2 (pbk.)
1. Art, Modern. I. Mansfield, Elizabeth - author. II. Title.
N6490.A713 2013
709.04--dc23
 2012029474

10 9 8 7 6 5 4 3 2 1

ISBN 10: 0-205-25948-0
ISBN 13: 978-0-205-25948-9

Contents

10

Picturing the Wasteland: Western Europe during World War I 213

11

Art in France after World War I 242

12

Clarity, Certainty, and Order: De Stijl and the Pursuit of Geometric Abstraction 262

Preface

Since it first appeared in 1968, *History of Modern Art* has emphasized the unique formal properties of artworks, and the book has long been recognized for the acuity of its visual analysis. To neglect the specifically visual quality of art and architecture would be akin to ignoring the use of language in poetry or the quality of sound in music. Only through close formal analysis can art and its effect on us be fully understood.

Visual analysis does not, however, constitute art history. The book's original author, H.H. Arnason, directed readers to consider modern art in terms of "everything that we can learn about the environment that produced it." The seventh edition of *History of Modern Art* preserves the text's sensitive approach to visual analysis while deepening its consideration of the social conditions that have affected the production and reception of modern and contemporary art.

Toward this end, the seventh edition retains its chronological organization. While not claiming that modernism's birth can be traced to a specific moment, *History of Modern Art* accords particular relevance to the year 1835. Two events in that year anchor the text's account of modernism: the production of the earliest photographs by William Henry Fox Talbot and the publication of Théophile Gautier's novel *Mademoiselle de Maupin*, with its provocative cross-dressing heroine and scandalous endorsement of *l'art pour l'art*—in other words, Art for Art's Sake. These events announce the conflicting impulses that have catalyzed the development of modern art since the nineteenth century.

Modern art is the cultural expression of a society shaped as much by scientific rationalism as by transcendent idealism.

The tension inherent in this social condition propels modernism, through which these competing worldviews are explored and often synthesized. The appearance of photography and the doctrine of Art for Art's Sake in the same year testify to the appeal of both viewpoints at this time. For many, photography promised to document the world accurately and objectively, to deliver absolute visual truth. Partisans of Art for Art's Sake celebrated instead a truth based on subjective aesthetic experiences that transcend lived reality. These two worldviews have continued to collide and commingle to the present day, with moments of resolution and irresolution continually giving rise to new forms of visual culture.

Talbot's photography and Gautier's novel also introduce themes that recur throughout the book. Intersections between art and science, for instance, are noted repeatedly, as is the role of technology in shaping modern art. Other sustained themes include the relationship between modernism and femininity, the influence of criticism on the reception of modern art, the development and effects of the art market, and the persistence of the exotic as an aesthetic ideal. Although these ideas are woven through the whole of *History of Modern Art*, each chapter maintains a distinct focus, addressing a particular movement or concept. The introductions address social and aesthetic issues particular to each chapter while linking these ideas to the central themes of the text.

Furthering the assertion of modern art's social import is the inclusion of new artists and artworks. These additions are intended to strengthen the central arguments of the book while also broadening its conception of modernism. Among other changes is the integration of women and African-American

artists into the main narrative. These important contributors to the history of modernism are not cast as extras in an otherwise male, white, and Eurocentric story. Rather, the main narrative encompasses their work while also addressing issues related to their marginalization in traditional histories of modern art. For instance, the relationship between modern art and women involves more than the history of women's exclusion from the institutions of artmaking and exhibition: it also concerns the significance of the female nude for the history of modernism as well as the decisive influence of women patrons of avant-garde art in the late nineteenth and early twentieth centuries. Likewise, to comprehend the position of African-American artists in this period requires an understanding of contemporary cultural assumptions about race and representation.

History of Modern Art closes with a chapter devoted to globalization, taking into consideration the economic and political conditions currently affecting artists and audiences internationally. The lessons of globalization have not been lost on artists. Many have adapted their practice to new digital media, often by-passing conventional venues for exhibition and instead broadcasting their work via personal websites or through social networking systems like Facebook or Twitter. Few have managed to digitally broadcast their work as effectively as the dissident Chinese artist Ai Wei Wei. The so-called "Arab Spring" and Occupy Movements of 2011 endowed even greater urgency to artistic interventions with digital media and global capitalism, and these issues are among those given scrutiny in this latest edition of *History of Modern Art.*

Pulsing beneath this account of communications systems and revolutionary politics is the legacy of European and American colonialism, which accompanied the rise of modernity. The most effective analysis of the relationship between imperialism and modernity has come from the field of postcolonial studies. By articulating the causes and consequences of Western imperialism, postcolonial theory has contributed significantly to a reformulation of what it means to be an artist just as it has led some collectors, dealers, and museum professionals to reconsider their practices.

The book concludes with discussions of two controversial museums designed by French architect Jean Nouvel. The Quai Branly Museum in Paris, which opened in 2006, houses ethnographic collections mostly from France's former colonial possessions. Designed with an eye toward making visible the outmoded ideologies of racial and sexual inequality that made colonialism possible, Nouvel's Quai Branly Museum appeals to the clarity promised by postcolonial theory. Yet the museum finds itself ensnared in the vexed history of actual colonial practice. Palpable, too, is the pulse of neocolonialism, which refers to the persistence of unequal political and economic relations between countries formerly bound by colonial practices. As an ethnographic museum, the Quai Branly testifies to France's former imperial status even as it attempts to allow the objects collected there to speak on their own account. But with its crepuscular galleries, interactive video stations, and alcoves animated with piped-in music indigenous to France's old colonial possessions, the museum recreates the fantasy of easy access and compliant natives that has spurred colonial ambitions since the sixteenth century. Such imaginings were as crucial to Paul Gauguin's Tahitian sojourns as to the work of contemporary artists like Emily Jacir or Walid Raad, who articulate a visual language of cultural identity and resistance in the face of such imperialist fantasies.

Expressive of a different set of global cultural ambitions is the Louvre Abu Dhabi. Intended as an anchor for the emirate's culture district, the new museum boasts the name of France's most prominent arts institution and it will, at least initially, exhibit artworks from the Louvre's collection. Nouvel's daringly innovative design for the museum invites comparison with canopied bazaars, emphasizing the capacity of material culture to serve as a medium of exchange. Yet it is the cultural patrimony of France, not Abu Dhabi, that will facilitate transactions, a trusted foreign currency sustaining a far-away market. Considered together, the Louvre Abu Dhabi and the Quai Branly Museum express the same tensions and contradictions that have informed modern art since its inception.

Acknowledgments

So many colleagues have contributed to my understanding and interpretation of the history of modern art that I cannot possibly name them all here. This revision of *History of Modern Art* benefited particularly from conversations with Aruna d'Souza, Pepe Karmel, Helen Molesworth, Shelley Rice, Julia Robinson, Kenneth Silver, Andres Zervigon and, especially, Philip Walsh. Their thoughts helped give clarity to the still unfolding history of modernism presented in the following pages. Rachel Federman contributed essential research, updating the bibliography and contributing to the book's online resources. Helen Ronan's perfectly timed and phrased editorial interventions transformed sometimes unwieldy ideas into arguments, and Donald Dinwiddie, Lis Ingles, and Emma Brown at Laurence King Publishing translated these ideas into a thoughtfully designed book.

History of Modern Art is a textbook, and its primary function is to provide an accurate account of the visual culture of modernity. Yet the book's authoritative voice is intended to provoke discussion among students and their instructors. As confident as the narrative might seem, it is the product of intellectual disagreement as well as consensus, and it is my hope that readers will come away from the text with as many questions as answers about the history of modern art. An essential forum for the kind of scholarly debate required for this project is the process of external review. I am grateful to the following referees, whose anonymous criticisms and suggestions can now be acknowledged: Cynthia Fowler, Emmanuel College; Kim Grant, University of Southern Maine; Sherri Lisota, Viterbo University; Walter Meyer, Santa Monica College; Robert Nauman, University of Colorado at Boulder; Caterina Pierre, Kingsborough Community College, CUNY; Rebecca Reynolds, University of West Georgia; Mysoon Rizk, University of Toledo; and Prudence Roberts, Portland Community College, Rock Creek.

I trust that these scholars, along with the students with whom they work, will agree that this seventh edition of *History of Modern Art* has been strengthened by their contributions to its revision.

Elizabeth Mansfield
February 2012
New York, NY

Why Use this Seventh Edition

In response to requests from instructors and students across the country, *History of Modern Art* is more user friendly than ever. Every effort has been made to secure as many pictures as possible in full color. In addition to the numerous content improvements to every chapter detailed below, *History of Modern Art* is now offered in a variety of formats—all with digital images for instructors—to suit any course need. See inside front cover for details.

New Digital Resources

Instructor PowerPoints

Powerpoints for nearly every image in the book are available to adopting instructors.

To request access to the collection, please visit **www.mysearchlab.com**

MySearchLab with eText

The Pearson eText available within **MySearchLab** lets students access their textbook any time, anywhere, and any way they want. The eText is enriched with multimedia including video links to Art21 clips and many other resources. Just like the printed text, students can highlight relevant passages and add their own notes. For even greater flexibility, students can download the eText to a tablet using the free Pearson eText app.

MySearchLab with eText offers a variety of research, writing, and citation tools, including *Writing About Art* by Henry Sayre, to help students hone key skills. With access to various academic journals, news feeds, and primary source readings, students are just a few clicks away from trusted source materials. Quizzes are also available for every chapter, enabling both instructors and students to track progress and get immediate feedback.

Please contact your local representative for ordering details or visit www.pearsonhighered.com/art.

Chapter-by-chapter Revisions

Chapter 1

A streamlined introduction to the origins of modern art commences with the famous Whistler vs. Ruskin trial. Traditional, academic approaches to art making are here explained in order to highlight modernity's challenges to long-held expectations about the forms artworks should take and the audiences they should address.

Chapter 2

A more nuanced discussion of Realism sharpens the distinctions among the various movements and techniques described under this heading. The role of photography in shaping the idea of Realism in the nineteenth century is given particular attention, contributing to an overall sensitivity to the relevance of medium and technique for understanding progressive art of this period. Impressionism is characterized as both indebted to and departing from Realism, a shift explored in relation to contemporary history as well as aesthetics. Women artists' contributions are fully integrated into the chapter, as is the significance of the female nude as a persistent subject of modern art.

Chapter 3

Acknowledging the historiography of the unwieldy designation "Post-Impressionism," this chapter focuses on the diverse artistic movements that emerged in France in the decades following the devastating Franco-Prussian War and Paris Commune. It now demonstrates that Post-Impressionism emerged as much from specific social conditions as from particular aesthetic concerns, and lengthy treatments of artists' biographies have been replaced with closer analyses of fewer artworks.

Chapter 4

Architecture's central role for Arts and Crafts and Art Nouveau is made clear by treating together the range of techniques and media addressed by these movements. Sculpture's importance, too, receives greater emphasis. The Wiener Werkstätte is now cast in relation to Arts and Crafts, as well as Jugendstil.

Chapter 5

This chapter on Fauvism crystallizes around the work of Henri Matisse and Constantin Brancusi. The relationship between photography and early twentieth-century experiments in expressive form and color is sharpened, with special note taken of Brancusi's use of photography as part of his artistic process.

Chapter 6

Not merely confined to the fine arts, German and Austrian Expressionism produced important works of decorative art and architecture, and examples are now included in order to give a more accurate account of the movement's scope. Expressionism's preoccupation with the theme of the female nude receives focused attention, and the theme

is examined in relation to contemporary social conventions as well as to broader aesthetic trends within modernism.

Chapter 7

Cubism emerged at a particular moment in European cultural history, and the social conditions particular to France in the early years of the twentieth century are discussed in order to give greater context to the artistic experiments undertaken by Picasso and Braque. Cubism's distinct aesthetic concerns—as grounded in art-historical tradition as in contemporary innovations by artists like Cézanne—are treated at length, but not as ideas divorced from history.

Chapter 8

To enable a better understanding of early twentieth-century architecture, photographs of buildings have been updated with an eye toward providing as close an interpretation of the sites' original appearance as possible. Additional plans further augment the chapter's presentation of architecture. The concept of functionalism has been elaborated to provide a stronger theoretical context for the buildings discussed.

Chapter 9

The international character of the European response to Cubism is conveyed by highlighting the strong connections forged in Paris by artists of diverse nationalities. Italian and Russian artists are singled out for sustained treatment as conduits for artistic innovations that would lead to the emergence of such movements as Futurism and Constructivism.

Chapter 10

New, sometimes stark, images have been added to this chapter in order to convey the depth of the social and cultural rupture caused by World War I. The intense outrage, confusion, and despair felt by those who experienced the war is unleashed through a variety of cultural strategies, including Dada and the New Objectivity.

Chapter 11

The artistic response to World War I is further explored in a chapter devoted to the Paris scene. There, the importance of art dealers in the promotion of avant-garde art is especially evident, and the role of the dealer is given renewed consideration. Artists, critics, dealers, and patrons were all deeply affected by the war, and each of these groups contributed momentum to the cultural "Call to Order" that characterizes the post-war period .

Chapter 12

New architectural views and plans have been added to enhance this chapter devoted to the de Stijl movement. The complex significance accorded to abstraction by Piet Mondrian is elaborated, with his ongoing spiritual investigations seen as alternately complementary to and at odds with the materialist social utopianism of the de Stijl project.

Chapter 13

Like the de Stijl movement, the Bauhaus was founded on the principle of arts integration in pursuit of a unified aesthetic. To support this account of the Bauhaus, clearer and more historically accurate images have been introduced.

Chapter 14

Surrealism's reliance on concepts derived from Freud's theories contributes to the movement's presumptions regarding femininity as a dangerous yet irresistibly seductive manifestation of the psyche. The movement's representation of women, along with its ambivalence toward women artists, now comes under sharper critique. Photographer Dora Maar's work is now included in the chapter.

Chapter 15

A restyled chapter on modern art produced in America prior to World War II begins with a consideration of Romaine Brooks. Her career provides an entry point for the chapter's look at American artists' relationship to the European avant-garde. Social concerns that especially animated progressive American artists are discussed, as well as their visual responses to conditions like urban poverty, child labor, and isolationism.

Conclusion

This is, in fact, a condensed introduction to the emergence of American modernism, presenting selected works with in-depth discussion. The focus here is on Abstract Expressionism, and this chapter provides a coda to the first part of modernism's history as the creation of avant-garde art becomes a global, rather than a largely European, form of cultural expression.

1
The Origins of Modern Art

"I have seen, and heard, much of cockney impudence before now; but never expected a coxcomb to ask two hundred guineas for flinging a pot of paint in the public's face."

John Ruskin, *Fors Clavigera*, 1877

With this affront, John Ruskin (1819–1900) touched off a firestorm in the staid art world of late Victorian Britain. Ruskin was Britain's most influential art critic. The target of his attack: **James McNeill Whistler**'s painting, *Nocturne in Black and Gold: The Falling Rocket* (fig. **1.1**). Ruskin's acidic review—in which he essentially accused the painter of being a charlatan whose only aim was to bilk art collectors of their money—provoked Whistler (1834–1913) to sue the critic for libel. The case went to court in 1878. The trial drew many spectators, eager to watch the eminent critic spar with the famously witty artist. Few observers were disappointed: according to newspaper accounts Whistler's testimony was loaded with irony and sarcasm. For instance, when Ruskin's attorney, John Holker, questioned the success of *Nocturne in Black and Gold*, asking of Whistler: "Do you think you could make me see beauty in that picture?" Whistler replied dryly: "No ... I fear it would be as impossible as for the musician to pour his notes into the ear of a deaf man."

As amusing as these theatrics were, there were nonetheless important issues at stake for the history of modern art. In many ways, the defendant in the case was not simply the art critic John Ruskin, but art—especially modern art—itself. What was in the balance here? One weighty question concerned the role of art in society. Ruskin believed that art possessed the power to improve society. For him, this was accomplished chiefly through an artwork's ability to represent nature faithfully. To encounter nature in its purity and grandeur, for Ruskin, was to contemplate the divine. Artists who adhered to his doctrine of "truth to nature" could, he thought, promote moral virtue as well as aesthetic pleasure. In Whistler's *Nocturne in Black and Gold*, Ruskin found neither the moral nor the pictorial clarity he desired. Whistler's attempt to capture the dazzling effects of a fireworks display over the Thames through startling, explosive brushwork defied the critic's understanding of nature as a product of divine creation.

Whistler subscribed to a very different understanding of art's purpose. An adherent of the doctrine of "Art for Art's Sake," Whistler believed that true art served no social purpose whatsoever. Followers of the Art for Art's Sake doctrine (see *Gautier, Preface to Mademoiselle de Maupin*, p. 2) held social utility under suspicion if not contempt, believing that a work's usefulness threatened to detract from its purely aesthetic purpose. "Art," Whistler explained, "has become foolishly confounded with education." For supporters of Art for Art's Sake, beauty was simply the measure of a work's ability to stimulate a pleasing aesthetic sensation. The

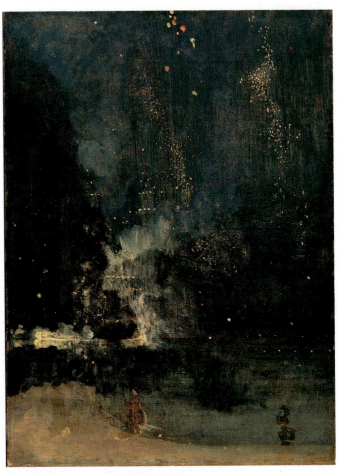

1.1 James McNeill Whistler, *Nocturne in Black and Gold: The Falling Rocket*, c. 1875. Oil on panel, 23 × 18″ (60.3 × 46.4 cm). Detroit Institute of Arts, Detroit.

SOURCE

Théophile Gautier
Preface to *Mademoiselle de Maupin* (1835)

The first statement of Art for Art's Sake appeared in Gautier's preface to a novel. Critics and censors found the preface objectionable for its seeming hedonism.

…Someone has said somewhere that literature and the arts influence morals. Whoever he was, he was undoubtedly a great fool. It was like saying green peas make the spring grow, whereas peas grow because it is spring…. Nothing that is beautiful is indispensable to life. You might suppress flowers, and the world would not suffer materially; yet who would wish that there were no flowers? I would rather give up potatoes than roses…. There is nothing truly beautiful but that which can never be of any use whatsoever; everything useful is ugly, for it is the expression of some need, and man's needs are ignoble and disgusting like his own poor and infirm nature. The most useful place in a house is the water-closet.

trial of Whistler vs. Ruskin pitted not just two men against each other, but provided a forum for the debate between those who looked to art as essential to social progress and those who insisted that art transcended social concerns. This debate would continue long after the conclusion of the trial, with various modernist movements allying themselves to one or the other viewpoint.

Making Art and Artists: The Role of the Critic

Ruskin's insistence on the ability of art to improve society led him to develop ways of bringing fine arts education to members of the working class. In addition to sponsoring art exhibitions and lectures for working-class audiences, Ruskin published a newsletter he hoped would appeal to working-class readers. It was in this newsletter, *Fors Clavigera*, that he published his provocative review of Whistler's painting. Ruskin's advocacy for the working class and his efforts to provide laborers with access to forms of culture typically beyond their experience likewise colored the clash between critic and artist. On the one hand, Ruskin's condemnation of Whistler's painting speaks to his interest in supporting art that offers an immediate and accessible social message. On the other hand, Ruskin drew on class-based stereotypes in his denigration of the artist. By attributing to Whistler a "cockney impudence," Ruskin delivers an insult that turns on class differentiation: the adjective "cockney" was used in the nineteenth century to designate a Londoner who lacked the refinement of the gentry. In this way, Ruskin not only tapped into Whistler's well-known sensitivity about his social status but also exposed the persistence of class as a means of differentiating artists from their patrons. As subsequent chapters will show, this divide between artists and patrons, between those who create art and those who consume it, troubled many modern artists.

Along with such artists, many critics of modern art sought to bridge the divide between culture and its diverse potential audiences. Art criticism as a distinct literary or journalistic activity emerged in the eighteenth century in response to the proliferation of public venues for exhibiting art. Prior to that, artworks had remained largely confined to the private galleries of the nobility or other wealthy collectors. For the most part, only religious art was regularly viewed by the general public. By the early eighteenth century, this had changed. Not only were art dealers and even auctioneers beginning to stage public displays of their wares, but large-scale exhibitions were being mounted throughout Western Europe, following the French model of public exhibitions sponsored by the monarchy. In France, these exhibitions were known as **Salons** because of the name of the room in which they were originally held at the Louvre Palace: the Salon Carré or "Square Parlor." The Paris Salon took place regularly, usually every two years, and would feature hundreds of artworks, mostly by members of France's Royal Academy of Painting and Sculpture. Works by promising Academy students as well as prominent foreign artists were also shown. An official, public event, the Salon was open to anyone who wished to view the works on display. Other European countries soon followed France's example, leading to a proliferation of regular public exhibitions in all the major European capitals by the early nineteenth century.

In the early years of the Salon, the unprecedented access to artworks brought viewers face to face with an often confusing variety of subjects, styles, and media. To help guide visitors through the exhibitions, self-appointed arbiters of aesthetic quality began to write reviews, which would then be disseminated as pamphlets, in newspapers, or by private subscription. It did not take long for the art critics to have an effect on public taste. Even artists occasionally followed the advice of critics in their pursuit of public approbation.

Of great interest to early critics of the Salon was the specific genre pursued by different artists. "**Genre**" refers generally to the type of subject represented in a painting. There were five main genres: history (depicting biblical, mythological, or historical subjects), landscape, portrait, **still life**, and (slightly confusingly) "**genre painting**" (scenes of everyday life). The French Royal Academy, at the time of its foundation in 1648, held that **history painting** was the greatest achievement for a painter because historical subjects demanded erudition as well as the highest degree of technical skill. Based on subjects from ancient or modern history, classical mythology, or the Scriptures, history painting required a thorough knowledge of important literary and historical texts. What is more, most history paintings were expected to present one or more heroic figures, often depicted nude, so anatomy and life drawing were an essential part of a history painter's education. Finally, history paintings are often set in real or imagined towns, on battlefields, or in other landscapes, and thus required the ability to execute works in that genre as well. As vaunted as history painting was by the Academy, early critics, such as Denis Diderot, often guided their readers toward other genres

such as landscape, still life, and genre painting. Among the most attentive readers of art criticism were art dealers and collectors. This remains the case today.

A Marketplace for Art

As mentioned above, many of the earliest public exhibitions of artwork were organized by dealers and auctioneers. This phenomenon marks an important shift in the role of art in society. Economic changes in Western Europe—the seventeenth-century expansion of mercantilism, which depended on favorable international trade balances and sales of manufactured goods, and the eighteenth-century development of capitalism, which encouraged the further spread of manufacturing beyond the limits of state control to encompass private investment as well—contributed to the ascendance of the bourgeoisie, a class of citizens with newly acquired economic strength and a taste for the fashions and habits of the nobility (see *Modernity and Modernism*, opposite). Collectors from the middle as well as upper registers of society now sought to fill their homes with beautiful things, including artworks, creating a demand especially for small paintings and tabletop sculptures that would fit comfortably in a townhouse or apartment. Thus, during the eighteenth century, a market force was introduced into the art world, leading to a proliferation in the nineteenth century of smaller works with themes suited to a bourgeois domestic interior. It is precisely this market, in fact, to which Whistler hoped to appeal with the modest scale and striking effects of his *Nocturne in Black and Gold*, a painting that measures less than two feet high and a foot and a half wide.

All of these currents—art's role in society, increasing class tension, proliferating art exhibitions, the growing influence of art critics, and the expanding market for art—converged in the Whistler vs. Ruskin trial. And all of these phenomena contributed to the development of modern art. But perhaps more than any of these pressures, the real issue motivating Whistler's confrontation with Ruskin involved a problem fundamental to modernism: What is art? Whistler in fact offered an answer to this question during the trial. When attorney Holker attempted to clear his client of libel by indicating that Whistler really was a charlatan committing fraud, he pointed out that *Nocturne in Black and Gold* could not possibly be a finished artwork because there simply had not been sufficient labor or time invested in the piece. Holker asked, "Did it take you long to paint the *Nocturne in Black and Gold*? How soon did you knock it off?" Whistler replied, "Oh, I knock one off in a couple of days." The barrister then asked Whistler if it was merely "the labour of two days" for which he charged more than £200? To this question Whistler responded, "No, I ask it for the knowledge of a lifetime."

Whistler won the case. Though it was a pyrrhic victory for the painter, whose receipt of only a farthing—less than a penny—in damages cast him into bankruptcy, Whistler's statement nonetheless announces the establishment of one of modernism's central tenets: that art is first and foremost the manifestation of an individual's emotional and intellectual will.

The Modern Artist

The notion that an artwork is fundamentally the expression of a particular artist's thoughts or desires seems obvious today. But this has not always been the case. The idea that Whistler put forward is rooted—like many sources of modernism—in the eighteenth century. Until the late eighteenth century, artists in the West since the Renaissance had understood their work as part of a tradition going back to classical antiquity. Though each artist was expected to contribute uniquely to this tradition, the practice of emulation remained central to any artist's training. Young artists would learn to create by first copying works acknowledged as superior examples of their genre, style, or **medium**. Only after a student fully understood the work of earlier artists and was able to reproduce such examples faithfully could he or she go on to create new forms. But even then, new works were expected to contribute to established traditions. This was the method of training used at art academies throughout Western Europe from the seventeenth through the nineteenth centuries. Artists achieved success by demonstrating their inventiveness *within the tradition* in which they worked.

For instance, one of the consummate achievements of eighteenth-century French academic art is **Jacques-Louis**

David's **Neoclassical** painting *The Oath of the Horatii* (fig. **1.2**). The subject is taken from classical sources and had been treated earlier by other painters. For his version, David (1748–1825) emulates the crisp linearity, rich colors, and sculptural treatment of figures by earlier painters such as Nicolas Poussin, relying on him for the clear, geometrical arrangement: the bold pentagon holding old Horatio and his sons, the oval grouping of despondent women on the right. David has radically compressed the clear, stage-like architectural setting in emulation of ancient **relief** sculpture. Of course, David's treatment of the theme as well as his rendering of figures and space was heralded for its freshness and novelty at the time of its initial exhibition in 1785. At this time, however, novelty and originality were subsumed within the conventions of artistic tradition.

What Does It Mean to Be an Artist?: From Academic Emulation toward Romantic Originality

The emphasis on emulation as opposed to novelty begun to lose ground toward the end of the eighteenth century when a new weight was given to artistic invention. Increasingly, invention was linked with imagination, that is to say, with the artist's unique vision, a vision unconstrained by academic practice and freed from the pictorial conventions that had been obeyed since the Renaissance. This new attitude underlies the aesthetic interests of **Romanticism**. Arising in the last years of the eighteenth century and exerting its influence well into the nineteenth, Romanticism exalted humanity's capacity for emotion. In music, literature, and the visual arts, Romanticism is typified by an insistence on subjectivity and novelty. Today, few would argue that art is simply the consequence of creative genius. Romantic artists and theorists, however, understood art to be the expression of an individual's will to create rather than a product of particular cultural as well as personal values. Genius, for the Romantics, was something possessed innately by the artist: It could not be learned or acquired. To express genius, then, the Romantic artist had to resist academic emulation and instead turn inward, toward making pure imagination visible. The British painter and printmaker **William Blake** (1757–1827) typifies this approach to creativity.

Producing prophetic books based in part on biblical texts as well as on his own prognostications, Blake used his training as an engraver to illustrate his works with forceful, intensely emotional images. His depictions of familiar

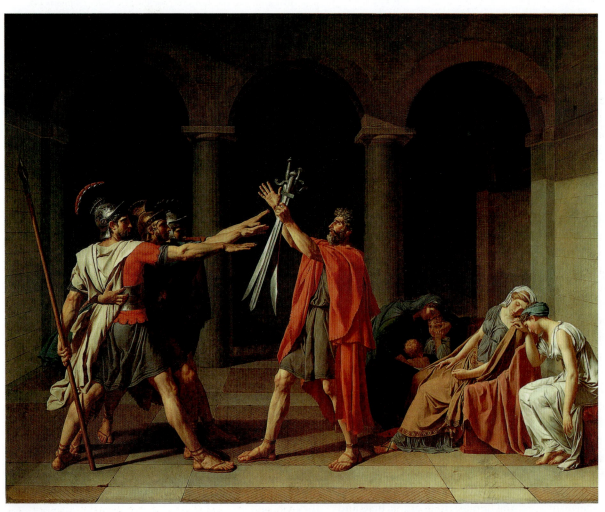

1.2 Jacques-Louis David, *The Oath of the Horatii*, 1784. Oil on canvas, 10' 10" × 14' (3.4 × 4.3 m). Musée du Louvre, Paris.

View the Closer Look for *The Oath of the Horatii* on mysearchlab.com

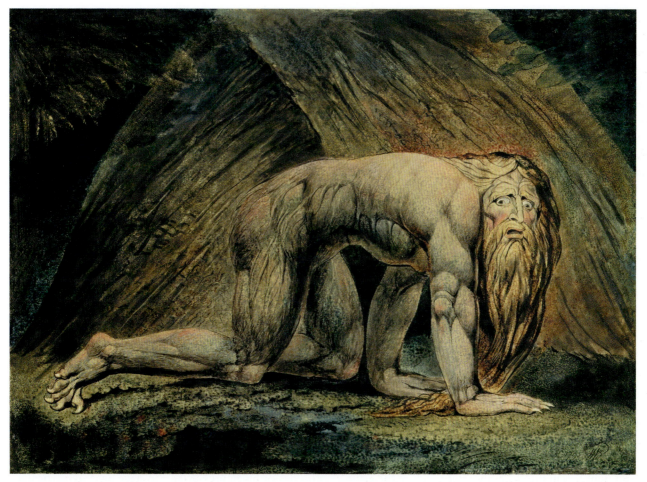

1.3 William Blake, *Nebuchadnezzar*, 1795. Color print finished in ink and watercolor on paper, 21 × 28″ (54.3 × 72.5 cm). Tate, London.

biblical personages, for instance, momentarily evoke for the viewer conventional representations before spinning away from the familiar into a strange new pictorial realm. His rendering of *Nebuchadnezzar* (fig. **1.3**) shows the Babylonian king suffering the madness described in the Book of Daniel. The nudity and robust muscularity of the king might initially remind the viewer of the heroic Old Testament figures who people Michelangelo's Sistine Chapel ceiling, but the grimacing expression and distortions of the figure—which emphasize the king's insanity as he "did eat grass as oxen"—quickly dispel thoughts of classical prototypes or quiet grandeur.

With Jacques-Louis David and William Blake, we have representatives of the two dominant art styles of the late eighteenth century: Neoclassicism and Romanticism. Both of these styles—along with the growing influence of art criticism, a proliferation of public art exhibitions, and an expansion in the number of bourgeois patrons and collectors—helped to lay the foundations of modern art. David's Neoclassicism carried into the nineteenth century an awareness of tradition along with a social conscience that enabled art to assume a place at the center of political as well as cultural life in Europe. Blake's Romanticism poured a different strain into the well from which modern art is drawn. With its insistence that originality is the mark of true genius, Romanticism demands of modern art an unceasing pursuit of novelty and renewal.

Making Sense of a Turbulent World: The Legacy of Neoclassicism and Romanticism

Neoclassicism, which dominated the arts in Europe and America in the second half of the eighteenth century, has at times been called a derivative style that perpetuated the classicism of Renaissance and Baroque art. Yet in Neoclassical art a fundamental Renaissance visual tradition was seriously opposed for the first time—the use of perspective to govern the organization of pictorial space. Perspective refers to a system for representing three dimensions on a two-dimensional surface, creating the illusion of depth. Artists since the Renaissance have used two main techniques for accomplishing this: **linear perspective** and **atmospheric perspective**. Linear perspective suggests the recession of space through the use of real or implied lines, called "orthogonals," which seem to converge at a point in the distance. Atmospheric perspective imitates the tendency of distant objects to appear less distinct to give the illusion of depth. It may be argued that David's manipulation of perspective was crucial in shaping the attitudes that led, ultimately, to twentieth-century **abstract art**.

David and his followers did not actually abandon the tradition of a pictorial structure based on linear and atmospheric perspective. They were fully wedded to the idea that

a painting was an adaptation of classical relief sculpture: they subordinated atmospheric effects; emphasized linear contours; arranged their figures as a **frieze** across the picture plane and accentuated that plane by closing off pictorial depth through the use of such devices as a solid wall, a back area of neutral color, or an impenetrable shadow. The result, as seen in *The Oath of the Horatii*, is an effect of figures composed along a narrow stage behind a proscenium, figures that exist in space more by the illusion of sculptural modeling than by their location within a pictorial space that has been constructed according to principles of perspective.

The clearest formal distinction between Neoclassical and Romantic painting in the nineteenth century may be seen in the approaches to **plastic** form and techniques of applying paint. Neoclassicism in painting established the principle of balanced frontality to a degree that transcended even the High Renaissance or the seventeenth-century classicism of Nicolas Poussin. Romantic painters relied on diagonal recession in depth and indefinite atmospheric–coloristic effects more appropriate to the expression of the inner imagination than the clear light of reason. The Neoclassicists continued the Renaissance tradition of glaze painting to attain a uniform surface unmarred by the evidence of active brushwork, whereas the Romantics were more experimental, sometimes reviving the richly **impastoed** surfaces of Baroque and **Rococo** paintings. During the Romantic era there developed an increasingly high regard for artists' sketches, which were thought to capture the evanescent touch of the artist, thereby communicating authentic emotion. Such attitudes were later crucial for much abstract painting in America and France following World War II (see Chapters 17 and 18).

Printmaking likewise experienced a resurgence. Eager to exploit the capacity of prints to produce multiple copies,

Romantic artists sought techniques that would endow prints with the spontaneity of drawings (see *Printmaking Techniques*, below). Blake created experimental relief **etchings** to pursue this interest. Romantic artists also quickly embraced the new process of **lithography** in order to achieve their goals. Among the earliest Romantic artists to utilize this medium was **Théodore Géricault** (1791–1824). His *Horse Devoured by a Lion* from 1820–21 (fig. **1.4**) uses lithography to explore a favorite Romantic theme: the nobility of animals in the face of unpitying nature. The immediacy of the lithographic line contributes to the subject's drama, while Géricault's manipulation of tone delivers velvety black passages that recede ominously in the background, framing the terrifying jaws of the lion.

History Painting

David and his followers tended toward history painting, especially moralistic subject matter related to the philosophic ideals of the French Revolution and based on the presumed stoic and republican virtues of early Rome. Yet painters were hampered in their pursuit of a truly classical art by the lack of adequate prototypes in ancient painting. There was, however, a profusion of ancient sculpture. Thus, it is not surprising that Neoclassical paintings such as *The Oath of the Horatii* (see fig. 1.2) should emulate sculptured figures in high relief within a restricted stage, which David saw in Rome, where he painted *The Oath*. The "moralizing" attitudes of his figures make the stage analogy particularly apt. Although commissioned for Louis XVI, whom David, as a deputy of the Revolutionary government, later voted to send to the guillotine, this rigorous composition of brothers heroically swearing allegiance to Rome came to be seen as a manifesto of revolutionary sentiment.

TECHNIQUE

Printmaking Techniques

Prior to the invention of photography, the easiest way to reproduce images was through printmaking. Some artists were particularly drawn to this, often preferring the intimate scale and wide circulation afforded by prints. Two techniques—aquatint and lithography—became especially popular among Romantic artists. Aquatint offered printmakers the ability to create passages of rich tone, ranging from pale grays to deep blacks. Early printmaking techniques—such as engraving—tended to rely on line only, which made it difficult to render shading. Engraving involves incising a line into a metal plate using a sharp instrument called a "burin." Once the design is inscribed onto the plate, ink is applied to the surface. The ink settles into the lines and the surface of the plate is wiped clean. A piece of paper is then placed atop the design and, to receive the ink resting in the incised lines, the plate and paper are run through a printing press that exerts enough pressure to force the paper into the line where it receives the ink. But how to reproduce areas of tone, like a wash, rather than just line? With aquatint a fine powdered resin is sprinkled onto the metal printing plate, which is heated so the resin melts and adheres

in a pebbled pattern. By dipping the plate into a pan of acid, the parts of it not covered by the resin are eaten away by the acid. This area, like the line of an engraving, holds ink for transfer onto a print. By using different patterns and thicknesses of resin along with varying strengths of acid, the tonal range of an aquatint can be manipulated. Lithography is a different technique altogether, and does not require the metal plate used in engraving and aquatint. With lithography, the artist uses a crayon or other grease-based medium to draw a design onto a specially prepared block of porous limestone. Water applied to the surface is absorbed by the porous stone but repelled by the greasy ink. An oil-based ink is then applied to the surface: because of the natural repulsion between oil and water, the ink remains only on the areas marked by the artist. This surface can then be covered by a sheet of paper and run through a press using much less pressure than for an engraving or an aquatint. Lithography, because it does not require incising into a metal plate or the use of noxious acids, allows artists to work much as they would when drawing, which accounts for the often free and spontaneous character of lithographs.

1.4 Théodore Géricault, *Cheval Devoré par un Lion* (*Horse Devoured by a Lion*), 1820–21. Lithograph; black lithographic ink on prepared "stone" paper, 10¹³⁄₁₆ × 14⁹⁄₁₆" (27.4 × 37 cm). British Museum, London.

Of course, not all Neoclassical painters used the style in support of overtly moralizing or didactic themes. **Jean-Auguste-Dominique Ingres** (1780–1867), a pupil of David who during his long life remained the exponent and defender of the Davidian classical tradition, exploited Neoclassicism for its capacity to achieve cool formal effects, leaving political agitation to others. His style was essentially formed by 1800 and cannot be said to have changed radically in works painted at the end of his life. Ingres represented to an even greater degree than did David the influence of Renaissance classicism, particularly that of Raphael. Although David was a superb colorist, he tended to subordinate his color to the classical ideal. Ingres, on the contrary, used a palette both brilliant and delicate, combining classical clarity with Romantic sensuousness, often in liberated, even atonal harmonies of startling boldness (fig. **1.5**). His *Grande Odalisque*, though not a figure from any specific historical or mythological text, maintains the

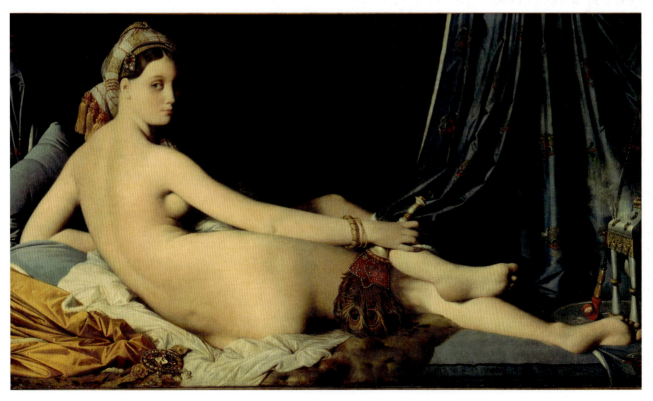

1.5 Jean-Auguste-Dominique Ingres, *Grande Odalisque*, 1814. Oil on canvas, 36 × 64" (91 × 162 cm). Louvre, Paris.

1.6 Jean-Auguste-Dominique Ingres, *Roger Delivering Angelica*, 1818. Graphite on white woven paper, 6¾ × 7¾" (17.1 × 19.7 cm). Harvard University Art Museums, Fogg Art Museum, Cambridge, MA. Bequest of Grenville L. Winthrop.

View the Closer Look to see another of Ingres's paintings on mysearchlab.com

monumentality and idealization typical of history painting. Ingres's preoccupation with tonal relationships and formal counterpoints led him to push his idealization of the female body to the limits of **naturalism**, offering abstractions of the models from which he worked.

The sovereign quality that Ingres brought to the classical tradition was that of drawing, and it was his drawing, his expression of line as an abstract entity—coiling and uncoiling in self-perpetuating complications that seem as much autonomous as descriptive—that provided the link between his art and that of Edgar Degas and Pablo Picasso (fig. **1.6**).

One of the major figures of eighteenth- and nineteenth-century Romantic history painting, who had a demonstrable influence on what occurred subsequently, was the Spaniard **Francisco de Goya y Lucientes** (1746–1828). In a long career Goya carried his art through many stages, from penetrating portraits of the Spanish royal family to a particular concern in his middle and late periods with the human propensity for barbarity. The artist expressed this bleak vision in monstrously fantastical scenes of human depravity. Like Géricault and Blake, he pursued printmaking, exploiting the relatively new medium of aquatint to endow his etchings with lush **chiaroscuro** effects. His brilliant cycle of prints, *The Disasters of War* (fig. **1.7**), depicts the devastating results of Spain's popular uprisings against Napoléon's armies during the Peninsular War (1808–14), triggered by Napoléon's determination to control the ports of Portugal and Spain. Facing certain invasion, the Spanish monarchy agreed to an alliance with the French emperor who nevertheless gave his army free rein to pillage Spanish towns as they marched to

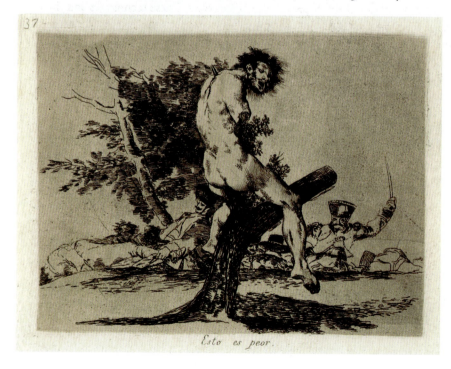

1.7 Francisco de Goya y Lucientes, "This Is Worse," Plate 37 from *The Disasters of War*, 1810–11. Etching, 1863 edition, image 5 × 6⅛" (12.8 × 15.5 cm). The Metropolitan Museum of Art, New York.

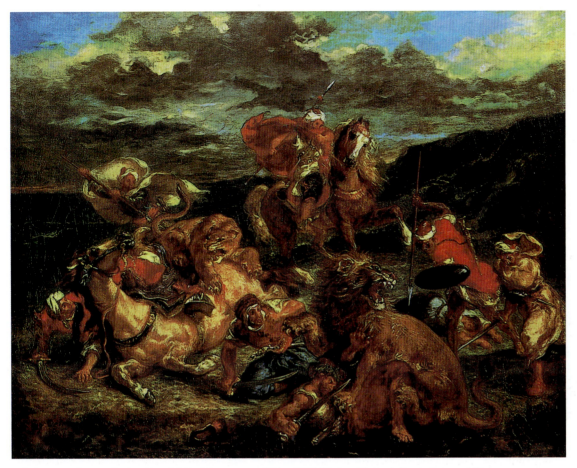

1.8 Eugène Delacroix, *The Lion Hunt*, 1861. Oil on canvas, 30⅛ × 38¾" (76.5 × 98.4 cm). The Art Institute of Chicago.

View the Closer Look to see another of Delacroix's paintings on mysearchlab.com

Portugal. In one of the most searing indictments of war in the history of art, Goya described, with reportorial vividness and personal outrage, atrocities committed on both sides of the conflict. While sympathetic to the modern ideas espoused by the great thinkers of the Enlightenment, or the Age of Reason, Goya was simultaneously preoccupied with the irrational side of human nature and its capacity for the most grotesque cruelty. Because of their inflammatory and ambivalent message, his etchings were not published until 1863, well after his death. During his lifetime Goya was not very well known outside Spain, despite his final years in voluntary exile in the French city of Bordeaux. Once his work had been rediscovered by Édouard Manet in the mid-nineteenth century it made a strong impact on the mainstream of modern painting.

The French Romantic movement really came into its own with **Eugène Delacroix** (1798–1863)—through his exploration of exotic themes, his accent on violent movement and intense emotion, and, above all, through his reassertion of Baroque color and emancipated brushwork (fig. **1.8**). He brought the same qualities to more conventional subjects drawn from literature and history. Not surprisingly, Delacroix felt drawn to scenes taken from Shakespeare, whose characters often succumb to their passions for power or love. Delacroix's intensive study of the nature and capabilities of color derived not only from the Baroque but also from his contact with English painters such as John Constable, Richard Bonington, and Joseph Mallord William Turner. His greatest originality, however, may lie less in the freedom and breadth of his touch than in the way he juxtaposed colors in blocks of mutually intensifying complementaries, such as vermilion and blue-green or violet and gold, arranged in large sonorous chords or, sometimes, in small, independent, "divided" strokes. These techniques and their effects had a profound influence on the Impressionists and Post-Impressionists, particularly Vincent van Gogh (who made several copies after Delacroix) and Paul Cézanne.

Landscape Painting

Fascinated with the awesome power of nature, Romantic artists were, not surprisingly, drawn to the genre of landscape painting. For some painters, the landscape offered a manifestation of the sublime, the rational workings of a deity; for others, a symbol of humanity's helplessness in the face of an irrational fate. Either way, the landscape served as a forceful vehicle for Romantic meditations on the limits of human understanding and the fragility of civilization. Landscape paintings were also much sought after by early nineteenth-century patrons, who could accommodate scenes of familiar as well as distant lands in their homes more easily than they could hang large-scale history paintings depicting arcane subjects from classical texts.

Although the main lines of twentieth-century painting are traditionally traced to French art, Romantic treatments of

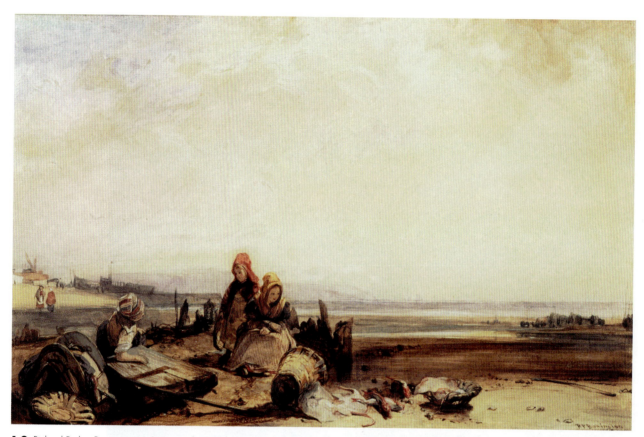

1.9 Richard Parkes Bonington, *A Scene on the French Coast*, c. 1825. Watercolor and pencil on paper, 8¼ × 13⅜″ (21.3 × 34.2 cm). Tate, London.

the landscape found their most characteristic manifestation in Germany. Indeed, there were critical contemporary developments in Germany, England, Scandinavia, and the Low Countries throughout much of the nineteenth century. One may, in fact, trace an almost unbroken Romantic tradition in Germany and Scandinavia—a legacy that extends from the late eighteenth century through the entire nineteenth century to Edvard Munch, the Norwegian forerunner of Expressionism, and the later German artists who admired him. Implicit in this Romantic vision is a sense that the natural world can communicate spiritual and cultural values, at times formally religious, at times broadly pantheistic.

Although landscape painting in France during the early nineteenth century was a relatively minor genre, by midcentury certain close connections with the English landscapists of the period began to have crucial effects. The painter **Richard Parkes Bonington** (1802–28), known chiefly for his watercolors, lived most of his brief life in France, where, for a short time, he shared a studio with his friend Delacroix. Bonington's direct studies from nature exerted considerable influence on several artists of the Romantic school, including Delacroix, as well as landscape painters associated with the Barbizon School, which will be discussed below. Although he painted cityscapes as well as genre and historical subjects, it was the spectacular effects of Bonington's luminous marine landscapes (fig. **1.9**) that directly affected artists such as Johan Barthold Jongkind and Eugène Boudin, both important precursors of Impressionism (see fig. 2.27). Indeed, many of the English landscapists visited France and exhibited in the Paris Salons, while Delacroix spent

time in England and learned from the direct nature studies of the English artists. Foremost among these were **John Constable** (1776–1837) and **Joseph Mallord William Turner** (1775–1851). Constable spent a lifetime recording in paint those locales in the English countryside with which he was intimately familiar (fig. **1.10**). The exhibition of several of his works, including his *The Hay Wain*, at the Paris Salon of 1824 brought him greater acclaim in France than he received in Britain. Delacroix, in particular, took to heart Constable's evocative brushwork and personal engagement with nature.

Though his paintings and the sketches he made from nature were the product of intensely felt emotion, Constable never favored the dramatic historical landscapes, with their sublime vision of nature, for which Turner was justifiably famous in his own day. Ambitious, prolific, and equipped with virtuosi technical skills, Turner was determined to make landscapes in the grand tradition of Claude Lorrain and Poussin, whose carefully constructed, Italianate landscapes defined classical landscape painting for over two centuries. Though both were French, each decided to pursue painting in the *campagna*, or countryside around Rome. Turner's first trip to Italy in 1819 was an experience with profound consequences for his art. In his watercolors and oils he explored his fascination with the often destructive forces of nature and the ever-changing conditions of light and atmosphere in the landscape. His dazzling light effects could include the delicate reflections of twilight on the Venetian canals or a dramatic view across the Thames of the Houses of Parliament in flames (fig. **1.11**). Turner's painterly style could sometimes

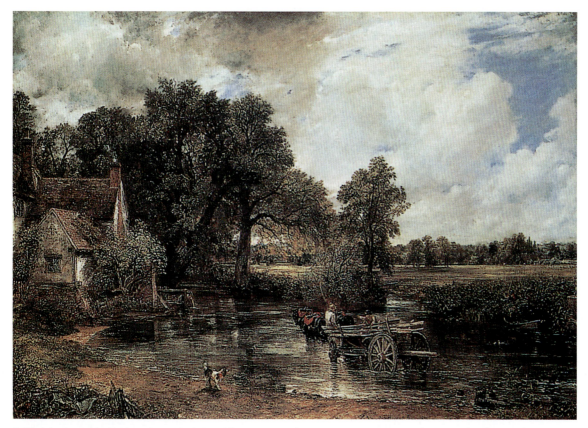

1.10 John Constable, *The Hay Wain*, 1819–21. Oil on canvas, 51¼ × 73" (130.2 × 190 cm). The National Gallery, London.

◉—|Watch| a video about Constable on myseachlab.com

verge on the abstract, and his paintings are especially relevant to developments in twentieth-century art.

The degree to which Turner's subjective exploration of nature led him toward abstraction did not deter John Ruskin from heralding the painter as the most significant of "modern" artists. Viewers looking today at Turner's *The Burning of the Houses of Parliament* alongside Whistler's *Nocturne in Black and Gold* might wonder at Ruskin's rejection of the latter. Like Turner, Whistler gives the majority of his canvas to the striking play of light and color against the sky. Both painters appeal to technical experimentation to achieve the dramatic incendiary effects at the center of their paintings. One place where the two differ, however, is in their handling of space. Turner remains true to the classical

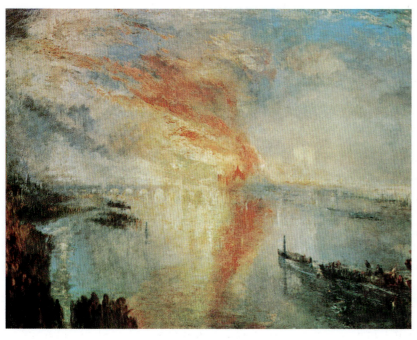

1.11 Joseph Mallord William Turner, *The Burning of the Houses of Parliament*, 1834–35. Oil on canvas, 36½ × 48½" (92.7 × 123.2 cm). The Cleveland Museum of Art. Bequest of John L. Severance. 1942.647.

✳—|Explore| more about Turner on mysearchlab.com

construction of pictorial space as divided into a clearly discernible fore-, middle-, and background. Despite its violent subject, his painting retains the balance and symmetry characteristic of classical works by Claude and Poussin. Whistler, on the other hand, abandons these conventions, plunging the viewer into an uncertain position *vis-à-vis* the flash of fireworks and their reflection on the surface of the river. What is more, Whistler's subject—the regular fireworks display over an amusement park popular among the working as well as middle classes—evokes the cheap and artificial pleasures of urban life. Turner's work instead conveys the awesomeness of nature—here, represented by the fire—which threatens to destroy a consummate symbol of civilization.

The principal French Romantic landscape movement was the Barbizon School, a loose group named for a village in the heart of the forest of Fontainebleau, southeast of Paris. The painters who went there to work drew from the seventeenth-century Dutch landscape tradition as well as that of England. Works by Bonington and Constable rather than Turner, however, had the greatest influence on the Barbizon painters. Thus, the emphasis continued to be on unified, tonal painting rather than on free and direct color. It was the interior of the forest of Fontainebleau, rather than the brilliant sunlight of the seashore, that appealed to them. This in itself could be considered a Romantic interpretation of nature, as the expression of intangibles through effects of atmosphere.

Among the artists most closely associated with the Romantic landscape of the Barbizon School was **Théodore Rousseau** (1812–67). Instead of following the classical approach by visiting Italy and painting an idealized version of the *campagna*, Rousseau deliberately turned to the French landscape for his subjects. What is more, he refused to endow his landscapes with mythological or other narrative scenes. He painted pure landscapes, believing that nature itself provided more than sufficient thematic content. In the forests around Fontainebleau Rousseau distilled the essence of French culture and nationality; not surprisingly, the period of his greatest popularity coincided with the establishment of France's brief Second Republic (1848–52). In his *Edge of the Forest of Fontainebleau, Sunset* (fig. **1.12**), Rousseau endows the scene with great intimacy by framing the view with trees that appear to bow as if acknowledging the presence of the viewer. The vegetation—especially the lone, backlit tree in the middle ground—seems more animated, more alive than even the cattle who staff the scene.

Other painters associated with the Barbizon School depended instead on a more literal human presence in order to animate their landscapes. **Jean-François Millet** (1814–75) peopled his landscapes with laborers, often treating them with a grandeur customarily reserved for biblical or classical heroes (fig. **1.13**). As if to redeem the grinding poverty of unpropertied farm life, he integrated his field laborers into landscape compositions of Poussinesque grandeur and calm. Because of this reverence for peasant subjects Millet exerted great influence on Van Gogh (see Chapter 3).

In the end, both Neoclassicism and Romanticism (and, ultimately, modernism) can be seen as products of the Enlightenment. The eighteenth-century valorization of rationality, the faith in reason exhibited by such *philosophes*

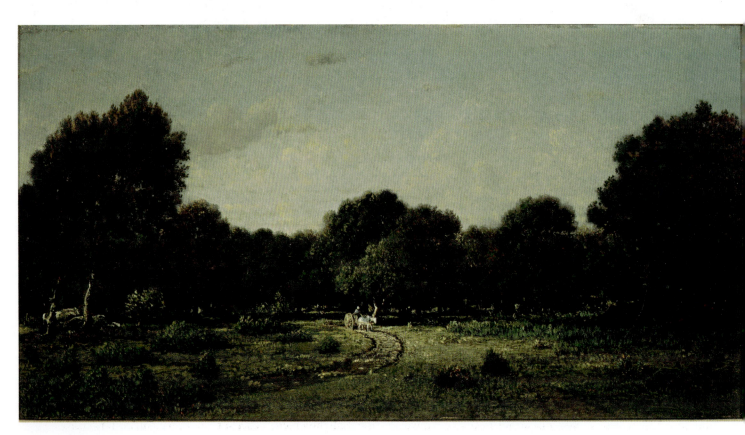

1.12 Théodore Rousseau, *Edge of the Forest of Fontainebleau, Sunset*, 1850. Oil on canvas, 55⅞ × 77⅞" (142 × 198 cm). Louvre, Paris.

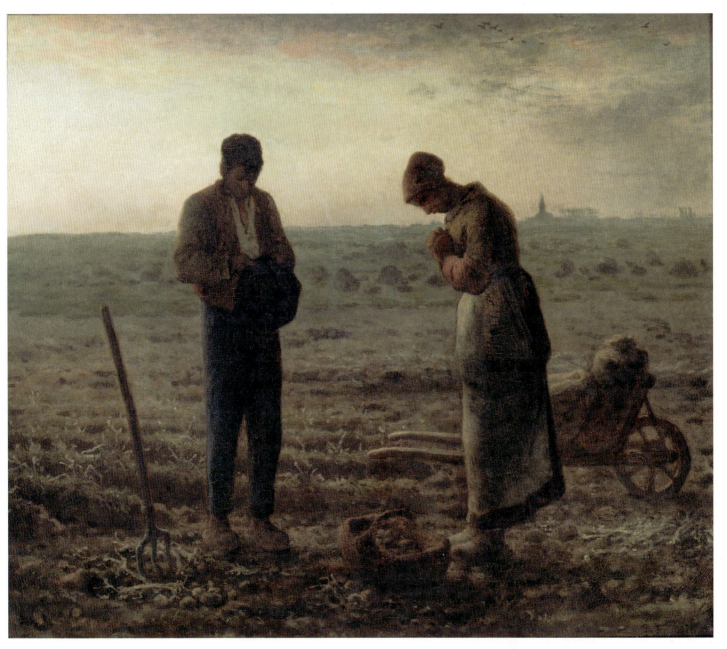

1.13 Jean-François Millet, *The Angelus*, 1857–59. Oil on canvas, 21½ × 25⅞" (55 × 66 cm). Musée d'Orsay, Paris.

Watch a video about Millet on mysearchlab.com

as Voltaire and Denis Diderot, undergirds the Neoclassical penchant for archeological accuracy, pictorial clarity, and even moral virtue. Through reason, the social as well as the natural order can be understood and, perhaps, even improved. Hence, rigorous academic training with its years of practice and emulation offered the most reliable guide to young painters. Yet, the Enlightenment had another face, a face that turned toward the emotional side of life. The *philosophe* Jean-Jacques Rousseau argued that natural, unpolluted human emotions offered the surest means of understanding truth. For Rousseau, only by feeling something could one truly know it. This strand of the Enlightenment finds itself at the center of Romanticism, where truth is sought by turning inward, where subjective experiences are the surest markers of genius. Just as, for Rousseau, conventional schools offered only corruption and lies, academic

practices struck some Romantic artists as similarly contrary to their aims.

It can fairly be said, however, that both Neoclassicism and Romanticism nourish the roots of modernism. In fact, modernism might be best understood as a struggle between the forces of objective rationality and subjective expression. At certain points in the history of modern art, one or the other might seem to gain the advantage. But the tension between the two continues to exert its influence, and the other side is never far from revealing itself. This condition makes itself felt early in the nineteenth century with the appearance of another artistic mode of representation that contributed to the evolution of modernism: Realism. A literary as well as visual style, Realism pushed the Enlightenment penchant for dispassionate rationality and social improvement to its zenith.

2

The Search for Truth: Early Photography, Realism, and Impressionism

At the start of the nineteenth century, both the Neoclassical and Romantic styles had their partisans. Typified by the work of Ingres, Neoclassicism offered viewers glimpses of an imaginary antique past or an exotic, otherworldly present rendered in a crisp, detached linearity. Romanticism, exemplified by the painting of Delacroix, likewise tended toward subjects drawn from distant cultures or literary fantasies, but depicted with an undisguised subjectivity and passionate colorism. Each offered its brand of escapism to Europeans weary of revolution and wary of the incipient imperialism emerging throughout the West. As European and North American economies grew increasingly reliant on manufacturing, many Western countries seized territories in Africa, South America, Asia, and the Pacific in search of both raw materials and new markets for their goods. Romantic depictions of colonized lands and peoples offered an appealing alternative to the reality of military occupation and economic exploitation sustaining the rise of capitalism.

Dispelling this escapism was an emphatic return to Enlightenment rationality in the form of Realism. The challenges posed by industrial expansion and political upheaval were not to be mastered by a retreat into fantasy but by a renewed search for truth. The truth promised by objective analysis and cold reason appealed to artists and writers as much as to philosophers and scientists. That **Positivism**—a philosophy that rejects metaphysical considerations in favor of a strictly empirical approach to understanding all forms of human experience—should gain adherents as a popular as well as intellectual movement gives an indication of the widespread craving for certainty, whether scientific, moral, economic, or political. Realism was the cultural response to this need.

New Ways of Seeing: Photography and Its Influence

The public taste for visual fact served as an all-important stimulant to the research that finally brought about the invention of the first practical photographic processes. The ingredients had existed, some for centuries. Ancient authors noted the use of the *camera obscura*, a dark chamber with a small aperture that projects external scenes onto the opposite wall. Lenses had likewise been in use for centuries. And the photosensitivity of silver salts—which would be used to record images in early photographs—had been familiar to chemists at least since the eighteenth century, perhaps from as early as the twelfth. So what pressed so many artists, inventors, and scientists to seek in the first decades of the nineteenth century a means of securing an image through photography? Unquestionably, industrialized Europe and North America had developed a cultural desire for the accuracy it promised. But as the earliest examples of photography demonstrate, the new medium undermined as much as it asserted its own allegiance to optical truths.

In August 1839, **Louis-Jacques-Mandé Daguerre** (1789–1851) publicly demonstrated a new mechanical technology, the **daguerreotype**, for permanently fixing upon a flat surface and in minute detail an exact tonal, if not full-color, image of the world. From that time, Western painters would hardly be able to create new imagery without some consciousness of the special conditions introduced by the medium of photography (literally "drawing with light"). Not until the twentieth century, it should be added, would photographers feel altogether free to work without deference to the rival aesthetic standards, qualities, and prestige imposed by the age-old, handwrought image-making processes of painting and drawing.

The most immediate and obvious impact of photography on painting can be seen in the work of artists eager to achieve a special kind of optical veracity unknown until then, a trend often thought to have culminated in the "instantaneity" of some Realist and Impressionist works, and resurgent in the Photorealism of the 1970s (see Chapter 23).

Other artists, however, or even the same ones, took the scrupulous fidelity of the photographic image as good reason to work imaginatively or conceptually and thus liberate their art from the requirement of pictorial verisimilitude. Some saw the aberrations and irregularities peculiar to photography as a source of fresh ideas for creating a whole new language of form. And among painters of the period were some accomplished photographers, such as Edgar Degas and Thomas Eakins. Photography could also serve painters as a shortcut substitute for closely observed preparatory drawings and as a vastly expanded repertoire of reliable imagery, drawn from any exotic-seeming corner of the

2.1 Louis-Jacques-Mandé Daguerre, An early daguerreotype, taken in the artist's studio, 1837. Société Française de Photographie, Paris.

globe into which adventurous photographers had been able to lug their cumbersome equipment.

Despite the widespread interest in photography by artists, the aesthetic status of photographs remained suspect. Institutional practices contributed to the aesthetic burden of proof placed on photographers. Photographs were not generally included in art exhibitions. For instance, at the Universal Exposition in Paris in 1855, photographs were absent from the Fine Arts galleries and instead presented in the industrial halls, highlighting their technical rather than aesthetic interest. Regardless of the contested status of photography's aesthetic merit, early photographers found their work relating closely to painting, just as painters were bound up with photography. Buoyed by pride in their technical superiority, photographers even felt compelled to match painting in its artistic achievements. For painters enjoyed the freedom to select, synthesize, and emphasize at will and thus attain not only the poetry and expression thought essential to art but also a higher order of visual,

if not optical, truth. Daguerre, who was already famous for his immense, sensationally illusionistic painted dioramas, had sought to emulate art as much as nature. This led him in 1829 to seek the assistance of Nicéphore Niépce, a French inventor whose experiments a few years previously had resulted in the earliest known permanent photographic images. The collaboration between Daguerre and Niépce led to the invention of the daguerreotype: by the time the process was made public in 1839, Niépce had died and Daguerre gave the technique its name. In one of his first successful photographs, Daguerre captured a still life arranged in a manner conventional to painting since at least the seventeenth century (fig. **2.1**). This was a daguerreotype, a metal plate coated with a light-sensitive silver solution, which, once developed in a chemical bath, resulted in a unique likeness that could not be replicated, but that recorded the desired image with astonishing clarity.

Simultaneously in England, the photographic process became considerably more versatile. **William Henry Fox Talbot** (1800–77) discovered a way of fixing a light-reflected image on the silver-treated surface of paper, producing what its creator called a "calotype." Talbot claimed that his earliest calotype dated to 1835, thus preceding the daguerreotype. Talbot's belated announcement allowed Daguerre to enjoy greater publicity and financial reward from the invention of photography, but the British inventor's process ultimately superseded that of his French rival (see *Daguerreotype versus Calotype*, below). Talbot's technique converted a negative image into a positive one, a procedure that remains core to film-based photography. Because the negative made it possible for the image to be replicated an infinite number of times, unlike the daguerreotype, painting-conscious photographers such as **Oscar G. Rejlander** (1813–75) could assemble elaborate, multifigure compositions in stage-like settings. They pieced the total image together from a variety of negatives and then orchestrated them, rather in the way history painters prepared their grand narrative scenes for

TECHNIQUE

Daguerreotype versus Calotype

Building upon the earlier experiments of the versatile inventor Nicéphore Niépce (1765–1833), Daguerre developed a photographic process in which an iodized silver plate was placed inside a rudimentary camera. When the lens was directed at the desired scene, an aperture would be manually opened for several minutes. This action would record a "latent" image on the plate, meaning that the image existed on the plate as a chemical reaction though it was not visible to the naked eye. Daguerre discovered he could reveal the latent black-and-white image by treating the plate with mercury fumes: one of many dangerous processes associated with early photography. The latent image would degrade upon exposure to additional light, however. Daguerre found the final step in the process in 1837 when he realized that a salt solution would fix the image. The resulting daguerreotype remains one of the clearest, most precise modes of photography. The main

drawback of daguerreotypes was their uniqueness: they could not be reproduced. Pursuing the invention of photography at the same time was William Henry Fox Talbot, who was familiar with the *camera obscura* as an aid to drawing. A disappointed amateur draftsman, Talbot developed a technique whereby a scene captured by a *camera obscura* would be projected onto paper coated with silver salt, thereby securing a black-and-white reproduction of it. These photographs reversed the depicted subject's brightness so that dark areas registered as light and light areas as dark. Talbot resolved this by using them as negatives. By projecting light through one and onto another piece of sensitized paper, he restored the lights and darks of the original, thus paving the wavy for numerous advances in negative-based photography during the nineteenth and twentieth centuries. Talbot called his process "calotype," meaning "beautiful type."

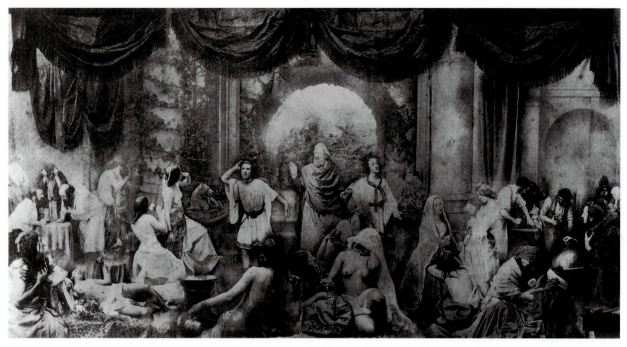

2.2 Oscar G. Rejlander, *The Two Ways of Life*, 1857. Combination albumen print. Royal Photographic Society, England.

Salon (fig. **2.2**). With his **combination prints**, Rejlander emulated not only the artistic methods and ambitions of academic masters, but also their pretensions to high moral purpose. British photographer **Henry Peach Robinson** (1830–1901) used sketches (fig. **2.3**) to prepare his elaborate exhibition photographs, which he compiled from multiple negatives (fig. **2.4**).

But just as the Realist spirit inspired some painters to seek truth in a more direct and simplified approach to subject and medium, many photographers sought to purge their work of the artificial, academic devices employed by Rejlander and instead report the world and its life candidly. One approach to achieving such immediacy is through photograms: objects are placed directly onto photosensitive paper

2.3 Henry Peach Robinson, sketch for *Carolling*, 1886–87. Pencil on paper, 13 × 25" (33 × 65.5 cm). Royal Photographic Society, England.

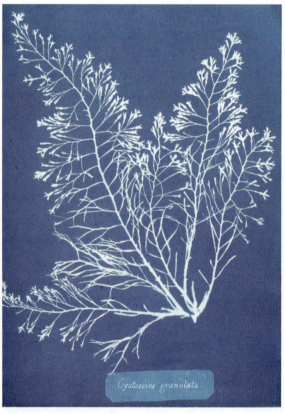

2.5 Anna Atkins, *Cystoseira granulata*, from *British Algae*, 1843–44. Cyanotype, 11¹⁄₃₂ × 8²¹⁄₃₂" (28.0 × 21.8 cm). Detroit Institute of Arts.

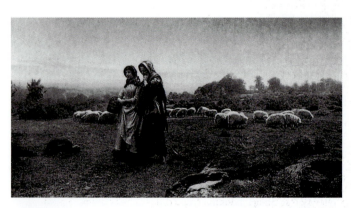

2.4 Henry Peach Robinson, *Carolling*, 1887. Combination albumen print. Royal Photographic Society, England.

which is then exposed to light. **Anna Atkins** (1799–1871) was a pioneer in this technique, creating richly hued **cyanotypes** of botanical specimens (fig. **2.5**). Atkins circulated her cyanotypes in volumes such as *British Algae* (1843–53), the first publication to be composed and printed photographically. The striking color of her photograms and their accurate yet ghostly record of plant forms point to both the aesthetic and documentary potential of photography.

For camera-based photography, other strategies could be used to enhance the medium's potential for objectivity and reportage. The practitioners of this kind of documentary photography achieved art and expression through the choice of subject, view, framing, light, and the constantly improving means for controlling the latter—lenses, shutter speeds, plates, and processing chemicals. Even the work of Daguerre and Talbot (figs. **2.6**, **2.7**) shows this taste for creating a straightforward record of the everyday world, devoid of theatrics or sentiment. Their first street scenes already have the oblique angles and random cropping of snapshots, if not the bustling life, which moved in and out of range too rapidly to be caught by the slow photosensitive materials of the 1830s and 40s. Contemporaries called Daguerre's Paris a "city of the dead," since the only human presence registered in images like *Boulevard du Temple* was that of a man who stood still long enough for his shoes to be shined and, coincidentally, for his picture to be taken.

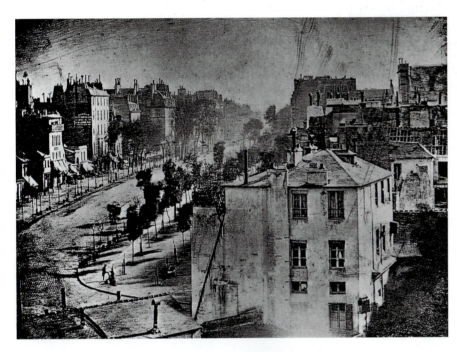

2.6 Louis-Jacques-Mandé Daguerre, *Boulevard du Temple, Paris*, c. 1838. Daguerreotype. Bayerisches Nationalmuseum, Munich.

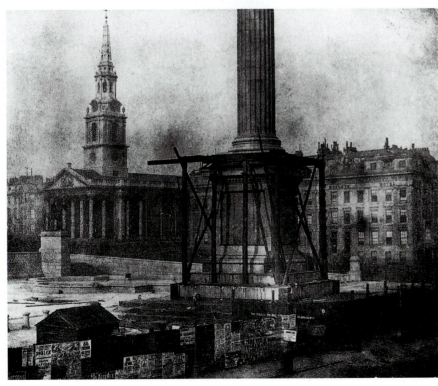

2.7 William Henry Fox Talbot, *Trafalgar Square, London, during the erection of the Nelson Column*, London, England, 1843. Salt print from a paper negative, 6¾ × 8⅜" (17.1 × 21.3 cm). The Museum of Modern Art, New York.

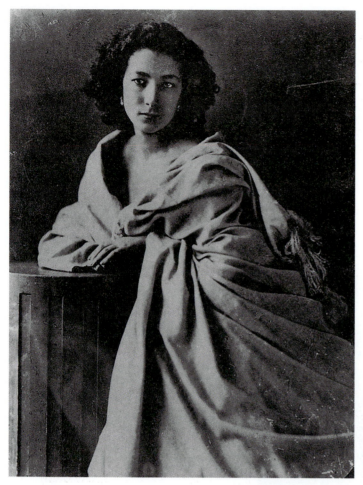

2.8 Nadar (Gaspard-Félix Tournachon), *Sarah Bernhardt*, 1864. Photograph, 9⅜ × 9⅜" (23.8 × 24.5 cm). Bibliothèque Nationale de France, Paris.

Among the first great successes in photography were the portraitists, foremost among them France's **Nadar** (Gaspard-Félix Tournachon; 1820–1910) and England's **Julia Margaret Cameron** (1815–79), whose powerful personalities gave them access to many illustrious people of the age and the vision to render these with unforgettable penetration (fig. **2.8**). A prolific writer, as well as caricaturist, hot-air balloon photographer, and dynamic man about Paris, Nadar wrote in 1856:

> Photography is a marvellous discovery, a science that has attracted the greatest intellects, an art that excites the most astute minds—and one that can be practiced by any imbecile. ... Photographic theory can be taught in an hour, the basic technique in a day. But what cannot be taught is the feeling for light. ... It is how light lies on the face that you as artist must capture. Nor can one be taught how to grasp the personality of the sitter. To produce an intimate likeness rather than a banal portrait, the result of mere chance, you must put yourself at once in communion with the sitter, size up his thoughts and his very character.

Cameron liked to dress up her friends and family and reenact scenes from the Bible and Tennyson's *Idylls of the King* (a series of poems based on the legends of King Arthur) as

photographed costume dramas. She also approached portraiture with an intensity that swept away all staginess but the drama of character and accentuated chiaroscuro (fig. **2.9**). Throughout her work, however, she maintained, like the good Victorian she was, only the loftiest aims. In answer to the complaint that her pictures always appeared to be out of focus, Cameron stated:

> What is focus—who has a right to say what focus is the legitimate focus—My aspirations are to ennoble Photography and to secure for it the character and uses of High Art by combining the real & ideal & sacrificing nothing of Truth by all possible devotion to Poetry & Beauty.

In addition to portraits and lyrical genre scenes, Cameron also participated in another of photography's earliest genres: ethnographic images. The emergence of photography coincided with the expansion of colonialism by European countries, especially Britain and France. This imperialism manifested itself culturally in the form of Orientalism: Western representations—literary and visual—of the Near East,

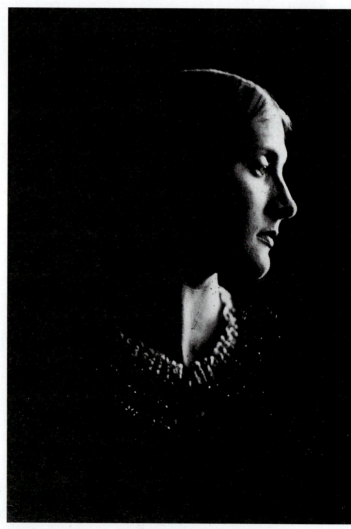

2.9 Julia Margaret Cameron, *Mrs Herbert Duckworth*, c. 1867. Albumen print, 13⅜ × 9⅝" (34 × 24.4 cm). International Museum of Photography at George Eastman House, Rochester, New York.

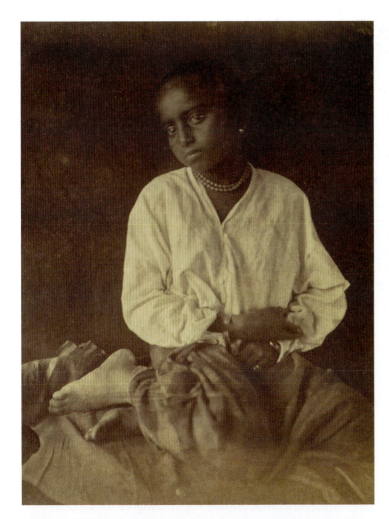

2.10 Julia Margaret Cameron, *Unknown Girl, Ceylon*, 1875–79. Albumen print. J. Paul Getty Museum, Los Angeles.

North Africa, and Asia, those regions under heaviest colonization during the mid-nineteenth century. Ethnography and the nascent discipline of anthropology likewise developed in response to national interests, fostering a better understanding of those cultures now under colonial rule. This desire to know the "other"—sometimes for altruistic reasons, sometimes out of simple curiosity, but also motivated by commercial and political considerations—led many photographers to turn their cameras to the landscapes and peoples of colonized regions. When Cameron's husband was appointed to a colonial post in Ceylon, she joined him there with her family and her camera. Unlike many of her contemporaries, Cameron's approach to ethnographic photography maintains much the same sensitivity and subjectivity that she accorded her English sitters (fig. **2.10**).

Quick to become one of journalistic photography's most abiding subjects was war. Photography robbed armed conflict of the operatic glamour often given it by traditional painting. This first became evident in the photographs taken by Roger Fenton during the Crimean War of 1853–56, but it had an even more shattering effect in the work of **Mathew Brady** (1823–96) and such associates as Alexander Gardner, who bore cameras onto the body-strewn fields in the wake of battle during the American Civil War (fig. **2.11**). (Because the required length of exposure was still several seconds, the battles themselves could not be photographed.) Now that beautifully particularized, mutely objective—or indifferent—pictures disclosed all too clearly the harrowing calm brought by violence, or the almost indistinguishable likeness of the dead on either side of the conflict, questions of war and peace took on a whole new meaning. It is important to keep in mind, however, that most early war photography was staged in order to endow images with narrative or formal coherence. This image shows how the presumed objectivity of photography could be—and was—used to translate manipulated scenes into seemingly factual records.

In America the daguerreotype experienced wild popularity from the moment the first instruction manuals and equipment arrived on the East Coast. The many commercial photographic studios that sprang up, especially in New York and Philadelphia, gave rise to hundreds of amateur photographers. They provided inexpensive portrait services to sitters who could never have afforded a painted portrait. From the countless efforts of anonymous photographers

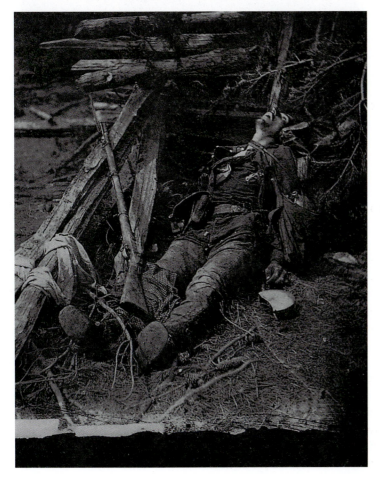

2.11 Mathew Brady, *Dead Soldier, Civil War*, c.1863. Gelatin-silver print. Library of Congress, Washington, D.C.

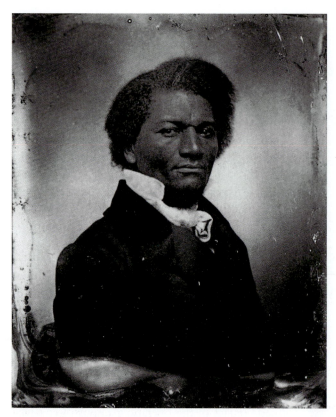

2.12 Unknown photographer, *Frederick Douglass*, 1847. Daguerreotype, 3¼ × 2¾" (8.3 × 7 cm). Collection William Rubel.

emerge forthright records of ordinary citizens and valuable likenesses of extraordinary personalities, such as the eminent abolitionist writer and orator Frederick Douglass (fig. **2.12**). An escaped slave, Douglass informed his eloquent public protests against slavery with firsthand experience. He was an adviser to President Abraham Lincoln during the Civil War and afterward became the first African-American to hold high office in the United States government. The photograph of Douglass as a young man was taken at the end of a lecture tour he had given in Great Britain and Ireland in order to avoid recapture in America. Like the best daguerreotypes, it possesses tremendous appeal by virtue of its unaffected, straightforward presentation of the sitter.

Only the Truth: Realism

Photography offered only one avenue for the exploration and documentation of observed reality. Realism was another. Any art-historical consideration of Realism is inextricably tied to the tumultuous political and social history of this period in France, the country where Realism developed most coherently. Following the final defeat of Napoléon in 1815, a succession of Bourbon monarchs resumed the governance of France. At first tolerant of moderate reforms, the monarchy grew increasingly authoritarian until revolution broke out anew in 1830. A relatively bloodless coup replaced the Bourbons with a king from the Orléans line: Louis-Philippe. The self-styled "Citizen King," Louis-Philippe agreed to govern as a constitutional monarch. Like his predecessors, he found in France's political instability

and economic difficulties cause to assume greater authority while limiting the rights of the citizenry and of the press. After he was finally toppled in yet another uprising—during the great revolutionary year of 1848—France's Second Republic was proclaimed. The Republic's president, Napoléon's nephew Louis-Napoléon Bonaparte, staged his own coup late in 1851 and, in 1852, inaugurated the Second Empire over which he would rule as supreme head. Reigning as Napoléon III, he lacked the military acumen of his uncle. His disastrous execution of the Franco–Prussian War resulted in the collapse of the Second Empire in 1870. It is against the backdrop of this tortuous journey away from empire and back again that the development of Realism in France must be understood.

Alongside these historical events, a new kind of journalism and a new kind of critical writing were everywhere evident. Many of the leading authors and critics of France and England wrote regularly for the new popular reviews. This phenomenon is perhaps best seen in the emergence of the **caricature**—the satirical comment on life and politics, which became a standard feature of journals and newspapers. Although visual attacks on individuals or corrupt economic and political systems have always existed, and artists such as Goya have been motivated by a spirit of passionate invective, drawings that ranged from gentle amusement to biting satire to vicious attack now became a commonplace in every part of Europe and America. These images could be cheaply disseminated through the popular medium of lithography (see *Printmaking Techniques*, Ch.1, p. 6).

France

The greatest of the satirical artists to emerge in this new environment was **Honoré Daumier** (1808–79), who was best known for some 4,000 lithographic drawings that he contributed to French journals such as *La Caricature* and *Le Charivari*, but was also an important sculptor and painter. His small caricatural busts were created between 1830 and 1832 to lampoon the eminent politicians of Louis-Philippe's regime. Daumier's studies of the theater, of the art world, and of politics and the law courts range from simple commentary to perceptive observation to bitter satire. His political caricatures were at times so biting in their attacks on the establishment that they were censored. The artist was imprisoned for six months for a caricature he did of the king.

The profundity of Daumier's horror at injustice and brutality is perhaps best illustrated in the famous lithograph *Rue Transnonain* (fig. **2.13**), which shows the dead bodies of a family of innocent workers murdered by the civil guard during the republican revolt of 1834. With journalistic bluntness, the title refers to the street where the killings took place. In its powerful exploitation of a black-and-white medium, as well as the graphic description of its gruesome subject, this is a work comparable to Goya's *The Disasters of War* (see fig. 1.7).

Like Daumier, **Gustave Courbet** (1819–77) inherited certain traits from his Romantic predecessors. Throughout his life, he produced both erotic subjects that border on

2.13 Honoré Daumier, *Rue Transnonain*, April 15, 1834, published in *L'Association Mensuelle*, July 1834. Lithograph, 11½ × 17½" (29.2 × 44.5 cm). Graphische Sammlung Albertina, Vienna.

academicism and Romantic self-portraits. But, most important, he created unsentimental records of contemporary life that secure his place as the leading exponent of modern Realism in painting. These works possess a compelling physicality and an authenticity of vision that the artist derived from the observed world. Most notably, Courbet insisted upon the very material with which a painting is constructed: **oil paint**. He understood that a painting is in itself a reality—a two-dimensional world of stretched canvas defined by the nature and textural consistency of paint—and that the artist's function is to define this world.

A Burial at Ornans (fig. **2.14**) is significant in the history of modern painting for its denial of illusionistic depth, its apparent lack of a formal composition, and an approach to subject matter so radical that it was seen as an insult to everything for which the venerable French Academy stood. In his

assertion of paint texture, the artist drew on and amplified the intervening experiments of the Romantics, although with a different end in view. Whereas the Romantics used broken paint surfaces to emphasize the intangible elements of the spirit or sublime natural phenomena (see fig. 1.11), Courbet employed them as a means to make the ordinary world more tangible. The *Burial* documents a commonplace event in Courbet's small provincial hometown in eastern France, but its ambitious size conforms to the dimensions of history painting, a category reserved for the noblest events from the past. Courbet's casual, frieze-like arrangement of village inhabitants, made up mostly of his friends and relatives, is an accurate depiction of local funerary customs (men and women are segregated, for example), but it carries no particular narrative message. It was not only this lack of compositional hierarchy and pictorial rhetoric that outraged French critics. Courbet's representation of ordinary residents of the countryside did not coincide with established Parisian norms for the depiction of rural folk. These are not the ennobled peasants of Millet (see fig. 1.13) or the pretty, happy maids of traditional academic painting. Rather, they are highly individualized, mostly unattractive, and aggressively real.

Combined with his unorthodox approach to formal matters, Courbet's Realism in his unpolished treatment of working-class subjects was associated with left-wing dissidence. Realism, and Courbet's sharpened political sensibilities, came to the fore during these decades of political turmoil, when republicans, Bonapartists, royalists, and socialists struggled to realign France's government. Courbet pursued his political sympathies on his canvases as he did in life, causing as much uproar with his Realist painting as with his activism. His contempt for the conservatism of official arts institutions spurred him in 1855 to mount a grand exhibition of

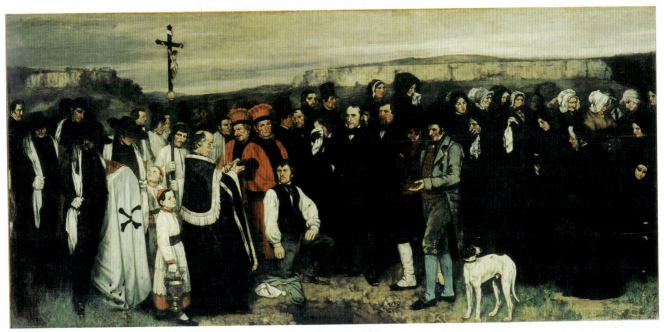

2.14 Gustave Courbet, *A Burial at Ornans*, 1849–50. Oil on canvas, 10' 3½" × 21' 9" (3.1 × 6.6 m). Musée d'Orsay, Paris.

 View the Closer Look for *A Burial at Ornans* on mysearchlab.com

his works—some of which had been rejected by the Salon jury—in a temporary Pavilion of Realism hastily erected near that year's Universal Exposition in Paris. This gesture encouraged later avant-garde artists, like the Impressionists, to establish similarly independent exhibitions. By the end of the century, the Salon would be displaced entirely as a venue for groundbreaking new art.

For the ardent socialist Courbet, peasant laborers and the rural landscape were the true sources of French identity and, hence, political authority. In a group of landscapes of the 1850s and 60s, *The Source of the Loue* among them (fig. **2.15**), Courbet had experimented with a form of extreme close-up of rocks abruptly cut off at the edges of the painting. A view from the artist's native province of Franche-Comté, *The Source* may owe something to the emerging art of photography, both in its fragmentary impression and in its subdued, almost monochromatic

2.15 Gustave Courbet, *The Source of the Loue*, 1864. Oil on canvas, 39 × 56" (99.7 × 142.2 cm). The Metropolitan Museum of Art, New York.

2.16 Rosa Bonheur, *Plowing in the Nivernais*, 1849. Oil on canvas, 70⅞ × 102⅜" (180 × 260 cm). Musée d'Orsay, Paris.

color. Courbet's landscape, however, combined a sense of observed reality with an even greater sense of the elements and materials with which the artist was working: the rectangle of the picture plane and the emphatic texture of the oil paint, which asserted its own nature at the same time that it was simulating the rough-hewn, sculptural appearance of exposed rocks.

Like Courbet, the Realist painter **Rosa Bonheur** (1822–99) largely addressed rural themes. Endowing her subjects with a grandeur akin to that of Millet's peasants, she nevertheless departs from her Barbizon contemporaries in her depiction of landscapes of crystalline clarity and rich color. Thanks to the progressive views of her parents, Bonheur was allowed to study painting and even permitted to visit farms and slaughterhouses disguised as a boy so she could sketch and acquire some knowledge of anatomy. The accuracy and sympathy of her paintings of animals, in particular, earned her fame as well as a fortune. *Plowing in the Nivernais* (fig.

2.16) exemplifies her approach to Realism in its respect for agricultural labor, its careful observation of livestock, and its glowing precision.

England

During the early decades of Queen Victoria's long reign (1837–1901), the social and artistic revolution that fueled the Realist movement in France assumed virtually religious zeal, as a group of young painters rebelled against what they considered the decadence of current English art. They called for renewal modeled on the piously direct, "primitive" naturalism practiced in Florence and Flanders prior to the late work of Raphael and the High Renaissance, which they saw as the beginning of what had become a stultifying academic tradition. **William Holman Hunt** (1827–1910),

2.17 William Holman Hunt, *The Hireling Shepherd*, 1851. Oil on canvas, 30 1/16 × 43 1/8" (76.4 × 109.5 cm). Manchester City Art Galleries, England.

John Everett Millais, and Dante Gabriel Rossetti joined with several other sympathetic spirits to form a secret, reform-minded artistic society, which they called the Pre-Raphaelite Brotherhood. The ardent Pre-Raphaelites determined to eschew all inherited Mannerist and Baroque artifice and to search for truth in worthwhile, often Christian, subject matter presented with naive, literal fidelity to the exact textures, colors, light, and, above all, the outlines of nature.

For *The Hireling Shepherd* (fig. **2.17**) Hunt pursued "truth to nature" in the countryside of Surrey, where he spent the summer and fall of 1851 working *en plein air*, or out-of-doors, to set down the dazzling effect of morning sunlight. Reviving the techniques of the fifteenth-century Flemish masters, Hunt laid—over a white wet ground—glaze after glaze of jewel-like, translucent color and used the finest brushes to detail every wildflower blossom and blade of grass. Late in life, he asserted that his "first object was to portray a real Shepherd and Shepherdess ... sheep and absolute fields and trees and sky and clouds instead of the painted dolls with pattern backgrounds called by such names in the pictures of the period." But it seems that he was also motivated to create a private allegory of the need for mid-Victorian spiritual leaders to cease their sectarian disputes and become true shepherds tending their distracted flocks. Thus, while the shepherd, ruddy-faced from the beer in his hip keg, pays court to the shepherdess, the lamb on her lap makes a deadly meal of green apples, just as the sheep in the background succumb from being allowed to feed on corn. Gone are the smooth chiaroscuro elisions, rhythmic sweep, and gestural grace of earlier art, replaced by a fresh-eyed naturalism. The critic John Ruskin wrote appreciatively of Holman Hunt's work, lending his influential voice in support of the Pre-Raphaelites.

Although he never became an official member of the Brotherhood, **Ford Madox Brown** (1821–93) was introduced to them by the precocious young poet and painter Rossetti. The large canvas *Work* (fig. **2.18**), which preoccupied him for several years, is Brown's monumental testament to the edifying and redemptive power of hard toil. Like

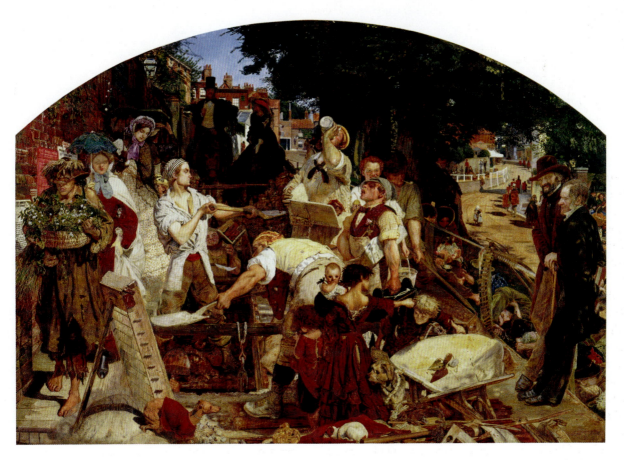

2.18 Ford Madox Brown, *Work*, 1852, 1855–63. Oil on canvas, 4' 5" × 6' 5 11/16" (1.35 × 2 m). Manchester City Art Galleries, England.

Hunt, he relies on a microscopic accuracy of detail to deliver his moralizing message. At the center of the sun-drenched composition are the muscular laborers who dig trenches for new waterworks in the London suburb of Hampstead. A proliferation of genre vignettes circles around this central action of the painting; these reinforce Brown's theme with emblems of the various social strata that made up contemporary Victorian society. At the far left, for example, is a ragged flower-seller followed by two women distributing temperance tracts. In the shade of a tree at the right, an indigent couple tends to an infant, while in the background an elegantly dressed couple rides horseback. The two men at the far right are portraits: the philosopher Thomas Carlyle and a leading Christian Socialist, Frederick Denison Maurice, "brainworkers" whose relatively conservative ideas about social reform dovetailed with Brown's own genuine attempts to correct social injustice. His painting is the most complete illustration of the familiar Victorian ethic that promoted work as the foundation of material advancement, national progress, and spiritual salvation.

Seizing the Moment: Impressionism and the Avant-Garde

The various scandals surrounding Courbet's life and work had introduced the French public to the idea of a radical, often shocking, alternative to academic Salon art that was more or less closely identified with left-wing politics. Largely through Courbet's image in the popular imagination, the idea of an artistic **avant-garde**, or vanguard, became firmly established. Each new wave of avant-garde art was greeted with outrage by conservative public opinion—an outrage that frequently turned to acceptance, and even admiration, with the passing of time and the arrival of newer, yet more shocking, developments in art.

Manet and Whistler

Although sympathetic to left-wing politics, **Édouard Manet** (1832–83) was a realist who nevertheless sought recognition through such conventional venues as the Salon, where he aimed to exhibit his modern depictions of contemporary

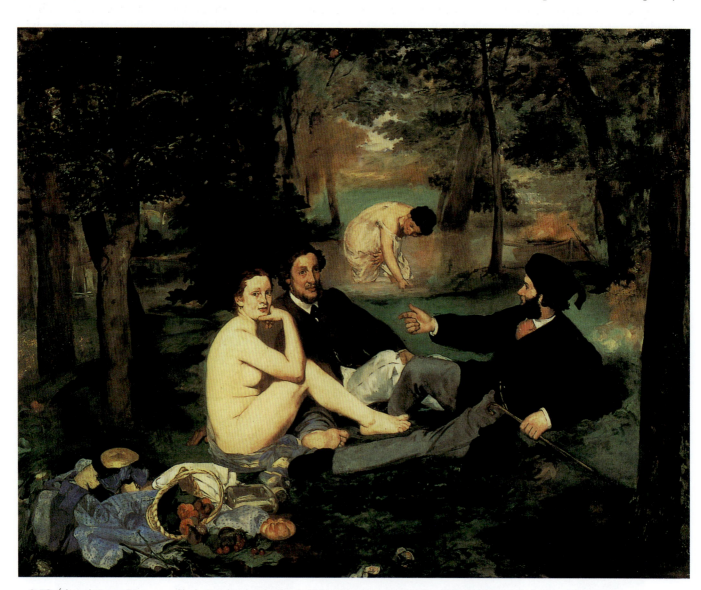

2.19 Édouard Manet, *Déjeuner sur l'herbe* (*Luncheon on the Grass*), 1863. Oil on canvas, 6' 9⅛" × 8' 10¼" (2.1 × 2.7 m). Musée d'Orsay, Paris.

View the Closer Look for *Déjeuner sur l'herbe* on mysearchlab.com

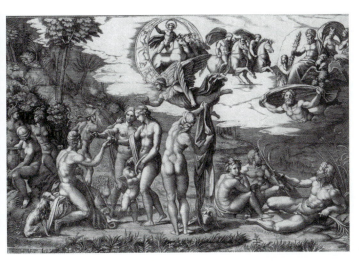

2.20 Marcantonio Raimondi, *The Judgment of Paris*, c. 1510–20. Based on a design by Raphael. Engraving, 11½ × 17³⁄₁₆″ (29.2 × 43.6 cm). The Metropolitan Museum of Art, New York. Rogers Fund, 1919.

life. His *Déjeuner sur l'herbe* (fig. **2.19**), rejected by the Salon of 1863, created a major scandal when it was shown in the Salon des Refusés, the exhibition mounted by the state that year to house the large number of works barred by jurors from the main Salon. Although the subject was based on Renaissance academic precedents—Giorgione's *Pastoral Concert* (1510) and an engraving by **Marcantonio Raimondi** (c. 1480–before 1534) of *The Judgment of Paris* (c. 1510–20), after a lost drawing by Raphael (fig. **2.20**)— few viewers understood Manet's historicizing project and

popular indignation arose because the classical, pastoral subject had been translated into contemporary terms. Raphael's goddesses and Giorgione's nymphs had become models, or even prostitutes, one naked, one partially disrobed, relaxing in the woods with two men whom Salon visitors would have recognized by their dress as artists or students. The woman in the foreground is Victorine Meurent, the same model who posed for *Olympia* (see fig. 2.21), and the men are Manet's relations. Manet abided by the convictions of his supporter Charles Baudelaire, the great poet and art critic who exhorted artists to paint scenes of modern life and to invent contemporary contexts for old subjects such as the nude. But in his ironic quotations from Renaissance sources, Manet created what seemed to be a conscious affront to tradition and accepted social convention.

Manet ostensibly adopted the structure of Raphael's original composition, with the bending woman in the middle distance forming the apex of the classical receding triangle of which the three foreground figures serve as the base and sides. However, his broad, abrupt handling of paint and his treatment of the figures as silhouettes rather than carefully modeled volumes tend to collapse space, flatten forms, and assert the nature of the canvas as a two-dimensional surface. Manet's subject, as well as the sketchiness of technique, infuriated the professional critics.

Manet's *Olympia* (fig. **2.21**), painted in 1863 and exhibited in the Salon of 1865, created an even greater furor than the *Déjeuner*. Here, again, the artist's source was

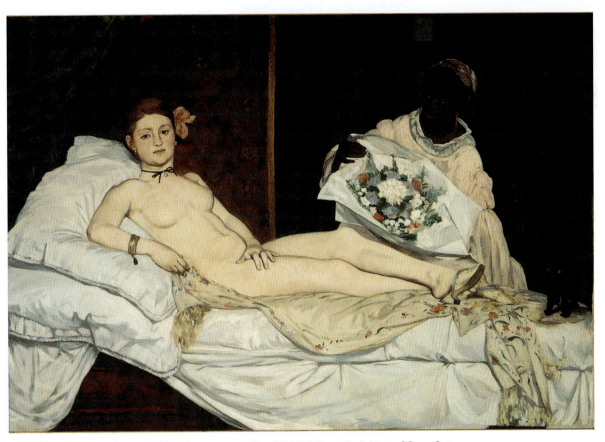

2.21 Édouard Manet, *Olympia*, 1863. Oil on canvas, 4′ 3″ × 6′ 2¾″ (1.3 × 1.9 m). Musée d'Orsay, Paris.

 View the Closer Look for *Olympia* on mysearchlab.com

2.22 Édouard Manet, *Portrait of Émile Zola*, 1868. Oil on canvas, 57⅛ × 44⅞" (145.1 × 114 cm). Musée d'Orsay, Paris.

exemplary: Titian's *Venus of Urbino*, which Manet had copied as a young man visiting Florence. *Olympia*, however, was a slap in the face to all the complacent academic painters who regularly presented their exercises in scarcely disguised eroticism as virtuous homage to the gods and goddesses of classical antiquity. Venus reclining has become an unidealized, modern woman who, by details such as her ribbon and slippers, as well as her name, would have been recognized as a prostitute. She stares out at the spectator with an impassive boldness that bridges the gap between the real and the painted world in a startling manner, and effectively shatters any illusion of sentimental idealism in the presentation of the nude figure. *Olympia* is a brilliant design in black and white, with the nude figure silhouetted against a dark wall enriched by red underpainting that creates a Rembrandtesque glow of color in shadow. The black maidservant brings flowers offered by a client; the cat clearly reacts to her. The volume of the figure is created entirely through its contours—again, the light-and-dark pattern and the strong linear emphasis annoyed the critics as much as the shocking subject matter.

Beyond the provocatively named figure, the bouquet of flowers, the black maid, and the cat also functioned as symbols of sexual licentiousness. Flowers were a long-standing metaphor for female genitalia. Black Africans were believed by many Europeans to be hyper-sexual. This racial stereotype would have been familiar to many contemporary viewers, thus heightening the outrage over the image. Finally, poets like Baudelaire had drawn on the association between cats and opportunistic sexual behavior. For Courbet, it was the painting's formal innovations that troubled him the most. He found *Olympia* so unsettling in the playing-card flatness of its forms, all pressed hard against the frontal plane, that he likened the picture to "a Queen of Spades getting out of a bath."

Manet's *Portrait of Émile Zola* (fig. **2.22**), an informal portrait, continues the Realists' critique of the academic concept of the grand and noble subject, carrying the attack several steps further in its emphasis on the plastic means of painting itself. Zola, the great Realist novelist and proponent of social reform, was Manet's friend and supporter. Manet included in the work certain details that are perhaps more revealing of his own credos than of those of the writer who had so brilliantly defended him against his detractors. On the desk, for example, is the pamphlet Zola wrote on Manet. Posted on the wall to the sitter's right is a small print of *Olympia*, behind which is a reproduction of *Bacchus* by

the seventeenth-century Spanish master Velázquez. Beside *Olympia* is a Japanese print, and behind Zola's figure is part of a Japanese screen. The Japanese print and screen are symptomatic of the growing enthusiasm for Asian, and specifically Japanese, art then spreading throughout Europe. In the art of Asia avant-garde French painters found some of the formal qualities they were seeking in their own work.

After photography, the most pervasive influence on the nineteenth-century advance of modernist form came from Asian art, especially the color woodcut prints that began finding their way west shortly after the American naval officer Matthew Perry had forced open the ports of Japan in 1853, ending two centuries of closure to Western vessels. With their steep and sharply angled views, their bold, snapshot-like croppings or near–far juxtapositions, and their flat-pattern design of brilliant, solid colors set off by the purest contour drawing, the works of such masters as Kitagawa Utamaro, Katsushika Hokusai, and Andō Hiroshige (1797–1858; fig. **2.23**) struck European eyes as amazingly new and fresh. These prints reinforced the growing belief in the West that pictorial truth lay not in illusion but in the intrinsic qualities of the artist's means and the opaque **planarity** of the picture surface.

Among the artists to absorb fully the lessons offered by Japanese prints was **Mary Cassatt** (1845–1926). The Philadelphia-born Cassatt, who arrived in Paris with her wealthy family in 1866, reveals her understanding both of the Japanese independence of line and of Manet's interest

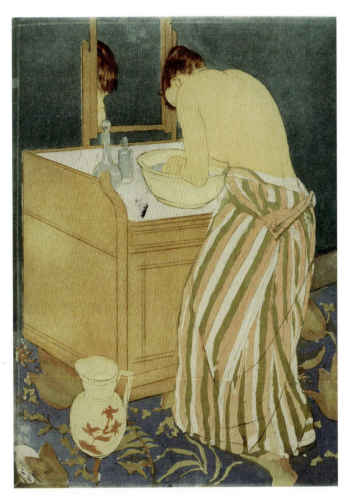

2.24 Mary Cassatt, *Woman Bathing*, 1890–91. Drypoint and aquatint, printed in color, 17 × 11¾" (43.2 × 29.8 cm). The Metropolitan Museum of Art, New York. Gift of Paul J. Sachs, 1916. 16.2.2.

View the Closer Look to see another of Cassatt's paintings on mysearchlab.com

in quotidian scenes of modern life. Cassatt's print, *Woman Bathing* (fig. **2.24**), presents a humble subject, which she animates through the play of strong contour line and surface patterning. The figure's boldly striped garment energizes the floral pattern of the carpet, with both surfaces merging into a single plane. Traditional perspective space is here abandoned in favor of color, line, and form arranged for the benefit of visual harmony rather than documentary information.

Likewise fascinated by Asian art as a means of creating a new pictorial reality suitable for "a painter of modern life" was James Whistler (see Ch. 1, p. 1). Whistler, who trained in Paris and resided in London, exhibited a painting at the 1863 Salon des Refusés that caused a critical scandal rivaling the one incited by Manet's *Déjeuner sur l'herbe*. Much more than Manet, however, Whistler transformed Japanese sources into an emphatic aestheticism. *Japonisme*, or the emulation of patterns and forms observed in Japanese or Japanese-inspired prints, textiles, ceramics, and screens, offered Whistler a means to divorce himself from Western pictorial conventions in order to express a fresh, lyrical, and atmospheric sensibility. Even so, in an authentic Realist manner, he consistently painted what he had observed. Whistler's approach was evident in the early 1860s, when

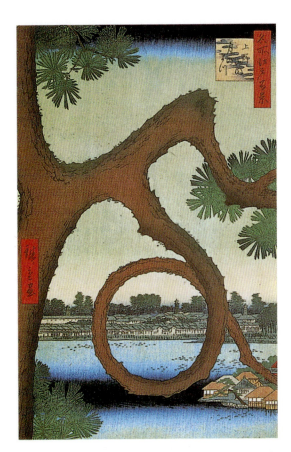

2.23 Andō Hiroshige, *Moon Pine at Ueno* from *One Hundred Views of Famous Places in Edo*, 1857. Color woodcut, 13¾ × 8⅝" (34.9 × 21.9 cm). The Brooklyn Museum, New York.

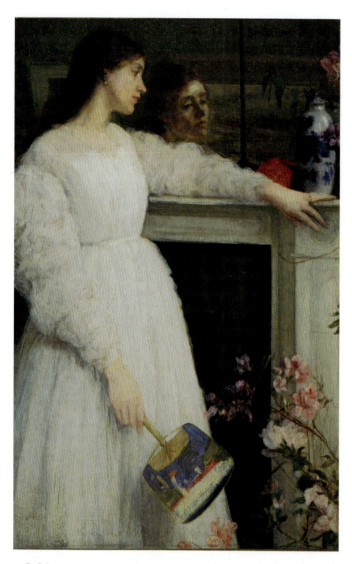

2.25 James McNeill Whistler, *Symphony in White No. II: The Little White Girl*, 1864. Oil on canvas, 30⅛ × 20⅛" (76.5 × 51.1 cm). Tate, London.

he made pictures like *Symphony in White No. II: The Little White Girl* (fig. **2.25**), where *japonisme* makes its presence felt not only in the obvious décor of an Asian blue-and-white porcelain vase, painted fan, and azalea blossoms, but also in the more subtle, and more important, flattening effects of the nuanced, white-on-white rendering of the model's dress and the rectilinear, screen-like divisions of the architectural framework. Further reinforcing the sense of an overriding formalism is the off-center composition, with its resulting crop of the figure along two edges of the canvas. To emphasize his commitment to the principle of Art for Art's Sake, Whistler gave his pictures musical titles—arrangements, symphonies, and nocturnes—thereby drawing analogies with a more immaterial, evocative, and non-descriptive medium. Such analogies were very much in the spirit of late nineteenth-century Aestheticism, summed up in 1873 in the English critic Walter Pater's dictum, "All art constantly aspires towards the condition of music." This approach emphasized the formal qualities of art as being more important than subject matter, and indeed Whistler's aim was to create not a duplicate of nature, but rather what he called "an arrangement of line, form, and color first."

From Realism to Impressionism

A great part of the struggle of nineteenth-century experimental painters was an attempt to recapture the color, light, and changeability of nature that had been submerged in the rigid stasis and studio gloom of academic tonal formulas. The color of the Neoclassicists had been defined in local areas but modified with large passages of neutral shadows to create effects of sculptural modeling. The color of Delacroix and the Romantics flashed forth passages of brilliant blues or vermilions from an atmospheric ground. As the Barbizon School of landscape painters sought to approximate more closely the effects of the phenomenal world with its natural light, they were almost inevitably bent in the direction of the subdued light of the interior of the forest, of dawn, and of twilight. Color, in their hands, thus became more naturalistic, although they did choose to work with those effects of nature most closely approximating the tradition of studio light. This tendency is exemplified in the work of **Camille Corot** (1796–1875), the innovative landscape painter around whom the Barbizon School first coalesced in the 1830s. Corot's increasingly delicate and abstract, almost monochromatic post-1850 landscapes may well have been an attempt to imitate the seamless, line-free value range of contemporary photography, a medium that greatly interested him (fig. **2.26**). In their smoky tissues of feathery leaves and branches, the moody, autumnal, park-like scenes painted by the aging Corot seem to be painterly counterparts of the blurred landscape photographs of the period.

Artists had always sketched in the open air and, as we have seen, some such as Corot and the Barbizon painters made compositions entirely *en plein air*, though even these artists usually completed paintings in the studio. The Impressionists were the most consistently devoted to *plein-air* painting, even for some of their most ambitious works, and to capturing on canvas as faithfully as possible the optical realities of the natural world. However, the more the Realist artists of the mid-nineteenth century attempted to reproduce the world as they saw it, the more they understood that reality rested not so much in the simple objective world of natural phenomena as in the eye of the spectator. Landscape in actuality could never be static and fixed. It was a continuously changing panorama of light and shadow, of moving clouds and reflections on the water. The same scene, observed in the morning, at noon, and at twilight, was actually three different realities. Further, as painters moved out of doors from the studio they came to realize that nature, even in its dark shadows, was not composed of black or muddy browns. The colors of nature were the full spectrum—blues, greens, yellows, and whites, accented with notes of red and orange, and often characterized by an absence of black.

Louis Leroy, the satirical critic for *Le Charivari*, was the first to speak of a school of "Impressionists," a term he derisively based on the title of a painting by **Claude Monet** (1840–1926) (fig. **2.27**) that was included in the first Impressionist exhibition, which opened on April 15, 1874, at the studio of the photographer Nadar. Featuring

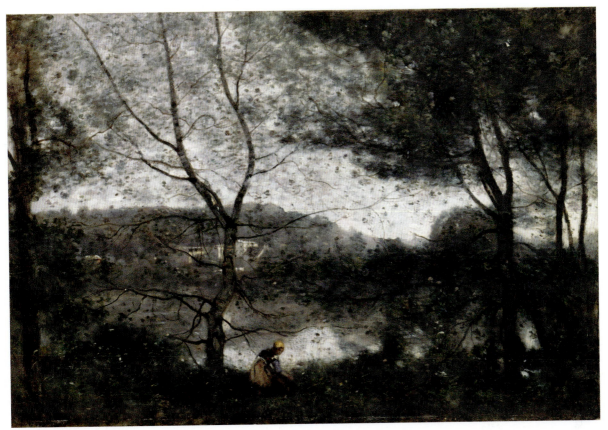

2.26 Camille Corot, *Ville d'Avray*, 1870. Oil on canvas, 21⅝ × 31½″ (54.9 × 80 cm). The Metropolitan Museum of Art, New York. Bequest of Catharine Lorillard Wolfe, 1887.

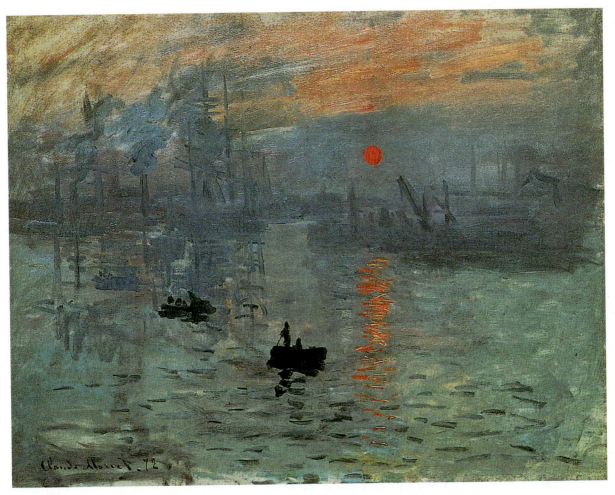

2.27 Claude Monet, *Impression: Sunrise*, 1872. Oil on canvas, 17¾ × 21¾″ (45.1 × 55.2 cm). Musée Marmottan, Paris.

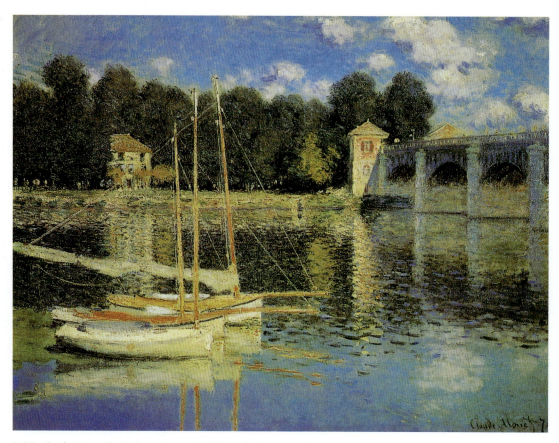

2.28 Claude Monet, *The Bridge at Argenteuil*, 1874. Oil on canvas, 23⅝ × 31½" (60 × 80 cm). Musée d'Orsay, Paris.

163 works by thirty-five artists, the exhibition drew mostly artists, writers, and adventurous viewers along with a clutch of critics. The estimated 3,500 visitors to the month-long show would have seemed quite few when compared with the 400,000 who attended the Salon that year. However, the show marked a significant historical occasion, for it was organized by a group of artists outside the official apparatus of the Salon and its juries: the first of many independent, secessionist group exhibitions that punctuate the history of avant-garde art in the modern period.

Monet's painting presents a thin veil of light gray-blue shot through with the rose-pink of the rising sun. Reflections on the water are suggested by short, broken brushstrokes, and the ghostly forms of boats and smoke-stacks are described with loose patches of color, rather than gradations of light and dark tones. *Impression: Sunrise*, for Monet, was an attempt to capture the ephemeral aspects of a changing moment, more so, perhaps, than any of his paintings until the late Venetian scenes or *Waterlilies* of 1905. *The Bridge at Argenteuil* (fig. **2.28**) might be considered a more classic version of developed Impressionism. It represents a popular sailing spot in the Parisian suburb, where Monet settled in 1871. Scenes of contemporary leisure were a mainstay of Impressionist subject matter. The painting glistens and vibrates, giving the effect of brilliant, hot sunlight shimmering on the water in a scene of contemplative stillness. Monet employed no uniform pattern of brushstrokes to define the surface: the trees are treated as a relatively homogeneous mass; the foreground blue of the water and the blue of the sky are painted quite smoothly

and evenly, while the tollhouse reflected in the water is conveyed by dabs of thick yellow impasto; the boats and the bridge are drawn in with firm, linear, architectural strokes. The complete avoidance of blacks and dark browns and the assertion of modulated hues in every part of the picture introduce a new world of light-and-color sensation. And even though distinctions are made among the textures of various elements of the landscape—sky, water, trees, architecture—all elements are united in their common statement as paint. The overt declaration of the actual physical texture of the paint itself, heavily brushed or laid on with a palette knife, derives from the broken paint of the Romantics, the heavily modeled impasto of Courbet, and the brush gestures of Manet. But now it has become an overriding concern with this group of young Impressionists. The point has been reached at which the painting ceases to be solely or even primarily an imitation of the elements of nature.

In this work, then, Impressionism can be seen not simply as the persistent surface appearance of natural objects but as a never-ending metamorphosis of sunlight and shadow, reflections on water, and patterns of clouds moving across the sky. This is the world as we actually see it: not a fixed, absolute perspective illusion in the eye of a frozen spectator within the limited frame of the picture window, but a thousand different glimpses of a constantly changing scene caught by a constantly moving eye.

Monet's retreat from the Realists' aim to represent their world as directly and objectively as possible was, of course, motivated not only by different aesthetic interests but by personal and social concerns as well. In 1871, France had

suffered a humiliating defeat at the hands of Otto von Bismarck's Prussian army. The terms of peace following the Franco–Prussian War (1870–71) left France in economic straits. So distasteful were the terms of the treaty with the newly established German Empire that an insurrection in Paris soon ignited. An independent, essentially socialist government was formed, known as the Commune. This lasted less than a year and was brutally suppressed by the French army, with huge losses especially among working-class members of the militia. Even those who did not take an active part in the combat suffered terrible privations. Supplies of food and other necessities had been cut off by the national government, leaving Parisians to attempt to feed themselves and their families by any means available. Those who survived the Commune faced further difficulties: thousands were arrested, with deportations and even summary executions following. The war and the ensuing Commune left their marks on Paris and the psyche of its citizens: many buildings, including the Tuileries Palace near the Louvre, were destroyed during the insurrection

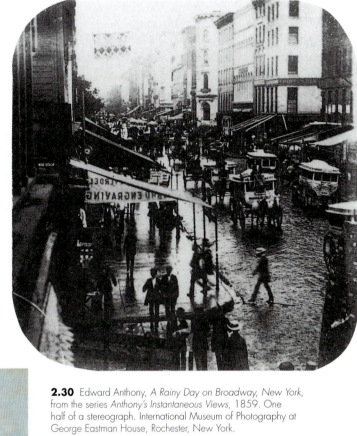

2.30 Edward Anthony, *A Rainy Day on Broadway, New York,* from the series *Anthony's Instantaneous Views,* 1859. One half of a stereograph. International Museum of Photography at George Eastman House, Rochester, New York.

and thousands were killed; few who remained in Paris emerged unscathed. Among those who lived in the city during the Commune was Courbet, whose socialist sympathies led him to actively support the uprising. Spared execution, he was forced into exile. Among those artists who would form themselves into the Impressionist group, many had served in the war or suffered in its aftermath. A few, like Monet, were able to escape to neutral territory. But none returned to Paris unchanged. The new aesthetic that Monet and the Impressionists developed must be reckoned as much a palliative as an aesthetic response to the formal innovations of their Realist, Romantic, and Neoclassical predecessors.

Monet's departure from the Realist insistence on the unwavering truth of **empiricism** toward an intuitive grasp of the reality of visual experience becomes particularly evident when a work like *Boulevard des Capucines, Paris* (fig. **2.29**)—painted from an upstairs window in Nadar's former studio—is compared with contemporary photographs of a similar scene (fig. **2.30**; see fig. 2.6). Whereas both camera-made images show "cities of the dead," the one because its slow emulsion could record virtually no sign of life and the other because its speed froze every horse, wheel, and human in mid-movement, Monet used his rapidly executed color spotting to express the dynamism of the bustling crowd and the flickering, light- and mist-suffused atmosphere of a wintry day, the whole perceived within an instant of time. Still,

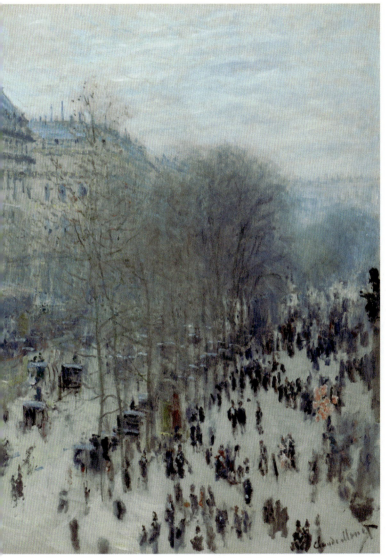

2.29 Claude Monet, *Boulevard des Capucines, Paris (Les Grands Boulevards),* 1873–74. Oil on canvas, 31¼ × 23¼" (79.4 × 59.1 cm). The Nelson-Atkins Museum of Art, Kansas City, Missouri.

far from allowing his broken brushwork to dissolve all form, he so deliberated his strokes that simultaneously every patch of relatively pure hue represents a ray of light, a moment of perception, a molecule of atmosphere or form in space, a tile within the mosaic structure of a surface design. With its decorative clustering of color touches, its firm orthogonals, and its oblique Japanese-style or photographic view, the picture is a statement of the artist's sovereign strength as a pictorial architect. Monet's is a view of modern Paris, for throughout the Second Empire Napoléon III, through his Prefect of the Seine, Baron Georges-Eugène Haussmann, undertook a major program of urban renewal that called for the construction of wide boulevards and new sewers, parks, and bridges. While the renovations generally improved circumstances for commerce, traffic, and tourism, they destroyed many of the narrow streets and small houses of old Paris. The bustle of these new *grands boulevards*, and the cafés and theaters that lined them, provided fertile subjects for the painters of modern life.

The artists associated with the Impressionist movement were a group of diverse individuals, all united by a common interest, but each intent on the exploration of his or her own separate path. **Auguste Renoir** (1841–1919) was essentially a figure painter who applied the principles of Impressionism in the creation of a lovely dreamworld

that he then transported to the Paris of the late nineteenth century. *Moulin de la Galette* (fig. **2.31**), painted in 1876, epitomizes his most Impressionist moment, but it is an ethereal fairyland in contemporary dress. This scene of a commonplace Sunday afternoon dance in the picturesque Montmartre district of Paris is transformed into a color- and light-filled reverie of fair women and gallant men, who, in actuality, were the painters and writers of Renoir's acquaintance and the working-class women with whom they chatted and danced. The lights flicker and sway over the colors of the figures—blue, rose, and yellow—and details are blurred in a romantic haze of velvety brushwork that softens their forms and enhances their beauty. This painting and his many other comparable paintings of the period are so saturated with the sheer joy of a carefree life that it is difficult to recall the financial problems that Renoir, like Monet, was suffering during these years.

The art of the Impressionists was largely urban. Even the landscapes of Monet had the character of a Sunday in the country or a brief summer vacation. But this urban art commemorated a pattern of life in which the qualities of insouciance, charm, and good living were extolled in a manner equaled only by certain aspects of the eighteenth century. Now, however, the portrayal of the good life no longer involved the pastimes of the aristocracy but reflected

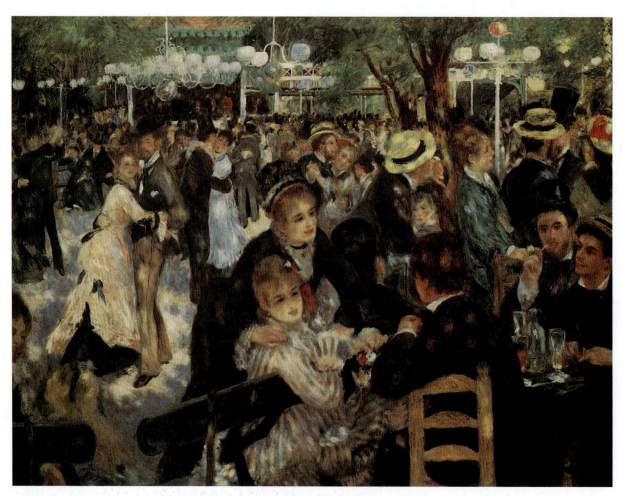

2.31 Auguste Renoir, *Moulin de la Galette*, 1876. Oil on canvas, 51½ × 69" (130.8 × 175.3 cm). Musée d'Orsay, Paris.

View the Closer Look to see another of Renoir's paintings on mysearchlab.com

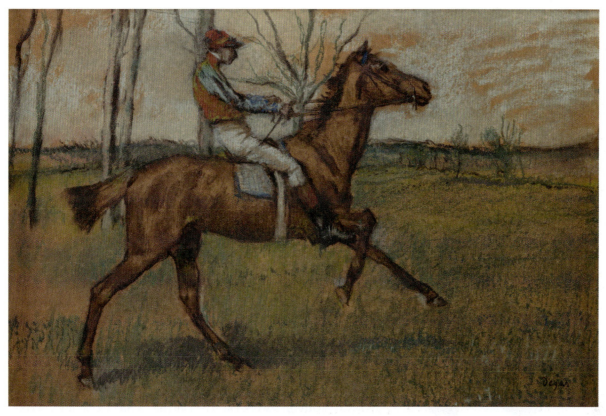

2.32 Edgar Degas, *The Jockey*, 1889. Pastel on paper, 12½ × 19¼″ (31.8 × 48.9 cm). Philadelphia Museum of Art. W. P. Wilstach Fund, 1921

the pleasures available even to poverty-stricken artists. But the moments of relaxation were relatively rare and spaced by long intervals of hard work and privation for those artists who, unlike Cézanne or Degas, were not blessed with a private income.

Though born into a family belonging to the *grande bourgeoisie*, **Edgar Degas** (1834–1917) was in fact far from financially secure, especially after the death of his father in 1874. He thought of himself as a draftsman in the tradition of Ingres, yet he seems to have had little interest in exhibiting at the Salon after the 1860s or in selling his works. On the contrary, he took an active part in the Impressionist exhibitions between 1874 and 1886, in which he showed his paintings regularly. But, while associated with the Impressionists, Degas did not share their enthusiasm for the world of the out-of-doors. Even his racehorse scenes

of the late 1860s and early 1870s, which were open-air subjects, were painted in his studio. Although he produced extraordinary landscapes in his color monotypes, drawing horses and people remained Degas's primary interest, and his draftsmanship continued to be more precise than that of Manet's comparable racetrack subjects (fig. **2.32**). This was particularly true in later works, where Degas became one of the first artists to exploit the new knowledge of animal movement recorded in the 1870s and 80s by **Eadweard Muybridge** (1830–1904) and others in a series of stop-action photographs (fig. **2.33**). These images made forever obsolete the "rocking-horse" pose—legs stretched forward and backward—long conventional in paintings of running beasts.

In addition to being a skilled draftsman, painter, and photographer, Degas was an accomplished sculptor and

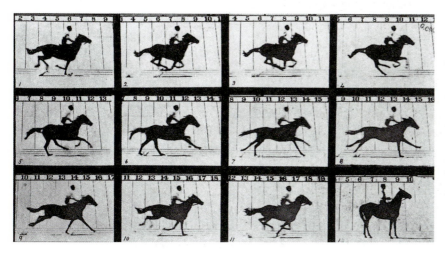

2.33 Eadweard Muybridge, *Horse in Motion,* 1878. Wet-plate photographs.

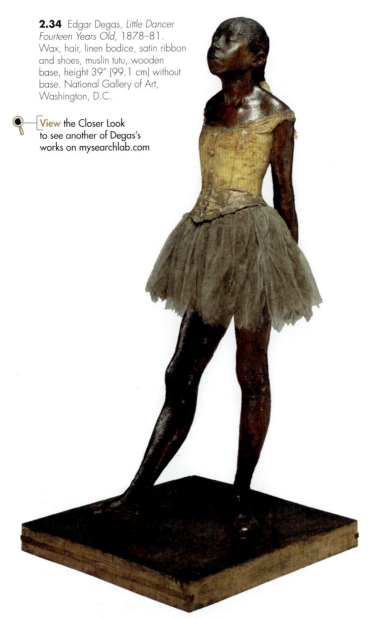

2.34 Edgar Degas, *Little Dancer Fourteen Years Old*, 1878–81. Wax, hair, linen bodice, satin ribbon and shoes, muslin tutu, wooden base, height 39" (99.1 cm) without base. National Gallery of Art, Washington, D.C.

View the Closer Look to see another of Degas's works on mysearchlab.com

printmaker. Like Daumier's, the sculpture of Edgar Degas was little known to the sculptors of the first modern generation, for most of it was never publicly exhibited during his lifetime. Degas was concerned primarily with the traditional formal problems of sculpture, such as the continual experiments in space and movement represented by his dancers and horses. His posthumous bronze casts retain the immediacy of his original modeling material, a pigmented wax, which he built up over an **armature**, layer by layer, to a richly articulated surface in which the touch of his hand is directly recorded. While most of his sculptures have the quality of sketches, *Little Dancer Fourteen Years Old* (fig. **2.34**) was a fully realized work that appeared in the 1881 Impressionist exhibition, the only time the artist showed one of his sculptures. By combining an actual tutu and a real satin hair ribbon with more traditional media, Degas created an astonishingly modern object that foreshadowed developments in twentieth-century sculpture (see fig. 23.44).

Increasingly, during the 1880s and 90s, Degas employed printmaking as well to explore commonplace subjects—milliners in their shops; exhausted laundresses; women occupied with the everyday details of their toilette: bathing, combing their hair, dressing, or drying themselves after the bath. In a work like *The Tub* (fig. **2.35**) Degas goes beyond any of his predecessors in presenting the nude figure as part of an environment in which she fits with seeming unselfconsciousness. Here the figure conveys perfect balance: not only does the bather's pose and gesture emphasize her careful coordination of her body, but the figure's position as a formal counterweight to the tabletop that cuts through the right half of the canvas anchors the work's compositional equilibrium. What is more, the routine, even awkward, character of her pose diverges from conventional treatments of the eroticized nude. Formally, the bird's-eye view and the cut-off edges translate the photographic fragment into an abstract arrangement reminiscent of Japanese prints. Psychologically, Degas's management of the scene flickers with the possibility of voyeurism, a mode of clandestine observation that elicits a sexual response. Mitigating, to some extent, the possibility of voyeuristic satisfaction is Degas's rough **facture**, which disrupts the impulse to see *The Tub* as a nude woman as opposed to a pastel drawing. When Degas exhibited this work among a group of similar pastels in the last Impressionist exhibition in 1886, many critics responded to them with descriptions, such as comparisons to animals, that betrayed a virulent

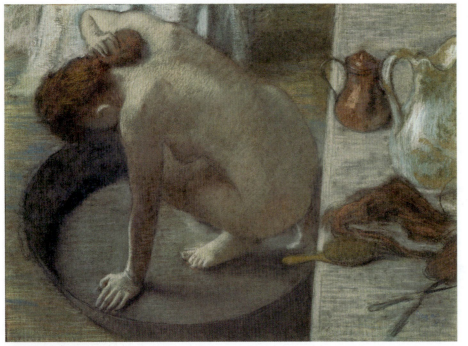

2.35 Edgar Degas, *The Tub*, 1886. Pastel on cardboard, 23⅝ × 32⅝" (60 × 82.9 cm). Musée d'Orsay, Paris.

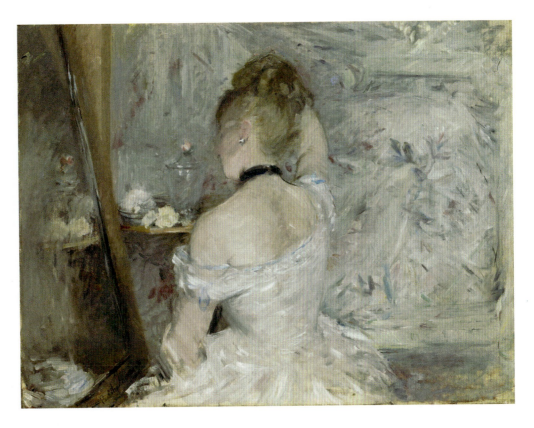

2.36 Berthe Morisot, *Woman at Her Toilette*, c. 1875. Oil on canvas, 23 × 31⅝" (60.3 × 80.4 cm). The Art Institute of Chicago. The Stickney Fund, 1924. 127.

but commonplace misogyny. In his unflattering, naturalistic depictions of women, Degas had failed to create the eroticized objects of desire that inhabited academic paintings of the nude and that were, as feminist art historians have pointed out, designed for consumption by a predominantly male audience. While Degas's pastels were destined for the same viewers, they skirt accepted norms of feminine beauty and, in their monumental simplicity, underscore the centrality of the female nude for modern art just as they signal an incipient critique of this theme, a critique that will reach its crescendo in the late twentieth century when feminist art practice asserts itself.

A critical eye was cast on the theme of women bathing or dressing by the Impressionists Mary Cassatt (see fig. 2.24) and **Berthe Morisot** (1841–95). Morisot's *Woman at Her Toilette* (fig. **2.36**) presents the viewer with an intimate view of a seated woman, seen from behind, arranging her hair. The face is mostly hidden, though one of her softly closed eyes—suggestive of patience and submission—is visible. Morisot's placement of a mirror in the scene allows her to generate multiple sources of light in the room as well as to show reflections of flowers, skin, and silk. Even with the prominent mirror, the artist avoids falling into a clichéd discourse on the subject of vanity—the allegorical theme typically given to depictions of women with mirrors. Morisot's woman is no personification of self-absorption. Her natural gesture and unselfconscious pose generate an intimacy that is underscored by the vibrant brushwork. The rapid, sketchy handling of the wallpaper is matched by the energetic treatment of the dress and skin, inviting the viewer to perceive the scene less as a voyeur than as an active, moving participant in the space depicted. Relieving the viewer of the awkward point of view established in Degas's bather

images, Morisot places the onlooker where he or she might stand to assist the woman with the addition of blossoms to her coiffure.

By the mid-1880s, the Impressionists were undergoing a period of self-evaluation, which prompted Monet and his circle to move in various directions to renew their art once again, some by reconsidering aspects of traditional drawing and composition, others by enlarging or refining the premises on which they had been working. Foremost among the latter stood Monet, who remained true to direct visual experience, but with such intensity, concentration, and selection as to push his art toward anti-naturalistic subjectivity and pure decorative abstraction. In series after series he withdrew from the urban and industrial world, once so excitingly consistent with the nineteenth century's materialist concept of progress, and looked to nature, as if to record its scenes quickly before science and technology could destroy them forever. Monet magnified his sensations of the individual detail perceived in an instant of time so that, instead of fragmenting large, complex views like that in *Boulevard des Capucines, Paris* (see fig. 2.29), he broke up simple, unified subjects—poplars, haystacks, the façade of Rouen Cathedral—into representations of successive moments of experience. Each, by its very nature, assumed a uniform tonality and texture that tended to reverse objective analysis into its opposite: subjective synthesis. In a long, final series, painted at his home at Giverny, in the French countryside, Monet retired to an environment of his own creation, a water garden, where he found a piece of the real world—a sheet of clear liquid with lily pads and flowers afloat on it, and reflections from the sky above—perfectly at one with his conception of the canvas as a flat, mirror-like surface shimmering with a dynamic materialization of light

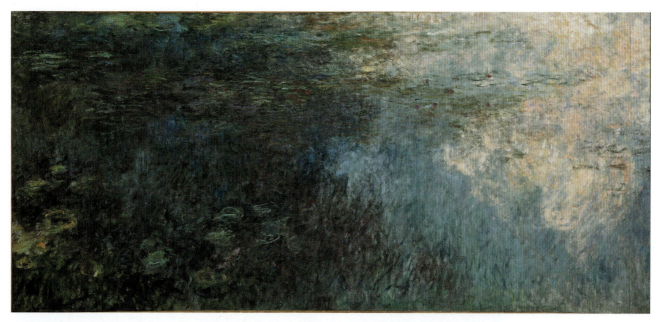

2.37 Claude Monet, *Les Nuages* (*Clouds*), 1916–26. Oil on canvas, left panel of three, each panel 6′ 6¾″ × 13′ 11⅜″ (2 × 4.3 m). Musée de l'Orangerie, Paris.

and atmosphere (fig. **2.37**). Monet's empirical interest in luminary phenomena had become a near-mystical obsession, its lyrical poetry often expressed in almost monochrome blue and mauve. As single, allover, indivisible images, they point the way toward the Abstract Expressionism of the late 1940s and the 50s, which would produce a similarly "holistic" kind of painting, environmental in its scale but now entirely abstract in its freedom from direct reference to the world outside (see fig. 16.8).

Nineteenth-Century Art in the United States

At the opening of the twentieth century, American painters and sculptors, like their counterparts in Great Britain, had not yet embraced the most progressive developments in continental Europe. American artists historically lacked the critical support systems of established art academies (therefore many studied abroad) and a tradition of government patronage. Despite the limitations of its art apparatus, American culture had generated major figures, such as Benjamin West and John Singleton Copley in colonial times, and the late nineteenth-century expatriates Whistler, Cassatt, and John Singer Sargent (see fig. 2.38), capable of holding their own in the European art capitals. After the Civil War Americans had proved vigorously original in architecture and through this medium (see Chapter 8) had made a decisive contribution to the visual arts. But that promising start was brought to a halt by the same academic bias that had held so many painters and sculptors in thrall to outmoded aesthetics inherited from the classical and Romantic past. While the more self-assured and talented European artists grew strong through resistance to the academy, Americans generally felt the need to master tradition rather than innovate against it. American artists were aware that, to progress in their art, it would be necessary to achieve their

own artistic identity, assimilating influences from the generative centers in Europe until these had been transformed by authentic native sensibility into something independent and distinctive.

Later Nineteenth-Century American Art

Whatever the developments in painting and sculpture back home, no American artists had sensed the coming of the new more presciently than expatriates such as Whistler and Cassatt. Similarly immersed in the European cultural milieu was **John Singer Sargent** (1856–1925). Born to American parents living abroad, he spent most of his career in Paris and London, though he received many portrait commissions from leading American families. His flashing, liquid stroke and flattering touch in portraiture made him one of the most famous and wealthy artists of his time. Moreover, in a major work like *Madame X* (fig. **2.38**) Sargent revealed himself almost mesmerized, like a latter-day Ingres (see fig. 1.5), by the abstract qualities of pure line and flat silhouette. At the same time, he so caught the explicit qualities

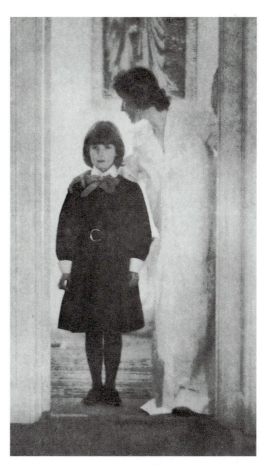

2.39 Gertrude Käsebier, *Blessed Art Thou Among Women*, c. 1900. Platinum print on Japanese tissue, 9⅜ × 5½" (23.8 × 13.9 cm). The Museum of Modern Art, New York.

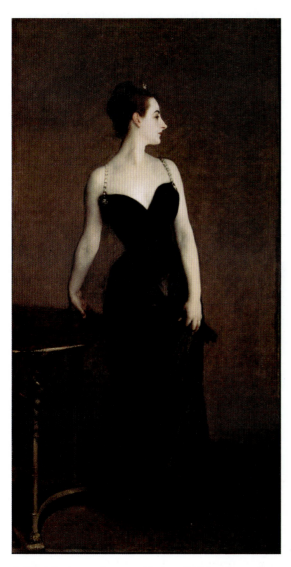

2.38 John Singer Sargent, *Madame X (Mme Pierre Gautreau)*, 1883–84. Oil on canvas, 6' 10⅛" × 3' 7" (2.1 × 1.1 m). The Metropolitan Museum of Art, New York. Arthur Hoppock Hearn Fund, 1916.

of surface and inner character that the painting created a scandal when publicly shown at the Salon, for in addition to the figure's already décolleté dress, Sargent had placed the left-hand strap off her shoulder. To placate an offended public, after the Salon closed he adjusted the strap as seen here. The experience prompted the artist to leave Paris and establish his practice in London. In his most painterly works, meanwhile, Sargent carried gestural virtuosity, inspired by Frans Hals and Diego Velázquez, to levels of pictorial autonomy not exceeded before the advent of the Abstract Expressionists after World War II.

Americans who chose photography as their medium of expression stood out in the international Salons organized for exhibiting the new camera-made art, and indeed often won the major prizes and set the standards for both technical mastery and aesthetic vision. Contemporaries of Whistler, Cassatt, and Sargent were the American photographers **Gertrude Käsebier** (1852–1934) and Clarence H. White, both of whom pursued Pictorialism—a style of photography that avoids the exactitude possible with photographs and instead emulates the softer lines and atmospheric quality of Impressionist painting (fig. **2.39**). Pictorialism arose in the late nineteenth century in part as a response to critics' charges that photography was not a legitimate art form (see *Baudelaire, "Salon of 1859,"* opposite). Like Cassatt, Käsebier specialized in the mother-and-child theme, while White aligned himself with the elite social content of

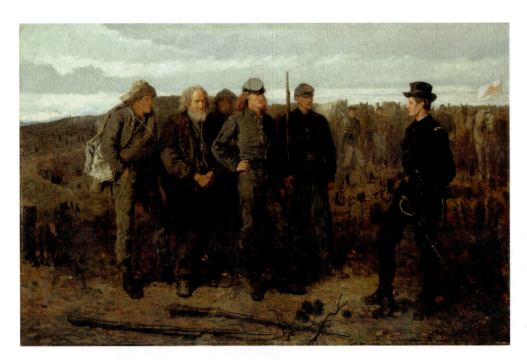

2.40 Winslow Homer, *Prisoners from the Front*, 1866. Oil on canvas, 24 × 38" (60.9 × 96.5 cm). The Metropolitan Museum of Art, New York.

the oil paintings he began to make during the war, Homer tended to focus on the quiet moments of camp life rather than the high drama of battle. A landscape laid waste by those battles is the setting for the artist's early work *Prisoners from the Front* (fig. **2.40**). At the left, three Confederate soldiers—a disheveled youngster, an old man, and a defiant young officer—surrender to a Union officer at the right. Although Homer's painting represents a fairly unremarkable occurrence in the war, it achieves the impact of history painting in the significance of its theme. His subtle characterization of the varying classes and types of the participants in the tragic conflict alludes to the tremendous difficulties to be faced during reconstruction between these warring cultures.

In 1866 Homer traveled to Paris, where *Prisoners from the Front* was being exhibited. While he shared in the practice of ***plein-air*** painting and some of the subject matter of the Impressionists, Homer always insisted on the physical substance of things, rarely allowing form to be disintegrated by paint. Much of his mature work centered on the ocean, either breezy, sun-drenched watercolors made in the Caribbean or dramatic views of the human struggle with the high seas off the coast of Maine, where he settled in 1884. In *After the Hurricane* (fig. **2.41**), the contest between the forces of nature plays itself out in an ambiguous beach scene where a seemingly lifeless man lies on the sand next to a dinghy. Both appear to have been tossed onto shore by the roiling waves in the background. Homer's fluid handling of watercolor suggests the translucency of the foam-flecked sea and shifting clouds. The delicacy of his medium enhances the uncertainty of a scene in which

Sargent's portraiture and the Orientalizing aestheticism of Whistler's musical "arrangements." The camera offered an unparalleled capacity to render the reality so beloved by Americans, but it could also transcend the particular details of a given subject. Using soft focus to infuse emotion and mystery into their images, Käsebier and White tempered the precision of their photographs with an evocative lyricism characteristic of their American peers Whistler and Cassatt.

More exclusively rooted in American experience than Whistler, Cassatt, and Sargent, and thus more representative of the point of departure for American art in the twentieth century, were **Winslow Homer** (1836–1910) and Thomas Eakins. As an illustrator for *Harper's Weekly* magazine in New York, Homer, a virtually self-taught artist, was assigned to the front during the Civil War. In his illustrations and in

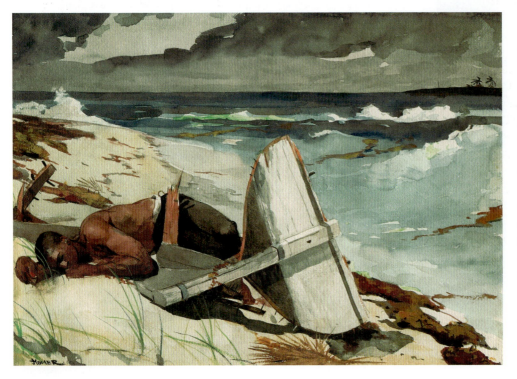

2.41 Winslow Homer, *After the Hurricane*, 1899. Watercolor, 14⁹⁄₁₀ × 21⅖" (38.0 × 54.3 cm). The Art Institute of Chicago.

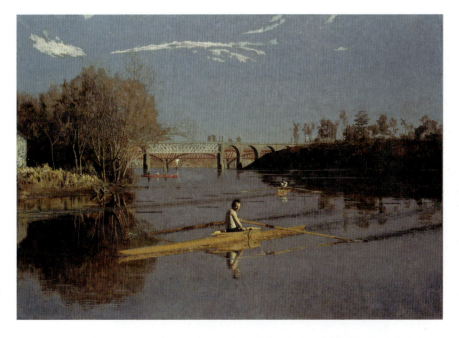

2.42 Thomas Eakins, *The Champion Single Sculls (Max Schmitt in a Single Scull)*, 1871. Oil on canvas, 32½ × 46¼" (82.6 × 117.5 cm). The Metropolitan Museum of Art, New York. Purchase, Alfred N. Punnett Endowment Fund and George D. Pratt Gift, 1934.

the man's condition—is he sleeping? or dead?—prevents easy comprehension.

In his determination to fuse art and science for the sake of an uncompromising Realism in painting, the Philadelphia painter **Thomas Eakins** (1844–1916) all but revived the Renaissance tenets of Leonardo da Vinci. Not only did he dissect cadavers alongside medical students (a traditional method of artistic training) and join Eadweard Muybridge in his studies of motion with stop-action photography (see fig. 2.33), especially those devoted to human movement, but he even had an assistant pose on a cross in full sunlight as the model for a Crucifixion scene and provided a nude male model for his female drawing students, a step that forced his resignation from the august Pennsylvania Academy of the Fine Arts. Eakins's extraordinary early painting *The Champion Single Sculls (Max Schmitt in a Single Scull)* (fig. **2.42**) was his first treatment of an outdoor subject. In the foreground the artist's friend, a celebrated oarsman, pauses momentarily while rowing on Philadelphia's Schuylkill River and looks toward the viewer; in the middle distance, Eakins has depicted himself mid-stroke, also looking at us. A crystalline light and carefully ordered composition lead us into this rational pictorial space, in which each detail is keenly observed and convincingly rendered. Eakins has here produced a Realism that transcends mere illusionism by way of a magical clarity, as if time were momentarily suspended.

Eakins was arguably the greatest American portraitist of the nineteenth century, and his large painting *The Gross Clinic* (fig. **2.43**) is a masterpiece of the genre. The artist looked to the seventeenth-century precedent of Rembrandt's *Anatomy Lesson of Dr. Tulp* for his heroic portrayal of a distinguished surgeon performing an operation before his class. Like Max Schmitt, Dr. Gross looks up during a break in the action. In the midst of the dark, richly hued painting, light falls on his forehead, the intellectual focal point of the scene, and, even more dramatically, on the details of the surgery. Far from dispassionate in his objectivity, Eakins conveys the human toll of modern medicine through the horrified reaction of the seated female observer, presumably a

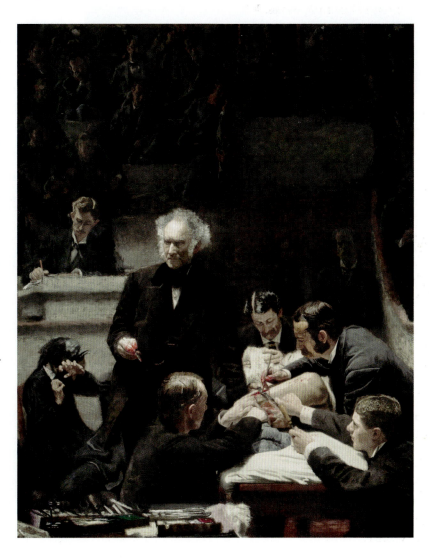

2.43 Thomas Eakins, *The Gross Clinic*, 1875. Oil on canvas, 8' × 6' 6" (2.4 × 2 m). Pennsylvania Academy of Fine Arts and the Philadelphia Museum of Art, Philadelphia.

View the Closer Look for *The Gross Clinic* on mysearchlab.com

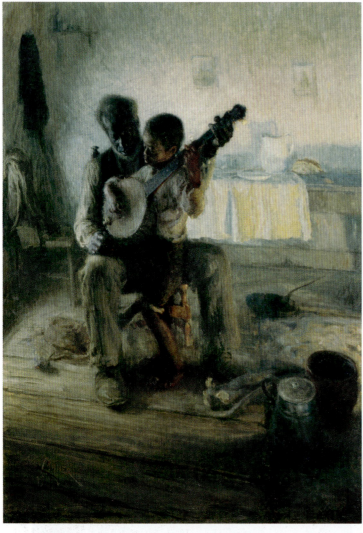

2.44 Henry Ossawa Tanner, *The Banjo Lesson*, 1893. Oil on canvas, 49 × 35½" (124.5 × 90.2 cm). Hampton University Museum, Hampton, Virginia.

relative of the patient. She becomes the bearer of emotional content, much as the female members of the Horatii family did in David's painting (see fig. 1.2).

Henry Ossawa Tanner (1859–1937) was an African-American artist who, by the end of the nineteenth century, had achieved significant international distinction. During the so-called Harlem Renaissance of the 1920s, he was recognized as the most important black artist of his generation. Though he studied in Philadelphia with Eakins, whose portrait style profoundly influenced his own, Tanner found a more accepting atmosphere in his adopted city of Paris. He exhibited widely during his lifetime, including at the Paris Salon, and eventually befriended members of the avant-garde circle around Paul Gauguin in the rural artists' communities of Brittany. The French government awarded him the prestigious Légion d'honneur. Tanner's best-known work, *The Banjo Lesson* (fig. **2.44**), was probably made during a trip to Philadelphia, when he said he painted "mostly Negro subjects," a genre he felt had been stereotypically cast by white artists. With a loose weave of elongated strokes, Tanner softly defines the central pair of figures, bathing them in a light that imparts a spiritual

stillness to the scene, a light not unlike that used in the religious subjects that make up the bulk of his work. The painting overcomes the stereotypical treatment of banjo-playing, as entertainment for a white audience, and instead focuses on familial intimacy.

In the art of **Albert Pinkham Ryder** (1847–1917) the sense of dream is utterly dominant, even in paintings so overloaded with the material substance of thick paint that, as the critic Lloyd Goodrich has written, "a tiny canvas weighs heavy in the hand." This was the product of years spent in a trial-and-error process of working and reworking a single picture, carried out by a painter who declared that "the artist should fear to become the slave of detail. He should strive to express his thought and not the surface of it. What avails a storm cloud accurate in form and color if the storm is not therein." The storm Ryder wanted was of the sort stirred up by the German composer Richard Wagner, whose sublimely Romantic music deeply touched the artist, as it did many of his contemporaries. Ryder, a solitary figure, was unfortunately a dangerously experimental technician, applying wet paint on wet paint and mixing his oils with what was probably bitumen, so that his pictures did not dry properly, but have gone on "ripening" until they have actually darkened and decayed, a process that has, ironically, destroyed many of the exquisite nuances he had sought in endless modifications. What remains, however, tends to dramatize the extraordinary reductiveness of the final image (fig. **2.45**). With all detail refined away and the whole simplified to an arrangement of broad, dramatically contrasted shapes, a painting by Ryder often evokes the convoluted, emotional rhythms of Rubens and Delacroix as well as the Gothic, visionary world of German Expressionism.

2.45 Albert Pinkham Ryder, *Moonlight Marine*, c. 1890s. Oil on panel, 11⅜ × 12" (28.9 × 30.5 cm). The Metropolitan Museum of Art, New York.

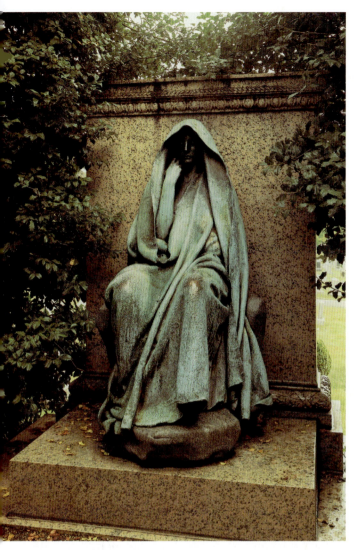

2.46 Augustus Saint-Gaudens, *Adams Memorial*, 1886–91. Bronze and granite, height 70" (177.8 cm). Rock Creek Cemetery, Washington, D.C.

American sculpture during the later nineteenth century was nothing if not prolific, especially in public commissions. The expanding economy led to innumerable sculptural monuments and architectural decorations, though these mostly followed the academic traditions of Rome or Paris. **Augustus Saint-Gaudens** (1848–1907) received academic training in New York, Paris, and Rome, though, contrary to most nineteenth-century academic sculptors, European or American, he took fresh inspiration from sculptures of the Renaissance, notably those of Donatello. By infusing the classical tradition with his own brand of naturalism, Saint-Gaudens produced a number of compelling portraits and could enliven the most banal of commemorative or allegorical monuments. But the request he received from the author Henry Adams to create a memorial to his late wife, who had committed suicide, presented quite other challenges (fig. **2.46**). The sculptor's inspired solution, stimulated by Adams's interest in Buddhism, was an austere, mysteriously draped figure that seems to personify a state of spiritual withdrawal from the physical world. With eyes downcast and face shrouded in shadow, the sculpture constitutes an unforgettable image of eternal repose.

Saint-Gaudens's figure bears kinship not only with artworks created during the Renaissance in Italy, but with Northern works as well. The pyramidal composition of the figure and her inward-turning, contemplative quality call to mind **Albrecht Dürer**'s (1471–1528) famous engraving, *Melencolia I* (fig. **2.47**). Dürer's dejected figure responds to the futility of the pursuit of knowledge in the face of time and mortality. By conjuring this sentiment, Saint-Gaudens invites comparison between the Positivism of the nineteenth century and the humanism of the Renaissance. Both periods looked to learning as the means of bettering society and of finding personal fulfillment. Dürer's personification of Melancholy warns that such intellectual pursuits remain meaningless in the face of death: no amount of empirical study can change this fundamental condition of human existence. Saint-Gaudens was not the only artist to evoke this sentiment. Like many modern artists, he captures the tension between the period's interest in empirical, scientific accounts of human experience and its similarly intense attraction to transcendent, spiritual explanations for events or daily struggles. In the wake of Realism and Impressionism, artists increasingly abandoned the empirical model. Instead of seeking truth through close observation of the natural world, artists began to seek the truth in their own minds, in their own consciences.

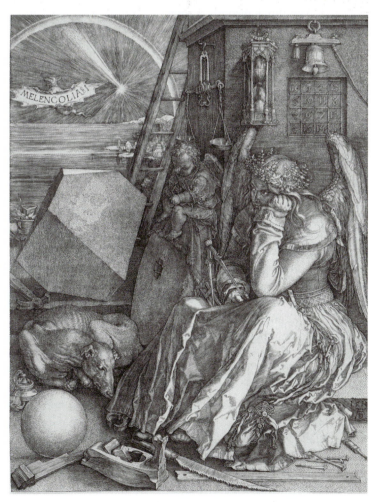

2.47 Albrecht Dürer, *Melencolia I*, 1514. Engraving, 9⁹⁄₁₆ × 7⁵⁄₁₆" (23.9 × 18.5 cm). Fogg Art Museum, Cambridge, MA.

3
Post-Impressionism

Whether through the new technical advantages of photography or the frankness and spontaneity of Realism and Impressionism, many progressive artists of the mid-nineteenth century retained their faith in empiricism. Careful observation coupled with aesthetic discrimination could be relied upon to deliver truths not only about particular moments or experiences but also about the world and humanity more generally. Or could it? Thomas Eakins's *The Gross Clinic* (see fig. 2.43) makes manifest the dilemma posed by such aesthetic empiricism. Offering access to the fundamental, physical nature of human life through his disinterested depiction of Dr. Gross's surgical intervention, Eakins simultaneously acknowledges the limits of this materialism. The intangible forces of emotion and imagination resist easy classification: the human experience cannot be reduced to anatomy or physiology. The violent reaction of the woman who attends the patient emphasizes that experiences are channeled largely through the imagination. Though she is presumably recoiling from the sight of the disconcerting incision in the patient's thigh, her view is, in fact, shielded by the body of Dr. Gross. Her response is a mark of her empathy, of her emotional connection to the patient, and, above all, of the power of her imagination. She responds to what she imagines to be happening.

The work of the Impressionists, too, must be understood as similarly divided between a faith in empiricism and a recognition of its insufficiency. Monet's intense, sustained observations of nature led him to produce dozens of variations on motifs like water lilies (see fig. 2.37), yet, as discussed in the previous chapter, this "truth to nature" must be understood as heavily mediated by each artist's emotional and political sensibilities. Those artists working in the wake of Realism and Impressionism would acknowledge the limits of empiricism, with some choosing to intensify their pursuit of objectivity through new forms of scientific analysis and others abandoning such presumed objectivity and instead turning inward to heed the impulses of imagination. Transformations in the social as well as physical landscape prompted many artists to wonder whether the world could be best understood by looking outward at nature or by retreating inward to a realm of fantasy. In the closing years of the nineteenth century, the responses to this question were as numerous as the artists addressing it.

By the 1880s, Western society had begun to change in ways that could only distress those imbued with the nineteenth-century positivist belief in ever-accelerating progress driven by science and industry. Change was rapid indeed at this time, but not always progressive. As industrial waste combined with expanding commerce to destroy the unspoiled rivers and meadows so often painted by Monet, he withdrew ever deeper into his "harem of flowers" at Giverny, a "natural" world of his own creation that was inextricably bound up with his late painting. As rising socio-economic expectations throughout industrialized Europe met with a conservative backlash, the clash of ideologies brought anarchist violence. At the same time, science reordered itself with the emergence of new theories of physics, chemistry, and psychology—theories that not only contradicted classical models but often defied even the closest observation of nature. The radical philosopher Friedrich Nietzsche announced the death of God and sharply criticized the moral outlook associated with traditional religion. This in turn provoked new debates concerning the role of religion and even morality. The most advanced artists of the period found little to satisfy their needs in the optimistic utilitarianism that had dominated Western civilization since the Enlightenment. Gradually, therefore, they abandoned the Realist tradition of Daumier, Courbet, and Manet (see Chapter 2) that had culminated in Impressionism. Instead, they sought to discover, or recover, a new and more complete reality, one that would encompass the inner world of mind and spirit as well as the outer world of physical substance and sensation.

Inevitably, this produced paintings that seemed even more shocking than Impressionism in their violation of both academic principles and the polished illusionism desired by eyes now thoroughly under the spell of photography. So various and distinctive were the reactions against the largely sensory nature and supposed formlessness of Impressionism that the English critic Roger Fry, who was among the first to take a comprehensive look at these developments, could do no better than sum them up, in 1910, with the vague designation Post-Impressionism. The inadequacy of the term is borne out by the fact that, unlike Impressionism, it did not become widely used until a quarter-century after the first appearance of the artistic phenomena it purported to

describe. Among other things, it implies that Impressionism was itself a homogeneous style, when in fact it covered a highly diverse range of artistic sensibilities. In reality, the Post-Impressionists were schooled in Impressionism and many of them continued to respect its exponents and share much of their outlook. And so, just as Monet and Renoir were beginning to enjoy a measure of critical and financial success, the emerging painters who inspired the term Post-Impressionist reopened the gap—wider now than ever before—that separated the world of avant-garde art from that of society at large.

The Poetic Science of Color: Seurat and the Neo-Impressionists

Trained in the academic tradition of the École des Beaux-Arts in Paris, **Georges Seurat** (1859–91) was a devotee of classical Greek sculpture and of such classical masters as Poussin and Ingres (see fig. 1.5). He also studied the drawings of Hans Holbein, Rembrandt, and Millet (see fig. 1.13), and learned principles of mural design from the academic Symbolist Pierre Puvis de Chavannes (see fig. 3.11). He early became fascinated by theories and principles of color organization, which he studied in the writings and

paintings of Delacroix, the texts of the critics Charles Blanc and David Sutter, and the scientific treatises of Michel-Eugène Chevreul, Ogden Rood, and Charles Henry. Among the phenomena considered in these texts were the ways in which colors affect one another when placed side by side. According to Chevreul, for example, each color will impose its own complementary on its neighbor: if red is placed next to blue, the red will cast a green tint on the blue, altering it to a greenish blue, while the blue imposes a pale orange on the red. Although the rational, scientific basis for such theories appealed to Seurat, he was no cold, methodical theorist. His highly personal form of expression evolved through careful experiments with his craft. Working with his younger friend Paul Signac, he sought to combine the color experiments of the Impressionists with the classical structure inherited from the Renaissance, employing the latest concepts of pictorial space, traditional illusionistic perspective depth, and recent scientific discoveries in the perception of color and light.

It is astonishing that Seurat produced such a body of masterpieces in so short a life (he died at thirty-one in a diphtheria epidemic). One of the landmarks of modern art is his *A Sunday Afternoon on the Island of La Grande Jatte* (fig. 3.1). Known as *La Grande Jatte*, it was the most notorious

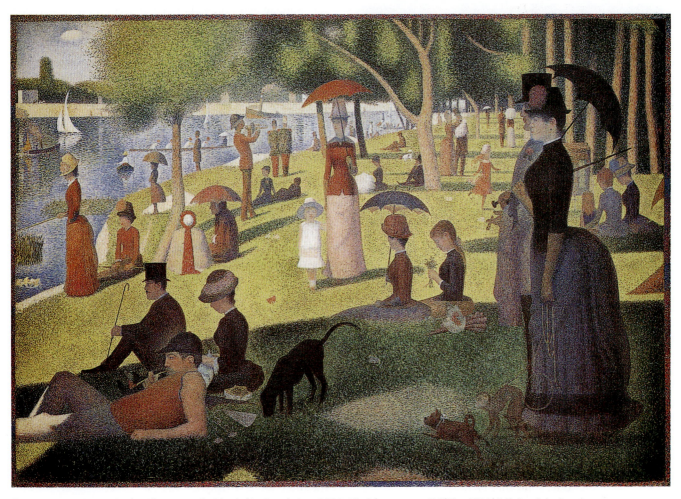

3.1 Georges Seurat, *A Sunday Afternoon on the Island of La Grande Jatte*, 1884–86. Oil on canvas, 6′ 9½″ × 10′ 1¼″ (2.1 × 3.1 m). The Art Institute of Chicago.

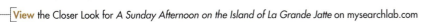

View the Closer Look for *A Sunday Afternoon on the Island of La Grande Jatte* on mysearchlab.com

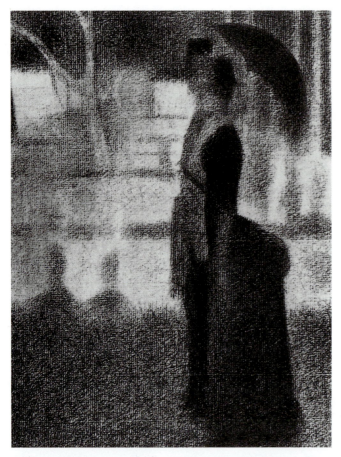

3.2 Georges Seurat, *The Couple*, study for *La Grande Jatte*, 1884. Conté crayon on paper, 12¼ × 9¼" (31.1 × 23.5 cm). The British Museum, London.

complementary colors—red and green, violet and yellow, blue and orange—and with white. Various names have been given to his method, including **Divisionism** (Seurat's own term), **Pointillism**, and Neo-Impressionism. Despite their apparent uniformity, on close inspection the "dots" vary greatly in size and shape and are laid down over areas where color has been brushed in more broadly. The intricate mosaic produced by Seurat's painstaking technique is analogous to the medium of actual **mosaic**; its glowing depth of luminosity gives an added dimension to color experience. Unfortunately, some of the pigments he used were unstable, and in less than a decade oranges had turned to brown and brilliant emerald green had dulled to olive, reducing somewhat the original chromatic impact of the painting.

Seurat's technique relates importantly to the content of *La Grande Jatte*. During the second half of the nineteenth century, commercial leisure spots where Parisians of the working, artisan, and professional classes as well as the bourgeoisie could amuse themselves by strolling, listening to music, dancing, or perhaps renting a small rowboat or sailboat proliferated along the Seine on the outskirts of the city. La Grande Jatte was among the most popular places for weekend and holiday amusement. Such sites had already attracted the Impressionists, who found appealing motifs in their bucolic settings, playful activities, and visitors' colorful "Sunday best" dress. For Seurat, a committed anarchist, the concentration of individuals from diverse class backgrounds offered even more. The capacity for individuals to form a harmonious group while each one maintains his or her autonomy was translated from a political ideal into an aesthetic one, with Seurat's Pointillist technique allowing indivisible units to coalesce into a luminous, coherent scene when viewed from the right perspective.

Along with its social significance, what drew Seurat to this particular scene, perhaps, was the manner in which the figures could be arranged in diminishing perspective along the banks of the river, although delightful inconsistencies in scale abound throughout the composition. At this point in the picture's evolution the artist was concerned as much with the recreation of a fifteenth-century exercise in linear perspective as with the creation of a unifying pattern of surface color dots. Broad contrasting areas of shadow and light, each built of a thousand minute strokes of juxtaposed color-dot complementaries, carry the eye from the foreground into the beautifully realized background. Certainly, Seurat was here attempting to reconcile the classical tradition of Renaissance perspective painting with a modern interest in light, color, and pattern. The immense size of the canvas gives it something of the impact of a Renaissance **fresco**, and is especially dramatic since it is composed of brushstrokes smaller than a pea. The painting's scale also shows avant-garde art asserting its status relative to the academic tradition (and thus, paradoxically, developing a new "grand tradition" of its own).

In a preparatory oil for a later painting, such as the study for *Le Chahut* (fig. **3.3**), the color dots are so large that the figures and their spatial environment are dissolved in color

item in the last of the eight Impressionist exhibitions, in 1886. Seurat worked for over a year on this monumental painting, preparing it with twenty-seven preliminary drawings (fig. **3.2**) and thirty color sketches. His hauntingly beautiful conté crayon drawings reveal his interest in earlier artists who had similarly exploited black and white, from Rembrandt to Goya. Seurat avoided lines to define contours and depended instead on shading to achieve soft, penumbral effects. In the preparatory works for *La Grande Jatte*, ranging from studies of individual figures to oils that laid in most of the final composition, Seurat analyzed, in meticulous detail, every color relationship and every aspect of pictorial space.

Seurat's unique color system was based on the Impressionists' realization that all nature was color, not neutral tone. But the Impressionist painters had generally made no organized, scientific effort to achieve their remarkable optical effects. Their technique involved placing pure, unblended colors in close conjunction on the canvas, perceived by the eye as glowing, vibrating patterns of mixed color. This effect appears in many paintings by Monet, as anyone realizes who has stood close to one of his works, first experiencing it simply as a pattern of discrete color strokes, and then moving gradually away from it to observe all the elements of the scene come into focus.

Building on Impressionism and his own further study of the science of optics, Seurat constructed his canvases with an overall pattern of small, dot-like brushstrokes of generally

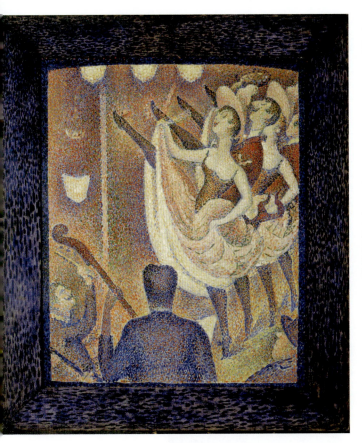

3.3 Georges Seurat, Study for *Le Chahut*, 1889. Oil on canvas, 21⅞ × 18⅜" (55.6 × 46.7 cm). Albright-Knox Art Gallery, Buffalo, New York. General Purchase Funds, 1943.

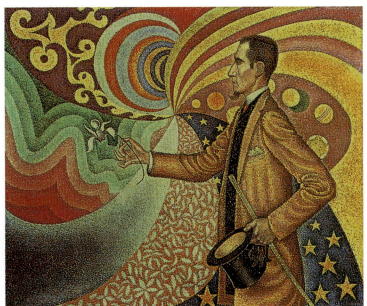

3.4 Paul Signac, *Opus 217. Against the Enamel of a Background Rhythmic with Beats and Angles, Tones and Tints, Portrait of M. Félix Fénéon in 1890*, 1890. Oil on canvas, 29⅛ × 36½" (73.5 × 92.5 cm). The Museum of Modern Art, New York.

patterns clinging to the surface of the picture. The painting depicts a provocative and acrobatic dance, then popular in Parisian cafés, which Seurat beautifully orchestrates into a series of decorative rhythms, giving form to a theory then current that ascending lines induce feelings of gaiety in the viewer. Seurat was clearly inspired by the colorful posters that were placed around Paris to advertise the dance halls. Around the study for *Le Chahut* he painted a border of multicolored strokes (as he had for *La Grande Jatte*), and he probably painted its wooden frame as well. The relationship between the painting and its frame was of growing concern to progressive painters. No longer content to accept the frame as simply a means of demarcating the borders of a picture, artists such as Seurat and the British Pre-Raphaelites insisted on designing unique frames for each artwork.

Seurat's chief colleague and disciple, **Paul Signac** (1863–1935), strictly followed the precepts of Neo-Impressionism in his landscapes and portraits. Like his colleagues, Signac regarded his revolutionary artistic style as a form of expression parallel to his radical political anarchism. Just as anarchists place the individual at the apex of social organization, Pointillism insists on the formal relevance of each unit of color, showing that harmony emerges by maintaining the integrity of constituent parts. This idea was closely associated with other Neo-Impressionists in France and Belgium who believed that only through absolute creative freedom could art help to bring about social change. In his later, highly coloristic seascapes, Signac provided a transition between

Neo-Impressionism and the Fauvism of Henri Matisse and his followers (see Chapter 5). Through his book *D'Eugène Delacroix au Néo-impressionnisme* (*From Eugène Delacroix to Neo-Impressionism*), he was also the chief propagandist and historian of the movement. His portrait of the critic Félix Fénéon (fig. **3.4**), who had been the first to use the term Neo-Impressionism, is a fascinating example of the decorative **formalism** that the artists around Seurat favored. The painting, with its spectacular spiral background inspired by patterns that Signac had found in a Japanese print, contains private references to the critic's ideas and to those of the color theorist Charles Henry, with which Signac was very familiar.

Form and Nature: Paul Cézanne

Of all the nineteenth-century painters who approached their medium as a means for endless experiment, the most significant was **Paul Cézanne** (1839–1906). Cézanne struggled throughout his life to express in paint his ideas about the nature of art, ideas that were among the most revolutionary in the history of art. Son of a well-to-do merchant turned banker in Aix-en-Provence in southern France, he had to resist parental disapproval to embark on his career, but once having won the battle, he did not need to struggle for mere financial survival. As we view the adamant composure of his mature paintings, it is difficult to realize that he was an isolated, socially awkward man of a sometimes violent disposition. This aspect of his character is evident, however, in some of his early mythological figure scenes, which were baroque in their movement and excitement. At the same time he was a serious student of the art of the past who studied the masters in the Louvre, from Paolo Veronese to Poussin to Delacroix.

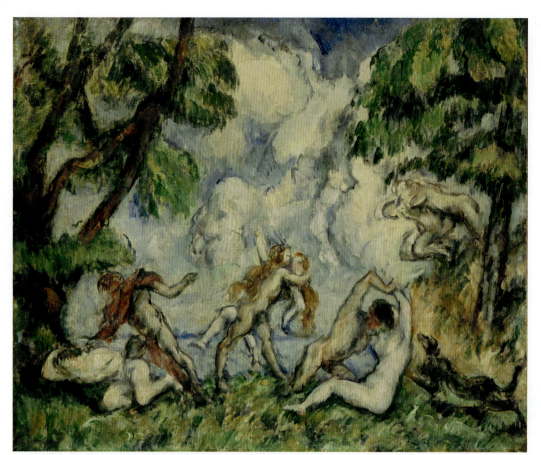

3.5 Paul Cézanne, *Battle of Love*, c. 1880. Oil on canvas, 14⅞ × 18¼" (37.8 × 46.2 cm). National Gallery of Art, Washington, D.C.

Early Career and Relation to Impressionism

Cézanne's unusual combination of logic and emotion represented the synthesis that he sought in his paintings. Outside of Degas, the Impressionists in the 1870s largely abandoned traditional drawing in an effort to communicate a key visual phenomenon—that objects in nature are not seen as separated from one another by defined contours. In their desire to realize the observed world through color, with both the objects themselves and the spaces between them rendered in terms of color intervals, they tended to destroy objects as three-dimensional entities existing in three-dimensional space. Instead they recreated solids and voids as color shapes functioning within a limited depth. Because it did not make a clear distinction between three-dimensional mass (objects) and three-dimensional depth (spaces), Impressionism was criticized as formless and insubstantial. Even Renoir felt compelled to restudy the drawing of the Renaissance in order to recapture some of that "form" which Impressionism was said to have lost. And Seurat, Gauguin, and Van Gogh, each in his own way, consciously or unconsciously, were seeking a kind of expression based on, but different from, that of the Impressionists.

Certainly, Cézanne's conviction that Impressionism ignored qualities of Western painting important since the Renaissance prompted his oft-quoted (and frequently misunderstood) remark that he wanted to "make of Impressionism something solid like the art of the museums." By this he did not mean to imitate the **Old Masters**. He realized, quite correctly, that artists like Veronese or Poussin had created in their paintings a world similar to but quite distinct from the world in which

they lived—that painting, resulting from the artist's various experiences, created a separate reality in itself. It was this kind of reality, the reality of the painting that was neither a direct reflection of life, like a photograph, nor a completely separate entity, that Cézanne sought in his own work. And he felt progressively that his sources must be nature and the objects of the world in which he lived, rather than stories or myths from the past. For this reason he expressed his desire "to do Poussin over again from nature."

Cézanne arrived at his mature position only after extended thought, study, and struggle with his medium. Late in his life, the theoretical position that he tried to express in his idiosyncratic language was probably achieved more through the discoveries he made painting from nature than through his studies in museums. In the art of the museum he found corroboration of what he already instinctively knew. Manet and Courbet are evident as sources, but the forceful temperament of the artist himself differs from that in the work of either predecessor. Throughout the 1860s, Cézanne exorcised his own inner conflict in scenes of murder and rape and, around 1870, he attempted his own *Déjeuner sur l'herbe* (see fig. 2.19) in a strange, heavy-handed variant on Manet's painting. After his exposure to the Impressionists, he returned to the violence of these essays in his *Battle of Love* (fig. **3.5**), a curious recasting of the classic theme of the bacchanal. Here he has moved away from the somber tonality and sculptural modeling of the 1860s into an approximation of the light blue, green, and white of the Impressionists. Nevertheless, this painting is remote from Impressionism in its subject and effect. The artist subdues his greens with grays

and blacks, and expresses an obsession with the sexual ferocity he is portraying that is notably different from the stately bacchanals of Titian and even more intense than comparable scenes by Rubens. At this stage he is still exploring the problem of integrating figures or objects and surrounding space. The figures are clearly outlined, and thus exist sculpturally in space. However, their broken contours, sometimes seemingly independent of the cream-colored area of their flesh, begin to dissolve solids and integrate figures with the shaped clouds that, in an advancing background, reiterate the carnal struggles of the bacchanal.

In the 1880s, all of Cézanne's ideas on nature and painting came into focus in a magnificent series of landscapes, still lifes, and portraits. During most of this period he was living at Aix, largely isolated from the Parisian art world. *The Bay of Marseilles, seen from L'Estaque* (fig. **3.6**) is today so familiar from countless reproductions that it is difficult to realize how revolutionary it was at the time. Viewed from the hills above the red-tiled houses of the village of L'Estaque and looking toward the Bay of Marseilles, the scene does not recede into a perspective of infinity in the Renaissance manner. Buildings in the foreground are massed close to the spectator and presented as simplified cubes with the side elevation brightly lit. They assert their fluctuating identity, both as frontal color shapes parallel to the picture plane and

as the walls of buildings at right angles to it. The buildings and intervening trees are composed in ocher, yellow, orange-red, and green, with little differentiation as objects recede from the eye. Cézanne once explained to a friend that sunlight cannot be "reproduced," but that it must be "represented" by some other means. That means was color. He wished to recreate nature with color, feeling that drawing was a consequence of the correct use of color. In *The Bay*, contours are the meeting of two areas of color. Since these colors vary substantially in value contrasts or in hue, their edges are perfectly defined. However, the nature of the definition tends to allow color planes to slide or "pass" into one another, thus to join and unify surface and depth, rather than to separate them in the manner of traditional outline drawing. The composition of this painting reveals Cézanne's intuitive realization that the eye takes in a scene both consecutively and simultaneously, with profound implications for the construction of the image and the future of painting.

The middle distance of *The Bay* is the bay itself, an intense area of dense but varied blue stretching from one side of the canvas to the other and built up of meticulously blended brushstrokes. Behind this is the curving horizontal range of the hills and, above these, the lighter, softer blue of the sky, with only the faintest touches of rose. The abrupt manner in which the artist cuts off his space at the sides of the

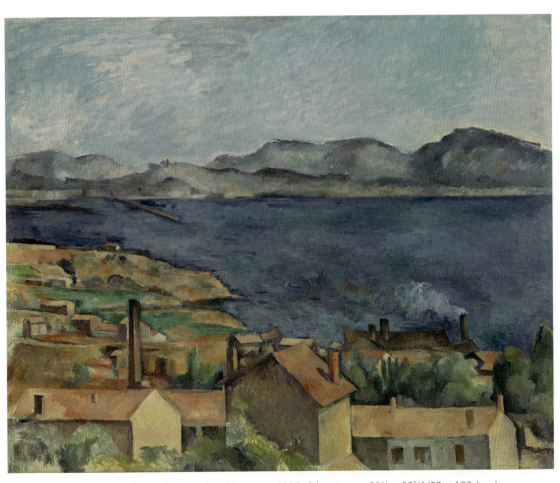

3.6 Paul Cézanne, *The Bay of Marseilles, seen from L'Estaque*, c. 1885. Oil on canvas, 31½ × 39⅝" (80 × 100.6 cm). The Art Institute of Chicago. Mr. and Mrs. Martin A. Ryerson Collection.

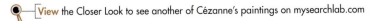 View the Closer Look to see another of Cézanne's paintings on mysearchlab.com

painting has the effect of denying the illusion of recession in depth. The blue of the bay asserts itself even more strongly than the ochers and reds of the foreground, with the result that space becomes both ambiguous and homogeneous. The painting must be read simultaneously as a panorama in depth and as an arrangement of color shapes on the surface.

Even at the end of his life, Cézanne never had any desire to abandon nature entirely. When he recommended treating "nature by means of the cylinder, the sphere, the cone, everything brought into perspective so that each side of an object or a plane is directed to a central point," he was not thinking of these geometric shapes as the end result, the final abstraction into which he wanted to translate the landscape or the still life, as has sometimes been assumed. Abstraction for him was a method of stripping off the visual irrelevancies of nature in order to begin rebuilding the natural scene as an independent painting. Thus the end result was easily recognizable from the original motif, as photographs of Cézanne's sites have proved, but it is essentially different: the painting is a parallel but distinct and unique reality.

Later Career

The fascination of the still life for Cézanne, as for generations of painters before him and after, lies in the fact that its subject is controllable as no landscape or portrait sitter can possibly be. In *Still Life with Basket of Apples* (fig. **3.7**), he carefully arranged the wine bottle and tilted basket of apples, scattered the other apples casually over the tablecloth, and placed the plate of biscuits at the back of the table, thus setting up the relationships between these elements on which the final painting would be based. The apple obsessed Cézanne as a three-dimensional form that was difficult to control as a distinct object and to assimilate into the larger unity of the canvas. To attain this goal and at the same time

to preserve the nature of the individual object, he modulated the circular forms with small, flat brushstrokes, distorted the shapes, and loosened or broke the contours to set up spatial tensions among the objects and unify them as color areas. By tilting the wine bottle out of the vertical, flattening and distorting the perspective of the plate, or changing the direction of the table edge under the cloth, Cézanne was able, while maintaining the appearance of actual objects, to concentrate on the relations and tensions existing among them. As Roger Fry observed, the subtleties through which Cézanne gained his final result "still outrange our pictorial apprehension." However, we can comprehend that he was one of the great constructors and colorists in the history of painting, one of the most penetrating observers, and one of the most subtle minds.

After 1890, Cézanne's brushstrokes became larger and more abstractly expressive, the contours more broken and dissolved, with color floating across the canvas, sustaining its own identity independent of the objects it defined. These tendencies were to lead to the wonderfully free paintings done at the very end of the artist's life, of which *Mont Sainte-Victoire Seen from Les Lauves* of 1902–06 is one of the supreme examples (fig. **3.8**). Here the brushwork acts the part of the individual musician in a superbly integrated symphony orchestra. Each stroke exists fully in its own right, but each is nevertheless subordinated to the harmony of the whole. This is both a structured and a lyrical painting, one in which the artist has achieved the integration of structure and color, of nature and painting. It belongs to the great tradition of classical landscape as exemplified by Poussin, seen, however, as an infinite accumulation of individual perceptions. These are analyzed by the painter into their abstract components and then reconstructed into the new reality of the painting.

To the end of his life, Cézanne held fast to his dream of remaking Poussin after nature, continuously struggling with the problem of how to pose classically or heroically nude figures in an open landscape. For the largest canvas he ever worked, Cézanne painted as Poussin had done—that is, from his imagination—and relied on his years of *plein-air* experience to evoke Impressionist freshness. *The Large Bathers* (fig. **3.9**), in many ways the culmination of thirty years of experiment with the subject of female bathers in an outdoor setting, was painted in the year of Cézanne's death and is unfinished. In it the artist subsumed the fierce emotions expressed in the earlier *Battle of Love* (see fig. 3.5) within the grandeur of his total conception. Thus, while the figures have been so

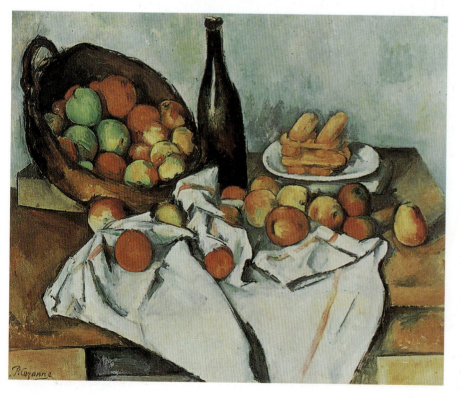

3.7 Paul Cézanne, *Still Life with Basket of Apples*, c. 1893. Oil on canvas, 24⅜ × 31" (61.9 × 78.7 cm). The Art Institute of Chicago. Helen Birch-Bartlett Memorial Collection.

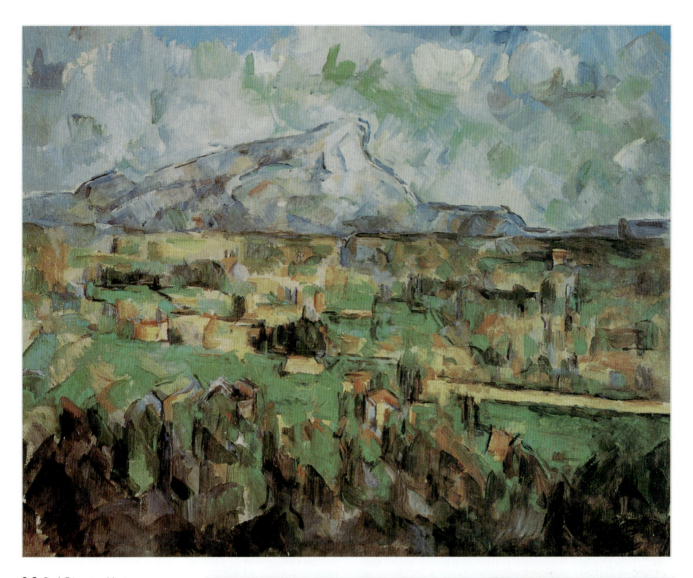

3.8 Paul Cézanne, *Mont Sainte-Victoire Seen from Les Lauves*, 1902–06. Oil on canvas, 25½ × 32" (64.8 × 81.3 cm). Collection Mrs. Louis C. Madeira, Gladwyne, Pennsylvania.

Watch a video about *Mont Sainte-Victoire* on mysearchlab.com

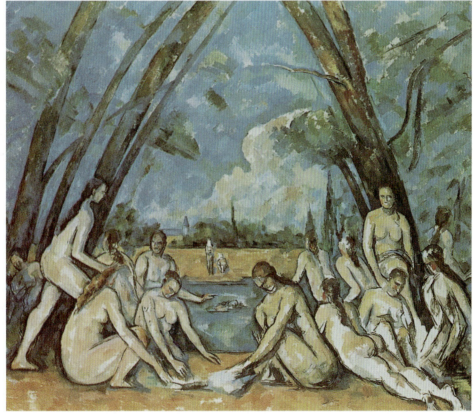

3.9 Paul Cézanne, *The Large Bathers*, 1906. Oil on canvas, 6' 10" × 8' 2" (2.1 × 2.5 m). Philadelphia Museum of Art.

Listen to a podcast about *The Large Bathers* on mysearchlab.com

formalized as to seem part of the overall pictorial architecture, their erotic potential now charges the scene. It can be sensed as much in the high-vaulted trees as in the sensuous, shimmering beauty of the brushwork, with its unifying touches of rosy flesh tones and earthy ochers scattered throughout the delicate blue-green haze of sky and foliage. *The Large Bathers*, in its integration of linear structure and painterly freedom, of form and color, of eye and idea, provided a touchstone for those progressive artists seeking to distill the nuances and contradictions of observed reality into a pure visual experience. Other artists, however, pursued a different model, distancing themselves further from empirical observation in order to create artworks that privileged imagination and aesthetic sensation.

The Triumph of Imagination: Symbolism

Symbolism in literature and the visual arts was a popular—if radical—movement of the late nineteenth century. A direct descendant of Romanticism, Symbolism must also be reckoned a response to the popularization of Art for Art's Sake. With no interest in influencing contemporary beliefs or social policies, Symbolist artists were even freer than their Romantic predecessors to delve into the recesses of their imagination. In literature, Symbolism's founders were mainly poets: Charles Baudelaire and Gérard de Nerval; the leaders at the close of the century were Jean Moréas, Stéphane Mallarmé, and Paul Verlaine. In music, Richard Wagner and Claude Debussy were great influences. Baudelaire had defined Romanticism as "a mode of feeling"—something found within rather than outside the individual—"intimacy, spirituality, color, aspiration toward the infinite." Symbolism arose from the intuitive ideas of the Romantics; it was an approach to an ultimate reality, a pure essence that transcended particular physical experience. The belief that the work of art should spring from the emotions, from the inner spirit of the artist rather than representing observed nature, dominated the attitudes of the Symbolist artists and was to recur continually in the philosophies of twentieth-century art.

For the Symbolists the inner idea, the dream or symbol, was paramount, but could be expressed only obliquely, as a series of images or analogies out of which the final revelation might emerge. Symbolism led some poets and painters back to organized religion, some to mysticism and arcane religious cults, and others to aesthetic creeds that were essentially anti-religious. During the 1880s, at the moment when artists were pursuing the idea of the dream, Sigmund Freud was beginning the studies that were to lead to his theories of the significance of dreams and the workings of the unconscious. Predicated on the understanding that the mind comprises both a sphere of conscious, rational decision-making and a realm of unconscious desires and fears, Freud's research led him to conclude that the unconscious—brimming with emotionally debilitating and, often, socially unacceptable fantasies and urges—could impose itself on the behavior and health of an individual if not properly managed. Unaware of the work of this young scientist, Symbolists nonetheless shared Freud's fascination with the self as an essentially interior experience, a continual renegotiation of reality through fantasy.

Symbolism in painting—the search for new forms, antinaturalistic if necessary, to express a new content based on emotion (rather than intellect or objective observation), intuition, and the idea beyond appearance—may be interpreted broadly to include most of the experimental artists who succeeded the Impressionists and rejected their reliance on empiricism. The Symbolist movement, while centered in France, was international in scope and had adherents in America, Belgium, Britain, and elsewhere in Europe. These artists had a common concern with problems of personal expression and pictorial structure. They were inspired and abetted by two older academic masters—Gustave Moreau and Pierre Puvis de Chavannes—and also by Odilon Redon, an artist born into the generation of the Impressionists who attained his artistic maturity much later than his exact contemporaries.

Reverie and Representation: Moreau, Puvis, and Redon

Gustave Moreau (1826–98) was appointed professor at the École des Beaux-Arts in 1892 and displayed remarkable talents as a teacher. Inspired by Romantic painters such as Delacroix, Moreau's art exemplified the spirit of the *mal-du-siècle*, an end-of-the-century tendency toward profound melancholy or soul sickness, often expressed in art and literature through decadent and morbid subject matter. In several compositions around 1876, Moreau interpreted the biblical subject of Salome, the young princess who danced for her stepfather Herod, demanding in return the execution of St. John the Baptist. The bloody head of the saint appears in Moreau's painting as if called forth in a grotesque hallucination (fig. **3.10**). He conveys his subject with meticulous draftsmanship and an obsessive profusion of exotic detail combined with jewel-like color and rich paint texture.

Moreau's spangled, languidly voluptuous art did much to glamorize decadence in the form of the *femme fatale*, or "deadly woman." The concept of woman as an erotic and destructive force was fostered by Baudelaire's great series of poems *Les Fleurs du Mal* ("The Flowers of Evil") (1857) and the mid-century pessimistic philosophy of Arthur Schopenhauer. Among scores of male artists in the last decades of the nineteenth century, Salome frequently served as the archetype of a castrating female who embodied all that is debased, sexually predatory, and perverse. The *femme fatale* also played a central role in the work of such composers as Wagner and Richard Strauss, such writers as Gustave Flaubert, Joris-Karl Huysmans (who admired Moreau's painting enormously), Stéphane Mallarmé, Oscar Wilde, and Marcel Proust, and a great number of artists. Moreover, the deadly temptress thrived well into the twentieth century, as she resurfaced in Picasso's *Les Demoiselles d'Avignon* (see fig. 7.7), the paintings and drawings of

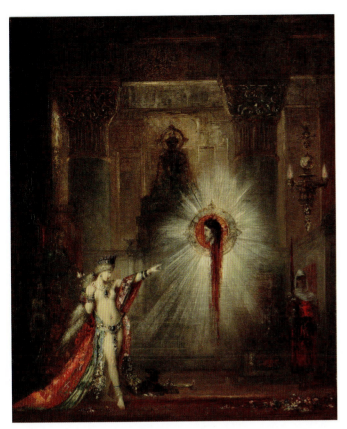

3.10 Gustave Moreau, *The Apparition*, c. 1876. Oil on canvas, 21¼ × 17½" (54 × 44.5 cm). Fogg Art Museum, Harvard University Art Museums, Cambridge, MA.

Egon Schiele, and the *amour fou* ("mad love") art of the Surrealists (see Chapter 14). Propelling this preoccupation with sexually alluring yet dangerous women was a generalized disorientation arising from changing social mores and gender roles in the late nineteenth and early twentieth centuries. As more women sought—and achieved—political and economic enfranchisement, long-held assumptions about women's physical and mental shortcomings were exposed as myths. The "New Woman," capable of thinking and acting for herself, provoked consternation and confusion as she made her presence felt throughout Western Europe and North America.

Although **Pierre Puvis de Chavannes** (1824–98), with his simple, naive spirit, bleached colors, and near-archaic handling, would seem to have stood at the opposite pole from the elaborate, hothouse art of Moreau, the two painters were alike in a certain academicism and in the curious attraction this held for the younger generation. In Puvis, the reasons for such an anomaly can be readily discerned in his mural painting *Summer* (fig. **3.11**). The allegorical subject and its narrative treatment are highly traditional, but the organization in

large, flat, subdued color areas, and the manner in which the plane of the wall is respected and even asserted, embodied a compelling truth in the minds of artists who were searching for a new idealism in painting. Although the abstract qualities of the mural are particularly apparent to us today, the classical withdrawal of the figures transforms them into emblems of that inner light that the Symbolists extolled.

Symbolism in painting found one of its earliest and most characteristic exponents in **Odilon Redon** (1840–1916), called the "prince of mysterious dreams" by the critic and novelist Huysmans. Redon felt Impressionism lacked the ambiguity that he sought in his art, and though he frequently found his subjects in the study of nature, at times observed under the microscope, they were transformed in his hands into beautiful or monstrous fantasies.

Redon studied for a time in Paris with the painter Jean-Léon Gérôme, but he was not temperamentally suited to the rigors of academic training. He suffered from periodic depression—what he called his "habitual state of melancholy"—and much of his early work stems from memories of an unhappy childhood in and around Bordeaux, in southwest France. Like Seurat, Redon was a great colorist who also excelled at composing in black and white, and the first twenty years of his career were devoted almost exclusively to **monochrome** drawing, etching, and lithography, works he referred to as his "noirs," or works in black. His printmaking activity contributed to the rise in popularity of etching in the 1860s, prompted in part by a new appreciation in France of Rembrandt's prints, which Redon especially admired for their expressive effects of light and shadow. Redon studied etching with Rodolphe Bresdin, a strange and solitary artist who created a graphic world of meticulously detailed fantasy based on the work of the northern European masters Dürer (see fig. 2.47) and Rembrandt. Redon later found a closer affinity with the graphics of Francisco Goya (see fig. 1.7). Redon revealed the potential of the medium of lithography, in which he invented a world of dreams and nightmares based not only on the examples of past artists but also on his close and scientific study of anatomy.

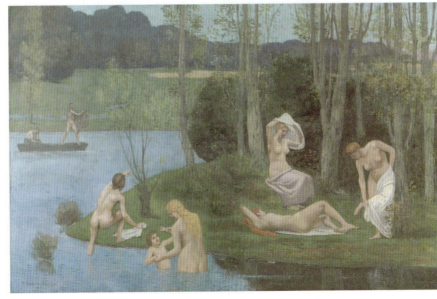

3.11 Pierre Puvis de Chavannes, *Summer*, 1891. Oil on canvas, 4' 11" × 7' 7½" (1.5 × 2.3 m). The Cleveland Museum of Art. Gift of Mr. and Mrs. J. H. Wade, 1916. 1056.

Redon's own predilection for fantasy and the macabre drew him naturally into the orbit of the Symbolists. In his drawings and lithographs, where he pushed his rich, velvety blacks to extreme limits of expression, he developed and refined the fantasies of Bresdin in nightmare visions of monsters, or tragic-romantic themes taken from mythology or literature. Redon was close to the Symbolist poets and was almost the only artist who was successful in translating their words into visual equivalences. He dedicated a portfolio of his lithographs to Edgar Allan Poe, whose works had been translated by Baudelaire and Mallarmé, and he created three series of lithographs inspired by Gustave Flaubert's *Temptation of St. Anthony*, a novel that achieved cult status among Symbolist writers and artists in the 1880s. Conceived as visual correspondences rather than illustrations to the text, Redon's homage to Poe includes a fantastic image of an eye that has been transformed into a hot-air balloon floating above a lake or bay. Suspended beneath the hovering eye is a plate on which a skull rests (fig. **3.12**). The eye's upward glance recalls long-standing conventions for the representation of divine contemplation, as if Redon is affirming the possibility of human perception of an ideal state. Yet the skull seems to weigh the balloon down, threatening to pull it into the abyss below. Redon exploits lithography's capacity for rich, velvety blacks and misty gradations of tone to conjure a shadowed but not murky dreamscape. Huysmans reviewed Redon's exhibitions enthusiastically at the same time that he was himself moving away from Émile Zola's naturalism and into the Symbolist stream with his novel of artistic decadence *Against the Grain*, in which he discussed at length the art of Redon and of Gustave Moreau.

The Naive Art of Henri Rousseau

Although **Henri Rousseau** (1844–1910) was almost the same age as Monet, his name tends to be linked with a younger generation of progressive artists, because of the remarkable artistic circles with which he associated, sometimes unwittingly, in Paris. Though Rousseau shared many formal concerns with his Post-Impressionist contemporaries, such as Gauguin and Seurat, he is often regarded as a phenomenon apart from them, for he worked in isolation, admired the academic painters they abhorred, and was "discovered" by several younger avant-garde artists. In its rejection of traditional illusionism and search for a poetic, highly personalized imagery, his work embraces concerns held by many Symbolist artists at the end of the century. For younger artists, however, his work chimed with their growing interest in "primitive" art—whether the prehistoric or folk art of Europe, or the art of other cultures and peoples whose works were untouched by what they saw as the dead hand of Western academic tradition.

In 1893, Rousseau retired from a full-time position as an inspector at a municipal toll station in Paris. He was called Le Douanier ("the customs agent") by admiring young artists and poets who were more intrigued by his outsider status than by the exact nature of his day job. Once he turned his full energies to painting, Rousseau seems to have developed a native ability into a sophisticated technique and an artistic vision that, despite its ingenuousness, was not without aesthetic sincerity or self-awareness.

Rousseau was a fascinating mixture of naivety, innocence, and wisdom. Seemingly humorless, he combined a strange imagination with a way of seeing that was magical, sharp, and direct. In 1886, he exhibited his first painting, *Carnival Evening* (fig. **3.13**), at the Salon des Indépendants. The black silhouettes of the trees and house are drawn in painstaking detail—the accretive approach typically used by self-taught painters. Color throughout is low-keyed, as befits a night scene, but the lighted bank of clouds beneath the dark sky creates a sense of clear, wintry moonlight, as do the two tiny figures in carnival costumes in the foreground, who glow with an inner light. Despite the laboriously worked surface and the untutored quality of his drawing, the artist fills his painting with poetry and a sense of dreamy unreality.

By 1890 Rousseau had exhibited some twenty paintings at the Salon des Indépendants. His work had achieved a certain public notoriety, thanks to the constant mockery it endured in the press, but it also increasingly excited the interest of serious artists such as Redon, Degas, and Renoir and important writers like the poet and playwright Alfred Jarry and, somewhat later, Guillaume Apollinaire. Despite

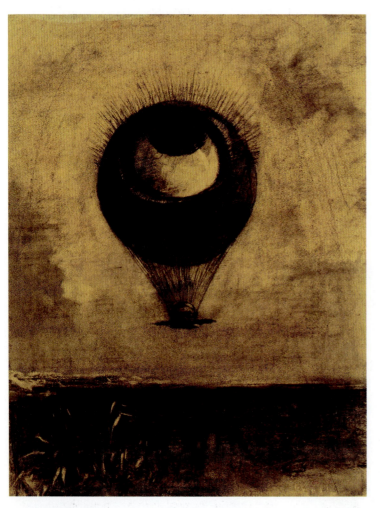

3.12 Odilon Redon, *The Eye Like a Strange Balloon Mounts toward Infinity*, 1882. Lithograph, image: 10³⁄₁₆ × 7¹¹⁄₁₆" (25.9 × 19.6 cm). The Museum of Modern Art, New York.

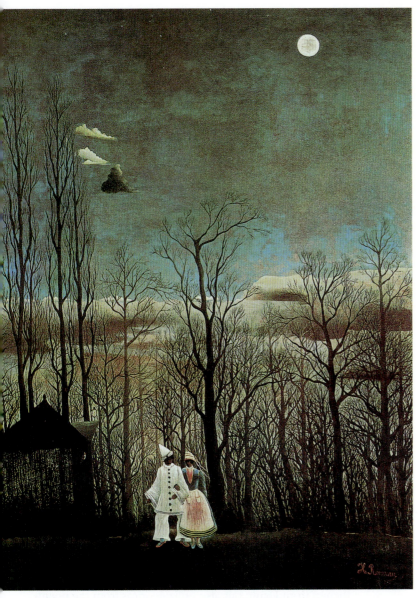

3.13 Henri Rousseau, *Carnival Evening*, 1886. Oil on canvas, 46 × 35⅛" (116.8 × 89.2 cm). Philadelphia Museum of Art.

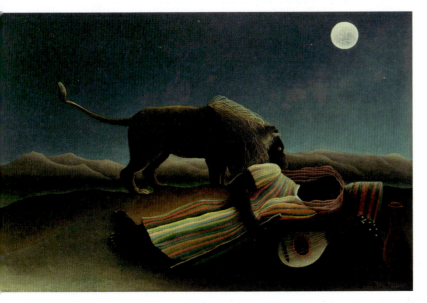

3.14 Henri Rousseau, *The Sleeping Gypsy*, 1897. Oil on canvas, 4′ 3″ × 6′ 7″ (1.3 × 2 m). The Museum of Modern Art, New York.

such recognition, Rousseau never made a significant living from his painting and spent most of his post-retirement years in desperate poverty. Yet to the end of his life he continued his uncritical admiration for the Salon painters, particularly for the technical finish of their works. *The Sleeping Gypsy* (fig. **3.14**) is one of the most entrancing and magical paintings in modern art. By this time he could create mood through a few elements, broadly conceived but meticulously rendered. The composition has a curiously abstract quality, but the tone is overpoweringly strange and eerie—a vast and lonely landscape framing a mysterious scene. This painting was lost for years until it was rediscovered in 1923 in a charcoal dealer's shop by the art critic Louis Vauxcelles. This "discovery" by the critic would further the modernist idea that artistic genius is not always apparent to all viewers; the discriminating eye of a sensitive artist or critic must be relied upon to discern aesthetic achievement, even in the unlikeliest of places. During his later years, Rousseau became something of a celebrity for the new generation of artists and critics. He held regular musical soirées at his studio. In 1908 Picasso, discovering a portrait of a woman by Rousseau at a junk shop (though he no doubt knew Rousseau's work already), purchased it for five francs and gave a large party for him in his studio, a party that has gone down in the history of modern painting. It was partly intended as a joke on the innocent old painter, who took himself so seriously as an artist, but more as an affectionate tribute to a naive man heralded as a genius. In 1910, the year of his death, Rousseau's first solo exhibition was held in New York at Alfred Stieglitz's 291 Gallery, thanks to the efforts of the young American painter Max Weber (see fig. 15.10), who had befriended Rousseau in Paris.

An Art Reborn: Rodin and Sculpture at the *Fin de Siècle*

It was the achievement of the French artist **Auguste Rodin** (1840–1917) to rechart the course of sculpture almost singlehandedly and to give the art an impetus that led to a major renaissance. There is no one painter who occupies quite the place in modern painting that Rodin can claim in modern sculpture. He introduced modern ideas into the tradition-bound form of figural public sculpture, depicting bodies that exert the material weight of their physical existence while simultaneously revealing the play of thoughts and emotions that underlie a

figure's movement. In this way, Rodin's works show their indebtedness to Realism and Symbolism.

Early Career and *The Gates of Hell*

Rodin began his revolution, as had Courbet in painting (see Ch. 2, pp. 20–22), with a reaction against the sentimental idealism of the academicians. His examination of nature was coupled with a re-examination of the art of the Middle Ages and the Renaissance—most specifically, of Donatello and Michelangelo. Rodin was in possession of the full range of historical sculptural forms and techniques by the time he returned in 1875 from a brief but formative visit to Italy, where he studied firsthand the work of Michelangelo, who, he said, "liberated me from academicism."

The Age of Bronze (fig. **3.15**), Rodin's first major signed work, was accepted in the Salon of 1877, but its scrupulous realism led to the suspicion that it might have been in part cast from the living model—which became a legitimate technique for making sculpture only in the 1960s (see fig. 19.20). Although Rodin had unquestionably observed the model closely from all angles and was concerned with capturing and unifying the essential quality of the living form,

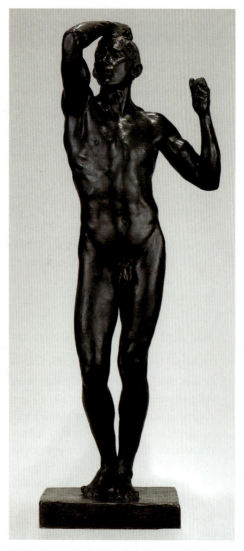

3.15 Auguste Rodin, *The Age of Bronze*, 1876. Bronze, 71 × 28" (180.3 × 71.1 cm). Minneapolis Institute of Arts.

he was also concerned with the expression of a tragic theme, inspired perhaps by his reaction to the Franco–Prussian War of 1870–71, so disastrous for the French. The figure, which once held a spear, was originally titled *Le Vaincu* ("The Vanquished One") and was based firmly on the *Dying Slave* of Michelangelo. By removing the spear, Rodin created a more ambivalent and ultimately more daring sculpture. The suggestion of action, frequently violent and varied, had been an essential part of the repertory of academic sculpture since the Late Renaissance, but its expression in nineteenth-century sculpture normally took the form of a sort of tableau of frozen movement. Rodin, however, studied his models in constant motion, in shifting positions and attitudes, so that every gesture and transitory change of pose became part of his vocabulary. As he passed from this concentrated study of nature to the more expressive later works, even his most melodramatic subjects and most violently distorted poses were given credibility by their secure basis in observed nature.

In 1880 Rodin received a commission, the most important one of his career, for a portal to the proposed Museum of Decorative Arts in Paris. He conceived the idea of a free interpretation of scenes from Dante's *Inferno*, within a design scheme based on Lorenzo Ghiberti's great fifteenth-century gilt-bronze portals for the Florence Baptistery, popularly known as the *Gates of Paradise*. Out of his ideas emerged *The Gates of Hell* (fig. **3.16**), which remains one of the masterpieces of nineteenth- and twentieth-century sculpture. It is not clear whether the original plaster sculpture of *The Gates* that Rodin exhibited at the Exposition Universelle in 1900 was complete, though it is clear that the idea of academic "finish" was abhorrent to the artist. The portal was never installed in the Museum of Decorative Arts, and the five bronze casts that exist today were all made posthumously. Basing his ideas loosely on individual themes from Dante but also utilizing ideas from the poems of Baudelaire, Rodin created isolated figures, groups, or episodes, experimenting with different configurations over more than thirty years.

The Gates contains a vast repertory of forms that the sculptor developed in this context and then adapted to other uses, and sometimes vice versa. For example, he executed the central figure of Dante, a brooding nude seated in the upper panel with his right elbow perched on his left knee, as an independent sculpture and exhibited it with the title *The Thinker; The Poet; Fragment of the Gate*. It became the artist's best-known work, in part because of the many casts that exist of it in several sizes. The work is crammed with a dizzying variety of forms on many different scales, above and across the lintel, throughout the architectural frieze and framework, and rising and falling restlessly within the turmoil of the main panels. To convey the turbulence of his subjects, Rodin depicted the human figure bent and twisted to the limits of endurance, although with remarkably little actual distortion of anatomy. Imprisoned within the drama of their agitated and anguished state, the teeming figures—coupled, clustered, or isolated—seem a vast and melancholy meditation on the tragedy of the human condition, on the

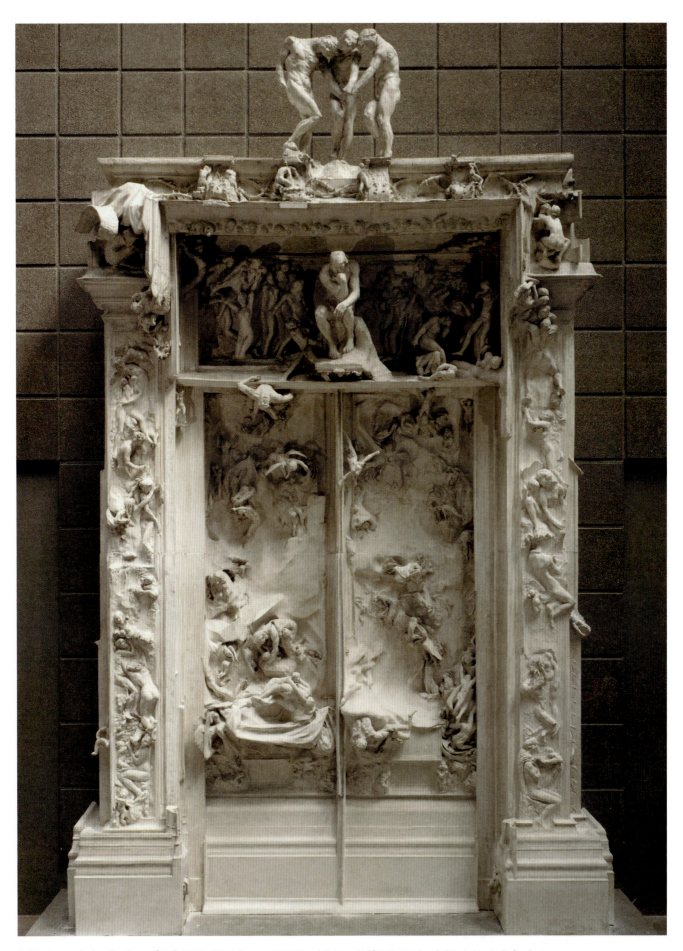

3.16 Auguste Rodin, *The Gates of Hell*, 1880–1917. Bronze, 20′ 10″ × 13′ 1″ × 2′ 9½″ (6.4 × 4 × 0.85 m). Musée Rodin, Paris.

Watch a video about *The Gates of Hell* on mysearchlab.com

plight of souls trapped in eternal longing, and on the torment of guilt and frustration. Like *The Thinker*, many of the figures made for *The Gates of Hell* are famous as individual sculptures, including *The Three Shades*, who stand hunched atop the gates. The tragedy and despair of the work are perhaps best summarized in *The Crouching Woman*, whose contorted figure, a compact, twisted mass, attains a beauty that is rooted in intense suffering.

The violent play on the human figure seen here was a forerunner of the Expressionist distortions of the figure developed in the twentieth century. An even more suggestive and modern phenomenon is to be found in the basic concept of *The Gates*—that of flux or metamorphosis, in which the figures emerge from or sink into the matrix of the bronze itself, in the process of birth from, or death and decay into, a quagmire that both liberates and threatens to engulf them. Essential to the suggestion of change in *The Gates* and in most of the mature works of Rodin is the exploitation of light. A play of light and shadow moves over the peaks and crevasses of bronze or marble, becoming analogous to color in its evocation of movement, of growth and dissolution.

Although Rodin, in the sculptural tradition that had persisted since the Renaissance, was first of all a modeler, starting with clay and then casting the clay model in plaster and bronze, many of his most admired works are in marble. One reason for collectors' preference for Rodin's marble works derives from the belief that carving more closely approximates the artist's original conception. Bronze sculptures are made from casts, which can be used to produce many copies of the same work. Uniqueness has been especially highly prized in the art world since the Romantic period, when the notion of artistic "genius" was linked to originality. Since then, techniques that seem to require the artist's direct, physical involvement—like drawing and painting along with carving or modeling—have been accorded high status to the detriment of printmaking or casting. Rodin, like most professional sculptors of his time, understood that his works would circulate as multiples, with no single example of a sculpture taking precedence over another. What is more, because the production of sculpture is comparatively slow and costly, the capacity for multiples helped sculptors earn a living.

Attributing greater artistic involvement or "purity" to Rodin's marbles would be a mistake. These also were normally based on clay and plaster originals, with much of the carving, as was customary, done by assistants. Rodin closely supervised the work and finished the marbles with his own hand. The marbles were handled with none of the expressive roughness of the bronzes (except in deliberately unfinished areas) and without deep undercutting. He paid close attention to the delicate, translucent, sensuous qualities of the marble, which in his later works he increasingly emphasized—inspired by unfinished works of Michelangelo—by contrasting highly polished flesh areas with masses of rough, unfinished stone. In his utilization of the raw material of stone for expressive ends, as in his use of the partial figure (the latter suggested no doubt by fragments of ancient sculptures), Rodin was initiating the movement away from

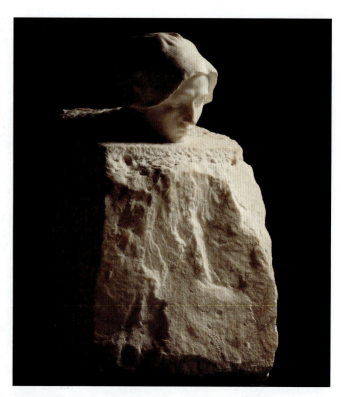

3.17 Auguste Rodin, *Thought (Camille Claudel)*, 1886. Marble, 29½ × 17 × 18" (74.9 × 43.2 × 45.7 cm). Musée d'Orsay, Paris.

the human figure as the prime medium of sculptural expression. The remarkable portrait of his lover and fellow sculptor Camille Claudel (fig. **3.17**) does away with the torso altogether to personify meditation through the abrupt juxtaposition of a smoothly polished, disembodied head with a coarsely hewn block of marble.

The Burghers of Calais and Later Career

As a somewhat indirect memorial to French losses in the Franco–Prussian War, the city of Calais began formulating plans in 1884 for a public monument in memory of Eustache de Saint-Pierre, who in 1347, during the Hundred Years' War, had offered himself, along with five other prominent citizens, as hostage to the English in the hope of raising the long siege of the city. The commission held particular appeal for Rodin. In the old account of the event, the medieval historian Froissart describes the hostages as delivered barefoot and clad in sackcloth, with ropes around their necks, bearing the keys to the city and fortress; this tale permitted the artist to be historically accurate and yet avoid the problem of period costumes without resorting to nudity. After winning the competition with a relatively conventional heroic design set on a tall base, Rodin created a group of greater psychological complexity, in which individual figures, bound together by common sacrifice, respond to it in varied ways (fig. **3.18**). He studied each figure separately and then assembled them all on a low rectangular platform, a nonheroic arrangement that allows the viewer to approach the figures directly. It took some doing for Rodin to persuade Calais to accept the work, for rather than an image of a readily recognizable historical event, he presented six particularized variations on the theme of human courage,

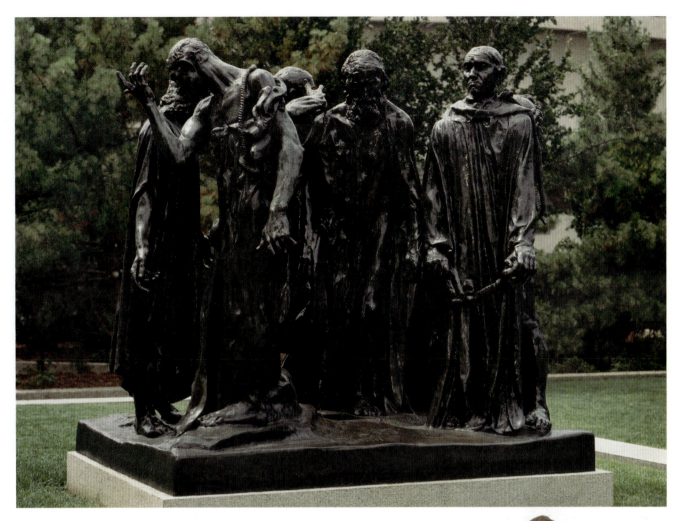

3.18 Auguste Rodin, *The Burghers of Calais*, 1886. Six figures, bronze, 6′ 10½″ × 7′ 11″ × 6′ 6″ at base (2.1 × 2.4 × 2 m). Hirshhorn Museum and Sculpture Garden, Smithsonian Institution, Washington, D.C.

deeply moving in their emotional range and thus very much a private monument as well as a public one.

The debt of *The Burghers of Calais* to the fourteenth- and fifteenth-century sculptures of Claus Sluter and Claus de Werve is immediately apparent, but this influence has been combined with an assertion of the dignity of common humanity analogous to that in the nineteenth-century sculptures of the Belgian artist **Constantin Meunier** (1831–1904), whose *The Dock Hand* endows its subject with a heroic bearing and monumentality without sacrificing a Realist's eye for accuracy (fig. **3.19**). The rough-hewn faces, powerful bodies, and the enormous hands and feet transform Rodin's burghers into laborers and peasants and at the same time enhance their physical presence, as do the outsize keys. Rodin's tendency to dramatic gesture is apparent here, and the theatrical element is emphasized by the unorthodox organization, with the figures scattered about the base like a group of stragglers wandering across a stage. The informal, open arrangement of the figures, none of which touches another, is one of the most daring and original aspects of the sculpture. It is a direct attack on the classical tradition of closed, balanced groupings for monumental sculpture. The detached placing of the masses gives the intervening spaces an importance that,

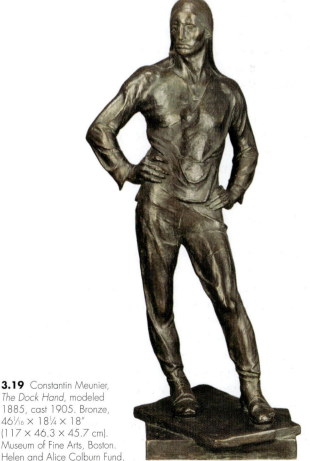

3.19 Constantin Meunier, *The Dock Hand*, modeled 1885, cast 1905. Bronze, 46¹⁄₁₆ × 18¼ × 18″ (117 × 46.3 × 45.7 cm). Museum of Fine Arts, Boston. Helen and Alice Colburn Fund.

for almost the first time in modern sculpture, reverses the traditional roles of solid and void, of mass and space. Space not only surrounds the figures but interpenetrates the group, creating a dynamic, asymmetrical sense of balance. Rodin's wish that the work be placed not on a pedestal but at street level, situating it directly in the viewer's space, anticipated some of the most revolutionary innovations of twentieth-century sculpture.

Rodin's *Monument to Balzac* (see this sculpture in a haunting portrayal of it by the photographer Edward Steichen, fig. 15.8), a work he called "the sum of my whole life," was commissioned in 1891 by the French Writers' Association, at the urging of the novelist Émile Zola. Here the artist plunged so deeply into the privacy of individual psychology—his own perhaps even more than the subject's—that he failed to gain acceptance by the patrons. What they and the public perceived was a tall, shapeless mass crowned by a shaggy head so full of Rodin's "lumps and hollows" that it seemed more a desecrating caricature than a tribute to the great novelist Honoré de Balzac, who had died in 1850. Little were they prepared to appreciate what even the artist characterized as a symbolism of a kind "yet unknown." The work provoked a critical uproar, with some proclaiming it a masterpiece and others reviling it as a monstrosity, whereupon it was withdrawn from the Paris Salon in 1898.

Rodin struggled to realize a portrait that would transcend any mere likeness and be a sculptural equivalent of a famously volcanic creative force. He made many different studies over a period of seven years, some of an almost academic exactness, others more emblematic. In the end, he cloaked Balzac in the voluminous "monk's robe" he had habitually worn during his all-night writing sessions. The anatomy has virtually disappeared beneath the draperies, which are gathered up as if to muster and concentrate the whole of some prodigious inspiration, all reflected like a tragic imprint on the deep-set features of the colossal head. The figure leans back dramatically beneath the robe, a nearly abstract icon of generative power.

Exploring New Possibilities: Claudel and Rosso

Until the 1980s, when long overdue retrospectives of her work were held, **Camille Claudel** (1864–1943) was known largely as Rodin's assistant and mistress. She never recovered from her failed relationship with the sculptor and was confined to mental hospitals for the last thirty years of her life. Claudel's work shares many formal characteristics with that of her mentor; nevertheless, hers was a highly original talent in a century that produced relatively few female sculptors of note, and at a time when it was still extremely difficult for female artists to be taken seriously. By the time she entered Rodin's studio at age twenty, she was already exhibiting at the Salon. Though she was an accomplished portraitist—she produced a memorable image of Rodin—Claudel's particular strength lay with inventive solutions to multifigure compositions. An unusual and decidedly unheroic subject for sculpture, *Chatting Women* (fig. **3.20**) presents four seated figures, rapt in discussion, who form a tightly knit group in

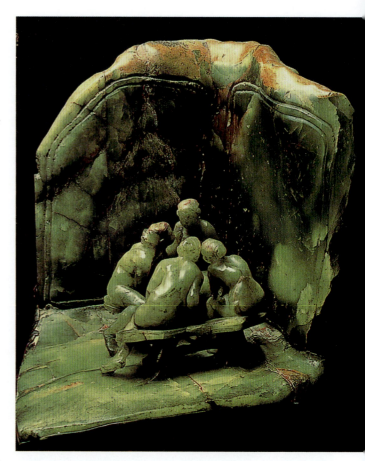

3.20 Camille Claudel, *Chatting Women*, 1897. Onyx and bronze, 17¾ × 16⅝ × 15⅜" (45 × 42.2 × 39 cm). Musée Rodin, Paris.

the corner of a room. An immediacy of expression and the quotidian nature of the subject seem at odds with the inexplicable nudity of the figures and the use of strongly veined and colored onyx, which serves to underscore the abstract nature of the representation.

Medardo Rosso (1858–1928) was born in Turin, Italy, and worked as a painter until 1880. After being dismissed from the Accademia di Brera in Milan in 1883, he lived in Paris for two years, worked in Dalou's **atelier**, and met Rodin. After 1889 Rosso spent most of his remaining active career in Paris, and thus was associated more with French sculpture than with Italian. In a sense, he always remained a painter. Rosso extended the formal experiments of Rodin, deliberately dissolving sculptural forms until only an impression remained. His favorite medium, wax, allowed the most imperceptible transitions, so that it becomes difficult to tell at exactly what point a face or figure emerges from an amorphous shape and many-textured surface. "Nothing is material in space," Rosso said. The primacy he gave to the play of light and shadow is evident in the soft *sfumato* that envelops the portrait of his old doorkeeper (fig. **3.21**), a work once owned by Émile Zola. This quality has sometimes led critics to call him an Impressionist sculptor. In his freshness of vision and his ability to catch and record the significant moment, Rosso added a new dimension to sculpture, in works that are invariably *intimiste*, small-scale, and antiheroic, and anticipated the search for immediacy that characterizes so much of the sculpture to follow.

3.21 Medardo Rosso, *The Concierge* (*La Portinaia*), 1883. Wax over plaster, 14½ × 12⅝" (36.8 × 32 cm). The Museum of Modern Art, New York.

Primitivism and the Avant-Garde: Gauguin and Van Gogh

Gauguin

Paul Gauguin (1848–1903) was unquestionably the most influential artist to be associated with the Symbolist movement. But while he became intimate with Symbolist poets, especially Mallarmé, and enjoyed their support, Gauguin avoided the literary content and traditional form of such artists as Moreau and Puvis. He also rejected the optical naturalism of the Impressionists, while initially retaining their rainbow palette before vastly extending its potential for purely decorative effects. He sought what he termed a "synthesis of form and color derived from the observation of the dominant element." Gauguin advised a fellow painter not to "copy nature too much. Art is an abstraction; derive this abstraction from nature while dreaming before it, but think more of creating than the actual result."

In these statements may be found many of the concepts of twentieth-century experimental painting, from the idea of color used arbitrarily rather than to describe an object visually, to the primacy of the creative act, to painting as abstraction. Gauguin's ideas, which he called **Synthetism**, involved a synthesis of subject and idea with form and color, so that his paintings are given their mystery, their visionary quality, by their abstract color patterns. His purpose in creating such an anti-Realist art was to express invisible, subjective meanings and emotions. He attempted to free himself from the corrupting sophistication of the modern industrial world, and to renew his spirit, by contact with an innocence and sense of mystery that he sought in non-industrial societies. He constantly described painting in terms of an analogy with music, of color harmonies, of color and lines as forms of abstract expression. In his search he was attracted, to a greater degree even than most of his generation, to so-called "primitive" art. In his work we find the expression of modern **primitivism**, the tendency to understand non-Western or pre-industrial societies as more pure, more authentic than those of the West. Primitivism simultaneously valorizes and denigrates pre-industrial cultures, because their appeal rests in their perceived simplicity and resistance to progress. Only by casting these societies as relatively naive and ineffectual could their potential as sources for aesthetic as well as economic exploitation be justified. Such notions were, of course, forged at a time when European countries were aggressively colonizing the very societies Western artists sought to emulate. For Gauguin, primitivism held appeal as a means of relieving himself of the burden of Western culture, industrialization, and urbanization. Attracted not only to primitive-seeming motifs, Gauguin also cultivated a deliberately naive style. Like the paintings of Henri Rousseau, Gauguin's works convey an immediacy and authenticity that is generally absent in academic art.

In searching for the life of a "savage," he became, sometimes to the detriment of a serious consideration of his art, a romantic symbol, the personification of the artist as rebel against society. After years of wandering, first in the merchant marine, then in the French navy, he settled down, in 1871, to a prosaic but successful life as a stockbroker in Paris, married a Danish woman, and had five children. For the next twelve years the only oddity in his respectable, bourgeois existence was the fact that he began painting, first as a hobby and then with increasing seriousness. He even managed to show a painting in the Salon of 1876 and to exhibit in four Impressionist exhibitions from 1879 to 1882. He lost his job, probably because of a stock-market crash, and by 1886, after several years of family conflict and attempts at new starts in Rouen and Copenhagen, he had largely severed his family ties, isolated himself, and become involved with the Impressionists.

Gauguin had spent the early years of his childhood in Peru, and he appears almost always to have had a nostalgia for far-off, exotic-seeming places. This feeling ultimately crystalized in the conviction that his salvation, and perhaps that of all contemporary artists, lay in abandoning modern civilization to return to some simpler, more elemental pattern of life. From 1886 to 1891 he moved between Paris and the Breton villages of Pont-Aven and Le Pouldu, with a seven-month interlude in Panama and Martinique in 1887 and a tempestuous but productive visit with Vincent van Gogh in Arles the following year. In 1891 he sailed for Tahiti, returning to France for two years in 1893 before settling in the South Seas for good (see *Gauguin, excerpt from Noa Noa*, p. 61). His final trip, in the wake of years of illness and suffering, was

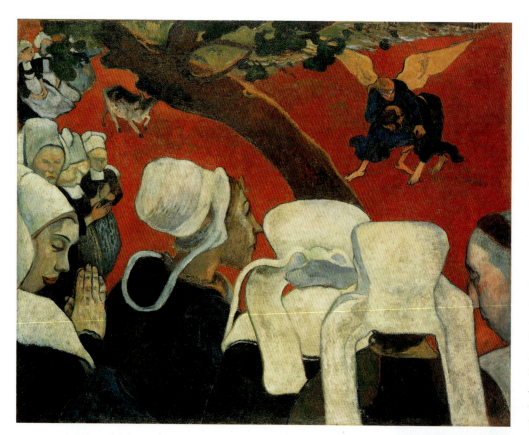

3.22 Paul Gauguin, *Vision after the Sermon*, 1888. Oil on canvas, 28¾ × 36¼" (73 × 92.1 cm). National Gallery of Scotland, Edinburgh.

📖— Read the document related to Gauguin on mysearchlab.com

and sculpture, or between so-called "fine art" and "craft" practice, than artists of earlier post-Renaissance generations.) By the late 1880s Gauguin had ventured into print-making, another medium to which he brought all his experimental genius. One of his most enigmatic works, made in Brittany during an especially despondent period, is a wooden panel that he carved in low relief, painted, and titled with the cynical admonition *Be in Love and You Will Be Happy* (fig. **3.23**). Here a woman, "whom a demon takes by the hand," faces the forces of temptation, symbolized in part by a small fox. Such themes, the struggle between knowledge and innocence, good and evil, life and death, recur in Gauguin's Tahitian compositions. Among the faces in the relief, the one with its thumb in its mouth, at the upper right, is the artist himself.

to the island of Hiva-Oa in the Marquesas Islands, where he died in 1903.

The earliest picture in which Gauguin fully realized his revolutionary ideas is *Vision after the Sermon*, painted in 1888 in Pont-Aven (fig. **3.22**). This is a startling and pivotal work, a pattern of red, blue, black, and white tied together by curving, sinuous lines and depicting a Breton peasant's biblical vision of Jacob wrestling with the Angel. The innovations used here were destined to affect the ideas of younger groups such as the Nabis and the Fauves. Perhaps the greatest single departure is the arbitrary use of color in the dominating red field within which the protagonists struggle, their forms borrowed from a Japanese print. Gauguin has here constricted his space to such an extent that the dominant red of the background visually thrusts itself forward beyond the closely viewed heads of the peasants in the foreground. Though the brilliant red hue may have been stimulated by his memory of a local religious celebration that included fireworks and bonfires in the fields, this painting was one of the first complete statements of color as an expressive end in itself.

From the beginning of his life as an artist, Gauguin did not restrict himself to painting. He carved sculptures in marble and wood and learned the rudiments of ceramics to become one of the most innovative ceramicists of the century. (It is a feature of modern art in general that many artists, including Picasso, Matisse, and others, have been less constrained by the boundaries between the academic disciplines of painting

3.23 Paul Gauguin, *Soyez amoureuses vous serez heureuses* (*Be in Love and You Will Be Happy*), 1889. Carved and painted linden wood, 37½ × 28½" (95.3 × 72.4 cm). Museum of Fine Arts, Boston. Arthur Tracy Cabot Fund.

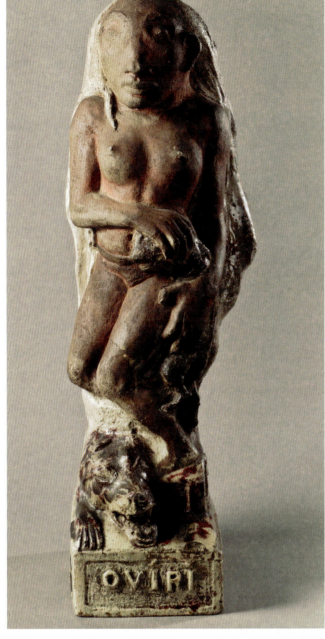

3.24 Paul Gauguin, *Oviri*, 1894. Partially glazed stoneware, 29½ × 7½ × 10⅝" (74.9 × 19.1 × 27 cm). Musée d'Orsay, Paris.

Paul Gauguin
from *Noa Noa* (1893)

Gauguin arranged for the publication of his journal, which he hoped would stimulate interest in the artworks he had produced there. The title means "beautiful fragrance." It was initially published in a version heavily revised by the poet Charles Morice. This extract comes from Gauguin's original version.

I began to work—notes, sketches of all sorts. Everything in the landscape blinded and dazzled me. Coming from Europe I was always uncertain of a color, unable to see the obvious: yet it was so easy to put a red and a blue on my canvas, naturally. In the streams, golden shapes enchanted me. Why did I hesitate to make all that gold and all that sunny rejoicing flow on my canvas? Probably old habits from Europe, all that timidity of expression of our old degenerate races.

In order to understand the secret in a Tahitian face, all the charm of a Maori smile, I had been wanting for a long time to do the portrait of a neighboring woman of pure Tahitian race. One day, when she had been bold enough to come into my hut to look at some pictures and photographs of paintings, I asked her if I could do it.

She was specially interested in the photograph of Manet's *Olympia*. Using the few words I had learned in her language (for two months I'd spoken not a word of French) I questioned her. She told me that this Olympia was very beautiful: I smiled at this opinion and was moved by it. She had a sense of the beautiful (whereas the École des Beaux-Arts finds it horrible).

her side. Whether she embraces the cub or suffocates it is unclear, though Gauguin did refer to her as a "murderess" and a "cruel enigma." The head was perhaps inspired by the mummified skulls of Marquesan chiefs, while the torso derives from the voluptuous figures, symbols of fecundity, on the ancient Javanese reliefs at Borobudur in Southeast Asia, of which Gauguin owned photographs.

Another attempt at inventing suitably "primitive" sculpture on behalf of the Tahitians can be seen at the left in his grand, philosophical painting *Where Do We Come From? What Are We? Where Are We Going?* (fig. **3.25**). Over twelve feet (3.7 m) long, this is the most ambitious painting of Gauguin's career. It presents a summation of his Polynesian imagery, filled with Tahitians of all ages situated at ease within a terrestrial paradise devoid of any sign of European civilization. "It's not a canvas done like a Puvis de Chavannes," Gauguin said, "with studies from nature, then preliminary cartoons etc. It is all dashed off with the tip of the brush, on burlap full of knots and wrinkles, so that its appearance is terribly rough." The multiple forms and deep spaces of this complex composition are tied together by its overall tonalities in green and blue. It was this element—color—that the artist called "a mysterious language, a language of the dream."

Gauguin was disappointed, upon his arrival in Tahiti, to discover how extensively Western missionaries and colonials had encroached upon native life. The capital, Papeete, was filled with French government officials, and Tahitian women often covered themselves in ankle-length missionary dresses. Nor was the island filled with the indigenous carvings of ancient gods Gauguin had hoped for, so he set about making his own idols, based in part on Egyptian and Buddhist sculptures that he knew from photographs. One example of this is his largest sculpture, *Oviri* (fig. **3.24**), executed during a visit to Paris between two Tahitian sojourns. The title means "savage" in Tahitian, a term with which Gauguin personally identified, for he later inscribed "Oviri" on a self-portrait. The mysterious, bug-eyed woman crushes a wolf beneath her feet and clutches a wolf cub to

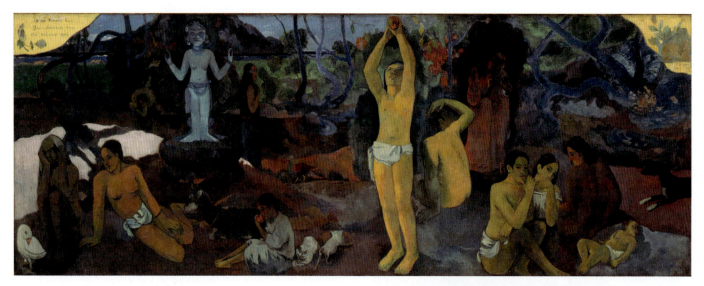

3.25 Paul Gauguin, *Where Do We Come From? What Are We? Where Are We Going?*, 1897–98. Oil on canvas, 4′ 6¾″ × 12′ 3″ (1.4 × 3.7 m). Museum of Fine Arts, Boston. Tompkins Collection. Arthur Gordon Tompkins Fund.

Van Gogh

Whereas Gauguin was an iconoclast, caustic in speech, cynical, indifferent, and at times brutal to others, **Vincent van Gogh** (1853–90) was filled with enthusiasm for his fellow artists and an, at times overwhelming, love for humanity. This impulse toward compassion had led him, after a short-lived experience as an art dealer and an attempt to follow theological studies, to become a lay preacher in a Belgian coal-mining area. There, in 1880, he first began to draw. After study in Brussels, The Hague, and Antwerp, he went to Paris in 1886, where he met Seurat, Signac, and Gauguin, as well as members of the original Impressionist group.

In his early drawings, Van Gogh revealed his roots in traditional Dutch landscape, portrait, and genre painting, using the same perspective structures, and depicting the broad fields and low-hanging skies that the seventeenth-century artists had portrayed. Van Gogh never abandoned perspective even in later years, when he developed a style with great emphasis on the linear movement of paint over the surface of the canvas. For him—and this is already apparent in his early drawings—landscape itself had an expressive, emotional significance.

After his exposure to the Impressionists in Paris, Van Gogh changed and lightened his palette. Indeed, he discovered his deepest single love in color—brilliant, unmodulated color—which in his hands took on a character radically different from the color of the Impressionists. Even when he used Impressionist techniques, the peculiar intensity of his vision gave the result a specific and individual quality that could never be mistaken for any other painter's.

The intensity in Van Gogh's art arose from his overpowering response to the world in which he lived and to the people he knew. His emotional problems are, though not well understood, a famous part of his larger-than-life reputation as it developed during the twentieth century. Such episodes as the incident in which he sliced off part of his ear during Gauguin's visit have overshadowed a reasoned understanding of his work. More than any other artist, Van Gogh has come to typify the figure of the lone artist-genius, spurned and misunderstood by society. This legend is only partly borne out by the more complex reality of his life and work. Van Gogh may have suffered from a neurological disorder, perhaps a severe form of epilepsy, that was no doubt exacerbated by physical ailments and excessive drinking. As much as he wished to cultivate close relationships with other artists, especially Gauguin, his volatile personality rendered intimate associations difficult to maintain. He was prone to depression and suffered acutely during seizures, but he painted during long periods of lucidity, bringing tremendous intelligence and imagination to his work. His letters to his brother Theo, an art dealer who tried in vain to find a market for Vincent's work, are among the most moving and informative narratives by an artist that we have (see *Letter to Theo van Gogh*, below). They reveal his wide

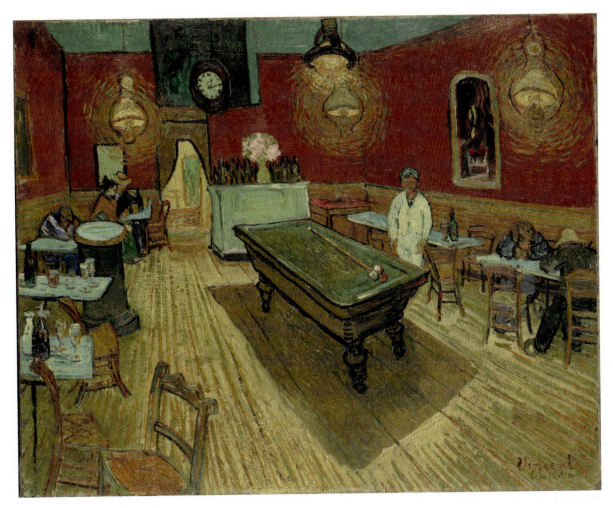

3.26 Vincent van Gogh, *The Night Café*, 1888. Oil on canvas, 27½ × 35″ (69.9 × 88.9 cm). Yale University Art Gallery, New Haven. Bequest of Stephen Carlton Clark, B.A. 1903.

knowledge of art and literature, and a highly sensitive perception that is fully equal to his emotional response. He was sharply aware of the extraordinary effects he was achieving through his expressive use of color. "Instead of trying to reproduce exactly what I have before my eyes, I use color more arbitrarily," he wrote, "in order to express myself forcibly." Echoing the Symbolist ideas of Gauguin, Van Gogh told Theo that he "was trying to exaggerate the essential and to leave the obvious vague."

Van Gogh could also present the darker side of existence. Thus, of *The Night Café* (fig. **3.26**) he says: "I have tried to express the terrible passions of humanity by means of red and green." *The Night Café* is a nightmare of deep-green ceiling, blood-red walls, and discordant greens in the furniture. The perspective of the brilliant yellow floor is tilted so precipitously that the contents of the room threaten to slide toward the viewer. The result is a terrifying experience of claustrophobic compression that anticipates the Surrealist explorations of fantastic perspective, none of which has ever quite matched it in emotive force.

Vincent van Gogh carried on the great Dutch tradition of portraiture, from his first essays in drawing to his last self-portraits, painted a few months before his suicide in 1890. The intense *Self-Portrait* from 1888 was made in Arles and was dedicated to Gauguin (fig. **3.27**). It formed part of an exchange of self-portraits among Van Gogh's artist friends to support his notion of an ideal brotherhood of painters. The beautifully sculptured head (which Van Gogh said

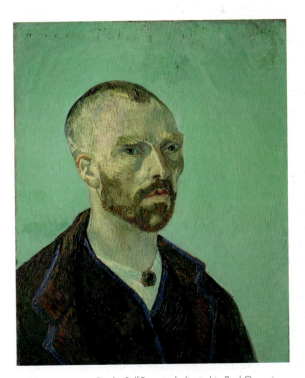

3.27 Vincent van Gogh, *Self-Portrait*, dedicated to Paul Gauguin. 1888. Oil on canvas, 24½ × 20½″ (62.2 × 52.1 cm). Fogg Art Museum, Harvard University Art Museums, Cambridge, MA. Bequest from the Maurice Wertheim Collection, Class of 1906.

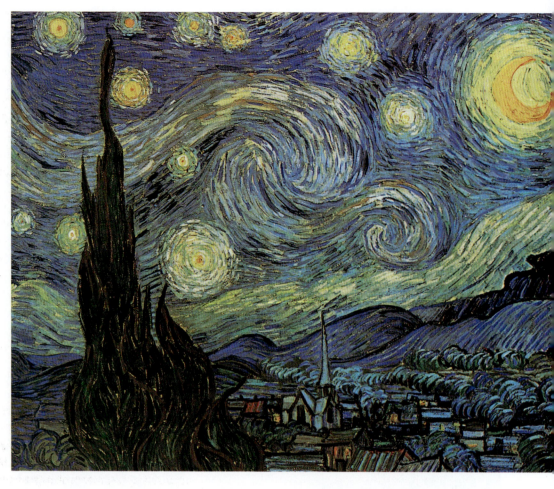

3.28 Vincent van Gogh, *The Starry Night*, 1889. Oil on canvas, 29 × 36¼" (73.7 × 92.1 cm). The Museum of Modern Art, New York.

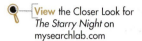

View the Closer Look for *The Starry Night* on mysearchlab.com

resembled that of a Buddhist monk) and the solidly modeled torso are silhouetted against a vibrant field of linear rhythms painted, according to the artist, in "pale malachite," akin to the monochrome backgrounds used by Northern Renaissance portraitists such as Lucas Cranach the Younger. The coloristic and rhythmic integration of all parts, the careful progression of emphases, from head to torso to background, all demonstrate an artist in superb control of his plastic means. "In a picture," he wrote to Theo, "I want to say something comforting as music. I want to paint men and women with that something of the eternal which the halo used to symbolize, and which we seek to give by the actual radiance and vibration of our colorings."

This conception of the eternal is represented in *The Starry Night* (fig. **3.28**). This work was painted in June 1889 at the sanatorium of Saint-Rémy, in southern France, where Van Gogh had been taken after his second breakdown. The color is predominantly blue and violet, pulsating with the scintillating yellow of the stars. *The Starry Night* is both an intimate and a vast landscape, seen from a high vantage point in the manner of the sixteenth-century landscapist Pieter Bruegel the Elder. In fact, the peaceful village, with its prominent church spire, is a remembrance of a Dutch rather than a French town. The great poplar tree in the foreground shudders before our eyes, while above whirl and explode all the stars and planets of the universe. Van Gogh was intrigued by the idea of painting a nocturnal landscape from his imagination. Scholars have tried to explain the content of the painting through literature, astronomy,

and religion. Although their studies have shed light on Van Gogh's interests, none has tapped a definitive source that accounts for the astonishing impact of this painting, which today ranks among the most famous works of art ever made. The defining quality of Van Gogh's paintings is that, as much as they depart from observed reality, they arise from a touch as meticulous as though the artist were painfully and exactly copying what he was observing before his eyes.

A New Generation of Prophets: The Nabis

Paul Sérusier (1863–1927), one of the young artists under Gauguin's spell at Pont-Aven, experienced something of an epiphany when the older master undertook to demonstrate his method during a painting session in a picturesque wood known as the Bois d'Amour: "How do you see these trees?," Gauguin asked. "They are yellow. Well then, put down yellow. And that shadow is rather blue. Render it with pure ultramarine. Those red leaves? Use vermilion." This permitted the mesmerized Sérusier to paint a tiny work on a cigar-box cover (fig. **3.29**), which proved so daring in form, even verging on pure abstraction, that the artist and his friends thought it virtually alive with supernatural power. And so they entitled the painting *The Talisman* and dubbed themselves the Nabis, from the Hebrew name for "prophet." The Nabis were a somewhat eclectic group of artists whose principal contributions—with some outstanding exceptions—lay in a synthesizing approach to masters

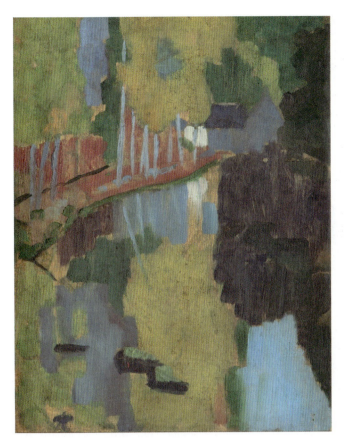

3.29 Paul Sérusier, *The Talisman (Landscape of the Bois d'Amour)*, 1888. Oil on wood cigar-box cover, 10½ × 8⅜" (26.7 × 21.3 cm). Musée d'Orsay, Paris.

of the earlier generation, not only to Seurat but also to Cézanne, Redon, and Gauguin; particularly the last, for his art theory as well as the direct example of his painting.

Gauguin had been affected by the ideas of his young friend Émile Bernard when the two were working together in Pont-Aven in the summer of 1888. He derived important elements of his style from Bernard's notion of *cloisonnisme*, a style based on medieval enamel and stained-glass techniques. Certainly, the arbitrary, nondescriptive color, the flat areas of color bounded by dark, emphatic contours, the denial of depth and sculptural modeling—all stated by Gauguin in *Vision after the Sermon* (see fig. 3.22)—were congenial to and influential for the Nabis.

The group included Sérusier, Maurice Denis, Pierre Bonnard, Paul Ranson, and later Aristide Maillol, Édouard Vuillard, Félix Vallotton, Ker-Xavier Roussel, and Armand Séguin. The Nabis epitomized the various interests and enthusiasms of the end of the century. Among these were literary tendencies toward organized theory and elaborate celebrations of mystical rituals. Denis and Sérusier wrote extensively on the theory of

modern painting; and Denis was responsible for the formulation of the famous phrase, "a picture—before being a warhorse, a female nude, or some anecdote—is essentially a flat surface covered with colors assembled in a particular order." The Nabis sought a synthesis of all the arts through continual activity in architectural painting, the design of glass and decorative screens, book illustration, poster design, and stage design for the advanced theater of Ibsen, Maurice Maeterlinck, Strindberg, Wilde, and notably Alfred Jarry's shocking satirical farce *Ubu Roi* ("King Ubu", see Ch. 14, p. 320).

Vuillard and Bonnard

Édouard Vuillard (1868–1940) and Pierre Bonnard exemplify the spirit and aims of the Nabis. Their long working lives linked the art of *fin-de-siècle* France to the mid-twentieth century. Both were much admired; their reputations, however, were for a long time private rather than public. Their world is an intimate one, consisting of corners of the studio, the living room, the familiar view from the window, and portraits of family and close friends. In his early works Vuillard used the broken paint and small brushstroke of Seurat or Signac, but without their rigorous scientific methods. In *Woman in Blue with Child* (fig. 3.30) he portrayed the Parisian apartment of Thadée Natanson, co-founder of *La Revue Blanche*, and his famously beautiful and talented wife, Misia, who is depicted in the painting playing with her niece. As was often his practice, Vuillard probably used his own photograph of the apartment as an *aide-mémoire* while working up his composition. It is a typical turn-of-the-century interior, sumptuously decorated with flowered wallpaper, figured upholstery, and ornaments. In Vuillard's hands, the interior became a dazzling surface pattern of muted blues, reds, and yellows, comparable to a Persian painting in its harmonious richness.

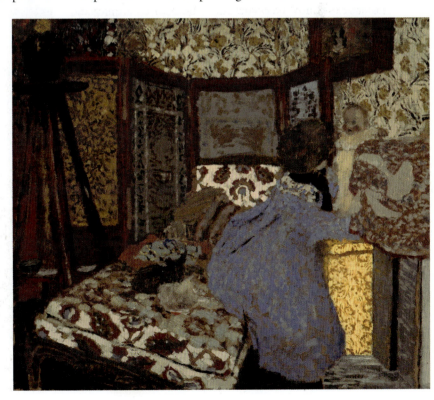

3.30 Édouard Vuillard, *Woman in Blue with Child*, c.1899. Oil on cardboard, 19⅛ × 22¼" (48.6 × 56.5 cm). Glasgow Art Gallery and Museum, Kelvingrove.

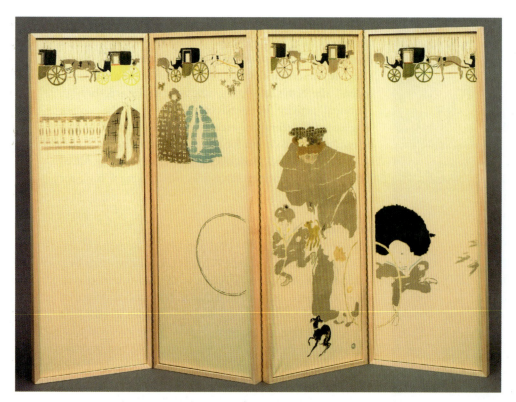

3.31 Pierre Bonnard, *Promenade of the Nursemaids, Frieze of Fiacres*, 1899. Color lithograph on four panels, each 54 × 18¾" (137.2 × 47.6 cm). The Museum of Modern Art, New York.

at his most *japoniste* and decorative. At the same time, the figures of mother and children, the three heavily caped nurses, and the marching line of fiacres, or carriages, reveal a touch of gentle satire that well characterizes the penetrating observation Bonnard combined with a brilliant simplicity of design. Like his fellow Nabis, Bonnard believed in eliminating barriers between the popular decorative arts and the high-art traditions of painting and sculpture. He envisioned an art of "everyday application" that could extend to fans, prints, furniture, or, in this case, color litho.

In *Nude against the Light* (fig. **3.32**), Bonnard has moved from the public sphere of Parisian streets to the intimate world of the nude in a domestic interior, a subject he exploited throughout his career as a means to investigate light and color. Bonnard silhouetted the model, his

Space may be indicated by the tilted perspective of the chaise longue and the angled folds of the standing screen, but the forms of the woman and child are flattened so as to be virtually indistinguishable from the surrounding profusion of patterns. Such quiet scenes of Parisian middle-class domesticity have been called *intimiste*; in them, the flat jigsaw puzzle of conflicting patterns generates shimmering after-images that seem to draw from everyday life an ineffable sense of strangeness and magic.

Of all the Nabis, **Pierre Bonnard** (1867–1947) was the closest to Vuillard, and the two men remained friends until the latter's death. Like Vuillard, Bonnard lived a quiet and unobtrusive life, but whereas Vuillard stayed a bachelor, Bonnard early became attached to a young woman whom he ultimately married in 1925. It is she who appears in so many of his paintings, as a nude bathing or combing her hair, or as a shadowy but ever-present figure seated at the breakfast table, appearing at the window, or boating on the Seine.

After receiving training both in the law and in the fine arts, Bonnard soon gained a reputation making lithographs, posters, and illustrated books. His most important early influences were the work of Gauguin and Japanese prints. The impact of the latter can be seen in his adaptation of the *japoniste* approach to the tilted spaces and decorative linear rhythms of his paintings. But from the beginning Bonnard also evinced a love of paint texture. This led him from the relatively subdued palette of his early works to the full luminosity of high-keyed color rendered in fragmented brushstrokes, a development that may well owe something to both the late works of Monet and the Fauve paintings of Matisse.

The large folding screen *Promenade of the Nursemaids, Frieze of Fiacres* (fig. **3.31**) is made up of four lithographs, based on a similarly painted screen. With its tilted perspectives and abbreviated, silhouetted forms, it shows Bonnard

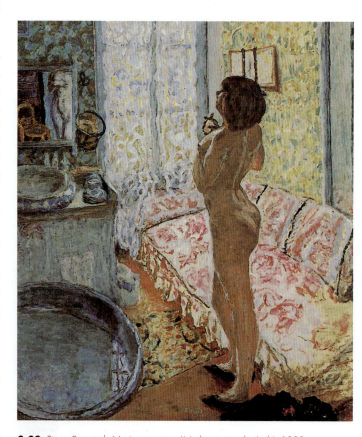

3.32 Pierre Bonnard, *Nu à contre jour* (*Nude against the Light*), 1908. Oil on canvas, 49 × 42½" (124.5 × 108 cm). Musées Royaux des Beaux-Arts de Belgique, Brussels.

ever-youthful wife Marthe, against the sun-drenched surfaces of her boudoir. Light falls through the tall French windows, strongly illuminating the side of the woman turned from our view but visible in the mirror at left.

This use of reflections to enlarge and enrich the pictorial space, to stand as a picture within a picture, became a common strategy of Bonnard's as well as Matisse's interiors (see fig. 11.10). But in its quiet solemnity and complete absence of self-consciousness, Bonnard's nude is deeply indebted to the precedent of Degas's bathers, even to the detail of the round tub (see fig. 2.35). Like those of the older artist, Bonnard's composition is disciplined and complex, carefully structured to return the eye to the solid form of the nude, which he surrounds with a multitude of textures, shapes, and colors. But Bonnard creates an expressive mood all his own. As she douses herself with perfume, the model seems almost transfixed by the warm, radiant light that permeates the scene.

Bonnard's color became progressively brighter. By the time he painted *Dining Room on the Garden*, in 1934–35 (fig. **3.33**), he had long since recovered the entire spectrum of luminous color, and had learned from Cézanne that color could function constructively as well as sensually. In this ambitious canvas Bonnard tackled the difficult problem of depicting an interior scene with a view through the window to a garden beyond, setting the isolated, geometric forms of a tabletop still life against a lush exterior landscape. Now the model, his wife Marthe, is positioned to one side, an incidental and ghostly presence in this sumptuous display. By the mid-1930s, virtually all the great primary revolutions of twentieth-century painting had already occurred, including Fauvism, with its arbitrary, expressive color, and Cubism, with its reorganization of Renaissance pictorial space. Moreover, painting had found its way to pure abstraction in various forms. Perfectly aware of all this, Bonnard was nonetheless content to go his own way. In the work seen here, for instance, there is evidence that he had looked closely at Fauve and Cubist paintings, particularly the works of Matisse—who was a devoted admirer—and had used what he wanted of the new approaches without at any time changing his basic attitudes.

While some Post-Impressionists like Gauguin and Van Gogh preferred to work in isolation or in the company of one or two like-minded colleagues, others, such as the Nabis, sought to develop new organizations that might provide the practical as well as moral support artists enjoyed when affiliated with a traditional academy or guild. Neo-Impressionism, the quasi-scientific handling of color created by Seurat and Signac, made its appearance in 1884, when a number of artists who were to be associated with the movement exhibited together at the Groupe des Artistes Indépendants in Paris. Later that year the Société des Artistes Indépendants was organized through the efforts of Seurat, Henri-Edmond Cross, Redon, and others, and was to become important to the advancement of early twentieth-century art as an exhibition forum. Also important were the exhibitions of Les XX (Les Vingt, or "The Twenty")

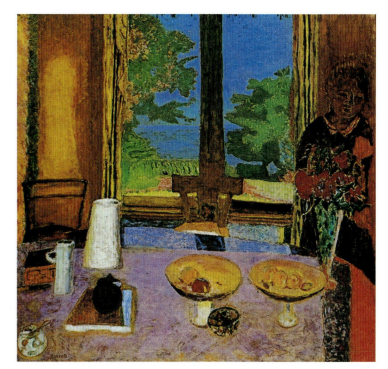

3.33 Pierre Bonnard, *Dining Room on the Garden*, 1934–35. Oil on canvas, 50⅛ × 53½″ (127.3 × 135.9 cm). Solomon R. Guggenheim Museum, New York.

in Brussels. Van Gogh, Gauguin, Toulouse-Lautrec, and Cézanne exhibited at both the Indépendants and Les XX. James Ensor, Henry van de Velde, and Jan Toorop exhibited regularly at Les XX and its successor, La Libre Esthétique, whose shows became increasingly dominated first by the attitudes of the Neo-Impressionists and then by the Nabis.

La Revue Blanche, a magazine founded in 1891, became one of the chief organs of expression for Symbolist writers and painters, the Nabis, and other artists of the avant-garde. Bonnard, Vuillard, Denis, Vallotton, and Toulouse-Lautrec (who was never officially a Nabi, although associated with the group) all made posters and illustrations for the magazine, which was a meeting ground for experimental artists and writers from every part of Europe, among them Van de Velde, Edvard Munch, Marcel Proust, André Gide, Ibsen, Strindberg, Wilde, Maxim Gorky, and Filippo Marinetti.

Montmartre: At Home with the Avant-Garde

Just outside the nineteenth-century Paris city limits was the butte of Montmartre, a district where working-class Parisians driven from their neighborhoods by Haussmannization could find affordable housing. Dance halls and cabarets also proliferated in Montmartre, where alcohol was cheaper thanks to the absence of the city's liquor taxes. This combination of affordability and relaxed social mores made the district attractive to artists as well as dancers, singers, and prostitutes. By the 1880s, Montmartre had replaced the Latin Quarter as the center of bohemian life in Paris. And it was in Montmartre that **Henri de Toulouse-Lautrec** (1864–1901) found the subjects for his remarkable lithographs.

Although Toulouse-Lautrec may be seen as the heir of Daumier in the field of printmaking, he also served, along with his contemporaries Gauguin and Van Gogh, as one of the principal bridges between nineteenth-century avant-garde painting and the early twentieth-century experiments of Edvard Munch, Pablo Picasso, and Henri Matisse. Lautrec was interested in Goya and the line drawings of Ingres, but he was above all a passionate disciple of Degas, both in his admiration of Degas's draftsmanship and in the disengaged attitude and calculated formal strategies that he brought to the depiction of his own favorite subjects—the theaters, brothels, and bohemian cabarets of Paris.

Because of years of inbreeding in his old, aristocratic family, Lautrec was permanently disfigured from a congenital disease that weakened his bones. Against his family's wishes, he pursued art as a profession after receiving an education in the private Parisian studios of Léon Bonnat and Fernand Cormon, painters who provided students with a more open and tolerant atmosphere than that found in the École des Beaux-Arts. In Cormon's studio Lautrec met Bernard and Van Gogh, both of whom he rendered in early portraits.

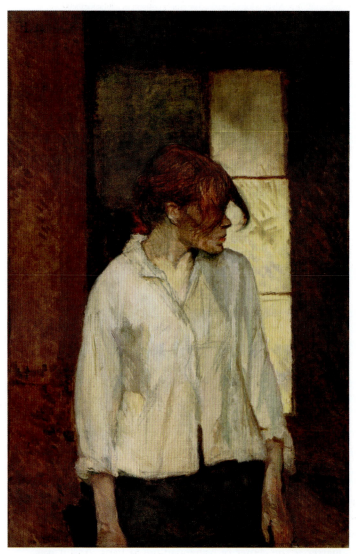

3.34 Henri de Toulouse-Lautrec, "À Montrouge"—Rosa La Rouge, 1886–87. Oil on canvas, 28½ × 19¼" (72.4 × 48.9 cm). The Barnes Foundation, Philadelphia, Pennsylvania.

Lautrec is best known for his 1890s color lithographs of performers in Montmartre dance halls; his inventive and striking graphic style elevated poster design to the realm of avant-garde art, a shift in the perception of ephemeral works that would influence generations of progressive artists. But before devoting himself largely to graphic works, he had already proved himself to be a sensitive portraitist with paintings and drawings of a colorful cast of characters, including Carmen Gaudin, the woman portrayed in "À Montrouge"—Rosa La Rouge (fig. **3.34**). The artist was drawn to the simple clothes, unruly red hair, and tough look of this young working-class woman, who, arms dangling informally, averts her face as she is momentarily silhouetted against the lighted window. Lautrec creates this simplified composition out of his characteristically long strokes of color in warm, subdued tonalities. But the somber mood of the painting has also to do with its subject. Lautrec's painting was inspired by a gruesome song written by his bohemian friend, the famous cabaret singer Aristide Bruant, about a prostitute who conspires to kill her clients.

The naturalism of Lautrec's early portraits gave way in the 1890s to the brightly colored and stylized works that make his name synonymous with turn-of-the-century Paris. His earliest lithographic poster, designed for the notorious dance hall called the Moulin Rouge (fig. **3.35**), features the scandalous talents of La Goulue ("the greedy one"), a dancer renowned for her gymnastic and erotic interpretations of the *chahut*, the dance that had attracted Seurat in 1889 (see fig. **3.3**). Lautrec's superb graphic sensibility is apparent in the eye-catching shapes that, albeit abbreviated, were the result of long observation.

At least as familiar as Toulouse-Lautrec with the district of Montmartre was **Suzanne Valadon** (1867–1939). Born in central France, she was the child of a peasant woman who moved with her infant daughter to Montmartre. As a teenager, Valadon joined the circus as a performer but soon left because of an injury. She became a popular model in a neighborhood filled with artists, posing for Toulouse-Lautrec as well as Puvis, Renoir, and Degas. An instinctive aptitude for drawing enabled this self-taught artist to achieve a remarkable degree of success in the male-dominated art world of the time. By the 1890s, some of her drawings had even been purchased by Degas, who introduced her to the technique of etching. Valadon made still lifes and the occasional landscape, but the bulk of her oeuvre was devoted to portraits and nudes. *Woman at her Toilet* (fig. **3.36**) reveals her familiarity with Degas's images of bathers, yet departs from his treatment of them in her emphatic use of contour line and the unselfconscious intimacy of the two women, one of whom gently combs through the hair of the other. Here, the scene of women bathing avoids falling into the hackneyed territory of voyeuristic fantasy and instead conveys the dignity of its working-class subjects. In her paintings, Valadon embraced the intense color of her Post-Impressionist contemporaries while continuing to explore the body as the locus of physical as well as emotional intensity. The figure in her *Blue Room* (fig. **3.37**) assumes a traditional **odalisque**

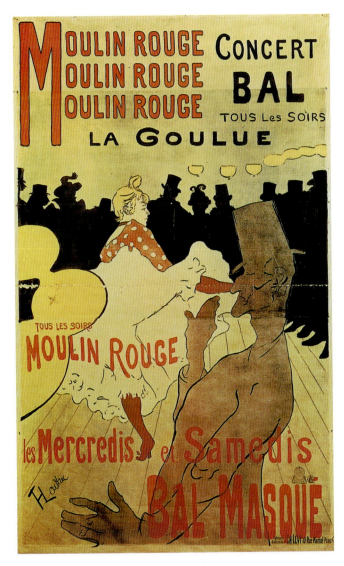

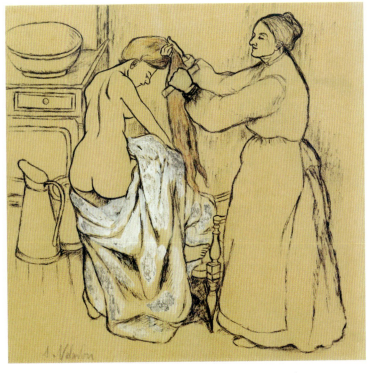

3.36 Suzanne Valadon, *Woman at her Toilet*, 1904–10. Tempera and pastel with white accent on paper, 14⅜ × 14¾" (36.4 × 37.4 cm). National Museum, Belgrade.

pose. But this forthright woman, unconventionally dressed in striped pants, has little in common with the bold courtesans of Manet (see fig. 2.21). Valadon's model follows intellectual pursuits (note the book on the bed), and she smokes a cigarette, hardly the habit of a "respectable" woman, even in 1923 when this work was completed. While her frank representations of a female subject recall depictions of prostitutes by her friend Toulouse-Lautrec, Valadon inventively places her unconventional odalisque in a richly decorative space redolent with the *intimisme* of Vuillard's and Bonnard's scenes of quiet domestic life. She thus confounds the titillation of brothel imagery by merging it with the formal patterns and reassuring domestic imagery of the Nabis. Valadon's conception of the interior as a space where fantasy and reality might collide, commingle, or merge would find a literal counterpart in Art Nouveau architecture and design.

3.35 Henri de Toulouse-Lautrec, *Moulin Rouge—La Goulue*, 1891. Color lithograph, 6' 3¼" × 4' (1.9 × 1.2 m). Victoria and Albert Museum, London.

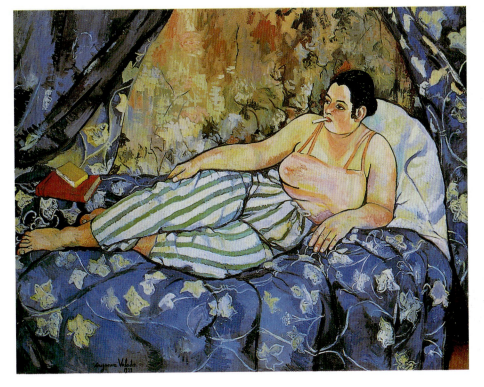

3.37 Suzanne Valadon, *Blue Room*, 1923. Oil on canvas, 35⅜ × 45⅝" (90 × 115.9 cm). Musée National d'Art Moderne, Centre d'Art et de Culture Georges Pompidou, Paris.

4

Arts and Crafts, Art Nouveau, and the Beginnings of Expressionism

The turn of the century was a time of synthesis in the arts, a time when artists sought new directions that in themselves constituted a reaction against the tide of "progress" represented by industrialization. Some artists looked to traditional forms and techniques for reassurance, finding in historic approaches to design an attentiveness to craftsmanship, scale, and function that seemed absent from much modern manufacture. The Arts and Crafts Movement exemplifies this response. It should, perhaps, come as no surprise that this movement arose in Britain before taking an equally strong hold in North America, where industrialization was exerting an especially acute transformation of society. However, some architects and designers recognized that new patterns of life in the industrial age called for new types of buildings—bridges, railroad stations, and skyscrapers. Innovators like Charles Rennie Mackintosh were able to draw selectively upon older styles without resorting to academic pastiche, and to create from the past something new and authentic for the present. At the same time, the search of the Symbolist poets, painters, and musicians for spiritual values was part of this reaction to modernity. Gauguin used the term Synthetism to characterize the liberating color and linear explorations that he pursued and transmitted to disciples. This synthesizing spirit became, in the last decades of the nineteenth century and the first of the twentieth, a great popular movement that affected the taste of every part of the population in both Europe and the United States.

What remains especially curious about this taste for synthesis is that it involved the reconciliation of two seemingly incompatible ideas: the complete aesthetic liberty of Art for Art's Sake and the necessity of a social role for art characteristic of the Arts and Crafts Movement. Among the most successful attempts at reconciling these impulses was the movement called Art Nouveau, a French term meaning simply "new art." Art Nouveau draws equally upon the inward-turning, fantastical experiments of Symbolism, the exotic forms and decorative exuberance of *japonisme*, and the innovative experiments with industrial materials undertaken by designers such as Paxton, Labrouste, and Eiffel. Art Nouveau was a definable style that emerged from the experiments of painters, architects, craftspeople, and designers and, for a decade, permeated not only painting, sculpture, and architecture, but also graphic design, magazine

and book illustration, furniture, textiles, glass and ceramic wares, jewelry, and even clothing. As the name implies, Art Nouveau represented a conscious search for new and genuine forms that were capable of expressing modernism at the turn of the century, a period often referred to by the French *fin de siècle*. Meaning literally "end of the century," the French term conveys a sense of decline and uncertainty that is absent in its English counterpart.

"A Return to Simplicity": The Arts and Crafts Movement and Experimental Architecture

Architecture monumentalized the nineteenth century's ambivalence toward modernity and industrialization. For some architects, industrialization was viewed as an assault on Western culture, threatening to obliterate its traditional values and social behavior. Those who held such views tended to embrace revivalism in architectural and interior design. Classical, Gothic, Renaissance, Baroque, and even Rococo styles gained new currency in the industrialized West, permitting architects to articulate reassuringly familiar **façades** and spaces. How could human dignity be completely trammeled by commerce and industry, such revivalists asked, in an environment punctuated by Greek and Roman temples, Gothic chapels, or Baroque palaces? Other designers viewed industrialization with less suspicion. Moves to large-scale manufacturing and the development of new processes for producing iron and steel were seen by sympathetic architects as boons to design, fueling innovation while damping costs. Progress in society, such designers argued, demanded similar progress in the built environment. Ultimately, modern architecture emerged from the conversation and conflict between those who welcomed industrialization, urbanization, and capitalism and those who wished to hold these forces at bay.

The British critic and philosopher John Ruskin was among those who attempted to identify and resist the forces propelling modernity and industrialization. The tremendous expansion of machine production during the nineteenth century resulted in mass consumption of new, more cheaply manufactured products. This growing mass market put

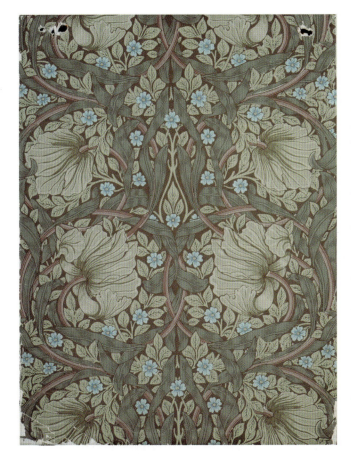

4.1 William Morris, Detail of *Pimpernel* wallpaper, 1876. Victoria and Albert Museum, London.

Explore more about Morris on mysearchlab.com

the emphasis on cheapness rather than quality or beauty. Thus there arose early in the nineteenth century the profession of modern advertising, which followed the principle that the most ornate, unoriginal products sell best. To a Romantic, progressive nineteenth-century thinker and artist like **William Morris** (1834–96), friend of Ruskin and collaborator of the Pre-Raphaelites (see Ch. 2, pp. 22–24), the machine was destroying the values of individual craftsmanship on which the high level of past artistic achievement had rested. Poet, painter, designer, and social reformer, Morris fought against the rising tide of what he saw as commercial vulgarization, for he passionately believed that the industrial worker was alienated both from the customer and the craft itself and was held hostage to the dictates of fashion and profit.

Like his mentor John Ruskin, Morris believed that a society was reflected in its arts and, furthermore, that artworks contribute directly to the values and organization of society. Of chief importance to Morris was the human, spiritual quality of culture. Factory-produced lace, furnishings, and dinnerware were, for Morris, lacking in both quality and integrity. Using such items in a household—any household—signaled the acceptance that soulless machines now dominated domestic as well as commercial life. Like Ruskin, Morris looked back to the Middle Ages with nostalgia, seeing in medieval society the emphasis on community and spirituality that he found lacking in Victorian Britain, and emulating the forms and ornament of medieval design. This interest in an idealized past was fused with a love of nature, leading Morris to invent vegetal and animal patterns for cloth and wallpaper that remain popular today.

Morris and fellow artists established Morris, Marshall, Faulkner & Co. (later shortened to Morris and Co.), which made household furnishings of the highest quality (fig. **4.1**). There he put into practice his admiration for the Middle Ages, producing works based on his and others' organic patterns and organizing skilled laborers as if they were members of a medieval crafts guild. His friend, the artist and designer Walter Crane, summarized their common goals by calling for "a return to simplicity, to sincerity; to good materials and sound workmanship; to rich and suggestive surface decoration, and simple constructive forms." Morris's designs were intended to raise the dignity of craftsperson and owner alike and to enhance the beauty of ordinary homes. The Firm's aesthetic and social sensibilities gave rise to the Arts and Crafts Movement in the British Isles, which exerted tremendous influence in the United States, especially on the oak Mission Style furniture of Gustav Stickley.

Morris asked the architect **Philip Webb** (1831–1915) to design his own home, the Red House, in Kent in 1859 (fig. **4.2**). In accordance with Morris's desires, the house was generally Gothic in design, but Webb interpreted his

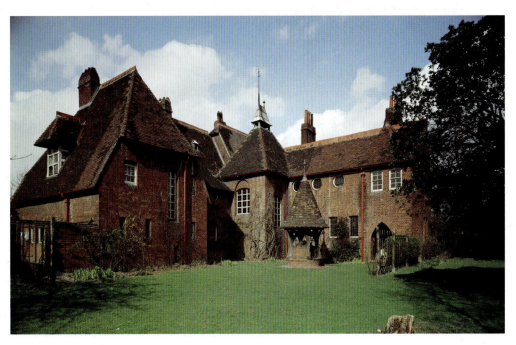

4.2 Philip Webb and William Morris, Red House, 1859–60. Bexleyheath, Kent, England.

Watch a video about the Red House on mysearchlab.com

commission freely. Into a simplified, traditional, red-brick Tudor Gothic manor house, with a steeply pitched roof, he introduced exterior details of classic Queen Anne windows and oculi. The effect of the exterior is of harmony and compact unity, despite the disparate elements. The plan is an open L-shape with commodious, well-lit rooms arranged in an easy and efficient asymmetrical pattern. The interior, from the furniture and stained-glass windows down to the fire irons, was designed by Webb and Morris in collaboration with Morris's wife, Jane, and the Pre-Raphaelite artists Rossetti and Burne-Jones. Aware of such English experiments, the influential American architect Henry Hobson Richardson (see Ch. 8, pp. 169–70) developed his own style of domestic architecture, which fused American traditions with those of medieval Europe. The Stoughton House, in Cambridge, Massachusetts, is one of his most familiar structures in the shingle style (named for the wooden tiles or shingles used as wall cladding) then rising to prominence on the eastern seaboard. The main outlines recall **Romanesque**- and Gothic-revival traditions, but these are architecturally less significant than the spacious, screened entry and the extensive windows, which suggest his concern with the livability of the interior. The shingled exterior wraps around the structure of the house to create a sense of simplicity and unity.

Experiments in Synthesis: Modernism beside the Hearth

Not all late nineteenth-century designers shied away from modernism in architecture: far from it. The century witnessed the invention of many new types of structure including railway stations, department stores, and exhibition halls, all presenting radically new spaces and constructed using mass-produced, industrial materials. These were buildings without tradition, however, which made it easier for architects to persuade their patrons to pursue innovative design and construction. The public was generally less receptive to progressive tendencies in traditional structures like churches, houses, or apartment blocks. Despite this conservatism, many of modern architecture's most revolutionary concepts—attention to utility and comfort, the notion of beauty in undecorated forms, and of forms that follow function—were first conceived in modest individual houses and small industrial buildings. The pioneering efforts of Webb in England and of Richardson and McKim, Mead & White in the United States were followed by the important experimental housing of Charles F. A. Voysey, Arthur H. Mackmurdo, and Charles Rennie Mackintosh in the British Isles, and in the United States by the revolutionary house designs of Frank Lloyd Wright. Unlike their Arts and Crafts contemporaries such as William Morris, architects like Voysey and Mackintosh viewed new technologies and industrial materials without suspicion, using the advantages promised by such innovations to map out a middle path between nostalgic historicism and the brand of unapologetic modernism that would eventually give rise to the steel-and-glass-clad skyscraper.

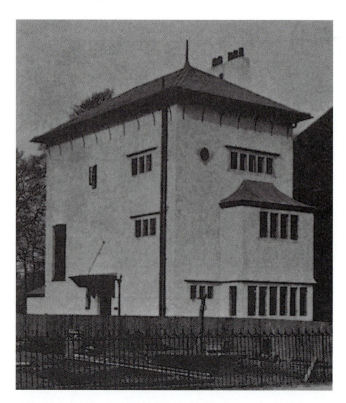

4.3 Charles F. A. Voysey, Forster House, 1891. Bedford Park, London.

Charles F. A. Voysey (1857–1941), through his wallpapers and textiles, had a more immediate influence on progressive European design than did the Arts and Crafts Movement of Morris. The furniture he designed had a rectangular, medievalizing form with a simplicity of decoration and a lightness of proportion that some historians have claimed anticipated later Bauhaus furniture, though Voysey was perplexed by such assertions. Voysey's architecture was greatly influenced by Arthur H. Mackmurdo, who, in structures such as his own house and his Liverpool exhibition hall, went beyond Webb in the creation of a style that eliminated almost all reminiscences of English eighteenth-century architecture. A house by Voysey in Bedford Park, London, dated 1891 (fig. **4.3**), is astonishingly original in its rhythmic groups of windows and door openings against broad white areas of unadorned, starkly vertical walls. While Voysey was a product of the English Gothic Revival, he looked not to the great cathedrals for inspiration, but to the domestic architecture of rural cottages. In his later country houses he returned, perhaps at the insistence of clients, to suggestions of more traditional Tudor and Georgian forms. He continued to treat these, however, in a ruggedly simple manner in which plain wall masses were lightened and refined by articulated rows of windows.

Largely as a result of the work of **Charles Rennie Mackintosh** (1868–1928), Glasgow was one of the most remarkable centers of architectural experiment at the end of the nineteenth century. Mackintosh's most considerable work of architecture, created at the beginning of his career, is the Glasgow School of Art of 1898–99, with its library addition of 1907–09 (fig. **4.4**). The essence of this building is simplicity, clarity, monumentality, and, above all, an organization

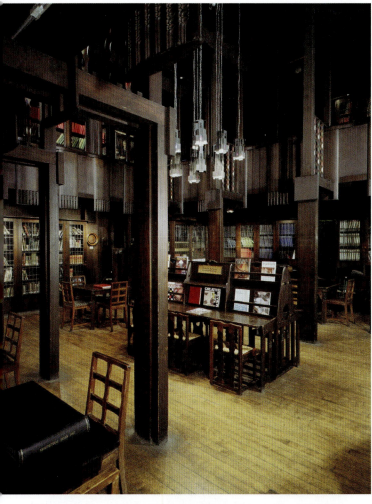

4.4 Charles Rennie Mackintosh, Library, Glasgow School of Art, 1907–09.

4.5 Charles Rennie Mackintosh, Willow Tea Rooms, 1903. Glasgow.

✳—Explore more about Mackintosh on mysearchlab.com

of interior space that is not only functional but also highly expressive of its function. The huge, rectangular studio windows are imbedded in the massive stone façade, creating a balance of solids and voids. The rectangular heaviness of the walls, softened only by an occasional curved masonry element, is lightened by details of fantasy, particularly in the ironwork, that show a relationship to Art Nouveau, but derive in part from the curvilinear forms of medieval Scottish and Celtic art. The library addition is a large, high-ceilinged room with surrounding balconies. Rectangular beams and columns are used to create a series of views that become three-dimensional, geometric abstractions.

The same intricate play with interior vistas seen in this library is apparent in a series of four public tea rooms, also in Glasgow, commissioned by Catherine Cranston. For the last of these, the Willow Tea Rooms, Mackintosh was able to design the entire building (fig. **4.5**). Most details of the interior design, furniture, and wall painting are the products of both Mackintosh and his wife, Margaret Macdonald. They shared with Morris and the followers of the Arts and Crafts Movement the notion that all architectural elements, no matter how small, should be integrated into a total aesthetic experience. In 1900, Mackintosh exhibited with the Vienna Secession, a group of mostly Austrian artists who

had decided to leave the Vienna Academy in 1897 in order to advance progressive ideas through exhibitions, a magazine (*Ver Sacrum*, "Sacred Spring"), and their teaching. Mackintosh's inventive architectural designs, furniture, glass, and enamels were received more favorably there than they had been in London. He died virtually penniless, and it was not until the 1960s that his reputation was fully revived. Today his furniture and decorative arts are among the most coveted of the modern era.

Where Voysey and Mackintosh offered something of a middle way, taking advantage of innovations in manufacturing and new materials while maintaining traditional expectations about scale and aesthetic utility, their European counterparts associated with Art Nouveau adopted with enthusiasm a new approach to design that incorporated unapologetically industrial media and techniques and combined them with a fantastical aesthetic redolent of Symbolism, a movement that embraced the principles of Art for Art's Sake. Britain, too, had its apologists for Art for Art's Sake, a doctrine that, when taken to its extreme, asserted that art should serve no utilitarian function at all. Britain's chief champion of Art for Art's Sake was the essayist Walter Pater (see *Pater, from Studies in the History of the Renaissance*, p. 74).

Walter Pater
from the Conclusion to *Studies in the History of the Renaissance* (1873)

A brief chapter that furnished the conclusion to the first edition of Pater's collection of essays on Renaissance art and poetry prompted an outcry from critics who found his aesthetic ideas salacious and potentially harmful to young readers. Pater removed the offending chapter from subsequent editions of the book.

The service of philosophy, of speculative culture, towards the human spirit, is to rouse, to startle it to a life of constant and eager observation. Every moment some form grows perfect in hand or face; some tone on the hills or the sea is choicer than the rest; some mood of passion or insight or intellectual excitement is irresistibly real and attractive to us—for that moment only. Not the fruit of experience, but experience itself, is the end. A counted number of pulses only is given to us of a variegated, dramatic life. How may we see in them all that is to be seen in them by the finest senses? How shall we pass most swiftly from point to point, and be present always at the focus where the greatest number of vital forces unite in their purest energy?

To burn always with this hard, gemlike flame, to maintain this ecstasy, is success in life....

We are all under sentence of death but with a sort of indefinite reprieve ... we have an interval, and then our place knows us no more. Some spend this interval in listlessness, some in high passions, the wisest, at least among "the children of this world," in art and song. For our one chance lies in expanding that interval, in getting as many pulsations as possible into the given time. Great passions may give us this quickened sense of life, ecstasy and sorrow of love, the various forms of enthusiastic activity, disinterested or otherwise, which come naturally to many of us. Only be sure it is passion—that it does yield you this fruit of a quickened, multiplied consciousness. Of such wisdom, the poetic passion, the desire of beauty, the love of art for its own sake, has most. For art comes to you proposing frankly to give nothing but the highest quality to your moments as they pass, and simply for those moments' sake.

With Beauty at the Reins of Industry: Aestheticism and Art Nouveau

Among the British art movements buoyed by Pater's writings in support of Art for Art's Sake was Aestheticism. Encompassing both literary and visual works, Aestheticism did not designate a particular style so much as adhere to the idea that art should not be expected to serve any social purpose. Artists associated with the Aesthetic Movement often represented figures or subjects drawn from literary sources, as did **Frederic Leighton** (1830–96) in his painting of *The Bath of Psyche* (fig. **4.6**). Like his Symbolist contemporaries, Leighton offers a visual response to the

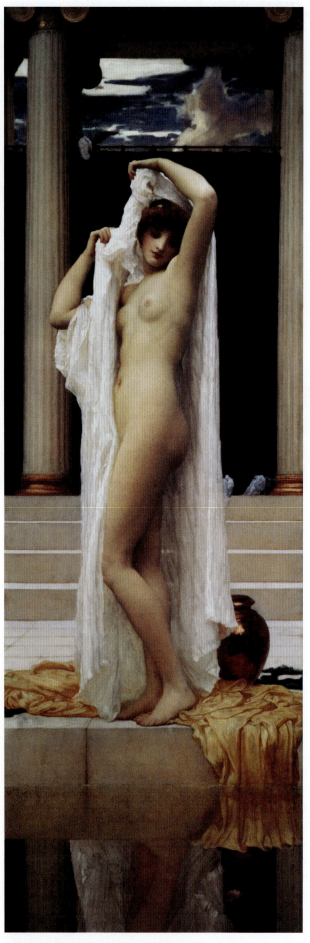

4.6 Frederick Leighton, *The Bath of Psyche*, 1890. Oil on canvas, 35⅛ × 24⅜" (89.2 × 62.2 cm). Tate, London.

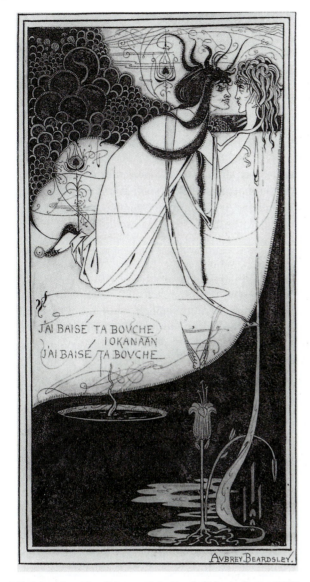

4.7 Aubrey Beardsley, *Salome with the Head of John the Baptist*, 1893. India ink and watercolor, 10⅞ × 5¾" (27.6 × 14.6 cm). Aubrey Beardsley Collection, Manuscripts Division, Department of Rare Books and Special Collections, Princeton University Library, New Jersey.

to the classical figure of Psyche as opposed to a direct illustration of a specific text. Leighton's concern here is with the achievement of compositional balance and unity, color harmonies, and seductive counterpoints of texture. The archeological accuracy of his pictures is intended to enhance the attentive viewer's experience and satisfaction with the piece, not to contribute to any narrative or moral significance. What matters is the viewer's pleasure in looking, thematized by Psyche's reverie as she gazes at her own reflection. Highly eroticized, Aestheticist works often vacillate between heterosexual and homosexual readings, as does Psyche with her well-muscled physique. While the shading that defines her torso beneath her raised left arm endows her with a feminine waist, it also subtly disguises a contour line tracing a more masculine transition from chest to hips. The ambiguity of the figure's gender contributes to the unmooring of the subject, suggestive of the dreamy quality of many works of the Aestheticists.

The drawings of the young English artist **Aubrey Beardsley** (1872–98) were immensely elaborate in their black-and-white stylization and decorative richness (fig. **4.7**). Associated with the so-termed "aesthetic" or "decadent" literature of Oscar Wilde and other *fin-de-siècle* writers, they were admired for their beauty and condemned for their sexual content. Beardsley, like Edgar Allan Poe and certain of the French Symbolists, was haunted by Romantic visions of evil, of the erotic and the decadent. In watered-down imitations, his style in drawing appeared all over Europe and America in popularizations of Aestheticist book illustrations and posters. Beardsley based one of his illustrations for Wilde's 1894 play *Salomé* on this drawing, in which the stepdaughter of Herod holds up the severed head of St. John the Baptist in a gesture of grotesque eroticism.

Less doctrinaire than their continental counterparts, these British adherents to the Art for Art's Sake doctrine accepted that a successful work of art might possess some utility beyond its purely aesthetic function to excite an emotional response in the viewer. James McNeill Whistler's famous Peacock Room from 1876–77 (fig. **4.8**), made in collaboration with the architect Thomas Jeckyll (1827–81) for the London house of the shipping magnate Frederick Richards Leyland, exemplifies this. Designed to showcase Leyland's Chinese porcelain collection, the Peacock Room was eclectic in style, as was typical of the Aesthetic Movement, but it is generally suffused with an exoticism akin to *japonisme* (see Ch. 2, pp. 27–28). Like his exact contemporary William Morris (and perhaps in response to him), Whistler, known for his paintings and prints (see figs. 1.1 and 2.25), wished to prove his strength as a designer of

4.8 James McNeill Whistler, The Peacock Room, 1876–77. Panels: oil color and gold on tooled leather and wood. Installed in the Freer Gallery of Art, Washington, D.C.

an integrated decorative environment. The result is a shimmering interior of dark greenish-blue walls embellished with circular abstract patterns and golden peacock motifs, which Whistler called *Harmony in Blue and Gold*. On one wall of the room are two fighting peacocks, one rich and one poor, which slyly alluded to a protracted quarrel between the artist and his patron. Leyland, who refused to pay Whistler for a great deal of the work on the room that he had never commissioned, finally banned the irascible artist from the house after he invited the public and press to view his creation without Leyland's permission. The room was later acquired intact by an American collector and is now housed in the Freer Gallery of Art in Washington, D.C. With its emphasis on beautiful but useful objects and a decorative style largely shaped by the reigning craze for *japonisme*, the Aesthetic Movement was an important forerunner of Art Nouveau.

Natural Forms for the Machine Age: The Art Nouveau Aesthetic

Art Nouveau grew out of the English Arts and Crafts Movement, whose ideas spread rapidly throughout Europe and found support in the comparable theories of French, German, Belgian, and Austrian artists and writers. A key characteristic of the movement was the concept of a synthesis of the arts based on an aesthetic of dynamic linear movement. Many names were given to this phenomenon in its various manifestations, but ultimately "Art Nouveau" became the most generally accepted, through its use by the Parisian shop and gallery owned by Siegfried Bing, the Maison de l'Art Nouveau, which was influential in propagating the style. In Germany the term *Jugendstil*, or "youth style," after the periodical *Jugend*, was adopted.

In 1890, it must be remembered, large quantities of mainstream painting, sculpture, and architecture were still being produced in accepted academic styles using traditional methods. The Arts and Crafts Movement offered one alternative, advocating organic design, traditional materials, and handcrafting. In contrast to that movement, Art Nouveau made use of new materials and machine technologies both in buildings and in decoration. Moreover, although Art Nouveau artists could not avoid the influence of past styles, they explored those that were less well known and out of fashion with the current academicians. They looked not only to medieval but also to Asian art forms or devices that were congenial to their search for an abstraction based on linear rhythms. Thus the linear qualities and decorative synthesis of eighteenth-century **Rococo**; the wonderful linear interlace of Celtic and Saxon illumination and jewelry; the bold, flat patterns of Japanese paintings and prints (see fig. 2.23); the ornate motifs of Chinese and Japanese ceramics and jades, were all used as sources for ideas. The Art Nouveau artists, while seeking a kind of abstraction, discovered most of the sources for their decoration in nature, especially in plant forms, often given a symbolic or sensuous overtone. They also drew on scientific discoveries, such as the forms of micro-organisms becoming familiar from explorations in botany and zoology. Their willingness to depart from

their models in order to achieve suggestive, often fantastical forms testifies to the influence of Symbolism as well.

Painting and Graphic Art

One of the most influential figures in all the phases of Art Nouveau was the Belgian **Henry van de Velde** (1863–1957). Trained as a painter, he eventually produced abstract compositions in typical Art Nouveau formulas of color patterns and sinuous lines (fig. **4.9**). For a time he was interested in Impressionism and read widely on the scientific theory of color and perception. He soon abandoned this direction in favor of the Symbolism of Gauguin and his school, and attempted to push his experiments in symbolic statement through abstract color expression further than had any of his contemporaries. Ultimately, Van de Velde came to believe that easel painting was a dead end and that the solution for contemporary society was to be found in the industrial arts. Though significantly influenced by the theories of the British designer William Morris, Van de Velde regarded the machine as a potentially positive agent that could "one day bring forth beautiful products." It was finally as an architect and designer that he made his major contributions to Art Nouveau and the origins of twentieth-century art.

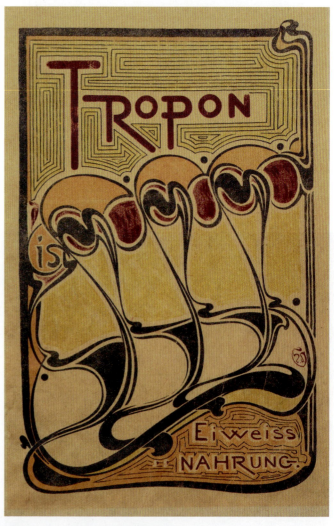

4.9 Henry van de Velde, *Tropon*, c. 1899. Advertising poster, 47⅝ × 29⅛" (121 × 74 cm). Museum für Kunst und Gewerbe, Hamburg.

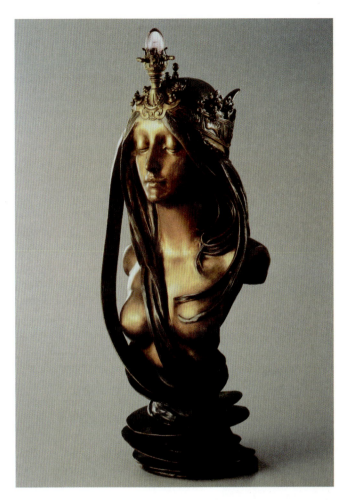

4.10 Alphonse Marie Mucha, *Nature*, c. 1900. Gilt bronze, silver, and marble, 27¼ × 11 × 12" (69.2 × 27.9 × 30.5 cm). Virginia Museum of Fine Arts, Richmond, Virginia.

Klimt (1862–1918), in many ways the most talented exponent of pure Art Nouveau style in painting. Klimt was well established as a successful decorative painter and fashionable portraitist, noted for the brilliance of his draftsmanship, when he began in the 1890s to be drawn into the stream of new European experiments. He became conscious of Symbolism, Pre-Raphaelitism, and Aestheticism. His style also encompassed a study of Byzantine mosaics. A passion for erotic themes led him not only to the creation of innumerable drawings, sensitive and explicit, but also to the development of a painting style that integrated sensuous nude figures with brilliantly colored decorative patterns of a richness rarely equaled in the history of modern art. He was increasingly drawn to murals. Those he created for the Palais Stoclet in Brussels, designed by Josef Hoffmann between 1905 and 1910 (fig. **4.11**; see also fig. 4.21), are executed in glass, enamel, metal, and semiprecious stones. They combined figures conceived as flat patterns (except for modeled heads and hands) with an overall pattern of

Van de Velde's proficiency in a variety of techniques and media is typical of the artists contributing to the Art Nouveau movement. **Alphonse Mucha** (1860–1939), a Czech artist who encountered Art Nouveau tendencies during his study in Paris in the late 1880s, adopted the new style for his early graphic works. Attracted to ephemeral media such as product packaging and posters as much for the opportunity to produce works rapidly for a guaranteed audience as for commercial advantage, Mucha employed the sinewy, flowing lines and broad areas of saturated color typical of the movement. Mucha translated the Art Nouveau aesthetic into sculpture, too, producing sensuous, mildly erotic figures (fig. **4.10**). Along with Art Nouveau's characteristic organic forms, Mucha also embraced the movement's heterogeneity of materials. Combining metal with stone and rough-hewn surfaces with areas of highly polished finish, pieces like *Nature* simultaneously evoke time-consuming handcrafting and speedy industrial processes.

In Austria, the ideas of Art Nouveau were given expression in the founding in 1897 of the Vienna Secession and, shortly thereafter, in its publication, *Ver Sacrum*. This diverse group was so named because it seceded from Vienna's conservative exhibiting society, the Künstlerhaus, and opposed the intolerance toward new, antinaturalist styles at the Academy of Fine Arts. The major figure of the Secession was **Gustav**

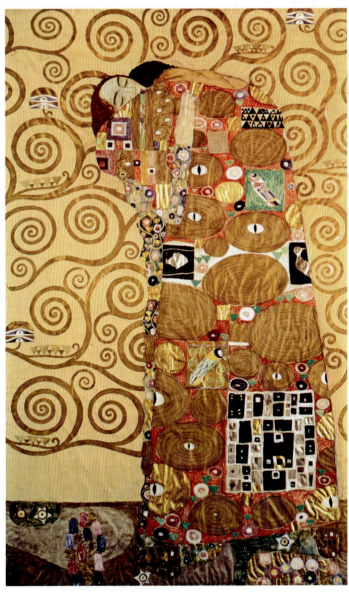

4.11 Gustav Klimt, Detail of dining-room mural, c. 1905–08. Mosaic and enamel on marble. Palais Stoclet, Brussels.

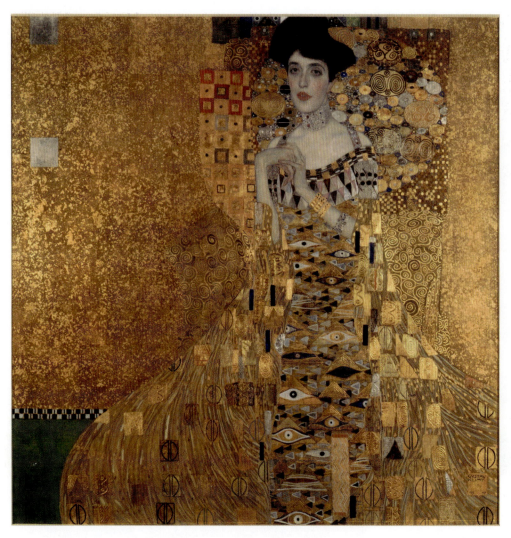

4.12 Gustav Klimt, *Adele Bloch-Bauer I*, 1907. Oil, silver, and gold on canvas, 53¼ × 53¼" (138 × 138 cm). Neue Galerie, New York.

abstract spirals—a glittering complex of volumetric forms imbedded in a mosaic of jeweled and gilded pattern. Although essentially decorative in their total effect, the Stoclet murals mark the moment when modern painting was on the very edge of nonrepresentation.

The undisguised eroticism and unsettling symbolism of Klimt's large-scale commissions failed to appeal to most institutional or commercial patrons. Portraiture thus served as his primary means of supporting himself. Even in this conventional genre, Klimt exerts his passion for the abstract and decorative. Refusing to be hamstrung by the customary flattery and tired poses endemic to society portraits, he casts his wealthy sitters, such as Adele Bloch-Bauer, as Byzantine royalty who peer out from behind a curtain of shattered golden glass, a cascade punctuated by shards of absinthe green and blood red (fig. **4.12**). In Klimt's portraits those citizens of *fin-de-siècle* Vienna—who so preoccupied Freud in his clinical practice—are seen as the psychoanalyst may have seen them: hovering between the realms of dream and waking existence (see *Freud, The Interpretation of Dreams*, below).

SOURCE

Sigmund Freud
from *The Interpretation of Dreams*, 1899

Freud's theories about the influence of childhood experiences on personality development were formulated and tested during the course of his clinical practice in Vienna. Dream interpretation, when conducted under the guidance of a psychoanalyst, could, Freud believed, aid in a patient's treatment.

In the course of [my] psychoanalytic studies, I happened upon the question of dream-interpretation. My patients, after I had pledged them to inform me of all the ideas and thoughts which occurred to them in connection with a given theme, related their dreams, and thus taught me that a dream may be interpolated in the psychic concatenation, which may be followed backwards from a pathological idea into the patient's memory. The next step was to treat the dream itself as a symptom, and to apply to it the method of interpretation which had been worked out for such symptoms. For this a certain psychic preparation on the part of the patient

is necessary. A twofold effort is made, to stimulate his attentiveness in respect of his psychic perceptions, and to eliminate the critical spirit in which he is ordinarily in the habit of viewing such thoughts as come to the surface. For the purpose of self-observation with concentrated attention it is advantageous that the patient should take up a restful position and close his eyes; he must be explicitly instructed to renounce all criticism of the thought-formations which he may perceive. He must also be told that the success of the psychoanalysis depends upon his noting and communicating everything that passes through his mind, and that he must not allow himself to suppress one idea because it seems to him unimportant or irrelevant to the subject, or another because it seems nonsensical. He must preserve an absolute impartiality in respect to his ideas; for if he is unsuccessful in finding the desired solution of the dream, the obsessional idea, or the like, it will be because he permits himself to be critical of them.

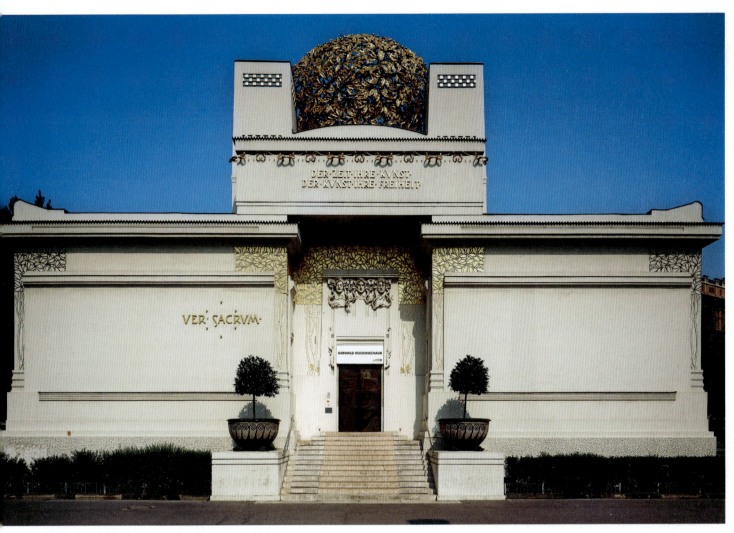

4.13 Joseph Maria Olbrich, Secession building, 1897–98. Vienna.

Joseph Maria Olbrich (1867–1908) designed the Secession building, an exhibition space intended for use by the group (fig. **4.13**). The exterior of the building proclaims the aesthetic ambitions of the Secession. The emphatically cubic structure eschews the standard classical ornamentation typical of Beaux-Arts architecture even as it insists on its typological relationship to ancient Greek and Roman temples. In place of the usual **stucco** decorative motifs like dentil molding or elaborately layered fascia, Olbrich instead adorns the building with passages of shimmering gold leaves and undulating vines. The group's motto appears in gold letters above the entrance: *Der Zeit ihre Kunst. Der Kunst ihre Freiheit* ("To every age its art; to art its freedom"), and *Ver Sacrum* appears on the building's façade. Surmounting the building is a dome figured as a golden lattice of laurel leaves that seems to float weightlessly. Olbrich's juxtaposition of strong geometric volumes with delicate, animated metallic ornamentation and suggestive text combines to proclaim the Vienna Secession's embrace of artistic progress even as it announces the group's veneration for classical principles. Inside the building, Klimt's complex *Beethoven Frieze* provides a dense allegorical response to Wagner's assertion that Beethoven's Ninth Symphony conveys "the struggle [of] the soul striving for joy."

Art Nouveau Architecture and Design

As Olbrich's idiosyncratic Secession building shows, it is difficult to speak of a single, unified Art Nouveau style in architecture except in the realms of surface ornament and interior decoration. Despite this fact, certain aspects of architecture derive from Art Nouveau graphic art and decorative or applied arts, notably the use of the whiplash line in ornament and a generally curvilinear emphasis in decorative and even structural elements. The Art Nouveau spirit of imaginative invention, linear and spatial flow, and non-traditionalism fed the inspiration of a number of architects in continental Europe and the United States and enabled them to experiment more freely with ideas opened up to them by the use of metal, glass, and **reinforced-concrete** construction. Since the concept of Art Nouveau involved a high degree of specialized design and craftsmanship, it did not lend itself to the developing field of large-scale mass construction. However, it did contribute substantially to the outlook that was to lead to the rise of a new and experimental architecture in the early twentieth century.

The outstanding American name in Art Nouveau was that of **Louis Comfort Tiffany** (1848–1933), but his expression lay in the fields of interior design and decorative arts, notably his table lamps. These combined the stylized natural

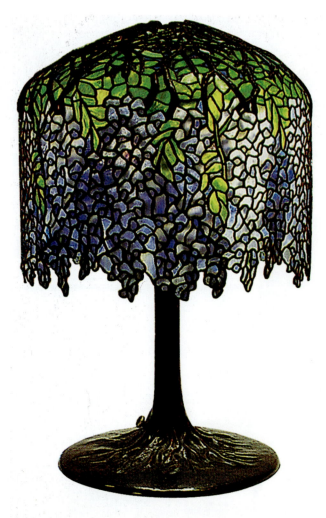

4.14 Louis Comfort Tiffany, Table lamp, c. 1900. Bronze and Favrile glass, height 27″ (68.6 cm), shade diameter 18″ (45.7 cm). Lilian Nassau LLC, New York.

it involved a highly idiosyncratic use of materials, particularly in textural and coloristic arrangement, and an even more imaginative personal style in ornamental ironwork. His wrought-iron designs were arrived at independently and frequently in advance of the comparable experiments of mainstream Art Nouveau. Throughout his later career, from the late 1880s until his death in 1926, Gaudí followed his own direction, which at first was parallel to Art Nouveau and later became independent of anything that was being done in the world or would be done until the middle of the twentieth century, when his work was reassessed.

Gaudí's first major commission was to complete the Church of the Sagrada Família (Holy Family) in Barcelona (fig. **4.15**), already begun as a Gothic Revival structure by the architect Francisco de Villar. Gaudí worked intermittently on it from 1883 until his death, leaving it far from complete. The main parts of the completed church, particularly the four great spires of one transept, are only remotely Gothic. Although influences of Moorish and other architectural styles may be traced, the principal effect is of a building without historic style—or rather one that expresses the imagination of the architect in the most personal and powerful sense. The decoration of the church contains a profusion of fantasy in biological ornament flowing into naturalistic figuration and abstract decoration. Brightly colored mosaic embellishes the finials of the spires. These forms were not arbitrary; they were tied to Gaudí's structural principles and his often hermetic language of symbolic form, informed by his spiritual beliefs. To complete the church according to the architect's plans, an enormous amount of construction has been undertaken since his death and continues today.

Completed during Gaudí's lifetime was Casa Milá, an apartment house in Barcelona (fig. **4.16**). This was a large structure around open courts, conceived as a single continuous movement of sculptural volumes. The façade, flowing around the two main elevations, is an alternation of void and sculptural mass. The undulating roof lines and the elaborately twisted chimneypots carry through the unified sculptural theme. Ironwork grows over the balconies like luscious, exotic vegetation. The sense of organic growth continues in the floor plan, where one room or corridor flows without interruption into another. Walls are curved or angled throughout, to create a feeling of everlasting change, of space without end. In his concept of architecture as dynamic space joining the interior and exterior worlds and as living organism growing in a natural environment, in his daring engineering experiments, in his imaginative use of materials—from stone that looks like a natural rock formation to the most wildly abstract color organizations of ceramic mosaic—Gaudí was a visionary and a great pioneer.

If any architect might claim to be the founder of Art Nouveau architecture, however, it is the Belgian **Victor Horta** (1861–1947). Trained as an academician, he was inspired by Baroque and Rococo concepts of linear movement in space, by his study of plant growth and of Viollet-le-Duc's structural theories, and by the engineer Gustave Eiffel, designer of the famous Paris landmark.

forms so typical of Art Nouveau with his patented Favrile glass, which appeared handmade although it was industrially manufactured (fig. **4.14**). Tiffany was not only in close touch with the European movements but himself exercised a considerable influence on them.

In Spain, **Antoni Gaudí** (1852–1926) was influenced as a student by a Romantic and Symbolist concept of the Middle Ages as a golden age, which for him and for other Spanish artists became a symbol for the rising nationalism of Catalonia. Also implicit in Gaudí's architecture was his early study of natural forms as a spiritual basis for architecture. He was drawn to the work of the influential French architect and theorist Eugène Emmanuel Viollet-le-Duc. The latter was a leading proponent of the Gothic Revival and a passionate restorer of medieval buildings who analyzed Gothic architectural structure in the light of modern technical advances. His writings on architecture, notably his *Entretiens* ("Discussions"), which appeared in French, English, and American editions in the 1860s and 70s, were widely read by architects. His bold recommendations on the use of direct metal construction influenced not only Gaudí, but a host of other experimental architects at the end of the nineteenth century. While Gaudí's early architecture belonged in part to the main current of Gothic Revival,

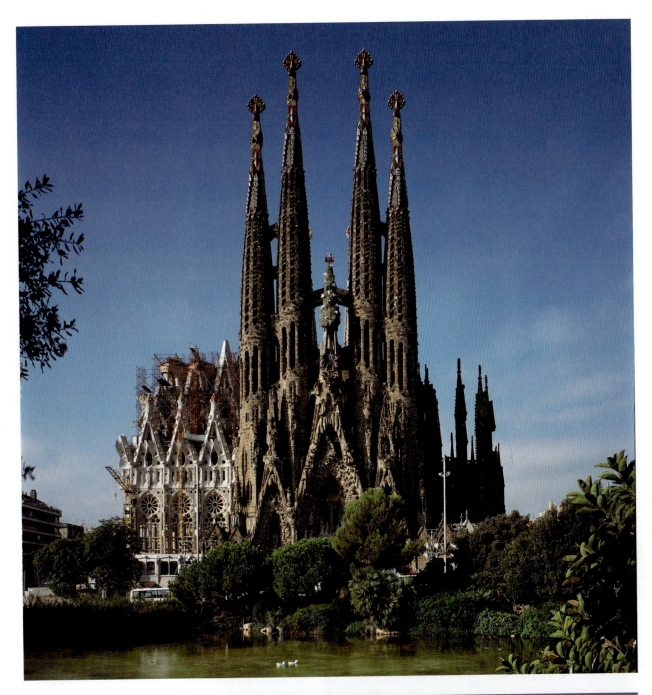

4.15 Antoni Gaudí, Church of the Sagrada Família, 1883–1926. Barcelona.

Watch a video about the Church of the Sagrada Família on mysearchlab.com

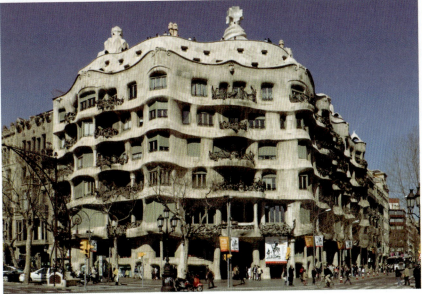

4.16 Antoni Gaudí, Casa Milá, 1905–07. Barcelona.

Explore more about Gaudí on mysearchlab.com

The first important commission carried out by Horta was the house of a Professor Tassel in Brussels, where he substantially advanced Viollet-le-Duc's theories about the use of metal construction. The stair hall (fig. **4.17**) is an integrated harmony of linear rhythms, established in the **balustrades** of ornamental iron, the whiplash curves atop the capitals, the **arabesque** designs on the walls and floor, and the winding steps. Line triumphs over sculptured mass as a multitude of fanciful, tendril-like elements blends into an organic whole that boldly exposes the supporting metal structure.

Many of the chief examples of Art Nouveau architecture are to be found in the designs of department stores and similar commercial buildings. The large-scale department store was a characteristic development of the later nineteenth century, superseding the older type of small shop and enclosing the still older form of the bazaar. Thus it was a form of building without traditions, and its functions lent themselves to an architecture that emphasized openness and spatial flow as well as ornate decorative backgrounds. The façade of Horta's department store in Brussels, À l'Innovation (fig. **4.18**), is a display piece of glass and curvilinear metal supports. Such department stores sprang up all over Europe and America at the beginning of the twentieth century. Their utilitarian purpose made them appropriate embodiments of the new discoveries in mass construction:

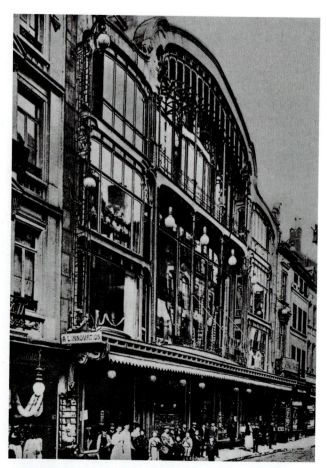

4.18 Victor Horta, À l'Innovation department store, 1901. Brussels. Destroyed by fire 1967.

glass and exposed metal structure and decorative tracery. Horta's design was notable for its expression of the interior on the glass skin of the exterior, so that the three floors, with a tall central "**nave**" and flanking, four-story side aisles, are articulated in the façade.

Many distinguished architects were associated with Art Nouveau in one context or another, but few of their works can be identified with the style to the same degree as Horta's. The stations designed by **Hector Guimard** (1867–1925) for the Paris Métropolitain (subway) can be considered pure Art Nouveau, perhaps because they were not so much architectural structures as decorative signs or symbols. His Métro stations were constructed for the 1900 Universal Exposition out of prefabricated parts of cast iron and glass. At odds with the prevailing taste for classicism, they created a sensation in Paris, causing one critic to compare them to a dragonfly's wings. The entrance to the Porte Dauphine station (fig. **4.19**) is a rare example of an original Guimard canopy still intact.

Aside from the elaborate "sea-horse" ornament on its façade, the Atelier Elvira by **August Endell** (1871–1925) in Munich (fig. **4.20**) is a relatively simple and austere structure. However, details of the interior, notably the stair hall, did continue the delicate undulations of Art Nouveau. The Palais Stoclet in Brussels (fig. **4.21**) by the Austrian architect **Josef Hoffmann** (1870–1955) is a flat-walled, rectangular structure, although the dining-room murals by Klimt (see

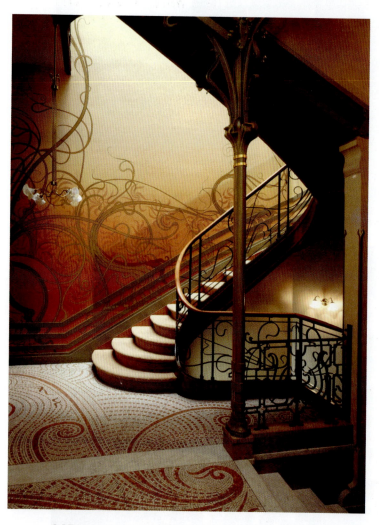

4.17 Victor Horta, Stairwell of interior, Tassel House, 1892–93. Brussels.

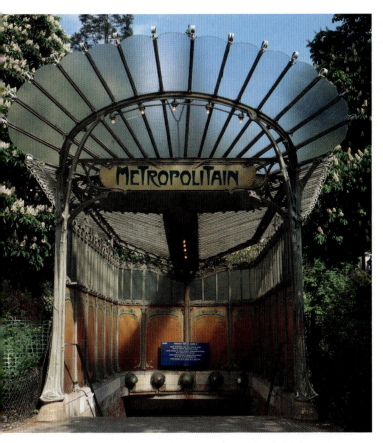

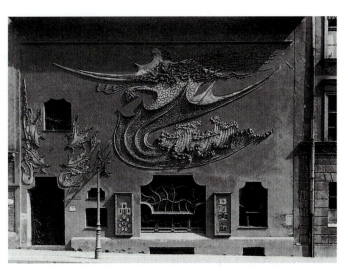

4.20 August Endell, Atelier Elvira, 1897. Munich

fig. 4.11) and the interior furnishings and decorations represent a typical Art Nouveau synthesis of decorative accessories. Hoffmann's starkly abstract language is closer to the elegant geometry of the Viennese *Jugendstil* school than to the flourishes of the Belgian Art Nouveau and typifies the formal vocabulary of the Wiener Werkstätte (Vienna Workshops). Founded in 1903 by Hoffmann along with fellow Austrian Koloman Moser, the Wiener Werkstätte was a design cooperative that adhered to principles akin to those

4.19 Hector Guimard, Entrance to the Porte Dauphine Métropolitain station, 1901. Paris.

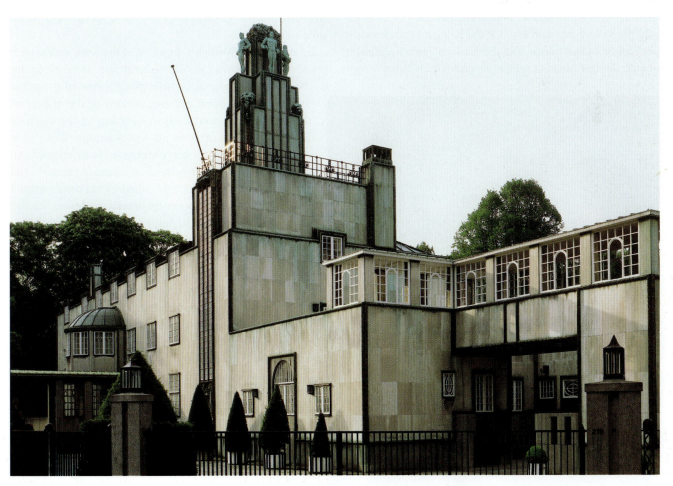

4.21 Josef Hoffmann, Palais Stoclet, 1905–11. Brussels.

promoted by the Arts and Crafts Movement. A guiding belief of those affiliated with the Wiener Werkstätte was that uplifting aesthetic experiences should suffuse everyday life. Architecture, furniture, textiles, ceramics, and metalwork were all afforded importance, each seen as a crucial component of a *Gesamtkunstwerk*, the "total work of art" that any domestic, civic, or commercial space could be if designed thoughtfully and built carefully. The Palais Stoclet is among the most complete manifestations of the Wiener Werkstätte design ethos. Along with sharing the lofty ideals of the Arts and Crafts Movement, the Wiener Werkstätte experienced similar economic difficulties: the refined design, expert craftsmanship, and exquisite materials of its products made them too expensive for most consumers. Attempts by the cooperative to expand its studios (and sales) throughout Central Europe and even to New York City failed to secure a sufficient audience. The Wiener Werkstätte's studios closed for good in 1932.

Toward Expressionism: Late Nineteenth-Century Avant-Garde Painting beyond France

In retrospect it is apparent that *Jugendstil* was as important for the new ideas it evoked in painters of the era as for the immediate impetus given architects and designers working directly in an Art Nouveau style. The Norwegian Edvard Munch, who had a sizable impact on German Expressionism; the Swiss Ferdinand Hodler; the Belgian James Ensor, a progenitor of Surrealism; and the Russian Vasily Kandinsky, one of the first abstract artists, all grew up in the environ-

ment of *Jugendstil* or Art Nouveau. Although some of the artists in this section formed their highly individual styles in response to advanced French art, they also drew extensively from their own local artistic traditions.

Scandinavia

By 1880, at the time **Edvard Munch** (1863–1944) began to study painting seriously, Oslo (then Kristiania), Norway, had a number of accomplished painters with a degree of patronage for their work. But the tradition was largely academic, rooted in the French Romantic Realism of the Barbizon School and in German lyrical naturalism, in part because Norwegian painters usually trained in Germany. In Kristiania, Munch was part of a radical group of bohemian writers and painters who worked in a naturalist mode.

Thanks to scholarships granted by the Norwegian government, Munch lived intermittently in Paris between 1889 and 1892, where he had already spent three weeks in 1885. Although it is not certain what art he saw while in France, the Post-Impressionist works he must have encountered surely struck a chord with his incipient Symbolist tendencies. In 1892 his reputation had grown to the point where he was invited to exhibit at the Verein Berliner Künstler (Society of Berlin Artists). His retrospective drew such a storm of criticism that the members of the Society voted to close it after less than a week. Sympathetic artists, led by Max Liebermann, left the Society and formed the Berlin Secession. This recognition—and controversy—encouraged Munch to settle in Germany, where he spent most of his time until 1908.

In evaluating Munch's place in European painting it could be argued that he was formed not so much by his Norwegian origins as by his exposure, first to Paris during one of the most exciting periods in the history of French painting, and then to Germany at the moment when a new and dynamic art was emerging. The singular personal quality of his paintings and prints, however, is unquestionably a result of an intensely literary and even mystical approach, intensified by his own tortured psyche. The painter moved in literary circles in Norway as well as in Paris and Berlin, was a friend of noted writers, among them the playwright August Strindberg, and in 1906 made stage designs for Ibsen's plays *Ghosts* and *Hedda Gabler*.

Although he lived to be eighty years old, the specters of sickness and death hovered over Munch through much of his life. His mother and sister died of tuberculosis while he was still young. His younger brother succumbed in 1895, five years after the death of their father, and Munch himself suffered from serious illnesses. Sickness and death began to appear early in his painting and recurred continually. The subject of *The Sick Girl*, related to the illness and death of his sister (fig. **4.22**), haunted him for years. He reworked the painting

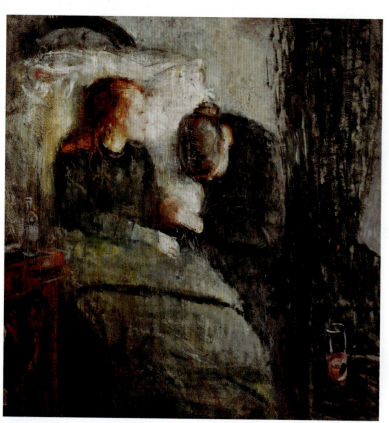

4.22 Edvard Munch, *The Sick Girl*, 1885–86. Oil on canvas, 47 × 46⅝" (119.4 × 118.4 cm). Nasjonalgalleriet, Oslo.

over and over, and made prints of the subject as well as two later versions of the painting.

Munch's mentor, the leading Norwegian naturalist painter **Christian Krohg** (1852–1925), had earlier explored a similar theme, common in the art and literature of the period, but he did so in an astonishingly direct and exacting style (fig. **4.23**). This sitter confronts the viewer head-on, her pale skin and white gown stark against the white pillow. Krohg, who had also watched his sister die of tuberculosis, avoided the usual sentimentality or latent eroticism that normally pervaded contemporary treatments of such subjects. While his version could not have predicted the melodrama or painterly handling of Munch's painting, the connection between the two canvases is obvious, though Munch, typically, denied the possibility of influence.

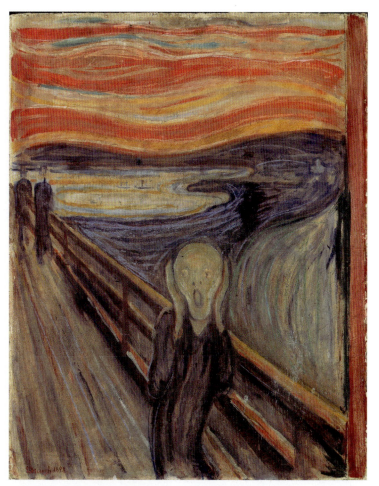

4.24 Edvard Munch, *The Scream*, 1893. Oil and tempera on board, 35¾ × 29″ (90.8 × 73.7 cm). Nasjonalgalleriet, Oslo.

Munch was enormously prolific, and throughout his life experimented with many different themes, palettes, and styles of drawing. The works of the turn of the century, in which the symbolic content is most explicit, are characterized by the sinuous, constantly moving, curving line of Art Nouveau, combined with color dark in hue but brilliant in intensity. Influences from Gauguin and the Nabis are present in his work of this period. The anxieties that plagued Munch were frequently given a more general and ambiguous, though no less frightening, expression. *The Scream* (fig. **4.24**) is an agonized shriek translated into bands of color that echo like sound waves across the landscape and through the blood-red sky. The image has its source in Munch's experience. As he walked across a bridge with friends at sunset, he was seized with despair and "felt a great, infinite scream pass through nature." *The Scream*, the artist's best-known and most widely reproduced image, has become a familiar symbol of modern anxiety and alienation.

Munch was emerging as a painter at the moment when Sigmund Freud was developing his theories of psychoanalysis. Munch's obsessions with sex, death, and woman as a destructive force seem at times to provide classic examples of the problems Freud was exploring. In many works, *The Dance of Life* among them (fig. **4.25**), Munch transformed the moon and its long reflection on the water into a phallic

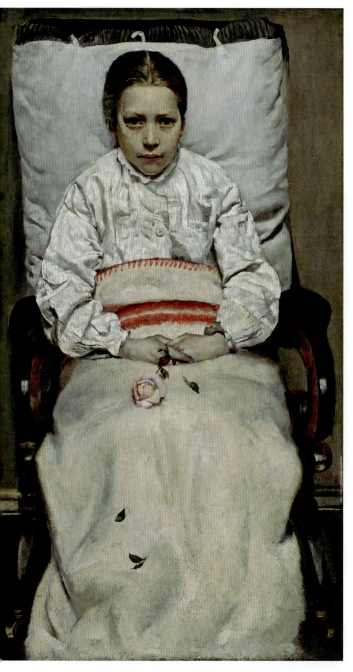

4.23 Christian Krohg, *The Sick Girl*, 1880–81. Oil on wood, 40⅛ × 22⅞″ (101.9 × 58.1 cm). Nasjonalgalleriet, Oslo.

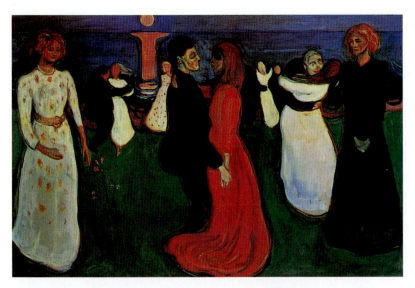

4.25 Edvard Munch, *The Dance of Life*, 1900. Oil on canvas, 4' 1½" × 6' 3½" (1.26 × 1.9 m). Nasjonalgalleriet, Oslo.

symbol. *The Dance of Life* belongs to a large series Munch called *The Frieze of Life*, which contained most of his major paintings (including *The Scream*), addressing the central themes of love, sexual anxiety, and death. The subject of this painting, based on Munch's troubled personal history of love and rejection, was in step with international trends in Symbolist art.

Munch was one of the major graphic artists of the twentieth century and, like Gauguin, he took a very experimental approach to printmaking and contributed to a revival of the **woodcut** medium. He began making etchings and lithographs in 1894 and for a time was principally interested in using the media to restudy subjects he had painted earlier. The prints, however, were never merely reproductions of the paintings. In each case he reworked the theme in terms of the new medium, sometimes executing the same subject in **drypoint**, woodcut, and lithography, and varying each of these just as each was modified from the painting. For *Vampire* (fig. **4.26**), Munch used an ingenious method he had invented for bypassing the tedious printmaking process of color registration, which involves inking separate areas of the woodblock for each color and painstakingly aligning the sheet for every pass (one for each color) through the press. Munch simply sawed his block into sections, inked each section separately, and assembled them like a puzzle for a single printing. In *Vampire*, he actually combined this technique with lithography to make a "combination print." Through these innovative techniques, Munch gained rich graphic effects, such as subtly textured patterns (by exploiting the rough grain of the woodblock), and translucent passages of color. His imagery, already explored in several

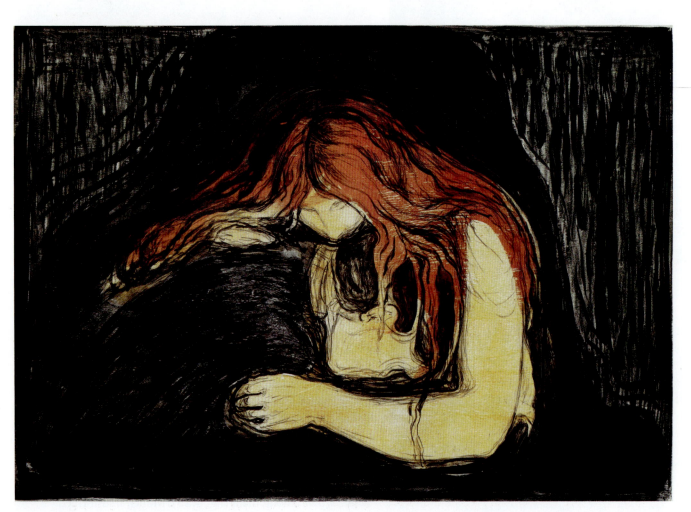

4.26 Edvard Munch, *Vampire*, 1902. Woodcut and lithograph, from an 1895 woodcut, 14⅞ × 21½" (38 × 54.6 cm). Munch-Museet, Oslo.

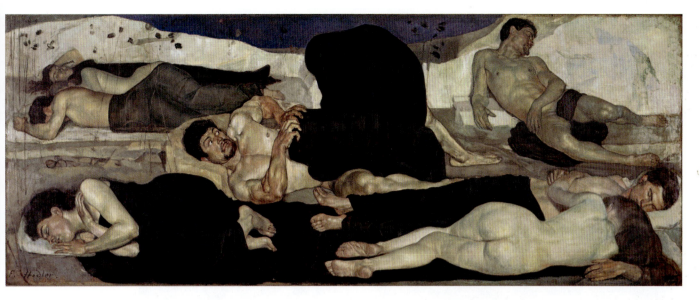

4.27 Ferdinand Hodler, *Night*, 1889–90. Oil on canvas, 3' 9¾" × 9' 9¾" (1.17 × 3 m). Kunstmuseum, Bern.

drawings and paintings made in Berlin, is typically ambiguous. While the redheaded woman could be embracing her lover, the ominous shadow that looms above them and the title of the work imply something far more sinister.

Northern and Central Europe

The Swiss artist **Ferdinand Hodler** (1853–1918) also knew the ravages of sickness and death, and, like Van Gogh, had undergone a moral crisis in the wake of deep religious commitment. In his paintings, he avoided the turbulent drama of earlier Romantic expressions and sought instead frozen stillness, spareness, and purity, the better to evoke some sense of the unity within the apparent confusion and complexity of the world of experience. This can be discerned in the famous *Night* (fig. **4.27**), where the surfaces and volumes of nature have been described in exacting detail, controlled by an equally intense concern for abstract pattern, a kind of rigorously balanced, frieze-like organization the artist called "parallelism." As in Munch's *The Scream*, the imagery in *Night* was an expression of Hodler's own obsessive fears. The central figure, who awakens to find a shrouded phantom crouched above him, is a self-portrait, as is the man at the upper right, while the women in the foreground are depictions of his mistress and ex-wife. The painting was banned from an exhibition in Geneva in 1891 as indecent, but encountered a better reception when it was later shown in Paris.

The Belgian **James Ensor** (1860–1949), whose long life was almost exactly contemporary with Munch's, emerged from a similar political and economic milieu. Both Belgium and Norway were preoccupied with establishing distinctive national identities during the second half of the nineteenth century. Belgium's emphatic claims to a cultural patrimony distinct from its former Dutch governors provided Ensor with an acute appreciation for an artistic lineage that linked him to painters such as Peter Paul Rubens and Pieter Bruegel the Elder. The consciousness of this heritage even

compelled him to assume, from time to time, though half satirically, the appearance of Rubens (fig. **4.28**). Outside of a three-year period of study at the Royal Academy of Fine Arts in Brussels, Ensor spent his entire life in his native Ostend, on the coast of Belgium, where his Flemish mother and her relatives kept a souvenir shop filled with toys, seashells, model ships in bottles, crockery, and, above all, the grotesque masks popular at Flemish carnivals.

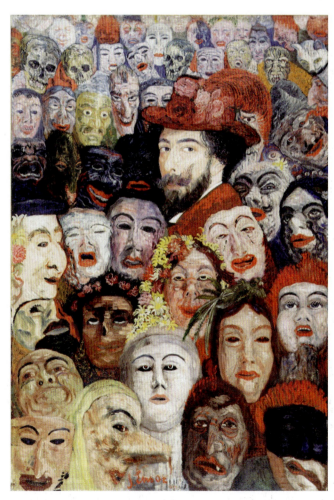

4.28 James Ensor, *Portrait of the Artist Surrounded by Masks*, 1899. Oil on canvas, 47 × 31½" (119.4 × 80 cm). Menard Art Museum, Aichi, Japan.

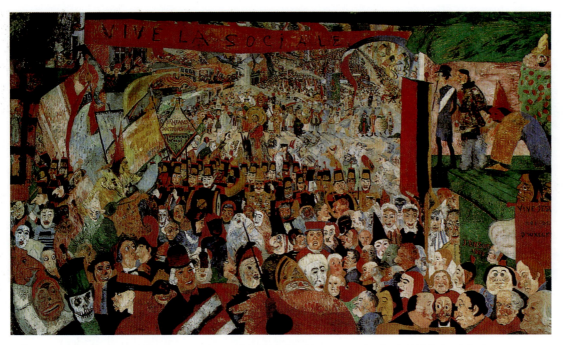

4.29 James Ensor, *The Entry of Christ into Brussels in 1889*, 1888–89. Oil on canvas, 8′ 5″ × 12′ 5″ (2.6 × 3.8 m). J. Paul Getty Museum, Los Angeles.

✳ ⎯ Explore more about *The Entry of Christ into Brussels in 1889* on mysearchlab.com

By 1881, Ensor could produce such accomplished traditional Realist–Romantic paintings that he was accepted in the Brussels Salon and by 1882 in the Paris Salon. His approach was already changing, however, with the introduction of brutal or mocking subject matter—harshly authentic pictures of miserable, drunken tramps and inexplicable meetings of masked figures.

Ensor's mature paintings still have the capacity to shock. He was something of an eccentric and much affected by nineteenth-century Romanticism and Symbolism, evident in his passionate devotion to the tales of Poe and Balzac, the poems of Baudelaire, and the work of several contemporary Belgian writers. He searched the tradition of fantastic painting and graphic art for inspiration—from the tormented visions of Matthias Grünewald and Bosch to Goya. Ensor was further affected by Daumier and his social commentaries (see fig. 2.13), the book illustrator Gustave Doré, Redon, and the decadent-erotic imagery of the Belgian artist Félicien Rops.

During the late 1880s Ensor turned to religious subjects, frequently the torments of Christ. They are not interpreted in a narrowly religious sense, but are, rather, a personal revulsion for a world of inhumanity that nauseated him. This feeling was given its fullest expression in the most important painting of his career, *The Entry of Christ into Brussels* in 1889 (fig. **4.29**), a work from 1888–89 that depicts the Passion of Christ as the center of a contemporary Flemish *kermis*, or carnival, symptomatic of the indifference, stupidity, and venality of the modern world. Ensor describes this grotesque tumult of humanity with dissonant color, compressing the crowd into a vast yet claustrophobic space. Given the enormous size of *The Entry of Christ* (it is over twelve feet, or 3.5 m, wide), it has been suggested that

Ensor painted it in response to Seurat's *La Grande Jatte* (see fig. 3.1), which had been much heralded at an exhibition in Brussels in 1887. While the French painting was a modern celebration of middle-class life, Ensor's was an indictment of it. The figure of Christ, barely visible far back in the crowd, was probably based on the artist's own likeness. This conceit—the artist as persecuted martyr—had been promoted by the Symbolists, with Gauguin among those who effectively exploited the theme. By extension, Ensor's hideous crowd refers to the ignorant citizens of Ostend, who greeted his work with incomprehension.

Even members of a more liberal exhibiting group in Brussels, called L'Essor, were somewhat uneasy about Ensor's new paintings. This led in 1884 to a withdrawal of some members, including Ensor, to form the progressive society Les XX (The Twenty). For many years the society was to support aspects of the new art in Brussels. Although it exhibited Manet, Seurat, Van Gogh, Gauguin, and Toulouse-Lautrec, and exerted an influence in the spread of Neo-Impressionism and Art Nouveau, hostility to Ensor's increasingly fantastic paintings grew even there. *The Entry of Christ* was refused admission and was never publicly exhibited before 1929. The artist himself was saved from expulsion from the group only by his own vote.

During the 1890s Ensor focused much of his talent for invective on the antagonists of his paintings, frequently with devastating results. Some of his most brilliant and harrowing works were produced at this time. The masks reappeared at regular intervals, occasionally becoming particularly personal, as in *Portrait of the Artist Surrounded by Masks* (see fig. 4.28), a painting in which he portrayed himself in the manner of Rubens's self-portraits—with debonair mustache and beard, plumed hat, and piercing glance directed

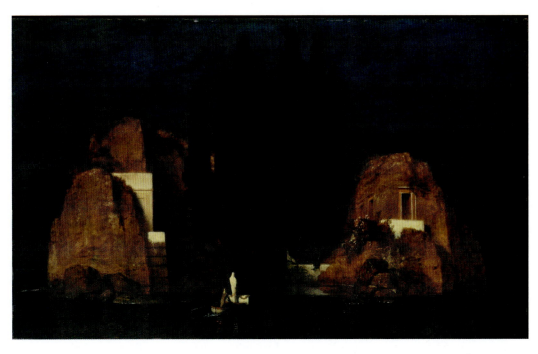

4.30 Arnold Böcklin, *Island of the Dead*, 1880. Oil on wood, 29 × 48" (73.7 × 122 cm). The Metropolitan Museum of Art, New York.

at the spectator. The work is reminiscent of an earlier 1883 self-portrait by Ensor and, in a curious way, of a painting by Hieronymus Bosch of Christ surrounded by his tormentors (here, Ensor's critics): the personification of Good, isolated by Evil but never overwhelmed.

The ancestors of twentieth-century Surrealism can also be found in a trio of artists who emerged in German-speaking Europe during the Symbolist era: Böcklin, Klinger, and Kubin. The eldest of these was **Arnold Böcklin** (1827–1901), born in Basel, educated in Düsseldorf and Geneva, and then resident in Italy until the end of his life. Like so many others within contemporary German culture, Böcklin fell prey to the classical dream, which prompted him to paint, with brutal, almost grotesque academic Realism, such mythical beings as centaurs and mermaids writhing in battle, or some sexual contest between a hapless, depleted male and an exultant *femme fatale*. One of his most haunting images, especially for later painters like Giorgio De Chirico and the Surrealists, came to be called *Island of the Dead* (fig. **4.30**), a scene depicting no known reality but universally appealing to the late Romantic and Symbolist imagination. With its uncanny stillness, its ghostly white-cowled figure, and its eerie moonlight illuminating rocks and the entrances to tombs against the deep, mysteriously resonant blues and greens of sky, water, and tall, melancholy cypresses, the picture provided inspiration not only for subsequent painters but also for numerous poets and composers.

The German artist **Max Klinger** (1857–1920) paid homage to Böcklin by making prints after several of his paintings, including *Island of the Dead*. Klinger is best known for a ten-part cycle of prints entitled *The Glove* (fig. **4.31**), whose sense of fantasy may owe something to the dark, sinister imaginings of Goya. The Czech artist and illustrator Alfred Kubin proved capable of phantasms well in excess of those found in the art of either Böcklin or Klinger. Indeed, he may be compared with Redon, though his obsession with woman-as-destroyer themes places him alongside *fin-de-siècle* artists like Rops as well as anticipating the Freudian world of Surrealism. Kubin was to become a member of Kandinsky's Munich circle, and in 1911 he joined a set of brilliant experimental artists in Germany called Der Blaue Reiter (The Blue Rider). Meanwhile, in 1909, he published his illustrated novel entitled *The Other Side*, often regarded as a progenitor of the hallucinatory fictions of Franz Kafka.

As progressive artists working in Scandinavia, Belgium, Germany, and Austria turned inward to explore the realms of private desire and inner struggle, a group of French artists took to heart Cézanne's admonition to focus on the formal character of their work, to achieve new types of visual expression through experiments with color, line, form, and space. Fantasy and reverie, while undoubtedly furnishing fuel for creative work, required a new visual language for expression. The Fauves would finally achieve formal independence of the visual arts without sacrificing the narrative ambiguity and seductive themes that had so entranced the Symbolists.

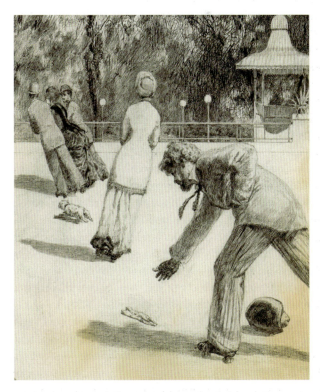

4.31 Max Klinger, *An Action* from *The Glove*, 1882. Etching, 9⅞ × 7½" (25 × 18.9 cm). Staatliche Museen zu Berlin, Preussicher Kulturbesitz, Kupferstichkabinett.

5
The New Century: Experiments in Color and Form

As the twentieth century dawned, the malaise of the *fin de siècle* subsided and *la belle époque*, "the beautiful age," was under way. The ambivalence toward industrial and commercial expansion gave way to renewed optimism. Stunning new inventions promised to ease the burden of manual labor, to conquer disease, and to enhance leisure. Automobiles, cinemas, even airplanes became part of the imagination if not the everyday experience of the inhabitants of industrialized Europe and America. A willingness to experiment, to attempt what seemed impossible only months earlier, emboldened progressive artists along with their counterparts in industry and science. This zeal for experimentation brought radical new styles to the fore: Fauvism, Cubism, and Expressionism, just to name a few. It also meant that new styles evolved rapidly, with one succeeding another at a dizzying pace. In contrast to earlier periods when an established style would endure for decades or even centuries, the avant-garde styles of the early twentieth century were quickly developed then often immediately modified or abandoned.

As already indicated, this passion for innovation was not unique to the visual arts. Scientists and engineers, for instance, advanced their fields with similar energy. Aside from what might be described as a generally optimistic and progressive milieu at the start of the century, artistic innovation must also be understood as a response to a particular aesthetic demand. Originality had, since the advent of Romanticism in the late eighteenth century, become an increasingly important measure of aesthetic success for progressive artists. Yet even the avant-garde recognized that they were part of an artistic tradition. To remain in conversation with that tradition meant that artists had to retain some of the vocabulary and syntax of its language. How to balance innovation against tradition would remain a central concern for modern artists of the early twentieth century, no matter how radical their work became.

The quest for originality had already led some artists, such as Paul Gauguin, to turn away from Western formulas and instead pursue primitivism. This interest in non-Western art peaked in the early twentieth century with a particular focus on African cultures. As was the case with late nineteenth-century primitivism, this preoccupation with African art resulted in large part from European colonization of most

of the continent. Though not initially greeted with the same enthusiasm as Asian or Oceanic artworks, by the 1920s sub-Saharan African sculpture, in particular, came to symbolize the "primitive," pre-industrial "other" in the imaginations of many Europeans and North Americans. By extension, African or African-seeming forms and motifs were seen as markers of novelty and, hence, originality. So potent was the link between African art and originality that several artists and critics claimed to have been the "discoverer" of this art. Of course, most Western artists gained familiarity with African works through magazine illustrations or through visits to ethnographic museums, a reminder that the avant-garde's understanding of non-Western cultures was highly mediated by the desires and assumptions of their own societies. These tensions—between Western and non-Western forms, between tradition and innovation—make themselves felt acutely in the work of Henri Matisse and the Fauves.

Fauvism

"*Donatello au milieu des fauves!*" ("Donatello among the wild beasts!") was the ready quip of Louis Vauxcelles, art critic for the review *Gil Blas*, when he entered Gallery VII at Paris's 1905 Salon d'Automne and found himself surrounded by blazingly colored, vehemently brushed canvases in the midst of which stood a small neo-Renaissance sculpture. With this witticism Vauxcelles gave its name to the first French avant-garde style to emerge in the twentieth century. It should be noted, however, that Vauxcelles was generally sympathetic to the work presented by the group of young painters, as were other liberal critics.

The starting point of Fauvism was later identified by Henri Matisse, its sober and rather professorial leader, as "the courage to return to the purity of means." Matisse and his fellow Fauves—André Derain, Maurice de Vlaminck, Georges Rouault, Raoul Dufy, and others—allowed their search for immediacy and clarity to show forth with bold, almost unbearable candor. While divesting themselves of Symbolist literary aesthetics, along with *fin-de-siècle* morbidity, the Fauves reclaimed Impressionism's direct, joyous embrace of nature and combined it with Post-Impressionism's heightened color contrasts and emotional, expressive depth. Following the example of Post-Impressionists like Gauguin

and Van Gogh, they emancipated color from its role of describing external reality and concentrated on the medium's ability to communicate directly the artist's experience of that reality by exploiting the pure chromatic intensity of paint. Fauvism burst onto the Parisian art scene at a time when the heady pace of change in the arts, as in society as a whole, was coming to be seen as part of the new, modern world order. Moreover, as artists from many different countries and backgrounds were drawn to Paris, seeking contact with the exciting new developments there, Fauve paintings made a deep impression on the new generation of avant-garde artists who were also coming to terms with the possibilities for painting opened up by Cézanne.

Inevitably, the Fauves' emphasis on achieving personal authenticity meant that they would never form a coherent movement. But before drifting apart as early as 1907, the Fauves made certain definite and unique contributions. Though none of them attempted complete abstraction, as did their contemporaries Vasily Kandinsky or Robert Delaunay, for example, they extended the boundaries of representation, based in part on their exposure to non-Western sources, such as African art. For subject matter they turned to portraiture, still life, and landscape. In the last, especially in the art of Matisse, they revisualized Impressionism's culture of leisure as a pagan ideal of *bonheur de vivre*, the "joy of life." Most important of all, the Fauvist painters practiced an art in which the painting was conceived as an autonomous creation, freed from serving narrative or symbolic ends.

"Purity of Means" in Practice: Henri Matisse's Early Career

Henri Matisse (1869–1954) first studied law, but by 1891 he had enrolled in the Académie Julian, studying briefly with the rigidly academic painter William Bouguereau, who came to represent everything he rejected in art. The following year he entered the École des Beaux-Arts and was fortunate enough to study with Gustave Moreau (see fig. 3.10), a dedicated teacher who encouraged his students to find their own directions not only through individual experiment but also through constant study in museums. In Moreau's studio, Matisse met Georges Rouault, Albert Marquet, Henri-Charles Manguin, Charles Camoin, and Charles Guérin, all of whom were later associated with the Fauves.

Matisse's work developed slowly from the dark tonalities and literary subjects he first explored. By the late 1890s he had discovered the Pointillist paintings of Seurat and his followers, known collectively as Neo-Impressionists, along with artists such as Toulouse-Lautrec and, most importantly, Cézanne. In about 1898 he began to experiment with figures and still lifes painted in bright, non-descriptive color. In 1900, Matisse entered the atelier of Eugène Carrière, a maker of dreamily romantic figure paintings. There he met André Derain, who introduced him to Maurice de Vlaminck the following year, completing the principal Fauve trio. Around that time, Matisse also worked in the studio of the sculptor Antoine Bourdelle, making his first attempts

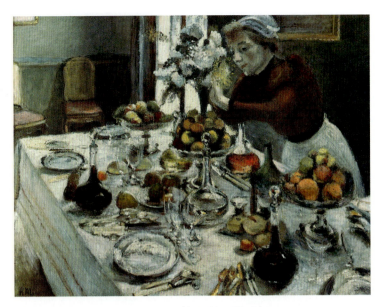

5.1 Henri Matisse, *La Desserte* (*Dinner Table*), 1896–97. Oil on canvas, 39¼ × 51½" (99.7 × 130.8 cm). Private collection.

at sculpture and demonstrating the abilities that were to make him one of the great painter–sculptors of the twentieth century.

Earliest Works

Moreau's admonition to copy the Old Masters instilled in Matisse an unflagging concern for artistic tradition and his relationship to it. Among the paintings that Matisse copied in the Louvre during his student days was a still life by the seventeenth-century Dutch painter Jan Davidszoon de Heem. Matisse's version was a free copy, considerably smaller than the original. In 1915, he would even make a Cubist variation of the work. At the Salon de la Société Nationale des Beaux-Arts (known as the Salon de la Nationale) of 1897, he exhibited his own composition of a still life, *Dinner Table* (fig. **5.1**), which was not favorably received by the conservatives. Though highly traditional on the face of it, this work was one of Matisse's most complicated and carefully constructed compositions to date, and it was his first truly modern work. While it still depended on locally descriptive color, this painting revealed in its luminosity an interest in the Impressionists. The abruptly tilted table that crowds and contracts the space of the picture anticipated the artist's subsequent move toward radical simplification in his later treatment of similar subjects (see fig. 5.21). *Male Model* of about 1900 (fig. **5.2**) carried this process of simplification and contraction several stages further, even to the point of some distortion of perspective, to achieve a sense of delimited space. Again, Matisse has chosen to experiment with a very conventional subject: a male nude. A single male figure, often clearly in a studio pose, was known as an *académie* and was central to the training of any aspiring academician. The modeling of the figure in abrupt facets of color was a direct response to the paintings of Cézanne, whose influence Matisse here brings to bear on what most progressive painters would perceive as a tired academic exercise. On the contrary, Matisse's fusion of Cézanne's radical

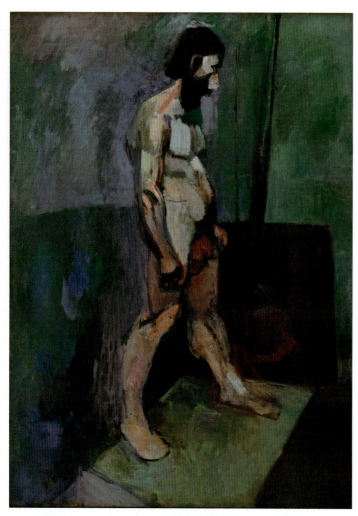

5.2 Henri Matisse, *Male Model* (*L'Homme Nu; "Le Serf" Académie bleue; Bevilacqua*), Paris, 1900. Oil on canvas, 39⅛ × 28⅝" (99.3 × 72.7 cm). The Museum of Modern Art, New York.

of paintings by Matisse, Vlaminck, Derain, and Rouault, among others, is supposed to have occasioned the remark by Vauxcelles that gave the group its permanent name.

Matisse's Fauve Period

The word *fauve* made particular reference to these artists' brilliant, arbitrary color, more intense than the "scientific" color of the Neo-Impressionists and the non-descriptive color of Gauguin and Van Gogh, and to the direct, vigorous brushwork with which Matisse and his friends had been experimenting the previous year at St. Tropez and Collioure in the south of France. The Fauves accomplished the liberation of color toward which, in their different ways, Cézanne, Gauguin, Van Gogh, Seurat, and the Nabis had been experimenting. Using similar means, the Fauves were intent on different ends. They wished to use pure color squeezed directly from the tube, not to describe objects in

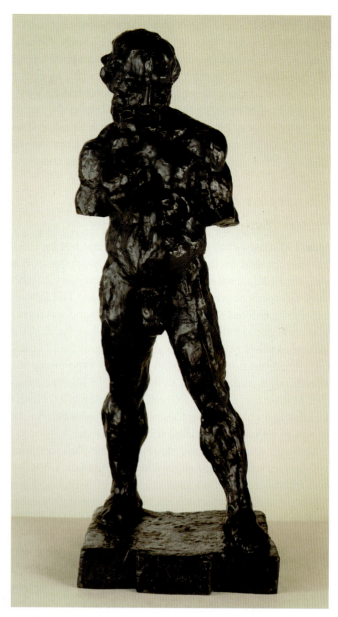

5.3 Henri Matisse, *The Serf*, 1900–04. Bronze, 36 × 13⅞ × 12¼" at base (91.4 × 35.3 × 31.1 cm). Hirshhorn Museum and Sculpture Garden, Smithsonian Institution, Washington, D.C.

treatment of space, pigment, and brushwork with an *académie* announces Matisse's intention of realizing Cézanne's dream to "make of Impressionism something solid and lasting like the art in the museums."

At around the same time, Matisse began working on a related sculpture (fig. **5.3**). *The Serf* was begun in 1900, but not completed until 1904. Although sculpted after the well-known model Bevilacqua, who had not only posed for Matisse's *Male Model* but also for Rodin, *The Serf* was adapted in attitude and concept (although on a reduced scale) from a Rodin sculpture called *Walking Man*. In *The Serf* Matisse carried the expressive modeling of the surface even further than Rodin, and halted the forward motion of the figure by adjusting the position of the legs into a solidly static pose and truncating the arms above the elbow.

Between 1902 and 1905 Matisse exhibited at the Salon des Indépendants and at the galleries of Berthe Weill and Ambroise Vollard. The latter was rapidly becoming the principal dealer for the avant-garde artists of Paris. When the more liberal Salon d'Automne was established in 1903, Matisse showed there, along with the Nabi painter Pierre Bonnard (see figs. 3.31, 3.32, and 3.33) and a fellow alumnus of Moreau's studio, Albert Marquet. But most notorious was the Salon d'Automne of 1905, in which a room

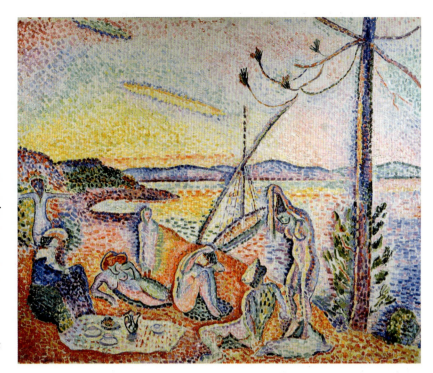

5.4 Henri Matisse, *Luxe, calme et volupté (Luxury, Calm, and Pleasure)*, 1904–05. Oil on canvas, 37 × 46" (94 × 116.8 cm). Musée d'Orsay, Paris.

> ⏵ Watch a video about *Luxe, calme et volupté* on mysearchlab.com

nature, not simply to set up retinal vibrations, not to accentuate a romantic or mystical subject, but to build new pictorial values apart from all these. For the Fauves, all pictorial elements could be realized through the use of pure color. Even space and the modeling of form could be rendered through color without recourse to Renaissance tricks of perspective or chiaroscuro. Thus, in a sense, they were using the color of Gauguin and Seurat, freely combined with their own linear rhythms, to reach effects similar to those constantly sought by Cézanne, whom Matisse revered.

Earlier in 1905, at the Salon des Indépendants, Matisse had already exhibited his large Neo-Impressionist composition *Luxe, calme et volupté* (fig. **5.4**), a title taken from a couplet in Baudelaire's poem *L'Invitation au voyage* (see *Baudelaire, Invitation to the Voyage*, below). In this important work, which went far along the path to abstraction, he combined the mosaic landscape manner of Signac (who bought the painting) with figure organization that recalls Cézanne's many compositions of bathers (see fig. 3.9), one of which Matisse owned. At the left of this St. Tropez beach scene, Matisse depicted his wife, Amélie, beside a picnic spread. But this mundane activity is transported to a timeless, **arcadian** world populated by languid nudes relaxing along a beach that has been tinged with dazzling red. With *Luxe*, therefore, Matisse offered a radical reinterpretation of the grand pastoral tradition in landscape painting, best exemplified in France by the seventeenth-century painters Claude Lorrain and Nicolas Poussin.

As in many of the paintings that postdate this work, Matisse's idyllic world is exclusively female. The significance of this inclination deserves consideration at this point. As mentioned earlier, the nude male figure, the subject of countless *académies*, was traditionally considered the most important subject for an ambitious young artist to learn to manage. Decorum as well as a predilection for themes from classical antiquity led academic artists to view the heroic nude male (as opposed to nude female) body as a particularly elevated motif. Nude women were largely confined to

the lesser genres: minor classical subjects such as the Loves of the Gods or scenes of everyday life. Avant-garde artists since Courbet, however, tended to address their nude studies to female models. This shift might be explained in terms of the avant-garde's rejection of academic hierarchies. Another, more compelling, factor that contributed to this shift is the long-standing association between femininity and nature. The female body served for many artists as a metaphor for essential, uncorrupted nature. In this way, the nude female figure served the avant-garde in much the same way that non-Western motifs did: as guarantors of aesthetic authenticity. Of course, the erotic character of many avant-garde treatments of the female body also reveals the enduring association between artistic creativity and masculine sexual potency, a link that will come under sharp scrutiny by later, especially feminist, artists.

While Matisse wrestled with the legacy of classicism through his work, the sculptor **Aristide Maillol** (1861–1944) found in classical antiquity a reassuring source for his formal experiments. Maillol began as a painter and tapestry designer; he was almost forty when the onset of a dangerous eye disease made the meticulous practice of weaving difficult, and he decided to change to sculpture. He began with wood carvings that had a definite relation to his paintings and to the Nabis and the Art Nouveau environment in which he had been working at the turn of the century (see Chapters 3 and 4). However, he soon moved to clay modeling and developed a mature style that changed little throughout his life. That style is summarized in one of his very first sculptures, *The Mediterranean* (fig. **5.5**), a massive, seated female nude, integrated as a set of curving volumes in space. He developed a personal brand of classicism that simplified the body into idealized, geometric forms and imparted a quality of psychological withdrawal and composed reserve.

Shown at the infamous Salon d'Automne of 1905 (known as the Fauve Salon), Maillol's *Mediterranean* would have provided a cool, monumental counterpoint to the flashing scenes mounted on the walls. It was there that Matisse exhibited *The Open Window* (fig. **5.6**), which is perhaps

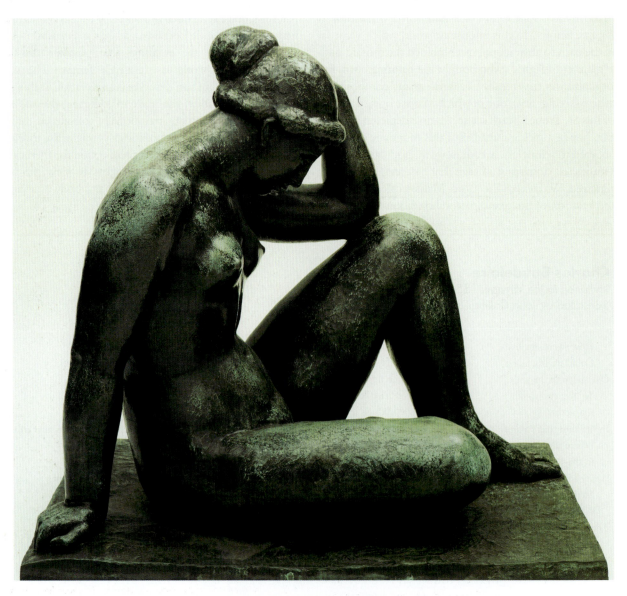

5.5 Aristide Maillol, *The Mediterranean*, 1902–05 (cast c. 1951–53). Bronze, 41 × 45 × 29¾" (104.1 × 114.3 × 75.6 cm). The Museum of Modern Art, New York.

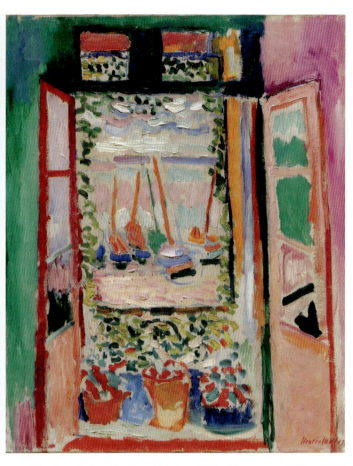

5.6 Henri Matisse, *The Open Window*, 1905. Oil on canvas, 21¾ × 18⅛" (55.2 × 46 cm). National Gallery of Art, Washington, D.C. Collection of Mr. and Mrs. John Hay Whitney, 1998. 74.7.

broader and flatter than those of Cézanne, suppressing all sense of atmosphere; internal illumination, the play of light within a painting that suggests physical depth, is replaced with a taut, resistant skin of pigment that reflects the light. Rather than allowing the viewer to enter pictorial space, this tough, vibrant membrane of color and pattern draws the eye over and across, but rarely beyond, the picture plane. And even in the view through the window, the handling is so vigorously self-assertive that the scene appears to advance more than recede, as if to turn inside out the Renaissance conception of the painting as a simulacrum of a window open into the infinite depth of the real world. As presented by Matisse, the window and its sparkling view of a holiday marina become a picture within a picture. This is a theme the artist often pursued, transforming it into a metaphor of the modernist belief that the purpose of painting was not to represent the perceptual world but rather to use visual stimuli to take the viewer beyond the perceptual reality—or the illusion of perceptual reality—that was the stock-in-trade of earlier Western art.

Shortly after exhibiting *The Open Window*, Matisse painted an audacious portrait of his wife. In *Portrait of Madame Matisse/The Green Line* (fig. **5.7**), the sitter's face is dominated by a brilliant pea-green band of shadow

the first fully developed example of a theme favored by him throughout the rest of his life. It is simply a small fragment of the wall of a room, taken up principally with a large window whose casements are thrown wide to the outside world—a balcony with flowerpots and vines, and beyond that the sea, sky, and boats of the harbor at Collioure. It was at this Mediterranean port, during the summer of 1905, that Matisse and Derain produced the first Fauve paintings. In *The Open Window* the inside wall and the casements are composed of broad, vertical stripes of vivid green, blue, purple, and orange, while the outside world is a brilliant pattern of small brushstrokes, ranging from stippled dots of green to broader strokes of pink, white, and blue in sea and sky. This diversity of paint handling, even in adjoining passages within the same picture, was typical of Matisse's early Fauve compositions. Between his painterly marks, Matisse left bare patches of canvas, reinforcing the impact of brushstrokes that have been freed from the traditional role of describing form in order to suggest an intense, vibrating light. By this date, the artist had already moved far beyond any of the Neo-Impressionists toward abstraction.

In Neo-Impressionism, as in Impressionism, the generalized, allover distribution of color patches and texture had produced a sense of atmospheric depth, at the same time that it also asserted the physical presence and impenetrability of the painting surface. Matisse, however, structured an architectural framework of facets and planes that are even

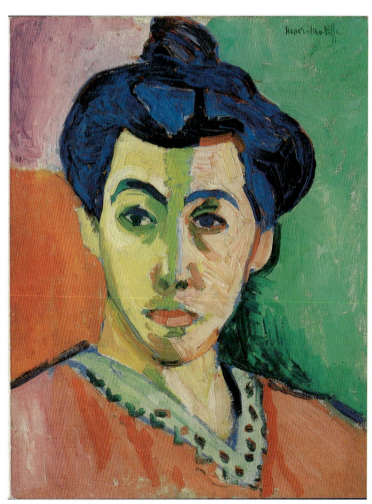

5.7 Henri Matisse, *Portrait of Madame Matisse/The Green Line*, 1905. Oil and tempera on canvas, 15⅞ × 12⅞" (40.3 × 32.7 cm). Statens Museum for Kunst, Copenhagen.

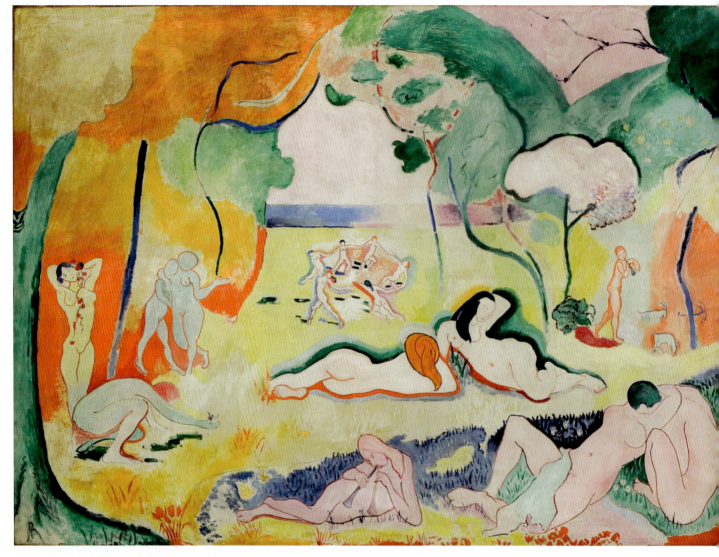

5.8 Henri Matisse, *Le Bonheur de vivre* (*The Joy of Life*), 1905–06. Oil on canvas, 5′ 8½″ × 7′ 9¾″ (1.74 × 2.4 m). The Barnes Foundation, Philadelphia, Pennsylvania.

dividing it from hairline to chin. At this point Matisse and his Fauve colleagues were building on the thesis put forward by Gauguin, the Symbolists, and the Nabis: that the artist is free to use color independently of natural appearance, building a structure of abstract color shapes and lines foreign to the figure, tree, or still life that remains the basis of the structure. Perhaps Matisse's version was more immediately shocking because his subject was so simple and familiar, unlike the exotic scenes of Gauguin or the mystical fantasies of Redon, in which such arbitrary colorism seemed more acceptable. With its heavy, emphatic strokes and striking use of complementary hues, the painting is actually closest to portraits by Van Gogh (see fig. 3.27).

The artist's experiments with Poussinesque arcadian figure compositions climaxed in the legendary *Le Bonheur de vivre* (fig. **5.8**), a painting filled with diverse reminiscences of past art, from *The Feast of the Gods*, by Giovanni Bellini and Titian, to Persian painting, from prehistoric cave paintings to a composition by Ingres (see fig. 1.5). In this large work (it is nearly eight feet, or 2.5 m, wide), the artist has blended all these influences into a masterful arrangement of figures and trees in sinuous, undulating lines reminiscent of

contemporary Art Nouveau design (see Ch. 4, pp. 74–84). *Le Bonheur de vivre* is filled with a mood of sensual languor; figures cavort with Dionysian abandon in a landscape that pulsates with rich, riotous color. Yet the figure groups are deployed as separate vignettes, isolated from one another spatially as well as by their differing colors and contradictory scales. As Matisse explained, *Le Bonheur de vivre* "was painted through the juxtaposition of things conceived independently but arranged together." He made several sketches for the work, basing his vision on an actual landscape at Collioure, which he painted in a lush sketch without figures that still contains some of the broken color patches of Neo-Impressionism. The circle of ecstatic dancers in the distance of *Le Bonheur de vivre*, apparently inspired by the sight of fishermen dancing in Collioure, became the central motif of Matisse's 1909–10 painting, *Dance (II)* (see fig. 5.22). *Le Bonheur de vivre* is an all-important, breakthrough picture; it was bought immediately by the American writer Gertrude Stein and her brother Leo, among the most adventurous collectors of avant-garde art at the time. It was through the Steins, in fact, that Matisse was eventually introduced to Picasso, who admired *Le Bonheur de vivre* in their apartment.

The Influence of African Art

In 1906 Matisse, Derain, and Vlaminck began to collect art objects from Africa, which they had first seen in ethnographic museums, and to adapt those forms into their art. Of all the non-Western artistic source material sought out by European modernists, none proved so radical or so far-reaching as the art of Africa. Modern artists appropriated the forms of African art in the hope of investing their work with a kind of primal truth and expressive energy, as well as a touch of the exotic, what they saw as the "primitive," or, in Gauguin's word, the "savage." Unlike the myriad other influences absorbed from outside contemporary European culture—Asian, Islamic, Oceanic, medieval, folk, and children's art—these African works were not only sculptural, as opposed to the predominantly pictorial art of Europe, but they also embodied values and conventions outside Western tradition and experience. Whereas even the most idealized European painting remained ultimately bound up with perceptual realities and the ongoing history of art itself, African figures did not observe classical proportions and contained no history or stories that Europeans understood. With their relatively large, mask-like heads, distended torsos, prominent sexual features, and squat, abbreviated, or elongated limbs, they impressed Matisse and his comrades with the powerful plasticity of their forms (mostly unbound by the literal representation of nature), their expressive carving, and their iconic force.

An early example of African influence in Matisse's art occurred most remarkably in *Blue Nude: Memory of Biskra* (fig. **5.9**), which, as the subtitle implies, was produced following the artist's visit to Biskra, a lush oasis in the North African desert. The subject of the painting—a reclining female nude—is a dynamic variation of a classic Venus pose, with one arm bent over the head and the legs flexed forward. Matisse had made the reclining nude central to *Le Bonheur*

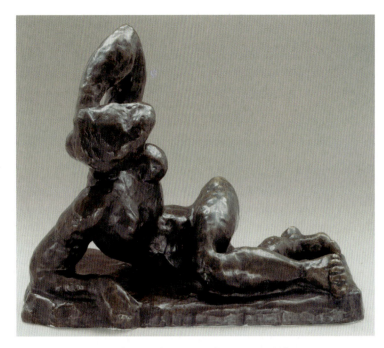

5.10 Henri Matisse, *Reclining Nude, I* (*Nu couché, I; Aurore*), Collioure, winter 1906–07. Bronze, 13½ × 19¾ × 11¼" (34.3 × 50.2 × 28.6 cm). The Museum of Modern Art, New York.

de vivre, and such was the interest it held for him that he then restudied it in a clay sculpture, a variation of which was later cast in bronze (fig. **5.10**). Now, working from memory and his own clay model, and evidently encouraged by the example of African sculpture, he abstracted his image further. These influences produced the bulbous exaggeration of breasts and buttocks; the extreme **contrapposto** that makes torso and hips seem viewed from different angles, or assembled from different bodies; the scarified modeling, or vigorously applied contouring in a brilliant, synthetic blue; and the mask-like character of the face. But however much these traits reveal the impact of African art, they have been translated from the plastic, freestanding, iconic sculpture of Africa into a pictorial expression by means of the Cézannism that Matisse had been cultivating all along. This can be seen in the dynamic character of the whole, in which rhyming curves and countercurves, images and afterimages, and interchanges of color and texture make figure and ground merge into one another.

In its theme, *Blue Nude* belongs to the tradition in nineteenth-century painting of the odalisque, or member of a North African harem (see fig. 1.5). This subject of the exotic, sexually available woman, exploited by Delacroix, Ingres, and countless lesser Salon artists, was destined for visual consumption by a predominantly heterosexual male audience. But the level of abstraction Matisse

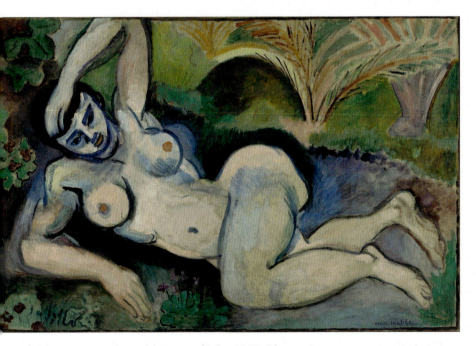

5.9 Henri Matisse, *Blue Nude: Memory of Biskra*, 1907. Oil on canvas, 36¼ × 56⅛" (92.1 × 142.5 cm). The Baltimore Museum of Art.

imposes on his subject, as with Cézanne's bathers, moves the figure beyond the explicitly erotic. Responding to the charges of ugliness made against *Blue Nude*, Matisse said: "If I met such a woman in the street, I should run away in terror. Above all, I do not create a woman, I make a picture." Inspired by the example of what he called the "invented planes and proportions" of African sculpture, Matisse used these sources in his own subtle, reflective fashion, assimilating and synthesizing until they are scarcely discernible. Another example of this experimentation is his small *Two Women* (fig. **5.11**), which consists of two figures embracing, one front view, the other back view. Although it may have some connection with Early Renaissance exercises in anatomy in which artists depicted athletic nudes in front and back views, its blocky, rectangular structure has a closer connection with some frontalized examples of African sculpture. This influence is not surprising, given that Matisse began to collect such sculpture shortly before he made *Two Women*, which is based on a photograph from an ethnographic magazine depicting two Tuareg women from North Africa.

With *Le Luxe II*, a work of 1907–08 (fig. **5.12**), Matisse signaled a move away from his Fauve production of the preceding years. It is a large painting, nearly seven feet (2.1 m) tall, which Matisse elaborately prepared with full-scale charcoal and oil sketches, as was customary for large-scale academic commissions. The oil sketch *Le Luxe I* is much looser in execution, and closer to Fauvism than are the flat, unmodulated zones of color in the final version. Though *Le Luxe II* explores a theme similar to that of *Luxe, calme et volupté* and *Le Bonheur de vivre* (see figs. 5.4, 5.8), the figures are now life-size and dominate the landscape. Coloristically, *Le Luxe II* is far more subdued, relying on areas of localized color bound by crisp lines. Despite the artist's abandonment of perspective, except for the arbitrary diminution of one figure, and modeling in light and shadow, the painting is not merely surface decoration. The figures, modeled only by the contour lines, have substance; they exist and move in space, with the illusion of depth, light, and air created solely by flat color shapes that are, at the same time, synonymous spatially with the picture plane. The actual subject of the painting remains elusive. The crouching woman, a beautiful, compact shape, seems to be tending to her companion in some way (perhaps drying her feet?), while another rushes toward the pair, proffering a bouquet of flowers. Matisse may have implied a mythological theme, such as Venus's birth from the sea, but, typically, he only hints at such narratives. Even so, the monumentality of the figure, and its evocation of the mythological subjects that characterized Salon art for the previous two centuries, indicate that Matisse perceives his project to be an extension of the French artistic tradition rather than a violent rupture with it. In this way, Matisse's endeavor might be seen as closer to Manet's than that of the Impressionists, in that he is seeking deliberately to enter into a conversation with the chief standard-bearer of French academicism, Nicolas Poussin.

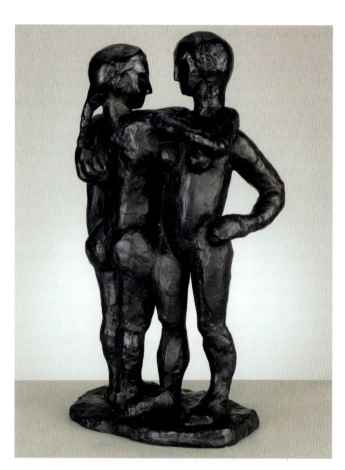

5.11 Henri Matisse, *Two Women*, 1907. Bronze, 18¼ × 10½ × 7⅞" (46.6 × 25.6 × 19.9 cm). Hirshhorn Museum and Sculpture Garden, Smithsonian Institution, Washington, D.C.

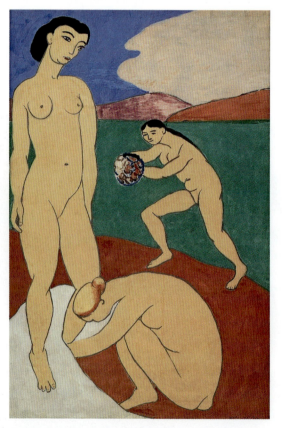

5.12 Henri Matisse, *Le Luxe II*, 1907–08. Casein on canvas, 6' 10½" × 4' 6" (2.1 × 1.38 m). Statens Museum for Kunst, Copenhagen.

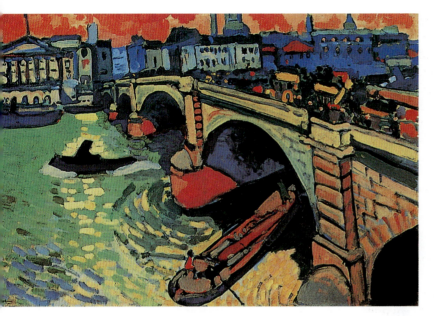

to free brushwork, most characteristic, perhaps, are works such as *London Bridge* (fig. **5.13**). This was painted during a trip commissioned by the dealer Ambroise Vollard, who wanted Derain to make paintings that would capture the special atmosphere of London (Claude Monet's many views of the city had just been successfully exhibited in Paris). To compare Derain's painting with the Impressionist's earlier work, *The Bridge at Argenteuil* (see fig. 2.28), is to understand the transformations art had undergone in roughly thirty years, as well as the fundamental role Impressionism had played in those transformations. While in London, Derain visited the museums, studying especially the paintings of Turner (see fig. 1.11), Claude, and Rembrandt, as well as African sculpture. Unlike Monet's view of the Seine, Derain's painting of the Thames is a brilliantly synthetic color arrangement of harmonies and dissonances. The background sky is rose-pink; the buildings silhouetted against it are complementary green and blue. By reiterating large color areas in the foreground and background and tilting the perspective, Derain delimits the depth of his image. In the summer of 1906, several months after the trip to London, Derain spent time in L'Estaque, the famous site of paintings by Cézanne (see fig. 3.6). But his grand panorama of a bend in the road (fig. **5.14**) takes its cue from Gauguin (see figs. 3.22, 3.25) in its brilliant palette and the evocation of an idealized realm far from the urban bustle of London's waterways. With this work Derain travels to new extremes of intensity and anti-naturalism in his color, a world in which the hues of a single tree can shift dramatically half a dozen times.

"Wild Beasts" Tamed:
Derain, Vlaminck, and Dufy

André Derain (1880–1954) met the older Matisse at Carrière's atelier in 1900, as already noted, and was encouraged by him to proceed with his career as a painter. He already knew Maurice de Vlaminck, whom Derain in turn had led from his various careers as violinist, novelist, and bicycle racer into the field of painting. Unlike Vlaminck, Derain was a serious student of the art of the museums who, despite his initial enthusiasm for the explosive color of Fauvism, was constantly haunted by a more ordered and traditional concept of painting.

Although Derain's Fauve paintings embodied every kind of painterly variation, from large-scale Neo-Impressionism

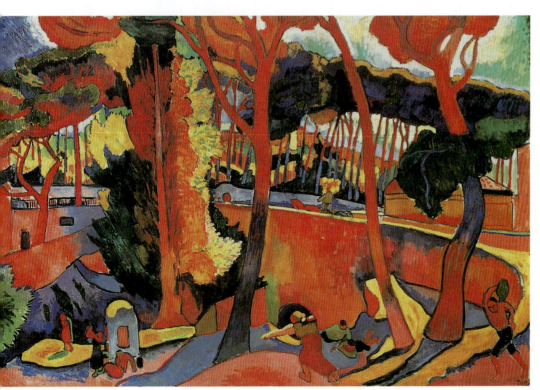

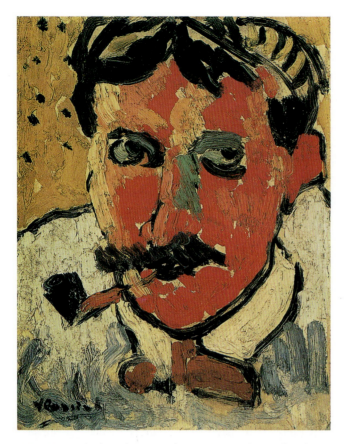

5.15 Maurice de Vlaminck, *Portrait of Derain*, 1906. Oil on cardboard, 10¾ × 8¾" (27.3 × 22.2 cm). The Metropolitan Museum of Art, New York.

The career of **Maurice de Vlaminck** (1876–1958) presents many parallels with Derain's, even though the artists were so different in personality and in their approach to the art of painting. Impulsive and exuberant, Vlaminck was a self-taught artist with anarchist political leanings who liked to boast of his contempt for the art of museums. From the time he met Derain and turned to painting, he was enraptured with color. Thus the Van Gogh exhibition at the Bernheim-Jeune Gallery in Paris in 1901 was a revelation to him. At the Salon des Indépendants in the same year, Derain introduced him to Matisse, but it was not until 1905, after exposure to the work of both artists, that Vlaminck's work reached its full potential, despite his false claims to have been the leader of the Fauves. Van Gogh remained his great inspiration, and in his Fauve paintings Vlaminck characteristically used the short, choppy brushstrokes of the Dutch painter to attain a comparable kind of coloristic dynamism. His small but dramatic *Portrait of Derain* (fig. **5.15**) is one of several likenesses the Fauves made of one another. Vlaminck has here moved to a boldly conceived image in which Derain's face is predominantly an intense, brilliant red with black contours, yellow highlights, and a few strokes of contrasting green shadow along the bridge of the nose, recalling Matisse's *Portrait of Madame Matisse/The Green Line* (see fig. 5.7).

Raoul Dufy (1877–1953) was shocked out of his reverence for the Impressionists and Van Gogh by his discovery of Matisse's 1905 painting *Luxe, calme et volupté* (see fig. 5.4), when, he said, "Impressionist realism lost all its

charm." In a sense, he remained faithful to this vision and to Fauve color throughout his life. His *Street Decked with Flags, Le Havre* (fig. **5.16**) takes up a subject celebrated by the Impressionists, but the bold, close-up view of the flags imposes a highly abstracted geometric pattern on the scene.

After 1908, Dufy experimented with a modified form of Cubism, but he was never really happy in this vein. Gradually he returned to his former loves—decorative color and elegant draftsmanship—and formulated a personal style based on his earlier Fauvism. His pleasurable subjects were the horse races and regattas of his native Le Havre and nearby Deauville, the nude model in the studio, and the view from a window to the sea beyond. He maintained a rainbow, calligraphic style until the end of his life, applying it to fabrics, theatrical sets, and book illustrations as well as paintings.

For Matisse, Fauvism was only a beginning from which he went on to a rich, productive career spanning the first half of the twentieth century. Derain and Vlaminck, however, did little subsequently that had the vitality of their Fauve works. It is interesting to speculate on why these young men should briefly have outdone themselves, but the single overriding explanation is probably the presence of Henri Matisse—older than the others, more mature and, ultimately, more gifted as an artist. But in addition to Matisse and Rouault (see opposite), there was also Georges Braque, who, after discovering his first brief and relatively late inspiration in Fauvism, went on to restudy Cézanne, with consequences for twentieth-century art so significant that they must be examined under Cubism (see Chapter 7).

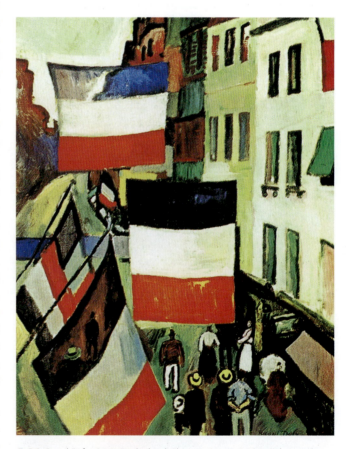

5.16 Raoul Dufy, *Street Decked with Flags, Le Havre*, 1906. Oil on canvas, 31⅞ × 25⅞" (81 × 65.7 cm). Musée National d'Art Moderne, Paris.

Religious Art for a Modern Age: Georges Rouault

Georges Rouault (1871–1958) exhibited three works in the Fauve Salon of 1905 and thus is associated with the work of the group, although his paintings were not actually shown in the room with theirs. Throughout his long and productive career, Rouault remained deeply religious, deeply emotional, and profoundly moralistic. He came from a family of craftsmen, and he himself was first apprenticed to a stained-glass artisan, an experience that would have a lasting effect on his work. In the studio of Gustave Moreau he met Matisse and other future Fauves, and soon became Moreau's favorite pupil, for he followed most closely Moreau's own style and precepts.

By 1903 Rouault's art, like that of Matisse and others around him, was undergoing profound changes, reflecting a radical shift in his moral and religious outlook. Like his friend the Catholic writer and propagandist Léon Bloy, Rouault sought subjects to express his sense of indignation and disgust over the evils that, as it seemed to him, permeated bourgeois society. The prostitute became his symbol of this rotting society. Rouault invited prostitutes to pose in his studio, painting them with attributes such as stockings or corsets to indicate their profession. Absent from Rouault's treatment of this subject is either the detachment of Degas or the sympathetic complicity of Toulouse-Lautrec. His contortion of the figure and aggressive handling result in a decidedly bleak view of Paris's *demi-monde*.

Rouault's moral indignation further manifested itself, like Daumier's, in vicious caricatures of judges and politicians. His counterpoint to the corrupt prostitute was the figure of the circus clown, sometimes the carefree nomad beating his drum, but more often a tragic, lacerated martyr. As early as 1904 he had begun to depict subjects taken directly from the Gospels—the Crucifixion, Jesus and his disciples, and other scenes from the life of Christ. He represented the figure of Christ as a tragic mask of the Man of Sorrows, deriving directly from a crucified Christ by Grünewald or a tormented Christ by Bosch. Rouault's religious and moral sentiments are perhaps most movingly conveyed in a series of fifty-eight prints, titled *Miserere*, commissioned by his dealer Vollard (whose heirs the artist later had to sue to retrieve the contents of his studio) (fig. **5.17**). For years, Rouault devoted himself to the production of the etchings and aquatints of *Miserere* (Latin for "Have Mercy"), which were printed between 1914 and 1927, but not published until 1948, when the artist was seventy-seven. Some of the images and accompanying text are forthrightly Christian, while others can be interpreted more broadly as commentaries on contemporary social conditions and World War I, recalling Goya's earlier series *Disasters of War* (see fig. 1.7). Technically, the prints are masterpieces of graphic compression. The black tones, worked over and over again, have the depth and richness of his most vivid oil colors.

The characteristics of Rouault's later style are seen in *The Old King* (fig. **5.18**). The design has become geometrically

5.17 Georges Rouault, *Jesus Reviled*, from *Miserere*, 1914–27. Aquatint, etching, drypoint. Sewanee: The University of the South Special Collections, Permanent Collection, and University Archives, Tennessee.

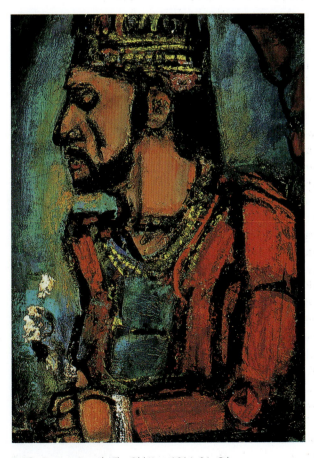

5.18 Georges Rouault, *The Old King*, 1916–36. Oil on canvas, 30¼ × 21¼" (76.8 × 54 cm). Carnegie Museum of Art, Pittsburgh.

abstract in feeling, and colors are intensified to achieve the glow of stained glass, a medium with which he was familiar from his early apprenticeship. A thick black outline is used to define the rather Egyptian-style profile of the king's head and the square proportions of his torso. Paint is applied heavily with the underpainting glowing through, in the manner of Rembrandt. Rouault also captures some of Rembrandt's mood in this serene image of a world-weary ruler, who clutches a flower in his hand, one of the few traces of white in the entire painting. Although Rouault never entirely gave up the spirit of moral indignation expressed in the virulent satire that marked his early works, the sense of calm and the hope of salvation in the later paintings mark him as one of the few authentic religious painters of the modern world.

The *Belle Époque* on Film: The Lumière Brothers and Lartigue

Developments in photography contemporary with the years of Fauvism include color processes, after one was finally made commercially feasible in 1907 by **Auguste** and **Louis Lumière** (1862–1954; 1864–1948) of Lyons, France (fig. **5.19**). By coating one side of a glass plate with a mixture of tiny, transparent starch particles, each dyed either red, green, or blue (the three primary photographic colors), and the other side with a thin **panchromatic** emulsion, the Lumières created a light-sensitive plate that, once exposed, developed, and projected onto a white ground, reproduced a full-color image of the subject photographed. The Autochromes—as the Lumières called the slides made by their patented process—rendered images in muted tonalities with the look of a fine-grained texture, an effect that simply heightened the inherent charm of the bright subject matter. This was especially true for a Fauve generation still entranced with Neo-Impressionism. Their invention was immediately taken up by professional photographers, especially the so-called Pictorialists (see fig. 2.39), as well as amateurs around the world. (See also the related subject of *Early Motion Pictures*, opposite.)

Dufy's privileged, *belle époque* world of regattas and racecourses was also celebrated by the French contemporary photographer **Jacques-Henri Lartigue** (1894–1986), once the fast-action handheld camera had been introduced in 1888 and progressively improved. Such developments encouraged experimentation and enabled this affluent child artist (he began making photographs at age seven) to capture

Early Motion Pictures

Along with color photography, motion pictures were proliferating during the first decade of the twentieth century. The modern fascination with capturing motion on film led Eadweard Muybridge to develop in the 1870s a means of photographing a rapid sequence of actions (see fig. 2.33). Thomas Edison, following a visit to Muybridge's laboratory, took the idea even further, recording a series of images on a continuous strip of film. This film could then be viewed using Edison's Kinetoscope, through which a single viewer watched the short film. The Kinetoscope made its public debut in 1894; Kinetoscope "parlors" were soon introduced throughout North America and Europe. Among those impressed by the technology—and relieved by Edison's failure to secure an international patent on the device—were the brothers Auguste and Louis Lumière (see fig. 5.19). They felt that the "peep show" experience of the Kinetoscope limited its appeal. The Lumière brothers conceived motion-picture viewing in terms of a tradition of visual spectacle long popular in Europe. Magic lantern shows, which date back to the seventeenth century, used an oil-fueled lamp to project glass slides onto a screen. By moving, interchanging, or superimposing slides, the effect of motion could be simulated. Another popular form of visual spectacle was the diorama, invented by Louis Daguerre in 1822 (see discussion of Daguerre in Chapter 2). Dioramas were specially built theaters in which huge paintings executed on scrims were dramatically backlit to create breathtaking scenes that seemed to move and change before the viewers' eyes. With this legacy in mind, in 1895 the Lumière brothers developed a projector based on Edison's Kinetoscope. Quickly copied, the invention led to the opening of permanent movie theaters or cinemas in the first years of the twentieth century. They were known as "nickelodeons" in the United States, since patrons paid five cents to view films that generally lasted from five to fifteen minutes.

5.19 Lumière brothers, *Young Lady with an Umbrella*, 1906–10. Autochrome photograph. Fondation Nationale de la Photographie, Lyons, France.

not only his family and friends at their pleasures, but also the gradual advent of such twentieth-century phenomena as auto races and aviation. At his death in 1986 Lartigue, who was a painter professionally, left behind a huge number of photographs and journals that document a charmed life of holidays, swimming holes, and elegantly clad ladies and gentlemen. He was eleven when he aimed his camera at the toy cars in his bedroom (fig. **5.20**), and his image adopts a child's angle on the world. The tiny cars, at eye level, take on strange dimensions, the whole compounded by the mysteriously draped fireplace that looms above them. Owing to his view of photography as a pursuit carried on for private satisfaction and delight, Lartigue did not become generally known until a show at New York's Museum of Modern Art in 1963, when his work took an immediate place in the history of art as a direct ancestor of the "straight" but unmistakable vision of such photographers as Brassaï and Henri Cartier-Bresson.

Modernism on a Grand Scale: Matisse's Art after Fauvism

Fauvism was a short-lived but tremendously influential movement that had no definitive conclusion, though it had effectively drawn to a close by 1908. The direction of Matisse's art explored in *Le Luxe II* is carried still further in *Harmony in Red* (fig. **5.21**), a large painting destined for the Moscow dining room of Sergei Shchukin, his important early patron who, along with Ivan Morozov, is the reason Russian museums are today key repositories of Matisse's greatest work. This astonishing painting was begun early in 1908 as *Harmony in Blue* and repainted in the fall, in a radically different color scheme. Here Matisse returned to the formula of *Dinner Table*, which he had painted in 1896–97 (see fig. 5.1). A comparison of the two canvases dramatically reveals the revolution that had occurred in this artist's works—and in fact in modern painting—during a ten-year period. Admittedly, the first *Dinner Table* was still an apprentice piece, a relatively conventional exploration of Impressionist light and color and contracted space, actually more traditional than paintings executed by the Impressionists twenty years earlier. Nevertheless, when submitted to the Salon de la Nationale it was severely criticized by the conservatives as being tainted with Impressionism.

In *Harmony in Red* we have moved into a new world, less empirical and more abstract than anything ever envisioned by Gauguin, much less the Impressionists. The space of the interior is defined by a single unmodulated area of red, the flatness of which is reinforced by arabesques of plant forms that flow across the walls and table surface. These patterns were actually derived from a piece of decorative fabric that Matisse owned. Their meandering forms serve to confound any sense of volumetric space in the painting and to create pictorial ambiguities by playing off the repeated pattern of flower baskets against the "real" still lifes on the table. This ambiguity is extended to the view through the window of abstract tree and plant forms silhouetted against a green ground and blue sky. The red building in the extreme upper distance, which reiterates the color of the room, in some manner establishes the illusion of depth in the landscape, yet the entire scene, framed by what may be a window sill and

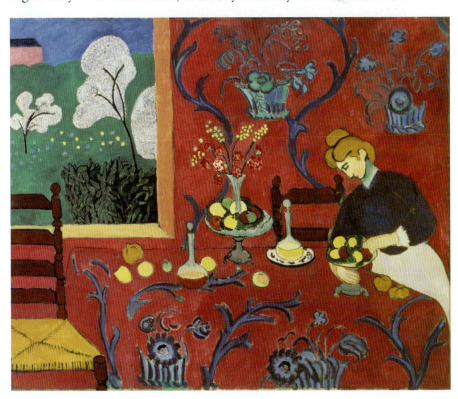

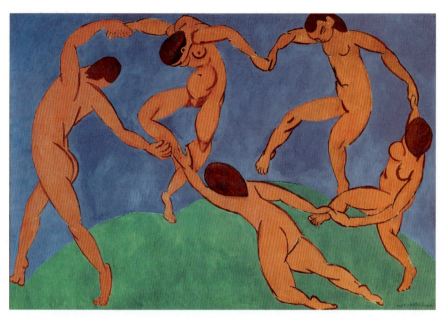

5.22 Henri Matisse, *Dance (II)*, 1909–10. Oil on canvas, 8' 5⅝" × 12' 9½" (2.6 × 3.9 m). The Hermitage Museum, St. Petersburg.

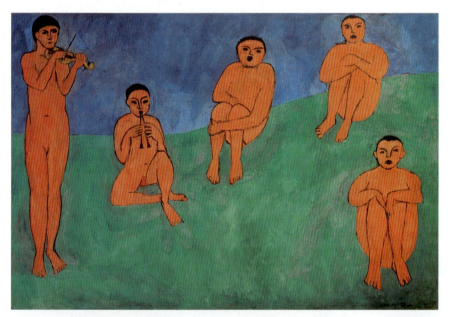

5.23 Henri Matisse, *Music*, 1909–10. Oil on canvas, 8' 5⅝" × 12' 9½" (2.6 × 3.9 m). The Hermitage Museum, St. Petersburg.

cut off by the picture edge like other forms in the painting, could also itself be a painting on the wall. In essence Matisse has again—and to an even greater degree than in *Le Luxe II*—created a new, tangible world of pictorial space through color and line.

Matisse used the term "decorative" to describe the fusion of form and meaning in his work. Expression arose not from any explicit or implicit narrative, just as content did not depend upon a naturalistic rendering of the figure or of space. In other words, to create a decorative artwork meant fusing completely form and content. As Matisse himself explained, "composition is the art of arranging in a decorative manner the diverse elements at the painter's command to express his feelings." Over the years, hostile critics occasionally used the term "decorative" pejoratively,

to trivialize Matisse's project. In this sense, the decorative is dismissed as banal and lacking in originality. For Matisse and many avant-garde artists working at the turn of the century, however, engagement with the decorative signaled a refusal to be cowed by centuries of subservience to anecdote and naturalism.

In two huge paintings of the first importance, *Dance (II)* and *Music*, both of 1909–10 (figs. **5.22**, **5.23**) and both commissioned by Shchukin, Matisse boldly outlined large-scale figures and isolated them against a ground of intense color. The inspiration for *Dance* has been variously traced to Greek vase painting or peasant dances. Specifically, the motif was first used by Matisse, as we have seen, in the background group of *Le Bonheur de vivre*. In *Dance*, the colors have been limited to an intense green for the earth, an equally intense blue for the sky, and brick-red for the figures, which are sealed into the foreground by the color areas of sky and ground, and by their proximity to the framing edge and their great size within the canvas. They nevertheless dance ecstatically in an airy space created by these contrasting juxtaposed hues and by their own modeled contours and sweeping movements. The depth and intensity of the colors change in different lights, at times setting up visual vibrations that make the entire surface dance. *Music* is a perfect foil for the kinetic energy of *Dance*, in the static, frontalized poses of the figures arranged like notes on a musical staff, each isolated from the others to create a mood of trance-like withdrawal. Matisse's explanation of Fauvism as "the courage to return to a 'purity of means'" still holds true here. In both paintings the arcadian worlds of earlier painters such as Nicolas Poussin have been transformed into an elemental realm beyond the specificities of time and place. When they were exhibited in the 1910 Salon d'Automne, these two extraordinary paintings provoked little but negative and hostile criticism, and Shchukin at first withdrew his commission, though he soon changed his mind. These monumental works further show Matisse locating his art in relation to the grand classical tradition. Modernist in conception, they nevertheless aligned him with the elite world of wealthy patronage that had previously sustained (and indeed still continued to sustain) conventional academic art. Other modernist artists—notably Picasso—were to tread a comparable path, simultaneously becoming respected public figures while retaining, at least to a degree, the avant-garde ability to disconcert conventionally minded viewers.

In *The Red Studio* (fig. **5.24**), Matisse returned to the principle of a single, unifying color that he had exploited in *Harmony in Red*. The studio interior is described by a

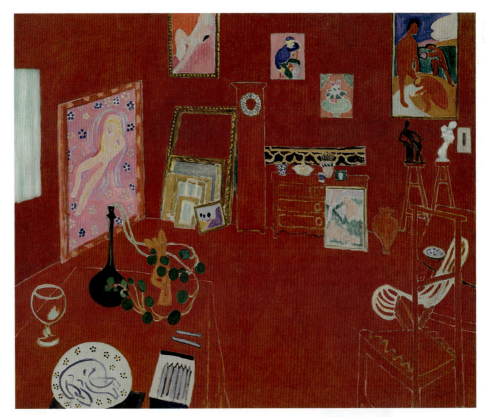

5.24 Henri Matisse, *The Red Studio*, Issy-les-Moulineaux, 1911. Oil on canvas, 5′ 11¼″ × 7′ 2¼″ (1.81 × 2.2 m). The Museum of Modern Art, New York.

▶—[**Watch** a video about *The Red Studio* on mysearchlab.com

uniform area of red, covering floor and walls. The space is given volumetric definition only by a single white line that indicates the intersection of the walls and floor, and by the paintings and furniture lined up along the rear wall. Furnishings—table, chair, cupboard, and sculpture stands—are dematerialized, ghost-like objects outlined in white lines. The tangible accents are the paintings of the artist, hanging on or stacked against the walls, and (in the foreground) ceramics, sculptures, vase, glass, and pencils. *Le Luxe II* can be seen at the upper right.

Matisse's most ambitious excursion in sculpture was the creation of the four great *Backs*, executed between 1909 and c. 1930 (fig. **5.25**). While most of his sculptures are small-scale, these monumental reliefs are more than six feet (1.8 m) high. They are a development of the theme stated in *Two Women*, now translated into a single figure in **bas-relief**, seen from the back. But Matisse has here resorted to an upright, vertical surface like that of a painting on which to sculpt his form. *Back I* is modeled in a relatively representational manner, freely expressing the modulations of a muscular back, and it reveals the feeling Matisse had

for sculptural form rendered on a monumental scale. *Back II* is simplified in a manner reflecting the artist's interest in Cubism around 1913. *Back III* and *Back IV* are so reduced to their architectural components that they almost become abstract sculpture. The figure's long ponytail becomes a central spine that serves as a powerful axis through the center of the composition. Here, as in the *Blue Nude* (see fig. 5.9), Matisse has synthesized African and Cézannesque elements, this time, however, in order to acknowledge, as well as resist, the formal discoveries made by the Cubists.

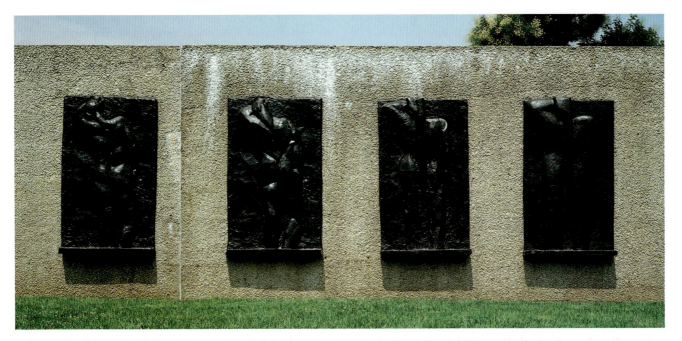

5.25 Henri Matisse, *Reliefs*, from left to right: *Back I*, 1909. Bronze, 74 × 44 × 6½″ (188 × 113 × 16.5 cm). *Back II*, 1913. Bronze, 74 × 47 × 8″ (188 × 119.4 × 20.3 cm). *Back III*, 1916–17. Bronze, 74 × 44¼ × 6″ (188 × 112.4 × 15.2 cm). *Back IV*, c. 1930. Bronze, 74 × 45 × 7″ (188 × 114.3 × 17.8 cm). Hirshhorn Museum and Sculpture Garden, Smithsonian Institution, Washington, D.C.

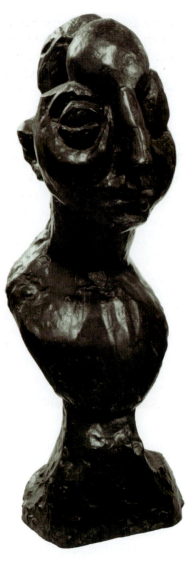

5.26 Henri Matisse, *Jeannette V* (Jeanne Vaderin, 5th state), Issy-les-Moulineaux, 1916. Bronze, 22⅞ × 8⅜ × 10⅝" (58.1 × 21.3 × 27.1 cm). The Museum of Modern Art, New York.

Matisse's other major effort in sculpture was a series of five heads of a woman, done between 1910 and 1916. *Jeannette I* and *Jeannette II* are direct portraits done from life in the freely expressive manner of late Rodin bronzes. But with *Jeannette III*, *Jeannette IV*, and *Jeannette V* (fig. **5.26**), he worked from his imagination, progressively transforming the human head first into an expressive study, exaggerating all the features, and then into a geometric organization of shapes. In Matisse's work, serial sculptures such as the *Backs* and the *Jeannettes* do not necessarily constitute a set of progressive steps toward the perfection of an idea. Rather, they are multiple but independent states, each version a definitive solution in and of itself.

Forms of the Essential: Constantin Brancusi

Matisse's experimentation with the distillation of form, with the interaction of positive and negative space, and with non-Western influences bears kinship with the work of **Constantin Brancusi** (1876–1957), whose sculpture, like Matisse's post-Fauvist painting, is difficult to link to a particular school or movement. Born to peasants in Romania, he left home at the age of eleven. Between 1894 and 1898 he

was apprenticed to a cabinetmaker and studied in the provincial city of Craiova, and then at the Bucharest Academy of Fine Arts. In 1902 he went to Germany and Switzerland, arriving in Paris in 1904. After further studies at the École des Beaux-Arts under the sculptor Antonin Mercié, he began exhibiting, first at the Salon de la Nationale and then at the Salon d'Automne. Impressed by his contributions to the 1907 Salon d'Automne, Rodin invited him to become an assistant. Brancusi stayed only a short time. As he later declared, "Nothing grows under the shade of great trees."

The sculpture of Brancusi is in one sense isolated, in another universal. He worked with few themes, never really deserting the figure, but he touched, affected, and influenced most of the major strains of sculpture after him. From the tradition of Rodin's late studies came the figure *Sleep*, in which the realistic form of a shadowed face appears to sink into the matrix of the marble. The theme of the *Sleeping Muse* was to become an obsession with Brancusi, and he played variations on it for some twenty years. In the next version (fig. **5.27**), and later, the head was transformed into an egg shape, with the features lightly but sharply cut from the mass. As became his custom with his basic themes, he presented this form in marble, bronze, and plaster, almost always with slight adjustments that turned each version into a unique work.

In a subsequent work, the theme was further simplified to a teardrop shape in which the features largely disappeared, with the exception of an indicated ear. To this 1911 piece he gave the name *Prometheus*. The form in turn led to *The Newborn*, in which the oval is cut obliquely to form the screaming mouth of the infant or, when viewed from another angle, to suggest swaddling clothes. He returned to the polished egg shape in the ultimate version, entitled *The Beginning of the World* (fig. **5.28**), closely related to a contemporary work called *Sculpture for the Blind*. In this, his ultimate statement about creation, Brancusi eliminated all reference to anatomical detail. A similar work, as well as *The Newborn*, can be seen at the bottom of Brancusi's photograph of his studio, taken around 1927 (fig. **5.29**). The artist preferred that his work be discovered in the context of his own studio, amid tools, marble dust, and incomplete works. He was constantly rearranging it, grouping the sculptures into a carefully staged environment. Brancusi left the entire content of his studio to the French state; a reconstruction of it is in the Georges Pompidou Center in Paris. The artist took photographs of his own works (a privilege he rarely allowed others) in order to disseminate their images beyond Paris and to depict his sculptures in varying, often dramatic light. His many pictures of corners of his studio convey the complex interplay of his sculptural shapes. With different juxtapositions and points of view, Brancusi's studio photographs propose diverse possibilities for interpretation. "Why write [about my sculptures]?" he once said. "Why not just show the photographs?" Narrative, even, is suggested by his photographs as sculptures seem to engage in new relationships. For instance, the polished bronze sculpture shown on the far left of the studio—titled

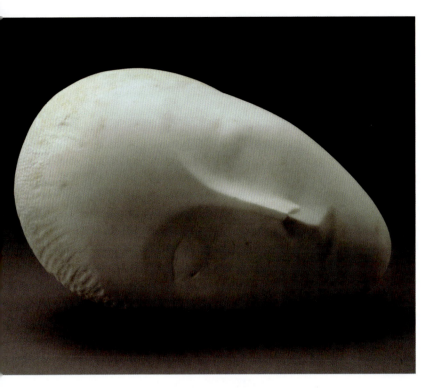

5.27 Constantin Brancusi, *Sleeping Muse I*, 1909–10. Marble, 7 × 11½ × 8" (17.8 × 29.2 × 20.3 cm). Hirshhorn Museum and Sculpture Garden, Smithsonian Institution, Washington, D.C.

Princess X and as suggestive of a woman's bust surmounted by a long neck and inclined head as it is of a phallus—seems to peer down at a version of *The Beginning of the World*, which enjoys the added vigilance of *Bird in Space* and a pair of variations on the *Endless Column*. No great leap of imagination is required to see the scene as a reference to the Nativity, a theme popular in Christian art since the Middle Ages. Brancusi's use of photography to unsettle rather than fix the meanings of his sculptures bears a kinship with the playful estrangement of Lartigue's views of his bedroom.

This analysis of the egg was only one of a number of related themes that Brancusi continued to follow, with a hypnotic concentration on creation, birth, life, and death. In 1912 he made his first marble portrait of a young Hungarian woman named Margit Pogany, who posed several times in his studio. He portrayed her with enormous oval eyes and hands held up to one side of her face. This form was developed further in a number of drawings and in later variations in marble and polished bronze, in which Brancusi refined

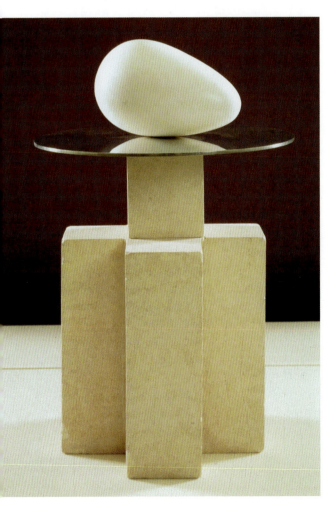

5.28 Constantin Brancusi, *The Beginning of the World*, c. 1920. Marble, metal, and stone, 29⅝ × 11⅜" (75.2 × 28.9 cm). Dallas Museum of Art.

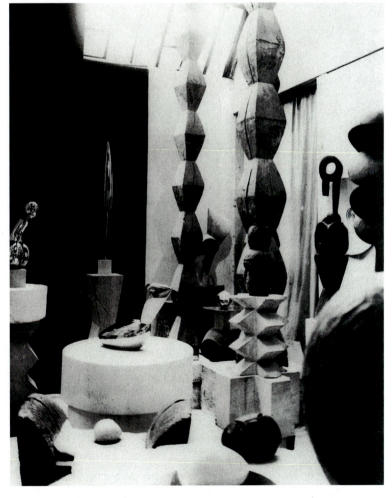

5.29 Constantin Brancusi, *The Studio*, c. 1927. Photograph, mounted on glass, 23¾ × 19¾" (60.3 × 50.2 cm). Pascal Sernet Fine Art, London.

and abstracted his original design, omitting the mouth altogether and reducing the eyes to an elegant, arching line of a brow that merges with the nose. *Torso of a Young Man* (fig. **5.30**) went as far as Brancusi ever did in the direction of geometric form. In this polished bronze from 1924, he abstracted the softened, swelling lines of anatomy introduced in his earlier wood versions of the sculpture into an object of machine-like precision. Brancusi was clearly playing on a theme of androgyny here, for while the *Torso* is decidedly phallic, it could also constitute an interpretation of female anatomy.

The subjects of Brancusi were so elemental and his themes so basic that, although he had few direct followers, little that happened subsequently in sculpture seems foreign to him. *The Kiss*, 1916 (fig. **5.31**), depicts with the simplest of means an embracing couple, a subject Brancusi had first realized in stone in 1909. Although this had been the subject of one of Rodin's most famous marbles, in the squat,

blockish forms of *The Kiss* Brancusi made his break with the Rodinesque tradition irrefutably clear. The artist was particularly obsessed with birds and the idea of conveying the essence of flight. For over a decade he progressively streamlined the form of his 1912 sculpture *Maiastra* (or "Master Bird," from Romanian folklore), until he achieved the astonishingly simple, tapering form of *Bird in Space* (fig. **5.32**). The image ultimately became less the representation of a bird's shape than that of a bird's trajectory through the air. Brancusi designed his own bases and considered them an integral part of his sculpture.

In *Bird in Space*, the highly polished marble bird (he also made bronze versions) fits into a stone cylinder that sits atop a cruciform stone base. This, in turn, rests on a large X-shaped wooden pedestal. He made several variations on these forms, such as that designed for *Torso of a Young Man*. These bases augment the sense of soaring verticality of the bird sculptures. In addition, they serve as transitions

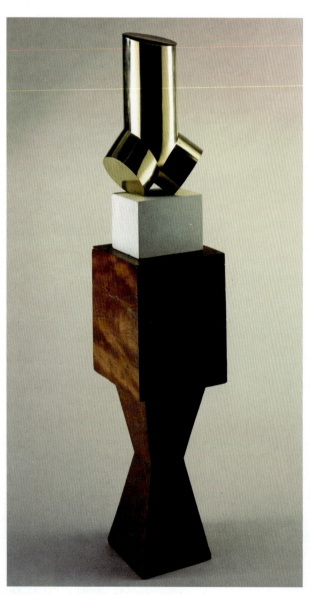

5.30 Constantin Brancusi, *Torso of a Young Man*, 1924.
Polished bronze, 18 × 11 × 7" (45.7 × 28 × 17.8 cm), stone and wood base, height 40⅜" (102.6 cm). Hirshhorn Museum and Sculpture Garden, Smithsonian Institution, Washington, D.C.

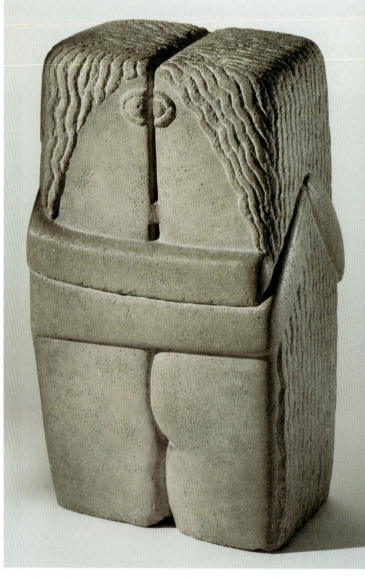

5.31 Constantin Brancusi, *The Kiss*, 1916. Limestone, 23 × 13 × 10" (58.4 × 33 × 25.4 cm). Philadelphia Museum of Art.

((•—[Listen] to a podcast about *The Kiss* on mysearchlab.com

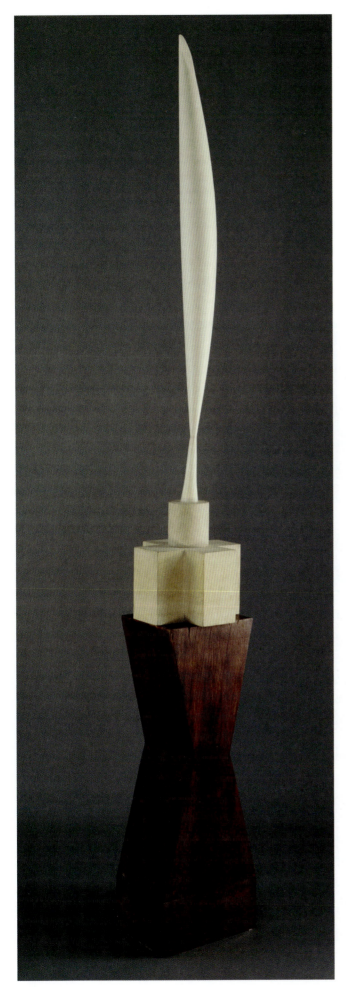

5.32 Constantin Brancusi, *Bird in Space*, 1925. Marble, stone, and wood, marble 71⅝ × 5⅜ × 6⅜" (181.9 × 13.7 × 16.2 cm), stone pedestal 17⅝ × 16⅜ × 16⅜" (44.8 × 41.6 × 41.6 cm), wood pedestal 7¾ × 16 × 13⅜" (19.7 × 40.6 × 34 cm). National Gallery of Art, Washington, D.C.

((•—|Listen| to a podcast about *Bird in Space* on mysearchlab.com

between the mundane physical world and the spiritual realm of the bird, for Brancusi sought a mystical fusion of the disembodied light-reflecting surfaces of polished marble or bronze and the solid, earthbound mass of wood. He said, "All my life I have sought the essence of flight. Don't look for mysteries. I give you pure joy. Look at the sculptures until you see them. Those nearest to God have seen them."

In his wood sculptures, although he occasionally strove for the same degree of finish, Brancusi usually preferred a primitive, roughed-out totem. In *King of Kings* (fig. **5.33**),

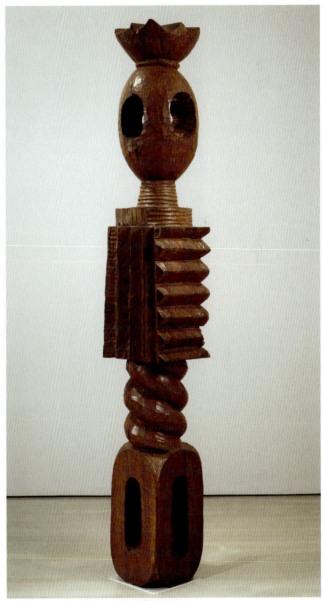

5.33 Constantin Brancusi, *King of Kings*, c. 1930. Oak, height 9′ 10″ (3 m). Solomon R. Guggenheim Museum, New York.

which he had previously titled *The Spirit of Buddha*, reflecting his interest in Eastern spirituality, the great, regal shape comprises superimposed forms that are reworkings of the artist's wooden pedestals. Brancusi intended this sculpture for a temple of his design in India, commissioned by the Maharajah of Indore, who owned three of the artist's *Birds in Space*. The temple was never built. In fact, Brancusi's only outdoor work on a vast scale was a sculptural ensemble installed in the late 1930s in Tîrgu-Jiu, Romania, not far from his native village. This included the immense cast-iron *Endless Column* (fig. **5.34**), which recalls ancient obelisks but also draws upon forms in Romanian folk art. The rhomboid shapes of *Endless Column* also began as socle (pedestal) designs that were, beginning in 1918, developed as freestanding sculptures. Wood versions of the sculpture can be seen in Brancusi's photograph of his studio (see fig. 5.29).

Endless Column was the most radically abstract of his sculptures, and its reliance upon repeated modules became enormously important for Minimalist artists of the 1960s.

That Brancusi sought to elicit universal, transcendent experiences through his sculpture speaks to a certain optimism about humanity's essential nature. Feelings of "pure joy" are, presumably, accessible to anyone who opens him- or herself up to the experience. Brancusi's hopeful views were not, of course, shared by all artists at this time. Many viewed the conditions generated by modernity with suspicion or disgust. Some of the most compelling visual manifestations of these concerns would come through the work of the German Expressionists. Just as engaged with non-Western art as Brancusi and just as inclined to attribute essential characteristics to all of humanity, the German Expressionists offered a radically different image of the human condition.

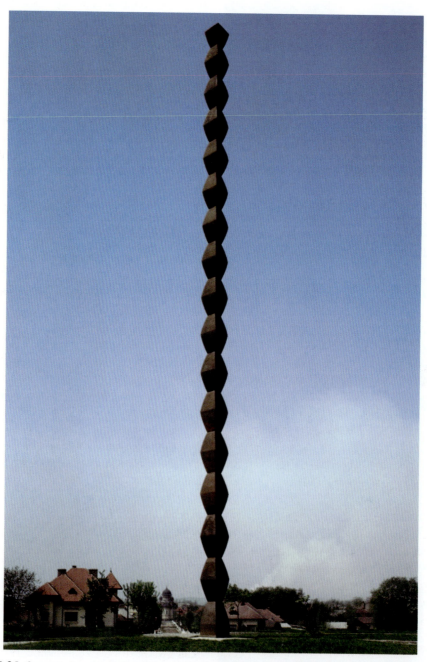

5.34 Constantin Brancusi, *Endless Column*, 1937–38. Cast iron, height 98' (29.9 m). Tîrgu-Jiu, Romania.

6
Expressionism in Germany and Austria

God is dead." This assertion, put forth by the then little-known German philosopher Friedrich Nietzsche in 1882, succinctly sums up the moral quandary of Western society in the late nineteenth century. With the advent of Positivism earlier in the century, scientific rationalism had gained cachet as a means of understanding and improving all areas of human experience. The fruit of this faith in reason seemed abundant by the early years of the twentieth century: *la belle époque* was in full swing, giving rise to a culture of exuberant experimentation of the sort that led to Fauvism. But Positivism also had some unsettling side effects. One of them, Nietzsche observed, was nihilism—existence outside a certain, unquestioned moral framework. If all human experience could be accounted for through recourse to objective, rational analysis, then what is the basis for morality? Why should individuals embrace one set of values over another? Historically, these questions had been answered by the Church and seconded by the state, typically personified by a sovereign. The spread of **secularism** and of varying degrees of democracy during the nineteenth century displaced these authorities.

What arose in their place? For some, science promised authoritative guidance. Human nature and cultural values might be best divined through objective study and experimentation. Thus the modern fields of psychology, anthropology, sociology, and even art history were effectively established at this time. For others, only religion could provide a genuine moral framework for life. A resurgence of religiosity characterized the dawn of the new century, with some returning to the traditional faiths of their parents or grandparents, while others adopted Eastern, esoteric, or occult practices such as Buddhism, **Theosophy**, or animism. Nationalism presented yet another rallying point for those seeking a set of ready values to which they could anchor themselves. With European and American imperialism reaching a peak, national pride likewise spiked. Personal identity became an extension of national identity, and native folk cultures were increasingly viewed as "pure" expressions of an authentic national culture. In Central Europe, nationalism had taken on a particularly strong character in the wake of Kaiser Wilhelm I's establishment of a unified empire in 1871. Creation of this new state of Germany propelled the concept of a distinctively Teutonic cultural identity, a notion that prompted strong, and diverse, responses from artists living in the Empire. Subsuming individual identities to a collective national character offered many Europeans a remedy for the nihilism Nietzsche viewed as nascent in his time. For those unmoved by nationalism, unawed by religion, and uncertain of the motives of science and industry, Nietzsche's flat declaration resonated with the bleak certainty that humanity had only its own basest instincts to guide it. German Expressionism is the visual corollary to Nietzsche's statement.

The term "expressionism" is used generally to refer to artworks with a particular emphasis on emotional content. In such works, strong emotion is conveyed not only thematically but also by means of technique and medium. Thus, Delacroix's *The Lion Hunt* (see fig. 1.8) can be characterized as expressionistic insofar as the undulating lines, rich color, and loose brushwork support the violence and chaos of the subject. Likewise, Munch's *The Scream* (see fig. 4.24) exemplifies expressionism in its agitated, disorienting rendering of a theme of desperation and alienation. German Expressionism refers to a specific movement in Northern Europe that flourished in the first few decades of the twentieth century. Its genesis can be found in Romanticism, with its emphasis on intensely personal aesthetic explorations. It also bears a strong kinship to Fauvism. Like the Fauves, German Expressionist painters of the early twentieth century used a vibrant palette that strayed from natural observation. Other points of similarity include the distortion or flattening of perspective space, the energetic handling of media, and an interest in art-historical tradition. There are some important differences, however. Unlike their Fauve contemporaries, the German Expressionists were largely freed from any lingering academic influence. In fact, many of the leading Expressionists never received the long academic training that informed the work of Fauves such as Matisse and Derain. Perhaps the singular distinction between Fauvism and German Expressionism is the latter's engagement with contemporary social issues. Far from dispassionate analysts like Matisse or his great influence Cézanne, Expressionists used their artworks to provide a rejoinder to the proposition that "God is dead."

From Romanticism to Expressionism: Corinth and Modersohn-Becker

The strong emotional content of Expressionism was not new to German art. Romantic painters like the early nineteenth-century Caspar David Friedrich conveyed intense feelings of loss and longing, of reverence and hope through their work. Even German medieval and Renaissance artists valued emotionalism in artworks in a way that often puzzled their southern contemporaries. German Expressionism draws from these northern sources. Paving the way from Romanticism to Expressionism were such northerners as Van Gogh, Munch, Klimt, Hodler, Ensor, Böcklin, Klinger, and Kubin. However, the young Expressionists in Germany also drew inspiration from their own native folk traditions or children's art, as well as the art of other cultures, especially Africa and Oceania. Among those whose work played a particularly strong role in bridging the divide between earlier northern strains of expressionism and the full-blown Expressionism that appeared in the first decade of the twentieth century were Lovis Corinth and Paula Modersohn-Becker.

The paintings and graphic arts of **Lovis Corinth** (1858–1925) form a clear link between German Romanticism and later German Expressionist art. His lengthy academic training included study in his native Germany and in France, where he entered the Académie Julian in 1884. One of his professors there was William Bouguereau, the academician whose teaching and methods Matisse would, a few years later, dismiss as moribund. Like Matisse, Corinth rejected the idealism of Bouguereau's style. But Corinth did not turn to avant-garde art for an alternative to the academic approach. He, in fact, claimed to be unaware of Impressionism during his time in Paris. Instead, he internalized the lessons of the Académie, rendering what he saw with exacting draftsmanship and a real colorist's sensitivity to complements and tonal relations. Corinth's is not the dispassionate gaze of a realist, though: the dynamic brushwork, startling yet naturalistic color, and palpable emotional tension of his work call to mind the work of Munch (see figs. 4.22, 4.24, 4.25). This equipoise between objective analysis and subjective encounter in works like *Nude Girl* (fig. **6.1**) charges Corinth's work with an internal tension that would later give way to fierce Expressionism.

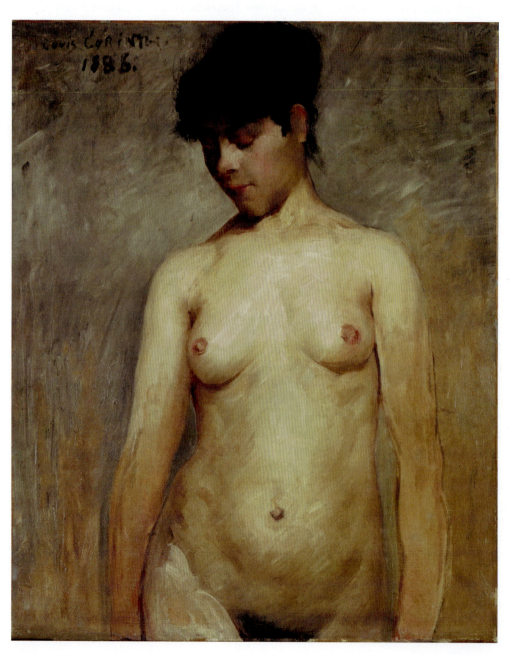

6.1 Lovis Corinth, *Nude Girl*, 1886. Oil on canvas, 30 × 25¼" (76.2 × 64.14 cm). Minneapolis Institute of Arts. Gift of Mr. and Mrs. Donald Winston.

Paula Modersohn-Becker (1876–1907) was born in Dresden and settled in the artists' colony at Worpswede near Bremen in 1897. Worpswede, like the French town of Pont-Aven in Brittany where Gauguin painted before traveling to Tahiti, appealed to artists interested in a simpler, more authentic-seeming culture. In Worpswede, Modersohn-Becker developed a primitivist style, drawing from folk art and non-Western sources while avoiding the finicky brushwork, smooth blending of pigment, and high finish of academic painting. Although she was not associated with any group outside of the provincial school of painters at Worpswede, Modersohn-Becker was in touch with new developments in art and literature through her friendship with the poet Rainer Maria Rilke (who had been Rodin's secretary), as well as through a number of visits to Paris. In these she discovered successively the French Barbizon

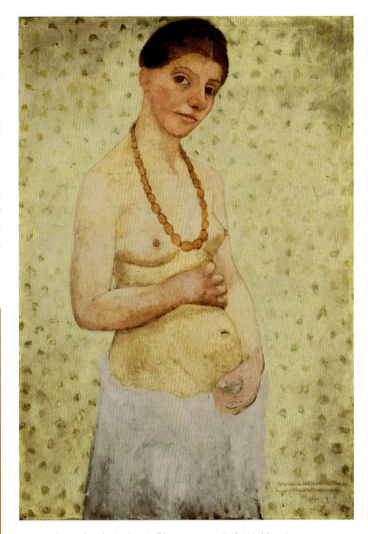

6.2 Paula Modersohn-Becker, *Self-Portrait on Her Sixth Wedding Anniversary*, 1906. Oil on canvas, 39¾ × 27½" (101 × 69.9 cm). Kunstsammlungen Böttcherstrasse/Paula Modersohn-Becker Museum, Bremen.

SOURCE

Paula Modersohn-Becker
Letters and journal

From an undated journal entry, c. August 1897
Worpswede, Worpswede, I cannot get you out of my mind. There was such atmosphere there—right down to the tips of your toes. Your magnificent pine trees!… And your birch trees—delicate, slender young virgins who delight the eye. With that relaxed and dreamy grace, as if life had not really begun for them yet. They are so ingratiating—one must give oneself to them, they cannot be resisted. But then there are some already masculine and bold, with strong and straight trunks. Those are my "Modern Women."

From a letter to the painter Otto Modersohn (whom she would later marry) written in Paris and dated February 29, 1900
In several salons, where one trips over the long gowns of elegant Paris, there were many things to be seen, much shallow, sweet, and bad stuff. But I keep thinking that somewhere hidden treasure must lie. There is much beauty and depth in Puvis de Chavannes. He is someone who suddenly stands quite alone among others. … Do you know Monet? I had heard his name in Germany. I saw a number of paintings by him recently. Even here the concept of nature seemed superficial.

From a letter to the sculptor Bernhard Hoetger written in the summer of 1907
I have not done much work this summer, and I have no idea if you will like any of the little that I have accomplished. In conception, all the work has probably remained much the same. But the execution, I think, is quite another matter. What I want to produce is something compelling, something full, an excitement and intoxication of color—something powerful … I wanted to conquer Impressionism by trying to forget it. What happened was that it conquered me. We must work with digested and assimilated Impressionism

painters, the Impressionists, and then, in 1905 and 1906, the works of Van Gogh, Gauguin, and Cézanne. Following this last trip, she embarked on a highly productive and innovative period, distilling and simplifying forms while heightening the expressiveness of color. In her extensive letters and diaries, the artist wrote of her desire for an art of direct emotion, of poetic expression, of simplicity and sensitivity to nature: "Personal feeling is the main thing. After I have clearly set it down in form and color, I must introduce those elements from nature that will make my picture look natural" (see *Modersohn-Becker, Letters and journal*, opposite). She worried about the implications of marriage and motherhood for her professional life and died prematurely following the birth of her only child, leaving us with merely a suggestion of what she might have achieved.

What sets Modersohn-Becker's work apart from other primitivists like Gauguin as well as from her Fauve contemporaries is its daring exploration of novel subjects. Her *Self-Portrait on Her Sixth Wedding Anniversary* (fig. **6.2**) fuses the conventional theme of the artist's self-portrait with the favored modernist motif of the nude woman. Far from treating the nude female form as simply a cipher for formal experimentation—as Matisse claimed to be doing with

his *Blue Nude* (see fig. 5.9)—Modersohn-Becker presents a body, her own body, redolent with personality, agency, and creativity. She reveals herself frankly in the full bloom of her pregnancy. Artists' self-portraits have long served as a means to represent their claims to authorship. Here, Modersohn-Becker asserts her body as a source for artistic creation and the creation of life itself. With this gesture, she not only invents a genre of portraiture unavailable to male artists, but she also reclaims the female nude as a fully human subject, not simply another formal motif that might just as well be a still life. Modersohn-Becker's insistence on endowing the female nude with creative and intellectual agency extended beyond her self-portraits to encompass her depictions of women more generally. Her approach differed from that of many of her contemporaries, who equated the female body with humanity's instinctive and irrational character. Seen as especially vulnerable to corruption by social ills, the female body became a favorite motif, whether as a savage yet salubrious symbol of elemental "nature" or as a dangerous and defiled victim of urban vice.

Technically, Modersohn-Becker points the way to Expressionism. Simplified areas of color and spatial compression testify to her understanding of Post-Impressionist and Fauve experimentation. What is more, like the Expressionists who followed her, Modersohn-Becker acknowledges the necessity of tying the formal attributes of a work of art to its theme. Here, the abstract pattern surrounding her serves to flatten pictorial space, enhancing the planar surface of the canvas. Yet, at the same time, this pattern suggests floral wallpaper, implying that she rests within a domestic space. The muted ocher tones of the work combine with the mask-like rendering of her face and simple amber necklace to endow the work with an earthy primitivism, as if to assert the universal resonance of her highly personal experience of pregnancy.

Spanning the Divide between Romanticism and Expressionism: Die Brücke

In 1905 Ernst Ludwig Kirchner, Erich Heckel, Karl Schmidt-Rottluff, and Fritz Bleyl formed an association they called Die Brücke, or "The Bridge," linking "all the revolutionary and fermenting elements." These young architecture students, all of whom wanted to be painters, were drawn together by their opposition to the art that surrounded them, especially academic art and fashionable Impressionism, rather than by any preconceived program. Imbued with the spirit of Arts and Crafts and *Jugendstil* (see Ch. 4, pp. 70–73, 76–79), they rented an empty shop in a workers' district of Dresden, in eastern Germany, and began to paint, sculpt, and make woodcuts together. The influences on them were many and varied: the art of medieval Germany, of the French Fauves, of Edvard Munch, of non-Western sculpture. For them, Van Gogh was the clearest example of an artist driven by an "inner force" and "inner necessity"; his paintings presented an ecstatic identification

or empathy of the artist with the subject he was interpreting. Even more familiar to them was Munch, whose graphic works were widely known in Germany by 1905 (see fig. 4.26), and the artist himself was spending most of his time there. His obsession with symbolic subjects struck a sympathetic chord in the young German artists, and from his mastery of the graphic techniques they could learn much. Among historic styles, the most exciting discovery was art from Africa and the South Pacific, of which notable collections existed in the Dresden Ethnographic Museum.

In 1906 Emil Nolde and Max Pechstein joined Die Brücke. In the same year Heckel, then working for an architect, persuaded a manufacturer for whom he had executed a showroom to permit the Brücke artists to exhibit there. This was the historic first Brücke exhibition, which marked the emergence of twentieth-century German Expressionism. Little information about the exhibition has survived, since no catalog was issued, and it attracted virtually no attention.

During the next few years the Brücke painters exhibited together and produced publications designed by members and manifestos in which Kirchner's ideas were most evident. The human figure was studied assiduously in the way Rodin had studied the nude: not posed formally but simply existing in the environment. Despite developing differences in style among the artists, a hard, Gothic angularity permeated many of their works.

The Brücke painters were conscious of the revolution that the Fauves were creating in Paris and were affected by their use of color. However, their own paintings maintained a Romantic sense of expressive subject matter and a characteristically jagged, Gothic structure and form. Their subjects, too, strayed from the arcadian landscapes and portraits of friends and family so favored by the Fauves to include stark portrayals of prostitutes and dancers, frankly eroticized depictions of child models, and unsettling scenes of urban leisure and decadence. When Brücke artists turned to the landscape, they likewise emphasized tension rather than harmony between humanity and nature. By 1911 most of the Brücke group were in Berlin, where a new style appeared in their works, reflecting the increasing consciousness of French Cubism (see Chapter 7) as well as Fauvism, given a Germanic excitement and narrative impact. By 1913 Die Brücke was dissolved as an association, and the artists proceeded individually.

Kirchner

The most creative member of Die Brücke was **Ernst Ludwig Kirchner** (1880–1938). In addition to his extraordinary output of painting and prints, Kirchner, like Erich Heckel, made large, roughly hewn and painted wooden sculptures. These works in a primitivist mode were a result of these artists' admiration for African and Oceanic art. Kirchner's early ambition to become an artist was reinforced by his discovery of the sixteenth-century woodcuts of Albrecht Dürer and his Late Gothic predecessors. Yet his own first woodcuts, done before 1900, were probably most influenced by Félix Vallotton and Edvard Munch. Between 1901 and

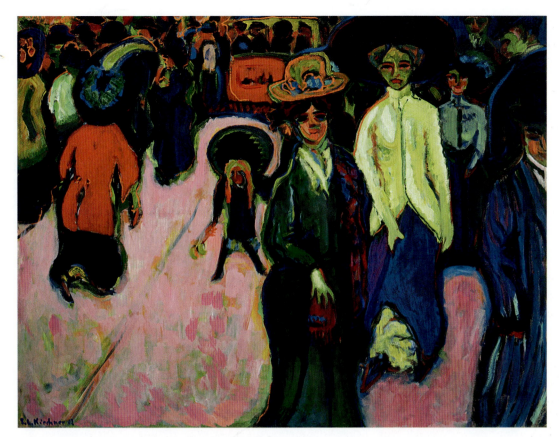

6.3 Ernst Ludwig Kirchner, *Street, Dresden*, 1908 (dated 1907 on painting). Oil on canvas, 4′ 11¼″ × 6′ 6⅞″ (1.51 × 2 m). The Museum of Modern Art, New York.

View the Closer Look to see another of Kirchner's paintings on mysearchlab.com

1903 Kirchner studied architecture in Dresden, and then, until 1904, painting in Munich. Here he was attracted to Art Nouveau designs and repelled by the retrograde paintings he saw in the exhibition of the Munich Secession. Like so many of the younger German artists of the time, he was particularly drawn to German Gothic art. Of modern artists, the first revelation for him was the work of Seurat. Going beyond Seurat's research, Kirchner undertook studies of nineteenth-century color theories that led him back to Johann Wolfgang von Goethe's essay *History of the Theory of Colors* (1805–10).

Kirchner's painting style by about 1904 showed influences from the Neo-Impressionists combined with a larger, more dynamic brushstroke related to that of Van Gogh, whose work he saw, along with paintings by Gauguin and Cézanne, in the exhibition of the Munich Artists' Association held that year. His return to Dresden and architecture school in 1904, and his acquaintance with Heckel, Schmidt-Rottluff, and Bleyl, led to the founding of the Brücke group.

For subject matter Kirchner looked to contemporary life, rejecting the artificial trappings of academic studios. In both Dresden and Berlin, where he moved in 1911, he recorded the streets and inhabitants of the city and the bohemian life of its nightclubs, cabarets, and circuses. *Street, Dresden* (fig. **6.3**) of 1908 is an assembly of curvilinear figures who undulate like wraiths, moving toward and away from the viewer without individual motive, drifting in a world of dreams. Kirchner probably had Munch's street painting *Spring Evening on Karl Johan Street* in mind when he made this

work, and, as was frequently his habit, he reworked it at a much later date. In Berlin he painted a series of street scenes in which the spaces are confined and precipitously tilted, and the figures are elongated into angular shards by long feathered strokes. Kirchner made rapid sketches of these street scenes, then worked up the images in more formal drawings in his studio before making the final paintings.

A frequent subject of Kirchner's art was the girl Fränzi Fehrmann, who, with her siblings, was a favorite model of the Brücke group (fig. **6.4**). Children of a deceased circus performer, they modeled as a way to help their widowed mother support the household. In this painting by Kirchner, Fränzi is represented as an adolescent, neither completely a child nor fully adult. Posed on a bed with a pink flower in her hair and assertively gazing toward the viewer, Fränzi conveys an incipient sexuality. Yet her boxy jumper, small hands, and loose hair testify to her status as a child. The stylized figure against a black background to the left of her is part of an African wall-hanging, serving for Kirchner as a symbol of authenticity and renewal—ideas he here associates with Fränzi's youth. Kirchner's use of color—especially the acidic green of her mask-like face—complicates further the sitter's personality. Formally, Kirchner uses the green-yellow much as a Fauve painter might, to sculpt the sitter's face by juxtaposing complements like red or blue to model her lips and cheekbones. But for Kirchner the Expressionist, his color choices telegraph a mood of uncertainty or even danger. Why isn't the skin of Fränzi's arms rendered in a

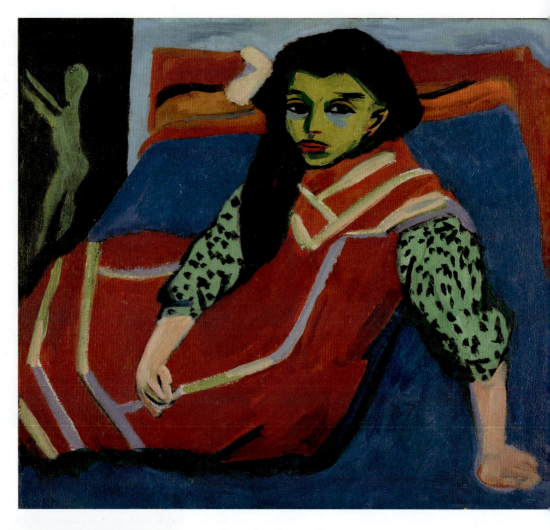

6.4 Ernst Ludwig Kirchner, *Seated Girl (Fränzi Fehrmann)*, 1910; altered 1920. Oil on canvas, 31¾ × 35⅞″ (80.6 × 91.1 cm). Minneapolis Institute of Arts. The John R. Van Derlip Fund.

✳ Explore more about Die Brücke on mysearchlab.com

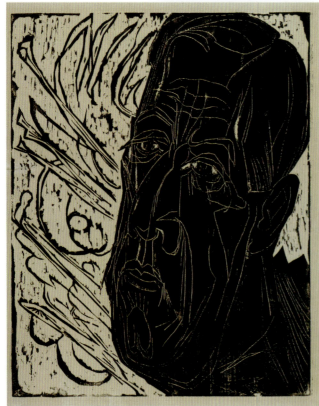

6.5 Ernst Ludwig Kirchner, *Portrait of Henry van de Velde*, 1917. Woodcut, 19½ × 15¾″ (49.6 × 40 cm). Harvard University Art Museums, Cambridge, MA. Museum Funds. M13167.

similar color? Their placid pink hue heightens the disconcerting intensity of her face, estranging her countenance and reminding the viewer of the impossibility of fully knowing another.

One of the principal contributions of Die Brücke was its revival of printmaking as a major form of art. During the nineteenth century many experimental painters and sculptors had made prints, and toward the end of the century, in the hands of artists like Toulouse-Lautrec (see fig. 3.35), Gauguin, and Redon, printmaking assumed an importance as an independent art form beyond anything that had existed since the Renaissance. In Germany, however, a country with a particularly rich tradition of printmaking, this art form occupied a special place, and its revival contributed to the character of painting and sculpture. It was especially the simplified forms of the woodcut, a form of printmaking with a long and distinguished history in German art, that Expressionists like Kirchner felt conveyed emotion most authentically. The artists of Die Brücke brought about a veritable renaissance of this medium. Kirchner, in both black-and-white and color woodcuts, developed an intricate, linear style that looked back to the woodcuts of Dürer and the earlier Martin Schongauer (see *Woodcuts and Woodblock Prints*, opposite). In a powerful portrait of the Belgian Art Nouveau architect Henry van de Velde, he used characteristic V-shaped gouges to create complex surface patterns (fig. **6.5**).

Woodcuts and Woodblock Prints

Using carved wooden blocks to print images onto paper or fabric is one of the oldest printmaking techniques. Developed in China before the first century CE, the method has been employed in the West since at least the fifteenth century. The technique of woodcut, or woodblock printing, as it is alternately called, is fairly straightforward. A design is drawn onto a block of wood, which is then carved so that the desired image remains in relief. Ink is applied to the raised design and the block pressed onto a flat surface such as paper. No great pressure is needed to transfer the ink to paper, though a press is often used to ensure even, consistent pressure from one impression to the next. The image can also be transferred easily by rubbing a piece of the paper placed over the inked surface of the block. In the hands of Albrecht Dürer, Renaissance woodcuts reached their zenith.

Color prints can be produced in a number of ways. An existing print can be colored, or color can be introduced during the printmaking process. One method for color printing involves applying colored inks to the block before printing. Another technique requires two or more blocks, each carved to print a different part of the scene. These blocks are then printed in different hues, adding depth as well as vibrancy to the scene. Japanese *ukiyo-e* prints exemplify this approach (see fig. 2.23). Edvard Munch took an innovative turn with color printing by cutting his woodblocks into pieces, like a jigsaw puzzle, applying different colors of ink to the various pieces, then reassembling them for printing (see fig. 4.26).

Nolde

Emil Nolde (1867–1956) was the son of a farmer from northwestern Germany, near the Danish border. The reactionary, rural values of this area had a profound effect on his art and his attitude toward nature. Strong emotional ties to the landscape and a yearning for a regeneration of the German spirit and its art characterized the popular *völkisch* or nationalist tradition. Early in his career, Nolde depicted the landscape and peasants of this region in paintings reminiscent of the French artist Millet (see fig. 1.13). As an adult, he even took as his surname the name of his native village (he was born Emil Hansen) to underscore a strong identification with the land.

Nolde studied woodcarving and worked for a time as a designer of furniture and decorative arts in Berlin. His first paintings, of mountains transformed into giants or hideous trolls, drew on themes of traditional Germanic fantasy. The commercial success of some of these images enabled Nolde to return to school and to take up painting seriously in Munich, where he encountered the work of contemporary artists such as Adolph Menzel and Arnold Böcklin (see fig. 4.30), and then in Paris. While in Paris in 1899–1900, he, like so many art students, worked his way gradually from the study of Daumier and Delacroix to Manet and the Impressionists, and his color took on a new brilliance and violence as a result of his exposure to the latter. In 1906 he accepted an invitation to become a member of Die Brücke. Essentially a solitary person, Nolde left Die Brücke after a year and devoted himself increasingly to a personal form of Expressionist religious paintings and prints.

Among his first visionary religious paintings was *The Last Supper* of 1909 (fig. **6.6**). When compared with celebrated Old Master paintings of Jesus among his disciples, such as Rembrandt's *Christ at Emmaus* or even Leonardo da Vinci's *Last Supper*, Nolde's mood is markedly different from their quiet restraint. His figures are crammed into a practically nonexistent space, the red of their robes and the yellow-green of their faces flaring like torches out of the surrounding shadow. The faces themselves are skull-like masks that derive from the carnival processions of Ensor (see fig. 4.29). Here, however, they are given intense personalities—no longer masked and inscrutable fantasies but individualized human beings passionately involved in a

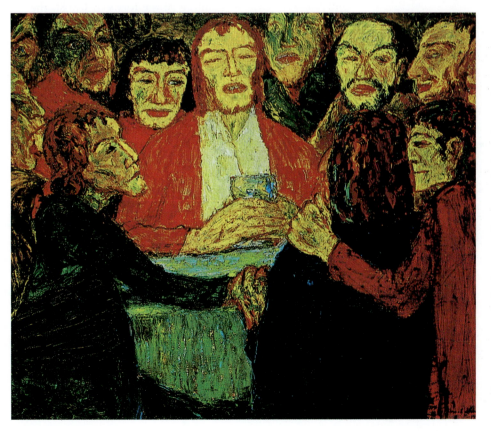

6.6 Emil Nolde, *The Last Supper*, 1909. Oil on canvas, 33⅞ × 42⅛" (86 × 107 cm). Statens Museum for Kunst, Copenhagen.

situation of extreme drama. The compression of the group packed within the frontal plane of the painting—again stemming from Ensor—heightens the sense of impending crisis.

Of the Brücke group, Nolde was already an accomplished etcher by the time he made his first woodcuts. These owe something to Late Gothic German woodcuts as well as the prints of Munch, with their intense black-and-white contrast and bold, jagged shapes that exploit the natural grain of the woodblock. His lithographs, which differ in expression from the rugged forms of his woodcuts, include *Female Dancer* (fig. **6.7**). Nolde appreciated the artistic freedom afforded him by the lithographic medium, which he used in experimental ways, brushing ink directly onto the stone printing matrix to create thin, variable washes of color. He was interested in the body as an expressive vehicle, and had made sketches in the theaters and cabarets of Berlin, as had Kirchner. But the sense of frenzied emotion and wild abandon in *Female Dancer* evokes associations with some imagined primal ritual rather than with the urban dance halls with which he was familiar. Nolde had studied the work of non-European cultures in museums such as the Berlin Ethnographic Museum, concluding that Oceanic and African art possessed a vitality lacking in much Western art. He argued for their study as objects of aesthetic as well as scientific interest and made drawings of objects that were then incorporated into his still-life paintings. In 1913, shortly after making this lithograph, Nolde joined an official ethnographic expedition to New Guinea, then a German colony in the South Pacific, and later traveled to East Asia. He made sketches of the landscapes and local inhabitants on his journeys, from which he returned highly critical of European colonial practices.

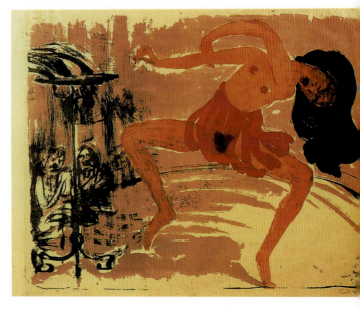

6.7 Emil Nolde, *Female Dancer*, 1913. Color lithograph, 20⅞ × 27⅛″ (53 × 69 cm). Nolde Stiftung Seebüll, Germany.

Heckel, Müller, Pechstein, and Schmidt-Rottluff

Erich Heckel (1883–1970) was a more restrained Expressionist whose early paintings at their best showed flashes of psychological insight and lyricism. After 1920 he turned increasingly to the production of colorful but essentially Romantic–Realist landscapes. A painting such as *Two Men at a Table* (fig. **6.8**) evokes a dramatic interplay in which not only the figures but the contracted, tilted space of the room are charged with emotion. This painting, dedicated "to Dostoyevsky," is almost a literal illustration from the Russian novelist's *Brothers Karamazov* (1880). The painting of the tortured Christ, the suffering face of the man at the left, the menace of the other—all refer to Ivan's story, in the novel, of Christ and the Grand Inquisitor, when the atheist Ivan shares a chillingly nihilistic parable with his brother, who has decided to become a monk. Arguing that most human beings will not willingly lead virtuous lives—even in recognition of Christ's sacrifice—the Inquisitor asserts that "Anyone who can appease a man's conscience can take his freedom away from him." True liberty—whether of the soul or the body—is a responsibility few are prepared to manage conscientiously—a foreshadowing of Nietzsche's nihilistic observation. By contrast, Heckel's color woodcut

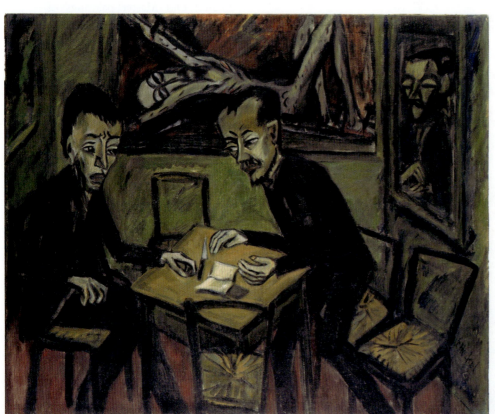

6.8 Erich Heckel, *Two Men at a Table*, 1912. Oil on canvas, 38⅛ × 47¼″ (96.8 × 120 cm). Kunsthalle, Hamburg.

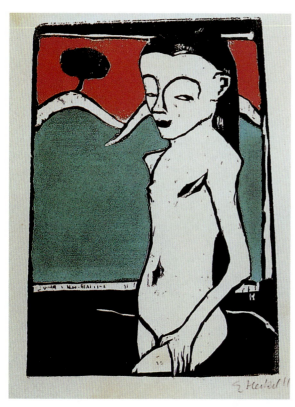

6.9 Erich Heckel, *Standing Child*, 1910. Color woodcut, 14¾ × 10¾" (37.5 × 27.5 cm). Los Angeles County Museum of Art.

Standing Child (fig. **6.9**) involves no narrative. It is a spare composition representing the then twelve-year-old Fränzi Fehrmann, the subject of Kirchner's painting *Seated Girl* (see fig. **6.4**). The artist reserved the color of the paper for the model's skin and employed three woodblocks—for black, green, and red inks—in the puzzle technique invented by Munch (see fig. 4.26) for the brilliant, abstracted landscape behind her. It is a gripping image for its forthright design and the frank, precocious sexuality of the sitter.

Using the most delicate and muted colors of all the Brücke painters, **Otto Müller** (1874–1930) created works that suggest an Oriental elegance in their organization. His nudes are attenuated, awkwardly graceful figures whose softly outlined, yellow-ocher bodies blend imperceptibly and harmoniously into the green and yellow foliage of their setting (fig. **6.10**). He was impressed by ancient Egyptian wall paintings and developed techniques to emulate their muted tonalities. The unidealized, candid depiction of nudes in open nature was among the Brücke artists' favorite subjects. They saw the nude as a welcome release from nineteenth-century prudery and a liberating plunge into primal experience. As Nolde proclaimed, echoing the widely shared, if unwittingly patronizing, view of "primitive" peoples that was current at the time, "Primordial peoples live in their nature, are one with it and are a part of the entire universe." The relative

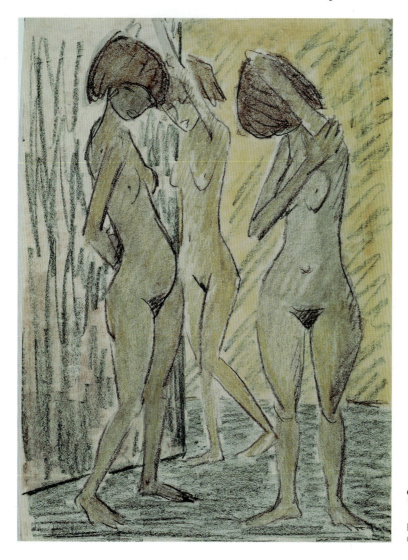

6.10 Otto Müller, *Bathing Women*, 1912. Crayon on paper, 17⅜ × 13⅜" (43.7 × 33.5 cm). Bildarchiv Rheinisches Museum, Cologne.

gentleness of Müller's treatment of this theme found an echo in the contemporary photographs of the German-born photographer **Heinrich Kühn** (1866–1944), who, like early twentieth-century modernists in painting, sought to flatten space and create a more two-dimensional design—a Pictorial effect, as the photographers would have said—by viewing his subject or scene from above (fig. **6.11**).

Max Pechstein (1881–1953) had a considerable head start in art by the time he joined Die Brücke in 1906. He had studied for several years at the Dresden Academy, and in general enjoyed an earlier success than the other Brücke painters. In 1905 he had seen a collection of wood carvings from the Palau Islands in the Royal Ethnographic Museum in Dresden, and these had a formative influence on his work. In 1914 he traveled to these islands in the Pacific to study the art firsthand. Pechstein was the most eclectic of the Brücke group, capable of notable individual paintings that shift from one style to another. The early *Indian and Woman* (fig. **6.12**) illustrates the interests of the Expressionists with its exotic subject, modeling of the figures, and Fauve-inspired color. Pechstein's drawing is sculptural and curvilinear in contrast to that of Müller or Heckel, and it was not tinged by the intense anxiety that informed so much of Kirchner's work. Like Nolde, Pechstein chose dance as his subject for a color woodcut of 1910 (fig. **6.13**), a work he may have been inspired to make after seeing a Somali dance group perform in Berlin that year. The dancers are portrayed against a colorful backdrop that resembles the kind of hangings with which the Brücke artists decorated their studios, like the one just visible on the left side of Kirchner's *Seated Girl* (see fig. 6.4). Pechstein sought a deliberately crude execution here, with schematically hewn figures and a surface covered with irregular smudges of ink.

In 1910 **Karl Schmidt-Rottluff** (1884–1976) portrayed himself as the very image of the arrogant young

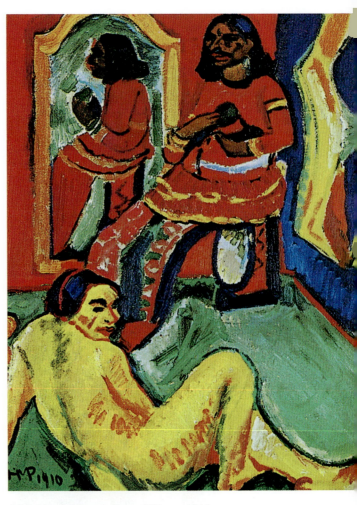

6.12 Max Pechstein, *Indian and Woman*, 1910. Oil on canvas, 32¼ × 26¼″ (81.9 × 66.7 cm). The Saint Louis Art Museum, Missouri.

6.11 Heinrich Kühn, *Der Malschirm* (*The Artist's Umbrella*), 1908. Photogravure on heavy woven paper, 9 × 11⅜″ (23 × 28.9 cm). The Metropolitan Museum of Art, New York. The Alfred Stieglitz Collection, 1949.

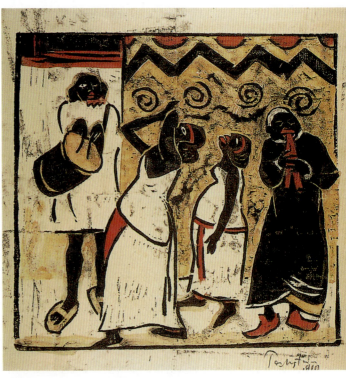

6.13 Max Pechstein, *Somali Dancers*, 1910. Hand-colored woodcut, 12½ × 14⅜″ (31.8 × 36.5 cm). Brücke-Museum, Berlin.

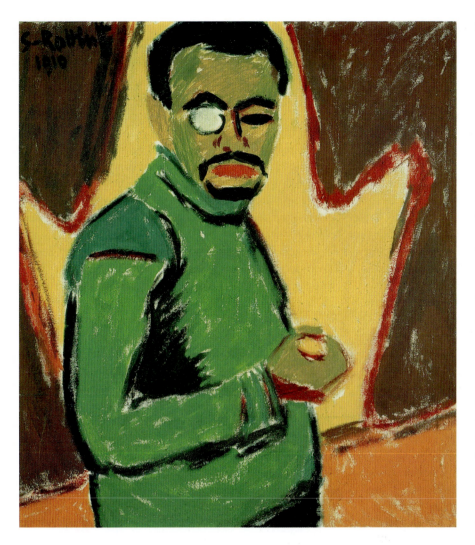

6.14 Karl Schmidt-Rottluff, *Self-Portrait with Monocle*, 1910. Oil on canvas, 33⅛ × 30″ (84.1 × 76.2 cm). Staatliche Museen zu Berlin, Preussischer Kulturbesitz, Nationalgalerie.

Expressionist—in a green turtleneck sweater, complete with beard and monocle, against a roughly painted background of a yellow doorway flanked by purplish-brown curtains (fig. **6.14**). Aside from Nolde, Schmidt-Rottluff was the boldest colorist of the group, given to vivid blues and crimsons, yellows and greens, juxtaposed in jarring but effective dissonance. Although never a fully abstract painter, he was probably the member of Die Brücke who moved furthest and most convincingly in the direction of abstract structure.

Die Brücke's Collapse

Die Brücke finally dissolved in 1913 after members either drifted away or, at the end, left in deliberate protest at Kirchner's public assertion of his leadership of the group. Most continued to explore the possibilities of Expressionism, but the outbreak of World War I in 1914 interrupted or halted altogether the artistic work of those involved in the movement. Kirchner enlisted in the field artillery; suffering a mental and physical breakdown, he was discharged in 1915. He recuperated in Switzerland, where he continued to live and work near the town of Davos until his suicide in 1938. During this late period Kirchner continued to renew his style, painting many of his older themes along with serene Alpine landscapes and sympathetic portrayals of Swiss peasant life. Schmidt-Rottluff, traumatized by his service in Russia during World War I, was later commissioned to

redesign the imperial German eagle, casts of which were placed on buildings throughout Germany. Despite this service to his country, when the Nazis came to power he was dismissed from his position as professor of art in Berlin in 1933 and forbidden to work. In 1937, the Nazis confiscated his *Self-Portrait with Monocle* from the museum that had acquired it in 1924, denigrating his work as unwholesome and "degenerate" (see *Degenerate Art*, p. 240). For his part, Nolde returned to Germany from his expedition during the war and resumed artmaking. As critical as he may have been toward colonialism, he nevertheless believed in the ethnic superiority of Nordic people, an attitude that would lead him later to sympathize with the Nazis. Nazi ideology and policies were to have far-reaching effects on the arts in Germany (see Chapter 10).

The Spiritual Dimension: Der Blaue Reiter

The Brücke artists were the first manifestation of Expressionism in Germany but not necessarily the most significant. While they were active, first in Dresden and then in Berlin, a movement of more far-reaching implications was germinating in Munich around one of the great personalities of modern art, Vasily Kandinsky. Calling themselves Der Blaue Reiter (The Blue Rider), this group espoused no single style, though their work falls under the heading of Expressionism because of its free use of form, color, and space along with their interest in conveying intense moods and ideas through this formal experimentation. Like Die Brücke, Der Blaue Reiter viewed contemporary, industrialized society with skepticism. But instead of engaging in a direct critique as, for example, Kirchner did with his urban scenes and disquieting portraits, the artists of Der Blaue Reiter tended to retreat from the city and modern life, turning instead to folk culture, an idealized rendering of nature, or a romanticized medieval past. Above all, an attraction to spirituality guided Der Blaue Reiter, as an unblinking confrontation with modern society had guided Die Brücke.

Kandinsky

Born in Moscow, **Vasily Kandinsky** (1866–1944) studied law and economics at the University of Moscow. Visits to Paris and an exhibition of French painting in Moscow aroused his interest to the point that, at age thirty, he refused a professorship of law in order to study painting. He then went to Munich, where he was soon caught up in the atmosphere of Art Nouveau and *Jugendstil* then permeating the city.

Since 1890, Munich had been one of the most active centers of experimental art in Europe. Kandinsky was soon taking a leading part in the Munich art world, even while undergoing the more traditional discipline of study at the Academy and with older artists. In 1901 he formed a new artists' association, Phalanx, and opened his own art school. In the same year he was exhibiting in the Berlin Secession, and by 1904 had shown works in the Paris Salon d'Automne and Exposition Nationale des Beaux-Arts. That year the Phalanx had shown the Neo-Impressionists, as well as Cézanne, Gauguin, and Van Gogh. By 1909 Kandinsky was leading a revolt against the established Munich art movements that resulted in the formation of the Neue Künstler Vereinigung (NKV, New Artists' Association). In addition to Kandinsky, the NKV included Alexej von Jawlensky, Gabriele Münter, Alfred Kubin, and, later, Franz Marc. Its second exhibition, in 1910, showed the works not only of Germans but also of leading Parisian experimental painters: Picasso, Braque, Rouault, Derain, and Vlaminck.

During this period, Kandinsky was exploring revolutionary ideas about non-objective or abstract painting, that is, painting without literal subject matter, that does not take its form from the observed world. He traced the beginnings of this interest to a moment of epiphany he had experienced in 1908. Entering his studio one day, he could not make out any subject in his painting, only shapes and colors: he then realized it was turned on its side. In 1911 a split in the NKV resulted in the secession of Kandinsky, accompanied by Marc and Münter, and the formation of the association Der Blaue Reiter, a name taken from a book published by Kandinsky and Marc, in turn named after a painting by Kandinsky. The historic exhibition held at the Thannhauser Gallery in Munich in December 1911 included works by Kandinsky, Marc, August Macke, Heinrich Campendonck, Münter, the composer Arnold Schoenberg, and "Le Douanier" Henri Rousseau, among others. Paul Klee, already associated with the group, showed with them in a graphics exhibition in 1912. This was a much larger show. The entries were expanded to include artists of Die Brücke and additional French and Russian artists: Roger de La Fresnaye, Kazimir Malevich, and the Alsatian Jean Arp.

In his book *Concerning the Spiritual in Art*, published in 1911, Kandinsky formulated the ideas that had obsessed him since his student days in Russia. Always a serious student, he had devoted much time to the question of the relations between art and music. He had first sensed the dematerialization of the object in the paintings of Monet, and this direction in art continued to intrigue him as, through exhibitions in Munich and his continual travels, he learned more about the revolutionary new discoveries of the Neo-Impressionists, the Symbolists, the Fauves, and the Cubists. Advances in the physical sciences had called into question the "reality" of the world of tangible objects, strengthening his conviction that art had to be concerned with the expression of the spiritual rather than the material.

Despite his strong scientific and legal interests, Kandinsky was attracted to Theosophy, **spiritism**, and the occult. Theosophy, in particular, gained adherents among intellectuals and artists at the turn of the century. A metaphysical formulation that combined elements of Eastern religions, especially Buddhism and Hinduism, with mysticism and an esoteric belief in the pursuit of spiritual knowledge, Theosophy was established by Helena Petrovna Blavatsky, who founded the Theosophical Society in New York in 1875. Like others attracted to Theosophy, Kandinsky sought precisely the spiritual transcendence that nineteenth-century Positivism had discounted as useless superstition. There was always a mystical core in Kandinsky's thinking—something he at times attributed to his Russian roots. This sense of an inner creative force, a product of the spirit rather than of external vision or manual skill, enabled him to arrive at an art entirely without representation other than colors and shapes. Deeply concerned with the expression of harmony in visual terms, he wrote, "The harmony of color and form must be based solely upon the principle of the proper contact with the human soul." And so, Kandinsky was one of the first, if not—as traditionally thought—the very first, modern European artist to break through the representational barrier and carry painting into total abstraction.

As Kandinsky was moving toward abstraction, his early paintings went through various stages of Impressionism and Art Nouveau decoration, but all were characterized by a feeling for color. Many also had a fairytale quality of narrative, reminiscent of his early interest in Russian folktales and mythology. Kandinsky pursued this line of investigation in the rural setting of the Bavarian village of Murnau, where he lived for a time with Gabriele Münter. Münter took up *Hinterglasmalerei* ("painting behind glass"), a form of German folk art in which a painting is done on the underside of a sheet of glass so that the final image can be viewed through the glass. The technique involves starting with foreground elements and highlights and other details meant to be perceived as closer to the viewer. Areas intended to be seen as farther away are added subsequently. Münter taught the technique to Kandinsky. The archaism of the style and its spiritual purity forecast the more radical simplifications soon to come. Like his contemporaries in Germany and France, Kandinsky was interested in native Russian art forms and in 1889 had traveled on an ethnographic expedition to study the people of Vologda, a remote Russian province north of Moscow. He was moved by the interiors of the peasants' houses, which were filled with decorative painting and furniture. "I learned not to look at a picture from outside," he said, "but to move within the picture, to live in the picture."

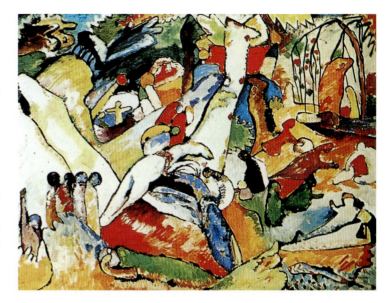

6.15 Vasily Kandinsky, *Sketch for Composition II*, 1909–10. Oil on canvas, 38⅜ × 51¾" (97.5 × 131.5 cm). Solomon R. Guggenheim Museum, New York.

Because of his wish to associate his work with an image-free art form that spoke directly to the senses in modernist fashion, Kandinsky began using titles derived from music, such as "Composition," "Improvisation," or "Impression," a gesture akin to Whistler's practice earlier (see Ch. 2, p. 28). He made ten major paintings titled *Composition*, which he considered to be his most complete artistic statements, expressive of what he called "inner necessity" or the artist's intuitive, emotional response to the world. A close examination of *Sketch for Composition II* (fig. **6.15**) reveals that the artist is still employing a pictorial vocabulary filled with standing figures, riders on horseback, and onion-domed churches, but they are now highly abstracted forms in the midst of a tumultuous, heaving landscape of mountains and trees painted in the high-keyed color of the Fauves. Although Kandinsky said this painting had no theme, it is clear that the composition is divided into two sections, with a scene of deluge and disturbance at the left and a garden of paradise at the right, where lovers recline as they had in Matisse's *Le Bonheur de vivre* (see fig. 5.8). Kandinsky balances these opposing forces to give his all-embracing view of the universe.

In general, Kandinsky's compositions revolve around themes of cosmic conflict and renewal, specifically the Deluge from the biblical Book of Genesis and the Apocalypse from the Book of Revelation. From such cataclysm would emerge, he believed, a rebirth, a new, spiritually cleansed world. In *Composition VII* (fig. **6.16**), an enormous canvas from 1913, colors, shapes, and lines collide across the

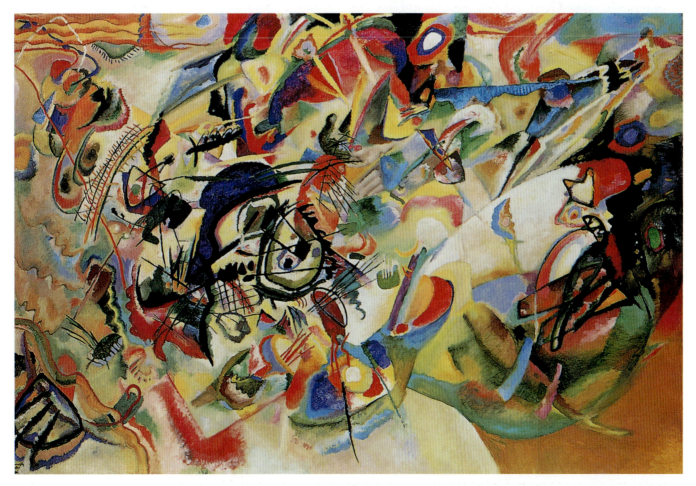

6.16 Vasily Kandinsky, *Composition VII*, 1913. Oil on canvas, 6' 6¾" × 9' 11⅛" (2 × 3 m). Tretyakov Gallery, Moscow.

▶ Watch a video about *Composition VII* on mysearchlab.com

pictorial field in a furiously explosive assembly. Yet even in the midst of this symphonic arrangement of abstract forms, the characteristic motifs Kandinsky had distilled over the years can still be deciphered, such as the glyph of a boat with three oars at the lower left, a sign of the biblical floods. He did not intend these hieroglyphic forms to be read literally, so he veiled them in washes of brilliant color. Though the artist carefully prepared this large work with many preliminary drawings and oil sketches, he preserved a sense of spontaneous, unpremeditated freedom in the final painting.

In 1914 the cataclysm of World War I forced Kandinsky to return to Russia, and, shortly thereafter, another phase of his career began (discussed in Chapter 9), a pattern repeated in the careers of many artists at this time. In looking at the work of the other members of Der Blaue Reiter up to 1914, we should recall that the individuals involved were not held together by common stylistic principles but rather constituted a loose association of young artists, enthusiastic about new experiments and united in their oppositions. Aside from personal friendships, it was Kandinsky who gave the group cohesion and direction. In the yearbook *Der Blaue Reiter*, edited by Kandinsky and Marc, which appeared in 1912 and served as a forum for the opinions of the group, the new experiments of Picasso and Matisse in Paris were discussed at length, and the aims and conflicts of the new German art associations were described. In the creation of the new culture and new approach to painting, much importance was attached to the influence of so-called "primitive" and "naive" art.

Münter

Gabriele Münter (1877–1962) became acquainted with Kandinsky in 1902 as a student at the Phalanx School, which he had founded in order to teach progressive art precepts in accord with the ideas of the Arts and Crafts Movement and *Jugendstil*. They soon became engaged, but never married, devoting their first few years together to travel and artmaking. Their time in Paris was particularly influential. Münter continued her artistic experimentation during this period, and some of her linocuts were exhibited at the 1907 Paris Salon d'Automne (fig. **6.17**). Once resettled in Munich in 1908, Münter exhibited with the

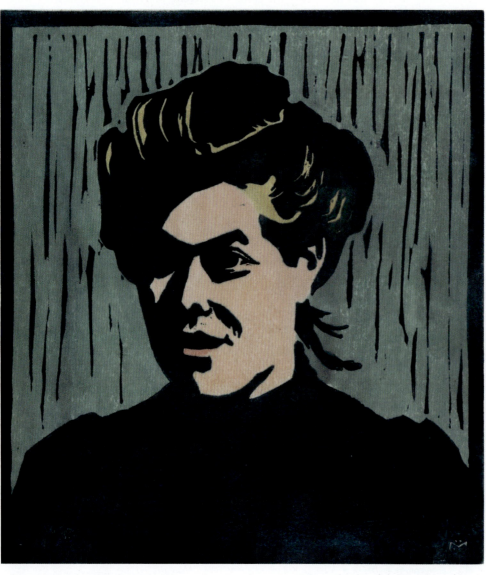

6.17 Gabriele Münter, *Aurelie*, 1906. Linocut, 7¼ × 6½" (18.3 × 16.6 cm). Städtische Galerie im Lenbachhaus, Munich.

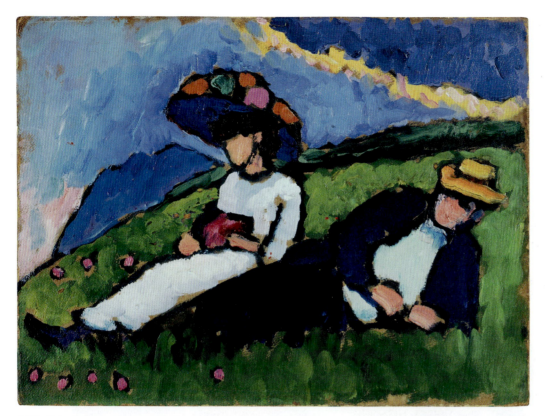

6.18 Gabriele Münter, *Alexej von Jawlensky and Marianne von Werefkin*, 1908–09. Oil on cardboard, 13 × 17½" (32.7 × 44.5 cm). Städtische Galerie im Lenbachhaus, Munich.

NKV, withdrawing from the group along with Kandinsky in 1911 to help found Der Blaue Reiter. She looked to nature and folk culture for her models, developing a personal style evocative of the *Hinterglasmalerei* technique she had explained to Kandinsky. Her portrait of her friends and fellow artists Alexej von Jawlensky and Marianne von Werefkin (fig. **6.18**) uses thick black outlines to subdivide the scene into discrete areas of vibrant, Fauve color, emulating the surface effects and spatial compression of *Hinterglasmalerei*. Despite its abstraction, the image functions successfully as an Expressionist portrait. Münter conveys through her bravura brushwork the warmth of the sunshine that dapples the grassy bank even as the figures' color and pose suggest a momentary alienation from one another. Only through probing observation can such an economic use of gesture transmit so much feeling.

Werefkin

One of several Russians to join Der Blaue Reiter, **Marianne von Werefkin** (1860–1938) pursued several years of academic study in Moscow and St. Petersburg before relocating to Munich in 1895 with her companion Alexej von Jawlensky. At first devoting herself to supporting Jawlensky's career, she resumed painting in 1902. She helped to found the NKV, but left to show with the more progressive Blaue Reiter artists in 1912. Her 1910 *Self-Portrait* (fig. **6.19**) contrasts fiercely with the pastoral image rendered by her friend Gabriele Münter (see fig. **6.18**). While the background hints at an outdoor setting and the pulsating carnation on her hat nods to the standard portrait convention

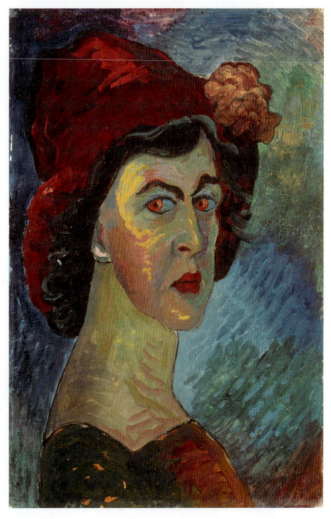

6.19 Marianne von Werefkin, *Self-Portrait*, 1910. Tempera on paper, 20 × 13½" (51 × 34 cm). Städtische Galerie im Lenbachhaus, Munich.

that associates female sitters with nature, Werefkin presents herself as anything but a decorative complement to the landscape. The cylindrical forms of her neck and hat anchor the composition, which vibrates with energetic brushwork and insistent color complements. Modeling her features with alternating strokes of vermilion, ocher, forest green, and even an acidic chartreuse, she engages the viewer with red eyes glowing like two cigarette tips. Here, the Expressionists' frank scrutiny of contemporary society is directed squarely by the artist at herself.

Marc

Of the Blaue Reiter painters, **Franz Marc** (1880–1916) was the closest in spirit to the traditions of German Romanticism and lyrical naturalism. In Paris in 1907 he sought personal solutions in the paintings of Van Gogh, whom he called the most authentic of painters. From an early date he turned to the subject of animals as a source of spiritual harmony and purity in nature. This became for him a symbol of that more primitive and arcadian life sought by so many of the Expressionist painters. Through his friend the painter August Macke, Marc developed, in about 1910, enthusiasm for colors whose richness and beauty were expressive also of the harmonies he was seeking. *The Large Blue Horses* of 1911 is exemplary of Marc's mature style (fig. **6.20**). The three brilliant blue beasts are fleshed out sculpturally from the equally vivid reds, greens, and yellows of the landscape. The artist used a close-up view, with the bodies of the horses filling most of the canvas. The horizon line is high, so that the curves of the red hills repeat the lines of the horses' curving flanks. Although the modeling of the animals gives them the effect of sculptured relief projecting

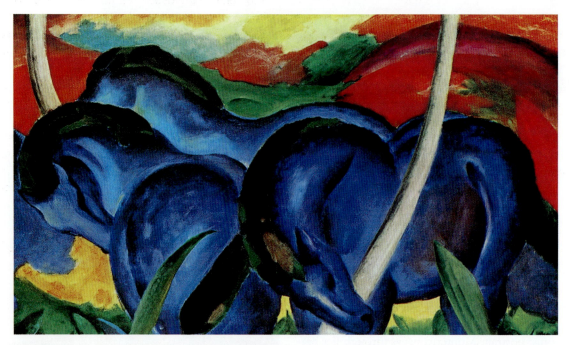

6.20 Franz Marc, *The Large Blue Horses*, 1911. Oil on canvas, 41⅝ × 71⁵⁄₁₆″ (105.7 × 181.1 cm). Walker Art Center, Minneapolis.

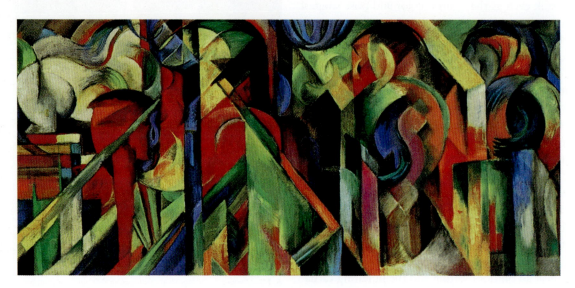

6.21 Franz Marc, *Stables*, 1913–14. Oil on canvas, 29⅛ × 62¼″ (74 × 158.1 cm). Solomon R. Guggenheim Museum, New York.

from a uniform background, there is no real spatial differentiation between creatures and environment, except that the sky is rendered more softly and less tangibly to create some illusion of distance. In fact, Marc used the two whitish tree trunks and the green foliage in front of and behind the horses to tie foreground and background together.

At this time Marc's color, like that of Kandinsky, had a specifically symbolic rather than descriptive function. Marc saw blue as a masculine principle, robust and spiritual; yellow as a feminine principle, gentle, serene, and sensual; red as matter, brutal and heavy. In the mixing of these colors to create greens and violets, and in their proportions one to the other on the canvas, the colors formed abstract shapes and took on spiritual or material significance independent of the subject. His approach to art was religious in a manner that could be described as pantheistic, although it is interesting that in his paintings only animals are assimilated harmoniously into nature—never humans. Unlike Kandinsky's, Marc's imagery was predominantly derived from the material world.

During 1911–12 Marc was absorbing the ideas and forms of the Cubists and finding them applicable to his own concepts of the mystery and poetry of color. In *Stables* (fig. **6.21**) he combined his earlier curvilinear patterns with a new rectangular geometry. The horses, massed in the frontal plane, are dismembered and recomposed as fractured shapes, dispersed evenly across the surface of the canvas. The forms are composed parallel to the picture plane rather than tilted in depth. Intense but light-filled blues and reds,

greens, violets, and yellows flicker over the structurally and spatially unified surface to create a dazzling illusion. Marc's use of color at this stage owed much to Macke, who frequently used the theme of people reflected in shop windows as a means of distorting space and multiplying images. In a group of small compositions from 1914 and in notebook sketches, there was evidence of a move to abstraction.

Macke

Of the major figures in Der Blaue Reiter, **August Macke** (1887–1914), despite his close association with and influence on Franz Marc, created work that was as elegantly controlled as it was expressive. Macke, like Marc, was influenced by Kandinsky and by the color concepts of Gauguin and Matisse.

After some Fauve- and Cubist-motivated exercises in semi-abstraction, Macke began to paint city scenes in high-keyed color, using diluted oil paint in effects close to that of watercolor. *Great Zoological Garden*, a **triptych** of 1912 (fig. **6.22**), is a loving transformation of a familiar scene into a fairyland of translucent color. Pictorial space is delimited by foliage and buildings that derive from the later watercolors of Cézanne. The artist moves easily from passages as abstract as the background architecture to passages as literally representational as the animals and the foreground figures. The work has a unity of mood that is light and charming, disarming because of the naive joy that permeates it.

Macke occasionally experimented with abstract organization, but his principal interest from 1912 to 1914 continued

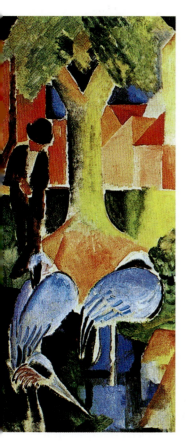
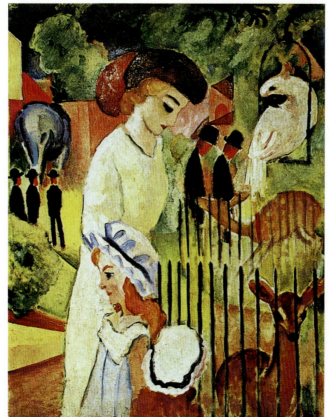
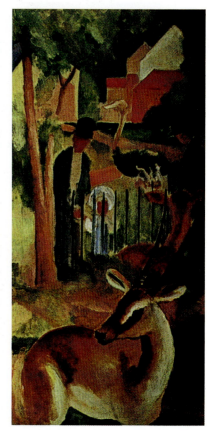

6.22 August Macke, *Great Zoological Garden*, 1912. Oil on canvas, 4′ 3⅛″ × 7′ 6¾″ (1.3 × 2.3 m). Museum am Ostwall, Dortmund, Germany.

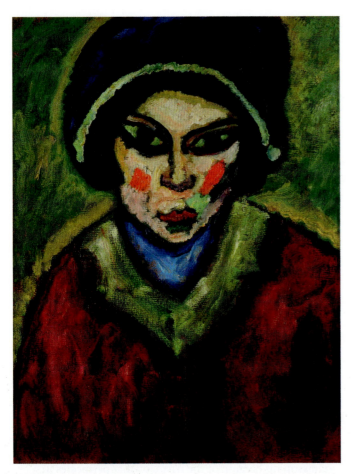

6.23 Alexej von Jawlensky, *Madame Turandot*, 1912. Oil on canvas, 23 × 20″ (58.4 × 50.8 cm). Collection Andreas Jawlensky, Locarno, Switzerland.

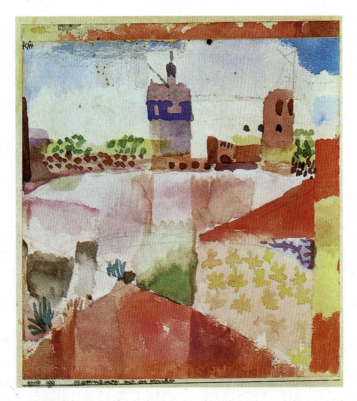

6.24 Paul Klee, *Hammamet mit der Moschee* (*Hammamet with the Mosque*), 1914. Watercolor and pencil on paper on cardboard, 8⅛ × 7½″ (20.6 × 19.1 cm). The Metropolitan Museum of Art, New York. The Berggruen Klee Collection.

✳ — Explore more about Paul Klee on mysearchlab.com

to be his cityscapes, which were decorative colored impressions of elegant ladies and gentlemen strolling in the park or studying the wares in brightly lit shop windows. In numerous versions of such themes, he shows his fascination with the mirror-like effects of windows as a means of transforming the perspective space of the street into the fractured space of Cubism.

Jawlensky

Alexej von Jawlensky (1864–1941) was well established in his career as an officer of the Russian Imperial Guard before he decided to become a painter. After studies in Moscow he took classes in the same studio in Munich as Kandinsky. Although not officially a member of Der Blaue Reiter, Jawlensky was sympathetic to its aims and continued for years to be close to Kandinsky. After the war he formed the group called Die Blaue Vier (The Blue Four), along with Kandinsky and other former members of Der Blaue Reiter.

By 1905 Jawlensky was painting in a Fauve palette, and his drawings of nudes of the next few years are suggestive of Matisse. About 1910 he settled on his primary theme, the portrait head, which he explored thenceforward with mystical intensity. *Madame Turandot* is an early example (fig. **6.23**), painted in a manner that combines characteristics of Russian folk painting and Russo-Byzantine icons—sources that would dominate Jawlensky's work.

Klee

Paul Klee (1879–1940) was one of the most varied, influential, and brilliant talents of the twentieth century. His stylistic development is difficult to trace, since the artist continually re-examined his themes and forms to arrive at a reality beyond the visible world. He developed a visual language seemingly limitless in its invention and in the variety of its formal means. His complex language of personal signs and symbols evolved through private fantasy and a range of interests from plant and zoological life to astronomy and typography. Also interested in music, he wanted to create imagery infused with the rhythms and counterpoint of musical composition, saying that color could be played like a "chromatic keyboard."

Klee was born in Switzerland. The son of a musician, he was initially inclined toward music, but having decided on the career of painting, went to Munich to study in 1898. During the years 1903–06 he produced a number of etchings that in their precise, hard technique suggest the graphic tradition of the German Renaissance, in their mannered linearity Art Nouveau, and in their mad fantasy a personal vision reflecting the influence of the Expressionist printmaker Alfred Kubin. These were also among the first of Klee's works in which the title formed an integral part of his creative work. Klee brought tremendous verbal skill and wit to his paintings, drawings, and prints, using letters and words literally as formal devices in his compositions, which he then gave a literary dimension with poetic and often humorous titles.

Between 1901 and 1905 Klee traveled extensively in Italy and France and probably saw works by Matisse. Between

1908 and 1910 he became aware of Cézanne, Van Gogh, and the beginnings of the modern movement in painting. In 1911 he had a solo exhibition at the Thannhauser Gallery in Munich and in the same year met the Blaue Reiter painters. Over the next few years he participated in the Blaue Reiter exhibitions, wrote for progressive art journals, and returned to Paris in 1912 when he saw further paintings by Picasso, Braque, and Henri Rousseau.

He took a trip with Macke to Tunis and other parts of North Africa in 1914. Like Delacroix and other Romantics before him, he was affected by the brilliance of the region's light and the color and clarity of the atmosphere. To catch the quality of the scene Klee, like Macke, turned to watercolor and a form of semi-abstract color pattern based on a Cubist grid, a structure he frequently used as a linear scaffolding for his compositions (fig. **6.24**). Although he made larger paintings, he tended to prefer small-scale works on paper. Klee had a long and fertile career, the later phases of which involved him in the Bauhaus at Weimar (see Ch. 13, pp. 282–85).

Feininger

Although **Lyonel Feininger** (1871–1956) was born an American of German-American parents, as a painter he belongs within the European orbit. The son of distinguished musicians, he was, like Klee, early destined for a musical career. But before he was ten he was drawing his impressions of buildings, boats, and elevated trains in New York City. He went to Germany in 1887 to study music, but soon turned to painting. In Berlin between 1893 and 1905 Feininger earned his living as an illustrator and caricaturist for German and American periodicals, developing a brittle, angular style of figure drawing related to aspects of Art Nouveau, but revealing a very distinctive personal sense of visual satire. The years 1906–08, in Paris, brought him in touch with the early pioneers of modern French painting. By 1912–13 he had arrived at his own version of Cubism, particularly the form of Cubism with which Marc was then experimenting. Feininger was invited to exhibit with Der Blaue Reiter in 1913. In *Harbor Mole* of 1913 (fig. **6.25**),

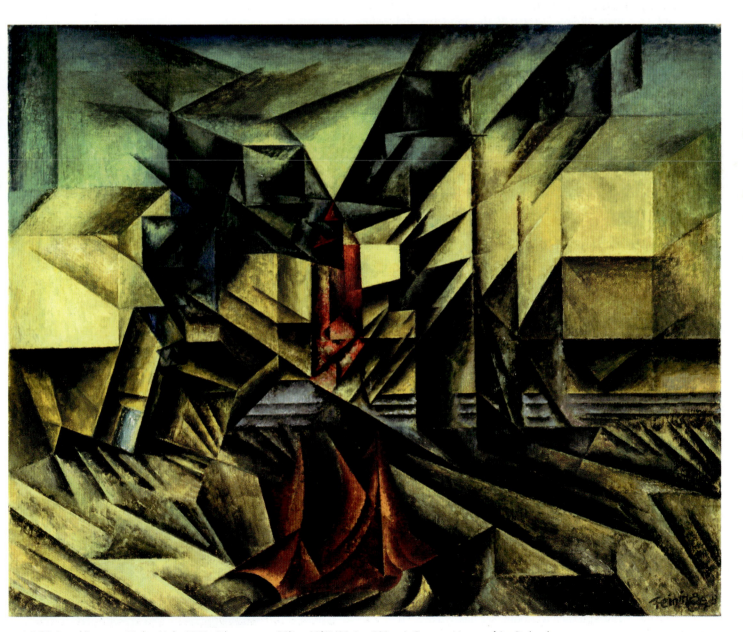

6.25 Lyonel Feininger, *Harbor Mole*, 1913. Oil on canvas, 31¾ × 39¾" (80.6 × 101 cm). Carnegie Museum of Art, Pittsburgh.

he recomposed the scene of a breakwater into a scintillating interplay of color facets, geometric in outline but given a sense of rapid change by the transparent, delicately graded color areas. In this work Feininger stated in a most accomplished manner the approach he was to continue, with variations, throughout the rest of his long life: that of strong, straight-line structure played against sensuous and softly luminous color. The interplay between taut linear structure and Romantic color, with space constantly shifting between abstraction and representation, created a dynamic tension in his paintings.

Germany's entry into World War I put an end to the exhibitions of Der Blaue Reiter and the publication of their yearbook. The artists dispersed, with German citizens like Klee, Marc, and Macke sent into military service. Macke was killed within weeks; Marc survived until 1916, only to be killed at Verdun. Münter relocated to Sweden, Jawlensky and Werefkin took refuge in Switzerland, and Kandinsky returned to Russia. Even before the war, another center for avant-garde activity had taken its place alongside Die Brücke and Der Blaue Reiter. In 1912, the musician and critic Herwarth Walden opened a gallery in Berlin for avant-garde art, the Galerie Der Sturm, using the name of the avant-garde art journal *Der Sturm* ("The Storm"), which he had founded in 1910. At the gallery, he exhibited Kandinsky and Der Blaue Reiter, Die Brücke and the Italian Futurists, and grouped as "French Expressionists" the artists Braque, Derain, Vlaminck, Auguste Herbin, and others. Also shown were Ensor, Klee, and Robert Delaunay. In 1913 came the climax of the Galerie Der Sturm's exhibitions, the First German Autumn Salon, including 360 works. Henri Rousseau's room contained twenty paintings, and almost the entire international range of experimental painting and sculpture at that moment was shown. Although during and after the war the various activities of Der Sturm lost their impetus, Berlin between 1910 and 1914 remained a rallying point for most of the new European ideas and revolutionary movements, largely through the leadership of Walden.

Expressionist Sculpture

With the exception of such older masters as Maillol, the tradition of Realist or Realist–Expressionist sculpture flourished more energetically outside France than within after 1910. The human figure was so thoroughly entrenched as the principal vehicle of expression for sculptors that it was even more difficult for them to depart from it than for painters to depart from landscape, figure, or still life. It was also difficult for sculptors to say anything new or startlingly different from what had been said before. Expressionist sculptors came closest to investing the subject with new relevance and vigor. In Germany the major figure was **Wilhelm Lehmbruck** (1881–1919). After an academic training, Lehmbruck turned for inspiration first to the Belgian sculptor of miners and industrial workers Constantin Meunier (see fig. 3.19), and then to Rodin (see figs. 3.15, 3.16, 3.17, 3.18). During the four years he spent in Paris, between

1910 and 1914, Lehmbruck became acquainted with Matisse, Brancusi, and Aleksandr Archipenko. His *Kneeling Woman* (fig. **6.26**) of 1911 reveals the influence of Maillol, as well as classical Greek sculpture. The emotional power of Lehmbruck's work, however, comes not from his studies of the past but from his own sensitive and melancholy personality. His surviving works are few, for the entire oeuvre belongs to a ten-year period. In *Seated Youth* (fig. **6.27**), his last monumental work, the artist utilized extreme elongation—possibly suggested by figures in Byzantine mosaics and Romanesque sculpture—to convey a sense of contemplation and withdrawal. This work represents a departure from Maillol and from a nineteenth-century tradition that emphasized volume and mass. Lehmbruck's figure, with its long, angular limbs, is penetrated by space, and exploits for expressive ends the abstract organization of solids and voids. With its mood of dejection and loss, *Seated Youth* expresses the trauma and sadness Lehmbruck experienced in Germany during World War I—suffering that finally, in 1919, led him to suicide.

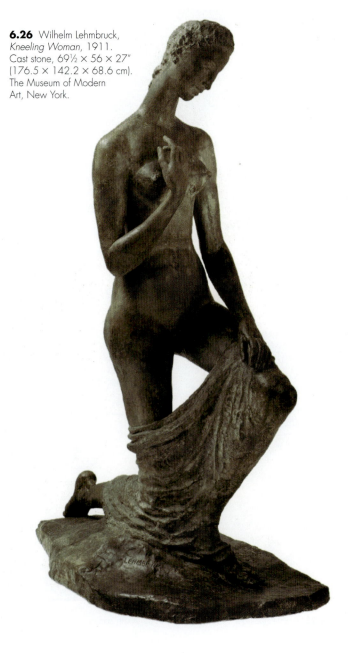

6.26 Wilhelm Lehmbruck, *Kneeling Woman*, 1911. Cast stone, 69½ × 56 × 27" (176.5 × 142.2 × 68.6 cm). The Museum of Modern Art, New York.

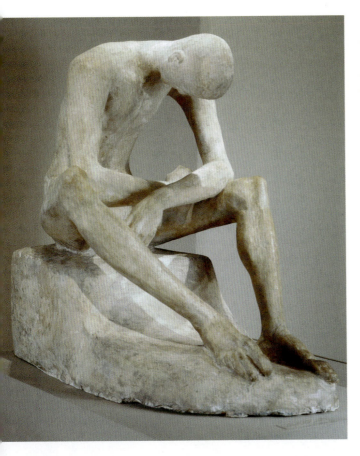

6.27 Wilhelm Lehmbruck, *Seated Youth*, 1917. Composite tinted plaster, 40⅝ × 30 × 45½″ (103.2 × 76.2 × 115.5 cm). National Gallery of Art, Washington, D.C.

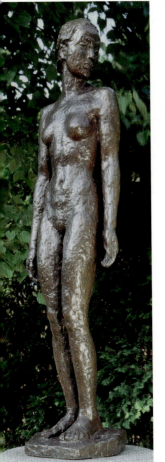

6.28 Georg Kolbe, *Young Woman*, 1926. Bronze, height 50⅝″ (128.6 cm). Walker Art Center, Minneapolis.

Other leading German sculptors of the early twentieth century included **Georg Kolbe** (1877–1941) and Ernst Barlach. Kolbe began as a painter but developed an interest in sculpture during a two-year stay in Rome. His later encounter with Rodin's work in Paris had considerable impact on his work. For his figures or portrait heads, Kolbe combined the formal aspects of Maillol's figures with the light-reflecting surfaces of Rodin's. After some essays in highly simplified figuration, Kolbe settled into a lyrical formula of rhythmic nudes (fig. **6.28**)—appealing, but essentially a Renaissance tradition with a Rodinesque broken surface. His depictions in the 1930s of heroic, idealized, and specifically Nordic figures now seem uncomfortably compatible with the Nazis' glorification of a "master race."

In addition to making sculpture carved from wood or cast in bronze, **Ernst Barlach** (1870–1938) was an accomplished poet, playwright, and printmaker. Although, like Lehmbruck, he visited Paris, he was not as strongly influenced by French avant-garde developments. His early work took on the curving forms of *Jugendstil* and aspects of medieval German sculpture. In 1906 he traveled to Russia, where he was deeply impressed by the peasant population, and his later sculptures often depicted Russian beggars or laborers. Once he was targeted as a "degenerate artist" by the Nazi authorities in the 1930s, Barlach's public works, including monumental sculptures for cathedrals, were dismantled or destroyed. He was capable of works of sweeping power and the integration in a single image of humor, pathos, and primitive tragedy, as in *The Avenger* (fig. **6.29**). His was a storytelling art, a kind of socially conscious Expressionism that used the outer forms of contemporary experiment for narrative purposes.

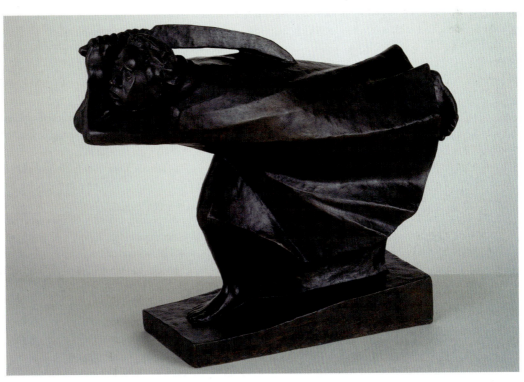

6.29 Ernst Barlach, *The Avenger*, 1914. Bronze, 17¼ × 23 × 8¼″ (43.8 × 58.4 × 21 cm). Hirshhorn Museum and Sculpture Garden, Smithsonian Institution, Washington, D.C.

Self-Examination: Expressionism in Austria

To understand the various directions in which Expressionism developed, we may look at two artists who were associated in some degree with Expressionism in Austria, where its practitioners were never formally organized into a particular group. Like Klee and Feininger, the Austrians Egon Schiele and Oskar Kokoschka each had a highly individualized interpretation of the style.

Schiele

Egon Schiele (1890–1918) lived a short and tragic life, dying in the worldwide influenza epidemic of 1918. He was a precocious draftsman and, despite opposition from his uncle (who was his guardian after his father died insane, an event that haunted him), studied at the Vienna Academy of Art. His principal encouragement came from Gustav Klimt (see Ch. 4, pp. 77–78), at his height as a painter and leader of the avant-garde in Vienna when they met in 1907. The two artists remained close, but although Schiele was deeply influenced by Klimt, he did not fully share his inclination toward the decorative.

Schiele's many self-portraits rank among his supreme achievements. They range from self-revelatory documents of personal anguish to records of a highly self-conscious and youthful bravado. *Schiele, Drawing a Nude Model before a Mirror* (fig. **6.30**) demonstrates his extraordinary natural skill as a draftsman. The intense portrayal, with the artist's

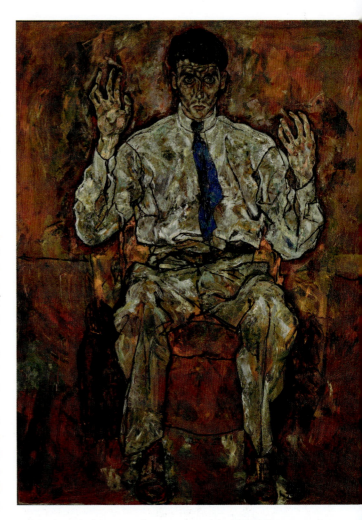

6.31 Egon Schiele, *Portrait of Paris von Gütersloh*, 1918. Oil on canvas, 55⅛ × 43⁷⁄₁₆" (140 × 110.3 cm). Minneapolis Institute of Arts. Gift of the P. D. MacMillan Land Company.

narrowed gaze and the elongated, angular figure of the model, differs from even the most direct and least embellished of Klimt's portraits. Here Schiele explores the familiar theme of the artist and model, but does so to create an atmosphere of psychological tension and explicit sexuality. Schiele's models included his sister Gerti, as well as friends, professional models, and prostitutes. But when, albeit innocently, in 1912 he sought out children for models in his small village, he was imprisoned for twenty-four days for "offenses against public morality."

A comparison of paintings by Klimt and Schiele is valuable in illustrating both the continuity and the change between nineteenth-century Symbolism and early twentieth-century Expressionism. Klimt's painting *Adele Bloch-Bauer I* (see fig. 4.12) subsumes its sitter within rich and colorful patterns. Schiele's unfinished *Portrait of Paris von Gütersloh* (fig. **6.31**), painted in 1918, is comparable in subject, but the approach could not be more different. Both portraits give special attention to their sitters' hands: a gesture reminiscent of prayer in the Byzantine-influenced portrait by Klimt and a similarly suggestive gesture of religious ecstasy on the part of Schiele's friend Gütersloh, a painter and writer. Yet in contrast to the still, geometric design that locks Bloch-Bauer in place, Gütersloh's entire body seems animated by a

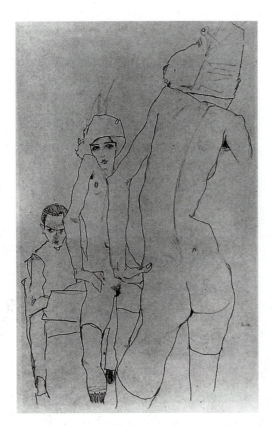

6.30 Egon Schiele, *Schiele, Drawing a Nude Model before a Mirror*, 1910. Pencil on paper, 21¾ × 13⅞" (55.2 × 35.2 cm). Graphische Sammlung Albertina, Vienna.

nervous energy. The paint is built up in jagged brushstrokes of harsh and dissonant tones of ocher, red, and cobalt.

Far from enveloping the sitter, Schiele's background functions as an undulating, animated counterpart to his friend. Thus, the fluid, seemingly timeless monumentality of Klimt's *Adele Bloch-Bauer I* confronts in Gütersloh a frenetic, continuously evolving modern portrait, in which medium and technique are used to reveal psychology as much as physical likeness.

Kokoschka

Oskar Kokoschka (1886–1980), like Schiele, was a product of Vienna, but he soon left the city, which he found gloomy and oppressive, for Switzerland and Germany, embracing the larger world of modern art to become one of the international figures of twentieth-century Expressionism. Between 1905 and 1908 Kokoschka worked in the Viennese Art Nouveau style, showing the influence of Klimt and Aubrey Beardsley (see fig. 4.7). Even before going to Berlin at the invitation of Herwarth Walden of Galerie Der Sturm in 1910, he was instinctively an Expressionist. Particularly in his early "black portraits," he searched passionately to expose an inner sensibility—which may have belonged more to himself than to his sitters. Among his very first images is the 1909 portrait of his friend the architect Adolf Loos (fig. 6.32), who early on recognized Kokoschka's talents and provided him with moral as well as financial support. The figure projects from its dark background, and the tension in the contemplative face is echoed in Loos's nervously clasped hands. The Romantic basis of Kokoschka's early painting appears in *The Tempest* (fig. 6.33), a double portrait of himself with his lover, Alma Mahler, in which the two figures, composed with flickering, light-saturated brushstrokes, are swept through a dream landscape of cold blue mountains and valleys lit only by the gleam of a shadowed moon. The painting was a great success when Kokoschka exhibited it in the 1914 New Munich Secession. The year before, he wrote to Alma about the work, then in progress: "I was able to express the mood I wanted by reliving it. … Despite all the turmoil in the world, to know that one person can put eternal trust in another, that two people can be committed to themselves and other people by an act of faith."

Mahler's decision to end their relationship in 1915 shattered Kokoschka, who, some four years later, commissioned

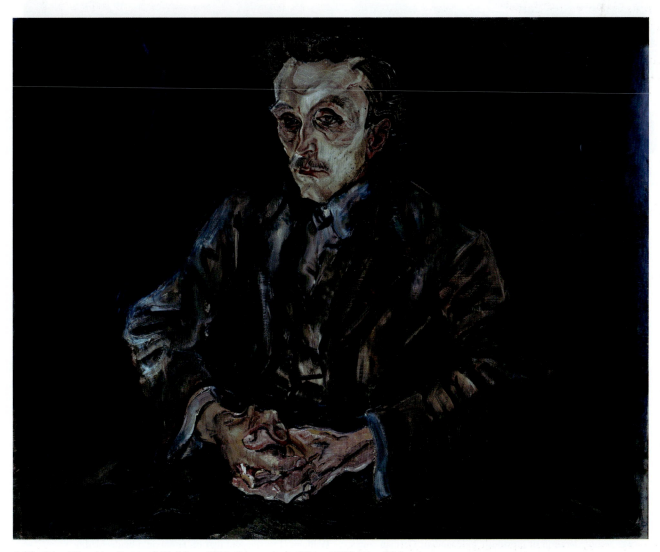

6.32 Oskar Kokoschka, *Portrait of Adolf Loos*, 1909. Oil on canvas, 29⅛ × 35⅞″ (74 × 91.1 cm). Staatliche Museen zu Berlin, Preussischer Kulturbesitz, Nationalgalerie.

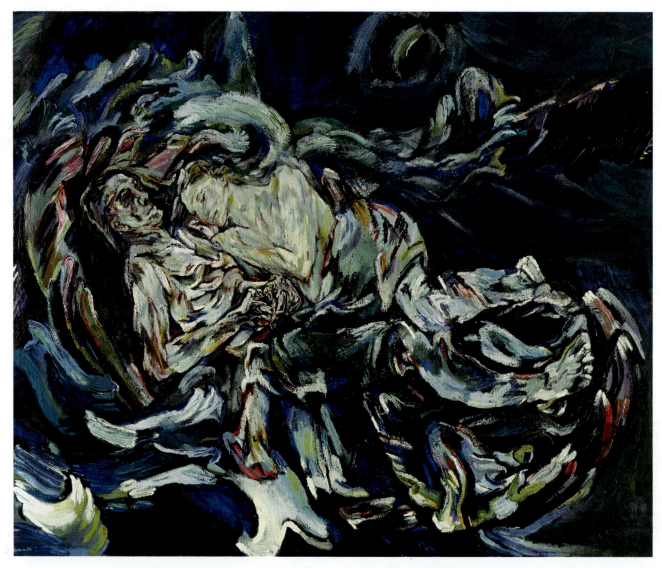

6.33 Oskar Kokoschka, *The Tempest*, 1914. Oil on canvas, 5′ 11¼″ × 7′ 2⅝″ (1.81 × 2.2 m). Öffentliche Kunstsammlung, Kunstmuseum Basel.

The German Empire

As disastrous as the Franco–Prussian War had been for Napoléon III of France, it was a well-calculated success for the Prussian prime minister, Otto von Bismarck. Bismarck had counted on Napoléon III's willingness to go to war with his German neighbors, if only to confirm his legitimacy as the successor to his uncle, the famed general Napoléon Bonaparte. Bismarck provoked Napoléon III by maneuvering a relative of the Prussian King Wilhelm I into possible succession to the Spanish throne. When the French ambassador met with Wilhelm to persuade him to withdraw Prussian claims to rule Spain, the king dictated a measured response for his prime minister to convey to France. Bismarck changed Wilhelm's calm language into a fiery, provocative retort and the French emperor declared war. Prussia's mechanized army quickly decimated the French lines, and Napoléon III was captured on August 31, 1870, just six weeks into the war. The resulting victory led to the formation of the German Empire, in which Prussia assumed leadership over a confederation of previously independent German states.

King Wilhelm became Kaiser, or emperor, of the Germans, and Bismarck served as his chancellor. Accelerating even further Northern Europe's industrialization, Bismarck made Germany the wealthiest, most literate, and most urban nation in Europe. To accomplish this, though, he drafted an oppressive constitution, designed to minimize the strength of opposition. Shortly after succeeding to the imperial throne, Wilhelm II dismissed Bismarck, fearing that his authoritarian policies would lead to an insurrection. Even with Bismarck's departure, the German Empire continued its industrial and military growth, but without addressing realistically the demands of its new and enormous working-class population. Political and social tensions mounted until Wilhelm II entered World War I under pressure from his generals, whom he had long mollified by building up the army and navy. Unable to manage any longer the uncertain balance he had achieved among his generals, the working class, political dissidents, wealthy manufacturers, and powerful landowners, Wilhelm II would find that his fate would be decided by war.

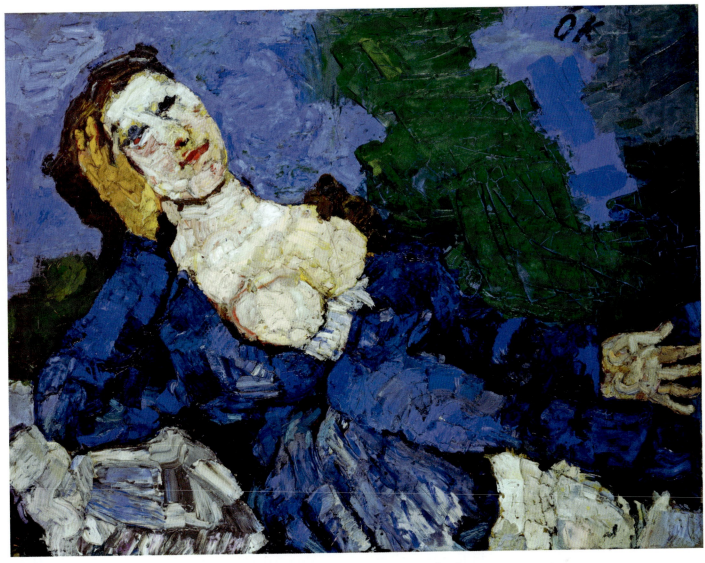

6.34 Oskar Kokoschka, *Woman in Blue*, 1919. Oil on canvas, 30¾ × 40½" (78 × 103 cm). Staatsgalerie Stuttgart.

a Munich mannequin- and doll-maker to fabricate a convincing substitute. Despite detailed instructions, the final product was less than satisfying. In trying to emulate the texture of skin, the artisan had applied downy feathers to the doll's exterior, but this only heightened its artificiality. The dejected Kokoschka used the doll as a prop in several paintings (fig. **6.34**), creating a series of works whose eerie quality would not again be matched until the Surrealists began in earnest to elicit states of psychological unease from their viewers. Kokoschka's emotional difficulties were not solely due to his failed relationship with Mahler; service in World War I compounded his fragile emotional state. Seriously wounded in the war, Kokoschka produced little for several years, but his ideas and style were undergoing constant change. In 1924 he abruptly set out on some seven years of travel, during which he explored the problem of landscape, combining free, arbitrary, and brilliant Impressionist or Fauve color with a traditional perspective in which space is organized in clear fore-, middle-, and background planes. Throughout his long life Kokoschka remained true to the spirit of Expressionism—to the power of emotion and the deeply felt sensitivity to the inner qualities of nature and the

human soul. In 1933, in financial difficulties, the painter returned from his long travels, going first to Vienna and then to Prague. During this period his works in public collections in Germany were confiscated by the Nazis as examples of "degenerate art." In 1938, as World War II approached, London became his home, and later Switzerland, although whenever possible he continued his restless traveling.

But in the 1910s, when German Expressionism emerged, the calamitous world wars and Depression of the next decades were unimaginable. Germany was an empire with expanding territorial claims and a booming industrial economy (see *The German Empire*, opposite). While many in Germany—including most of the Expressionists—feared the imperial ambitions of their government, artists working in France were experiencing a different cultural atmosphere. Forthrightly political statements had receded from progressive French art since the apogee of Realism in the nineteenth century. Formal questions seemed to propel the work of the Fauves, just as they appeared to many viewers to be the only concern of the Cubists. Yet even in Cubist works the social and cultural conditions of the *fin de siècle* can be discerned.

7
Cubism

Modern artists rested on the brink of total abstraction in 1910. Whether in pursuit of pure emotion or aesthetic autonomy, progressive artists were abandoning the tradition of naturalism that had guided the visual arts since the Renaissance. Expressionists like Kandinsky sought to trigger emotional or spiritual experiences through their art. The fundamental problem, for Kandinsky, rested with the West's attachment to **mimesis**, which reproduces aspects of the visible world. Kandinsky wanted his art to prompt viewers to contemplate a higher, spiritual realm, not remind them of their earthly concerns. In music he found an art form free from the shackles of imitation. Thus, Kandinsky treated color, line, and form as visual counterparts to notes, chords, rhythms, and harmonies arranged to elicit a specific emotional response.

In the case of the Fauves, the desire to elevate a work's formal attributes to a footing equal, if not superior, to its subject led painters like Matisse to liberate color, line, form, and space from their status as mere tools for documenting the visible world. One way to understand Matisse's strategy is to compare his approach to that of a poet. Poets choose words as much for their sounds and rhythms as for their meanings. For this reason, poetry can seem abstruse or even incomprehensible without prolonged consideration. Matisse likewise uses each of the formal elements at his disposal to fulfill a specific aesthetic need, allowing visual harmony to take precedence over the naturalism or narrative clarity of his work.

As these examples show, abstraction served a variety of ends. The degree to which an artist moved toward abstraction depended on his or her aesthetic aims. For an artist in search of spiritual transcendence, like Kandinsky, pure or "strong" abstraction ultimately best served his goals. Strong abstraction does not proceed from the observation of a real-world model; it is instead generated wholly by the artist's imagination. For most avant-garde artists working in the early twentieth century, though, abstraction was simply a means of distilling to its essential qualities a form observed in the real world. Referred to as "weak" abstraction, this approach demanded from artists the same level of engagement with nature and visual phenomena required since the Renaissance.

Cubism, more than any other avant-garde movement of the early twentieth century, reveals the degree to which modern artists were conscious of their relationship to artistic conventions born in the Renaissance. A form of weak abstraction, Cubism maintained an emphatic hold on the physical world. Rather than challenging the significance of material reality—as Expressionists such as Kandinsky and Marc were doing—Cubists Georges Braque and Pablo Picasso questioned the means by which this reality was understood and represented. They were not the only ones re-examining conventional accounts of the physical world. In 1905, Albert Einstein published his special theory of relativity, which asserts that neither space nor time is a fixed, stable measure. Both space and time are elastic, changing in relation to the speed and position of an observer. Accounts of a possible fourth dimension—where a body could move through time just as a human being moves through space—were circulated. Though poorly understood by laymen like Picasso and Braque, the notion that space and time were essentially the same was very exciting and certainly motivated some of their thinking.

More accessible were the ideas of the philosopher Henri Bergson, whose theories on the nature of consciousness were published in *Matter and Memory* (1896) and quickly popularized in Europe and North America. Among Bergson's key points was his assertion that consciousness is the accumulation of experiences. In other words, no rational being can ever experience a single instant of time: the past, present, and future are not separate moments of awareness but an unbreakable continuum. Perception, Bergson explained, was also an experience of duration, leading artists like the Cubists to create artworks addressed to this model.

The invention of Cubism was truly a collaborative affair, and the close, mutually beneficial relationship between Picasso and Braque was arguably the most significant of its kind in the history of art. According to Braque, it was "a union based on the independence of each." We have seen how much of the modern movement was the result of collective efforts between like-minded artists, as with the Fauves in France (see Ch. 5, pp. 90–102) or Die Brücke or Der Blaue Reiter in Germany (see Ch. 6, pp. 114–30). But there was no real precedent for the intense level of professional exchange that took place between Picasso and Braque, especially from 1908 to 1912, when they were in close, often daily contact. "We were like two mountain climbers roped together," Braque

said. Picasso called him "pard," in humorous reference to the Western novels they loved to read (especially those about Buffalo Bill), or "Wilbur," likening their enterprise to that of the American aviation pioneers Wilbur and Orville Wright. In collaborating, each brought his own experiences and abilities to bear. Whereas Picasso was impulsive, prolific, and anarchic, Braque was slow, methodical, and meditative. Their backgrounds and training were also quite different. Thus, to understand fully the sources of Cubism, their early careers must first be treated individually.

Immersed in Tradition: Picasso's Early Career

Pablo Ruiz Picasso (1881–1973) was born in the provincial town of Málaga in southern Spain. Though an Andalusian by birth (and a resident of France for most of his life), he always identified himself as a Catalan, from the more industrialized, sophisticated city of Barcelona, where the family moved when he was thirteen. Picasso's father was a painter and art teacher who gave his son his earliest instruction. Though Picasso was no child prodigy, by the age of fourteen he was making highly accomplished portraits of his family.

Barcelona and Madrid

In the fall of 1895, when his father took a post at Barcelona's School of Fine Arts, the young Picasso was allowed to enroll directly in the advanced courses. At his father's urging, Picasso next spent eight or nine months in Madrid in 1897, where he enrolled at but rarely attended the Royal Academy of San Fernando, the most prestigious school in the country. He studied Spain's Old Masters at the great Prado Museum, admiring especially Diego Velázquez, whose work he copied. Picasso suffered serious poverty in Madrid and chafed under the strictures of academic education, already setting his sights on Paris. First, however, he returned for a time to Barcelona. As the capital of Catalonia, a region fiercely proud of its own language and cultural traditions, Barcelona was undergoing a modern renaissance. Its citizens were striving to establish their city as the most prosperous, culturally enlightened urban center in Spain. At the same time, poverty, unemployment, and separatist sentiments gave rise to political unrest and strong anarchist tendencies. As in Madrid, the latest artistic trend in Barcelona was *modernista*, a provincial variation on Art Nouveau and Symbolism (see fig. 4.15) practiced by young progressive artists that left its mark on Picasso's early work.

Picasso's work from this period was in step with the pessimistic mood that permeated international Symbolist art toward the end of the century, as seen in the melancholic soul sickness of works by artists such as Aubrey Beardsley (see fig. 4.7) and Edvard Munch (see fig. 4.24). Picasso's preoccupation with poverty and mortality was to surface more overtly in the work of his so-called Blue Period.

Blue and Rose Periods

In 1900 one of Picasso's paintings was selected to hang in the Spanish Pavilion of the Universal Exposition in Paris. At age nineteen he traveled to the French capital for the first time with his friend and fellow painter Carles Casagemas. Picasso, who spoke little French, took up with a community of mostly Catalan artists in Paris and soon found benefactors in two dealers, Pedro Mañach, a fellow Catalan, and Berthe Weill, also an early collector of works by Matisse. She sold the first major painting Picasso made in Paris, *Le Moulin de la Galette* (fig. 7.1), a vivid study of closely packed figures in the famous dance hall in Montmartre. Although he no doubt knew Renoir's Impressionist rendition of the same subject (see fig. 2.31), Picasso rejected its sun-dappled congeniality in favor of a nocturnal and considerably more sinister view. This study of figures in artificial light relates to the dark, **tenebrist** scenes typical of much Spanish art at the time, but the seamy ambience recalls the work of Degas or Toulouse-Lautrec, both shrewd chroniclers of Parisian café life.

Picasso's friend Casagemas became completely despondent over a failed love affair after the artists arrived back in Spain. He eventually returned to Paris without Picasso and, in front of his friends, shot himself in a restaurant. Picasso experienced pangs of guilt for having abandoned Casagemas, and he later claimed that it was the death of his friend that prompted the gloomy paintings of his Blue Period. Between 1901 and 1904, in both Barcelona and

7.1 Pablo Picasso, *Le Moulin de la Galette*, 1900. Oil on canvas, 35½ × 46" (90.2 × 116.8 cm). Solomon R. Guggenheim Museum, New York.

Paris, Picasso used a predominantly blue palette in many works for the portrayal of figures and themes expressing human misery—frequently hunger and cold, the hardships he himself experienced as he was trying to establish himself. The thin, attenuated figures of Spain's sixteenth-century Mannerist painter El Greco found echoes in these works by Picasso, as did the whole history of Spanish religious painting, with its emphasis on mourning and physical torment.

A signal work of this period is the large allegorical composition Picasso made in Barcelona, *La Vie* (fig. **7.2**), for which he prepared several sketches. For the gaunt couple at the left Picasso depicted Casagemas and his lover, though

X-rays reveal that the male figure was originally a self-portrait. They receive a stern gaze from the woman holding a baby at the right, who emerged from studies of inmates Picasso had made in a Parisian women's prison (where he could avail himself of free models), many of them prostitutes suffering from venereal disease. By heavily draping the woman, he gives her the timeless appearance of a madonna, thus embodying in a single figure the contradictory view of women as either saints or seductresses, a tension likewise stereotyped in Symbolist images of the *femme fatale*. In their resemblance to a shamed Adam and Eve, the lovers (like their equivalent in the painting behind them) also yield

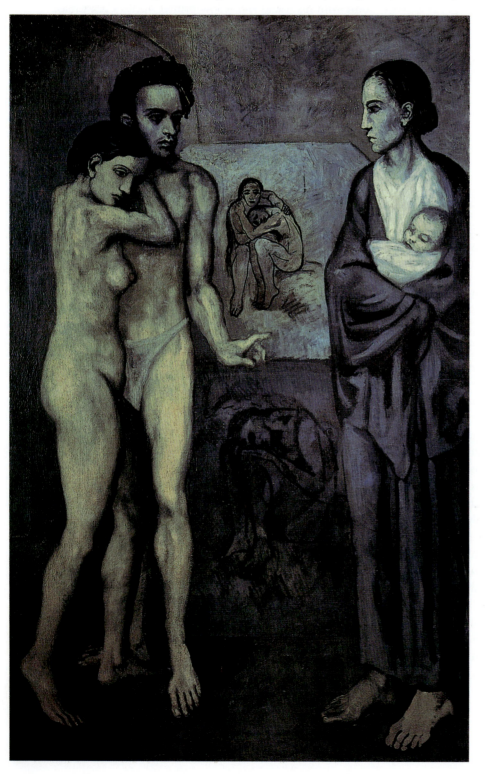

a religious reading. The pervasive blue hue of *La Vie* turns flesh into a cold, stony substance while compounding the melancholy atmosphere generated by the figures. In the spring of 1904 Picasso settled in Paris; he was never to live in Barcelona again. He moved into a tenement on the Montmartre hill dubbed by his friends the Bateau Lavoir ("laundry boat," after the ungainly laundry barges docked in the Seine), which was ultimately made famous by his presence there. Until 1909 Picasso lived at the Bateau Lavoir in the midst of an ever-growing circle of friends: painters, poets, actors, and critics, including the devoted Max Jacob, who was to die in a concentration camp during World War II, and the poet Guillaume Apollinaire, who was to become the literary apostle of Cubism.

Among the first works Picasso made upon arriving in Paris in 1904 is a macabre pastel in which a woman with grotesquely elongated fingers and hunched shoulders kisses a raven (fig. **7.3**). The subject evokes Edgar Allan Poe, a favorite writer among *fin-de-siècle* Parisian artists, particularly Odilon Redon, whose own brilliant pastels may have been a source for Picasso's. The model for *Woman with a Crow* was an acquaintance who had trained her pet bird to scavenge crumbs from the floors of the Lapin Agile (Nimble Rabbit), a working-class cabaret in Montmartre frequented by the artist and his entourage. Her skeletal form is silhouetted against an intense blue, but the chilly hues and downcast mood of the Blue Period were

7.2 Pablo Picasso, *La Vie* (*Life*), 1903. Oil on canvas, 6′ 5⅜″ × 4′ 2⅜″ (2 × 1.29 m). The Cleveland Museum of Art. Gift of Hanna Fund. 1945.24.

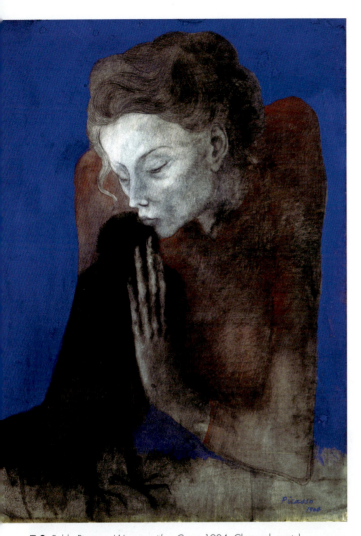

7.3 Pablo Picasso, *Woman with a Crow*, 1904. Charcoal, pastel, and watercolor on paper, 25½ × 19½" (64.7 × 49.5 cm). Toledo Museum of Art, Toledo, Ohio.

Like his predecessor Daumier, Picasso chose not to depict the *saltimbanque* in the midst of boisterous acrobatics but during moments of rest or quiet contemplation. His supreme achievement in this genre is *Family of Saltimbanques* (fig. **7.4**); at seven-and-a-half feet tall (2.3 m), it was the largest painting he had yet undertaken and stands as a measure of his enormous ambition and talent in the early years of his career. He made several preparatory studies, and X-rays reveal that at least four variations on the final composition exist beneath the top paint layer. The painting began as a family scene, with women engaging in domestic chores and Harlequin (the figure seen here at the far left) watching a young female acrobat balance on a ball. But in the end Picasso settled upon an image virtually devoid of activity, in which the characters, despite their physical proximity, hardly take note of one another. Stripped of anecdotal details, the painting gains in poetry and mystery. The acrobats gather in a strangely barren landscape painted in warm brown tones that the artist loosely brushed over a layer of blue paint. An enigmatic stillness has replaced the heavy pathos of the Blue Period pictures, just as the predominant blues of the earlier work have shifted to a delicately muted palette of earth tones, rose, and orange.

The identities of the individual *saltimbanques* have been ascribed to members of Picasso's circle, but the only identification experts agree upon is that of Picasso, who portrayed himself, as he often did, in the guise of Harlequin, easily identifiable by the diamond patterns of his motley costume. These homeless entertainers, who eked out a living through their creative talents, existing on the margins of society, have long been understood as modernist surrogates for the artist. Before completing this large canvas,

giving way to the new th[...] and the warmer tonalities that characteri[...] Picasso's work, the Rose [...]

In 1905 and 1906 [...] with the subject of ac[...] traveled from town [...] makeshift stages. C[...] itinerant entertainer[...] and Pierrot, the cl[...] Italian tradition of *commedia* [...] pete for the amorous attentions of Columbine. These subjects were popular in France as well as Spain in nineteenth-century literature and painting, and Picasso certainly knew pictorial variations on the themes by artists such as Daumier and Cézanne. His own interest in circus subjects was stimulated by frequent visits to the Cirque Médrano, located near his Montmartre studio.

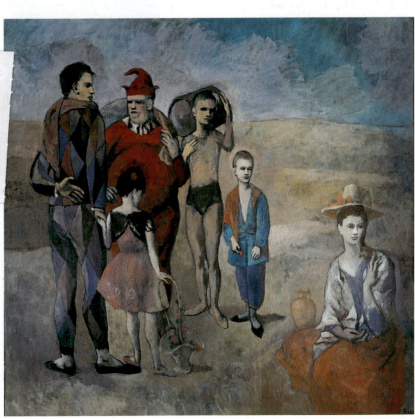

7.4 Pablo Picasso, *Family of Saltimbanques*, 1905. Oil on canvas, 6' 11¾" × 7' 6⅜" (2.1 × 2.3 m). National Gallery of Art, Washington, D.C.

Women as Patrons of the Avant-Garde

American women played an important role as collectors and promoters of avant-garde art. The socially well-placed Mary Cassatt introduced a number of American collectors to her Impressionist colleagues, facilitating the first sustained import of European avant-garde art into the U.S. In the early twentieth century, a number of women took up the cause of the avant-garde. Some, such as the poet Gertrude Stein, were like-minded artists or writers who associated with its members. Others, like sisters Claribel and Etta Cone of Baltimore, expressed their sympathy for groundbreaking art by collecting and commissioning works. Claribel Cone had met Stein while the two were medical students at Johns Hopkins University and it was this friendship that led to the Cones' introduction to the world of the Paris avant-garde. The Cones amassed a substantial collection of works by Manet, Degas, Cézanne, Gauguin, and Picasso, among others. Above all, the pair felt attracted to Matisse's art: their collection, bequeathed to the Baltimore Museum of Art, ultimately included over 500 pieces by him. Other collectors, like Lillie P. Bliss, responded to

a deep, personal attraction to modern art despite objections by family members who found the work too unconventional and disturbing. Bliss used her considerable fortune to acquire artworks beginning in 1907, though her mother insisted the collection be confined to the basement. Abby Aldrich Rockefeller, too, kept her collection of avant-garde art segregated in the mansion she shared with husband John D. Rockefeller, Jr. Along with Bliss, the Rockefellers helped to found The Museum of Modern Art in 1929. Katherine S. Dreier, Gertrude Vanderbilt Whitney, and Peggy Guggenheim likewise recognized the significance of modern art, especially pure abstraction, when few Americans were prepared to acknowledge the aesthetic value of artworks that pushed beyond the formal experimentation of Impressionism. Their foresight led to the establishment in New York City of three of the most daring venues for the display of avant-garde art in the first half of the twentieth century: the Société Anonyme (1920–41), the Whitney Museum of American Art (founded in 1930), and Art of This Century (1942–47).

Picasso exhibited over thirty works at a Paris gallery, including several *saltimbanque* subjects. Little is known about the sales, if any, that resulted from the show, but subsequently Picasso tended to refrain from exhibiting his work in Paris, except in small shows in private galleries (his favorite venue was his own studio). Although he was still seriously impoverished, his circumstances improved somewhat during these years as his circle of admirers—critics, dealers, and collectors—continued to grow.

One remarkable member of that circle was the American writer Gertrude Stein, who, with her brothers Leo and Michael, had lived in Paris since 1903 and was building one of the foremost collections of contemporary art in the city (see *Women as Patrons of the Avant-Garde*, above). She met Picasso in 1905 and introduced him the following year to Matisse, whose work the Steins were collecting. In their apartment Picasso had access to one of the great early Matisse collections, including the seminal *Le Bonheur de vivre* (see fig. 5.8). Gertrude Stein said

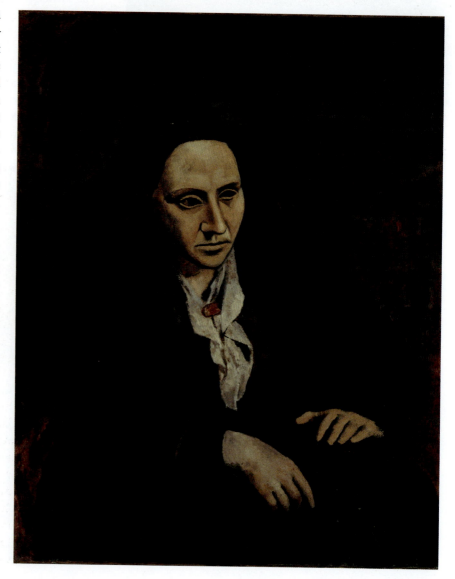

7.5 Pablo Picasso, *Gertrude Stein*, 1906. Oil on canvas, 39¼ × 32" (99.7 × 81.3 cm). The Metropolitan Museum of Art, New York. Bequest of Gertrude Stein, 1946.

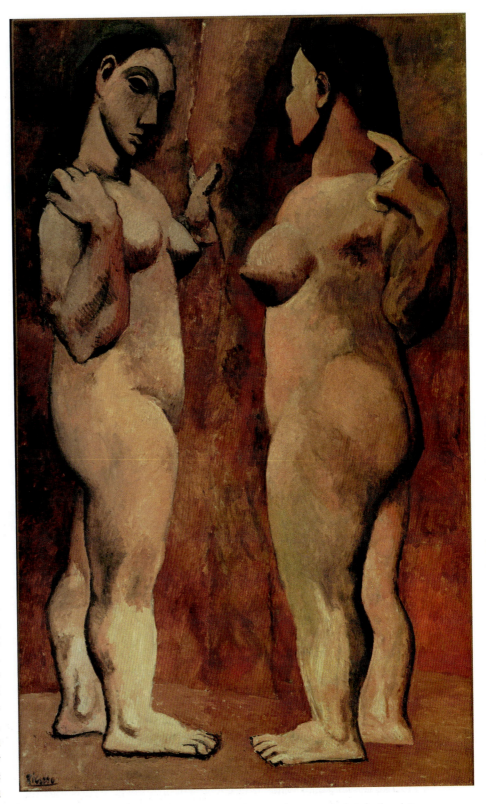

she sat for Picasso ninety times while he painted her portrait (fig. **7.5**). Her ample frame, characteristically draped in a heavy, loose-fitting dress, assumes an unconventional pose for a female sitter, one that clearly conveys the self-assured nature of a woman who freely proclaimed her own artistic genius. She fills her corner of space like some powerful, massive work of sculpture. Picasso abandoned the portrait over the summer while he vacationed in Spain, and repainted Stein's face from memory upon his return. Its mask-like character, with eyes askew, anticipates the distortions of coming years.

By the end of 1905 Picasso's figures had taken on an aura of beauty and serenity that suggests a specific influence from ancient Greek white-ground vase paintings. This brief classical phase was prompted by several factors, including his studies of antiquities in the Louvre, and the 1905 retrospective of the work of the Neoclassical painter Jean-Auguste-Dominique Ingres (see figs. 1.5 and 1.6). Picasso's subjects during this period were primarily nudes, either young, idealized women or adolescent boys, all portrayed in a restrained terracotta palette evoking the ancient Mediterranean. By the end of 1906, following a trip to the remote Spanish village of Gósol, this classical ideal had evolved into the solid, thick-limbed anatomies of *Two Nudes* (fig. **7.6**), a mysterious composition in which we confront a woman and what is nearly but not quite her mirror reflection. The image is drained of the sentimentalism that inhabited the artist's Blue and Rose Period pictures. Significantly, Picasso was making sculpture around this time and earlier in 1906 had seen a show at the Louvre of Iberian sculpture from the sixth and fifth centuries BCE. These works, produced by a people that inhabited the eastern and southeastern coastal region of Spain during the first millennium BCE., were of particular interest to him since they had been excavated fifty miles (80 km) from his hometown. In 1907 he actually purchased two ancient Iberian stone heads, which he returned in 1911, after discovering that they had been stolen from the Louvre. In

addition, the 1906 Salon d'Automne had featured a large retrospective of Gauguin's work, including the first important public presentation of his sculpture (see fig. 3.24). As an artist who plundered the art of non-Western and ancient cultures for his own work, Gauguin provided Picasso with a crucial model. Picasso's own preoccupation with sculptural form at this time, his encounter with the blocky contours of the ancient Iberian carvings, and the revelatory encounter with Gauguin's "primitivizing" examples left an indelible mark on paintings such as *Two Nudes*.

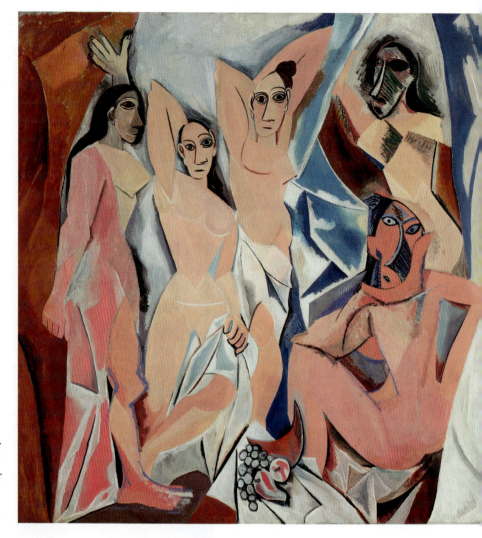

7.7 Pablo Picasso, *Les Demoiselles d'Avignon*, June–July 1907. Oil on canvas, 8' × 7' 8" (2.4 × 2.3 m). The Museum of Modern Art, New York.

View the Closer Look for *Les Demoiselles d'Avignon* on mysearchlab.com

Les Demoiselles d'Avignon

Picasso's large canvas *Les Demoiselles d'Avignon* (fig. 7.7) has been called the single most important painting of the twentieth century. It is an astonishing image that, in the iconoclastic spirit of modernism, virtually shattered every preceding pictorial and iconographical convention. Scholars have generated hundreds of pages scrutinizing its history and pondering its meaning, and the painting still has the power to assault the viewer with its aggressively confrontational imagery. Long regarded as the first Cubist painting, the *Demoiselles* is now generally seen as a powerful example of expressionist art—an "exorcism painting," Picasso said, in which he did not necessarily initiate Cubism, but rather obliterated the lessons of the past. In fact, this type of multifigure composition did not persist in high Cubism, which was the domain of the single figure, the still life, and, to a lesser degree, the landscape. Nor did this violent, expressive treatment of the subject find a place in a style famous for emotional and intellectual control.

The five *demoiselles*, or young ladies, represent prostitutes from Avignon Street, in Barcelona's notorious red-light district, which Picasso knew well. The title, however, is not his; Picasso rarely named his works. That task he left to dealers and friends. The subject of prostitution, as we saw with Manet's scandalous *Olympia* (see fig. 2.21), had earned a prominent place in avant-garde art of the nineteenth century. Cézanne responded to Manet's painting with his own idiosyncratic versions of the subject. Other French artists, especially Degas and Toulouse-Lautrec, had portrayed the interior life of brothels, attracted as much by the availability of nude or nearly-nude potential models as by the frankly sexualized environs. Artistic activity was often associated with sexuality by modern artists and critics, making prostitutes an especially compelling subject (see Ch. 6, pp. 114, 132). But none of Picasso's modernist predecessors addressed the motif with the vehemence or enormous scale seen here, where the theme of sexuality is raised to an explosive pitch.

When confronted with the *Demoiselles*, it is difficult for the viewer to recall that the gentle *Saltimbanques* painting (see fig. 7.4) was only two years old. When compared to *Two Nudes* (see fig. 7.6), the anatomies of the *Demoiselles* seem crudely flattened and simplified, reduced to a series of interlocking, angular shapes. Even the draperies—the white cloth that spills off the table in the foreground and the bluish curtains that meander around the figures—have hardened into threatening shards. The composition is riddled with deliberately disorienting and contradictory points of view. The viewer looks down upon the table at the bottom of the canvas, but encounters the nudes head-on. Eyes are presented full face, while noses are in profile. The seated figure at the lower right faces her cohorts but manages to turn her head 180 degrees to address the viewer. The two central figures offer themselves up for visual consumption by assuming classic Venus poses, while their companion to the left strides into the composition like a fierce Egyptian statue. All of the prostitutes stare grimly ahead, with emotions seemingly as hardened as the knife-edge forms themselves.

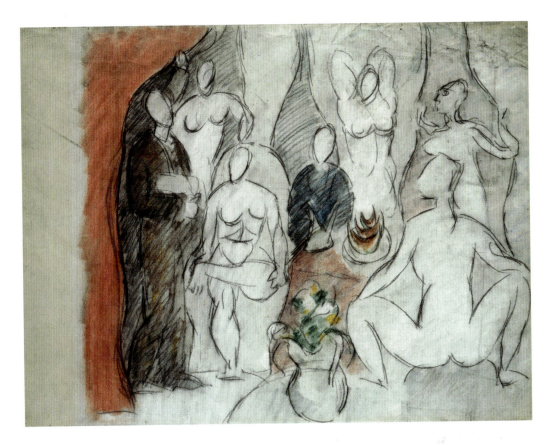

7.8 Pablo Picasso, *Medical Student, Sailor, and Five Nudes in a Bordello* (study for *Les Demoiselles d'Avignon*), March–April 1907. Graphite and pastel on paper, 18⅞ × 25" (47.7 × 63.5 cm). Öffentliche Kunstsammlung, Kunstmuseum Basel.

The three women at the left bear the simplified "Iberian" features familiar from *Two Nudes*. Most shocking of all, however, are the harshly painted masks that substitute for faces on the two figures at the right.

The *Demoiselles* evolved over several months in 1907, during which Picasso prepared his work in the manner of a traditional academic artist, executing dozens of drawings (fig. **7.8**). Through these preparatory works we are able to observe his progress as he honed his composition from a complex narrative to the startlingly iconic image we encounter today. In the drawing reproduced here, executed in the spring of 1907, Picasso's early idea for the painting is shown. At the far left is a figure the artist identified as a medical student. He holds a book in his right arm (in earlier studies it was a skull) and draws back a curtain with his left. In this curiously draped, stage-like setting, the student encounters a provocative quintet of naked women, one of whom theatrically opens more curtains at the right. They surround a lone sailor, who is seated before a table holding a plate of spiky melons and a phallic *porrón*, a Spanish wine flask. A second still life on a round table projects precipitously into the room at the bottom of the sheet. Even on this small scale the women appear as aggressive, sexually potent beings, compared to their rather docile male clients. For Picasso, a frequenter of brothels in his youth, the threat of venereal disease was of dire concern in an era in which such afflictions could be fatal. The inclusion of a skull-toting medical student (who resembled Picasso in related sketches) probably reflects the artist's morbid conflation of sex and death and his characteristically misogynistic view of women as the carriers of life-threatening disease. As he worked toward the final painting, Picasso transformed the medical student into a woman in a similar pose and eliminated the sailor altogether. The prostitutes, for the most part, have shifted their attention from their clients to the viewer. It is this conception, deprived of the earlier narrative clues, that emerges as the large painting. Picasso also made drastic changes in his formal conception of the subject. The space is compressed, the figures are highly schematized, and rounded contours have given way to sharp, angular forms. Even the table is now a triangle, jutting into the room.

Picasso's conflation of women's bodies, disease, violence, and primitivism was, of course, far from idiosyncratic. Long associated in Western art with "savage," "natural," and irrational instincts, the female nude became a site for anxious projections of personal as well as cultural fears (see Ch.5, pp. 93–98, 104 and Ch. 6, pp. 118–120, 132). France's often ruthless pursuit of its imperial ambitions, especially in West Africa, had triggered well-publicized rebellions. Put down with unshrinking brutality, these revolts prompted a mixed response among residents of France. Some found in such uprisings a cause for even firmer policies; others saw the desperate attempts at insurrection as evidence of a disturbing hypocrisy on the part of a country whose motto remained "liberty, equality, fraternity." The ambivalence that would prevent France from divesting itself of its African colonies for another half century had already gripped its citizens by 1907, and Picasso's *Demoiselles* can be seen to emanate from this broader cultural uncertainty. With its terrifying yet alluringly posed nudes who conjure dizzying associations with classical civilizations and "primitive" cultures, with sexual pleasure and venereal disease, and, ultimately, with fecundity and death, the *Demoiselles* plunges the viewer into an abyss of aesthetic, political, and personal doubt.

Equipped with a prodigious visual memory and keen awareness of past art, Picasso could have had several paintings in mind as he set to work on his large canvas in June. In 1905 he had seen Ingres's round painting *Turkish Bath* of 1863, a titillating Salon piece that displays intertwined female nudes in myriad erotic poses. While staying in Gósol in 1906 Picasso produced his own version of a harem subject. But in that painting, unlike the *Demoiselles*, the sitters (all likenesses of his lover Fernande Olivier) are represented in conventional bather poses, washing themselves or brushing their hair. Matisse's spectacular painting *Le Bonheur de vivre* (see fig. 5.8) had surely made a great impact on Picasso in the 1906 Salon des Indépendants, the juryless Salon that had been an important showcase for avant-garde art since 1884. The following year he had probably also seen Matisse's *Blue Nude* (see fig. 5.9). It is possible that Picasso undertook the *Demoiselles* partly as a response to these radical compositions. Most important of all for the artist (and for the subsequent development of Cubism) was the powerful example of Cézanne, who died in 1906 and whose work was shown in a retrospective at the 1907 Salon d'Automne. It is important to recall that many of the French master's early depictions of bathers (see fig. 3.5) were fraught with an anxiety and violence that no doubt attracted Picasso, but a major instigating force for the *Demoiselles* was the group of Cézanne's later bather paintings (see fig. 3.9). Indeed, certain figures in Picasso's composition have been traced to precedents in Cézanne. Picasso, however, chose not to cast his models as inhabitants of a timeless pastoral, but as sex workers in a contemporary brothel.

The work of many other painters has been linked to Picasso's seminal painting, from El Greco to Gauguin, but more significant was the artist's visit in June 1907 to Paris's ethnographic museum, where he saw numerous examples of African and Oceanic sculpture and masks. According to Apollinaire (who no doubt embellished the artist's words), Picasso once said that African sculptures were "the most powerful and the most beautiful of all the products of the human imagination." He had already seen such works during studio visits to artists who were collecting African art, including Matisse, Derain, and Vlaminck (see Ch. 5, p. 97). But his encounter at the museum, which took place while he was at work on the *Demoiselles*, provoked a "shock," he said, and he went back to the studio and reworked his painting (though not specifically to resemble anything he had just seen). It was at this time that he altered the faces of the two figures at the right from the "Iberian" countenances to violently distorted, depersonalized masks. Picasso not only introduced dramatically new, incongruous imagery into his painting, but he rendered it in a manner unlike anything else in the picture. When he added the women's mask-like visages at the right he used dark hues and rough hatch marks that have been likened to scarification marks on African masks. By deploying such willfully divergent modes throughout his painting Picasso heightened its disquieting power.

Beyond Fauvism: Braque's Early Career

When the French artist **Georges Braque** (1882–1963) first saw *Les Demoiselles d'Avignon* in Picasso's studio in 1907, he compared the experience to swallowing kerosene and spitting fire. Most of Picasso's supporters, including Apollinaire, were horrified, or at least stymied, by the new painting. Derain ventured that one day Picasso would be found hanged behind his big picture. According to the dealer Daniel-Henry Kahnweiler, the *Demoiselles* "seemed to everyone something mad or monstrous." As more and more visitors saw it in the studio (it was not exhibited publicly until 1916), the painting sent shock waves throughout the Parisian artistic community. For Braque, the painting had direct consequences for his art, prompting him to apply his current stylistic experiments to the human figure.

Just one year younger than Picasso, Braque was the son and grandson of amateur painters. He grew up in Argenteuil, on the River Seine, and the port city of Le Havre in Normandy, both famous Impressionist sites. In Le Havre he eventually befriended the artists Raoul Dufy and Othon Friesz, who, like Braque, became associates of the Fauve painters. As an adolescent Braque took flute lessons and attended art classes in the evening at Le Havre's École des Beaux-Arts. Following his father's and grandfather's trade, he was apprenticed as a house painter and decorator in 1899 and at the end of 1900 he went to Paris to continue his apprenticeship. Some of the decorative and *trompe l'oeil* effects that later entered his paintings and **collages** were the result of this initial experience. After a year of military service and brief academic training, Braque settled in Paris, but he returned frequently to Le Havre to paint landscapes, especially views of the harbor. Like his artist contemporaries in Paris, he studied the Old Masters in the Louvre and was drawn to Egyptian and archaic sculpture. He was attracted by Poussin among the Old Masters, and his early devotion to Corot continued. During the same period he was discovering the Post-Impressionists, including Van Gogh, Gauguin, and the Neo-Impressionist Signac, but it was ultimately the art of Cézanne that affected him most deeply and set him on the path to Cubism.

In the fall of 1905 Braque was impressed by the works of Matisse, Derain, and Vlaminck at the notorious Salon d'Automne where Fauvism made its public debut, and the following year he turned to a bright, Fauve-inspired palette. Unlike Picasso, Braque submitted work regularly to the Salons in the early years of his career. His paintings were included in the 1906 Salon des Indépendants, but he later destroyed all the submitted works. In the company of Friesz and Derain, he spent the fall and winter of 1906 near Marseilles at L'Estaque, where Cézanne had painted (see fig. 3.6). He then entered a group of his new Fauve paintings in the Salon des Indépendants of March 1907 that included Matisse's *Blue Nude*. One of his works was purchased by Kahnweiler, who was to become the most important dealer of Cubist pictures. Though the record is not certain, Braque

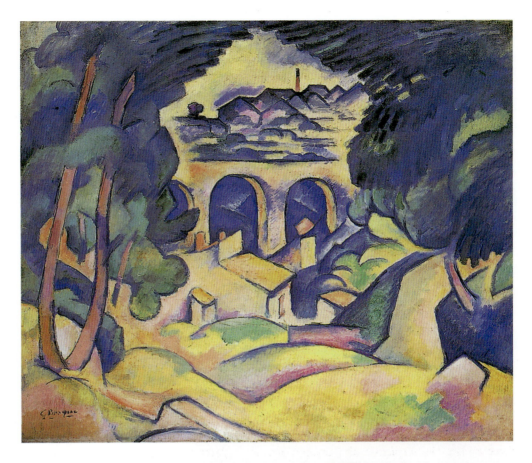

and Picasso probably met around this time. It was inevitable that their paths should cross, for they had several friends in common, including Derain, Matisse, and Apollinaire.

During his brief exploration of Fauvism, Braque developed his own distinctive palette, beautifully exemplified in the clear, opalescent hues of *Viaduct at L'Estaque* (fig. **7.9**). Despite the bright coloration of this landscape, made on the site in the fall of 1907, its palette is tame compared with the radical color experiments of Matisse's Fauve work (see fig. 5.6). Owing largely to lessons absorbed from Cézanne, Braque was not willing to forgo explicit pictorial structure in his landscapes. The composition of *Viaduct at L'Estaque* is rigorously constructed: the hills and houses, though abbreviated in form, retain a palpable sense of volume, created through Cézannist patches of color and blue outlines, rather than through traditional chiaroscuro. Braque built these forms up toward a high horizon line and framed them within arching trees, a favorite device of Cézanne. These tendencies in Braque's work are often referred to as "Cézannism."

At the end of 1907 Braque visited Picasso's studio with Apollinaire, possibly for the first time. By the end of the next year he and Picasso were regular visitors to one another's studios. On this visit Braque saw the completed *Demoiselles* and the beginnings of Picasso's most recent work, *Three Women* (see fig. 7.12). Until this point Braque had rarely painted the human form, but early in 1908 he made a multifigure painting, since lost, which was clearly inspired by *Three Women*. That spring he produced *Large Nude* (fig. **7.10**), a painting that signals his imminent departure from Fauvism. Like Picasso, Braque had seen Matisse's *Blue Nude* the previous fall (see fig. 5.9), and his massively muscular

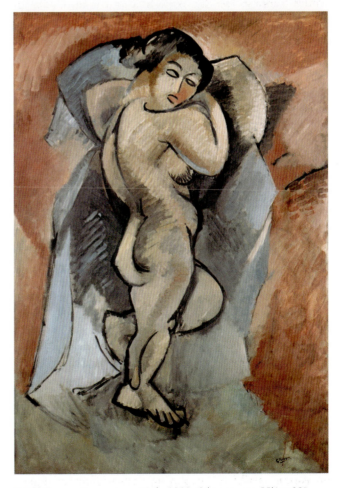

7.10 Georges Braque, *Large Nude*, 1908. Oil on canvas, 55⅛ × 39" (140 × 99.1 cm). Musée National d'Art Moderne, Centre d'Art et de Culture Georges Pompidou, Paris.

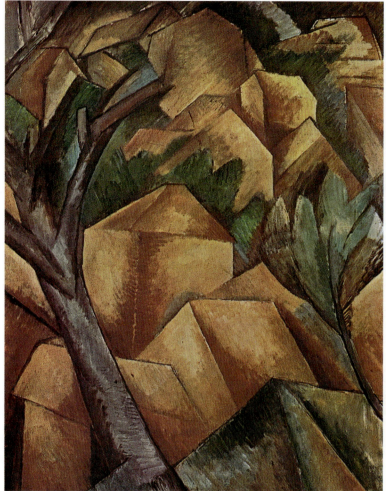

inconsistencies (of the sort that abound in Cézanne's work), including conflicting orthogonals and vantage points, or roof edges that fail to line up, or disappear altogether, Braque managed a wholly convincing, albeit highly conceptualized, space—one that exemplifies modernist concerns in being true to sense perceptions rather than to pictorial conventions. Color is limited to the fairly uniform ocher of the buildings, and the greens and blue-green of the trees. Whereas Cézanne built his entire organization of surface and depth from his color, Braque, in this work and increasingly in the paintings of the next few years, subordinates color in order to focus on pictorial structure.

With *Houses at L'Estaque* Braque established the essential syntax of early Cubism. He is generally credited with arriving at this point single-handedly, preliminary to the steady exchanges with Picasso that characterize the subsequent development of high Cubism. These works at L'Estaque confirmed Braque's thorough abandonment of Fauvism. "You can't remain forever in a state of paroxysm," he said. In fact, Fauvism was a short-lived experiment for most of its artists, partly because painters such as Derain, Dufy, and Vlaminck fell increasingly under the spell of Cézanne's work. In the world of the Parisian avant-garde during this remarkably fertile period, there was a growing sense of polarization between the followers of Matisse and the Cézannist and Cubist faction. Gertrude Stein described the competing camps as "Picassoites" and "Matisseites."

In the fall of 1908 Braque showed his new L'Estaque works to Picasso and submitted them to the progressive Salon d'Automne. The jury, which included Matisse, Rouault, and the Fauve painter Albert Marquet, rejected all his entries. According to Apollinaire, who told the story many ways over the years, it was upon this occasion that Matisse referred to Braque's "little cubes." By 1912 this had become the standard account for the birth of the term Cubism. Following his rejection, Braque exhibited twenty-seven paintings in November 1908 at the Kahnweiler Gallery, with a catalog by Apollinaire. Louis Vauxcelles, the critic who had coined the term Fauve, reviewed the exhibition and, employing Matisse's term, observed that Braque "reduces everything, places and figures and houses, to geometrical schemes, to cubes."

"Two Mountain Climbers Roped Together": Braque, Picasso, and the Development of Cubism

The remarkable artistic dialog between Braque and Picasso began in earnest toward the end of 1908, when they started visiting one another's studios regularly to see what had materialized during the day. "We discussed and tested each

figure, set down with bold brushwork and emphatic black outlines, bears the memory of that work. But Braque repudiated the rich pinks and blues of *Viaduct at L'Estaque* for a subdued palette of ochers, browns, and gray-blue. While the model's simplified facial features and the angular drapery that surrounds her recall the *Demoiselles*, Braque was not motivated by the sexualized themes of Picasso's painting. With *Large Nude*, he said he wanted to create a "new sort of beauty … in terms of volume, of line, of mass, of weight."

A comparison between *Viaduct at L'Estaque* and Braque's painting from August 1908, *Houses at L'Estaque* (fig. **7.11**), makes clear the transformations that took place in his style after fall 1907. With the suppression of particularizing details, the houses and trees become simplified, geometric volumes experienced at close range and sealed off from surrounding sky or land. Braque explained that in such pictures he wished to establish a background plane while "advancing the picture toward myself bit by bit." Rather than receding into depth, the forms seem to come forward, approximating an appearance of low-relief sculpture, or bas-relief.

Braque's illusion of limited depth is not dependent upon traditional, single-point linear perspective. Cézanne, he later said, was the first to break with that kind of "erudite, mechanized perspective." Instead, he achieves illusion by the apparent volume of the buildings and trees—their overlapping, tilted, and shifting shapes create the effect of a scene observed from various positions. Despite many

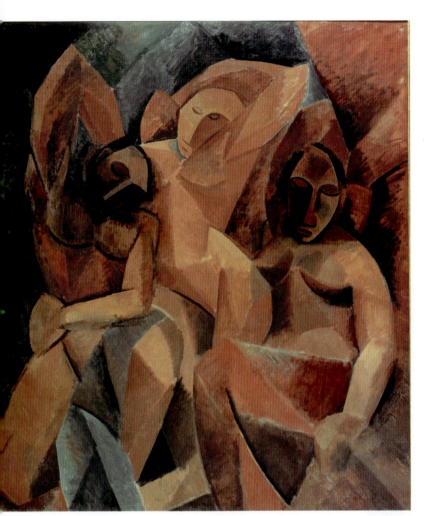

7.12 Pablo Picasso, *Three Women*, 1907–08. Oil on canvas, 6' 6¾" × 7' 6½" (2 × 2.3 m). The Hermitage Museum, St. Petersburg.

Analytic Cubism, 1909–11

Cubism is often mistakenly characterized as a complete rejection of artistic conventions in use since the Renaissance. A more accurate way to understand it is as a dialog with tradition, a recalibration of some of the assumptions motivating Western art since the fifteenth century. For instance, the Cubists recognized that Renaissance linear perspective, in which spatial recession is illusionistically rendered on a two-dimensional surface by means of geometry, was simply one of many ways in which three-dimensional space might be translated into two dimensions. There is nothing natural about the way linear perspective works. Viewers learn to perceive the illusion of space in a painting using linear perspective just as viewers today learn how to negotiate the three-dimensional worlds created by interactive maps (like Google's "Street View") or by "first-person shooter" computer games. Western viewers are simply so accustomed to encountering scenes constructed according to linear perspective that it seems a natural and accurate record of observed reality. With Analytic Cubism, Braque and Picasso sought to develop a new system for depicting space. The same three dimensions rendered in paintings like David's *Oath of the Horatii* (see fig. 1.2) exist in Cubist works. The difference is that Braque and Picasso use different techniques to represent space and volume: the modeling of a form might be suggested by a few parallel lines; the recession of one plane behind another is signaled by an L- or V-shaped mark, suggestive of two planes intersecting. Picasso and Braque held that a viewer will learn to "read" space and volume within a Cubist work just as he or she learned to perceive space in paintings by David or Poussin. Another characteristic of Cubism that testifies to their concern with artistic tradition is the artists' attraction to some of the most staid genres in Western art: figure studies and still lifes. Both were essential components of academic training. For example, the exquisitely rendered fan and hookah in Ingres's *Grande Odalisque* (see fig. 1.5) are essentially still lifes executed in support of a larger genre scene. Braque and Picasso's attraction to still life derived not only from their engagement with artistic tradition, but also from simple expediency: models are costly and even the best cannot maintain a pose as long as a loaf of bread or a guitar can, an important consideration given the Cubists' method of sustained analysis of form and space. Materials drawn from the café and the studio, the milieux most familiar to these artists, became standard motifs in their work. Newspapers, bottles of wine, or food—the objects literally within their reach—were often elliptically coded with personal, sometimes humorous, allusions to their private world. Musical instruments, too, appear often in their Cubist still lifes. Not only were they close at hand, but they also evoke the idea

other's ideas as they came to us," Braque said, "and we compared our respective works." At this time Picasso completely revised *Three Women* (fig. 7.12), a painting he had begun the year before in response to Braque's Cubist paintings from L'Estaque. Those new experiments led Picasso toward a more thorough absorption of Cézannism, as he developed his own variation on the bas-relief effects he saw in Braque's work. The three women here seem to be a reprise of the two central figures of the *Demoiselles*, although these mammoth beings seem even less like flesh and blood and appear as though chiseled from red sandstone. In earlier states of the painting, known from vintage photographs, the faces were boldly inscribed with features inspired by African masks, but Picasso altered those features in the final state. The women no longer stare boldly ahead, as in the *Demoiselles*, but seem to hover on the edge of deep slumber. Picasso here employs Cézanne's *passage*, a technique whereby the edges of color planes slip away and merge with adjacent areas. For example, on the proper left leg of the central figure (meaning her left, not ours) is a pale green triangle that dually functions as a facet of her thigh and part of her neighbor's breast. This passage mitigates any sense of clear demarcation between the figures and their environment. Such ambiguity of figure and ground, facilitated by an opening up of contours, is a fundamental characteristic of Cubism.

of music. A fundamental property of music is duration: music is essentially sound organized in time. Thus, the presence of musical instruments, sheet music, or song lyrics in Cubist works can be seen as a response to Henri Bergson's ideas about perception, an attempt to give visual form to his account of consciousness. But further experimentation was needed before Cubism would fully emerge in its first, analytic form.

Picasso's majestic painting *Bread and Fruit Dish on a Table* (fig. **7.13**) is an especially intriguing example of still life, since the artist initiated it as a figurative composition and then gradually transformed the human figures into bread, fruit, and furniture. We know from small studies that he was planning a painting of several figures seated and facing the viewer from behind the drop-leaf table seen here (just like one in his studio). Evacuating the figures' bodies from the scene, he nonetheless retained their legs, thus explaining the strange, plank-like forms under the table. Other shapes from the old composition were retained to take on new identities in the still life. For example, the loaves of bread at the right, mysteriously propped up against a backdrop, were once the arms of a figure. At the opposite end of the table sat a woman, whose breasts were retained as fruit in a bowl. Thus, Picasso makes a sly visual pun on a hackneyed symbol of fecundity and womanhood, while balancing this rounded, feminine form with the phallic loaves at the opposite end of the table.

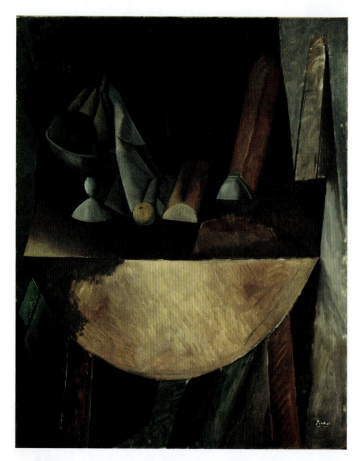

7.13 Pablo Picasso, *Bread and Fruit Dish on a Table*, 1909. Oil on canvas, 64⅝ × 52¼" (164 × 132.5 cm). Öffentliche Kunstsammlung, Kunstmuseum Basel.

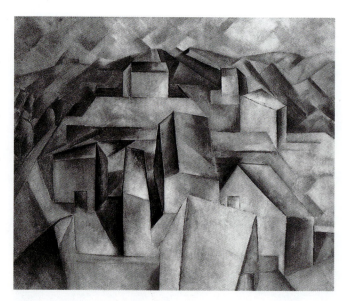

7.14 Pablo Picasso, *Houses on the Hill, Horta de Ebro*, summer 1909. Oil on canvas, 25⅝ × 31⅞" (65 × 81 cm). The Museum of Modern Art, New York.

Picasso spent the summer of 1909 in the Spanish hill town of Horta de Ebro (today Horta de San Juan), where his early Cubist style reached its apogee. Among the landscapes he made that summer is *Houses on the Hill, Horta de Ebro* (fig. **7.14**), in which the stucco houses of the village, seen from above, are piled up into a pyramidal structure of such refinement and delicate coloration that the expressionist intensity of *Demoiselles* seems a distant memory. Painted in facets of pale gold and gray, the highly geometricized houses are presented in multiple, often contradictory perspectives. Rather than creating forms that recede predictably into the distance, Picasso often reversed the orthogonals to project toward the viewer. His juxtaposition of light and dark planes enhances the overall sculptural configuration but fails to convey any single or consistent light source. The result is a shimmering, prismatic world where space and mass are virtually synonymous. Even the sky has been articulated into a crystalline pattern of intersecting planes—realized through subtle shifts in value of light gray or green—that suggests a distant mountain range.

During this crucial summer Picasso also made several paintings and drawings of Fernande Olivier, including portrait studies that articulate the sculptural mass of her head into a series of curving planes. After returning to Paris in September he worked in the studio of a friend, the Catalan sculptor Manuel Hugué, known as Manolo, and sculpted a head based on his Horta studies of Olivier. Several bronzes were then cast at a later date from the artist's original plaster casts. Picasso, who is arguably one of the most inventive sculptors of all time, had experimented with sculpture intermittently for several years. With *Woman's Head (Fernande)* (fig. **7.15**) he recapitulates in three dimensions the pictorial experiments of the summer by carving Olivier's features into facets as geometric as one of his Horta hillsides. Despite its innovative treatment of plastic form as a ruptured, discontinuous surface, this sculpture still depends upon the conventional methods and materials of modeling clay into a

continuously in space but are broken up into tightly woven facets that open into the surrounding void. At the same time, the interstices between objects harden into painted shards, causing space to appear as concrete as the depicted objects. It was this "materialization of a new space" that Braque said was the essence of Cubism.

At the top of *Violin and Palette* Braque depicted his painting palette, emblem of his métier, hanging from a carefully drawn nail. The shadow cast by the nail reinforces the object's existence in three-dimensional space. By employing this curious detail of *trompe l'oeil*, Braque calls attention to the ways in which his new system departs from conventional means of depicting volumetric shapes on a flat surface. In so doing, he declares Cubism's challenge to the hegemony of Renaissance conceptions of space, which had been under assault since Manet. In its place, Braque offers a conceptual reconfiguration of that world. This kind of artistic legerdemain, in which different systems of representation simultaneously exist within one painting, was soon to be most fully exploited in Cubist collage and ***papier collé***.

Picasso also treated musical themes in his early Cubist compositions. One of the best-known examples is his *Girl with a Mandolin (Fanny Tellier)* (fig. **7.17**), made in Paris in the spring of 1910. Still working from nature, Picasso

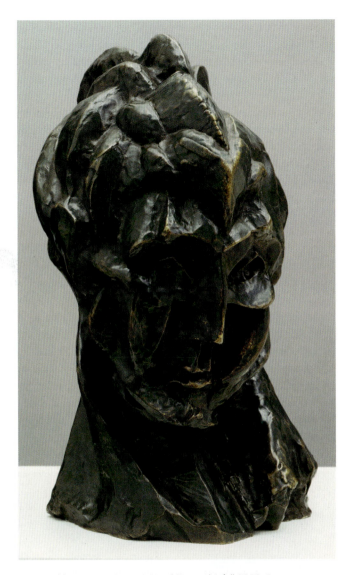

7.15 Pablo Picasso, *Woman's Head (Fernande)*, fall 1909. Bronze, 16¼ × 9¾ × 10½" (41.3 × 24.7 × 26.6 cm). The Museum of Modern Art, New York.

solid mass and making plaster casts (two were made) from the clay model that are then used to cast the work in bronze.

While Picasso was concentrating on his sculpture, Braque spent the winter of 1909 in Paris, composing several still lifes of musical instruments. Braque was an amateur musician, and the instruments he kept in his studio were common motifs in his paintings throughout his career. He preferred violins, mandolins, or clarinets to other objects, for they have, he said, "the advantage of being animated by one's touch." Despite the intensified fragmentation that Braque had by now adopted, the still-life subjects of *Violin and Palette* (fig. **7.16**) are still easily recognizable. Within a long, narrow format he has placed, in descending order, his palette, a musical score propped up on a stand, and a violin. These objects inhabit a shallow, highly ambiguous space. Presumably the violin and music stand are placed on a table, with the palette hanging on a wall behind them, but their vertical disposition within the picture space makes their precise orientation unclear. Although certain forms, such as the scroll at the top of the violin neck, are rendered naturalistically, for the most part the objects are not modeled

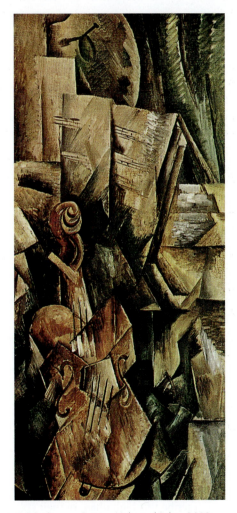

7.16 Georges Braque, *Violin and Palette*, 1909. Oil on canvas, 36⅛ × 16⅞" (91.7 × 42.9 cm). Solomon R. Guggenheim Museum, New York.

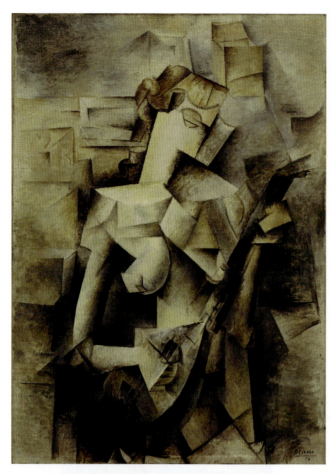

7.17 Pablo Picasso, *Girl with a Mandolin (Fanny Tellier)*, late spring 1910. Oil on canvas, 39½ × 29" (100.3 × 73.7 cm). The Museum of Modern Art, New York.

hired a professional model to pose nude in his studio. When this portrait is compared with Braque's *Violin and Palette*, Picasso's style appears somewhat less radical than Braque's. The figure still retains a sense of the organic and, in some areas, is clearly detached from the background plane by way of sculptural modeling, seen especially in the rounded volumes of the model's right breast and arm. Picasso's chromatic range, however, is even more restricted than that of Braque's still life. Employing soft gradations of gray and golden brown, Picasso endowed this lyrical portrait with a beautifully tranquil atmosphere.

By 1910 Picasso and Braque had entered the period of greatest intensity in their collaborative, yet highly competitive, relationship. Over the next two years they produced some of the most cerebral, complex paintings of their careers, working with tremendous concentration and in such proximity that some of their compositions are virtually indistinguishable from one another. For a time they even refrained from signing their own canvases on the front in order to downplay the individual nature of their contributions. "We were prepared to efface our personalities in order to find originality," Braque said. Analytic Cubism, in which the object is analyzed, broken down, and dissected, is the term used to describe this high phase of their collaboration.

An exemplary work of Analytic Cubism is Picasso's *Portrait of Daniel-Henry Kahnweiler* (fig. **7.18**), made a few

months after *Girl with a Mandolin*. The painting belongs to a series of portraits of art dealers that Picasso made in 1910. Kahnweiler was an astute German dealer who had been buying works by Braque and Picasso since 1908. He was also a critic who wrote extensively about Cubist art, producing the first serious theoretical text on the subject, which interprets the style in **semiological** terms as a language of signs. In this portrait, for which Kahnweiler apparently sat about twenty times, the modeled forms of *Girl with a Mandolin* have disappeared, and the figure, rather than disengaged from the background, seems merged with it. Here the third dimension is stated entirely in terms of flat, slightly angled planes organized within a linear grid that hovers near the surface of the painting. Planes shift in front of and behind their neighbors, causing space to fluctuate and solid form to dissolve into transparent facets of color. Although he delineated his figure not as an integrated volume but as a lattice of lines dispersed over the visual field, Picasso nevertheless managed a likeness of his subject. In small details—a wave of hair, the sitter's carefully clasped hands, a schematic still life at the lower left—the painter particularized his subject and helps us to reconstruct a figure seated in a chair. Though Picasso kept color to the bare minimum, his canvas emits a shimmering, mesmerizing light, which he achieved by applying paint in short daubs that contain generous admixtures of

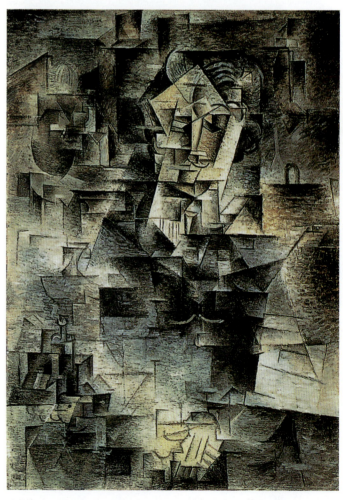

7.18 Pablo Picasso, *Portrait of Daniel-Henry Kahnweiler*, 1910. Oil on canvas, 39½ × 28⅝" (100.6 × 72.8 cm). The Art Institute of Chicago.

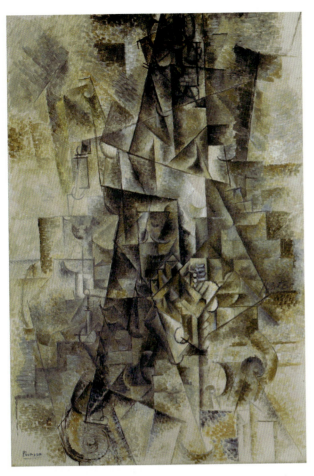

7.19 Pablo Picasso, *Accordionist*, summer 1911. Oil on canvas, 51¼ × 35¼" (130.2 × 89.5 cm). Solomon R. Guggenheim Museum, New York. Solomon R. Guggenheim Museum Founding Collection. Gift, Solomon R. Guggenheim.

brown. Variation in values in these hues and in the direction of the strokes creates almost imperceptible change and movement between surface and depth.

However indecipherable their images, Braque and Picasso never relinquished the natural world altogether, and they provided subtle clues to the apprehension of their obscure subject matter. In the *Accordionist* (which represents a young girl, according to Picasso, not a man, as critics have often presumed) curvilinear elements near the bottom edge of the painting stand for the arms of a chair, while the small circles and step patterns toward the center indicate the keys and bellows of an accordion. *The Portuguese (The Emigrant)*, Braque said, shows "an emigrant on the bridge of a boat with a harbor in the background." This would explain, at the upper right, the transparent traces of a docking post and sections of nautical rope. In the lower portion are the strings and sound hole of the emigrant's guitar. Braque introduced a new element with the stenciled letters and numbers in the painting's upper zone. Like other forms in *The Portuguese*, the words are fragmentary. The letters D BAL at the upper right, for example, may derive from Grand Bal, probably a reference to a common dance-hall poster. While Braque had incorporated a word into a Cubist painting as early as 1909, his letters there were painted freehand as a descriptive local detail. For *The Portuguese* he borrowed a technique from

white pigment. The Italian critic Ardengo Soffici, whose early writings about Picasso and Braque helped bring the Italian Futurists in contact with Cubism, referred to the "prismatic magic" of such works.

The degree to which the pictorial vocabularies of Picasso and Braque converged during the Analytic phase of Cubism can be demonstrated through a comparison of two works from 1911. Picasso's *Accordionist* (fig. 7.19) dates from the astonishingly productive summer of that year, which he spent with Braque in Céret, a village in the French Pyrenees. At a nearly identical state of exploration is Braque's *The Portuguese (The Emigrant)* (fig. 7.20), begun in Céret after Picasso's departure and completed in Paris. Both artists reorder the elements of the physical world within the shallow depths of their respective compositions, using the human figure as a pretext for an elaborate scaffolding of shifting, interpenetrating planes. The presence of the figure is made evident principally by a series of descending diagonal lines that helps concentrate the geometric structure down the center of the picture. That structure opens up toward the edges of the canvas where the pictorial incident diminishes, occasionally revealing the bare, unpainted ground. Both Picasso and Braque at this stage used a stippled, delicately modulated brushstroke so short as to be reminiscent of Seurat, though their color is restricted to muted gray and

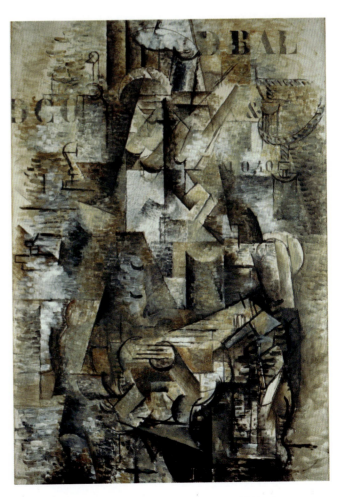

7.20 Georges Braque, *The Portuguese (The Emigrant)*, 1911. Oil on canvas, 46⅛ × 32" (117.2 × 81.3 cm). Öffentliche Kunstsammlung, Kunstmuseum Basel.

commercial art and stenciled his letters, which here function not as illusionistic representations but as autonomous signs dissociated from any context that accounts for their presence. Inherently flat, the letters and numbers exist "outside of space," Braque said. And because they are congruent with the literal surface of the painting, they underscore the nature of the painted canvas as a material object, a physical fact, rather than a site for an illusionistic depiction of the real world. At the same time, they make the rest of the image read as an illusionistically shallow space. Braque's introduction of words in his painting, a practice soon adopted by Picasso, was one of many Cubist innovations that had far-reaching implications for modern art. Like so many of their inventions, the presence in the visual arts of letters, words, and even long texts is today commonplace (see figs. 19.13, 24.40, 26.40).

Synthetic Cubism, 1912–14

In May 1912 the Cubists' search for alternative modes of representation led Picasso to adopt collage, a technique previously used mainly by folk artists (see *Collage*, opposite). The result was a small but revolutionary work, *Still Life with Chair Caning* (fig. **7.21**). Within this single composition Picasso combined a complex array of pictorial vocabularies, each imaging reality in its own way. Painted on an oval support, a shape Picasso and Braque had adopted earlier, this still life depicts objects scattered across a café table. The fragment of a newspaper, *Le Journal*, is indicated by the letters JOU, which, given the artist's penchant for puns, could refer to *jouer*, meaning "to play" and implying that all this illusionism is a game. Over the letters Picasso depicted a pipe in a naturalistic style, while at the right he added the highly abstracted forms of a goblet, a knife, and a slice of lemon.

The most prominent element here, however, is a section of common oilcloth that has been mechanically printed with a design simulating chair caning. Picasso glued the cloth directly to his canvas. While this *trompe l'oeil* fabric offers an exacting degree of illusionism, it is as much a fiction as Picasso's painted forms, since it remains a facsimile of chair caning, not the real thing. After all, Picasso once said, art is "a lie that helps us

Collage

Generally associated with early twentieth-century modernism, collage had been a technique popular among craft artists and amateurs for centuries. The term "collage" is of modern coinage, derived by Georges Braque from the French verb *coller*, meaning "to stick" or "to paste." Prior to its adoption by the Cubists, it was a domestic pastime pursued in the eighteenth and nineteenth centuries mostly by women who affixed memorabilia, pressed flowers, and other items to a sheet of paper or a board. Bringing diverse items into relation with one another in this way provokes the viewer to discover connections among them, to invent the narrative that joins them. This potential for generating multiple narratives through a kind of free association appealed to avant-garde artists as much as it did to the hobbyists who used the technique to articulate bonds between friends and family members or with nature. The modernist author Virginia Woolf captures both the domestic and avant-garde associations of collage in her novel *To the Lighthouse* (1927), which she begins with the description of a boy seated at his knitting mother's feet, cutting out items advertised in a catalog. This scene at first conveys a cozy domesticity. But the boy's activity—making cutouts of objects that seem to have no relationship to one another, objects listed repeatedly as if to evoke some hidden connection—alerts the reader to the unconventional, stream-of-consciousness narrative that will structure the novel. A friend of the art critic and avant-garde champion Roger Fry (see Ch. 3, p. 42), Virginia Woolf was well aware of modern artists' use of collage when she wrote the book in the mid-1920s.

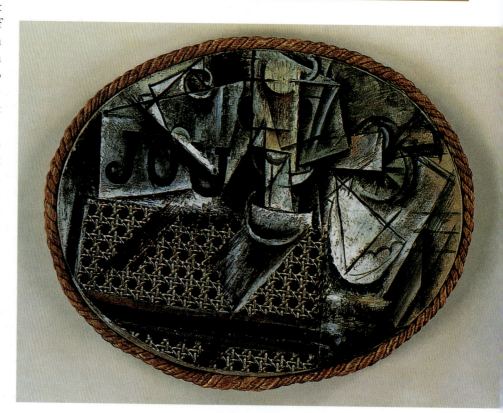

7.21 Pablo Picasso, *Still Life with Chair Caning*, 1912. Oil and oilcloth on canvas, edged with rope, 10⅝ × 14⅝" (27 × 37 cm). Musée Picasso, Paris.

View the Closer Look to see another of Picasso's works on mysearchlab.com

understand the truth." But he did surround his painting with actual rope, in ironic imitation of a traditional gold frame. The rope could have been suggested by a wooden table molding (see the table in fig. 7.25, for example) or the kind of cloth edged with upholstery cord that Picasso had placed on a table in his studio. Combined with the oilcloth, a material from the actual world, the rope encourages a reading of the painted surface itself as a horizontal tabletop, a logical idea, given the presence of still-life objects. Such spatial ambiguity is one of the many ways Picasso challenged the most fundamental artistic conventions. His incorporation of unorthodox materials not associated with "high" or "fine" art offered a radically new connection to the external world and an alternative to the increasingly hermetic nature of his Analytic Cubist compositions. Around the same time he and Braque were reintroducing color to their Cubist paintings with bright, commercial enamel paint.

Following Picasso's adoption of collage, Braque originated *papiers collés* ("pasted papers"). While this technique also involved gluing materials to a support, it is distinguished from collage in that only paper is used. Collage, on the other hand, capitalized on disparate elements in jarring juxtaposition. Braque made his first *papier collé*, *Fruit Dish and Glass* (fig. **7.22**), in September 1912, during an extended stay with Picasso in Sorgues, in the south of France. It has been proposed that Braque deliberately postponed his experiment until Picasso, who regarded any idea as fair game for stealing, had left Sorgues for Paris. Once he was satisfied with the results, Braque presented them to Picasso. "I have to admit that after having made the *papier collé*," he said, "I felt a great shock, and it was an even greater shock for Picasso when I showed it to him." Picasso soon began making his own experiments with Braque's "new procedure."

The precipitating event behind Braque's invention was his discovery in a store window of a roll of wallpaper printed with a *faux bois* (imitation wood-grain) motif. Braque had already used a house painter's comb to create *faux bois* patterns in his paintings, a technique he passed on to Picasso, and he immediately saw the paper's potential for his current work. Like the oilcloth in *Still Life with Chair Caning*, the *faux bois* offered a readymade replacement for hand-wrought imagery. In *Fruit Dish and Glass* Braque combined the *faux bois* paper with a charcoal drawing of a still life that, judging from the drawn words "ale" and "bar," is situated in the familiar world of the café. With typical ambiguity, the cut-outs of pasted paper play multiple roles, both literal and descriptive. Although their location in space is unclear, the *faux bois* sections in the upper portion of the still life are signs for the wall of the café, while the rectangular piece below represents a wooden table. In addition, the *faux bois* enabled Braque to introduce color into his otherwise monochrome composition and to enlist its patterns as a kind of substitute chiaroscuro. At this point Braque was thinking of the *papiers collés* in relation to his paintings, for virtually the same composition exists as an oil.

Once Picasso took up the challenge of Braque's *papier collé*, the contrast in sensibility between the two became

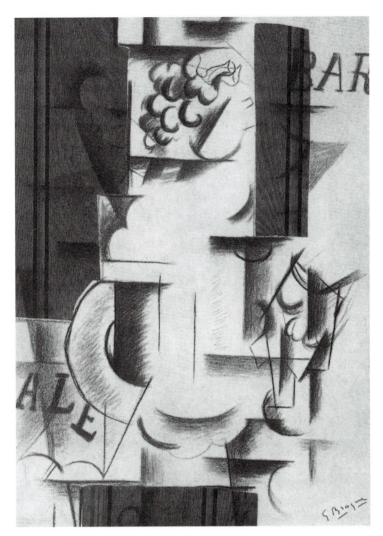

7.22 Georges Braque, *Fruit Dish and Glass*, September 1912. Charcoal and pasted paper on paper, 24⅜ × 17½" (62 × 44.5 cm). Private collection.

obvious. While Braque relied on his elegant Cubist draftsmanship to bind the imagery of his *papiers collés* together, Picasso immediately deployed more colorful, heterogeneous materials with greater irony and more spatial acrobatics. In one of his earliest *papiers collés*, *Guitar, Sheet Music, and Wine Glass* of 1912 (fig. **7.23**), a decorative wallpaper establishes the background for his still life (and implies that the depicted guitar is hanging on a wall). Picasso bettered Braque by actually painting a simulated wood-grain pattern on paper, which he then cut out and inserted into his composition as part of the guitar. But the instrument is incomplete; we must construct its shape by decoding the signs the artist provides, such as a section of blue paper for the bridge and a white disk for the sound hole.

As in Picasso's collage *Still Life with Chair Caning*, different signifying systems or languages of representation are here at work, complete with charcoal drawing (the glass at the right) and a guitar-shaped cut-out of painted *faux bois* paper. We have seen the way in which the Cubists represented newspapers in their painted compositions. The next step was to glue the actual newsprint to the surface of a *papier collé*. In this example, even the headline of the Paris newspaper *Le Journal*, LA BATAILLE S'EST ENGAGÉ

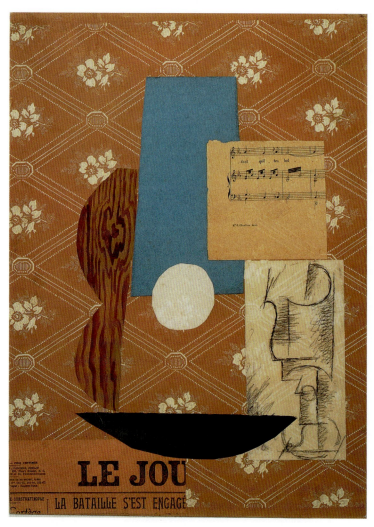

7.23 Pablo Picasso, *Guitar, Sheet Music, and Wine Glass*, fall 1912. Pasted papers, gouache, and charcoal on paper, 18⅞ × 14¾" (47.9 × 37.5 cm). McNay Art Museum, San Antonio, Texas.

of the Cubist style by many new practitioners, whose work is addressed later in this chapter. If earlier Cubist works analyzed form by breaking it down and reconstructing it as lines and transparent planes, the work after 1912 generally constructs an image from many diverse components. Picasso and Braque began to make paintings that were not primarily a distillation of observed experience but, rather, were built up by using all plastic means at their disposal, both traditional and experimental. In many ways, Synthetic Cubist pictures are less descriptive of external reality, for they are generally assembled with flat, abstracted forms that have little representational value until they are assigned one within the composition. For example, the bowl-shaped black form in figure 7.23 is ambiguous, but once inserted in the composition, it stands for part of a guitar.

The dynamic new syntax of Synthetic Cubism, directly influenced by collage, is exemplified by Picasso's *Card Player* (fig. **7.24**), from 1913–14. Here the artist has replaced the shimmering brown-and-gray scaffolding of *Accordionist* (see fig. 7.19) with flat, clearly differentiated shapes in bright and varied color. We can make out a mustachioed card player seated at a wooden table, indicated by the *faux bois* pattern, on which are three playing cards. Below the table Picasso schematically inscribed the player's legs and on either side of the sitter he included an indication of wainscoting on the back wall. Here the cropped letters

("the battle is joined"), has a dual message. It literally refers to the First Balkan War then being waged in Europe and thus adds a note of contemporaneity. Some specialists have argued that its deeper meaning is personal, that it is Picasso's friendly challenge to Braque on the battlefield of a new medium; others have read it as more directly political, an effort to confront the realities of war. By appropriating materials from the vast terrain of visual culture, even ones as ephemeral as the daily newspaper, and incorporating them unaltered into their works of art, Braque and Picasso undermined definitions of artistic authenticity that made it the exclusive province of drawing and painting, media that capture the immediacy of the individual artist's touch. As always, this was accomplished with irony and humor—here again, JOU implies "game" or "play." It was a challenge that had profound consequences for twentieth-century art, one that in many ways still informs debates in contemporary art.

The inventions in 1912 of collage and *papier collé*, as well as Cubist sculpture (discussed below), essentially terminated the Analytic Cubist phase of Braque and Picasso's enterprise and initiated a second and more extensive period in their work. Called Synthetic Cubism, this new phase lasted into the 1920s and witnessed the adoption and variation

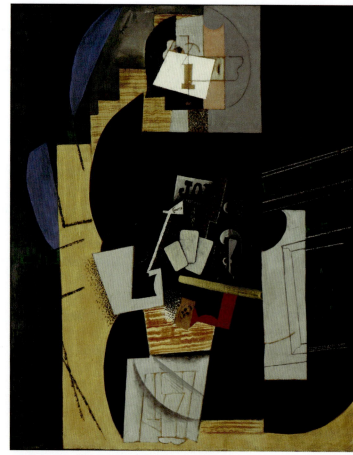

7.24 Pablo Picasso, *Card Player*, winter 1913–14. Oil on canvas, 42½ × 35¼" (108 × 89.5 cm). The Museum of Modern Art, New York.

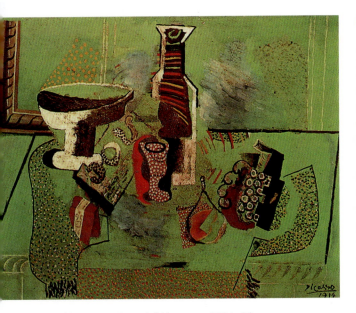

7.25 Pablo Picasso, *Green Still Life*, summer 1914. Oil on canvas, 23½ × 31¼" (59.7 × 79.4 cm). The Museum of Modern Art, New York.

JOU, by now a signature Cubist conceit, have an obvious relevance. Picasso emulates in oil the pasted forms of collage and *papiers collés* by partially obscuring with a succeeding layer of paint each of the flat shapes that make up the figure.

After 1913 the principal trend in paintings by both Picasso and Braque was toward enrichment of their plastic means and enlargement of their increasingly individual Cubist vocabularies. In Picasso's *Green Still Life* (fig. **7.25**), we can easily identify all the customary ingredients of a Cubist still life—compote dish, newspaper, glass, bottle, and fruit. Following the intellectual rigors of Analytic Cubism, the artist seems to delight here in a cheerfully decorative mode. Alfred Barr, an art historian and the first director of The Museum of Modern Art, New York, called this decorative phase in Picasso's work Rococo Cubism. Here Picasso has disposed his still-life objects in an open, tangible space and, using commercial enamels, adds bright dots of color that resemble shiny sequins. The entire ground of the painting is a single hue, a bright emerald green, which Picasso allows to infiltrate the objects themselves. In so doing, he reiterates the flatness of the pictorial space and deprives the objects of volume. Picasso painted *Green Still Life* in Avignon during the summer of 1914. Perhaps the optimistic mood of his work at this time reflects the calm domesticity he was enjoying there with Eva Gouel, his companion since 1911. But this sense of wellbeing was soon shattered. In August 1914 war was declared in Europe; by the end of 1915 Eva was dead of tuberculosis.

Braque, who was called up to serve in the French military (along with Guillaume Apollinaire and André Derain), said goodbye to Picasso at the Avignon railroad station, bringing to an abrupt end one of the greatest collaborations in the history of art. Picasso remained in Paris until 1917, when he went to Rome with the writer Jean Cocteau and worked on stage designs for the Ballets Russes. Both Braque and Picasso went on working prolifically after the war, but separately (see Ch. 11, pp. 251–59).

Constructed Spaces: Cubist Sculpture

Even in the hands of modernist innovators such as Constantin Brancusi (see fig. 5.27), sculpture was still essentially conceived as a solid form surrounded by void. Sculptors created mass either through subtractive methods: carving form out of stone or wood; or additive ones: building up form by modeling in wax or clay. By these definitions, Picasso's *Woman's Head (Fernande)* (see fig. 7.15), regardless of its radical reconception of the human form, is still a traditional solid mass surrounded by space. Like collage, constructed sculpture is assembled from disparate, often unconventional materials. Unlike traditional sculpture, its forms are penetrated by void and create volume not by mass, but by containing space. With the introduction of constructed sculpture the Cubists broke with one of the most fundamental characteristics of sculptural form and provoked a rupture with past art equal to the one they fostered in painting.

Braque and Picasso

Documents prove that constructed Cubist sculpture was invented by Braque and that it predated the first *papiers collés*. Nevertheless, no such works from his hand exist. Because he did not preserve the works, it is assumed that he thought of them principally as aids to his *papiers collés*, not as an end in themselves. According to Kahnweiler, Braque made reliefs in wood, paper, and cardboard, but the only visual record of his sculpture is a 1914 photograph of a work taken in his Paris studio (fig. **7.26**). This unusual composition represents a familiar subject, a café still life, assembled

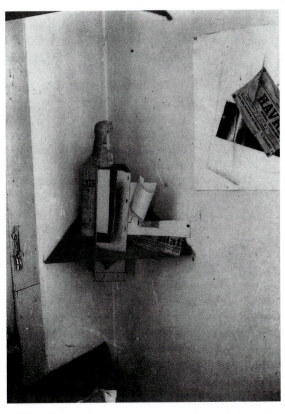

7.26 Georges Braque, 1914. The artist's Paris studio with a paper sculpture, now lost.

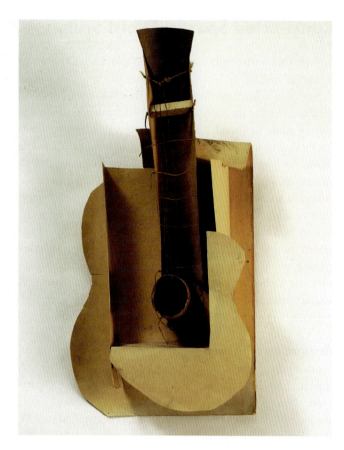

7.27 Pablo Picasso, *Maquette for Guitar*, Paris, October 1912. Construction of cardboard, string, and wire (restored), 25¾ × 13 × 7½" (65.1 × 33 × 19 cm). The Museum of Modern Art, New York.

bought in August 1912 during a visit to Marseilles with Braque. *Guitar* was revolutionary in showing that an artist's conceptual inventions of form are signs of or references to reality, not mere imitations of it. They can be entirely arbitrary and may bear only a passing resemblance to what they actually denote. Thus the sign for the guitar's sound hole was stimulated by a completely unrelated source—the eyes of an African mask.

We know from a 1913 photograph that Picasso inserted his cardboard guitar into a relief still-life construction on the wall of his studio. In an even more fascinating sculptural ensemble, also recorded only in a contemporary photograph, he drew a guitarist on a canvas and gave the figure projecting cardboard arms that held an actual guitar. A real table with still-life props on it completed the composition. In this remarkable tableau Picasso closed the breach that separated painting and sculpture, uniting the pictorial realm with the space of the external world. Much of modern sculpture has addressed this very relationship, in which a sculpture is regarded not as a separate work of art to be isolated on a pedestal, but rather as an object coexisting with the viewer in one unified space. Unlike his constructed sculptures, which were essentially reliefs, Picasso's *Glass of Absinthe* (fig. **7.28**) was conceived in the round

from paper (including newsprint) and cardboard on which Braque either drew or painted. He installed his sculpture across a corner of the room, thus incorporating the real space of the surrounding studio into his work.

Though constructed sculpture was Braque's invention, it was Picasso, typically, who made the most thorough use of it. His first attempt in the new technique is a guitar made from sheet metal, which he first prepared in October 1912 as a maquette made simply of cardboard, string, and wire (fig. **7.27**). Picasso's use of an industrial material such as sheet metal was highly unorthodox in 1912; in the years since, it has become a common sculptural medium. Clearly, the guitar was a significant impetus behind his *papiers collés*, for photographs taken in the artist's studio show it surrounded by works in this medium. In many ways, Picasso's guitar sculpture is the equivalent in three dimensions of the same motif in his *papier collé Guitar, Sheet Music, and Wine Glass* (see fig. 7.23), made several weeks later.

Through a technique of open construction, the body of the cardboard guitar has largely been cut away. Volume is expressed as a series of flat and projecting planes, resulting in a quality of transparency previously alien to sculpture. Picasso made the guitar sound hole, a void in a real instrument, as a projecting cylinder, just as he designed the neck as a concavity. The morphology of the guitar was directly inspired by a Grebo mask from the Ivory Coast in Africa, in which the eyes are depicted as hollow projecting cylinders. Picasso owned two such examples, one of which he

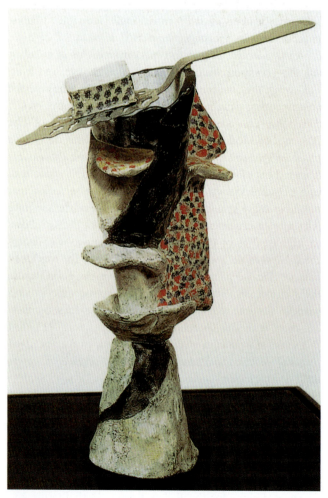

7.28 Pablo Picasso, *Glass of Absinthe*, spring 1914. Painted bronze with silver absinthe spoon, 8½ × 6½ × 3⅜" (21.6 × 16.4 × 8.5 cm); base diameter 2½" (6.4 cm). The Museum of Modern Art, New York.

and was originally modeled by conventional methods in wax. Absinthe is a highly addictive, stupor-inducing liquor, so lethal that by the end of 1914 it was outlawed in France. Upon completion of the wax model of *Glass of Absinthe*, Kahnweiler had the work cast in bronze in an edition of six, to each of which the artist added a **found object**, a perforated silver spoon, as well as a bronze sugar cube. He hand-painted five variants and coated one with sand, a substance that first Braque and then he had added to their paint medium. The bright color patterns on this example are similar to those found in the artist's contemporary paintings (see fig. 7.25). Picasso cut deep hollows in the glass to reveal the interior, where, as in the previous *Green Still Life*, the level of fluid reads as a horizontal plane. In this adaptation of collage methods to the medium of sculpture, Picasso adapts objects from the real world for expressive purposes in the realm of art. This lack of discrimination between the "high" art media of painting and sculpture and the "low" ephemera of the material world remained a characteristic of Picasso's sculpture (see fig. 14.40) and proved especially relevant for artists in the 1950s and 60s (see figs. 19.9, 19.50).

Archipenko

Aleksandr Archipenko (1887–1964) has a strong claim to priority as a pioneer Cubist sculptor. Born in Kiev, Ukraine, he studied art in Kiev and Moscow before going to Paris in 1908. Within two years he was exhibiting his highly stylized figurative sculptures, reminiscent of Gauguin's, with the Cubist painters at the Paris Salons. By 1913 he had established his own sculpture school in the French capital, and his works were shown at Berlin's Galerie Der Sturm and in the New York Armory Show (see Ch. 15, pp. 350–51). In 1913–14 Archipenko adapted the new technique of collage to sculpture, making brightly polychromed constructions from a variety of materials. He based some of the figures from this period on performers he saw at the Cirque Médrano, the circus that had also been one of Picasso's favorite haunts. In *Médrano II*, 1913 (fig. **7.29**), Archipenko assembled a dancing figure from wood, metal, and glass, which he then painted and attached to a back panel, creating a stage-like setting. This work was singled out for praise by Apollinaire in his review of the 1914 Salon des Indépendants. In the manner of constructed sculpture, Archipenko articulated volume by means of flat colored planes. Thus, the dancer's entire torso is a single plank of wood to which her appendages are hinged. Her skirt is a conical section of tin joined to a curved pane of glass, on which the artist painted a delicate ruffle. Over the next few years, Archipenko developed this idea of a figure against a backdrop in his so-called "sculpto-paintings," which are essentially paintings that incorporate relief elements in wood and sheet metal.

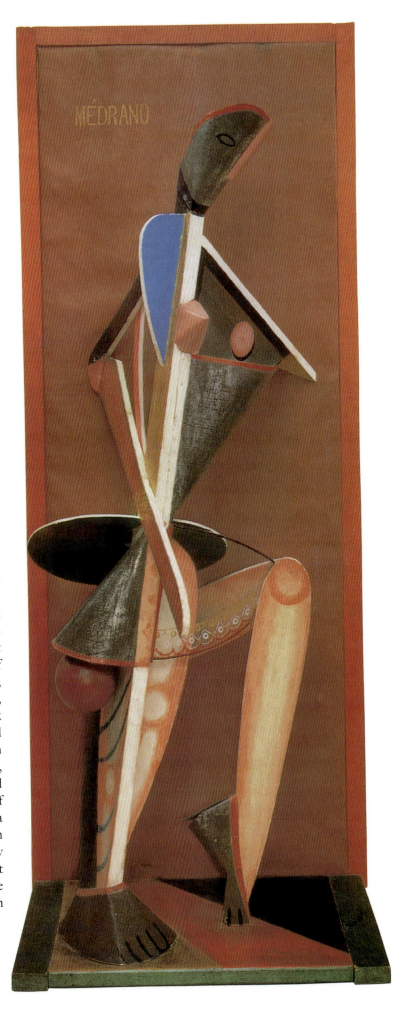

7.29 Aleksandr Archipenko, *Médrano II*, 1913. Painted tin, wood, glass, and painted oilcloth, 49⅞ × 20¼ × 12½" (133.2 × 51.4 × 31.8 cm). Solomon R. Guggenheim Museum, New York.

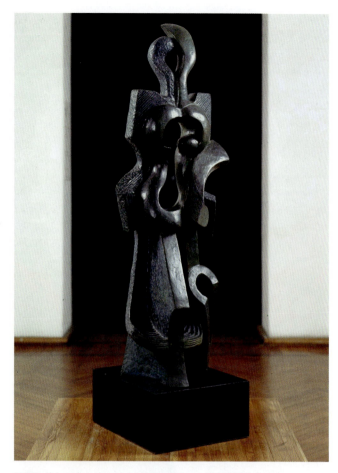

7.30 Aleksandr Archipenko, *Walking Woman*, 1918–19. Bronze, height 26⅜" (67 cm). Courtesy Frances Archipenko Gray.

Walking Woman, 1918–19 (fig. **7.30**), typifies Archipenko's later free-standing sculptures. In 1915 he began using the void as a positive element in figurative sculpture, effectively reversing the historic concept of sculpture as a solid surrounded by space. He believed that sculptural form did not necessarily begin where mass encounters space, but "where space is encircled by material." Here the figure is a cluster of open spaces shaped by concave and convex solids. Although Picasso's Cubist constructions were more advanced than those of Archipenko, the latter's Cubist figures had more immediate influence, first because they were more widely exhibited at an early date, and second because they applied Cubist principles to the long-familiar sculptural subject of the human figure, which revealed the implications of mass–space reversals more readily.

Duchamp-Villon

The great talents of **Raymond Duchamp-Villon** (1876–1918) were cut short by his early death in World War I. He was one of six siblings, four of whom became artists—the other three were Marcel Duchamp, Jacques Villon (both discussed below), and Suzanne Duchamp. In 1900 Duchamp-Villon abandoned his studies in medicine and took up sculpture. At first influenced by Rodin, like nearly all sculptors of his generation, he moved rapidly into the orbit of the Cubists. In his most important work, the bronze *Horse*, in 1914 (fig. **7.31**), the artist endows a pre-industrial

subject with the dynamism of a new age. Through several versions of this sculpture he developed the image from flowing, curvilinear, relatively representational forms to a highly abstracted representation of a rearing horse. The diagonal planes and spiraling surfaces resemble pistons and turbines as they move, unfold, and integrate space into the mass of the sculpture. "The power of the machine imposes itself upon us to such an extent," Duchamp-Villon wrote, "that we can scarcely imagine living bodies without it." With its energetic sense of forms being propelled through space, *The Horse* has much in common with the work of the Italian Futurist Umberto Boccioni, who had visited the studios of Archipenko and Duchamp-Villon in 1912 and whose sculptures (see fig. 9.17) were shown in Paris in 1913.

Lipchitz

Cubism was only one chapter in the long career of **Jacques Lipchitz** (1891–1973), though no other sculptor explored as extensively the possibilities of Cubist syntax in sculpture. Born in Lithuania in 1891 to a prosperous Jewish family, Lipchitz arrived in Paris in 1909 and there studied at the École des Beaux-Arts and the Académie Julian. In 1913 he met Picasso and, through the Mexican artist Diego Rivera, began his association with the Cubists. He also befriended a fellow Lithuanian, Chaim Soutine, as well as Amedeo Modigliani, Brancusi, Matisse, and, in 1916, Juan Gris. During this time he developed an abiding interest in the totemic forms of African sculpture. In 1913 he introduced geometric stylization into his figure sculptures and by 1915 was producing a wide variety of Cubist wood constructions as well as stone and bronze works. For Lipchitz, Cubism was a means of re-examining the essential nature of sculptural

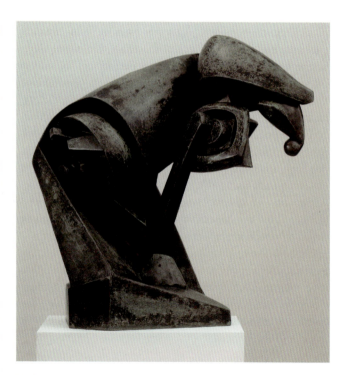

7.31 Raymond Duchamp-Villon, *The Horse*, 1914. Bronze (cast c. 1930–31); 40 × 39½ × 22⅜" (101.6 × 100.1 × 56.7 cm). The Museum of Modern Art, New York.

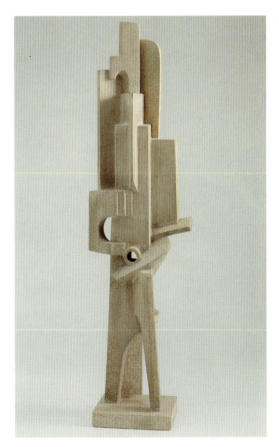

7.32 Jacques Lipchitz, *Man with a Guitar*, 1915. Limestone, 38¼ × 10½ × 7¾″ (97.2 × 26.7 × 19.5 cm). The Museum of Modern Art, New York.

form and of asserting sculpture as a self-contained entity, rather than an imitation of nature.

In a series of vertical compositions in 1915–16, including *Man with a Guitar* (fig. **7.32**), Lipchitz edged to the brink of abstraction. Conceived as a structure of rigid, intersecting planes, *Man with a Guitar* is an austere rendition of a familiar Cubist theme and was derived from the artist's earlier and more legible wood constructions of detachable figures. Late in life, Lipchitz, who often compared these abstracted sculptures to architecture, wrote about them in his autobiography, *My Life in Sculpture*: "I was definitely building up and composing the idea of a human figure from abstract sculptural elements of line, plane, and volume; of mass contrasted with void completely realized in three dimensions." Lipchitz preferred modeling in clay to carving in stone, and most of his later sculptures, which gradually increased in scale, were developed as clay models and plaster casts that were then cast in bronze or carved in stone by his assistants. A bronze from 1928, *Reclining Nude with Guitar*, shows how the artist was still producing innovative forms within an essentially Cubist syntax. In the blocky yet curving masses of the sculpture, Lipchitz struck a characteristic balance between representation and abstraction by effecting, in his words, "a total assimilation of the figure to the guitar-object." This analogy between the guitar and human anatomy was one already exploited by Picasso. From the 1930s to the end of his life, expressiveness became paramount in Lipchitz's sculpture and led to the free, rather baroque modeling of his later works. He moved to the United States to escape World War II in Europe and produced many large-scale public sculptures based on classical and biblical subjects.

Laurens

Henri Laurens (1885–1954) was born, lived, and died in Paris. He was apprenticed in a decorator's workshop and for a time practiced architectural stone carving. By the time of fully developed Analytic Cubism, he was living in Montmartre, immersed in the rich artistic milieu of the expanded Cubist circle in Paris. He was especially close to Juan Gris and Braque, whom he met in 1911. After his initial exposure to Cubism, Laurens absorbed the tenets of the style slowly. His earliest extant constructions and *papiers collés* (two media that are closely related in his oeuvre) date to 1915. Like Archipenko, whose Cubist work he knew well, Laurens excelled at polychromy in sculpture, integrating color into his constructions, low reliefs, and free-standing stone blocks. Referring to the long tradition of color in sculpture from antiquity to the Renaissance, he emphasized its function in reducing the variable effects of light on sculptural surfaces. As he explained, "When a statue is red, blue, or yellow, it remains red, blue, or yellow. But a statue that has not been colored is continually changing under the shifting light and shadows. My own aim, in coloring a statue, is that it should have its own light."

By 1919 Laurens had abandoned construction and embarked on a series of still-life sculptures in rough, porous stone. Drawing on his background in architectural stone carving and inspired by his love of French medieval sculpture, he carved *Guitar and Clarinet* (fig. **7.33**), 1920, in very low relief and then reinforced these flattened volumes with delicate, mat color. After 1920 Laurens relaxed the geometries of his Cubist style, adopting more curvilinear modes devoted to the depiction of the human figure.

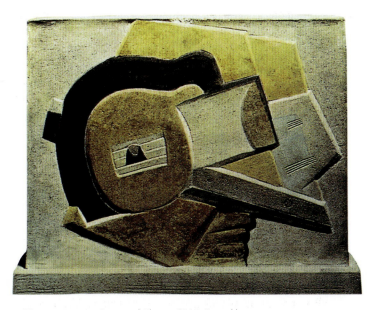

7.33 Henri Laurens, *Guitar and Clarinet*, 1920. Painted limestone, 12⅝ × 14½ × 3½″ (36.7 × 36.8 × 8.9 cm). Hirshhorn Museum and Sculpture Garden, Smithsonian Institution, Washington, D.C.

An Adaptable Idiom: Developments in Cubist Painting in Paris

The English critic Roger Fry, an early supporter of the Cubists, stated that "They do not seek to imitate form, but to create form, not to imitate life but to find an equivalent for life." By 1911 the Cubist search for new forms was gaining momentum well beyond the studios of Picasso and Braque, and eventually spawned a large school of Cubist painters in Paris. Of these, Albert Gleizes and Jean Metzinger also became talented critics and expositors of Cubism. Their book *On Cubism*, published in 1912, was one of the first important theoretical works on the movement. In Paris Gleizes and Metzinger met regularly with Robert Delaunay, Fernand Léger, and Henri Le Fauconnier, all of whom were sympathetic to the possibilities opened up by Cubism. The group convened regularly at the home of the socialist writer Alexandre Mercereau, at the café Closerie des Lilas and, on Tuesday evenings, at sessions organized by the journal *Vers et prose*. At the café these painters met with older Symbolist writers and younger, enthusiastic critics, such as Guillaume Apollinaire and André Salmon. (They were not, however, close to Cubism's inventors, Braque and Picasso.) In 1911 the group arranged to have their paintings hung together in the Salon des Indépendants. The concentrated showing of Cubist experiments created a sensation, garnering violent attacks from most critics, but also an enthusiastic champion in Apollinaire. That year Archipenko and Roger de La Fresnaye joined the Gleizes–Metzinger group, together with Apollinaire's friend the painter **Marie Laurencin** (1881–1956). Laurencin had portrayed Apollinaire (seated in the center), herself (at the left), Picasso, and his lover Fernande Olivier in her 1908 group portrait (fig. **7.34**), whose naïve style is reminiscent of Rousseau.

The three brothers Jacques Villon, Marcel Duchamp, and Raymond Duchamp-Villon, the Czech František Kupka, and the Spaniard Juan Gris were all new additions to the Cubist ranks. In the Salon des Indépendants of 1912 the Salon Cubists were so well represented that protests against their influence were lodged in the French parliament. Although Picasso and Braque did not take part in these Salons, their innovations were widely known. By then Cubist art had been shown in exhibitions in Germany, Russia, Britain, Spain, and the United States. In 1912 Kandinsky published works of Le Fauconnier and other Cubists in his yearbook *Der Blaue Reiter*, and Paul Klee visited the Paris studio of the Salon Cubist Robert Delaunay. Marc and Macke soon followed.

As these artists began to push the original Cubist concepts in various directions, testing limits in the process,

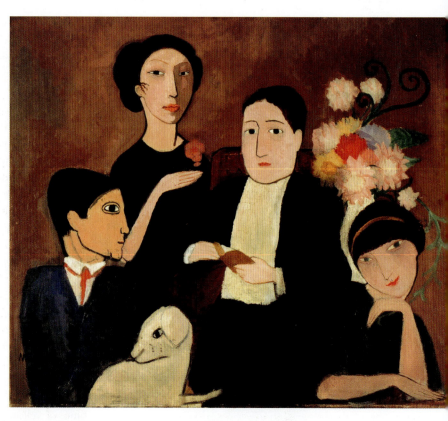

7.34 Marie Laurencin, *Group of Artists*, 1908. Oil on canvas, 25½ × 31⅞" (64.8 × 81 cm). The Baltimore Museum of Art.

they demonstrated that Cubism was a highly flexible and adaptable idiom. In a large exhibition at the Parisian gallery La Boëtie, held in October 1912 and entitled (probably by Jacques Villon) Section d'Or ("golden section"), entries by Marcel Duchamp, Francis Picabia, and Kupka signaled innovative alternatives to the Cubism of Picasso and Braque.

During 1912 and 1913 Gleizes and Metzinger's *On Cubism* was published, as well as Apollinaire's book *Les Peintres cubistes* (*The Cubist Painters*) and writings by various critics tracing the origins of Cubism and attempting to define it. Even today, when we are accustomed to the meteoric rise and fall of art movements and styles, it is difficult to appreciate the speed with which Cubism became an international movement. Beginning in 1908 with the isolated experiments of Braque and Picasso, by 1912 it was branching off in new directions and its history was already being written.

Gris

Juan Gris (1887–1927) was born in Madrid but moved permanently to Paris in 1906. While Gris was not one of Cubism's inventors, he was certainly one of its most brilliant exponents. Since 1908 he had lived next to his friend Picasso at the old tenement known as the Bateau Lavoir and had observed the genesis of Cubism, although he was then occupied in making satirical illustrations for French and Spanish journals.

Gris was closer to Braque and Picasso than were other members of the Cubist circle, and he was aware of their latest working procedures. Gris's sensibility differed significantly

from Picasso's: he was not drawn to the primitive, and his work is governed by an overriding refinement and logic. In fact, he later made compositions based on the classical notion of ideal proportion known as the golden section.

By 1912 he was making distinctive collages and *papiers collés* with varied textural effects, enhanced by his rich color sense. He tended to avoid Picasso's heterogeneous media and subversive approach to representation, preferring to marshal his pasted papers, which he usually applied to canvas, into precise, harmonious arrangements. *The Table*, 1914 (fig. **7.35**), depicting a typical Cubist still-life subject, incorporates Braque's *faux bois*, along with hand-applied charcoal and paper. Although the canvas is rectangular, the objects are contained within an oval format (the table itself is also rectangular) that seems to exist by virtue of a bright, elliptical spotlight. To achieve the layered complexity of this composition, Gris reordered the data of the visible world within at least two independent spatial systems. The foreshortened bottle of wine at the far right (which partially disappears under the *faux bois* paper) and the open book at the bottom are described as solid volumetric forms and exist in a relatively traditional space that positions the viewer above the table, looking down. The open book is drawn, but the

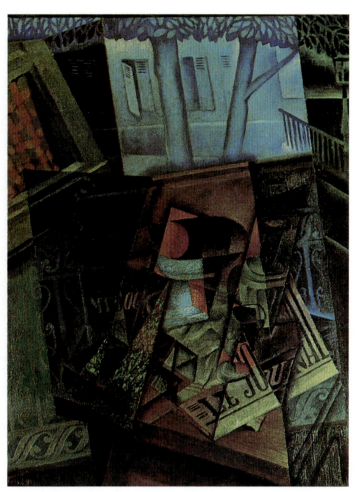

7.36 Juan Gris, *Still Life and Townscape (Place Ravignan)*, 1915. Oil on canvas, 45⅞ × 35⅛" (116.5 × 89.2 cm). Philadelphia Museum of Art.

text is an actual page from one of Gris's favorite detective novels. Toward the center of the work, a glass, bottle, and book, lightly inscribed in charcoal, are virtually transparent. They tilt at a precarious angle on what appears to be a second wooden table, introducing an altogether new space that is synonymous with the flat, upright surface of the painting. Perhaps the headline in the pasted newspaper, LE VRAI ET LE FAUX CHIC ("real and false chic"), refers not just to French fashion, but to the illusionistic trickery at play here.

Gris ceased making collages after 1914 but continued to expand his Cubist vocabulary in painting and drawing. In *Still Life and Townscape (Place Ravignan)* (fig. **7.36**) he employed a common Cubist device by mixing alternative types of illusionism within the same picture. In the lower half, a room interior embodies all the elements of Synthetic Cubism, with large, intensely colored geometric planes interlocking and absorbing the familiar collage components: the fruit bowl containing an orange; the newspaper, *Le Journal*; the wine label, MÉDOC. However, this foreground pattern of tilted color shapes leads the eye up and back to a window that opens out on a uniformly blue area of simple trees and buildings. Thus the space of the picture shifts abruptly from the ambiguity and multifaceted structure of Cubism to the cool clarity of a traditional Renaissance painting structure: the view through the window.

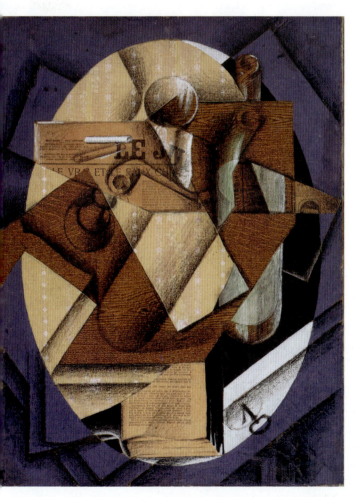

7.35 Juan Gris, *The Table*, 1914. Pasted and printed papers and charcoal on paper, mounted on canvas, 23½ × 17½" (59.7 × 44.5 cm). Philadelphia Museum of Art.

Listen to a podcast about *The Table* on mysearchlab.com

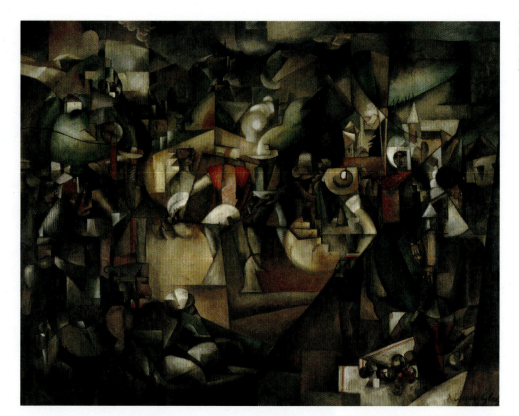

7.37 Albert Gleizes, *Harvest Threshing*, 1912. Oil on canvas, 8′ 10″ × 11′ 7″ (2.7 × 3.5 m). National Museum of Western Art, Tokyo.

Gleizes and Metzinger

The contributions of **Albert Gleizes** (1881–1953) and Metzinger to the Cubist movement are usually overshadowed by the reputation of their theoretical writings, specifically the pioneering book *On Cubism*, in which much of its pictorial vocabulary was first elucidated. Gleizes in particular was instrumental in expanding the range of the new art, in both type of subject and attitude toward that subject. His monumental 1912 painting *Harvest Threshing* (fig. **7.37**) opens up to a vast panorama the generally hermetic world of the Cubists. In its suggestions of the dignity of labor and the harmonious interrelationship of worker and nature, Gleizes explores a social dimension foreign to the unpeopled landscapes of Picasso and Braque. Although the palette remains within the subdued range—grays, greens, and browns, with flashes of red and yellow—the richness of Gleizes's color gives the work romantic overtones suggestive of Jean-François Millet (see fig. 1.13). In his later works, largely a response to the breakthrough Simultaneous Disk paintings of Robert Delaunay (see fig. 7.42), Gleizes turned to a form of lyrical abstraction based on curvilinear shapes, frequently inspired by musical motifs.

The early Cubist paintings of **Jean Metzinger** (1883–1956) are luminous variations on Cézanne, whose posthumous 1907 retrospective in Paris left an indelible impression on countless artists. *The Bathers* (fig. **7.38**), no doubt informed by Gris's immediate example, illustrates Metzinger's penchant for a carefully constructed rectangular design, in which the romantic luminosity of the paint plays against the strict geometry of the linear structure. He received his first solo exhibition in 1919 at Léonce Rosenberg's Galerie de l'Effort Moderne in Paris, which was dedicated to a rigorous form of Cubism dubbed

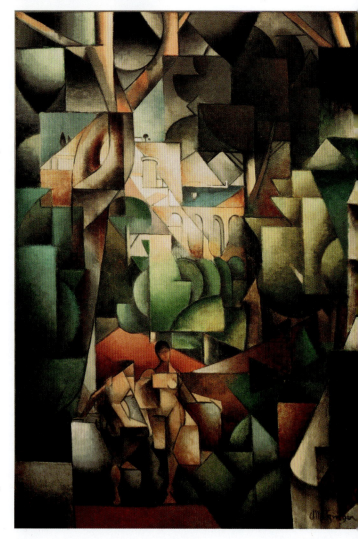

7.38 Jean Metzinger, *The Bathers*, 1913. Oil on canvas, 58¼ × 41⅞″ (148 × 106.4 cm). Philadelphia Museum of Art.

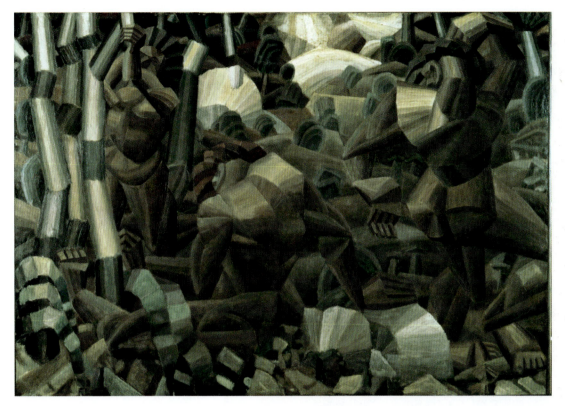

7.39 Fernand Léger, *Nude Figures in a Wood*, 1909–10. Oil on canvas, 47¼ × 66⅞" (120 × 169.9 cm). Kröller-Müller Museum, Otterlo, the Netherlands.

"crystal" Cubism, an apt designation for Metzinger's paintings at that time. Toward the end of World War I he began to assimilate photographic images of the figure or architectural scenes into a decorative Cubist frame. His later style, strongly influenced by Fernand Léger's work of the 1920s, was an idealized realism for which Cubist pattern was a decorative background—a formula that enmeshed many of the lesser Cubists.

Léger

One almost inevitable development from Cubism was an art celebrating the ever-expanding machine world within the modern metropolis, for the geometric basis of much Cubist painting provided analogies to machine forms. In his 1924–25 essay, "The Machine Aesthetic: Geometric Order and Truth," **Fernand Léger** (1881–1955) wrote: "Each artist possesses an offensive weapon that allows him to intimidate tradition. I have made use of the machine as others have used the nude body or the still life." Léger was not interested in simply portraying machines, for he opposed traditional realism as sentimental. Rather, he said he wanted to "create a beautiful object with mechanical elements."

Léger was from Normandy, in northwest France, where his family raised livestock. This agrarian background contributed to his later identification with the working classes and to his decision to join the Communist Party in 1945. Once he settled in Paris in 1900, Léger shifted his studies from architecture to painting and passed from the influence of Cézanne to that of Picasso and Braque. One of his first major canvases, *Nude Figures in a Wood* (fig. **7.39**), is an unearthly habitation of machine forms and wood-chopping

robots. Here Léger seems to be creating a work of art out of Cézanne's cylinders and cones, but it is also clear that he knew the work of artists such as Gleizes and Metzinger. The sobriety of the colors, coupled with the frenzied activity of the robotic figures, whose faceted forms can barely be distinguished from their forest environment, creates an atmosphere symbolic of a new, mechanized world. In 1913 Léger began a series of boldly non-objective paintings called *Contrastes de Formes* ("contrasts of forms"), featuring planar and tubular shapes composed of loose patches of color within black, linear contours. The metallic-looking forms, which interlock in rhythmical arrangements like the gears of some great machine, give the illusion of projecting toward the viewer. At first these shapes were nonreferential, but the artist later used the same morphology to paint figures and landscapes.

Other Agendas: Orphism and Other Experimental Art in Paris, 1910–14

Unlike Léger, **Robert Delaunay** (1885–1941) moved rapidly through his apprenticeship to Cubism and by 1912 had arrived at a formula of brilliantly colored abstractions with only the most tenuous roots in naturalistic observation. His restless and inquisitive mind had ranged over the entire terrain of modern art. Delaunay was developing his art of "simultaneous contrasts of color" based on the ideas of the color theorist Michel-Eugène Chevreul, who had so strongly influenced Seurat, Signac, and the Neo-Impressionists (see Ch. 3, p. 43). Also of interest to Delaunay were the space

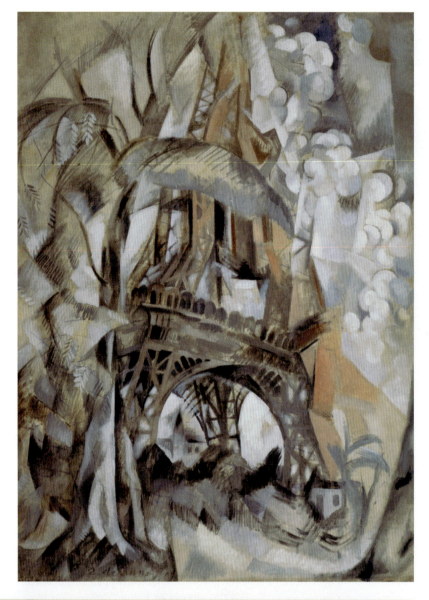

7.40 Robert Delaunay, *Eiffel Tower in Trees*, 1910. Oil on canvas, 49⅞ × 36½" (126.7 × 92.7 cm). Solomon R. Guggenheim Museum, New York. Solomon R. Guggenheim Museum Founding Collection.

concepts of Cézanne, Braque, and Picasso. In 1911 and 1912 he exhibited with Der Blaue Reiter in Munich and at Galerie Der Sturm in Berlin in 1912. This early contact with the German avant-garde, and especially the paintings and writings of Kandinsky (see Ch. 6, pp. 122–24), helped to make Delaunay one of the first French artists to embrace abstraction. He also joined the Cubists at the highly controversial Salon des Indépendants of 1911, where Apollinaire declared his painting the most important work in the show. Delaunay avoided the figure and the still life, two of the mainstays of orthodox Cubism, and in his first Cubist paintings took as themes two great works of Parisian architecture: the Gothic church of Saint-Séverin and the Eiffel Tower. He explored his subjects in depth, and made several variations of each. The *Eiffel Tower* series was begun in 1909. Like a work by Cézanne, the 1910 *Eiffel Tower in Trees* (fig. **7.40**) is framed by a foreground tree, depicted in light hues of ocher and blue, and by a pattern of circular cloud shapes that accentuate the staccato tempo of the painting. The fragmentation of the tower and foliage introduces not only the shifting viewpoints of Cubism, but also rapid motion, so that the tower and its environment seem to vibrate. With his interest in simultaneous views and in the suggestion of motion, Delaunay may be reflecting ideas published by the Futurists in their 1910 manifesto (see Ch. 9, p. 189).

Delaunay called his method for capturing light on canvas through color "simultaneity." In *Window on the City No. 3* (fig. **7.41**), 1911–12, which belongs to a series based on views of Paris, Delaunay applied his own variation of Chevreul's simultaneous contrast of colors. He used a checkerboard pattern of color dots, rooted in Neo-Impressionism and framed in a larger pattern of geometric shapes, to create a dynamic world of fragmented images.

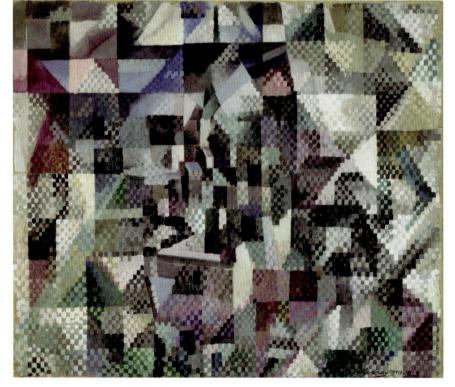

7.41 Robert Delaunay, *Window on the City No. 3*, 1911–12. Oil on canvas, 44¾ × 51½" (113.6 × 130.8 cm). Solomon R. Guggenheim Museum, New York. Solomon R. Guggenheim Museum Founding Collection.

7.42 Robert Delaunay, *Simultaneous Contrasts: Sun and Moon*, 1913 (dated 1912 on painting). Oil on canvas, diameter 53″ (134.6 cm). The Museum of Modern Art, New York.

her son. This remarkable object, which Delaunay said was based on examples made by Russian peasant women (and has much in common with the geometric pieced "crazy quilts" of nineteenth-century America), foreshadowed the abstract paintings she had begun to make by 1913. In her paintings, Sonia Delaunay explored the dynamic interaction of brilliant color harmonies. While they had much in common with Robert's work, they gave evidence of a creative personality quite distinct from his. After World War I she devoted more time to textile design. When worn, her clothing literally set into motion the geometric patterns she had first explored in 1911. Her highly influential designs were sold throughout America and Europe.

Born in the Czech Republic (then Bohemia, in the Austro-Hungarian Empire), **František Kupka** (1871–1957) attended the art academies of Prague and Vienna. The many forces in those cities that shaped his later art include exposure to the spiritually oriented followers of

This is essentially a work of abstraction, though its origin is still rooted in reality. In the spring of 1912 Delaunay began a new series, *Windows*, in which pure planes of color, fractured by light, virtually eliminate any recognizable vestiges of architecture and the observed world. Throughout this period, however, he continued to paint clearly representational works alongside his abstractions.

In his *Disk* paintings of 1913 (fig. **7.42**) Delaunay abandoned even the pretense of subject, creating arrangements of vividly colored circles and shapes. While these paintings, which he grouped under the title *Circular Forms*, have no overt relationship to motifs in nature, the artist did, according to his wife, Sonia Delaunay, observe the sun and the moon for long periods, closing his eyes to retain the retinal image of the circular shapes. His researches into light, movement, and the juxtaposition of contrasting colors were given full expression in these works.

Born Sonia Stern in a Ukrainian village, the same year as Robert Delaunay, **Sonia Delaunay** (1885–1979) moved to Paris in 1905. She married Robert in 1910 and, like him, became a pioneer of abstract painting. Her earliest mature works were Fauve-inspired figure paintings, and her first abstract work (fig. **7.43**), dated 1911, was a blanket that she pieced together from scraps of material after the birth of

7.43 Sonia Delaunay, *Blanket*, 1911. Appliquéd fabric, 42⅞ × 31⅞″ (109 × 81 cm). Musée National d'Art Moderne, Centre National d'Art et de Culture Georges Pompidou, Paris.

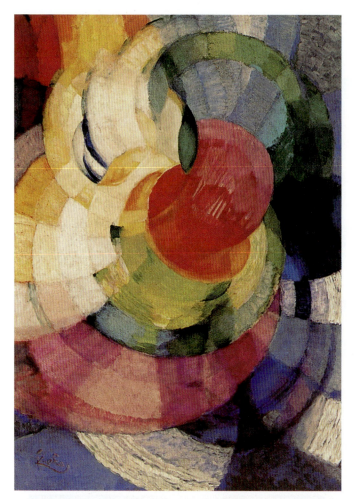

7.44 František Kupka, *Disks of Newton* (*Study for Fugue in Two Colors*), 1911–12. Oil on canvas, 39⅜ × 29″ (100 × 73.7 cm). Philadelphia Museum of Art.

((•— Listen to a podcast about *Disks of Newton* on mysearchlab.com

Nazarene art, decorative Czech folk art and other forms of ornament, knowledge of color theory, an awareness of the art of the Vienna Secession, and a lifelong involvement with spiritualism and the occult. Settling in Paris in 1896, he discovered chronophotography and the budding art form of cinematography. These, along with the color theory of Chevreul, contributed to his notion of an art, still based on the human figure, that suggested a temporal dimension through sequential movement. In this he shared concerns with the Futurists, though he developed his ideas before he saw their work in Paris in 1912.

Throughout his life Kupka was a practicing medium and maintained a profound interest in Theosophy, Eastern religions, and astrology. The visionary, abstract art he developed in Paris, beginning in 1910, was based on his mystical belief that forces of the cosmos manifest themselves as pure rhythmic colors and geometric forms. Such devotion to the metaphysical realm placed him at odds with most of the Cubist art he encountered in Paris. Though he arrived at a non-objective art earlier than Delaunay, and though he was

the first artist to exhibit abstract works in Paris, Kupka was then relatively unknown, and his influence was not immediately felt. In 1911–12, with the painting he entitled *Disks of Newton* (fig. **7.44**), Kupka created an abstract world of vibrating, rotating color circles. While his prismatic circles have much in common with Delaunay's slightly later *Disks*, it is not entirely clear what these two artists knew of one another's work.

In 1912 Apollinaire named the abstract experiments of Delaunay, Léger, Kupka, and others Orphism, a term that displeased the highly individualistic Kupka. The designation was intended to conjure the image of Orpheus, the doomed musician of Greek legend whose songs could tame wild beasts and soothe the gods. Apollinaire defined the style as one based on the invention of new structures "which have not been borrowed from the visual sphere," though the artists he designated had all relied on the "visual sphere" to some degree. It was, however, a recognition that this art was in its way as divorced as music from the representation of the visual world or literal subject. Kandinsky's approach to this was to equate his abstract paintings—done at about the same time—with pure musical sensation (see fig. 6.16).

Duchamp

Among the first artists to desert Cubism in favor of a new approach to subject and formal problems was **Marcel Duchamp** (1887–1968), one of the most fascinating, enigmatic, and influential figures in the history of modern art. As previously noted, Duchamp was one of four siblings who contributed to the art of the twentieth century, though none was nearly so significant as Marcel. Until 1910 he worked in a relatively conventional manner drawn from Cézanne and the Impressionists. In 1911 he painted his two brothers in *Portrait of Chess Players* (fig. **7.45**), obviously after coming

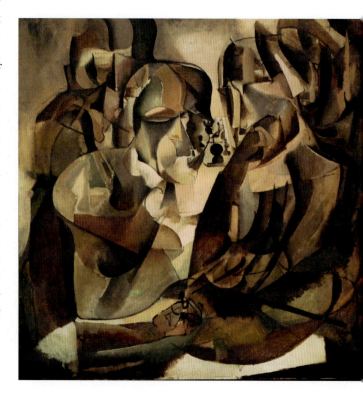

7.45 Marcel Duchamp, *Portrait of Chess Players*, 1911. Oil on canvas, 39¾ × 39¾″ (101 × 101 cm). Philadelphia Museum of Art.

under the influence of Picasso and Braque's Cubist explorations. The space is ambiguous and the color is low-keyed and virtually monochromatic, partly because Duchamp painted it by gaslight rather than daylight. The linear rhythms are cursive rather than rectangular, while the figures are characterized by tense energy and individuality; their fragmentation gives them a fantastic rather than a physical presence. Even at the moment when he was learning about Cubism, Duchamp was already transforming it into something entirely different from the conceptions of its creators, producing what leading Cubists regarded as a creative misreading of its principles. The game of chess is a central theme in Duchamp's work. In his later career, when he had publicly stopped making art, chess assumed a role tantamount to artistic activity in his life.

During 1911 Duchamp also painted the first version of *Nude Descending a Staircase*, a work destined to become notorious as a popular symbol of modern art. In the famous second version, 1912 (fig. **7.46**), the androgynous, mechanized figure has been fragmented and multiplied to suggest a staccato motion. Duchamp was fascinated by the art of cinema and by the nineteenth-century chronophotographs of **Étienne-Jules Marey** (fig. **7.47**), which studied the body's locomotion through stop-action photographs, similar to those of Eadweard Muybridge and Thomas Eakins (see fig. 2.33). Marey placed his subjects in black clothing with light metal strips down the arms and legs that would, when photographed, create a linear graph of their movement. Duchamp similarly indicated the path of his figure's movement with lines of animation and, at the elbow, small white dots. He borrowed the Cubists' reductive palette, painting the figure in what he called "severe wood colors." Cubists on the selection committee for the 1912 Salon des Indépendants objected to the work for its literal title and traditional subject. Duchamp refused to change the title and

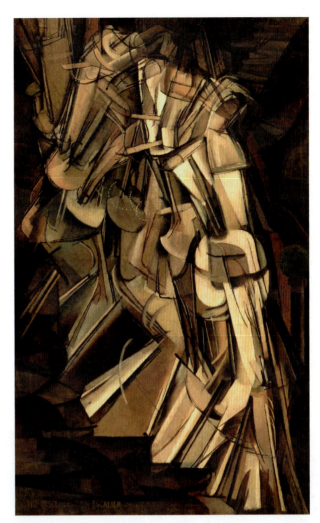

7.46 Marcel Duchamp, *Nude Descending a Staircase, No. 2*, 1912. Oil on canvas, 58 × 35″ (147.3 × 88.9 cm). Philadelphia Museum of Art.

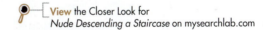

View the Closer Look for *Nude Descending a Staircase* on mysearchlab.com

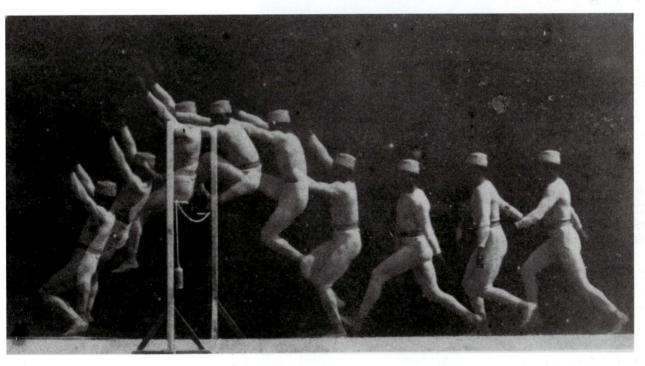

7.47 Étienne-Jules Marey, *A Man Doing a High Jump*, 1892. Chronophotograph.

withdrew his painting from the show. Throughout his life he used and subverted established artistic modes; in *Nude* he freely adapted Cubist means to a peculiarly personal aesthetic investigation. The rapidly descending nude is not a static form analyzed as a grid of lines and planes as is, for example, Picasso's *Portrait of Daniel-Henry Kahnweiler* (see fig. 7.18). Instead, by depicting the figure in several successive moments at once, Duchamp implies movement through space. *Nude Descending a Staircase* was shown in New York at the enormous 1913 Armory Show, the first international exhibition of modern art in the United States. The painting outraged American critics; one derided it as an "explosion in a shingle factory." Thanks to this exhibition, by the time Duchamp came to America in 1915 his reputation was already established. From an attack on Cubism that involved a new approach to subject, he passed, between 1912 and 1914, to an attack on the nature of subject painting, and finally to a personal re-evaluation of the very nature of art (see Ch. 10, pp. 219–225).

Duchamp's elder brother Gaston, who took the name **Jacques Villon** (1875–1963), was at the other extreme from Marcel, a committed Cubist. In 1906 he moved to Puteaux, on the outskirts of Paris, where he had a house that adjoined Kupka's. Puteaux, and particularly Villon's studio, became a remarkable nucleus of Cubist activity (the other being Montmartre, where Picasso and Braque worked) that eventually attracted Villon's brothers, Gleizes, Léger, Picabia, and Metzinger, among others. Villon established a personal, highly abstract, and poetic approach to Cubism, one he maintained throughout his long life. In addition to painting, he also made prints, a medium well suited to his particular Cubist idiom. The crystalline structure of jagged triangular shapes in the drypoint print depicting his sister, *Yvonne D. in Profile*, 1913, is indicated solely through parallel lines (fig. **7.48**). They switch directions and densities, creating volumetric rhythms and a sense of shifting light over the surface.

The influence of Cubism spread well beyond France in the years leading up to World War I. Modified to accommodate the aesthetic demands of artists from Britain, Italy, Russia, and the Netherlands, Cubism would serve as a springboard to experiments in pure abstraction, a direction that neither Braque nor Picasso would follow. Differing aesthetic demands were not the only forces reshaping Cubism. Artists like the Futurists and Vorticists (see Ch. 9, pp. 189–98), brought Cubism into line with their political aims as well.

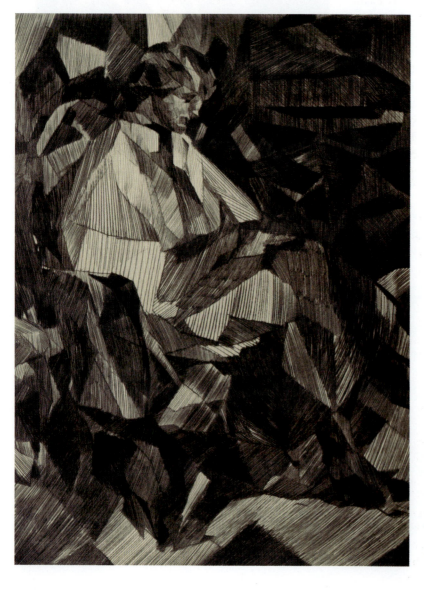

7.48 Jacques Villon, *Yvonne D. in Profile*, 1913. Drypoint in black on woven paper, 21½ × 16¼" (54.6 × 41.3 cm). National Gallery of Art, Washington, D.C.

8
Early Modern Architecture

In its germinal phase from 1909 to 1914, Cubism was not promoted by either Braque or Picasso as a means of changing society. While Cubist works from this period sometimes divulge an interest in a particular political event or issue, they were generally not created with the aim of serving specific social ends. But many of the artists and architects working in the early twentieth century embraced the possibility that their works might improve society. The belief that art could, and should, serve a salutary social or spiritual purpose had been a guiding principle for the British critic and philosopher John Ruskin, whose disciple William Morris introduced his ideas into modern design through his firm, Morris and Co., a major stimulus for the Arts and Crafts Movement.

Although the Arts and Crafts Movement influenced the development of Art Nouveau in Europe, its principles were adopted more thoroughly by the American architect Frank Lloyd Wright during the first years of the twentieth century. Wright shared Morris's faith in the social benefits of innovative design and careful handcrafting. Following his mentor, Louis Sullivan, he held above all that buildings as well as furnishings must give priority to **functionalism**, an approach to design that not only privileges the intended purpose a structure is to fulfill but also strives to manifest the building's function in its very design. In modernist architecture, an adherence to functionalism often resulted in the paring-down or even outright elimination of ornament, which was typically deemed unnecessary in terms of a building's strict purpose. Wright was a pioneer of the international modern movement, and his experiments in architecture as organic space in the form of abstract design antedate those of most of the early twentieth-century avant-garde European architects. His designs were published in Europe in 1910 and 1911, in two German editions by Ernst Wasmuth, and were studied by every major architect on the continent.

Just as Wright was making a name for himself, a very different tendency in avant-garde architecture was gathering momentum in Europe. From the late 1890s the Austrian architect Adolf Loos announced his opposition to the use of ornament in architecture, vehemently expressed in his 1908 article "Ornament and Crime." Emphasizing simple cuboid forms, he eschewed decorative features and even the curved lines so beloved by Art Nouveau. In contrast to the ethic of fine traditional craftsmanship and artistic finish that Art Nouveau had inherited from the Arts and Crafts Movement, Loos saw the industrial skills of the machine age as better fitted to serve the modern architecture. The tensions between these two approaches to architecture—one based in Arts and Crafts sensibilities, the other derived from Loos's commendation of a modern aesthetic of pure geometry—can be seen particularly clearly in the development of architecture in Austria and Germany during the first three decades of the twentieth century.

"Form Follows Function": The Chicago School and the Origins of the Skyscraper

Modern architecture may be said to have emerged in the United States with the groundbreaking commercial buildings of **Henry Hobson Richardson** (1838–86), an architect who, though eclectic, did not turn to the conventional historicist styles of Gothic pastiche and classical revival. In his Marshall Field Wholesale Store in Chicago (fig. **8.1**), now destroyed, Richardson achieved an effect of

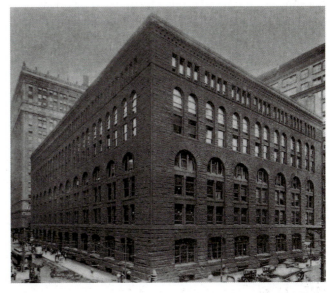

8.1 Henry Hobson Richardson, Marshall Field Wholesale Store, 1885–87. Chicago. Demolished 1931.

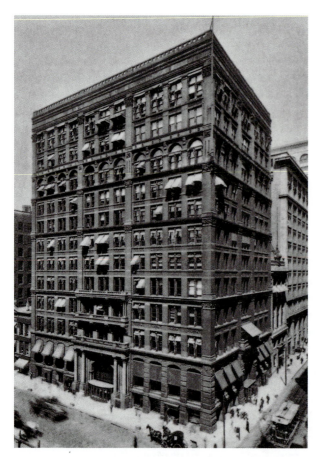

8.2 William Le Baron Jenney, Home Insurance Building, 1884–85. Chicago. Demolished 1929.

👁 Watch the architectural simulation on the skyscraper on mysearchlab.com

monumental mass and stability through the use of graduated rough blocks of reddish Massachusetts sandstone and Missouri granite in a heavily rusticated structure inspired by Romanesque architecture and fifteenth-century Italian Renaissance palaces. The windows, arranged in diminishing arcaded rows that mirror the gradual narrowing of the masonry wall from ground to roof, are integrated with the interior space rather than being simply holes punched at intervals into the exterior wall. The landmark Marshall Field building was constructed with traditional load-bearing walls, columns, and girders (rather than the steel frames of later skyscrapers), but its elemental design, free of picturesque ornament, influenced the later work of the Chicago School, specifically that of Louis Sullivan and, ultimately (though he would never acknowledge it), Frank Lloyd Wright.

Throughout the nineteenth century, continual expansion and improvement in the production of structural iron and steel permitted the height of commercial buildings to be raised, a necessity born of growing urban congestion and rising real-estate costs. At the same time, there were sporadic experiments in increasing the scale of windows beyond the dictates of Renaissance palace façades. A vast proportion of Chicago was destroyed in the great fire of 1871—an event that cleared the way for a new type of metropolis fully utilizing the new architectural and urban planning techniques and materials developed in Europe and America over the previous hundred years.

The Home Insurance Building in Chicago (fig. **8.2**), designed and constructed in 1884–85 by the architect **William Le Baron Jenney** (1832–1907), was only ten stories high, no higher than other proto-skyscrapers already built in New York (the illustration shown here includes the two stories that were added in 1890–91). Its importance rested in the fact that it embodied true skyscraper construction, in which the internal metal skeleton carried the weight of the external masonry shell. This innovation, which was not Jenney's alone, together with the development of the elevator, permitted buildings to rise to great heights and led to the creation of the modern urban landscape of skyscrapers. With metal-frame construction, architects could eliminate load-bearing walls and open up façades, so that a building became a glass box in which solid, supporting elements were reduced to a minimum. The concept of the twentieth-century skyscraper as a glass-encased shell framing a metal grid was here stated for the first time.

Among the many architects attracted to Chicago from the East or from Europe by the opportunities engendered by the great fire was the Dane Dankmar Adler (1844–1900), an engineering specialist. He was joined in 1879 by a young Boston architect, **Louis Sullivan** (1856–1924). The 1889 dedication of the Adler and Sullivan Auditorium helped stimulate a resurgence of architecture in Chicago after the devastations of the fire. And, like Jenney's Home Insurance Building, it emerged under the influence of Richardson's Marshall Field store (see fig. 8.1). The Auditorium included offices, a hotel, and, most significantly, a spectacular new concert hall, then the largest in the country, with a highly successful acoustical system designed by Adler. Shallow concentric arches in the hall made for a majestic yet intimate space, and Sullivan's use of a sumptuous decoration of natural and geometric forms, richly colored mosaics, and painted panels proved that ornament was one of the architect's great strengths as a designer. By the late 1920s, the Chicago Opera Company had moved to new quarters—fortunately, however, the demolition of the Auditorium during the ensuing years of national Depression proved too expensive to carry out.

Adler and Sullivan entered the field of skyscraper construction in 1890 with their Wainwright Building in St. Louis. Then, in the Guaranty Trust Building (now the Prudential Building) in Buffalo, New York, Sullivan designed the first masterpiece of the early skyscrapers (fig. **8.3**). Here, as in the Wainwright Building, the architect attacked the problem of skyscraper design by emphasizing verticality, with the result that the piers separating the windows of the top ten stories of the twelve-story structure are uninterrupted through most of the building's height. At the same time, he seemed well aware of the design problem peculiar to the skyscraper, which is basically a tall building consisting of a large number of superimposed horizontal layers. Thus, Sullivan accentuated the individual layers with ornamented bands under the windows, as well as throughout the attic story, and crowned the building with a projecting cornice that brings the structure back to the horizontal. This tripartite division

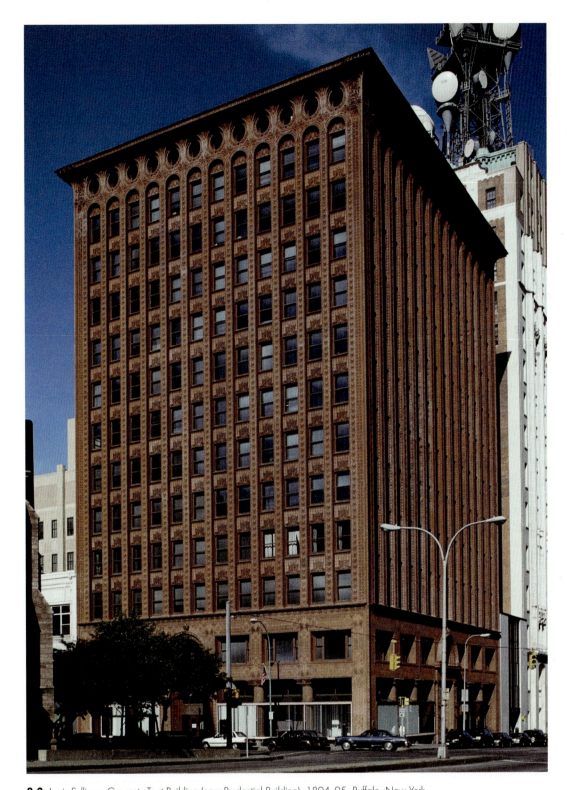

8.3 Louis Sullivan, Guaranty Trust Building (now Prudential Building), 1894–95. Buffalo, New York.

View the Closer Look for Sullivan's Wainwright Building on mysearchlab.com

of the façade—base, piers, and attic—has frequently been compared to the form of a classical column. Meanwhile, the treatment of the columns on the ground floor emphasizes the openness of the interior space. Above them, the slender piers between the windows soar aloft and then join under the attic in graceful arches that tie the main façades together. The oval, recessed windows of the attic blend into the elegant curve of the summit cornice. Sullivan's famed ornament covers the upper part of the structure in a light, overall pattern, helping to unify the façade while also emphasizing the nature of the terracotta sheathing over the metal skeleton as a weightless, decorative surface, rather than a weight-bearing element. "It must be every inch a proud and soaring thing," said Sullivan of the tall office building, "rising in sheer exaltation … from bottom to top as a unit without a single dissenting line." In theory, Sullivan felt that a building's interior function should determine its exterior form, hence his famous phrase, "form follows function" (see

Louis Sullivan, "The Tall Office Building Artistically Considered," below). But practical experience taught him that function and structure did not always generate the most appealing forms.

The progressive influence of Richardson and the Chicago School was counteracted after his death as more and more young American architects studied in Paris in the academic environment of the École des Beaux-Arts (where, in fact, Richardson had trained). The 1893 World's Columbian Exposition in Chicago, a world's fair celebrating the four-hundredth anniversary of Columbus's voyage, was a vast and highly organized example of quasi-Roman city planning (fig. **8.4**). It was a collaboration among many architects, including McKim, Mead & White, the Chicago firm of Burnham and

8.4 Richard Morris Hunt; McKim, Mead & White; Burnham and Root; and other architects, World's Columbian Exposition, Chicago, 1893. Demolished.

Root, and **Richard Morris Hunt** (1827–95), the doyen of American academic architecture. Though modeled on European precedents, the Columbian Exposition set out to assert American ascendancy in industry and particularly the visual arts. Ironically, while international expositions in London and Paris had unveiled such futuristic architectural marvels as the Crystal Palace and the Eiffel Tower, America looked to the classical European past for inspiration. This resulted, in part, from an anxiety that pragmatic Chicago-style architecture might give a provincial appearance to America's first world's fair. The gleaming white colonnades of the buildings, conceived on an awesome scale and arranged around an immense reflecting pool, formed a model for the future American dream city, one that affected a generation of architects and their clients. Thus, although the Chicago School of architecture maintained its vitality into the first decade of the twentieth century, neo-academic eclecticism remained firmly established, with New York architects leading the way.

Modernism in Harmony with Nature: Frank Lloyd Wright

Frank Lloyd Wright (1867–1959) studied engineering at the University of Wisconsin, where he read the work of John Ruskin and was particularly drawn to rational, structural interpretation in the writings of Eugène-Emmanuel Viollet-le-Duc. In 1887 he was employed by the Chicago architectural firm of Adler and Sullivan, establishing his own practice in 1893. There is little doubt that many of the Sullivan houses built when Wright worked there represented his ideas. Wright's basic philosophy of architecture was expressed primarily through the house form. The 1902–06 Larkin Building in Buffalo, New York (see fig. 8.10) was his only large-scale structure prior to Chicago's Midway Gardens (1914) and the Imperial Hotel in Tokyo (see fig. 8.11) (all three, incidentally, have been destroyed).

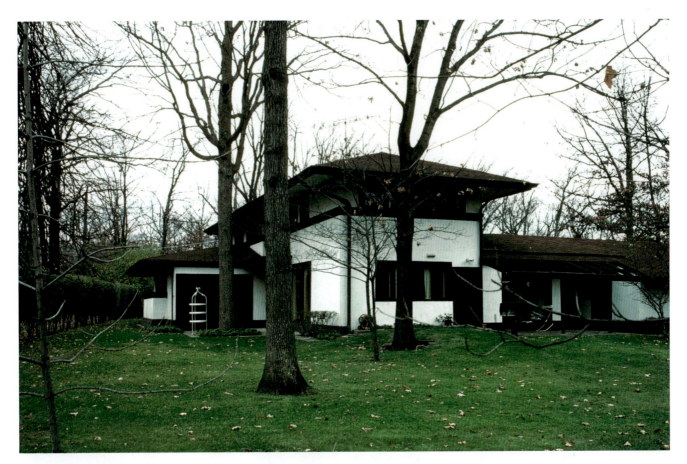

8.5 Frank Lloyd Wright, Ward Willits House, 1902–03. Highland Park, Illinois.

Early Houses

At the age of twenty-two Wright designed his own house in Oak Park, Illinois (1889), a quiet community thirty minutes by train from downtown Chicago. His earliest houses, including his own, reflect influences from the shingle-style houses of H. H. Richardson and McKim, Mead & White and developed the open, free-flowing floor plan of the English architects Philip Webb and Richard Norman Shaw. Wright used the characteristically American feature of the veranda, open or screened, wrapping around two sides of the house, to enhance the sense of outside space that penetrated to the main living rooms. The cruciform plan, with space surrounding the central core of fireplace and utility areas (kitchen, landing, etc.), also affected Wright's approach to house design as well as to more monumental design projects.

In the 1902–03 Ward Willits House in Highland Park, Illinois (fig. **8.5**), Wright made one of his first individual and mature statements of the principles and ideas that he had been formulating during his apprentice years. The house demonstrates his growing interest in a Japanese aesthetic. He was a serious collector of Japanese prints (about which he wrote a book), and before his trip to Japan in 1905 he probably visited the Japanese pavilions at the 1893 World's Columbian Exposition in Chicago. In the Willits House, the Japanese influence is seen in the dominant wide, low-gabled roof and the vertical striping on the façade. The sources, however, are less significant than the welding together of all the elements of the plan, interior and exterior, in a single

integrated unit of space, mass, and surface. From the compact, central arrangement of fireplace and utility areas, the space of the interior flows out in an indefinite expansion carried without transition to the exterior and beyond. The essence of the design in the Willits House, and in the series of houses by Wright and his followers to which the name Prairie Style has been given, is a predominant horizontal accent of rooflines with deep, overhanging eaves echoing the flat prairie landscape of the Midwest. The earth tones of the typical Prairie house were intended to blend harmoniously with the surroundings, while the massive central chimney served both to break the horizontal, low-slung line of the roof and to emphasize the hearth as the spiritual and psychological center of the house.

The interior of the Wright Prairie house (see fig. 8.9) is characterized by low ceilings, frequently pitched at unorthodox angles; a sense of intimacy; and constantly changing vistas of one space flowing into another. The interior plastered walls of the Willits House were trimmed simply in wood, imparting a sense of elegant proportion and geometric precision to the whole. Wright also custom-designed architectural ornaments for his houses, such as light fixtures, leaded glass panels in motifs abstracted from natural forms, and furniture, both built-in and free-standing (fig. **8.6**). Though his emphasis on simple design and the honest expression of the nature of materials is dependent in part on Arts and Crafts ideals (see Ch. 4, pp. 70–73), Wright fervently supported the role of mechanized production in architectural design. He regarded the machine as a metaphor

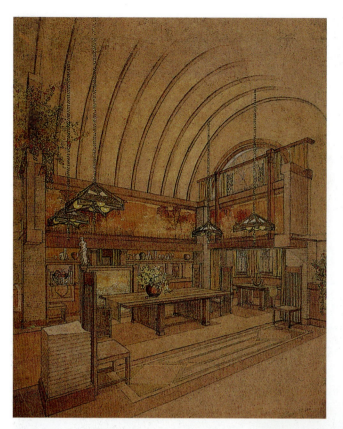

of the modern age but did not believe that buildings should resemble machines. Paramount in his house designs was the creation of a suitable habitat, in harmony with nature, for the middle-class nuclear family. Wright understood the way in which his domestic dwellings embodied the collective values and identity of a community. These early residences were designed for Chicago's fast-growing suburbs, where structures could extend horizontally, as opposed to the city, where Victorian townhouses were built in several stories to accommodate narrow urban plots.

The culmination of Wright's Prairie Style is the 1909 Robie House in Chicago (figs. **8.7**, **8.8**, **8.9**). The house is centered around the fireplace and arranged in plan as two sliding horizontal sections on one dominant axis. The horizontal roof **cantilevers** out on steel beams and is anchored at the center, with the chimneys and top-floor gables set at right angles to the principal axis. Windows are arranged in long, symmetrical rows and are deeply imbedded into the brick masses of the structure. The main, horizontally designed lines of the house are reiterated and expanded in the terraces and walls that transform interior into exterior space and vice versa. The elements of this house, combining the outward-flowing space of the interior and the linear

8.6 Frank Lloyd Wright, Susan Lawrence Dana House, 1902–04. Springfield, Illinois. Interior perspective, dining room. Pencil and watercolor on paper, 25 × 20⅜″ (63.5 × 51.7 cm). Avery Architectural and Fine Arts Library, Columbia University, New York.

👁 ⎯ Watch a video about Wright on mysearchlab.com

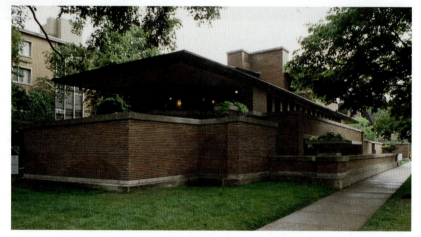

8.7 Frank Lloyd Wright, Robie House, 1909. Chicago.

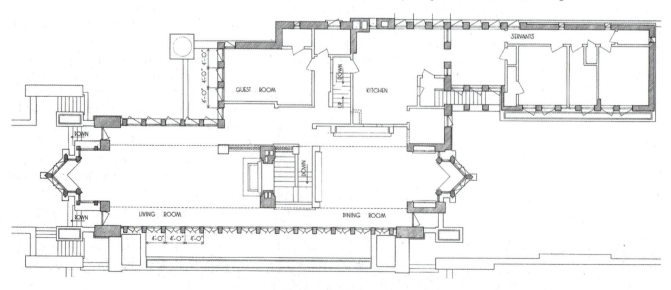

8.8 Frank Lloyd Wright, Robie House plan, 1909.

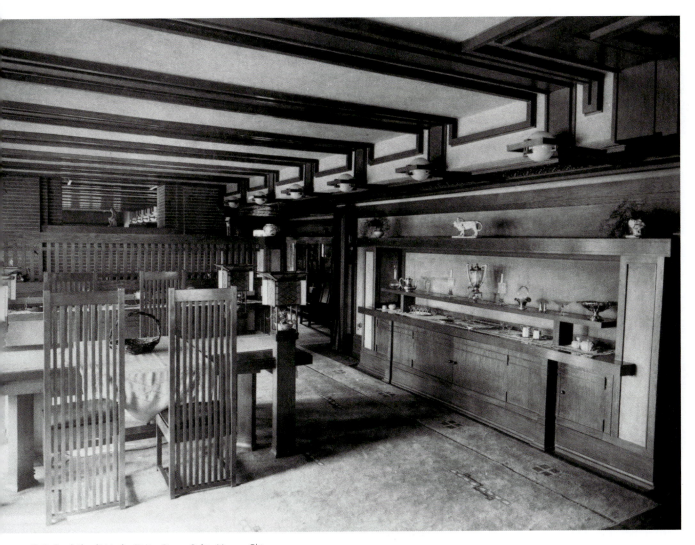

8.9 Frank Lloyd Wright, Dining Room, Robie House. Chicago.

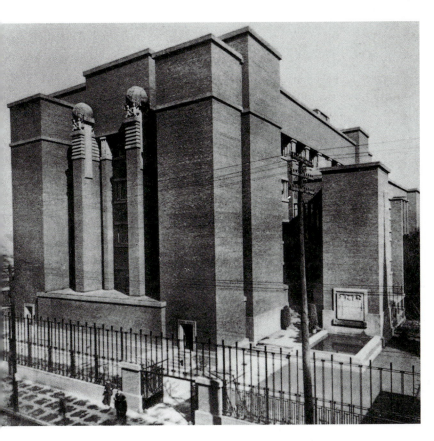

8.10 Frank Lloyd Wright, Larkin Building, 1902–06. Buffalo, New York. Demolished 1950.

and planar design of exterior roofline and wall areas with a fortress-like mass of chimneys and corner piers, summarize other experiments that Wright had carried on earlier in the Larkin Building (**fig. 8.10**).

The Larkin Building

The Larkin Building represented radical differences from the Prairie house in that it was organized as rectangular elements in which Wright articulated mass and space into a single, close unity. The building was, on the exterior, a rectangular, flat-roofed structure, whose immense corner piers protected and supported the window walls that reflected an open interior well surrounded by balconies. The open plan, filled with prototypes of today's "work stations," was Wright's solution for a commodious, light-filled office environment. The Larkin Building literally embodied the architect's belief in the moral value of

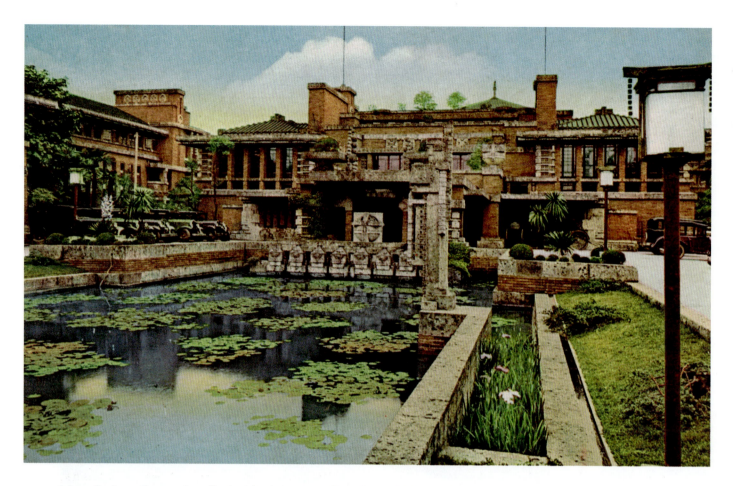

labor, for its walls were inscribed with mottoes extolling the virtues of honest work. This was an example of the early modern industrial structures that encompassed tremendous possibilities for developing innovative kinds of internal, expressive space in the new tall buildings of America (the economics of industrial building, however, soon destroyed these possibilities).

Mid-Career Crisis

In the years after 1910, just when he was becoming a world figure, Wright experienced a period of neglect and even vilification in his own country. Highly publicized personal problems, among them his decision to leave his wife and six children for another woman, Mamah Cheney, helped to drive him from the successful Midwestern practice he had built up in the early years of the century. In 1914 Cheney, along with her two children and four house-guests, was murdered by a servant who also set fire to Taliesin, the home Wright had built for himself in Wisconsin; he subsequently rebuilt it (the name is that of a mythic Welsh poet and means "shining brow"). Along with these personal factors were cultural and social changes that, by 1915, had alienated the patronage for experimental architecture in the Midwest and increased the popularity of historical revivalist styles. Large-scale construction of mass housing soon led to vulgarization of these styles.

About 1915, Wright began increasingly to explore the art and architecture of ancient cultures, including the Egyptian, Japanese, and Maya civilizations. The Imperial Hotel in Tokyo (fig. **8.11**), a luxury hotel designed for

Western visitors, occupied most of his time between 1912 and 1923 and represents his most ornately complicated decorative period, filled with suggestions of Far Eastern and Pre-Columbian influence. In addition, it embodied his most daring and intricate structural experiments to date—experiments that enabled the building to survive the wildly destructive Japanese earthquakes of 1923 (only to be destroyed by the wrecking ball in 1968). For twenty years after the Imperial Hotel, Wright's international reputation continued to grow. Although he frequently had difficulty earning a living, he was indomitable; he wrote, lectured, and taught, secure in the knowledge of his own genius and place in history, and he invented brilliantly whenever he received architectural commissions.

Temples for the Modern City: American Classicism 1900–15

Aside from Wright, a number of his followers, and a few isolated architects of talent, American architecture between 1915 and 1940 was largely in the hands of academicians and builders. Nevertheless, two landmark structures were erected during this period. New York City's Pennsylvania Station (fig. **8.12**), built between 1906 and 1910 and demolished in 1966, represents one of the most tragic architectural losses of the twentieth century. "Until the first blow fell," said an editorial in *The New York Times*, "no one

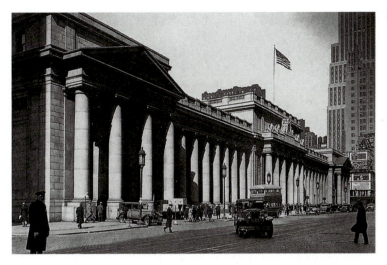

8.12 McKim, Mead & White, Pennsylvania Station, 1906–10. New York. Demolished 1966.

Listen to a podcast about McKim, Mead & White on mysearchlab.com

was convinced that Penn Station really would be demolished or that New York would permit this monumental act of vandalism." The station was designed by the Beaux-Arts architectural firm of McKim, Mead & White, who designed classically inspired civic buildings throughout America in the early years of the century. Penn Station was one of the firm's most ambitious undertakings. The exterior, a massive Doric colonnade based on the ancient Baths of Caracalla in Rome, presented a grand modern temple that underscored the power of the railroad as a symbol of progress. Inside, a visitor's first impression upon arrival was the dramatically vaulted spaces in the train concourse, its glass-and-steel construction recalling the crystal palaces of the previous century. In 1966 the city responded to the destruction of Penn Station by establishing the New York City Landmarks Preservation Commission.

At the same time, on the other side of the continent, a remarkable act of preservation was taking place. The Palace of Fine Arts in San Francisco (fig. **8.13**), designed by the architect **Bernard Maybeck** (1862–1957), was originally built in 1915 for the Panama–Pacific International Exposition. Celebrating the opening of the Panama Canal, the San Francisco Exposition was a world's fair that emulated the famous 1893 World's Columbian Exposition (see fig. 8.4). It was visited by nineteen million people during ten months in 1915, providing an economic boost to a city that had experienced the devastating earthquake and fire of 1906. Sited along a lagoon, Maybeck's popular ensemble included an open-air rotunda, a curving Corinthian peristyle, and a large gallery that housed the fair's paintings and sculptures. The unconventional Maybeck turned classicism into his own personal idiom, violating **canonical** rules and covering his structures with richly imaginative classical-style ornament. He sought a mood of melancholy and past grandeur, for he envisioned the Palace as "an old Roman ruin, away from civilization … overgrown with bushes and trees." It was a mood somehow appropriate for a world in the midst of the carnage of World War I. Though it was the only building not torn down after the fair, the Palace of Fine Arts was never intended as a permanent structure and it soon began to show signs of decay. Between 1962 and 1967 it was completely reconstructed out of concrete. Today it is still used as a city museum.

New Simplicity Versus Art Nouveau: Vienna Before World War I

The capital of the vast, disparate Austro-Hungarian Empire, which was dismembered after World War I, prewar Vienna was a cosmopolitan city characterized by both entrenched official conservatism and culturally progressive tendencies that were highly influential in many spheres, such as the psychoanalytic research being undertaken there by Sigmund Freud (see Ch 4, p. 78). In 1897, determined to break away from the stifling academicism of official art, a group of artists had formed the Vienna Secession (see Ch. 4, pp. 77–79). Their new exhibition building, designed in 1898 by **Joseph Maria Olbrich** (see fig. 4.13), combined different strands of Art Nouveau in the geometric lines of its façade and the intertwined foliage of its openwork gilt-bronze cupola. In early twentieth-century Viennese architecture, therefore, the relationship between Art Nouveau decoration and modernist geometric functionalism is far from a clear-cut opposition. Both elements can be found in buildings by major Austrian architects of the period, although the polemical writings of Loos in particular helped to define the austere simplicity he favored as the hallmark of avant-garde architecture.

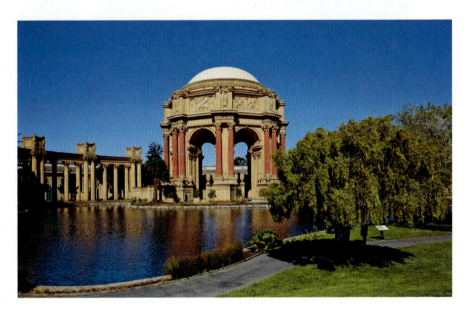

8.13 Bernard Maybeck, Palace of Fine Arts, 1915. San Francisco.

The founder of Viennese modernism, **Otto Wagner** (1841–1918), was first an academic architect. His stations for the Vienna subway (1896–97) were simple, functional buildings dressed with baroque details. In his 1894 book on modern architecture, however, Wagner had already demonstrated his ideas about a new architecture that used the latest materials and adapted itself to the requirements of modern life. His motto, "Necessity alone is the ruler of art," anticipated later twentieth-century functionalism. In the hall of his 1905 Vienna Post Office Savings Bank (fig. **8.14**) Wagner used unadorned metal and glass to create airy, light-filled, unobstructed space. While there is some stylistic similarity here to the organic designs by Art Nouveau architects like Victor Horta (see Ch. 4, pp. 80, 82), Wagner's approach shows a typically modernist concern for the increasing elimination of structural elements and the creation of a single unified and simple space.

Adolf Loos (1870–1933) was active in Vienna from 1896. After studying architecture in Dresden, he worked in the United States for three years from 1893 (when he attended the World's Columbian Exposition in Chicago), taking various odd jobs while learning about the new concepts of American architecture, particularly the skyscraper designs of Sullivan, and other pioneers of the Chicago School. After settling in Vienna, Loos followed principles established by Wagner and Sullivan favoring a pure, functional architecture, as seen in his 1910 Steiner House in Vienna (fig. **8.15**). Zoning rules allowed for only one story above street level, so Loos employed a **barrel-vaulted** roof on the front of the house, so deep that it allowed for two more levels facing the garden; both views are seen here. The garden façade is symmetrical; simple, large-paned windows arranged in horizontal rows are sunk into the planar surfaces of the rectilinear façade. Reinforced concrete appears here in one of its earliest applications in a private house. Although the architecture and ideas of Loos never gained wide appeal, the Steiner House is a key monument in the creation of the new style.

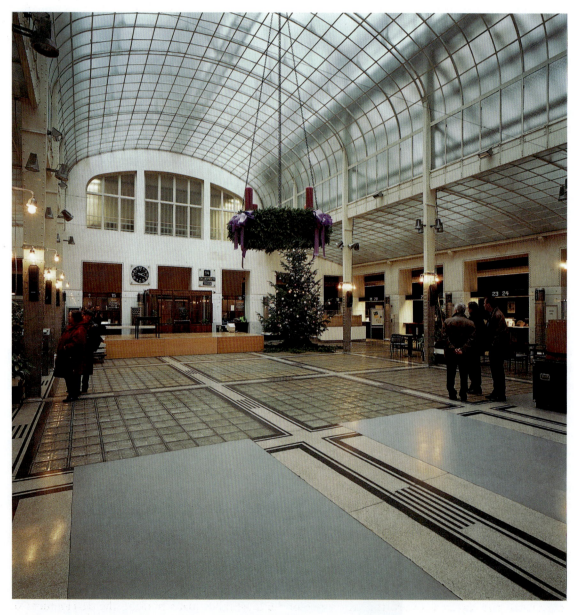

8.14 Otto Wagner, Post Office Savings Bank, 1905. Vienna.

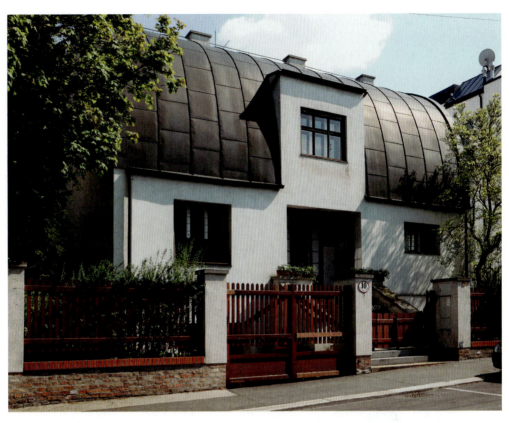

8.15 Adolf Loos, Front and garden view, Steiner House, 1910. Vienna.

Among the Art Nouveau architects attacked by Loos were Olbrich and Josef Hoffmann (see Ch. 4, pp. 79, 82–84), who, with the painter Gustav Klimt, were the founders of the Vienna Secession. Hoffmann's masterpiece is the Palais Stoclet, a luxurious house that he built for the Stoclet family in Brussels (see fig. 4.21). This splendid mansion is characterized by severe rectangular planning and façades, and broad, clear, white areas framed in dark, linear strips (betraying the influence of Charles Rennie Mackintosh). Its lavish interior design, an expression of the Secessionist belief in a total decorative environment, offers a marked contrast to the sobriety of Loos's Steiner House.

Hoffmann is perhaps more important for his part in establishing the Wiener Werkstätte (Vienna Workshops) than for his achievement as a practicing architect. The workshops, which originated in 1903, continued the craft traditions of William Morris and the English Arts and Crafts Movement, with the contradictory new feature that the machine was now accepted as a basic tool of the designer. For thirty years the workshops exercised a notable influence, teaching fine design in handicrafts and industrial objects.

Tradition and Innovation: The German Contribution to Modern Architecture

In Germany before 1930, largely as a result of enlightened governmental and industrial patronage, architectural experimentation, instead of depending only on brilliant individuals, was coordinated and directed toward the creation of a "school" of modern architecture. In this process,

the contributions of certain patrons such as Archduke Ernst Ludwig of Hesse and the AEG (General Electrical Company) were of the greatest importance.

Relations between Austrian and German architecture were extremely close in the early years of the twentieth century. When the Archduke of Hesse wished to effect a revival of the arts by founding an artists' colony at Darmstadt in Germany, he employed Olbrich to design most of the buildings, including the 1907 Hochzeitsturm (Wedding Tower) (fig. **8.16**). The Wedding Tower, which still dominates Darmstadt, was so named because it commemorated the archduke's second marriage; it was intended less as a functional structure than as a monument and a focal point for the entire project. Although it was inspired by the American concept of the skyscraper, its visual impact owes much to the towers of German medieval churches. Its distinctive five-fingered gable symbolizes an outstretched hand. The manner in which rows of windows below the gable are grouped within a common frame and wrapped around a corner of the building was an innovation of particular significance for later skyscraper design.

At about the same time that Hoffmann set up the Wiener Werkstätte a German cabinetmaker, Karl Schmidt, had started to employ architects and artists to design furniture for his shop in Dresden. Out of this grew the Deutsche Werkstätte (German Workshops), which similarly applied the principles of Morris to the larger field of industrial design. From these and other experiments, the Deutscher Werkbund (German Work or Craft Alliance) emerged in 1907. This was the immediate predecessor of the Bauhaus, one of the most influential schools in the development of modern architecture and industrial design (see Chapter 13).

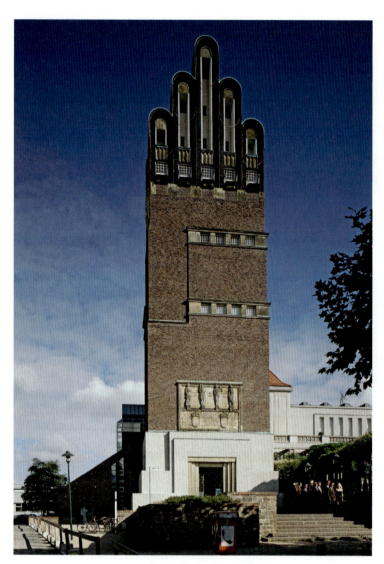

8.16 Joseph Maria Olbrich, Hochzeitsturm (Wedding Tower), 1907. Darmstadt, Germany.

Behrens and Industrial Design

More than any other German architect of the early twentieth century, **Peter Behrens** (1868–1940) forged a link between tradition and experiment. He began his career as a painter, producing Art Nouveau graphics, and then moved from an interest in crafts to the central problems of industrial design for machine production. Behrens turned to architecture as a result of his experience in the artists' collaborative at Darmstadt, where he designed his own house—the only one in the colony not designed by Olbrich. In 1903 Behrens was appointed director of the Düsseldorf School of Art, and in 1907 the AEG company, one of the world's largest manufacturers of generators, motors, and lightbulbs, hired him as architect and coordinator of design for everything from products to publications. This unusual appointment by a large industrial organization of an artist and architect to supervise and improve the quality of all its products was a landmark in the history of architecture and design.

One of Behrens's first buildings for AEG, a landmark of modern architecture, is the Turbine Factory in Berlin, completed in 1909 (fig. **8.17**). Although the building is given a somewhat traditional appearance of monumentality by

the huge corner masonry piers and the overpowering visual mass of the roof (despite its actual structural lightness), it is essentially a glass-and-steel structure. Despite the use of certain traditional forms, this building is immensely important in its bold structural engineering, in its frank statement of construction, and in the social implications of a factory built to provide the maximum of air, space, and light. It is functional for both the processes of manufacture and the working conditions of the employees—concerns rarely considered in earlier factories.

The hiring of Behrens by AEG and similar appointments by other industrial corporations mark the emergence of some sense of social responsibility on the part of large-scale industry. The established practice had been one of short-sighted and often brutal exploitation of natural and human resources. Certain enlightened industrialists began to realize that well-designed working spaces and products were not necessarily more expensive to produce than badly designed ones and had numerous economic and political advantages (see *The Human Machine*, below). In the rapidly expanding industrial scene and the changing political landscape of early twentieth-century Europe, the public image presented by industry was assuming increasing importance. It was becoming evident that industry had a powerful role to play in public affairs and even in promoting a national image.

CONTEXT

The Human Machine: Modern Workspaces

With the proliferation of factories and office buildings in the late nineteenth and early twentieth centuries, architects and engineers grappled with the problems posed by industry's need for such an intense concentration of laborers. Some of the most lasting innovations in industrial architecture were made by Albert Kahn, who designed factories used for the first assembly-line approach to manufacturing at the Ford Motor Co. in Detroit. By creating long, open spaces enclosed by glass **curtain walls** or covered by a roof with a continuous clerestory, Kahn introduced well-lit spaces that enhanced productivity while also taking safety into consideration. Along with the development of streamlined factory production, known as Fordism, came the advent of Taylorism, named for F. W. Taylor who advocated minute analysis of laborers' movements in order to establish practices and work stations that would eliminate all wasted actions. Not surprisingly, the leading metaphor for industrial architecture in the first decades of the twentieth century was the machine, suggesting that laborers—from factory workers to typists—were simply components of a ceaseless engine. This image, which strikes us today as grindingly inhuman, was embraced by many utopian-minded architects, including Le Corbusier, who saw in the seeming objectivity of Fordism, Taylorism, and the machine ideal a model for a new society that would be free of the oppressive economic and political discord fueling World War I.

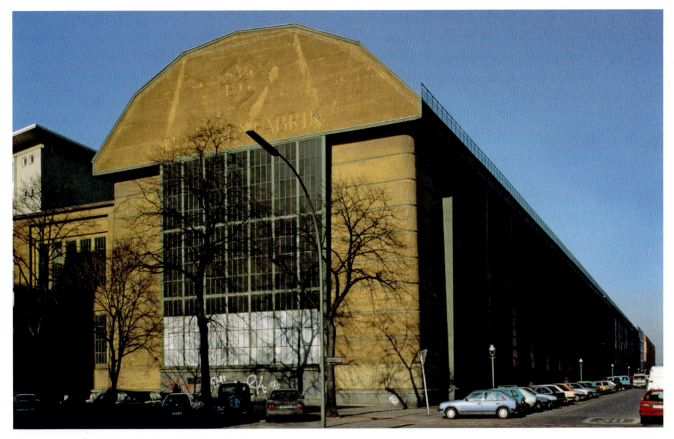

8.17 Peter Behrens, AEG Turbine Factory, 1908–09. Berlin.

Such ideas may have influenced Behrens's transformation of his functional glass-and-steel Turbine Factory into a virtual monument to the achievements of modern German industry. Behrens is important not only as an architect but as a teacher of a generation that included Gropius, Le Corbusier, and Mies van der Rohe—all of whom worked with him early in their careers.

Expressionism in Architecture

Between 1910 and 1925 the spirit of Expressionism manifested itself in German architecture, as in painting and sculpture (see Chapter 6). Expressionist architecture includes works in which specific ideas—often political—are conveyed through a building's form and materials. That a work of architecture can function as an argument on behalf of a particular ideology was already well understood by modern architects. What distinguishes Expressionist architecture is the emphasis on the thematic content of the structure itself, which takes on as much importance as the building's intended function. Although this trend did not result initially in many important buildings, and although Expressionism in architecture was terminated by the rise of Nazism, it did establish the base for a movement that was later realized in the 1950s and 60s, after the austerity and pristine elegance of the International Style (see Ch. 21, p. 542) had begun to pall.

Forerunners of Expressionism in architecture include Gaudí's creations in Barcelona (see figs. 4.15, 4.16) and the 1913–14 Werkbund Theater in Cologne (fig. **8.18**) by the Belgian architect **Henry Clemens van de Velde** (1863–1957; see p. 184), who worked in Germany from 1899 to 1914. The building's strongly sculptural exterior, for which Van de Velde used the molded forms of the façades to

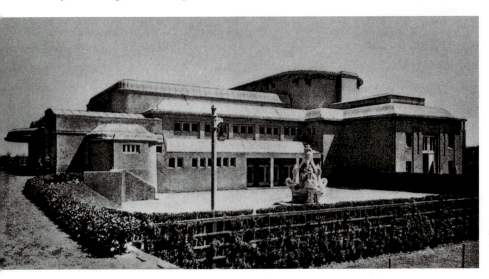

8.18 Henry Clemens van de Velde, Werkbund Theater, 1913–14. Cologne. Demolished 1920.

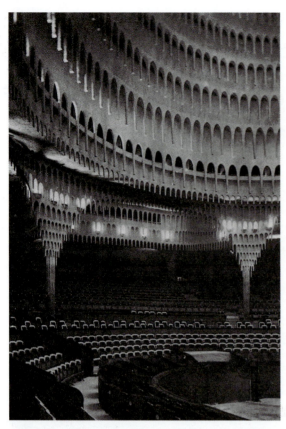

8.19 Hans Poelzig, Grosses Schauspielhaus (Great Theater), 1919. Berlin. Dismantled 1938.

define the volume of the interior, has been seen as the definitive break with the essentially linear emphasis of Art Nouveau architecture. Van de Velde's other achievements in Germany include the educational program that he developed at the School of Industrial Art, which he founded in Weimar in 1908 under the patronage of the Duke of Saxe-Weimar. This program put its emphasis on creativity, free experiment, and escape from dependence on past traditions.

One of the most startling examples of Expressionist architecture is the 1919 Grosses Schauspielhaus (Great Theater) in Berlin (fig. **8.19**), created by **Hans Poelzig** (1869–1936) for the theatrical impresario Max Reinhardt. This was actually a conversion of an old building, originally an enormous covered market that, after 1874, served as the Circus Schumann. Using stalactite forms over the entire ceiling and most of the walls, and filtering light through them, Poelzig created a vast cave-like arena of mystery and fantasy appropriate to Reinhardt's spectacular productions.

Of the architects who emerged from German Expressionism, perhaps the most significant was **Erich Mendelsohn** (1887–1953). Mendelsohn began practice in 1912, but his work was interrupted by World War I. Following the war, one of his first important buildings was the Einstein Tower in Potsdam (fig. **8.20**). One of the principal works of Expressionist architecture, it was built to study spectro-analytic phenomena, especially Einstein's theory of relativity. Instruments in the cupola reflected light vertically through the tower onto a mirror in the underground laboratory. On the exterior, Mendelsohn emphasized qualities of continuity and flow appropriate to the material of concrete (although the Einstein Tower was actually built of brick and covered with cement to look like cast concrete). The windows flow around the rounded corners, while the exterior stairs flow up and into the cavern of the entrance. The entire structure, designed as a monument as well as a functioning laboratory, has an essentially organic quality, prophetic of the later works of Le Corbusier and Eero Saarinen.

Many other architects, particularly in Germany and Holland, were affected by the spirit of Expressionism during the 1920s. The educator, philosopher, and occultist **Rudolf Steiner** (1861–

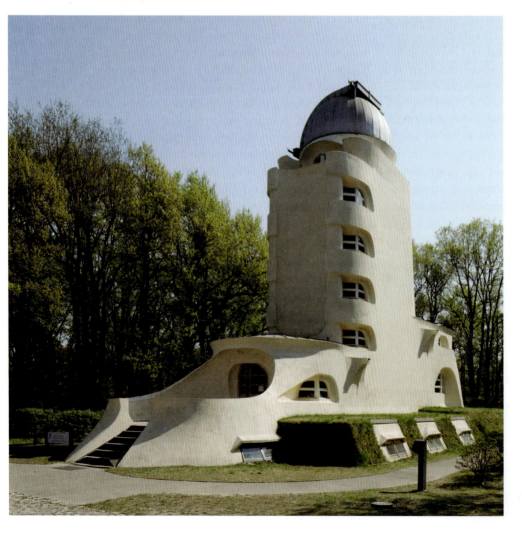

8.20 Erich Mendelsohn, Einstein Tower, 1920–21. Potsdam.

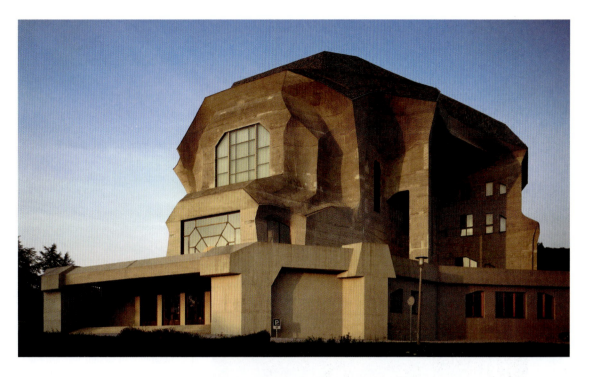

8.21 Rudolf Steiner, Goetheanum II, 1925–28. Dornach, Switzerland.

1925), although not trained as an architect, produced remarkable examples of utopian architecture in his Goetheanum I and II (fig. **8.21**), the latter of which became a tremendous sculptural monument of concrete that looked back to Gaudí and forward to post-World War II *architecture brut*.

Toward the International Style: The Netherlands and Belgium

Berlage and Van de Velde

Although he considered himself a traditionalist, the Dutch architect **Hendrik Petrus Berlage** (1856–1934) was passionately devoted to stripping off the ornamental accessories of academic architecture and expressing honest structure and function. He characteristically used brick as a building material, the brick that, in the absence of stone and other materials, has created the architectural face of the Low Countries. His best-known building, the Amsterdam Stock Exchange (fig. **8.22**) (now home to the Beurs van Berlage Foundation and the Dutch Philharmonic Orchestra), is principally of brick, accented with details of light stone. The brick is presented, inside and out, without disguise or embellishment, as is the steel framework that supports the glass ceiling. The general effect, with a massive corner tower and the low arcades of the interior, is obviously inspired by Romanesque architecture, in some degree seen through the eyes of the American architect H. H. Richardson, whose work he knew and admired (see fig. 8.1).

In his writings, Berlage insisted on the primacy of interior space. The walls defining the spaces had to express both the nature of their materials and their strength and bearing function, undisguised by ornament. Above all, through the use of systematic proportions, Berlage sought a total effect of unity analogous to that created by the Greeks of the fifth century BCE., whose temples and civic buildings were constructed with the careful application of proportional relationships between all parts of a building. He conceived of

8.22 Hendrik Petrus Berlage, Stock Exchange, 1898–1903. Amsterdam.

an interrelationship of architecture, painting, and sculpture, but with architecture in the dominant role.

Berlage's approach to architecture was also affected by Frank Lloyd Wright, whose work he discovered first through publications and then firsthand on a trip to the United States in 1911. He was enthusiastic about Wright and particularly about the Larkin Building (see fig. 8.10), with its analogies to his own Amsterdam Stock Exchange. What appealed to Berlage and his followers about Wright was his rational approach—his efforts to control and utilize the machine and to explore new materials and techniques in the creation of a new society.

Nearly every turn-of-the-century art or design movement, from Impressionism to Arts and Crafts, nourished the fertile career of the Belgian Van de Velde (see also Ch. 4, p. 76). Van de Velde was a painter, craftsman, industrial designer, architect, and critic who had an extensive influence on German architecture and design. He was a socialist who wanted to

Modern Materials

Louis Sullivan's dictate that "form ever follows function" could not have been fully expressed in modern architecture without the new materials developed for industry in the late nineteenth century. The construction of high-rises depended upon the availability of strong but relatively light steel girders that could be assembled into a sort of skeleton. Without such an internal structure, the walls required to support a building over seven stories tall would be so thick that its lower floors would be largely useless. In 1855, the English inventor Henry Bessemer patented a process for mass-producing high-grade steel, expanding the availability of the material while lowering its cost. Even without steel, high-rises could only ascend as far as people were willing to climb. Elisha Otis's 1853 introduction of the safety elevator, which has side brakes that deploy should the cable snap, led to steam- and electric-powered passenger elevators, making it possible for people to work, shop, or even live comfortably dozens of stories above ground. Even greater flexibility in design was afforded by **ferro-concrete**, likewise developed in the mid-nineteenth century. With wire mesh or iron bars as internal reinforcement, concrete could be poured into irregular, even curving forms. It could also be used to create larger spans, making it an inexpensive and flexible alternative to masonry.

make his designs available to the working classes through mass production. Trained as a painter, first in Antwerp and then in Paris, he was in touch with the Impressionists and was interested in Symbolist poetry. Back in Antwerp, painting in a manner influenced by Seurat, he exhibited with Les XX, the avant-garde Brussels group (see Ch. 3, p. 67). Through them he discovered Gauguin, Morris, and the English Arts and Crafts Movement. As a result, he enthusiastically took up the graphic arts, particularly poster and book design (see fig. 4.9), and then, in 1894, turned to the design of furniture. All the time, he was writing energetically, preaching the elimination of traditional ornament, the assertion of the nature of materials, and the development of new, rational principles in architecture and design.

New Materials, New Visions: France in the Early Twentieth Century

French architecture during the period 1900–1914 was dominated by the Beaux-Arts tradition, except for the work of two architects of high ability, Auguste Perret and Tony Garnier. Both were pioneers in the use of reinforced concrete (see *Modern Materials*, above). In his 1902–03 apartment building (fig. **8.23**) **Auguste Perret** (1874–1954) covered a thin reinforced-concrete skeleton with glazed terracotta tiles decorated in an Art Nouveau foliate pattern. The structure is clearly revealed and allows for large window openings on the façade. The architect increased daylight

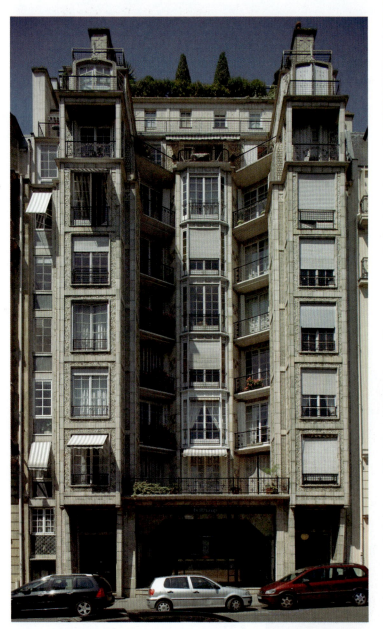

8.23 Auguste Perret, Apartment house, 25 Rue Franklin, 1902–03. Paris.

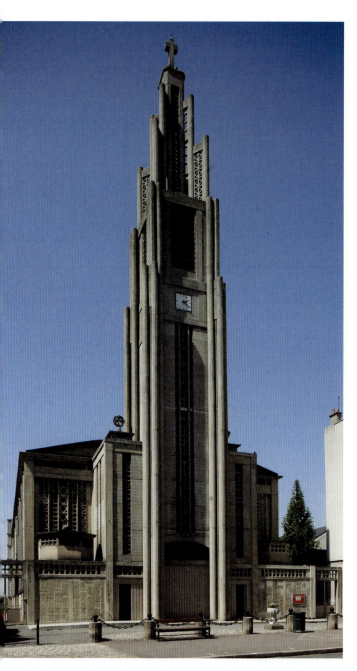

illumination by folding the façade around a front wall and then arranging the principal rooms so that all had outside windows. The strength and lightness of the material also substantially increased openness and spatial flow.

Perret's masterpiece in ferro-concrete building is probably his Church of Notre Dame at Le Raincy, near Paris, built in 1922–23 (fig. **8.24**). Here he used the simple form of the Early Christian **basilica**—a long rectangle with only a slightly curving **apse**, a broad, low-arched nave, and side aisles just indicated by comparably low transverse arches. Construction in reinforced concrete permitted the complete elimination of structural walls. The roof rests entirely on widely spaced slender columns, and the walls are simply constructed of stained glass (designed by the painter Maurice Denis) arranged on a pierced screen of precast-concrete elements. The church at Le Raincy remains a landmark of modern architecture, not only in the effective use of ferro-concrete but also in the beauty and refinement of its design.

While working in Rome around 1900, **Tony Garnier** (1869–1948) developed a radically new approach to urban planning that overturned the traditional academic approach based on symmetry and monumentality. In Garnier's model town, residential areas, industrial sites, transport infrastructure, and civic facilities are all rationally interrelated. From 1905, his designs as municipal architect for his native city of Lyons explored the architectural possibilities of steel and reinforced concrete. His 1913 hall for the city's cattle market and abattoirs (fig. **8.25**) achieved a steel span of 262 feet (80 m).

World War I interrupted many experiments in architecture, as well as in painting and sculpture, begun in the first years of the twentieth century. During the war years a new generation of architects emerged—Gropius and Mies van der Rohe in Germany; Le Corbusier in France; Oud and Rietveld in Holland; Eliel Saarinen and Alvar Aalto in Finland. Together with Frank Lloyd Wright in the United States, these architects built on the foundations of the pioneers discussed in this chapter to create one of the great architectural revolutions of history.

8.24 Auguste Perret, Church of Notre Dame, 1922–23. Le Raincy, France.

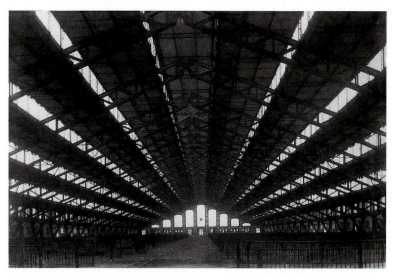

8.25 Tony Garnier, Lyons Market Hall, 1913. Lyons, France.

9

European Art after Cubism

As the buoyant first decade of the twentieth century came to a close, the glittering *belle époque* faded. The years leading up to World War I were marked by tragic reminders of the limits of human ingenuity, the cost of industrialization, and the terrible consequences of colonization. By the end of 1912, the mood in Europe and North America had darkened. Accounts of the Belgian King Leopold's rapacious exploitation of the central African colony of the Congo Free State from 1885 to 1908 were now circulating in the popular press. Treating the region's inhabitants as virtual slaves, Leopold unleashed a ruthless army of overseers bent on achieving the greatest profit possible through trade in commodities like rubber and ivory. Millions of Africans were killed or maimed: it was common practice for rubber harvesters' hands to be cut off when quotas were not met. It was also in 1912 that the "unsinkable" ship *Titanic* slipped majestically from its berth at Southampton, England, with great fanfare, only to founder after hitting an iceberg four days later. More than 1,500 were killed in the disaster.

While the *Titanic*'s fate illustrated the consequences of overestimating new fabrication techniques and advances in industrial engineering, there were chilling demonstrations of the capacity of machines to perform exactly as designed. Aerial bombing, used first by Italy against Turkish troops in 1911, added a terrifying new dimension to warfare. The bombing of a Turkish railway station by Bulgarian pilots the following year demonstrated the potential for airplanes to target buildings accurately, enhancing the anonymity of attacks on soldiers as well as civilians. The conflict that prompted the development of bombers and tanks was the Balkan Wars, in which the contracting Ottoman Empire came under assault from a number of its former states, including Bulgaria, Montenegro, Greece, and Serbia.

For most Europeans and Americans, territorial disputes between the waning Ottoman Empire and its neighbors seemed far away and scarcely relevant. Some saw these conflicts as evidence of a coming shift in the European balance of power. Ardent nationalists in Italy, France, Germany, and Britain supported engagement in the conflict in order to expand the political and economic influence and possibly even the borders of their countries. Such extreme nationalism manifested itself culturally in the Futurist and Vorticist movements. Most artists, however, viewed events in southeastern Europe with either detachment or suspicion. For instance, even though Picasso's *Guitar, Sheet Music, and Wine Glass* of 1912 (see fig. 7.23) includes a fragment of a newspaper headline, LA BATAILLE S'EST ENGAGÉ, taken from a story about the Balkan conflict, this representation of the images, conversations, and music animating a Paris café is anything but a call to arms.

The ambiguity of space and matter as well as content characteristic of prewar Cubism made it an unreliable vehicle for ideology. Many of the artists influenced by Cubism adapted its formal and thematic abstruseness to create fantastical and suggestive works. Such painters as Marc Chagall and Giorgio De Chirico, for instance, adapted Cubist innovations to enhance their dreamily naturalistic imagery. Yet many artists who found themselves under the spell of Cubism did not share this ideological circumspection, instead using Cubist-inspired artworks to promote specific political viewpoints. These impassioned artists show that abstraction—both weak abstraction like Cubism and strong abstraction in which no reference to observed reality is made—can be yoked to the service of a particular ideology, or set of political beliefs, whether these beliefs lean toward capitalism and nationalism, as in the case of Futurism, or toward socialism and collectivism, as in Russian Constructivism.

Fantasy Through Abstraction: Chagall and the Metaphysical School

Cubism emboldened even figurative artists to reconsider their assumptions about pictorial space. Among those most receptive to incorporating Cubist ideas into their art were descendants of Romanticism and Symbolism like Marc Chagall and Giorgio De Chirico. As Romanticism grew and spread in the nineteenth century, visions of imagined worlds appeared in many forms in painting, sculpture, and architecture. The dreamworlds of Moreau (see fig. 3.10), Redon (see fig. 3.12), Ensor (see fig. 4.28), Böcklin (see fig. 4.30), Klinger (see fig. 4.31), and Rousseau (see fig. 3.14) provided the initial transition from nineteenth-century Romanticism to twentieth-century fantasy. Abstraction expanded the boundaries of these realms of fantasy.

Chagall

The paintings of **Marc Chagall** (1887–1985) do not fit neatly into a category or movement, but their sense of fantasy testifies to the persistent legacy of Symbolism. Chagall was born to a large and poor Jewish family in Vitebsk, Russia. He acquired a large repertoire of Russian-Jewish folktales and a deep attachment to the Jewish religion and traditions, from which his personal and poetic visual language emerged. He attended various art schools in St. Petersburg, but derived little benefit until 1908, when he enrolled in an experimental school directed by the theater designer Léon Bakst, who was influenced by the new ideas emanating from France. In 1910, after two years of study, Chagall departed for Paris, a popular destination for progressive Russian painters since the late nineteenth century. Aesthetic ideas moved between the two capitals, thanks not only to the presence of Russian artists in Paris but also because of the proliferation of artistic manifestos and treatises that helped keep artists abreast of new currents.

Once in Paris, Chagall entered the orbit of Guillaume Apollinaire and the leaders of the new Cubism (see Chapter 7). Chagall's Russian paintings had largely been intimate genre scenes, often enriched by elements of Russian or Jewish folklore. His intoxication with Paris fueled his experimentation with Fauve color and Cubist space, and his subjects became filled with a lyricism that, within two years of his arrival, emerged in mature and uniquely poetic paintings.

Homage to Apollinaire (fig. **9.1**) was shown for the first time at Herwarth Walden's Galerie Der Sturm in Berlin in 1914. That show had an impact on the German Expressionists that extended well beyond World War I. Chagall's painting is a

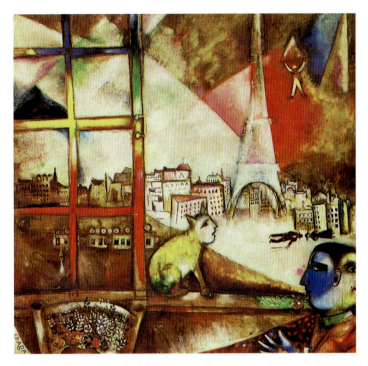

9.2 Marc Chagall, *Paris Through the Window*, 1913. Oil on canvas, 52⅜ × 54¾" (133 × 139.1 cm). Solomon R. Guggenheim Museum, New York.

homage to four people he admired, including Walden and Apollinaire, whose names are inscribed around a heart at the lower left. The artist included his own name in Roman and Hebrew letters at the top of the canvas. A circular pattern of color shapes, inspired by the paintings of his friend Robert Delaunay (see fig. 7.42), surrounds the bifurcated figure of Adam and Eve. The esoteric symbolism of *Homage to Apollinaire* has been variously interpreted. Beyond the traditional biblical meanings are references to alchemy and other mystical schools of thought. The bodies of Adam and Eve emerge from one pair of legs to symbolize the union and opposition of male and female, derived from medieval representations of the Fall from Grace. The numbers on the left arc of the outer circle introduce the notion of time. In fact, the figures themselves read like the hands of a clock. Such themes of lovers irrevocably joined extend throughout Chagall's work, as do references to both Jewish and Christian spirituality.

During the next years in Paris, Chagall continued to create new forms to express his highly personal vision. In *Paris Through the Window* (fig. **9.2**), the double-faced Janus figure (the Roman god of doorways) in the lower right corner, with its two profiles in contrasting light and shadow, suggests a double nature for the painting—the romantic yet real Paris, and the Paris transformed in the poet's dreams—with trains floating upside down, pedestrians promenading parallel to the sidewalks, and an aviator supported by a triangular kite. The window, with its frame of red, yellow, blue, and green, and its human-headed cat acting as a domesticated Cerberus (the mythical three-headed dog who guards the underworld), becomes a partition between the two realms. The composition of the sky in large geometric areas and the animated buildings, particularly the somewhat tilted

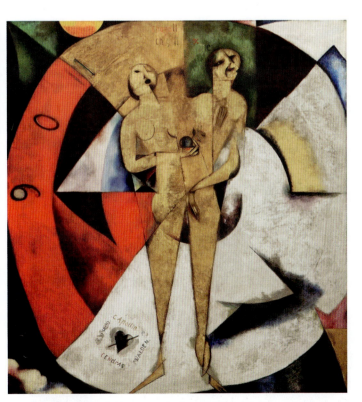

9.1 Marc Chagall, *Homage to Apollinaire*, 1911–12. Oil, gold and silver powder on canvas, 6' 6¾" × 6' 3⅝" (2 × 1.9 m). Stedelijk van Abbe Museum, Eindhoven, the Netherlands.

Eiffel Tower (which could not be seen from Chagall's studio), suggest Robert Delaunay's dynamic method (see fig. 7.42) imposed upon a dream of gentle nostalgia. Many of Chagall's contemporaries, including Delaunay, did not favor this strong imaginative element. It would be up to the poet André Breton, the principal theorist of Surrealism, to recognize only in the 1920s the significance of Chagall's "liberation of the object from the laws of weight and gravity." Chagall returned to Vitebsk in 1914 and, caught by the outbreak of war in Russia, stayed there until 1922.

De Chirico and the Metaphysical School

Working in Italy from around 1913 to 1920, the Metaphysical painters retained the forms of Renaissance reality, linear perspective, recognizable environments, and sculptural figures and objects, but used various juxtapositions to produce surprise and shock, and to create an atmosphere of strangeness, sometimes even of fear and horror. The naturalism and seemingly habitable landscapes of most Metaphysical images do not immediately divulge a debt to Cubism, but in both schools there is a conception of space as a formal element capable of conveying mood or meaning. Not simply an environment for figures or objects, space functions as part of a complex pictorial message.

The work of **Giorgio De Chirico** (1888–1978), in particular, links nineteenth-century Romantic fantasy with twentieth-century Surrealism. Born in Greece of Italian parents, De Chirico learned drawing in Athens. After the death of his father, the family moved to Munich in order to advance the artistic or musical leanings of the children. In Munich, De Chirico was exposed to the art of Böcklin (see fig. 4.30) and Klinger (see fig. 4.31). What impressed him about Böcklin was his ability to impart "surprise": to make real and comprehensible the improbable or illusory by juxtaposing it with normal everyday experience. De Chirico's concept of a painting as a symbolic vision was also affected by his readings of the philosophical writings of Nietzsche. For example, Nietzsche's insistence that art expresses deep-seated motivations within the human psyche led De Chirico to his metaphysical examination of still life.

While De Chirico was in Germany, from 1905 to 1909, Art Nouveau (see Ch. 4, pp. 74–84) was still a force, and the German Expressionists (see Chapter 6) were beginning to make themselves known. Ideal or mystical philosophies and pseudophilosophies were gaining currency among artists and writers everywhere, and modern Theosophy was an international cult. Kandinsky found a basis for his approach to abstraction in Theosophy (see Ch. 6, p. 122), and his mystical concepts of an inner reality beyond surface appearance would later affect artists as divergent as Mondrian and Klee. De Chirico constantly referred to the "metaphysical content" of his paintings, using the word "metaphysical" (which in philosophy refers to broad questions of the nature of causality, being, and time) loosely or inaccurately to cover various effects of strangeness, surprise, and shock.

De Chirico's approach to art during his early and most influential phase—up to 1920—was to examine a theme as though wringing from it its central mystery. In 1912 and 1913, while living in Paris, he painted a group of works incorporating a Hellenistic sculpture of a reclining Ariadne. One of these works, *The Soothsayer's Recompense* (fig. **9.3**), presents the darkened arches of a classical façade beneath a large clock. On the distant horizon a moving train introduces another modern element into a seemingly ancient context. Such anomalies are commonplace in Italian cities— a palazzo may become a nineteenth-century railway station. De Chirico used these anachronisms to suggest the melancholy of departure, a melancholy that saturates the shadowed square where deserted Ariadne mourns her departed lover Theseus. At times, the strange, sad loneliness of De Chirico's squares takes on dimensions of fear and isolation in a vast, empty space.

It was while in Paris and in close proximity to Apollinaire and the work of the Cubists that De Chirico restructured the depiction of space in his compositions, fragmenting and

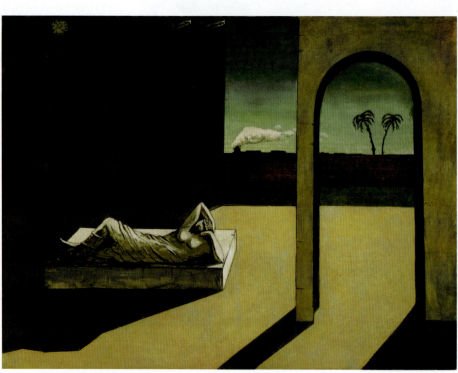

9.3 Giorgio De Chirico, *The Soothsayer's Recompense*, 1913. Oil on canvas, 53½ × 71" (135.9 × 180.3 cm). Philadelphia Museum of Art.

((•— Listen to a podcast about *The Soothsayer's Recompense* on mysearchlab.com

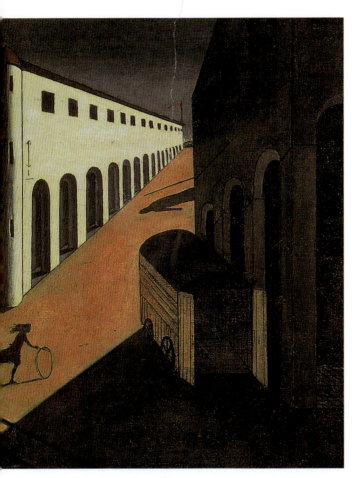

9.4 Giorgio De Chirico, *The Melancholy and Mystery of a Street*, 1914. Oil on canvas, 34¼ × 28⅛" (87 × 71.4 cm). Private collection.

"Running on Shrapnel": Futurism in Italy

It was left to the Italian Futurists to demonstrate how Cubist ideas could be deployed in the service of overt political goals. In their paintings and sculptures the Futurist artists sometimes verged on total abstraction, but for the most part they, like the Cubists, drew upon imagery derived from the physical world. Futurism was first of all a literary concept, born in the mind of the poet and propagandist Filippo Tommaso Marinetti (1876–1944) in 1908 and announced in a series of manifestos in 1909, 1910, and subsequently. From this point onward, the manifesto was to play a prominent and recurring role in modern art—indeed, it has been described as one of its most characteristic productions (see *The Founding and Manifesto of Futurism*, below).

destabilizing some planes in order to enhance the viewer's disorientation. *The Melancholy and Mystery of a Street* of 1914 (fig. **9.4**) is one of his finest examples of deep perspective used for emotional effect. On the right, an arcaded building in deep browns and grays casts a shadow filling the foreground; a lower white arcade on the left sweeps back toward infinity; the sky is threatening. Into the brightly lit space between the buildings emerges a little girl rolling her hoop inexorably toward a looming black specter of a figure standing behind the dark building. In the foreground of the palazzo on the right is an empty, old-fashioned freight car or carnival van whose open doors add another suggestive and disturbing element. The scene may be described matter-of-factly: an Italian city square with shadows lengthening in a late fall afternoon; an arcade of shops closed for the day; railway tracks in the lower left corner; the shadow of a heroic nineteenth-century statue; a little girl hurrying home. But from these familiar components the artist has created an ominous mood.

The haunting, dream-like fusion of reality and unreality in his paintings was aptly termed Metaphysical, following his own use of the word (see p. 188), leading to the formation of the Scuola Metafisica, or Metaphysical School. This group, as exemplified by De Chirico, its most prominent member, sought an elegiac and enigmatic expression, one that, unlike their Italian contemporaries the Futurists, did not reject the art of the Italian past.

Futurism began as a rebellion of young intellectuals against the cultural torpor into which Italy had sunk during the nineteenth century, when Renaissance and Neoclassical artistic values continued to dominate painting and sculpture, despite the avant-garde developments in neighboring France. Strongly nationalistic, the Futurists advocated the expansion of Italian industry and territory, which they believed could only be accomplished by crushing nostalgia and any reverence for the past. As so frequently happens in such movements, the Futurists' manifestos initially focused on what they had to destroy before new ideas could flourish. The first manifesto, written by Marinetti, demanded the destruction of the libraries, museums, academies, and cities of the past, which he called "mausoleums." In its wholesale assault on conventional values, it extolled the beauties of revolution, of war, and of the speed and dynamism of machine technology: "A roaring motorcar, which looks as though running on shrapnel, is more beautiful than the Victory of Samothrace." Much of the spirit of Futurism reflected the flamboyant personality of Marinetti himself; rooted in the anarchist and revolutionary fervor of the day, it attacked the ills of an aristocratic and bourgeois society and celebrated progress, energy, and change. By the 1930s, unfortunately, such impulses would have dire political consequences.

In late 1909 or early 1910 the painters Umberto Boccioni and Carlo Carrà, along with the artist and composer Luigi Russolo, joined Marinetti's movement. Later it also included Gino Severini, who had been working in Paris since 1906, and Giacomo Balla. The group drew up a second manifesto in 1910. This again attacked the old institutions and promoted the artistic expression of motion, metamorphosis, and the simultaneity of vision itself. The painted moving object was to merge with its environment, so that no clear distinction could be drawn between the two:

Everything is in movement, everything rushes forward, everything is in constant swift change. A figure is never stable in front of us but is incessantly appearing and disappearing. Because images persist on the retina, things in movement multiply, change form, follow one another like vibrations within the space they traverse. Thus a horse in swift course does not have four legs: It has twenty, and their movements are triangular.

The targets of the Futurists' critique included all forms of imitation, concepts of harmony and good taste, all art critics, all traditional subjects, tonal painting, and that perennial staple of art, the painted nude.

At this point, the paintings of the various Futurists had little in common. Many of their ideas still came from the unified color patterns of the Impressionists and even more explicitly from the Divisionist techniques of the Neo-Impressionists (see Ch. 3, pp. 43–45). But unlike Impressionism, Fauvism, and Cubism, all of which were generated by a steady interaction of theory and practice, Futurism emerged as a full-blown and coherent theory, the illustration of which the artists then set out to realize in paintings. The Futurists were passionately concerned with the problem of establishing empathy between the spectator and the painting, "putting the spectator in the center of the picture." In this they were close to the German Expressionists (see Chapter 6), who also sought a direct appeal to the emotions. Futurist art extolled metropolitan life and modern industry. This did not, however, result in a machine aesthetic in the manner of Léger, since the Italians were concerned with the unrestrained expression of individual ideals, with mystical revelation, and with the articulation of action. This is exemplified by Russolo's Futurist musical compositions, which utilized the aggressive sounds of urban, industrial life to create a cacophonous celebration of modernity. Russolo even invented a new set of instruments to replace those used by classical orchestras in order to perform his Art of Noises. Though Russolo and the other Futurists held in common their sense of purpose, Futurist art cannot be considered a unified style.

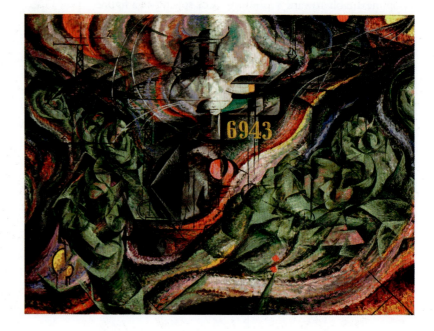

9.5 Umberto Boccioni, *States of Mind I: The Farewells*, 1911. Oil on canvas, 27¾ × 37⅞" (70.5 × 96.2 cm). The Museum of Modern Art, New York.

((•—[Listen] to a podcast about Futurism on mysearchlab.com

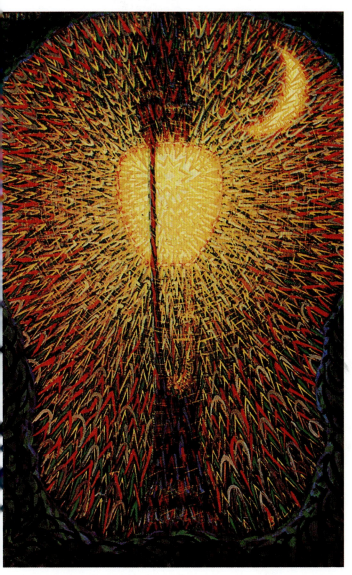

9.6 Giacomo Balla, *Street Light* (*Lampada—Studio di luce*), dated 1909 on canvas. Oil on canvas, 68¾ × 45¼" (174.7 × 114.5 cm). The Museum of Modern Art, New York.

The Futurist exhibition in Milan in May 1911 was the first of the efforts by the new group to make its theories concrete. In the fall of that year, Carrà and Boccioni visited Paris. Severini took them to meet Picasso at his studio, where they no doubt saw the latest examples of Analytic Cubist painting. What they learned is evident in the repainted version of Boccioni's *The Farewells* (fig. **9.5**), a 1911 work that is the first in a trilogy of paintings titled *States of Mind*, about arrivals and departures at a train station. Within a vibrating, curving pattern the artist introduces a Cubist structure of interwoven facets and lines designed to create a sense of great tension and velocity. Boccioni even added the shock of a literal, realistic collage-like element in the scrupulously rendered numbers on the cab of the dissolving engine. It will

be recalled that in 1911 Braque and Picasso first introduced lettering and numbers into their Analytic Cubist works (see figs. 7.20, 7.23). Boccioni's powerful encounter with Cubism reinforced his own developing inclinations, and he adapted the French style into his own dynamic idiom.

An exhibition of the Futurists, held in February 1912 at the gallery of Bernheim-Jeune in Paris, was widely noticed and reviewed favorably by Guillaume Apollinaire himself. It later circulated to London, Berlin, Brussels, The Hague, Amsterdam, and Munich. Within the year, from being an essentially provincial movement in Italy, Futurism suddenly became a significant element in international experimental art.

Balla

The oldest of the group and the teacher of Severini and Boccioni, **Giacomo Balla** (1871–1958) had earlier painted realistic pictures with social implications. He then became a leading Italian exponent of Neo-Impressionism and in this context most influenced the younger Futurists.

Balla's painting *Street Light* (fig. **9.6**) is an example of pure Futurism in the handling of a modern, urban subject. Using V-shaped brushstrokes of complementary colors radiating from the central source of the lamp, he created an optical illusion of light rays translated into dazzling colors so intense that they appear to vibrate. Balla, working in Rome rather than Milan, pursued his own distinctive experiments, particularly in rendering motion through simultaneous views of many aspects of objects. His *Dynamism of a Dog on a Leash* (fig. **9.7**), with its multiplication of legs, feet, and leash, has become one of the familiar and delightful creations of Futurist simultaneity. The little dachshund scurries along on short legs accelerated and multiplied to the point where they almost turn into wheels. This device for suggesting rapid motion or physical activity later became a cliché of comic strips and animated cartoons. Balla eventually returned to more traditional figure painting.

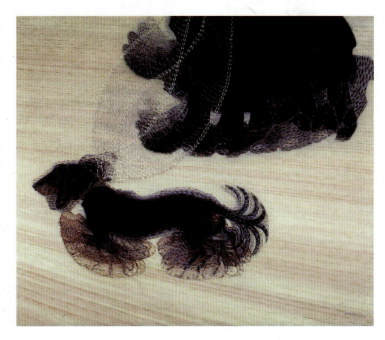

9.7 Giacomo Balla, *Dynamism of a Dog on a Leash* (*Leash in Motion*), 1912. Oil on canvas, 35 × 45½" (88.9 × 115.6 cm). Albright-Knox Art Gallery, Buffalo, New York.

▷— Watch a video about *Dynamism of a Dog on a Leash* on mysearchlab.com

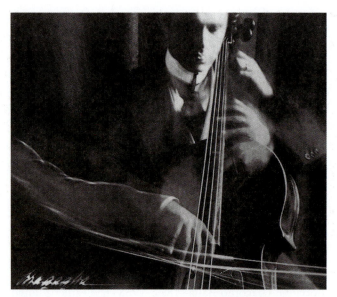

9.8 Antonio Giulio Bragaglia, *The Cellist*, 1913. Gelatin-silver print.

Bragaglia

Also at work within the ambience of Futurist dynamism was the Italian photographer and filmmaker **Antonio Giulio Bragaglia** (1889–1963), who, like Duchamp and Balla, had been stimulated by the stop-action photographs of Muybridge (see fig. 2.33), Eakins, and Marey (see fig. 7.47). Bragaglia, however, departed from those and shot time exposures of moving forms (fig. **9.8**), creating fluid, blurred images of continuous action. These, he thought, constituted a more accurate, expressive record than a sequence of discrete, frozen moments. In 1913 Bragaglia published a number of his "photodynamic" works in a book entitled *Fotodinamismo Futurista* (*Futurist Photodynamism*).

Severini

Living in Paris since 1906, **Gino Severini** (1883–1966) was for several years more closely associated than the other Futurists with the growth of Cubism, serving as a link between his Italian colleagues and French artistic developments. His approach to Futurism is summarized in *Dynamic Hieroglyphic of the Bal Tabarin* (fig. **9.9**), a lighthearted and amusing distillation of Paris nightlife. The basis of the composition lies in Cubist faceting put into rapid motion within large, swinging curves. The brightly dressed chorus girls, the throaty chanteuse, the top-hatted, monocled patron, and the carnival atmosphere are all presented in a spirit of delight, reminding us that the Futurists' revolt was against the deadly dullness of nineteenth-century bourgeois morality. This work is a *tour de force* involving almost every device of Cubist painting and collage, not only the color shapes contained in the Cubist grid, but also elements of sculptural modeling that create effects of advancing volumes. Additionally present are the carefully lettered words Valse, Polka, Bowling, while real sequins are added as collage on the women's costumes. The color has Impressionist freshness, its arbitrary distribution a Fauve boldness. Many areas and objects are mechanized and finely stippled in a Neo-Impressionist manner. Severini even included one or two passages of literal representation, such as the minuscule Arab horseman (upper center) and the tiny nude riding a large pair of scissors (upper left).

The sense of fragmented but still dominating reality that persisted in Severini's Cubist paintings between 1912 and 1914 found its most logical expression in a series of works on the subject of transportation, which began with studies of the Paris Métro. With the coming of the war,

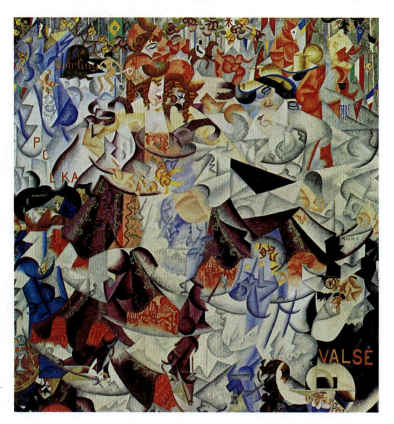

9.9 Gino Severini, *Dynamic Hieroglyphic of the Bal Tabarin*, 1912. Oil on canvas with sequins, 63⅝ × 61½" (161.6 × 156.2 cm). The Museum of Modern Art, New York.

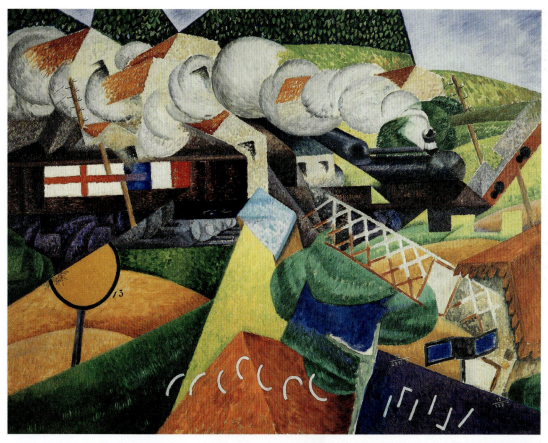

9.10 Gino Severini, *Red Cross Train Passing a Village*, 1915. Oil on canvas, 35¼ × 45¾" (89.5 × 116.2 cm). Solomon R. Guggenheim Museum, New York.

the theme of the train flashing through a Cubist landscape intrigued Severini as he watched supply trains pass by his window daily, loaded with weapons or troops. *Red Cross Train Passing a Village* (fig. **9.10**), one of several works from the summer of 1915 on this theme, is his response to Marinetti's appeal for a new pictorial expression for the subject of war "in all its marvelous mechanical forms." *Red Cross Train* is a stylization of motion, much more deliberate in its tempo than *Bal Tabarin*. The telescoped but clearly recognizable train, from which balloons of smoke billow, cuts across the middle distance. Large, handsome planes of strong color (in contrast to the muted palette of Analytic Cubism), sometimes rendered with a Neo-Impressionist brushstroke, intersect the train and absorb it into the painting's total pattern. The effect is static rather than dynamic and is surprisingly abstract in feeling. During these years Severini moved toward a pure abstraction stemming partly from the influence of Robert Delaunay. In *Dinamismo di Forme* (fig. **9.11**) he organized what might be called a

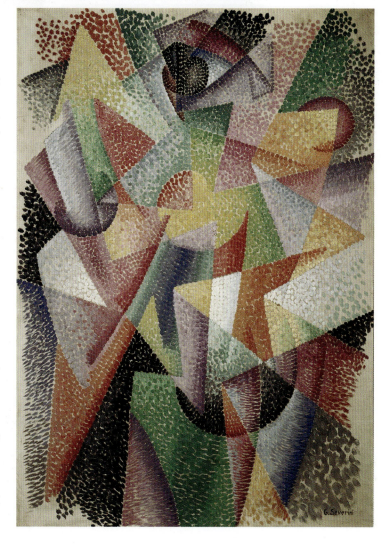

9.11 Gino Severini, *Dinamismo di Forme (Dynamism of Form)*, 1912. Oil on canvas. Galleria d'Arte Moderna, Rome.

Futurist abstract pattern of triangles and curves, built up of Neo-Impressionist dots. For some of the works in this series Severini extended the exuberant color dots onto his wooden frame.

Carrà

The capacity for Futurist artwork to express political messages in a dazzling and novel way is demonstrated by **Carlo Carrà** (1881–1966), whose propagandistic collage *Patriotic Celebration* (fig. **9.12**) employs radiating colors, words, and letters, Italian flags, and other lines and symbols to extol the king and army of Italy, and to simulate the noises of sirens and mobs. The spiraling composition with its radiating spokes of text suggests an automobile's spinning wheel, an airplane's propeller or a gear or turbine from a machine or factory—all subjects of delight to Futurists. Using "free words," as Marinetti did, to affect and stimulate the spirit and imagination directly through their visual associations, Carrà summons the tumult of a parade or demonstration where party slogans and patriotic songs commingle. A similar approach to text and imagery was being developed among Russian Futurist poets and artists. Carrà was also important in bridging the gap between Italian Futurism and the Metaphysical School.

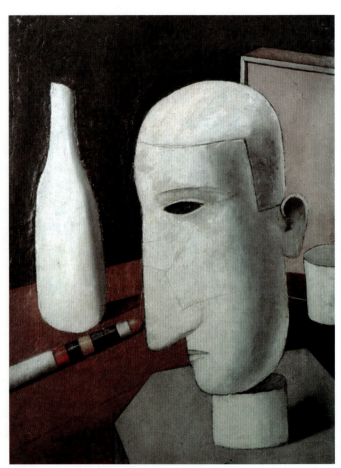

9.13 Carlo Carrà, *The Drunken Gentleman*, 1917 (dated 1916 on canvas). Oil on canvas, 23⅝ × 17½" (60 × 44.5 cm).

The war-weary Carrà eventually abandoned Futurism to join De Chirico in forming the Metaphysical School when the two met in 1917 (fig. **9.13**).

Boccioni

Umberto Boccioni (1882–1916) was perhaps the most visually inventive of the Futurists. In his monumental work *The City Rises* (fig. **9.14**) he sought his first "great synthesis of labor, light, and movement." Dominated by the large, surging figure of a horse before which human figures fall like ninepins, it constitutes one of the Futurists' first major statements: a visual essay on the qualities of violent action, speed, the disintegration of solid objects by light, and their reintegration into the totality of the picture by that very same light.

The greatest contribution of Boccioni during the last few years of his short life was the creation of Futurist sculpture. During a visit to Paris in 1912, he went to the studios of Archipenko, Brancusi, and Duchamp-Villon and saw sculpture by Picasso. Immediately upon his return to Milan he wrote the *Technical Manifesto of Futurist Sculpture* (1912), in which he called for a complete renewal of this "mummified art." He began the manifesto with the customary attack on all academic tradition. The attack became specific and virulent on the subject of the nude, which still dominated the work not only of the traditionalists but even of the leading progressive sculptors, Rodin, Bourdelle, and Maillol.

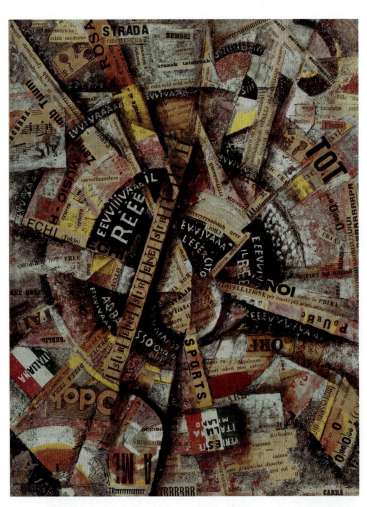

9.12 Carlo Carrà, *Patriotic Celebration (Free-Word Painting)*, 1914. Pasted paper and newsprint on cloth, mounted on wood, 15¼ × 12" (38.7 × 30.5 cm). Private collection.

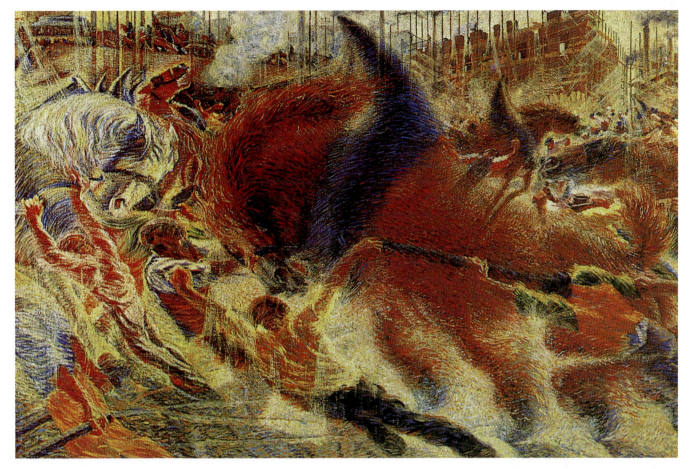

9.14 Umberto Boccioni, *The City Rises*, 1910. Oil on canvas, 6' 6½" × 9' 10½" (2 × 3 m). The Museum of Modern Art, New York.

Only in the Impressionist sculpture of Medardo Rosso (see fig. 3.21), then Italy's leading sculptor, did Boccioni find exciting innovations. Yet he recognized that, in his concern to capture the transitory moment, Rosso was bound to represent the subject in nature in ways that paralleled those of the Impressionist painters.

Taking off from Rosso, Boccioni sought a dynamic fusion between his sculptural forms and surrounding environment. He emphasized the need for an "absolute and complete abolition of definite lines and closed sculpture. We break open the figure and enclose it in [an] environment." He also asserted the sculptor's right to use any form of distortion or fragmentation of figure or object, and insisted on the use of every kind of material—"glass, wood, cardboard, iron, cement, horsehair, leather, cloth, mirrors, electric lights, etc., etc."

Boccioni's Futurist sculpture and his manifesto were the first of several related developments in three-dimensional art, among them Constructivist sculpture. *Development of a Bottle in Space* (fig. **9.15**) enlarged the tradition of the analysis of sculptural space. The bottle is stripped open, unwound,

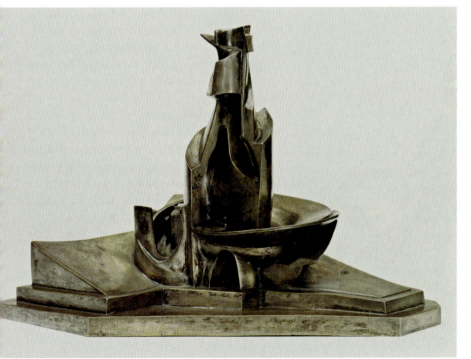

9.15 Umberto Boccioni, *Development of a Bottle in Space*, 1912. Silvered bronze (cast 1931), 15 × 23¾ × 12⅞" (38.1 × 60.3 × 32.7 cm). The Museum of Modern Art, New York.

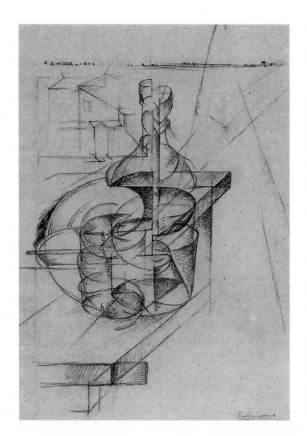

9.16 Umberto Boccioni, *Table + Bottle + House*, 1912. Pencil on paper, 13⅛ × 9⅜" (33.4 × 23.9 cm). Civico Gabinetto dei Disegni, Castello Sforzesco, Milan.

and integrated with an environmental base that makes the homely object, only fifteen inches (38 cm) high, resemble a model for a vast monument. In a related drawing (fig. **9.16**), possibly made in preparation for the sculpture, the forms of a bottle and glass are opened up, set in motion with rotational, curving lines, and penetrated by the flat planes of the table on which they sit.

Boccioni's most impressive sculpture, *Unique Forms of Continuity in Space* (fig. **9.17**), was also his most traditional and the one most specifically related to his paintings. The title suggests that, although the human body may lie at its foundation, the impetus behind the sculpture is the coincidence of abstract form. The figure, made up of fluttering, curving planes of bronze, moves essentially in two dimensions, like a translation of his painted figures into relief. It has something in common with the ancient Greek Victory of Samothrace so despised by Marinetti: the stances of both figures are similar—a body in dramatic mid-stride, draperies flowing out behind, and arms missing.

Sant'Elia

At the First Free Futurist Exhibition, held in Rome in 1914, the founders of Futurism were joined by a number of younger artists, including the architect Antonio Sant'Elia (1888–1916). Sant'Elia's *Manifesto of Futurist Architecture* was no doubt written with the ever-present assistance of Marinetti, who later published Sant'Elia's text again with his own modifications. In his text and drawings, Sant'Elia conceived of cities built of the newest materials, in terms of the needs of modern men and women, and as expressions of the dynamism of the modern spirit. His visionary ideas remained on the drawing board, for his renderings were not plans for potentially functioning buildings. They were rather more like dynamic architectural sculpture. His drawings for the *Città Nuova* (New City) (fig. **9.18**) gave visual form to his ideas about a modern metropolis built with the technology of the future. His city contained imaginary factories and power stations on multilevel highways and towers of fantastic proportions. Though his buildings never materialized, Sant'Elia's belief in an authentic architecture based on industrial mechanization epitomized Futurist ideas. Like Boccioni and so many other talented experimental artists, Sant'Elia died in World War I.

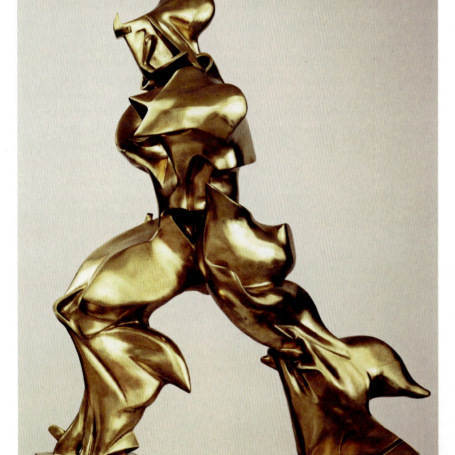

9.17 Umberto Boccioni, *Unique Forms of Continuity in Space*, 1913. Bronze (cast 1931), 43⅞ × 34⅞ × 15¾" (111.2 × 88.5 × 40 cm). The Museum of Modern Art, New York.

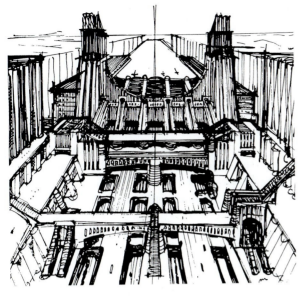

9.18 Antonio Sant'Elia, Train and plane station for project for *Città Nuova*, 1914. Probably black ink on paper. Musei Civici, Como.

"Our Vortex is Not Afraid": Wyndham Lewis and Vorticism

The most radical element in English art to emerge before World War I was the group calling themselves Vorticists (from "vortex"), founded in 1914 and led by the painter, writer, and polemicist **Percy Wyndham Lewis** (1886–1957). In its debt to Cubism and interest in representing movement and power, Vorticism exhibits a formal kinship with Futurism. Vorticism also promoted nationalism—even fascism—though, of course, in support of British rather than Italian interests. In the catalog of the only exhibition of Vorticism, at the Doré Galleries in 1915, Lewis described the movement with all the zealous rhetoric typical of the early twentieth-century avant-garde:

> By vorticism we mean (a) Activity as opposed to the tasteful Passivity of Picasso; (b) Significance as opposed to the dull and anecdotal character to which the Naturalist is condemned; (c) Essential Movement and Activity (such as the energy of a mind) as opposed to the imitative cinematography, the fuss and hysterics of the Futurists.

Of particular significance for Vorticism was the association of the American poet Ezra Pound, then living in England. He gave the movement its name and with Lewis founded the periodical *Blast*, subtitled *Review of the Great English Vortex* (fig. **9.19**). For the Vorticists, abstraction was the optimal artistic language for forging a link between art and life. As Lewis stated in *Blast*, they believed that artists must "enrich abstraction until it is almost plain life." Lewis was a literary man by character, and much of his contribution lay in the field of criticism rather than creation. He was early drawn to Roger Fry's experiments in arts organizations (see *The Omega Workshops*, above). He was influenced by Cubism

CONTEXT

The Omega Workshops

Though remembered today chiefly as an art critic and champion of avant-garde art, Roger Fry also exercised influence in his native Britain as an arts administrator and reformer. His most ambitious experiment in these areas was the Omega Workshops, a design firm he founded in 1913 along with the artists Vanessa Bell and Duncan Grant. The aims of the Omega Workshops were twofold: to provide a means for progressive artists to make a living through their art and to make Continental experiments in abstraction accessible to the British public, which showed little interest in avant-garde art. Many artists—and even some enthusiastic amateurs—were associated with the company from its inception until its collapse due to insolvency in 1920. Fry was less concerned with craft perfection than with promulgating a spirit of avant-garde experimentation. Omega artists worked collaboratively and anonymously, designing furnishings such as screens, rugs, ceramics, furniture, and even clothing, many decorated with bright colors and abstract figures evocative of Fauve paintings; all were signed simply with the firm's mark: Ω. Wyndham Lewis was affiliated with the group at its start, but soon withdrew his support, publicly denouncing the Omega Workshops as "a pleasant tea party" that lacked both "masculine" genius and political commitment.

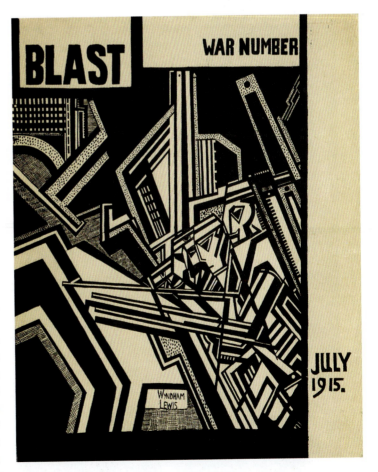

9.19 Percy Wyndham Lewis, *Blast* cover, July 1915. Harvard University Art Museums, Cambridge, MA.

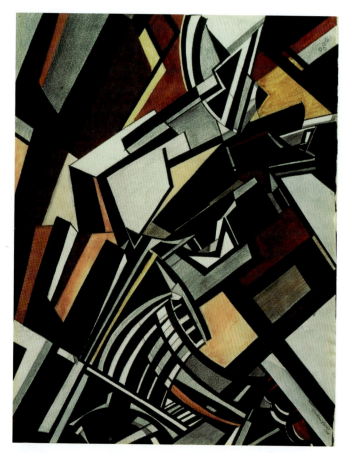

9.20 Percy Wyndham Lewis, *Composition*, 1913. Watercolor drawing on paper, 13½ × 10½″ (34.3 × 26.7 cm). Tate, London.

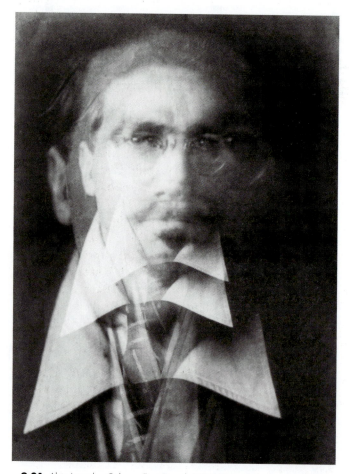

9.21 Alvin Langdon Coburn, *Ezra Pound*, 1917. Vortograph. Private collection.

from a very early date and, despite his polemics against it, by Futurism. In one of his few surviving pre-World War I paintings (fig. **9.20**), Lewis composed a dynamic arrangement of rectilinear forms that arch through the composition as though propelled by an invisible energy force. This adaptation of a Cubist syntax to metallic, machine-like forms has much in common with Léger's paintings around this date. Lewis was primarily attempting, by every means in his power, to attack and break down the academic complacency that surrounded him in England. In the vortex he was searching for an art of "activity, significance, and essential movement, and a modernism that should be clean, hard, and plastic."

Vorticism was a short-lived phenomenon. Nevertheless, it was of great importance in marking England's involvement in the new experimental art of Europe. As with other artists associated with the movement, few of Lewis's early Vorticist paintings survive. After the war he abandoned abstraction in favor of a stylized figurative art. He made portraits of Edith Sitwell, Ezra Pound, and other literary figures, giving them, through a suggestion of Cubist structure, an appearance of modernism.

Another Vorticist to experiment with Cubist-inspired portraiture was the photographer **Alvin Langdon Coburn** (1882–1966). Though born in the United States, Coburn spent much of his mature career in Britain after moving there in 1912. He was involved with Vorticism from its foundation, producing faceted photographs that present objects as if shattered and reassembled, much like Picasso and Braque's early experiments in Cubism (see fig. 7.16). Coburn called these photographs Vortographs and produced them using a Vortoscope, a pyramidal assemblage of mirrors attached to the camera's lens. His Vortographic portrait of Ezra Pound (fig. **9.21**) pulsates with energy and intensity. The rhythm of the image is conveyed not only by the illusion of a sequence of photographs taken at different moments, but also through the play of geometric shapes as the stark white triangles of his shirt collar oscillate beneath the circles formed by the rims of his glasses.

A World Ready for Change: The Avant-Garde in Russia

In the attempt to evaluate the Russian achievement in the early twentieth century, a number of points must be kept in mind. Since the eighteenth century of Peter and Catherine the Great, Russia had maintained a tradition of royal patronage of the arts and had close ties with the West. Russians who could afford to travel to Western Europe visited France, Italy, and Germany; books and periodicals provided another means for keeping abreast of new developments in avant-garde art. Artistic connections between Paris and Moscow were especially close. Russian literature and music attained great heights during the nineteenth century, as did theater and ballet, which began to draw on the visual arts in interesting collaborations. Art Nouveau and the ideas of French Symbolists and Post-Impressionist

Nabis made themselves widely felt in the late 1880s through the movement known as the World of Art (*Mir Iskusstva*); Russian artists mingled these influences with Byzantine and Russian painting and decorative traditions. There was constant, often heated, debate as to whether Russia should modernize on the Western European model or search its own history and folklore for a distinctively Russian route to reform. This division was to inform the development of Russian modernism in its turn.

In 1890, World of Art was joined by Sergei Diaghilev, destined to become perhaps the greatest of all ballet impresarios as well as an enthusiast for modern art in general. A few years later Diaghilev launched his career arranging exhibitions, concerts, theatrical and operatic performances, and ultimately the Ballets Russes, which opened in Paris in 1909 and went from success to success. From then on, Diaghilev drew on many of the greatest names in European painting to create his stage sets.

After the *World of Art* periodical, first published in 1898, came other avant-garde journals. Reading these journals was yet another way that Russian artists could watch and absorb the progress of Fauvism, Cubism, Futurism, and their offshoots. Great collections of the new French art were formed by the enlightened collectors Sergei Shchukin and Ivan Morozov in Moscow. By 1914, Shchukin's collection contained more than 200 works by French Impressionist, Post-Impressionist, Fauve, and Cubist painters, including more than fifty by Picasso and Matisse. Morozov's collection included Cézannes, Renoirs, Gauguins, and many works by Matisse. Both Shchukin and Morozov were generous in opening their collections to Russian artists, and the effect of the Western avant-garde on these creative individuals was incalculable. Through such modern art collections and the exhibitions of the Jack of Diamonds group, an alternative exhibition society founded in 1910 in Moscow,

Cubist experiments were known in St. Petersburg and Moscow almost as soon as they were inaugurated. By the time Marinetti, whose Futurist manifesto had long been available there, visited Russia in 1914, the Futurist movement in that country was in full swing.

Only since the 1980s, and especially following the dissolution of the Soviet Union in 1991, has scholarship on early twentieth-century Russian avant-garde art really come into its own. Before then, it was restricted and sometimes suppressed; Western scholars in particular were often denied access to archival materials and works of art during the Cold War. Official hostility to modernism dated back to the government of the Soviet leader Joseph Stalin, who, in 1932, decreed that Socialist Realism (naturalistic art that celebrated the worker) was the only acceptable form of art. The kinds of small, independent art groups that had until then flourished in Russia, particularly among the avant-garde, were proscribed, and paintings by many of the greatest artists were relegated to storerooms or even destroyed. Such was the fate of the works of Kazimir Malevich, for example, who, unlike many of his contemporaries, chose not to leave the country after Stalin's rise to power. Although known in the West through works acquired by foreign collectors and institutions, his paintings had not been seen in Russia for decades when they were at last exhibited there in 1988.

Larionov, Goncharova, and Rayonism

Lifelong companions and professional collaborators **Mikhail Larionov** (1881–1964) and **Natalia Goncharova** (1881–1962) are among the earliest proponents of the Russian avant-garde. Larionov was a founding member of the Jack of Diamonds group in 1910, but by the following year he and Goncharova had left it and formed a rival organization, the Donkey's Tail, claiming the need for a contemporary Russian art that drew less from Western Europe (since the Jack of Diamonds exhibitions included work by Western European artists) and more from indigenous artistic traditions. (Nevertheless, in 1912 they both participated in the second Blaue Reiter exhibition in Munich, as well as in a historic Post-Impressionist show in London.) They turned to Russian icons and *lubok* ("folk") prints for inspiration and made works in what they termed a Neo-Primitive style.

In 1912 Larionov created Rayonism, based on his studies of optics and theories about how intersecting rays of light reflect off the surface of objects (fig. **9.22** is a work from 1916). Rayonist works were first shown in December 1912 and then in a 1913 exhibition called The Target. Although Rayonism

9.22 Mikhail Larionov, *Rayonist Composition*, 1916. Gouache on paper, 21¼ × 17⅝" (54 × 45 cm). Private collection.

was indebted to Cubism, and also related to Italian Futurism in its emphasis on dynamic, linear forms, Larionov and his circle emphasized its Russian origins. His paintings were among the first non-objective works of art made in Russia. In them he sought to merge his studies of nineteenth-century color theories with more recent scientific experiments (such as radiation). His 1913 manifesto titled *Rayonism*, which extolled this style as "the true liberation of painting," was the first published discourse in Russia on non-objectivity in art.

Like Larionov, Goncharova was drawn to ancient Russian art forms. In addition to icons and *lubok* prints, she studied traditional examples of embroidery. This non-hierarchical distinction between craft and "high" art is a key characteristic of the Russian avant-garde and is perhaps one of the reasons why so many women were at the artistic forefront along with their male colleagues. After her Neo-Primitive phase, Goncharova produced paintings in a Futurist and Rayonist vein. Her colorful 1912 canvas *Linen* (fig. **9.23**) reveals a knowledge of Cubist painters such as Gleizes and Metzinger, but the Cyrillic letters add a distinctively Russian touch. She also continued to make paintings in a folk style, as can be seen in *Icon Painting Motifs* (fig. **9.24**). The conceptual nature of such images explains, to some degree, how an ancient heritage of icons and flat-pattern design prepared Russians to accept total abstraction.

Larionov and Goncharova left Russia in 1915 to design for Diaghilev. They settled in Paris, became French citizens in 1938, and married in 1955. Neither artist produced more than a few significant Rayonist

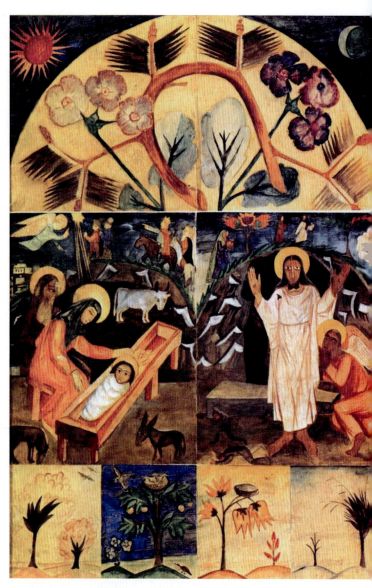

9.24 Natalia Goncharova, *Icon Painting Motifs*, 1912. Watercolor on cardboard, 19½ × 13⅝" (49.5 × 34.6 cm). State Tretyakov Gallery, Moscow.

paintings, but their ideas were instrumental for an art that synthesized Cubism, Futurism, and Orphism and that contained "a sensation of the fourth dimension." This pseudo-scientific concept of a fourth spatial dimension, popularized by scientists, philosophers, and spiritualists, gained currency among the avant-garde across Europe and in the United States in the early twentieth century.

Popova and Cubo-Futurism

One of the strongest artists to emerge within the milieu of the pre-revolutionary Russian avant-garde was the tragically short-lived **Lyubov Popova** (1889–1924), whose sure hand and brilliant palette are evident even in her earliest work. The daughter of a wealthy bourgeois family, Popova was able to travel extensively throughout her formative years, visiting Paris in 1912 and studying under the Cubists Le Fauconnier and Metzinger. In 1913 she began working in the studio of the Constructivist Vladimir Tatlin (see figs. 9.34, 9.35). She also knew Goncharova and Larionov

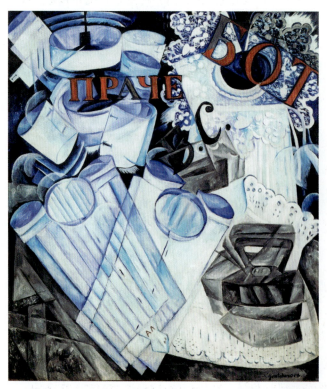

9.23 Natalia Goncharova, *Linen*, 1912. Oil on canvas, 35 × 27½" (89 × 70 cm). Tate, London.

and like them was interested in Russian medieval art. Unlike Tatlin, she was not concerned with the construction of objects in space, but rather found her expressive mode in painting. She developed a mature Cubo-Futurist style (the term is Malevich's, see p. 202), showing a complete assimilation of Western pictorial devices into her own dynamic idiom. Her still life *Subject from a Dyer's Shop* (fig. **9.25**) contains a rich chromatic scheme that probably reflects her study of Russian folk art. Here the Cubist-derived language of integrated, pictorialized form and space may have received its most authoritative expression outside the oeuvre of the two founding Cubists themselves. In late 1915 or early 1916, partly in response to Malevich's Suprematist canvases, Popova began to compose totally abstract paintings that she called Painterly Architectonics. In these powerful compositions she paid increasing attention to building up her paint surfaces with strong textures.

In the aftermath of the 1917 October Revolution, Russian artists were involved in serious debate about the appropriate nature of art under the new Communist regime. Constructivist artists abandoned traditional media such as

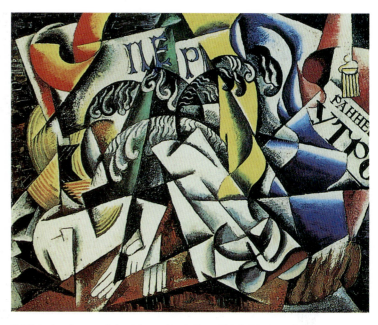

9.25 Lyubov Popova, *Subject from a Dyer's Shop*, 1914. Oil on canvas, 27¾ × 35" (70.5 × 88.9 cm). The Museum of Modern Art, New York.

painting and dedicated themselves to "production art." Their intention was to merge art with technology in products that ranged from utilitarian household objects to textile design, propagandistic posters, and stage sets for political rallies. Popova, who renounced easel painting in 1921, made designs for the theater, including a 1922 set for *The Magnanimous Cuckold* (fig. **9.26**), a play staged by Vsevolod Meyerhold, one of the leading figures of avant-garde theater. The set was organized according to the principles that informed Popova's abstract paintings. Like a large Constructivist environment, it consisted of arrangements of geometric shapes within a structure of horizontal and vertical elements.

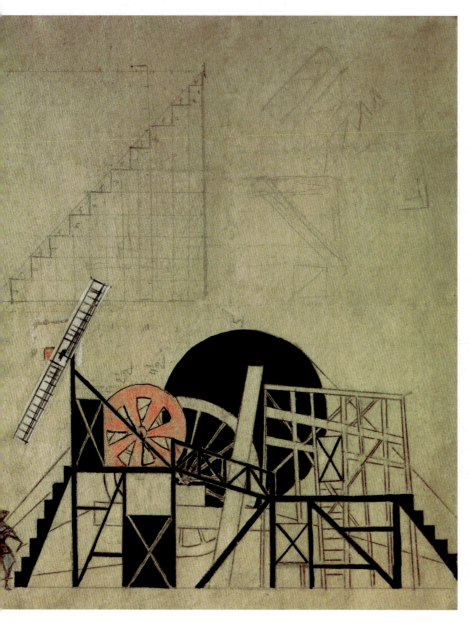

9.26 Lyubov Popova, Stage design for Vsevolod Meyerhold's *The Magnanimous Cuckold*, 1922. India ink, watercolor, paper collage, and varnish on paper, 19¾ × 27¼" (50.2 × 69.2 cm). State Tretyakov Gallery, Moscow.

Malevich and Suprematism

More than any other individual, even Delaunay or Kupka, it was **Kazimir Malevich** (1878–1935) who took Cubist geometry to its most radical conclusion. Malevich studied art in Moscow, where he visited the collections of Shchukin and Morozov. He was painting outdoors in an Impressionist style by 1903 and for a brief time experimented with the Neo-Impressionist technique of Seurat. In 1910 he exhibited with Larionov and Goncharova in the first Jack of Diamonds show in Moscow and subsequently joined their rival Donkey's Tail exhibition, in which he exhibited Neo-Primitivist paintings of heavy-limbed peasants in bright Fauvist colors. By 1912 he was painting in a Cubist manner. In *Morning in the Village after a Snowstorm* (fig. **9.27**) cylindrical figures of peasants move through a mechanized landscape, with houses and trees modeled in light, graded hues of red, white, and blue. The snow is organized into sharp-edged metallic-looking mounds. The resemblance to Léger's earlier machine Cubism is startling (see fig. 7.39), but it is questionable whether either man saw the other's early works for, unlike some of his colleagues, Malevich never traveled to Paris.

For the next two years Malevich explored different aspects and devices of Cubism and Futurism, and called his highly personalized amalgamation of the two Cubo-Futurism.

In 1913 he designed Cubo-Futurist sets and costumes for *Victory over the Sun*, an experimental performance billed as the First Futurist Opera. The actors were mostly amateurs who recited or sang their lines, accompanied by an out-of-tune piano. The non-narrative texts of *Victory over the Sun* were called *zaum*, meaning "transrational" or "beyond-the-mind," and were intended to divest words of all conventional meaning. In 1913–14 Malevich created visual analogs to these semantic experiments in a number of paintings, labeling the style Transrational Realism. Through the juxtaposition of disparate elements in his compositions, he mounted a protest "against logic and philistine meaning and prejudice." In certain paintings of 1914, autonomous colored planes emerge from a matrix of Cubo-Futurist forms. In Malevich's abstract work of the following year, these planes came to function as entirely independent forms suspended on a white ground. "In the year 1913," the artist wrote, "in my desperate attempt to free art from the burden of the object, I took refuge in the square form and exhibited a picture which consisted of nothing more than a black square on a white field."

Like Larionov (and a number of modern artists, for that matter), Malevich had a tendency to date his paintings retrospectively and assign them impossibly early dates. It was not until 1915 that he unveiled thirty-nine

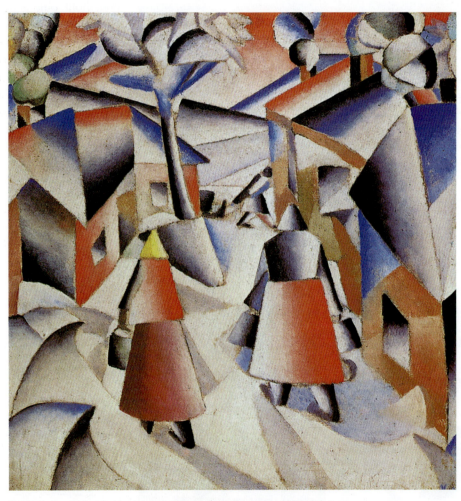

9.27 Kazimir Malevich, *Morning in the Village after a Snowstorm*, 1912. Oil on canvas, 31¾ × 31⅞" (80.6 × 80.9 cm). Solomon R. Guggenheim Museum, New York.

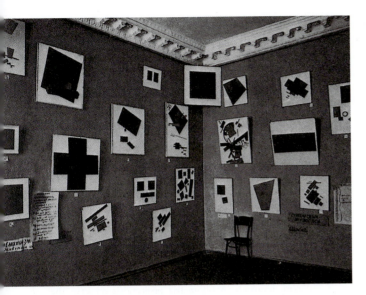

9.28 Kazimir Malevich, Installation photograph of his paintings in 0, 10 (Zero–Ten): The Last Futurist Exhibition in Petrograd (St. Petersburg), December 1915.

totally nonrepresentational paintings, whose style he called Suprematism, at a landmark exhibition in Petrograd (now St. Petersburg) called 0, 10 (Zero–Ten): The Last Futurist Exhibition (fig. **9.28**). Included in the exhibition was the painting *Black Square*, hung high across the corner of the room in the traditional place of a Russian icon. This emblem of Suprematism, the most reductive, uncompromisingly abstract painting of its time, represented an astonishing conceptual leap from Malevich's work of the previous year. In his volume of essays entitled *The Non-Objective World*, the artist defined Suprematism as "the supremacy of pure feeling in creative art." "To the Suprematist," he wrote, "the visual phenomena of the objective world are, in themselves, meaningless; the significant thing is feeling, as such, quite apart from the environment in which it is called forth."

As with Kandinsky and his first abstract paintings (see fig. 6.16), the creation of this simple square on a plain ground was a moment of spiritual revelation to Malevich. For the first time in the history of painting, he felt, it had been demonstrated that a painting could exist completely independent of any reflection or imitation of the external world—whether figure, landscape, or still life. Actually, of course, he had been preceded by Delaunay, Kupka, and Larionov in the creation of abstract paintings, and he was certainly aware of their efforts, as well as those of Kandinsky, who moved to largely non-objective imagery in late 1913. Malevich, however, can claim to have carried abstraction to an ultimate geometric simplification—the black square. Here, he taught, was a new beginning that corresponded to the social transformation occurring around him in the years leading

up to the Russian Revolution. It is noteworthy that the two dominant wings of twentieth-century abstraction—the painterly Expressionism of Kandinsky and the hard-edged geometric purity of Malevich—should have been founded by two Russians. And each of these men had a conviction that his discoveries were spiritual visions rooted in the traditions of Old Russia.

In his attempts to define this new Suprematist vocabulary, Malevich tried many combinations of rectangle, circle, and cross, oriented vertically and horizontally. His passionate curiosity about the expressive qualities of geometric shapes next led him to arrange clusters of colored rectangles and other shapes on the diagonal in a state of dynamic tension with one another. This arrangement of forms implied continuous motion in a field perpetually charged with energy. Malevich established three stages of Suprematism: the black, the red or colored, and the white. In the final phase, realized in monochromatic paintings of 1917 and 1918 (fig. **9.29**), the artist achieved the ultimate stage in the Suprematist ascent toward an ideal world and a complete renunciation of materiality, for white symbolized the "real concept of infinity." This example displays a tilted square of white within the canvas square of a somewhat different shade of white—a reduction of painting to the simplest relations of geometric shapes.

Malevich understood the historic importance of architecture as an abstract visual art and in the early 1920s, when he had temporarily abandoned painting, he experimented with drawings and models in which he studied the problems of form in three dimensions and crafted visions of Suprematist cities, planets, and satellites suspended in space. His abstract three-dimensional models, called Arkhitektons, were significant to the growth of Constructivism in Russia and, transmitted to Germany and Western Europe by his disciples, notably El Lissitzky, influenced the design teachings of the Bauhaus (see Ch. 13, pp. 275, 279).

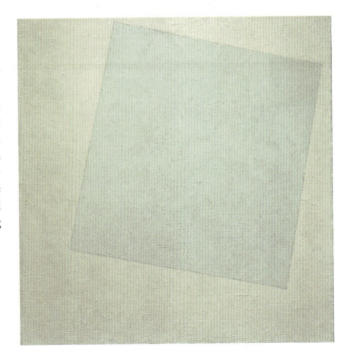

9.29 Kazimir Malevich, *Suprematist Composition: White Square on White*, 1918. Oil on canvas, 31¼ × 31¼" (79.4 × 79.4 cm). The Museum of Modern Art, New York.

👁 ⌐ **Watch** a video about *White Square on White* on mysearchlab.com

In the 1920s Malevich's idealist views were increasingly at odds with powerful conservative artistic forces in the Soviet Union who promoted Socialist Realism as the only genuine proletarian art. Eventually, this style was officially established as the only legitimate form of artistic expression. By the end of 1926 Malevich was dismissed from his position as director of Inkhuk, the Institute of Artistic Culture, and in 1930 he was even imprisoned for two months and interrogated about his artistic philosophy. In his late work Malevich returned to figurative style, though in several works between 1928 and 1932 he combined echoes of his early Cubo-Futurist work with Suprematist concepts. Perhaps the empty landscapes and faceless automaton figures of the last years express, as one discerning critic wrote in 1930, "the 'machine' into which man is being forced—both in painting and outside it."

El Lissitzky's Prouns

Of the artists emerging from Russian Suprematism the most influential internationally was **El (Eleazar) Lissitzky** (1890–1941), who studied architectural engineering in Germany. On his return to Russia at the outbreak of World

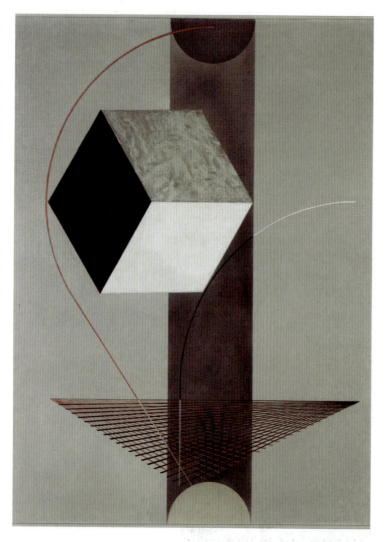

9.30 El Lissitzky, *Proun 99*, 1924–25. Water-soluble and metallic paint on wood, 50½ × 38¾" (128.3 × 98.4 cm). Yale University Art Gallery, New Haven. Gift of Société Anonyme.

Axonometry

The search for ways of representing three-dimensional space on a two-dimensional surface occupied scientists and designers as well as artists. Renaissance linear perspective, in which literal or implied orthogonal lines converge to give the illusion of spatial recession, follows a system codified by Leon Battista Alberti in the fifteenth century. The problem with using Renaissance linear perspective in designs for a structure or piece of equipment is that the system relies on distortion to achieve illusionism. While this poses no difficulties for artists and their patrons, it causes great problems for someone trying to build an exact replica of something rendered in this way. Axonometry, which was developed by military engineers and adopted by cartographers and architects in the nineteenth century, uses a different approach. Axonometric projections preserve the scale of an object and its constituent, mapping out accurately the relationships between forms. Such diagrams can be disorienting to viewers accustomed to renderings in linear perspective, just as Cubist representations of familiar objects can be difficult to read. Constructivists, such as El Lissitzky (see fig. 9.30), found in axonometry a means of overcoming the conventions of Renaissance pictorial space. Its associations with engineering endowed axonometry with a quality of objectivity and accuracy that further appealed to artists seeking to find new, stable truths about society through art.

War I, Lissitzky took up a passionate interest in the revival of Jewish culture, illustrating books written in Yiddish and organizing exhibitions of Jewish art. Like Marc Chagall, he was a major figure in the Jewish Renaissance in Russia around the time of the 1917 Revolution that brought about the fall of the Czarist regime. In 1919 Chagall appointed Lissitzky to the faculty of an art school in Vitebsk that he headed. There Lissitzky, much to the disappointment of Chagall, became a disciple of the art of another faculty member, Malevich, developing his own form of abstraction, which he called Prouns (fig. **9.30**). The exact origin of this neologism is unclear, but it may be an acronym for Project for the Affirmation of the New in Russian. Lissitzky's Prouns are diverse compositions made up of two- and three-dimensional geometric shapes floating in space. The forms, sometimes depicted axonometrically, represent the artist's extension of Suprematist theories into the realm of architecture (see *Axonometry*, above). Indeed, Lissitzky extended the Proun literally into the third dimension in 1923 with his *Prounenraum* (*Proun Room*) (fig. **9.31**), consisting of painted walls and wood reliefs in a room that the viewer was to walk through in a counterclockwise direction. The artist wanted the walls to dissolve visually to allow the Proun elements to activate the space. The room was destroyed, but was reconstructed from Lissitzky's original documents for an exhibition in the Netherlands in 1965.

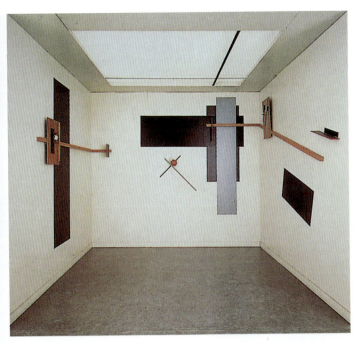

9.31 El Lissitzky, *Prounenraum (Proun Room)*, created for the Great Berlin Art Exhibition, 1923, reconstructed 1965. Wood, 9' 10⅛" × 9' 10⅛" × 8' 6⅜" (3 × 3 × 2.6 m). Stedelijk Van Abbemuseum, Eindhoven, the Netherlands.

👁 Watch a video about Prouns on mysearchlab.com

Lissitzky left Moscow in 1921 for Berlin. He was one of the key artists who brought Russian Suprematism and Constructivism together with related experiments being undertaken in Western Europe. In 1925 he resettled permanently in Moscow, where in the 1930s he became an effective propagandist for the Stalinist regime. Once he abandoned abstraction, he made photographs as well as typographic, architectural, and exhibition designs. Among his most memorable images is a photographic self-portrait from 1924, *The Constructor* (fig. **9.32**). In a double exposure, the artist's face is superimposed on an image of his hand holding a compass over grid paper—a reminder of his role as an architect.

Kandinsky in the Early Soviet Period

Vasily Kandinsky, the leading figure, with Marc and Münter, in the formation of the Blaue Reiter group in 1911 (see Ch. 6, pp. 122–24), was a great force in the transmission to the West of Russian experiments in abstraction and construction. Compelled by the outbreak of war to leave Germany, he went back to Russia in 1914. In the first years after the Revolution, the new Soviet government actively encouraged experimentalism and new forms in the arts to go with the new society communism was attempting to construct. In 1918 Kandinsky was invited to join the Department of Visual Arts (IZO) of Narkompros (NKP, the People's Commissariat for Enlightenment) in Moscow, and subsequently helped to reorganize Russian provincial museums. He remained in Revolutionary Russia for seven years but eventually found his spiritual conception of art coming into conflict with the utilitarian doctrines of the ascendant Constructivists. In 1921 he left the Soviet Union for good, conveying many of his and his colleagues' innovations to the new Bauhaus School in Weimar, Germany.

Meanwhile, until 1920, Kandinsky continued to paint in the manner of free abstraction that he had first devised during the period 1910–14 (see figs. 6.15, 6.16). That year he began to introduce, in certain paintings, regular shapes and straight or geometrically curving lines. During 1921

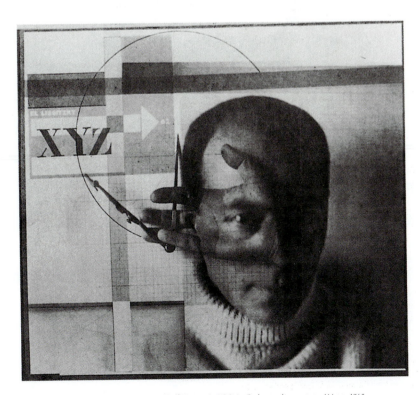

9.32 El Lissitzky, *The Constructor (Self-Portrait)*, 1924. Gelatin-silver print, 4½ × 4⅞" (11.3 × 12.5 cm). Stedelijk van Abbemuseum, Eindhoven, the Netherlands.

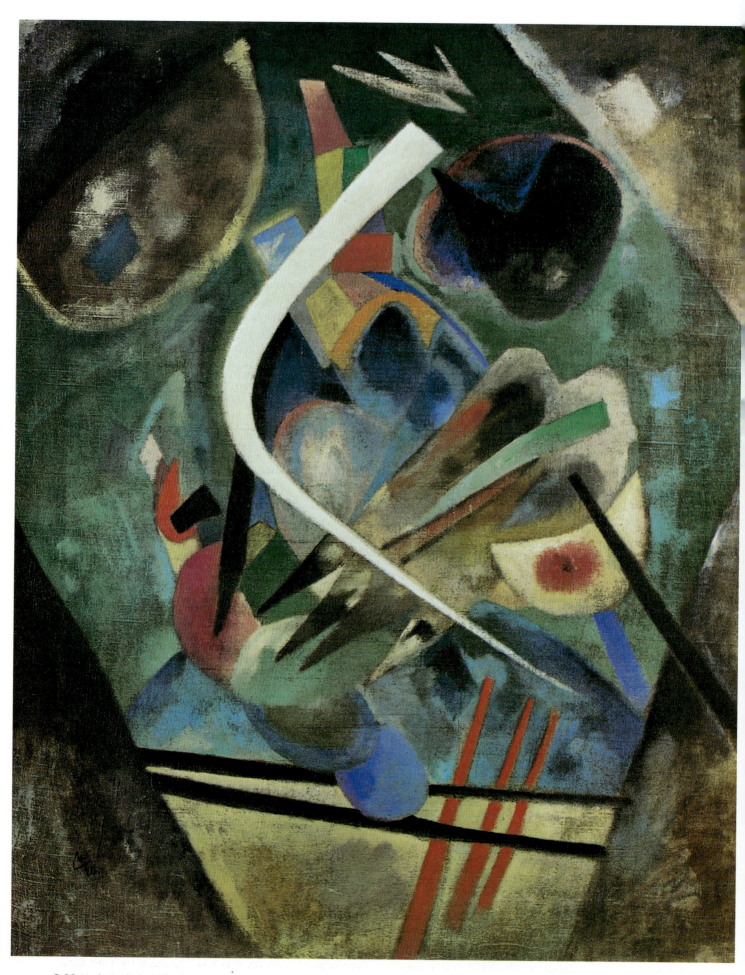

9.33 Vasily Kandinsky, *White Line, No. 232*, 1920. Oil on canvas, 38⅝ × 31½" (98.1 × 80 cm). Museum Ludwig, Cologne.

the geometric patterns began to dominate, and the artist moved into another major phase of his career. There can be no doubt that Kandinsky had been affected by the geometric abstractions of Malevich, Rodchenko, Tatlin, and the Constructivists. Despite the change from free forms to color shapes with smooth, hard edges, the tempo of the paintings remained rapid, and the action continued to be the conflict of abstract forms. *White Line, No. 232* (fig. **9.33**) is a transitional work: the major color areas are still painted in a loose, atmospheric manner, but they are accented by sharp, straight lines and curved forms in strong colors.

Utopian Visions: Russian Constructivism

The word *Konstruktivizm* (Constructivism) was first used by a group of Russian artists in the title of a small 1922 exhibition of their work in Moscow. It is a term that has been applied broadly in a stylistic sense to describe a Cubist-based art developed in many countries. In general, that art is characterized by abstract, geometric forms and a technique in which various materials, often industrial in nature, are assembled rather than carved or modeled. But Constructivism originally referred to a movement of Russian artists after the 1917 Revolution who enlisted art in the service of the new Soviet system. These artists believed that a full integration of art and life would help foster the ideological aims of the new society and enhance the lives of its citizens. Such utopian ideals were common to many modernist movements, but only in Russia were the revolutionary political regime and the revolution in art so closely linked. The artists not only made constructed objects, but were major innovators in such areas as typography, textiles, furniture, and theatrical design. The 1917 Revolution initially gave a huge boost to modernism in Russia as experimental art and the new social order seemed for a time to be marching in step. The head of the new People's Commissariat for Enlightenment, Anatoly Lunacharsky—a man described by Lenin as possessing "a sort of French brilliance"—eagerly involved avant-garde artists at every level of the Revolutionary cultural program.

Innovations in Sculpture

Constructivism was one of the significant new concepts to develop in twentieth-century sculpture. From the beginning of its history, sculpture had involved a process of creating form by taking away from the amorphous mass of the raw material (the carving of wood or stone), or by building up the mass (modeling in clay or wax, later to be cast in metal). These approaches presuppose that sculpture is mainly an art of mass rather than of space. Traditional techniques persisted well into the twentieth century, even in the work of so revolutionary a figure as Brancusi (see Ch. 5, pp. 106–10). The first Cubist sculpture of Picasso, the 1909 *Woman's Head* (see fig. 7.15), with its deep faceting of the surface, still respected the central mass.

True constructed sculpture, in which the form is assembled from elements of wood, metal, plastic, and other materials such as found objects, was a predictable consequence of the Cubists' experiments in painting. Even before Picasso, Braque had made Cubist constructions from pieces of paper and cardboard. Though Braque's works have not survived, an early photograph shows a constructed still life mounted across a corner of the artist's studio (see fig. 7.26). Picasso's 1912 *Guitar* (see fig. 7.27) and 1913 *Mandolin and Clarinet* preserve some idea of the Cubist approach to sculpture.

Tatlin may have seen these works by Braque and Picasso during his trip to Paris, before embarking on his Counter-Reliefs. The subsequent development of constructed sculpture, particularly in its direction toward complete abstraction, took place outside France. Boccioni's Futurist sculpture manifesto of 1912 recommended the use of unorthodox materials, but his actual constructed sculpture remained tied to literal or Cubist subjects. Archipenko's constructed Médrano figures (see fig. 7.29), executed between 1913 and 1914, were experiments in space–mass reversals, but the artist never deserted the subject—figure or still life—and soon reverted to a form of Cubist sculpture modeled in clay for casting in bronze.

In France and Italy the traditional techniques of sculpture—modeling, carving, bronze casting—were probably too powerfully imbedded to be overthrown, even by the leaders of the modern revolution. Sculptors who had attended art schools—Brancusi and Lipchitz, for example—were trained in technical approaches unchanged since the eighteenth century. Modern sculpture emerged from the Renaissance tradition more gradually than modern painting. Possibly as a consequence of this evolutionary rather than revolutionary process, even the experimentalists continued to utilize traditional techniques. The translation of Cubist collage into three-dimensional abstract construction was achieved in Russia first, then in Holland and Germany.

Tatlin

The founder of Russian Constructivism was **Vladimir Tatlin** (1895–1953). In 1914 he visited Berlin and Paris, where he saw Cubist paintings in Picasso's studio, as well as the constructions in which Picasso was investigating the implications of collage for sculpture. The result, on Tatlin's return to Russia, was a series of reliefs constructed from wood, metal, and cardboard, with surfaces coated with plaster, glazes, and broken glass. His exhibition of these works in his studio was among the first manifestations of Constructivism, just as the reliefs were among the first complete abstractions, constructed or modeled, in the history of sculpture. Tatlin's constructions, like Malevich's Suprematist paintings, were to exert a profound influence on the course of Constructivism in Russia.

Most of Tatlin's first abstract reliefs have disappeared, and the primary record of them is a number of drawings and photographs that document his preoccupation with articulating space. The so-called Counter-Reliefs, begun in 1914, were released from the wall and suspended by wires across the corner of a room (again, the location in Russian homes

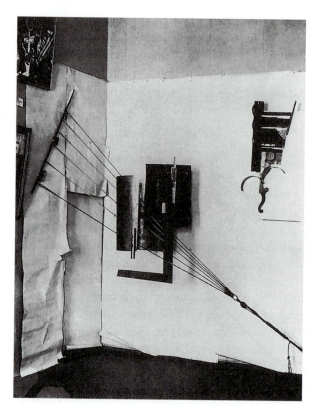

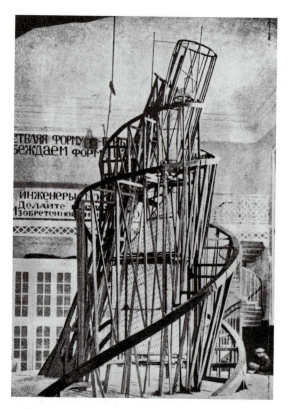

9.34 Vladimir Tatlin, *Counter-Relief*, 1915. Iron, copper, wood, and rope, 28 × 46½" (71 × 118 cm). Reconstruction. State Russian Museum, St. Petersburg.

9.35 Vladimir Tatlin, *Model for Monument to the Third International*, 1919–20. Wood, iron, and glass, height 20' (6.09 m). State Russian Museum, St. Petersburg.

for icons), as far removed from the earthbound tradition of past sculpture as the technical resources of the artist permitted. One of these reliefs (fig. **9.34**) has been assembled from Tatlin's original parts in St. Petersburg's State Russian Museum. Because the reliefs are made from ordinary materials, rather than traditional sculptural media such as bronze or marble, and because they are not isolated on a base, they tend to inhabit the space of the viewer more directly than conventional sculpture.

Tatlin developed a repertoire of forms in keeping with what he believed to be the properties of his chosen materials. According to the principles of what he called the "culture of materials" and "truth to materials," each substance, through its structural laws, dictates specific forms, such as the flat geometric plane of wood, the curved shell of glass, and the rolled cylinder or cone of metal. For a work of art to have significance, Tatlin came to believe that these principles must be considered in both the conception and the execution of the work, which would then embody the laws of life itself.

Like many avant-garde artists, Tatlin embraced the Russian Revolution. Thereafter, he cultivated his interest in engineering and architecture, an interest that saw its most ambitious result in his twenty-foot-high (over 6 m) model for a *Monument to the Third International* (fig. **9.35**), which was exhibited in Petrograd (St. Petersburg) and Moscow in December 1920. Had the full-scale project been built, it would have been approximately 1,300 feet (400 m) high, much taller than the Eiffel Tower and the biggest sculptural form ever conceived at that time. It was to have been a metal spiral frame tilted at an angle and encompassing

a glass cylinder, cube, and cone. These glass units, housing conferences and meetings, were to revolve, making a complete revolution once a year, once a month, and once a day, respectively. The industrial materials of iron and glass and the dynamic, **kinetic** nature of the work symbolized the new machine age. The tower was to function as a propaganda center for the Communist Third International, an organization devoted to the support of world revolution, and its rotating, ascending spiral form was a symbol of the aspirations of communism and, more generally, of the new era. It anticipated, and in scale transcended, all subsequent developments in constructed sculpture encompassing space, environment, and motion, and has come to embody the ideals of Constructivism.

After the consolidation of the Soviet system in the 1920s, Tatlin readily adapted his nature-of-materials philosophy to the concept of production art, which held that in the classless society art should be rational, utilitarian, easily comprehensible, and socially useful, both aesthetically and practically. At its best this idealist doctrine inspired artists to envision a world in which even the most mundane objects would be beautifully designed. But as the Soviet authorities grew intolerant of the radical artistic idealism that had flourished in the early years of the new order, and Socialist Realism became the official style, the ideals of production art turned to dogma. Socialist Realism worked tragically against such spiritually and aesthetically motivated artists as Malevich and Kandinsky, driving the latter out of Russia altogether. Tatlin, dedicated to Constructivist principles, went on to direct various important art schools and enthusiastically applied his

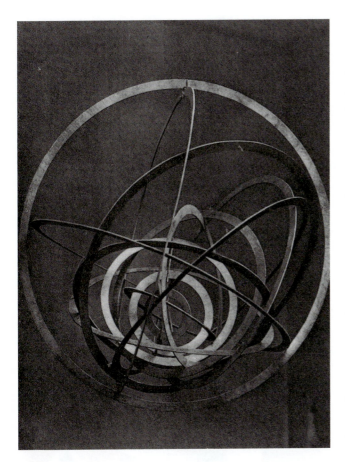

9.36 Aleksandr Rodchenko, *Hanging Construction*, 1920. Wood. Location unknown. Art © Estate of Alexander Rodchenko/RAO, Moscow/VAGA, New York.

Read a document about Rodchenko on mysearchlab.com

immense talent to designing workers' clothing, furniture, and even a Leonardesque flying machine called the Letatlin.

Rodchenko

By 1915–16, **Aleksandr Rodchenko** (1891–1956) had become familiar with the work of Malevich and Tatlin and he soon began to make abstract paintings and to experiment with constructions. By 1920 he, like Tatlin, was turning more and more to the idea that the artist could serve the revolution through a practical application of art in engineering, architecture, theater, and industrial and graphic design. His *Hanging Construction* (fig. **9.36**) is a nest of concentric circles, which move slowly in currents of air. The shapes, cut from a single piece of plywood, could be collapsed after exhibition and easily stored. Rodchenko also made versions (none of which survives) based on a triangle, a square, a hexagon, and an ellipse. This creation of a three-dimensional object with planar elements reveals the Constructivists' interest in mathematics and geometry. It is also one of the first works of constructed sculpture to use actual movement, in a form suggestive of the fascination with space travel that underlay many of the ideas of the Constructivists. Apparently Rodchenko liked to shine lights on the constructions so that they would reflect off the silver paint on their surfaces, enhancing the sense of dematerialization in the work.

Rodchenko was ardently committed to the Soviet experiment. After 1921 he devoted himself to graphic, textile, and theater design. His advertising poster from 1924 (fig. **9.37**) typifies the striking typographical innovations of the Russian avant-garde. Rodchenko also excelled at

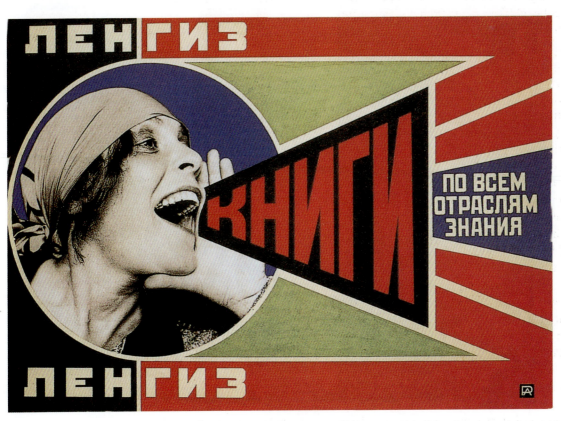

9.37 Aleksandr Rodchenko, Untitled advertising poster, 1924. Gouache and photomontage on paper, 27½ × 33⅞" (69.7 × 86.1 cm). Rodchenko-Stepanova Archive, Moscow. Art © Estate of Alexander Rodchenko/RAO, Moscow/VAGA, New York

photography. Commenting on images like the one reproduced here, he wrote in 1928:

> In photography there is the old point of view, the angle of vision of a man who stands on the ground and looks straight ahead or, as I call it, makes "bellybutton" shots.... The most interesting angle shots today are those "down from above" and "up from below," and their diagonals.

By 1928 artists had long since discovered the value of the overhead perspective as a device for realizing a more abstract kind of image (see figs. 7.13, 13.7). In the vertiginous view of *Assembling for a Demonstration* (fig. **9.38**) Rodchenko constructed a composition of sharp diagonals, light–dark contrasts, and asymmetrical patterns. Given the time and the place in which it was made, Rodchenko's photograph seems a metaphor for a new society where outdated perspectives have given way to dramatic new ones.

Stepanova and Rozanova

Like her husband, Rodchenko, Varvara Fedorovna Stepanova (1894–1958) gave up painting (at least until the 1930s) in order to devote herself to production art. This did not mean traditional decorative arts but rather functional materials manufactured in an equal partnership between artist and industrial worker. Within their utopian framework, these new art forms were intended to aid in the creation of a new society. Tatlin's phrase "Art into Life" was the rallying cry of the Constructivists. Stepanova, who made designs for the state textile factory in Moscow, created striking fabrics in repetitive, geometric patterns suitable for industrial printing methods. She designed clothing, as did Rodchenko and Tatlin, for the new man and woman (fig. **9.39**), with an emphasis on comfort and ease of movement for the worker. The severe economic crisis that crippled Russia during the years of civil war following the Revolution thwarted the implementation of many Constructivist goals. Not surprisingly, Stepanova's sophisticated designs, grounded as they were in a modernist sensibility, were received with greater enthusiasm when exhibited in Paris in 1925 than among the working people of Moscow.

9.38 Aleksandr Rodchenko, *Assembling for a Demonstration*, 1928. Gelatin-silver print, 19½ × 13⅞" (49.5 × 35.3 cm). The Museum of Modern Art, New York. Art © Estate of Alexander Rodchenko/RAO, Moscow/VAGA, New York.

9.39 Varvara Fedorovna Stepanova, Design for sportswear, 1923. Gouache and ink on paper, 11⅞ × 8½" (30.2 × 21.7 cm). Collection, Alexander Lavrentiev.

9.40 Olga Rozanova, *Untitled (Green Stripe)*, 1917–18. Oil on canvas, 28 × 20⅞" (71 × 53 cm). Rostovo-Yaroslavskij Arkhitekturno-Khudozhestrennyj Muzej-Zapovednik, Rostovo-Yaroslavskij, Russia.

The artists who adopted the name Constructivist in 1921 worked in three-dimensional form, but the origin of the aesthetic in Tatlin's philosophy of materials was in the *faktura* ("texture of paint") and the paint surface—its thickness, glossiness, and technique of application. *Faktura* could be considered and treated as autonomous expression, as texture that generates specific forms. In this way the narrative function of figurative art was replaced by a self-contained system. As early as 1913 **Olga Rozanova** (1886–1918) had asserted that the painter should "speak solely the language of pure plastic experience." In 1917, as if to illustrate the principle, she painted a remarkable picture (fig. **9.40**), its composition simply a wide, lavishly brushed green stripe running up, or down, the center and cutting through a creamy white field of contrasted but equally strong scumbled texture. The result seems to reach across the decades to the 1950s and Barnett Newman's more monumental but scarcely more radical Zip paintings (see fig. 16.23).

Pevsner, Gabo, and the Spread of Constructivism

The Constructivist experiments of Tatlin, Rodchenko, and Stepanova came to an end in the early 1930s, as the Soviet government began to discourage abstract experiment in favor of practical enterprises useful to a struggling economy. Many of the Suprematists and Constructivists left Russia in the early 1920s. The most independent contributions of those who remained, including Tatlin and Rodchenko, were to be in graphic and theatrical design. After the pioneering work in Russia, Constructivism developed elsewhere. The fact that artists like Kandinsky, Naum Gabo, and Anton Pevsner left Russia and carried their ideas to Western Europe was of primary importance in the creation of a new International Style in art and architecture.

The two leading Russian figures in the spread of Constructivism were the brothers Anton (Antoine) Pevsner (1886–1962) and **Naum Gabo** (1890–1977). Pevsner was first of all a painter whose history summarized that of many younger Russian artists. His exposure to non-academic art first came about through his introduction to traditional Russian icons and folk art. He then discovered the Impressionists, Fauves, and Cubists in the Morozov and Shchukin collections. In Paris between 1911 and 1914, he knew and was influenced by Archipenko and Modigliani. Between 1915 and 1917 he lived in Norway with his brother Naum and on his return to Russia after the Revolution taught at the Moscow Academy.

Naum Gabo (Naum Neemia Pevsner), who changed his name to avoid confusion with his elder brother, went to Munich in 1910 to study medicine but turned to mathematics and engineering. There he became familiar with the scientific theories of Albert Einstein, among others, attended lectures by the art historian and critic Heinrich Wölfflin, and read Kandinsky's *Concerning the Spiritual in Art*. He left Germany when war broke out and settled for a time in Norway. There, in the winter of 1915–16, he began to make a series of heads and whole figures of pieces

9.41 Naum Gabo, *Column*, c. 1923, reconstructed 1937. Wood, painted metal, and glass (later replaced with Perspex), 41½ × 29 × 29" (105.3 × 73.6 × 73.6 cm). Solomon R. Guggenheim Museum, New York.

metal, and transparent materials such as *Column* (fig. **9.41**). Originally conceived in 1920–21, these tower-shaped sculptures, like Tatlin's *Monument* (see fig. 9.35), were part of Gabo's experiments for a visionary architecture.

Between 1917 and 1920 the hopes and enthusiasms of the Russian experimental artists were at their peak. Most of the abstract artists were initially enthusiastic about the Revolution, hoping that from it would come the liberation and triumph of progressive art. By about 1920, however, Tatlin and the group around him had become increasingly doctrinaire in their insistence that art should serve the Revolution in specific, practical ways. Under government pressure, artists had to abandon or subordinate pure experiment in painting and sculpture and turn their energies to engineering, industrial, and product design.

Gabo's reaction to these developments was recorded in the *Realistic Manifesto*. It was signed by Gabo and Pevsner and distributed in August 1920 at a Moscow exhibition of their work, but Gabo drafted it and was principally responsible for the ideas it contained. In many ways the manifesto was the culmination of ideas that had been fermenting in the charged atmosphere of Russian abstract art over the previous several years. At first a supporter of the revolutionary regime, Gabo found himself increasingly at odds with those members of the avant-garde who denounced art in favor of utilitarian objects to aid in the establishment of the socialist state. In the *Realistic Manifesto*, in which the word "realistic" refers to the creation of a new, Platonic reality more absolute than any imitation of nature, Gabo distinguished between his idealistic though "politically neutral" art and the production art of Tatlin, Rodchenko, and others. With revolutionary fervor, he proclaimed that the art of the future would surpass what he regarded as the limited experiments of the Cubists and Futurists. He called on artists to join forces with scientists and engineers to create a sculpture whose powerful kinetic rhythms embodied "the renascent spirit of our time." Gabo later wrote:

The most important idea in the manifesto was the assertion that art has its absolute, independent value and a function to perform in society whether capitalistic, socialistic, or communistic—art will always be alive as one of the indispensable expressions of human experience and as an important means of communication.

Until 1921 avant-garde artists were allowed the freedom to pursue their new experiments. But as civil war abated, the Soviet state began to impose its doctrine of Socialist Realism. The result was the departure from Russia of Kandinsky, Gabo, Pevsner, Lissitzky, Chagall, and many other leading spirits of the new art throughout the 1920s who continued to develop their ideas in the West (see Chapter 13).

of cardboard or thin sheets of metal, figurative constructions transforming the masses of the head into lines or plane edges framing geometric voids. The interlocking plywood shapes that make up *Constructed Head No. 1* establish the interpenetration of form and space without the creation of a surface or solid mass.

In 1917, after the Russian Revolution, Gabo returned to Russia with Pevsner. In Moscow he was drawn into the orbit of the avant-garde, meeting Kandinsky and Malevich and discovering Tatlin's constructions. He abandoned the figure and began to make abstract sculptures, including a motor-propelled kinetic object consisting of a single vibrating rod, as well as constructions of open geometric shapes in wood,

10
Picturing the Waste Land: Western Europe during World War I

No single event influenced the development of modern art as profoundly as World War I. Sparked by the ongoing conflict in the Balkans, the war rapidly escalated to the point where not only most of Europe but, through international alliances and colonization, much of the world was involved. Most observers assumed that the war would be only "a brief storm." Even the British Foreign Secretary declared to the House of Commons in 1914 that "If we engage in war, we shall suffer little more than we shall suffer even if we stand aside."

But the war was neither brief nor easy: industrialization had enabled rapid manufacture of continuously evolving war machines. Increasingly powerful artillery, along with tanks and airplanes, was brought into service. Most terrifying, though, was the use of poison gas, introduced into combat in 1915. So effective were these weapons—used by both sides during the war—that troops had difficulty advancing across contested ground, thus prolonging battles and deferring decisive victories. Well before the conclusion of the war in 1918, wounded troops were returning home with terrible stories of the conditions at the front (especially those involved in trench warfare) and disabling injuries to testify to the experience. Plastic surgery emerged as a medical specialty in consequence of the disfiguring wounds caused by fragmentation grenades or land mines (see *The Art of Facial Prosthetics*, opposite). In addition to the more than ten million soldiers killed and twenty million physically wounded, there were further millions who returned from battle with profound psychological injuries, leading to a new understanding of the emotional consequences of war and to novel methods for treating those diagnosed with "shell shock." T. S. Eliot's 1922 poem *The Waste Land* conjures the terrible sight of soldiers advancing from trenches wearing gas masks as well as the bandaged faces of the disfigured veterans with its lament,

> Who are those hooded hordes swarming
> Over endless plains, stumbling over cracked earth[.]

Artistic responses to these events were stylistically and thematically diverse. Some, like the Futurists and Vorticists (see Ch. 9, pp. 189–98), welcomed war, what Marinetti called "the world's only hygiene," as the best means of pursuing their

nationalist ideas. Others observed with horror as a conflict over territorial claims that few understood (much less supported) escalated into a bloodbath of unprecedented proportions. Many sought to escape the war, moving to neutral countries like Switzerland or even to the United States, which entered the war in 1917 but remained geographically insulated from the devastation unfolding in Europe. A number of artists were killed, including Blaue Reiter painters Franz Marc and August Macke and the Futurist

CONTEXT

The Art of Facial Prosthetics

The unprecedented number and types of facial wounds inflicted on soldiers during World War I prompted numerous medical innovations. Plastic surgery had not been widely attempted before the war: it was rarely thought necessary and the large breathing masks required to deliver anesthesia made facial surgery difficult if not impossible. Now, with hundreds of patients who had survived terrible wounds but whose injuries—often involving missing noses, cheeks, ears, eyes, or chins and jaws—rendered them unrecognizable even to family members, army surgeons attempted a host of new procedures. The most successful innovator was Harold Gillies, who developed techniques for grafting or stretching skin over nasal, chin, or cheek implants. These early efforts produced uneven outcomes, and Gillies would vastly improve his techniques during World War II. But for those injured in World War I, plastic surgery might leave them at least as disfigured as had their original injuries. Social alienation and even suicide were too often the consequence, so doctors encouraged the (usually temporary, though sometimes permanent) use of facial prostheses: galvanized copper or tin masks, enameled to approximate the soldier's skin, hair, or eye color. Artists worked with physicians and dentists to produce these masks. Among the most noted was Anna Coleman Ladd (1881–1950), an American sculptor married to a physician. Both joined the Red Cross during the war, serving in France. There she used her knowledge of mold-making, modeling, and anatomy to create masks that were more lifelike than most then available. The clumsiness of many facial prostheses is satirized by Neue Sachlichkeit artists like Otto Dix (see fig. 10.33).

Umberto Boccioni. Those who survived gave visual expression to their reactions, drawing alternately on the new language of abstraction and on figurative or naturalistic styles. The movements born of World War I would contribute decisively to the directions modern art would take in the coming decades.

The World Turned Upside Down: The Birth of Dada

Zurich, in neutral Switzerland, was the first important center in which an art, a literature, and even a music and a theater of the fantastic and the absurd arose. In 1915 a number of artists and writers, almost all in their twenties and in one way or another displaced by the war, converged on this city. This international group included the German writers Hugo Ball and Richard Huelsenbeck, the Romanian poet Tristan Tzara, the Romanian painter and sculptor Marcel Janco, the Alsatian painter, sculptor, and poet Jean (Hans) Arp, the Swiss painter and designer Sophie Taeuber, and the German painter and experimental filmmaker Hans Richter. Many other poets and artists were associated with Zurich Dada, but these were the leaders whose demonstrations, readings of poetry, "noise concerts," art exhibitions, and writings assaulted the traditions and preconceptions of Western art and literature. Thrown together in Zurich, these young men and women expressed their reactions to the spreading hysteria of a world at war in forms that were intended as negative, anarchic, and destructive of all conventions. Dada was a means of expressing outrage at the war and disaffection for the materialist and nationalist views that promoted it. In Dada there was a central force of wildly imaginative humor, one of its lasting delights—whether manifested in free-word-association poetry readings drowned in the din of noise machines, in absurd theatrical or cabaret performances (see fig. 10.2), in nonsense lectures, or in paintings produced by chance or intuition uncontrolled by reason. Nevertheless, it had a serious intent: the Zurich Dadaists were engaging in a critical re-examination of the traditions, premises, rules, logical bases, even the concepts of order, coherence, and beauty that had guided the creation of the arts throughout history and remained central to the enterprise of high-minded, utopian modernism.

The Cabaret Voltaire and Its Legacy

Hugo Ball, a philosopher and mystic as well as a poet, was the first actor in the Dada drama. In February 1916, with the nightclub entertainer Emmy Hennings, he founded the Cabaret Voltaire in Zurich as a meeting place for these free spirits and a stage from which existing values could be attacked. Interestingly enough, across the street from the Cabaret Voltaire lived Vladimir Ilyich Lenin, who would stand at the forefront of the Russian Revolution the following year. Ball and Hennings were soon joined by Tzara, Janco, Arp, and Huelsenbeck.

The term Dada was coined in 1916 to describe the movement then emerging from the seeming chaos of the Cabaret Voltaire, but its origin is still doubtful. The popular version advanced by Huelsenbeck is that a French–German dictionary opened at random produced the word *dada*, meaning a child's rocking horse or hobbyhorse. Richter remembers the *da, da, da, da* ("yes, yes") in the Romanian conversation of Tzara and Janco. Dada in French also means a hobby, event, or obsession. Other possible sources are in dialects of Italian and Kru African. Whatever its origin, the name Dada is the central, mocking symbol of this attack on established movements, whether traditional or experimental, that characterized early twentieth-century art. The Dadaists used many of the formulas of Futurism in the propagation of their ideas— the free words of Marinetti, whether spoken or written; the noise-music effects of Luigi Russolo to drown out the poets; the numerous manifestos. But their intent was antithetical to that of the Futurists, who extolled the machine world and saw in mechanization, revolution, and war the rational and logical means, however brutal, of solving human problems.

Zurich Dada was primarily a literary manifestation, whose ideological roots were in the poetry of Arthur Rimbaud, in the theater of Alfred Jarry, and in the critical ideas of Max Jacob and Guillaume Apollinaire. In painting and sculpture, until the Cubist Francis Picabia arrived, the only real innovations were the free-form reliefs and collages "arranged according to the laws of chance" by Jean Arp (see fig. 10.3). With few exceptions, the paintings and sculptures of other artists associated with Zurich Dada broke little new ground. In abstract and Expressionist film—principally through the experiments of Hans Richter and Viking Eggeling—and in photography and typographic design, however, the Zurich Dadaists made important innovations.

The Dadaists' theatrical activity was anything but stale, however, and paved the way for later forms of **Performance art** that developed after World War II (see figs. 19.17, 19.18), particularly that of the Fluxus group. Arp described a typical evening at the Cabaret Voltaire thus:

> Tzara is wiggling his behind like the belly of an Oriental dancer. Janco is playing an invisible violin and bowing and scraping. Madame Hennings, with a Madonna face, is doing the splits. Huelsenbeck is banging away nonstop on the great drum, with Ball accompanying him on the piano, pale as a chalky ghost. We were given the honorary title of Nihilists.

The performers may have been wearing one of the masks created by **Marcel Janco** (1895–1984), made of painted paper and cardboard (fig. **10.1**). Ball said these masks not only called for a suitable costume but compelled the wearer to act unpredictably, to dance with "precise, melodramatic gestures, bordering on madness." Dada theater of this kind had precedents in Russian Futurist performances, such as the 1913 *Victory over the Sun*, for which Malevich designed sets and costumes.

Hugo Ball introduced abstract poetry at the Cabaret Voltaire with his poem *O Gadji Beri Bimba* in June 1916.

10.1 Marcel Janco, *Mask*, 1919. Paper, cardboard, string, gouache, and pastel, 17¾ × 8⅝ × 2" (45 × 22 × 5 cm). Musée National d'Art Moderne, Centre d'Art et de Culture Georges Pompidou, Paris.

revolutionary approach to the creative act, an approach still found in poetry, music, drama, and painting.

The year 1916 witnessed the first organized Dada evening at a public hall in Zurich and the first issue of the magazine *Collection Dada*, which Tzara would eventually take over and move to Paris. The following year, the first public Dada exhibitions were held at the short-lived Galerie Dada. Such activities ushered in a new, more constructive phase for Zurich Dada, broadened from the spontaneous performances of the Cabaret Voltaire. But with the end of World War I, Zurich Dada too was drawing to an end. The initial enthusiasms were fading; its participants were scattering. Ball abandoned Dada, and Huelsenbeck, who had opposed attempts to turn it into a conventional, codified movement, left for Berlin. Tzara remained for a time in Zurich and oversaw the last Dada soirée in 1919, after which he moved to Paris. The painter Francis Picabia arrived in 1918, bringing contact with similar developments in New York and Barcelona. Picabia, together with Marcel Duchamp and Man Ray, had contributed to a Dada atmosphere in New York. Returning to Paris at the end of the war, he became a link, as did Tzara, between the postwar Dadaists of Germany and France. Dada, which was perhaps more a state of mind than an organized movement, left an enormous legacy to contemporary art, particularly the Neo-Dada art of the 1950s and early 1960s (see figs. 19.8, 19.9, 19.13).

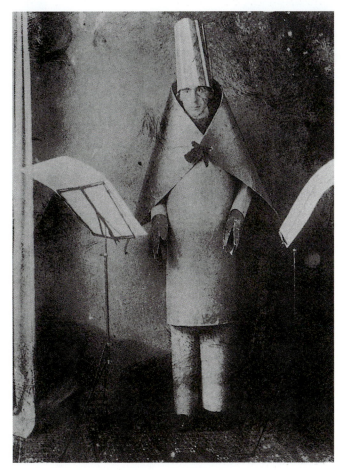

10.2 Hugo Ball reciting the poem *Karawane* at the Cabaret Voltaire, Zurich, 1916. Photograph, 28⅛ × 15¾" (71.5 × 40 cm). Kunsthaus, Zurich.

Wrapped in a cardboard costume (fig. **10.2**), he recited his "sound poem," *Karawane*, from the two flanking music stands. Ball's thesis—that conventional language had no more place in poetry than the outworn human image in painting—produced a chant of more or less melodic syllables without meaning such as "zimzim urallala zimzim zanzibar zimlalla zam…." Despite the frenzied reactions of the audience to this experiment, its influence—like much else presented at the Cabaret Voltaire—affected the subsequent course of twentieth-century poetry.

The Zurich Dadaists were violently opposed to any organized program in the arts, or any movement that might express the common stylistic denominator of a coherent group. Nevertheless, three factors shaped their creative efforts. These were *bruitisme* ("noise-music," from *le bruit*—"noise"—as in *le concert bruitiste*), **simultaneity**, and chance. *Bruitisme* came from the Futurists, and simultaneity from the Cubists via the Futurists. Chance, of course, exists to some degree in any act of artistic creation. In the past the artist had normally attempted to control or to direct it, but it now became an overriding principle. All three, despite the artists' avowed negativism, soon became the basis for their

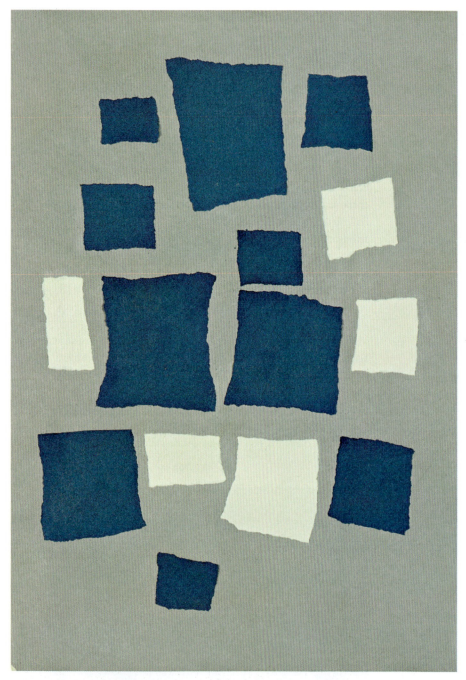

10.3 Jean (Hans) Arp, *Collage Arranged According to the Laws of Chance*, 1916–17. Torn and pasted paper, 19⅛ × 13⅝" (48.6 × 34.6 cm). The Museum of Modern Art, New York.

👁—Watch a video about Arp on mysearchlab.com

Arp

Jean (Hans) Arp (1887–1966) was the major visual artist to emerge from Zurich Dada. He was born in Strasbourg, then a German city in the disputed region of Alsace but subsequently recovered by France. He studied painting and poetry, and in Paris in 1904 he discovered modern painting, which he then pursued in studies at the Weimar School of Art and the Académie Julian in Paris. He also wrote poetry of great originality and distinction throughout his life. The disparity between his formal training and the paintings he was drawn to brought uncertainty, and he spent the years 1908–10 in reflection in various small villages in Switzerland. The

Swiss landscape seems to have made a lasting impression on him, and the abstraction to which he eventually turned was based on nature and organic shapes.

In Switzerland Arp met Paul Klee, and after his return to Germany he was drawn into the orbit of Kandinsky and the Blaue Reiter painters (see figs. 6.15, 6.16). In 1912 he exhibited in Herwarth Walden's first Autumn Salon, and by 1914, back in Paris, he found himself in the circle of Picasso, Modigliani, Apollinaire, Max Jacob, and Delaunay. Arp took an unusually long time finding his own direction. Since he destroyed most of his pre-1915 paintings, the path of his struggle is difficult to trace. He experimented with geometric abstraction based on Cubism, and by 1915, in Zurich, he was producing drawings and collages whose shapes suggest leaves and insect or animal life but which were actually abstractions. With **Sophie Taeuber** (1889–1943), whom he met in 1915 and married in 1922, he jointly made collages, tapestries, embroideries, and sculptures. Through his collaboration with her, Arp further clarified his ideas:

These pictures are Realities in themselves, without meaning or cerebral intention. We … allowed the elementary and spontaneous to react in full freedom. Since the disposition of planes, and the proportions and colors of these planes seemed to depend purely on chance, I declared that these works, like nature, were ordered according to the laws of chance, chance being for me merely a limited part of an unfathomable *raison d'être*, of an order inaccessible in its totality.

Also emerging at this time was the artist's conviction of the metaphysical reality of objects and of life itself—some common denominator belonging to both the lowest and the highest forms of animals and plants. It may have been his passion to express his reality in the most concrete terms possible, as an organic abstraction (or, as he preferred to say, an organic concretion), that led him from painting to collage and then to relief and sculpture in the round.

In 1916–17 Arp produced collages of torn, rectangular pieces of colored papers scattered in a vaguely rectangular arrangement on a paper ground (fig. **10.3**). The story is that he tore up a drawing that displeased him and dropped the pieces on the floor, then suddenly saw in the way they landed the solution to the problems with which he had been struggling. Arp continued to experiment with collages created in this manner, just as Tzara created poems

from words cut out of newspapers, shaken and scattered on a table. Liberated from rational thought processes, the laws of chance, Arp felt, were more in tune with the workings of nature. By relinquishing a certain amount of control, he was distancing himself from the creative process. This kind of depersonalization, already being explored by Marcel Duchamp in Paris, had profound consequences for later art.

The shift in emphasis from the individual artist and the unique artistic creation allowed for fruitful collaboration between Taeuber and Arp, who dubbed their joint productions Duo-Collages. Partly as a result of Taeuber's training in textiles, the couple did not restrict themselves to traditional fine art media. In their desire to integrate art and life they shared an outlook with contemporaries in Russia and artists such as Sonia Delaunay (see fig. 7.43). Taeuber developed a geometric vocabulary in her early Zurich compositions (fig. **10.4**). These rigorous abstractions, organized around a rhythmical balance of horizontals and verticals, had a decisive influence on Arp's work. He said that when he met Taeuber in 1915, "she already knew how to give direct and palpable shape to her inner reality. … She constructed her painting like a work of masonry. The colors are luminous, going from rawest yellow to deep red." Between 1918 and 1920 Taeuber made four remarkable heads in polychromed wood, two of which are portraits of Arp (fig. **10.5**). These heads, humorously reminiscent of hat stands, are among the few works of Dada sculpture made in Zurich. At the same time, Raoul Hausmann was creating similar mannequin-like constructions in Berlin (see fig. 10.19).

By 1915, Arp was devising a type of relief consisting of thin layers of wood shapes. These works, which he called "constructed paintings," represent a medium somewhere between painting and sculpture. They give evidence of Arp's awareness of Cubist collage and constructions, which he would have seen in Paris in 1914–15 (see figs. 7.23, 7.26, 7.27). To make his reliefs, Arp prepared drawings and gave them to a carpenter who cut them out in wood. While not executed by the same **aleatory** methods employed for the collages, the relief drawings sprang from Arp's willingness

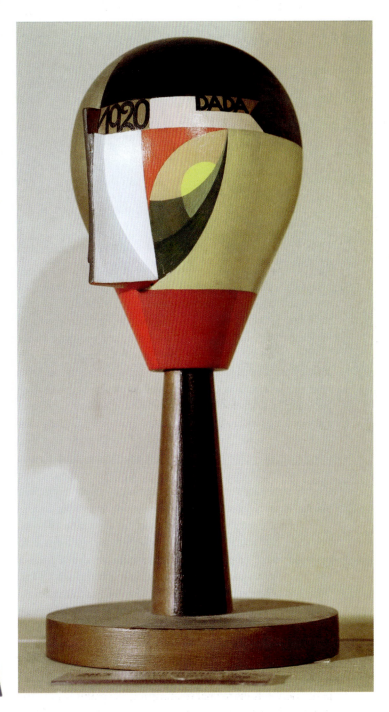

10.4 Sophie Taeuber, *Rythmes Libres (Free Rhythms)*, 1919. Gouache and watercolor on vellum, 14¾ × 10⅞" (37.6 × 27.5 cm). Kunsthaus, Zurich.

10.5 Sophie Taeuber, *Dada Head*, 1920. Painted wood, height 13⅜" (34 cm). Fondation Arp, Clamart, France.

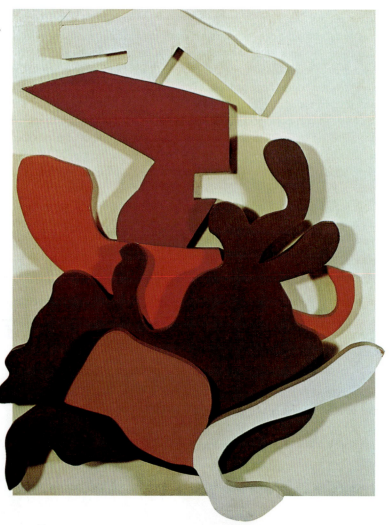

10.6 Jean (Hans) Arp, *Fleur Marteau* (*Hammer Flower*), 1916. Oil on wood, 24⅜ × 19⅝″ (61.9 × 49.8 cm). Fondation Arp, Clamart, France.

to let his pencil be guided unconsciously, without a set goal in mind. The curving, vaguely organic forms that resulted, which evoked the body and its processes or some other highly abstracted form in nature, have been called **biomorphic**, a term used to describe the abstract imagery of Arp's later work as well as that of many Surrealists who followed his lead. Arp developed a vocabulary of biomorphic shapes that had universal significance. An oval or egg shape, for example, was for him a "symbol of metamorphosis and development of bodies." A viola shape suggested a female torso, and then an accent was provided by a cut-out circle that became a navel. Arp's later painted reliefs suggested plants, exotic vegetables, crustaceans, or swarming amoebae, strongly implying life, growth, and metamorphosis. He used the term *Formes terrestres* or "earthly forms" to describe these reliefs. A particular shape might suggest a specific object and thus give the relief its name, as in *Fleur Marteau* (*Hammer Flower*) (fig. **10.6**). Although the origin of the shapes was initially intuitive (a line doodled on a piece of paper), the contour lines were as organic as the living organism that inspired them.

Although he was one of the founders of Zurich Dada who exerted tremendous influence on subsequent art, Arp did not perform in the theatrical presentations at the Cabaret Voltaire (unlike Taeuber, who danced in the Dada performances). "He never needed any hullabaloo," said Huelsenbeck, "Arp's greatness lay in his ability to limit himself to art." He also contributed drawings and poems to Dada publications between 1916 and 1919. In Arp's later, free-standing sculptures in marble or bronze (see Ch. 14, pp. 300–2), the suggestion of head or torso became more frequent and explicit. When asked in 1956 about a 1953 piece entitled *Aquatic*—which, reclining, suggests some form of sea life, and standing on end, a sensuous female torso—he commented, "In one aspect or another, my sculptures are always torsos." In the same way that De Chirico influenced the use by some Surrealists of illusionistic techniques and recognizable images, Arp's work would contribute to the different artistic tendency within Surrealism to employ abstract biomorphic shapes and arbitrary, nondescriptive color to create a world of fantasy. His work later influenced such artists as Joan Miró, André Masson, and Alexander Calder (see figs. 14.13, 14.15, 20.25).

"Her Plumbing and Her Bridges": Dada Comes to America

During World War I, Marcel Duchamp and Francis Picabia had both come to New York and found a congenial environment at 291, the avant-garde gallery founded by Alfred Stieglitz, who had introduced the American public to such European masters as Rodin, Toulouse-Lautrec, Henri

Rousseau, Matisse, and Picasso, as well as the "Stieglitz circle" of American artists (see Ch. 15, pp. 342–50). In 1915, assisted by Duchamp and Picabia, Stieglitz founded the periodical *291* to present the revolutionary convictions about modern art held by these artists. Thus, ideas comparable to those that would define Zurich Dada one year later were fermenting independently in a small, cohesive group in New York. Aside from the two Europeans, the most important figure in the group was the young American artist Man Ray. In addition, the remarkable collectors Louise and Walter Arensberg, whose salons regularly attracted many of the leading artists and writers of the day, were important patrons of Marcel Duchamp, the artist of greatest stature and influence in the group.

Duchamp's Early Career

The enormous impact made on twentieth-century art by **Marcel Duchamp** (1887–1968) is best summarized by the British Pop artist Richard Hamilton: "All the branches put out by Duchamp have borne fruit. So widespread have been the effects of his life that no individual may lay claim to be his heir, no one has his scope or his restraint." Duchamp, a handsome, charismatic man of great intellect, devoted a lifetime to the creation of an art that was more cerebral than visual. By the beginning of World War I he had rejected the works of many of his contemporaries as "retinal" art, or art intended to please only the eye. Although a gifted painter,

Duchamp ultimately abandoned conventional methods of making art in order, as he said, "to put art back at the service of the mind." He lived a simple but peripatetic existence, traveling between Europe and America for most of his adult life.

Duchamp's inquiry into the very nature of art was first expressed in such paintings as *Nude Descending a Staircase, No. 2* (see fig. 7.46), which used Cubist faceting to give, he said, "a static representation of movement." The Paris exhibition of the Futurists in February 1912 had helped the artist to clarify his attitudes, although his intention was at the opposite extreme from theirs. Futurist dynamism, with its "machine aesthetic," was an optimistic, humorless exaltation of the new world of the machine, with progress measured in terms of speed, altitude, and efficiency. Duchamp, though he used some of Futurism's devices, expressed disillusionment through satirical humor.

Duchamp spent the summer of 1912 painting machines of his own creation. While still in France, he made *The King and Queen Traversed by Swift Nudes* in which the figures are not only mechanized but are conceived as machines in operation, pumping some form of sexual energy from one to another. Subsequently in Munich the artist pursued his fantasies of sexualized machines in a series of paintings and drawings, including *The Passage from Virgin to Bride* (fig. 10.7) and the initial drawing for the important painting on glass, *The Bride Stripped Bare by Her Bachelors, Even* or *The*

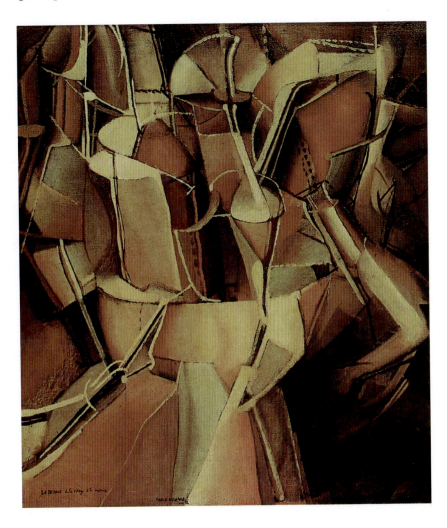

10.7 Marcel Duchamp, *The Passage from Virgin to Bride*, Munich, July–August 1912. Oil on canvas, 23⅜ × 21¼" (59.4 × 54 cm). The Museum of Modern Art, New York.

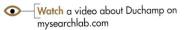 Watch a video about Duchamp on mysearchlab.com

Large Glass (see fig. 10.12). Although these works suggest anatomical diagrams of the respiratory, circulatory, digestive, or reproductive systems of higher mammals, in each Duchamp abandoned the physicality of the human body. The organic becomes mechanized, and human flesh is supplanted by tubes, pistons, and cylinders. The term "mechanomorphic" was eventually coined to describe Duchamp's distinctive grafting of machine forms onto human activity. Thus, while he restored traditional symbols of inviolable purity and sanctified consummation (i.e., the virgin and the bride), he destroyed any sense of convention by presenting them as elaborate systems of anatomical plumbing. Doubting the validity of traditional painting and sculpture as appropriate modes of contemporary expression, and dissatisfied with Cubism, Duchamp still created beautifully rendered, visually seductive works of art. His recognition of this fact no doubt contributed to his decision to abandon painting at the age of twenty-five. "From Munich on," Duchamp said, "I had the idea of *The Large Glass*. I was finished with Cubism and with movement—at least movement mixed up with oil paint. The whole trend of painting was something I didn't care to continue."

During 1912 the so-called Armory Show was being organized in New York, and the American painters Walt Kuhn and Arthur B. Davies and the painter and critic Walter Pach were then in Paris selecting works by French artists. Four paintings by Duchamp were chosen, including *Nude Descending a Staircase* and *The King and Queen Traversed by Swift Nudes*. When the Armory Show opened in February 1913, Duchamp's paintings, and most particularly the *Nude*, became the *succès de scandale* of the exhibition. Despite attacks in the press, all four of his works were sold, and he suddenly found himself notorious.

Duchamp was meanwhile continuing with his experiments toward a form of art based on everyday subject matter—with a new significance determined by the artist and with internal relationships proceeding from a relativistic mathematics and physics of his own devising. Although he had almost ceased to paint, Duchamp worked intermittently toward a climactic object: *The Large Glass* (see fig. 10.12), intended to sum up the ideas and forms he had explored in *The Passage from Virgin to Bride* and related paintings. For this project, he made, between 1913 and 1915, the drawings, designs, and mathematical calculations for *Bachelor Machine* and *Chocolate Grinder, No. 1*, later to become part of the male apparatus accompanying the bride in *The Large Glass*.

Duchamp's most outrageous and far-reaching assault on artistic tradition by far was his invention in 1913 of the "readymade," defined by the Surrealist André Breton as "manufactured objects promoted to the dignity of art through the choice of the artist." Duchamp said his selection of common "found" objects, such as a bottle rack (fig. **10.8**), was guided by complete visual indifference, or "anaesthesia," and the absence of good or bad taste. The readymades demonstrated, in the most irritating fashion to the art world of Duchamp's day, that art could be made out of virtually anything, and that it required little or no

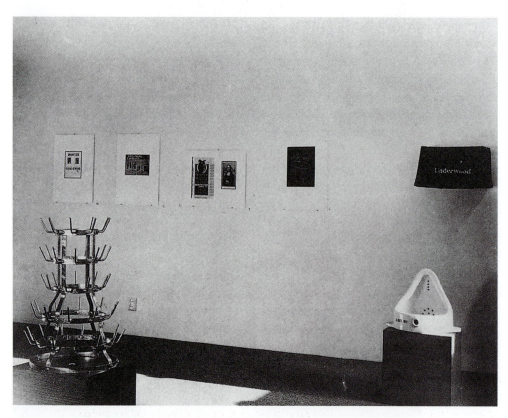

10.8 Marcel Duchamp, *Bottle Rack* and *Fountain*, 1917. Installation photograph, Stockholm, 1963.

Watch a video about *Bottle Rack* and *Fountain* on mysearchlab.com

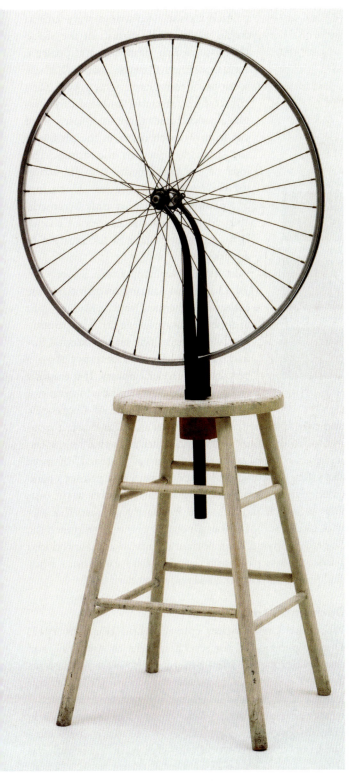

10.9 Marcel Duchamp, *Bicycle Wheel*, New York, 1951 (third version, after lost original of 1913). Assemblage: metal wheel, 25½" (63.8 cm) diameter, mounted on painted wooden stool, 23¾" (60.2 cm) high; overall 50½ × 25½ × 16⅝" (128.3 × 64.8 × 42.2 cm). The Museum of Modern Art, New York.

manipulation by the artist. Within Duchamp's vocabulary, his famously irreverent addition of a mustache and goatee to a reproduction of the *Mona Lisa* was a "rectified" ready-made. An "assisted" readymade also required some intervention by the artist, as when Duchamp mounted an old bicycle wheel on an ordinary kitchen stool (fig. **10.9**).

Because the readymade could be repeated indiscriminately, Duchamp decided to make only a small number yearly, saying, "for the spectator even more than for the artist, art is a habit-forming drug and I wanted to protect my readymade against such contamination." He stressed that it was in the very nature of the readymade to lack uniqueness, and since readymades are not originals in the conventional sense, a "replica will do just as well." To extend the perversity of this logic, Duchamp remarked: "Since the tubes of paint used by an artist are manufactured and readymade products we must conclude that all paintings in the world are assisted readymades." He limited the number of readymades so that their original concept would not lose its impact.

For Duchamp, the conception, the "discovery," was what made a work of art, not the uniqueness of the object. One glimpses in the works discussed so far the complex process of his thought—the delight in paradox, the play of visual against verbal, and the penchant for alliteration and double and triple meanings. In a deliberate act of provocation, Duchamp submitted a porcelain urinal, which he turned ninety degrees and entitled *Fountain* (see fig. 10.8), to the 1917 exhibition of the New York Society of Independent Artists. The work was signed "R. Mutt," a pun on the plumbing fixture manufacturer J. L. Mott Iron Works. Needless to say, the association with the popular Mutt and Jeff cartoons

10.10 Marcel Duchamp, *3 Stoppages Étalon* (*3 Standard Stoppages*), 1913–14. Assemblage: 3 threads glued to 3 painted canvas strips, each mounted on a glass panel; 3 wooden slats, shaped along one edge to match the curves of the threads; the whole fitted into a wooden box, 3 painted canvas strips, each mounted on a glass panel, 7¼ × 49⅜ × ¼" (18.4 × 125.4 × 0.6 cm); 3 wooden slats, 2½ × 43 × ⅛" (6.2 × 109.2 × 0.2 cm), 2½ × 47 × ⅛" (6.1 × 119.4 × 0.2 cm), 2½ × 43¼ × ⅛" (6.3 × 109.7 × 0.2 cm); overall, fitted into wooden box, 11⅛ × 50⅞ × 9" (28.2 × 129.2 × 22.7 cm). The Museum of Modern Art, New York.

did not escape Duchamp. Although the exhibition was in principle open to any artist's submission without the intervention of a jury, the work was rejected. Duchamp resigned from the association, and *Fountain* became his most notorious readymade (see *"The Richard Mutt Case,"* p. 221).

In 1913–14 Duchamp had carried out an experiment in chance that resulted in *3 Standard Stoppages* (fig. **10.10**) and was later applied to *The Large Glass.* In a spirit that mocked the notion of standard, scientifically perfect measurement, Duchamp dropped three strings, each one meter in length, from a height of one meter onto a

painted canvas. The strings were affixed to the canvas with varnish in the shape they assumed to "imprison and preserve forms obtained through chance." These sections of canvas and screen were then cut from the stretcher and laid down on glass panels, and three templates were cut from wooden rulers in the profile of the shapes assumed by the strings. The idea of the experiment—not the action itself—was what intrigued Duchamp. *3 Standard Stoppages* is thus a remarkable document in the history of chance as a controlling factor in the creation of a work of art.

In 1918, Duchamp made *Tu m'* (fig. **10.11**), his last painting on canvas, for the collector Katherine Dreier, a leading spirit in American avant-garde art. The painting has an unusually long and horizontal format, for it was destined for a spot above a bookcase in Dreier's library. It includes a compendium of Duchampian images: cast shadows, drawn in pencil, of a corkscrew and two readymades, *Bicycle Wheel* and *Hat Rack*; a pyramid of color samples (through which an actual bolt is fastened); a *trompe l'oeil* tear in the canvas "fastened" by three real safety pins; an actual bottle brush; a sign painter's hand (rendered by a professional sign painter), as well as the outlines at the left and right of *3 Standard Stoppages.* Together with Dreier and Man Ray, Duchamp eventually founded the Société Anonyme, an important organization that produced publications, gave lectures, and put on exhibitions while building an important collection of modern art.

Duchamp's Later Career

When the United States entered World War I in 1917, Duchamp relocated for several months to Argentina and then to Europe. In 1920 he returned to New York, bringing a vial he called *50 cc of Paris Air* as a gift for the art collector Walter Arensberg. During this period he invented a female *alter ego,* Rrose Sélavy, which when pronounced in French sounds like *"Eros, c'est la vie"* or *"Eros, that's life."* Duchamp inscribed works with this pseudonym and was

10.11 Marcel Duchamp, *Tu m'*, 1918. Oil on canvas, with bottle brush, three safety pins, and one bolt, 2' 3½" × 10' 2¾" (0.69 × 3.2 m). Yale University Art Gallery, New Haven. Gift from the Estate of Katherine S. Dreier.

photographed several times by Man Ray in the guise of his feminine persona. Such gestures were typical of his tendency to break down gender boundaries, and they demonstrate the degree to which Duchamp's activities and his personality were as significant, if not more so, than any objects he made.

In 1922, after yet another round of travel, Duchamp settled in New York and continued working on *The Large Glass* (fig. **10.12**). He finally ceased work on it in 1923. This painting on glass, which was in gestation for several years, is the central work of his career. The glass support dispensed with the need for a background since, by virtue

of its transparency, it captured the "chance environment" of its surroundings. *The Large Glass* depicts an elaborate and unconsummated mating ritual between the bride in the upper half of the glass, whose machine-like form we recognize from *The Passage from Virgin to Bride* (see fig. 10.7), and the uniformed bachelors in the lower half. These forms are rendered with a diagrammatic precision that underscores the pseudoscientific nature of their activities. Despite their efforts, the bachelors fail to project their "love gasoline" (the sperm gas or fluid constantly ground forth by the rollers of the chocolate machine) into the realm of the bride,

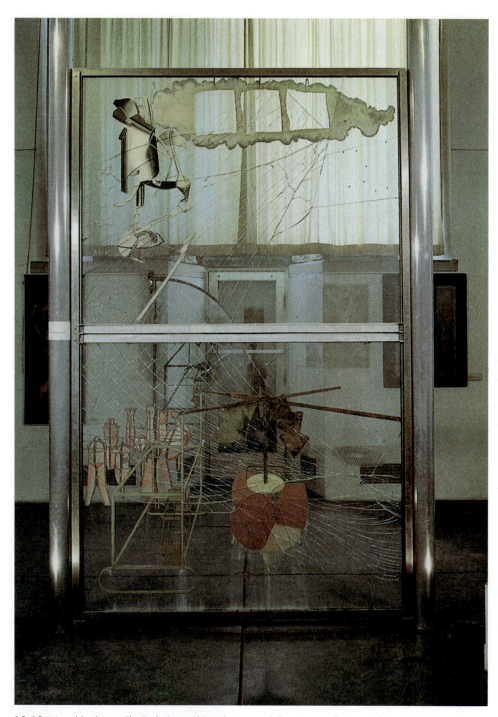

10.12 Marcel Duchamp, *The Bride Stripped Bare by Her Bachelors, Even* or *The Large Glass*, 1915–23. Oil, lead wire, foil, dust, and varnish on glass, 8' 11" × 5' 7" (2.7 × 1.7 m). Philadelphia Museum of Art.

((•— Listen to a podcast about *The Bride Stripped Bare...* on mysearchlab.com

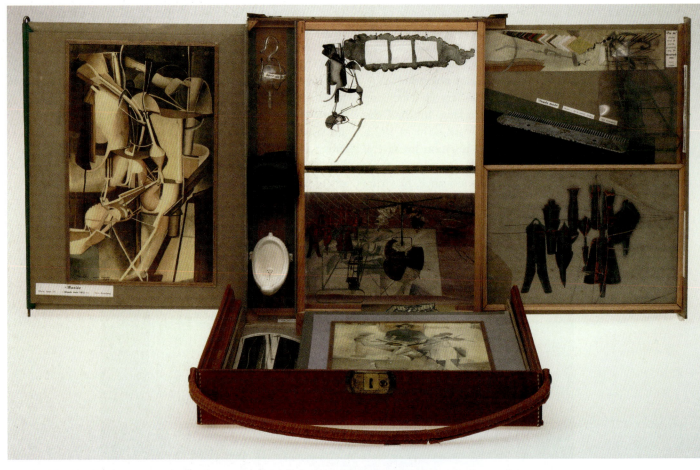

10.13 Marcel Duchamp, *Boîte en valise* (*Box in a Valise*), 1941. Leather valise containing miniature replicas, photographs, and color reproductions of works by Duchamp. Philadelphia Museum of Art.

10.14 Marcel Duchamp, *Étant Donnés 1. La Chute d'Eau, 2. Le Gaz d'Éclairage.* (*Given 1. The Waterfall, 2. The Illuminating Gas*), 1946–66. Mixed-media assemblage: wooden door, bricks, velvet, wood, leather stretched over an armature of metal, twigs, aluminum, iron, glass, Plexiglas, linoleum, cotton, electric lights, gas lamp (Bec Auer type), motor, etc., 7' 11½" × 5' 10" (2.42 × 1.78 m). Philadelphia Museum of Art.

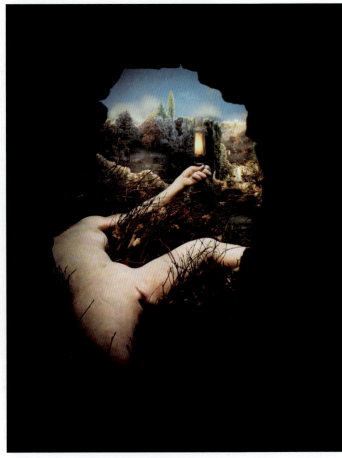

so the whole construction becomes a paradigm of pointless erotic activity. Breton described it as "a mechanistic and cynical interpretation of the phenomenon of love." To annotate and supplement this cryptic work, Duchamp assembled his torn scraps of notes, drawings, and computations in another work titled *The Green Box*. This catalog of Duchampian ideas was later published by the artist in a facsimile edition. Duchamp allowed New York dust to fall on *The Large Glass* for over a year and then had it photographed by Man Ray, calling the result *Dust Breeding*; then he cleaned everything but a section of the cones, to which he cemented the dust with a fixative. The final touch came when the *Glass* was broken while in transit and was thereby webbed with a network of cracks. Duchamp is reported to have commented with satisfaction, "Now it is complete."

Back in Paris in the mid-1930s, Duchamp devised a work of art that made all of his inventions easily portable. The *Boîte en valise* (*Box in a Valise*) (fig. **10.13**) was a kind of leather briefcase filled with miniature replicas of his previous works, including all the aforementioned objects. It provided a survey of Duchamp's work, like a traveling retrospective. When, like so many other European artists, Duchamp sought final refuge in America from World War II, he came equipped with his "portable museum." Friends such as the American artist Joseph Cornell, who also made art in box form (see figs. 16.39, 16.40), helped him assemble the many parts of *Boîte*. Like *The Green Box*, it was made into a multiple edition. Duchamp intended that the viewer participate in setting up and handling the objects in the valise. In this way, the viewer completes the creative act set in motion by the artist.

Although Duchamp let it be rumored that he had ceased all formal artistic activity in order to devote himself to chess (at which he excelled), he worked in secret for twenty years on a major sculptural project, completed in 1966. *Étant Donnés 1. La Chute d'Eau, 2. Le Gaz d'Éclairage* (*Given 1. The Waterfall, 2. The Illuminating Gas*) (fig. **10.14**) is one of the most disturbing and enigmatic works of the century, but it came to light only after the artist's death, when it was installed in the Philadelphia Museum of Art, which owns most of Duchamp's major works. A mixed-media **assemblage** built around the realistic figure of a nude woman sprawled on the ground, *Étant Donnés* can only be viewed by one person at a time through a peephole in a large wooden door. Duchamp's secret considerations of realism and voyeurism, coupled with the mysterious title, provide a challenging complement to the mechanical sexuality and person symbolism of *The Large Glass*.

Picabia

Francis Picabia (1879–1953) was born in Paris of wealthy Cuban and French parents. Between 1908 and 1911 he moved from Impressionism to Cubism. He joined the

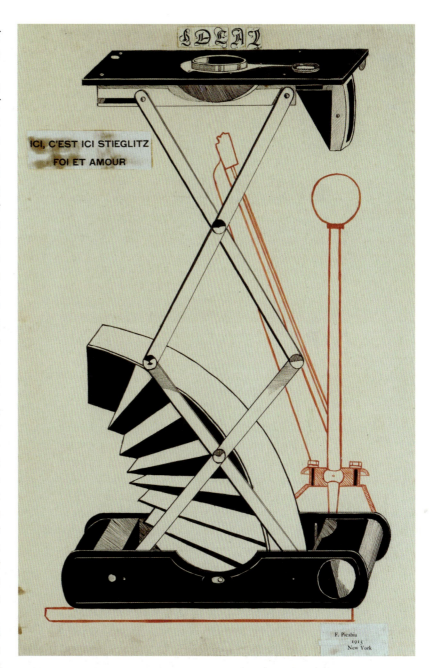

10.15 Francis Picabia, *Ideal*, 1915. Pen and red and black ink on paper, 29⅞ × 20" (75.9 × 50.8 cm). The Metropolitan Museum of Art, New York.

Section d'Or briefly and then experimented with Orphism and Futurism. In New York in 1915, he collaborated with Marcel Duchamp in establishing the American version of proto-Dada and, in the spirit of Duchamp, took up machine imagery as an emblematic and ironic mode of representation. "Almost immediately upon coming to America," Picabia said, "it flashed on me that the genius of the modern world is in machinery, and that through machinery art ought to find a most vivid expression." In this "mechanomorphic" style, Picabia achieved some of his most distinctive work, particularly a series of *Machine Portraits* of himself and his key associates in New York. Thus, he saw Stieglitz (fig. **10.15**) as a broken bellows camera, equipped with an automobile brake in working position and a gear shift in neutral, signifying the frustrations experienced by someone trying to present experimental art in philistine America. Both the

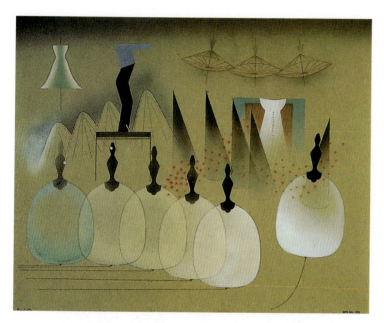

10.16 Man Ray, *Seguidilla*, 1919. Airbrushed gouache, pen and ink, pencil, and colored pencil on paper board, 22 × 27⅞" (55.9 × 70.8 cm). Hirshhorn Museum and Sculpture Garden, Smithsonian Institution, Washington, D.C.

Watch a video about Man Ray on mysearchlab.com

Gothic letters and the title, *Ideal*, confirm the conceptual or heraldic form of the portrait, while also establishing a witty contrast between the commonplace, mechanical imagery and the ancient, noble devices of traditional heraldry. Made for publication in Stieglitz's journal *291*, Picabia's 1915 portraits are modest in size, materials, and ambition, but in other works the artist developed his machine aesthetic—his "functionless" machines—into splendidly iconic paintings. They are tongue-in-cheek, however, in their commentary on the seriocomic character of human sexual drives, and have many parallels, both thematic and formal, with Duchamp's *The Large Glass*, then underway in New York.

Returning to Europe in 1916, Picabia founded his journal *391* in Barcelona and published it intermittently in New York, Zurich, and Paris until 1924. After meeting the Zurich Dadaists in 1918, he was active in the Dada group in Paris. He reverted to representational art and, after the emergence of Surrealism, painted a series of *Transparencies* in which he superimposed thin layers of transparent imagery delineating classically beautiful male and female images, sometimes accompanied by exotic flora and fauna. Although the *Transparencies*, and the greater part of Picabia's later work, were long dismissed as decadently devoid of either content or formal interest, they have assumed new importance among the acknowledged prototypes of 1980s Neo-Expressionism (see Ch. 25, pp. 666–80).

Man Ray and the American Avant-Garde

Relatively unburdened by tradition, some American artists who met Duchamp and Picabia in New York had little difficulty entering into the Dada spirit. Indeed, one of the most daring of all Dada objects was made by Philadelphia-born Morton Schamberg, who mounted a plumbing connection on a miter box and sardonically titled it *God*. Though

known primarily for this work, Schamberg was actually a painter and photographer who made a number of abstract, machine-inspired compositions in oil before his life was cut short by the massive influenza epidemic of 1918.

No less ingenious in his ability to devise Dada objects than to photograph them was **Man Ray** (1890–1976) (born Emmanuel Radnitsky), also from Philadelphia, who went on to pursue a lengthy, active career in the ambience of Surrealism. He gathered with Duchamp and Picabia at the Arensbergs' home and by 1916 had begun to make paintings inspired by a Dada machine aesthetic and three-dimensional constructions made with found objects. By 1919, Man Ray, who was always looking for ways to divest himself of the "paraphernalia of the traditional painter," was creating the first paintings made with an **airbrush**, which he called Aerographs. Normally reserved for commercial graphic work, the airbrush made possible the soft tonalities in the dancing fans and cones of *Seguidilla* (fig. **10.16**). The artist was delighted with his new discovery. "It was wonderful," he said, "to paint a picture without touching the canvas."

In 1921, disappointed that Dada had failed to ignite a full-scale artistic revolution in New York, Man Ray moved to Paris. His exhibition in December of that year was a Dada event. The gallery was completely filled with balloons that

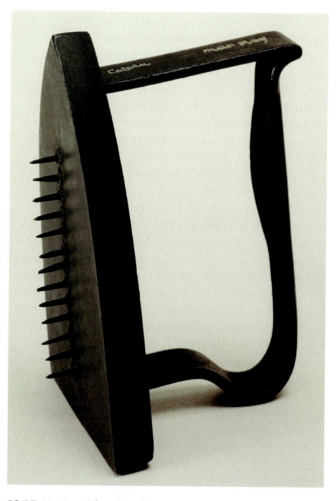

10.17 Man Ray, *Gift*, replica of lost original of 1921, c. 1958. Flatiron with nails, height 6½ × 3⅝ × 3¾" (16.5 × 9.2 × 9.5 cm). The Museum of Modern Art, James Thrall Soby Fund. 1966.

viewers had to pop in order to discover the art. *Gift* (fig. 10.17), which exists today as a replica of the 1921 original, was made in the spirit of Duchamp's slightly altered or "assisted" readymades. With characteristic black humor, Man Ray subverted an iron's normal utilitarian function by attaching fourteen tacks to its surface, transforming this familiar object into something alien and threatening. The work was made for the avant-garde French composer Erik Satie, hence its title.

Man Ray, who had taken up photography in 1915 through his association with Stieglitz, invented cameraless photographic images that he called Rayographs. These were made by placing objects on or near sensitized paper that was then exposed directly to light, technically akin to Anna Atkins's cyanotypes of the previous century (see fig. 2.5). In the proper Dada manner, the technique was discovered accidentally in the darkroom. By controlling exposure and by moving or removing objects, the artist used this "automatic" process to create images of a strangely abstract or symbolic character (fig. **10.18**).

Man Ray became an established figure in the Parisian avant-garde, gaining fame with his Dada films, with his experimental photographs, his portrayals of artists and art, and his fashion photography (see fig. 14.53). By the

mid-1920s, he was a central figure of the Surrealist circle (see Ch. 14, pp. 332–33). Several of his assistants became important photographers in their own right: Berenice Abbott (see fig. 15.43), Bill Brandt (see fig. 14.61), and Lee Miller (see fig. 16.43).

"Art is Dead": Dada in Germany

In 1917, with a devastating war, severe restrictions on daily life, and rampant inflation, the future in Germany seemed completely uncertain. This atmosphere, in which highly polarized and radical politics flourished, was conducive to the spread of Dada. Richard Huelsenbeck, returning to Berlin from Zurich, joined a small group including the brothers Wieland and Helmut Herzfelde (who changed his name to John Heartfield as a pro-American gesture), Hannah Höch, the painters Raoul Hausmann, George Grosz, and, later, Johannes Baader. Huelsenbeck opened a Dada campaign early in 1918 with speeches and manifestos attacking all phases of the artistic status quo, including Expressionism, Cubism, and Futurism. A Club Dada was formed, to which Kurt Schwitters, later a major exponent of German Dada, was refused membership because of his association with Galerie Der Sturm, regarded by Huelsenbeck as a bastion of Expressionist art and one of Dada's chief targets.

After the war and the fall of the German Empire came a period of political chaos, which did not end with the establishment of the Weimar Republic (1918–33) and democratic government under the moderate socialist president Friedrich Ebert. Experimental artists and writers were generally leftwing, hopeful that from chaos would emerge a more equable society, but disillusionment among members of the Dada group set in as they realized that the so-called socialist government was actually in league with business interests and the old imperial military. From their disgust with what they regarded as a bankrupt Western culture, they turned to art as a medium for social and political activity. Their weapons were mostly collage and **photomontage**. Berlin Dada, especially for Heartfield and Grosz, quickly took on a left-wing, pacifist, and Communist direction. The Herzfelde brothers' journal, *Neue Jugend*, and their publishing house, Malik-Verlag, utilized Dada techniques for political propaganda (see figs. 10.21, 10.31). George Grosz made many savage social and political drawings and paintings for the journal. One of the publications financed by the Herzfelde brothers was *Every Man Is His Own Football*. Although the work was quickly banned, its title became a rallying cry for German revolutionists. In 1919 the first issue of *Der Dada* appeared, followed in 1920 by the first international Dada-Messe, or Dada Fair, where the artists covered the walls of a Berlin gallery with photomontages, posters, and slogans like "Art is dead. Long live the new machine art of Tatlin." The rebellious members of Dada never espoused a clear program, and their goals were often ambiguous and sometimes contradictory: while they used art as a means of protest, they also questioned the very validity of artistic production.

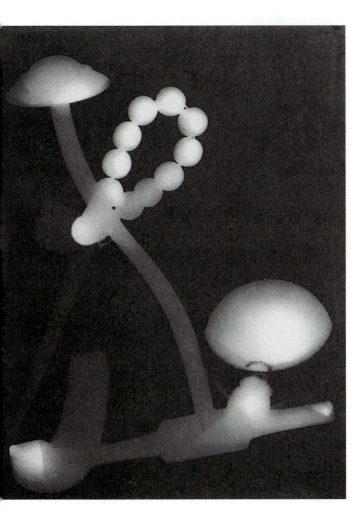

10.18 Man Ray, *Untitled*, 1922. Gelatin-silver print (Rayograph), 9⅜ × 7" (23.8 × 17.78 cm). The Museum of Modern Art, New York.

Hausmann, Höch, and Heartfield

The Zurich Dada experiments in noise-music and in abstract phonetic poetry were further explored in Berlin. **Raoul Hausmann** (1886–1971), the chief theoretician and writer of the group (nicknamed the Dadasoph), claimed the invention of a poetic form involving "respiratory and auditive combinations, firmly tied to a unit of duration," expressed in typography by "letters of varying sizes and thicknesses which thus took on the character of musical notations." In his *Spirit of Our Time (Mechanical Head)* (fig. **10.19**), 1919, Hausmann created a kind of three-dimensional collage. To a wooden mannequin head he attached real objects, including a metal collapsing cup, a tape measure, labels, and a pocketbook. Through his use of commonly found objects, Hausmann partook of the iconoclastic spirit of Duchamp's readymades and implied that human beings had been reduced to mindless robots, devoid of individual will.

In the visual arts, a major invention or discovery was photomontage, created by cutting up and pasting together photographs of individuals and events, posters, book jackets, and a variety of typefaces in new and startling configurations—anything to shock. The source material was supplied by the tremendous growth in the print media in Germany. Hausmann and Höch (who were lovers and occasional collaborators), along with Grosz, claimed to have originated Dada photomontage, although the technique had existed for years in advertising and popular imagery. Precedent can also be identified in Cubist collage of *papier collé* and Futurist collage (see fig. 9.12). Photomontage, with its clear integration of images of modern life into works of art, proved to be an ideal form for Dadaists and subsequently for Surrealists.

A large photomontage of 1919–20 by **Hannah Höch** (1889–1978), with a typically sardonic title, *Cut with the Kitchen Knife Dada Through the Last Weimar Beer Belly Cultural Epoch of Germany* (fig. **10.20**), was included in the Dada-Messe, despite the efforts of Grosz and Heartfield to exclude her work. The dizzying profusion of imagery here demonstrates how photomontage relies on material appropriated from its normal context, such as magazine illustration, and introduces it into a new, disjunctive context, thereby investing it with new meaning. Höch here presents a satirical panorama of Weimar society. She includes photographs of her Dada colleagues, Communist leaders, dancers, sports figures, and Dada slogans in varying typefaces. The despised Weimar government leaders at the upper right are labeled "anti-Dada movement." At the very center of the composition is a photo of a popular dancer who seems to toss her out-of-scale head into the air. The head is a photo of Expressionist printmaker Käthe Kollwitz (see discussion pp. 233–34 and figs. 10.27–10.29). Although the Dadaists reviled the emotive art of the Expressionists, it seems likely that Höch respected this leftwing artist. Throughout the

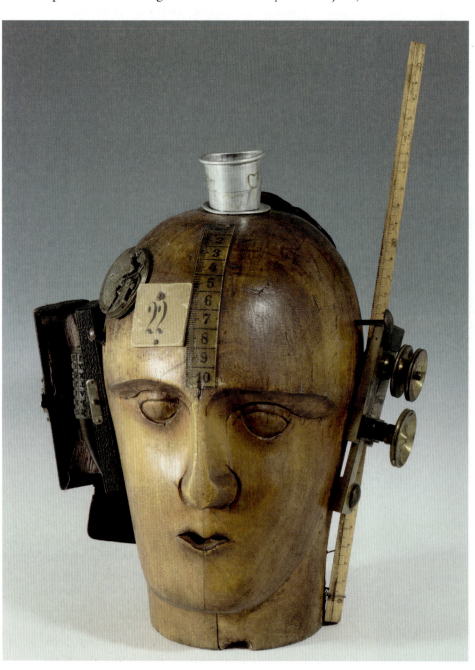

10.19 Raoul Hausmann, *The Spirit of Our Time (Mechanical Head)*, 1919. Wood, leather, aluminum, brass, and cardboard, 12⅝ × 9" (32.1 × 22.9 cm). Musée National d'Art Moderne, Centre d'Art et de Culture Georges Pompidou, Paris.

((••── Listen to a poem by Hausmann on mysearchlab.com

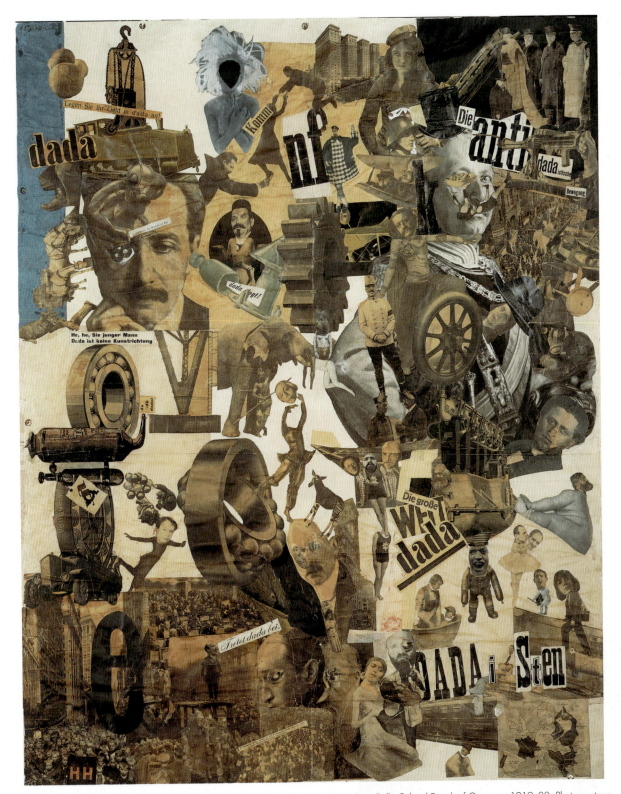

10.20 Hannah Höch, *Cut with the Kitchen Knife Dada Through the Last Weimar Beer Belly Cultural Epoch of Germany*, 1919–20. Photomontage, 44⅞ × 35½″ (114 × 90.2 cm). Staatliche Museen zu Berlin, Preussischer Kulturbesitz, Nationalgalerie.

View the Closer Look for *Cut with the Kitchen Knife...* on mysearchlab.com

composition are photographs of gears and wheels, both a tribute to technology and a means of imparting a sense of dynamic, circular movement. One difference between Höch and her colleagues is the preponderance of female imagery in her work, indicative of her interest in the new roles of women in postwar Germany, which had granted them the vote in 1918, two years before the United States.

John Heartfield (1891–1968) made photomontages of a somewhat different variety. He composed images from the clippings he took from newspapers, retouching them in order to blend the parts into a facsimile of a single, integrated image. These images were photographed and made into photogravures for mass reproduction. Beginning in 1930, as the rise of Nazism began to dominate the

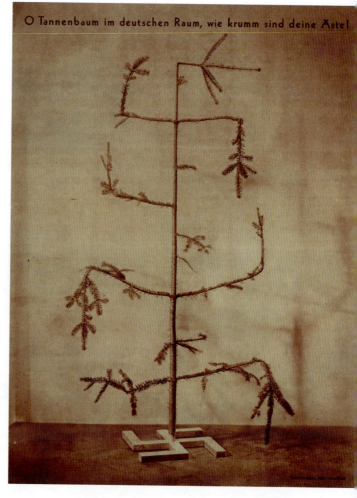

political landscape, Heartfield contributed illustrations regularly to the leftwing magazine *AIZ* or *Workers' Illustrated Newspaper*. For one of his most jarring images of protest, made in 1934 after Hitler had become German chancellor (and had assumed dictatorial powers), he altered the words of a traditional German Christmas carol and twisted the form of a Christmas tree into a swastika tree (fig. **10.21**). "O Tannenbaum im deutschen Raum, wie krumm/sind deine Äste!" ("O Christmas tree in German soil, how crooked are your branches!") the heading reads. The text below states that in the future all trees must be cut in this form.

Schwitters

Somewhat apart from the Berlin Dadaists was the Hanoverian artist **Kurt Schwitters** (1887–1948), who completed his formal training at the Academy in Dresden and painted portraits for a living. He quarreled publicly with Huelsenbeck and was denied access to Club Dada because of his involvement with the apolitical and pro-art circle around Walden's Galerie Der Sturm. He was eventually reconciled with other members of the group, however, and established his own Dada variant in Hanover under the designation *Merz*, a word in part derived from the word *commerzbank* included in one of his collages. "At the end of 1918," he

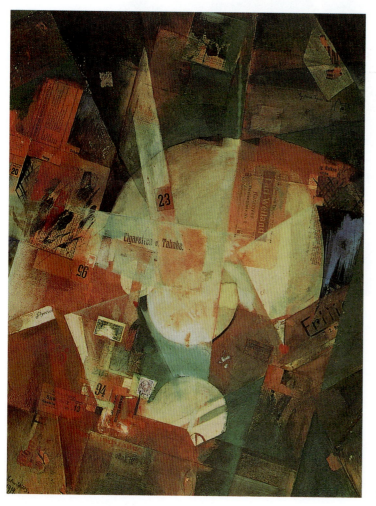

wrote, "I realized that all values only exist in relationship to each other and that restriction to a single material is one-sided and small-minded. From this insight I formed *Merz*, above all the sum of individual art forms, *Merz*-painting, *Merz*-poetry." Schwitters was a talented poet, impressive in his readings and deadly serious about his efforts in painting, collage, and construction. These always involved a degree of deadpan humor delightful to those who knew him, but disturbing to unfamiliar audiences.

Schwitters's collages were made of rubbish picked up from the street—cigarette wrappers, tickets, newspapers, string, boards, wire screens, and whatever caught his fancy. In these so-called *Merzbilder* or *Merzzeichnungen* (Merz-pictures or Merz-drawings) he transformed the detritus of his surroundings into strange and wonderful beauty. In *Picture with Light Center* (fig. **10.22**) we see how Schwitters could extract elegance from these lowly found materials. He carefully structured his circular and diagonal elements within a Cubist-derived grid, which he then reinforced by applying paint over the collage, creating a glowing, inner light that radiates from the picture's center. For his 1920 assemblage, *Merzbild 25A (Das Sternenbild) (Stars Picture)* (fig. **10.23**), Schwitters did not restrict himself to the two-dimensional

10.22 Kurt Schwitters, *Picture with Light Center*, 1919. Collage of cut-and-pasted papers and oil on cardboard, 33¼ × 25⅞" (84.5 × 65.7 cm). The Museum of Modern Art, New York.

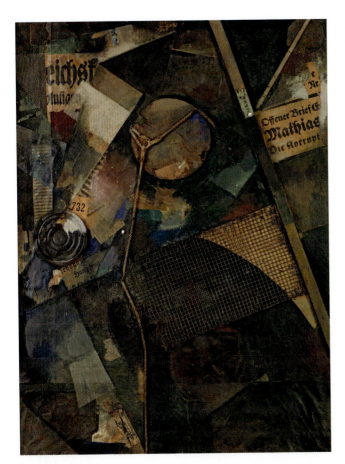

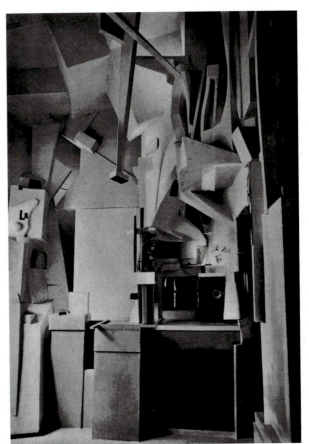

10.23 Kurt Schwitters, *Merzbild 25A (Das Sternenbild)* (*Stars Picture*), 1920. Assemblage, 41 × 31⅛" (104.5 × 79 cm). Kunstsammlung Nordrhein Westfalen, Düsseldorf.

10.24 Kurt Schwitters, *Hannover Merzbau* (*Hanover Merz-building*), destroyed. Photograph taken c. 1931.

Watch a video about Schwitters on mysearchlab.com

printed imagery we have seen in the photomontages of Heartfield and Höch. He incorporates rope, wire mesh, paint, and other materials, indicating a strong concern for physicality in his surfaces. But his are not accidental juxtapositions or ones made purely for formal effect. The snatches of text from German newspapers in this *Merzbild* can be decoded as referring to recent political events in Germany.

Schwitters introduced himself to Raoul Hausmann in a Berlin café in 1918 by saying, "I am a painter and I nail my pictures together." This description applies to all his relief constructions, since he drew no hard-and-fast line between them and *papiers collés*, but most specifically to the series of great constructions that he called *Merz-Column* or *Merzbau* (fig. **10.24**), the culmination of his attempts to create a *Gesamtkunstwerk*, or total work of art. He began the first one in his house in Hanover around 1920 as an abstract plaster sculpture with apertures dedicated to his Dadaist and Constructivist friends and containing objects commemorating them: Mondrian, Gabo, Arp, Lissitzky, Malevich, Richter, Mies van der Rohe, and Van Doesburg. The *Merzbau* grew throughout the 1920s with successive accretions of every kind of material until it filled the room. Having no place to go but up, he continued the environmental construction with implacable logic into the second story. "As the structure grows bigger and bigger," Schwitters wrote, "valleys, hollows, caves appear, and these lead a life

of their own within the overall structure. The juxtaposed surfaces give rise to forms twisting in every direction, spiraling upward." When he was driven from Germany by the Nazis and his original *Merzbau* was destroyed, Schwitters started another one in Norway. The Nazi invasion forced him to England, where he began again for the third time. After his death in 1948, the third *Merzbau* was rescued and preserved in the University of Newcastle. The example of Schwitters was crucial for later artists who sought to create sculpture on an environmental scale. They include figures as diverse as Louise Nevelson (see fig. 16.41), Red Grooms (see fig. 19.18), and Louise Bourgeois (see fig. 16.38).

Ernst

When **Max Ernst** (1891–1976) saw works by modern artists such as Cézanne and Picasso at the 1912 Sonderbund exhibition in Cologne, he decided to forgo his university studies and take up art. He went to Paris in 1913, and his works were included that year in the First German Autumn Salon at Galerie Der Sturm in Berlin, when the artist was only twenty-two years old. In 1919–20, Jean Arp established contact with Ernst in Cologne, and the two were instrumental in the formation of yet another wing of international Dada. The two had met in Cologne in 1914, but Ernst then served in the German army. At the end of the war, he discovered Zurich Dada and the paintings of De Chirico (see figs. 9.3, 9.4) and Klee (see fig. 6.24). Ernst's

early paintings were rooted in a Late Gothic fantasy drawn from Dürer, Grünewald, and Bosch. The artist was also fascinated by German Romanticism in the macabre forms of Klinger and Böcklin. This "gothic quality" (in the widest sense) remained a consistent characteristic of Ernst's fantasies. In 1919–20, a staggeringly productive period, he produced collages and photomontages that demonstrated a genius for suggesting the metamorphosis or double identity of objects, a topic later central to Surrealist **iconography**. In an ingenious work from 1920 (fig. **10.25**), Ernst invented his own mechanistic forms as stand-ins for the human body. As he frequently did during this period, the artist took a page from a 1914 scientific text illustrating chemistry and biology equipment and, by overpainting certain areas and inserting his own additions, he transformed goggles and other laboratory utensils into a pair of hilarious creatures before a landscape. The composition bears telling comparison with Picabia's mechanomorphic inventions (see fig. 10.15).

During the winter of 1920–21, Ernst and Arp collaborated on collages entitled *Fatagagas*, short for *Fabrication des Tableaux Garantis Gasométriques*. Ernst usually provided the collage imagery while Arp and other occasional collaborators provided the name and accompanying text. In the *Fatagaga* titled *Here Everything Is Still Floating*, an anatomical drawing of a beetle becomes, upside-down, a steamboat floating through the depths of the sea. Some of

the *Fatagagas* were sent to Tristan Tzara in Paris for illustration in his ill-fated publication *Dadaglobe*. Ernst had been in close contact with the Parisian branch of Dada and many of the artists who would develop Surrealism. By the time he moved to Paris in 1922, he had already created the basis for much of the Surrealist vocabulary.

Despite the close friendship between Ernst and Arp, their approaches to painting, collage, and sculpture were different. Arp's was toward abstract, organic Surrealism in which figures or other objects may be suggested but are rarely explicit. Ernst, following the example of De Chirico and fortified by his own "gothic" imagination, became a principal founder of the wing of Surrealism that utilized Magic Realism—that is, precisely delineated, recognizable objects, distorted and transformed, but nevertheless presented with a ruthless realism that throws their newly acquired fantasy into shocking relief. *Celebes* (fig. **10.26**) is a mechanized monster whose trunk-tail-pipeline sports a cowskull-head above an immaculate white collar. A headless classical torso beckons to the beast with an elegantly gloved hand. The images are unrelated on a rational level; some are threatening (the elephant), while others are less explicable (the beckoning torso). The rotund form of the elephant was actually suggested to Ernst by a photograph of a gigantic communal corn bin made of clay and used by people in southern Sudan. While not constructed as a collage, *Celebes*, with its

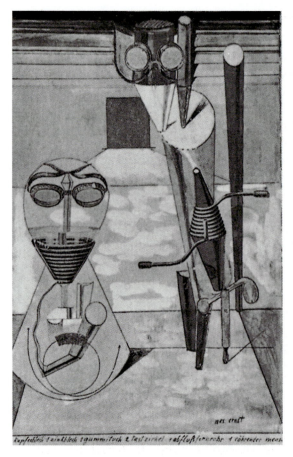

10.25 Max Ernst, *1 Copper Plate 1 Zinc Plate 1 Rubber Cloth 2 Calipers 1 Drainpipe Telescope 1 Pipe Man*, 1920. Gouache, ink, and pencil on printed reproduction, 9½ × 6½" (24.1 × 16.7 cm). Whereabouts unknown.

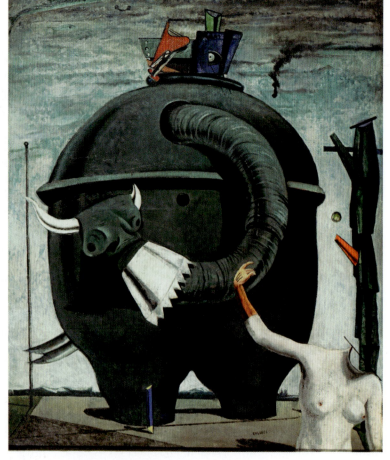

10.26 Max Ernst, *Celebes*, 1921. Oil on canvas, 51⅛ × 43¼" (129.9 × 109.9 cm). Tate, London.

many disparate motifs, is informed by a collage aesthetic as well as by the early paintings of De Chirico; it appeals to the level of perception below consciousness. Ernst, who worked in a remarkably broad range of media and styles, became a major figure of Surrealism (see figs. 14.5–14.8).

Idealism and Disgust: The "New Objectivity" in Germany

Immediately following Germany's defeat in World War I and the abdication of Kaiser Wilhelm II, some of the leaders of German Expressionism formed the November Group and were soon joined by Dadaists. In 1919, under the newly established Weimar Republic, the Workers' Council for Art was organized to seek more state support, more commissions from industry, and the reorganization of art schools. Its artists included many of the original Expressionists as well as leading poets, musicians, and critics. Many of the aims of the November Group and the Workers' Council were incorporated into the program of the Weimar Bauhaus.

In their exhibitions, the November Group re-established contact with France and other countries, and antagonisms among the various new alignments were submerged for a time to present a common front. The Expressionists were exhibited, as well as representatives of Cubism, abstraction, Constructivism, and Dada, while the new architects showed projects for city planning and large-scale housing. Societies similar to the November Group sprang up in many parts of Germany, and their manifestos read like a curious blend of socialist idealism and revivalist religion.

Among the artists associated with the November Group was the Expressionist printmaker and sculptor **Käthe Kollwitz** (1867–1945), who devoted her life and her art to a form of protest or social criticism. She was the first of the German Social Realists who developed out of Expressionism during and after World War I. Essentially a Realist, and powerfully concerned with the problems and sufferings of the underprivileged, she stands somewhat aside from other Expressionists such as the members of Die Brücke or Der Blaue Reiter. When she married a doctor, his patients, predominantly the industrial poor of Berlin, became her models.

As a woman, Kollwitz had been prevented from studying at the Academy, so she attended a Berlin art school for women. There she was introduced to the prints and writings of Max Klinger (see Ch. 4, p. 89) and decided to take up printmaking rather than painting. The graphic media appealed to Kollwitz for their ability to convey a message effectively and to reach a wide audience, because each image could be printed many times. Like Klinger, she produced elaborate print cycles on a central theme, such as the portfolio of woodcuts entitled *War*, executed from 1922 to 1923. The second image from this series of seven scenes shows a group of young men following Death, who beats out the march to battle on a drum (fig. **10.27**). With their gaunt faces contorted by expressions of fear, regret, and even hope, the youths attend to the crooked hand of Death urging them on. Already, though, an arc fills the space above the figures,

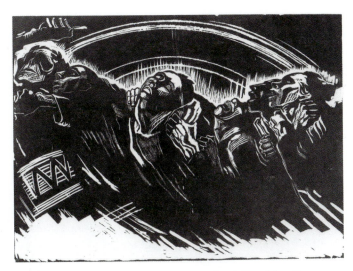

10.27 Käthe Kollwitz, *The Volunteers* (*Die Freiwilligen*), Plate 2 from *Der Krieg* (*War*), 1922–23. Woodcut, 35 × 49″ (47.5 × 65.2 cm).

suggesting a rainbow or halo: the harbinger of their fate as martyrs for a pointless cause. Kollwitz's youngest son had been killed just days after entering into the war in 1914, an event that only sharpened her activism. Although best known for her black-and-white prints and posters of political subjects, Kollwitz could be an exquisite colorist. Her lithograph of a nude woman (fig. **10.28**), with its luminous atmosphere and quiet mood, so unlike her declarative

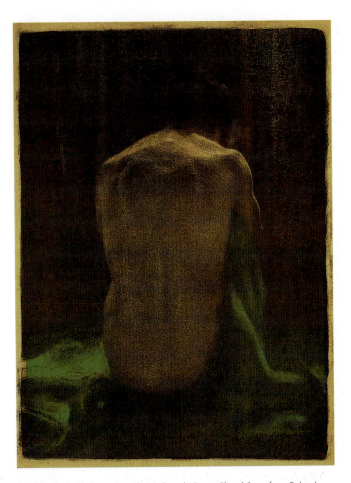

10.28 Käthe Kollwitz, *Female Nude with Green Shawl Seen from Behind*, 1903. Color lithograph, sheet 23½ × 18½″ (59.7 × 47 cm). Staatliche Kunstsammlungen, Dresden.

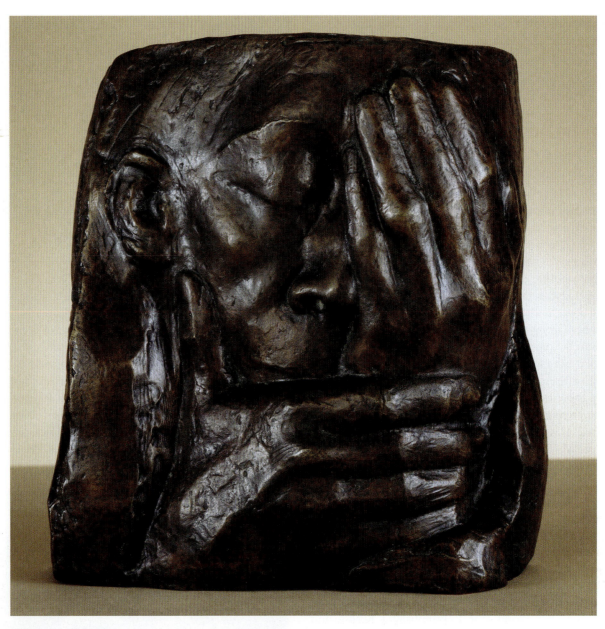

10.29 Käthe Kollwitz, *Lamentation: In Memory of Ernst Barlach (Grief)*, 1938. Bronze, height 10¼" (26 cm).
Hirshhorn Museum and Sculpture Garden, Smithsonian Institution, Washington, D.C.

political prints, demonstrates her extraordinary skill and sensitivity as a printmaker.

Kollwitz was capable of an equally intense expression in sculpture, with which she was increasingly involved throughout her last years. Given the intrinsically sculptural technique of carving and gouging a block of wood to make a woodcut, it is not surprising that a printmaker might be drawn to sculpture, though Kollwitz never actually made sculpture in wood. Like Lehmbruck (see Ch. 6, p. 130), she learned of Rodin's work on a trip to Paris and admired the sculpture of Constantin Meunier, whose subjects of workers struck a sympathetic chord. But perhaps the most significant influence on her work in three dimensions was that of her friend Ernst Barlach. The highly emotional tenor of her work, whether made for a humanitarian cause or in memory of her dead son, arose from a profoundly felt grief that transmitted itself to her sculpture and prints. *Lamentation: In Memory of Ernst Barlach (Grief)* (fig. **10.29**) is an example

of Kollwitz's relief sculpture, a moving, close-up portrait of her own grieving.

The November Group's common front of socialist idealism did not last long. The workers whom the artists extolled and to whom they appealed were even more suspicious of the new art forms than was the capitalist bourgeoisie. It was naturally from the latter that new patrons of art emerged. By 1924 German politics was shifting inexorably to the right, and the artists' utopianism was in many cases turning into disillusionment and cynicism. There now emerged a form of Social Realism in painting to which the name The New Objectivity (*Die Neue Sachlichkeit*) was given. Meanwhile, the Bauhaus, the design school run by Gropius since 1919 at Weimar, had tried to apply the ideas of the November Group and the Workers' Council to create a new relationship between artist and society. In 1925 it was forced by the rising tide of conservative opposition to move to Dessau. Its faculty members still clung to postwar Expressionist and

socialist ideas, although by 1925 their program mostly concerned the training of artists, craft workers, and designers for an industrial, capitalist society.

Grosz

The principal painters associated with the New Objectivity were **George Grosz** (1893–1959), Otto Dix, and Max Beckmann—three artists whose style touched briefly at certain points but who had essentially different motivations. Grosz studied at the Dresden Academy from 1909 to 1911 and at the Royal Arts and Crafts School in Berlin off and on from 1912 to 1916, partially supporting himself with drawings of the shady side of Berlin nightlife. These caustic works prepared him for his later violent statements of disgust with postwar Germany and humankind generally. In 1913 he visited Paris and, despite later disclaimers, was obviously affected by Cubism and its offshoots, particularly Robert Delaunay and Italian Futurism. After two years in the army (1914–16), Grosz resumed his caricatures while convalescing in Berlin. They reveal an embittered personality, now fortified by observations of autocracy, corruption, and the horrors of a world at war. Recalled to the army in 1917, Grosz ended his military career in an asylum on whose personnel and administration he made devastating comment.

After the war Grosz was drawn into Berlin Dada and its overriding leftwing direction. He made stage designs and collaborated on periodicals, but continued his own work of political or social satire. *Dedication to Oskar Panizza* of 1917–18 (fig. **10.30**) is his most Cubist-inspired work. The title refers to a writer whose work had been censored at the end of the nineteenth century. But the larger subject, according to Grosz, was "Mankind gone mad." He said that the dehumanized figures represent "Alcohol, Syphilis, Pestilence." Showing a funeral turned into a riot, the painting is flooded with a blood or fire red. The buildings lean crazily; an insane mob is packed around the black coffin on which Death sits triumphantly, swigging at a bottle; the faces are horrible masks; humanity is swept into a hell of its own making; and the figure of Death rides above it all. Yet the artist controls the chaos with a geometry of the buildings and the planes into which he segments the crowd.

The drawing *Fit for Active Service (The Faith Healers)* (fig. **10.31**) was used as an illustration in 1919 for *Die Pleite* (*Bankruptcy*), one of the many political publications with which Grosz was involved. The editors, Herzfelde, Grosz, and Heartfield, filled *Die Pleite* with scathing political satire, which occasionally got them thrown into prison. This work shows Grosz's sense of the macabre and his detestation of bureaucracy, with a fat complacent doctor pronouncing his "O.K." of a desiccated cadaver before arrogant Prussian-type officers. The spare economy of the draftsmanship in Grosz's illustrations is also evident in a number of the artist's paintings done in the same period. *Republican Automatons*

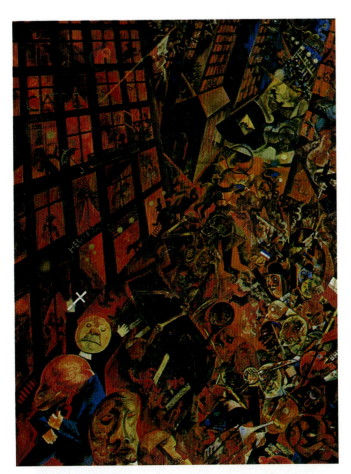

10.30 George Grosz, *Dedication to Oskar Panizza*, 1917–18. Oil on canvas, 55⅛ × 43¼" (140 × 109.9 cm). Staatsgalerie, Stuttgart. Art © Estate of George Grosz/Licensed by VAGA, New York, NY.

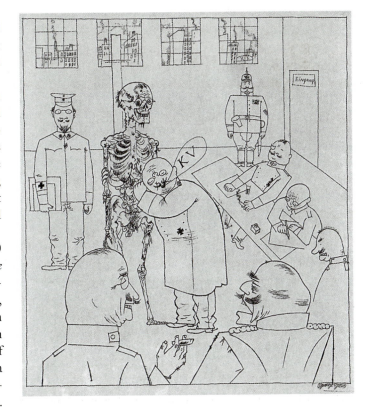

10.31 George Grosz, *Fit for Active Service (The Faith Healers)*, 1916–17. Pen, brush, and India ink, sheet 20 × 14⅜" (50.8 × 36.5 cm). The Museum of Modern Art, New York. Art © Estate of George Grosz/Licensed by VAGA, New York, NY.

The growth of Nazism rekindled his power of brutal commentary, and World War II caused Grosz to paint a series expressing bitter hatred and deep personal disillusionment. In the later works, sheer repulsion replaces the passionate convictions of his earlier statements. He did not return to Berlin until 1958, and he died there the following year.

Dix

The artist whose works most clearly define the nature of the New Objectivity was **Otto Dix** (1891–1969). Born of working-class parents, he was a proletarian by upbringing as well as by political conviction. Dix's combat experience made him fiercely anti-militaristic. His war paintings, gruesome descriptions of unaccountable horrors, are rooted in the expressive realism of German late medieval and Renaissance art. Dix responded to the war and its consequences with unblinking honesty, rendering brutal battlefield scenes as well as depictions of wounded and destitute veterans. *The Skat Players—Card Playing War Invalids* (fig. **10.33**) shows a trio of veterans engaged in a tragi-comic game of cards. War injuries have left them all as amputees, forced to hold their cards between their toes or with a mangled hand. Faces, too, have been damaged, along with ears, eyes, and skulls, leaving the men to cope with poorly

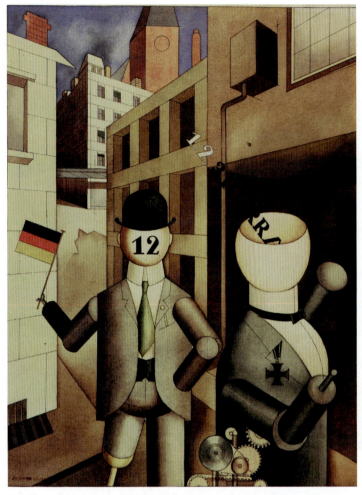

10.32 George Grosz, *Republican Automatons*, 1920. Watercolor and pencil on paper, 23⅝ × 18⅝" (60 × 47.3 cm). The Museum of Modern Art, New York. Art © Estate of George Grosz/Licensed by VAGA, New York, NY.

(fig. **10.32**) applies the style and motifs of De Chirico and the Metaphysical School to political satire, as empty-headed, blank-faced, and mutilated automatons parade loyally through the streets of a mechanistic metropolis on their way to vote as they are told. In such works as this, Grosz comes closest to the spirit of the Dadaists and Surrealists. But he expressed his most passionate convictions in drawings and paintings that continue an Expressionist tradition of savagely denouncing a decaying Germany of brutal profiteers and obscene prostitutes, and of limitless gluttony and sensuality in the face of abject poverty, disease, and death. Normally Grosz worked in a style of spare and brittle drawing combined with a fluid watercolor. In the mid-1920s, however, he briefly used precise realism in portraiture, close to the New Objectivity of Otto Dix (see below).

Grosz was frequently in trouble with the authorities, but it was Nazism that caused him to flee. In the United States during the 1930s, his personality was quite transformed. Although he occasionally caricatured American types, these portrayals were relatively mild, even affectionate. America for him was a dream come true, and he painted the skyscrapers of New York or the dunes of Provincetown in a sentimental haze. His pervading sensuality was expressed in warm portrayals of Rubenesque nudes.

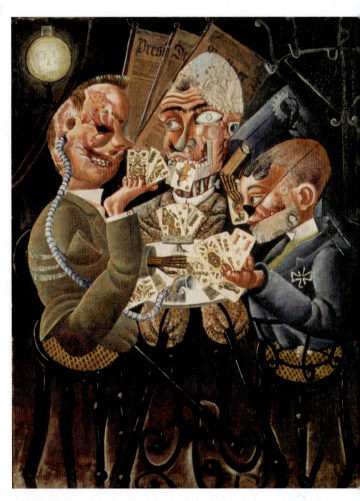

10.33 Otto Dix, *The Skat Players—Card Playing War Invalids*, 1920. Oil and collage on canvas, 43⁵⁄₁₆ × 34¼" (110 × 87 cm). Staatliche Museen zu Berlin, Preussischer Kulturbesitz, Nationalgalerie.

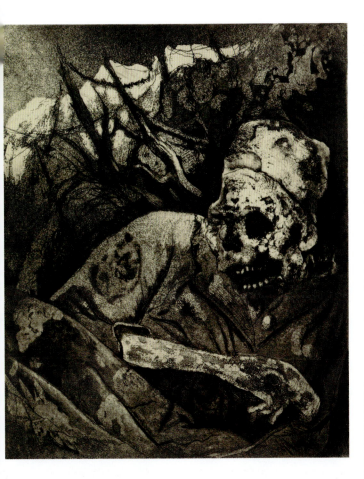

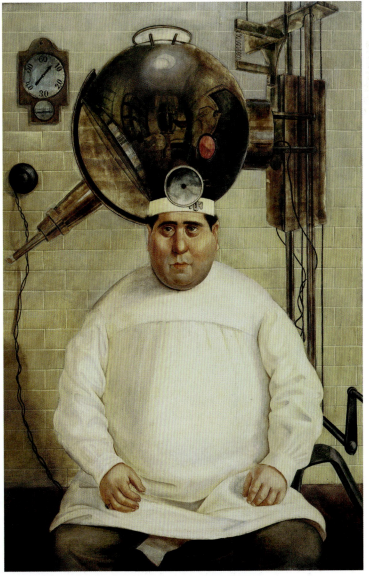

10.34 Otto Dix, *Corpse in Barbed Wire (Flanders) (Leiche im Drahtverhau [Flandern])* from *The War (Der Krieg)*, 1924. Etching and aquatint from a portfolio of fifty etchings, aquatints, and drypoints, plate: 11¾ × 9⅝″ (29.8 × 24.5 cm); sheet: 18⁹⁄₁₆ × 13¾″ (47.2 × 35 cm). Publisher: Karl Nierendorf, Berlin. Printer: Otto Felsing, Berlin. Edition: 70.

Propped up by barbed wire—a ubiquitous feature of the trenched battlefields—the figure seems eerily animated, his grinning skull mocking the viewer's horror.

Like Grosz, Dix was exposed to diverse influences from Cubism to Dada, but from the beginning he was concerned with uncompromising realism. This was a symptom of the postwar reaction against abstraction, a reaction most marked in Germany but also evident in most of Europe and in America. Even many of the pioneers of Fauvism and Cubism were involved in it. However, the superrealism of Dix was not simply a return to the past. In his portrait of the laryngologist *Dr. Mayer-Hermann* (fig. **10.35**), the massive figure is seated frontally, framed by the vaguely menacing machines of his profession. Although the painting includes

fitting facial and scalp prostheses. Simultaneously horrifying, pathetic, and ridiculous, Dix's treatments of the war refuse to let the viewer settle into a single, easy response. His images are as angry and fatalistic as they are wrenching. The bright, lurid colors he often uses lend an intensity evocative of the bright pigments of commercial imagery such as posters and popular prints. His paintings initially seduce with their candy store hues before slapping the viewer with their shocking realism. Dix was also a prolific printmaker, and his portfolio *Der Krieg* (*The War*) includes fifty images unified by an unrelenting, often shocking, visual indictment of modern combat. Stylistically, the images that make up *Der Krieg* run the gamut from the naturalism of Northern Renaissance artists such as Albrecht Dürer (see fig. 2.47) to the expressive distortions of Die Brücke artists Kirchner, Nolde, and Heckel (see figs. 6.5, 6.7, 6.9). Many of the compositions are based on battlefield sketches Dix made during the war. Like the earlier eyewitness to wartime atrocities Francisco Goya (see fig. 1.7), Dix delivers a suite of images that complement and collide with one another in order to emphasize the incoherence of war. His choice of technique—a combination of etching, drypoint, and aquatint—likewise points to Goya's importance for Dix's conception of the project. *Corpse in Barbed Wire* conveys the portfolio's warring sensibilities: the artist's virtuoso management of aquatint results in passages of seductive tonal gradation that lure the viewer to come closer while the horrific representation of the decomposing body of a dead soldier collides with the print's sensual surface (fig. **10.34**).

10.35 Otto Dix, *Dr. Mayer-Hermann*, 1926. Oil and tempera on wood, 58¾ × 39″ (149.2 × 99.1 cm). The Museum of Modern Art, New York

nothing bizarre or extraneous, the overpowering confrontation gives a sense of the unreal. For this type of superrealism (as distinct from Surrealism) the term Magic Realism was coined: a mode of representation that takes on an aura of the fantastic because commonplace objects are presented with unexpectedly exaggerated and detailed forthrightness. Dix remained in Germany during the Nazi regime, although he was forbidden to exhibit or teach and was imprisoned for a short time. After the war he turned to a form of mystical, religious expression.

The Photography of Sander and Renger-Patzsch

The portraiture of artists like Dix may very well have been influenced by the contemporary photographs of **August Sander** (1876–1964), a German artist and former miner who became a powerful exponent of the New Objectivity. Sander set out to accomplish nothing less than a comprehensive photographic portrait of "People of the Twentieth Century." He was convinced that the camera, if honestly and straightforwardly employed, could probe beneath appearances and dissect the truth that lay within. Sander photographed German society in its "sociological arc" of occupations and classes, mostly presenting cultural types in the environments that shaped them (fig. **10.36**). In 1929 he published a preview of his magnum opus—one of the most ambitious in the history of photography—under the title *Antlitz der Zeit* (*Face of Our Time*), only to see the book suppressed and the plates (but not the negatives) destroyed in 1936 by the Nazis, who inevitably found the photographer's ideas contrary to their own pathological views of race and class. For his part, Sander wrote: "It is not my intention

10.37 Albert Renger-Patzsch, *Irons Used in Shoemaking, Fagus Works,* c. 1925. Gelatin-silver print. Galerie Wilde, Cologne.

either to criticize or to describe these people, but to create a piece of history with my pictures."

The German photographer most immediately identified with the New Objectivity was **Albert Renger-Patzsch** (1897–1966). Like Paul Strand in the United States (see fig. 15.18), Renger-Patzsch avoided the double exposures and photographic manipulations of Man Ray (see fig. 10.18) and Moholy-Nagy (see fig. 13.6), as well as the artificiality and soulfulness of the Pictorialists, to practice "straight" photography closely and sharply focused on objects isolated, or abstracted, from the natural and manmade worlds (fig. **10.37**). But for all its stark realism, such an approach yielded details so enlarged and crisply purified of their structural or functional contexts that the overall pattern they produce borders on pure design. Still, Renger-Patzsch insisted upon his commitment to factuality and his "aloofness to Art for Art's Sake."

Beckmann

Max Beckmann (1884–1950) was the principal artist associated with the New Objectivity but could only briefly be called a precise Realist in the sense of Dix. Born of wealthy parents in Leipzig, he was schooled in the Early Renaissance art of Germany and the Netherlands, and the great seventeenth-century Dutch painters. After studies at the Weimar

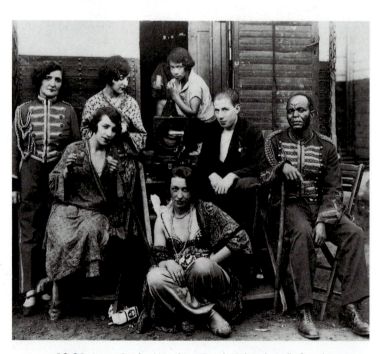

10.36 August Sander, *Wandering People (Fahrendes Volk),* from the series *People of the 20th Century (Menschen des 20 Jahrhunderts),* from the portfolio *Traveling People—Fair and Circus,* Düren (Cologne), Germany. 1926–32. Gelatin-silver print, 8¼ × 10″ (21 × 25.5 cm). The Museum of Modern Art, New York.

Academy and a brief visit to Paris, Beckmann settled in 1903 in Berlin, then a center of German Impressionism and Art Nouveau. Influenced by Delacroix and by the German academic tradition, he painted large religious and classical murals and versions of contemporary disasters such as the sinking of the *Titanic* (1912), done in the mode of Géricault's bleak masterpiece commemorating an 1816 shipwreck, *Raft of the "Medusa"*. By 1913 Beckmann was a well-known academician. His service in World War I brought about a nervous breakdown and, as he later said, "great injury to his soul." The experience turned him toward a search for internal reality. Beckmann assumed many guises in over eighty-five self-portraits made throughout his life. The *Self-Portrait with Red Scarf* of 1917 (fig. **10.38**) shows the artist in his Frankfurt studio, haunted and anxious. Beckmann's struggle is apparent in a big, unfinished *Resurrection*, on which he worked sporadically between 1916 and 1918. Here he attempted to join his more intense and immediate vision of the war years to his prewar academic formulas. This work liberated him from his academic past. In two paintings of 1917, *The Descent from the Cross* and *Christ and the Woman Taken in Adultery*, he found a personal expression, rooted

in Grünewald, Bosch, and Bruegel, although the jagged shapes and delimited space also owed much to Cubism. Out of this mating of Late Gothic, Cubism, and German Expressionism emerged Beckmann's next style.

Although he was not politically oriented, Beckmann responded to the violence and cruelty of the last years of the war by painting dramas of torture and brutality—symptomatic of the lawlessness of the time and prophetic of the state-sponsored genocide of the early 1940s. Rendered in pale, emotionally repulsive colors, the figures could be twisted and distorted within a compressed space, as in late medieval representations of the tortures of the damned (in Beckmann's work, the innocent), the horror heightened by explicit and accurate details. Such works, which impart symbolic content through harsh examination of external appearance, were close to and even anticipated the New Objectivity of Grosz and Dix.

In *Self-Portrait in Tuxedo* from 1927 (fig. **10.39**), Beckmann presents a view of himself quite different from the one ten years earlier. Now a mature figure, he appears serious and self-assured, debonair even. The composition is striking in its elegant simplicity, with deep blacks, for which

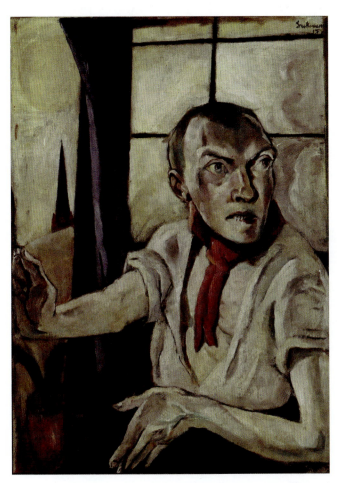

10.38 Max Beckmann, *Self-Portrait with Red Scarf*, 1917. Oil on canvas, 31½ × 23⅝" (80 × 60 cm). Staatsgalerie, Stuttgart.

10.39 Max Beckmann, *Self-Portrait in Tuxedo*, 1927. Oil on canvas, 55½ × 37¾" (141 × 96 cm). Busch-Reisinger Museum, Harvard University Art Museums, Cambridge, MA.

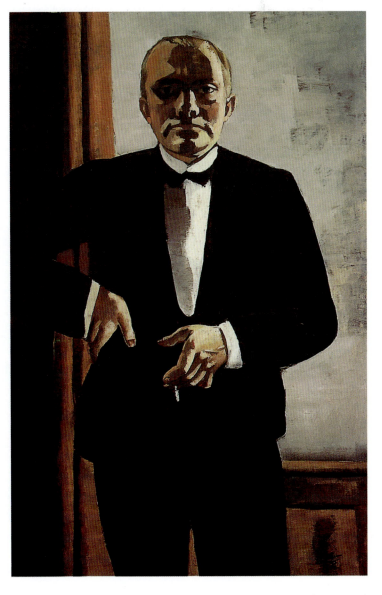

Beckmann is understandably admired, set against the blue-gray wall and the artist's stark white shirt. In the later 1920s, as is clear from this image, Beckmann, moving from success to success, was regarded as one of Germany's leading artists. Yet the isolation of the figure—dressed formally as if attending a party or other social affair—and his stony gaze testify to a continuing estrangement from society. When the Nazis came to power in 1933, Beckmann was stripped of his teaching position in Frankfurt, and 590 of his works were confiscated from museums throughout Germany. On the opening day of the 1937 Degenerate Art show in Munich, which included several of his works (including fig. 10.38), the artist and his wife fled to Amsterdam (see *Degenerate Art*, below). In 1947, after years of hiding from the Nazis (he never returned to Germany), Beckmann accepted a teaching position at Washington University, St. Louis, Missouri, where he filled a position vacated by the Abstract Expressionist painter Philip Guston (see fig. 16.15) and became a highly influential teacher. He remained in the United States for the rest of his life.

Throughout the 1930s and 40s, Beckmann continued to develop his ideas of coloristic richness, monumentality,

Degenerate Art

CONTEXT

As the Nazis gained power in Germany during the late 1920s, the party sought to bring all areas of society into line with its policies. The visual arts were no exception. By the time the Nazis assumed control of the government in 1933, a campaign to rid the country of artworks deemed *entartete* or "degenerate" was already underway. Any art that did not accord with Nazi ideology—which advocated German cultural primacy and Teutonic racial and ethnic superiority—was seized from public museums. In its early stages, the Nazi campaign against degenerate art was directed largely at Expressionism, which was considered too sympathetic toward "negro culture." As the campaign gained ground in the mid-1930s, anything seen as avant-garde, as "cosmopolitan and Bolshevik," or as somehow representing "Jewish influence" (an expansive category under this violently anti-Semitic regime) was denounced as "impure" and dangerous.

Overseen by Adolf Hitler's minister of propaganda, Josef Goebbels, the program against degenerate art culminated in the seizure of 16,000 works, some of which were exhibited in 1937 at the Degenerate Art (*Entartete Kunst*) show, staged first in Munich before touring the country. The point of the exhibition was to defame not only suspect artists but also the curators who had acquired their work. The deliberately chaotic installation (fig. **10.40**) included labels indicating how much each work cost, condemning the use of public funds for the purchase of, as Hitler put it, "putrefaction." The Degenerate Art exhibition included works by Gauguin, Van Gogh, Nolde, Kirchner, Lehmbruck, Kandinsky, Klee, and Marc. Goebbels initially announced that all of the seized art would be burned, but in the end a public bonfire consumed 4,829 artworks while the rest were auctioned in Switzerland.

10.40 Room 3 including Dada wall in Degenerate Art Exhibition, Munich, 1937.

and complexity of subject. The enriched color came from visits to Paris and contacts with French artists, particularly Matisse and Picasso. However, his emphasis on literary subjects with heavy symbolic content reflected his Germanic artistic roots. The first climax of his new, monumental–symbolic approach was the large 1932–33 triptych *Departure* (fig. **10.41**). Beckmann made nine paintings in the triptych format, obviously making a connection between his work and the great ecclesiastical art of the past: church **altarpieces** typically comprised two or more panels, which, when taken together, address a particular Christian theme or recount episodes from the life of Jesus or one of the saints. The right wing of *Departure* shows frustration, indecision, and self-torture; in the left wing, sadistic mutilation, and the torture of others. Beckmann said of this triptych in 1937:

On the right wing you can see yourself trying to find your way in the darkness, lighting the hall and staircase with a miserable lamp dragging along tied to you as part of yourself, the corpse of your memories, of your wrongs, of your failures, the murder everyone commits at some time of his life—you can never free yourself of your past, you have to carry the corpse while Life plays the drum.

In addition, despite his disavowal of political interests, the lefthand panel must refer to the rise of dictatorship that was driving liberal artists, writers, and thinkers underground.

The darkness and suffering in the wings are resolved in the brilliant sunlight colors of the central panel, where the king, the mother, and the child set forth, guided by the veiled boatman. It is important to emphasize that Beckmann's allegories and symbols were not a literal iconography, to be read by anyone given the key. The spectator had to participate actively, and the allusions could mean something different to each. In addition, the allusions in Beckmann's work could be very complex. He said of *Departure*: "The King and Queen have freed themselves of the tortures of life—they have overcome them. The Queen carries the greatest treasure—Freedom—as her child in her lap. Freedom is the one thing that matters—it is the departure, the new start."

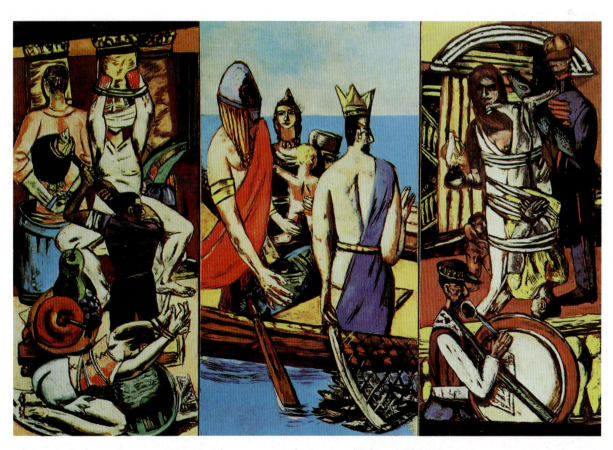

10.41 Max Beckmann, *Departure*, 1932–33. Oil on canvas, triptych, center panel 7′ ¾″ × 3′ 9⅜″ (2.2 × 1.15 m); side panels each 7′ ¾″ × 3′ 3¼″ (2.2 × 1 m). The Museum of Modern Art, New York.

11
Art in France after World War I

Not all artists responded to World War I with the cynicism and ferocity of the New Objectivity or Dada movements. Artists working in France immediately following the war gave visual form to other emotions: despair, nostalgia, even hope. Years of warfare had dampened enthusiasm for artistic experimentation, and cultural movements tended away from "scandalous" avant-gardism toward an art based on the values of the classical tradition. "After the war," said the former Fauve painter André Derain, "I thought I would never be able to paint—that after all that—no one would be interested." By the end of the war, Derain had himself turned from his earlier innovative work to a classicizing style, and in the 1920s the general trend toward classicism in all the arts gathered momentum. It was characterized by poet and playwright Jean Cocteau as a "call to order." Avant-garde experiments with radical abstraction, such as Cubism, were set aside in favor of styles and themes more easily understood as extensions of the French tradition of classicism that traced its lineage back through Ingres and David to the clarity of Poussin and the serenity of Claude. Like everyone else in France at the time, artists were seeking to regain their bearings and make sense of losses inflicted by the war.

Even with its tempered enthusiasm for avant-garde experimentation, Paris resumed its prewar status as a center for progressive art. A number of gifted artists in retreat from revolution in Russia, economic hardship in Germany, and provincialism in America were thus lured to Paris, assuring the continuing status of the city as the glittering, cosmopolitan capital of world art. These émigré artists were labeled—sometimes xenophobically—as the School of Paris, to distinguish them from French-born modernists like Matisse. Suspicion of foreigners was a sad fact not only of French culture but of Western societies generally as isolationism gained currency. Even Picasso suffered insults on the streets of Paris during the war, because he appeared to be an able-bodied young man shirking his military duty or because he was recognized as a foreigner. The label "School of Paris" has lost its xenophobic associations and is now used to describe art produced by artists living in the city from 1919 into the 1950s.

Eloquent Figuration: *Les Maudits*

The School of Paris embraced a wide variety of artists between the two world wars who shared common ground not only through their base in France but also in their independence from narrowly defined aesthetic categories. While distinctly modernist in their willingness to distort imagery for expressive purposes, they nonetheless regarded figurative imagery as fundamental to the meaning of their work. This diverse and distinguished group included Braque, Léger, Matisse, and Picasso. Perhaps even more representative of the polyglot School of Paris than those major figures, however, is a subgroup known as *les maudits*—Modigliani from Italy, Soutine from Lithuania, Suzanne Valadon (see figs. 3.36, 3.37), and her son, Maurice Utrillo. *Les maudits* means "the cursed"—an epithet that alluded not only to these artists' poverty and alienation but also to the picturesque, ultimately disastrous, bohemianism of their disorderly lifestyles. Much of this gravitated around the sidewalk cafés of Montparnasse and Saint-Germain-des-Prés, the quarters on the Left Bank of the Seine favored by the Parisian avant-garde since before the war, when Picasso and his entourage had abandoned Montmartre to the tourists.

Modigliani

Amedeo Modigliani (1884–1920) was born of well-to-do parents in Livorno, Italy. His training as an artist was often interrupted by illness, but he managed to get to Paris by 1906. Although he was essentially a painter, in around 1910, influenced by his friend Brancusi (see Ch. 5, pp. 106–110), he began to experiment with sculpture. Modigliani's short life has become the quintessential example of bohemian artistic existence in Paris, so much so that the myths and anecdotes surrounding his biography have tended to undermine serious understanding of his work. For fourteen years he worked in Paris, ill from tuberculosis (from which he eventually died), drugs, and alcohol, but drawing and painting obsessively. He quickly spent what little money he had, and he tended to support himself by making drawings in cafés that he sold for a few francs to the sitter.

In subject, Modigliani's paintings rarely departed from the depiction of single portrait heads, torsos, or full figures

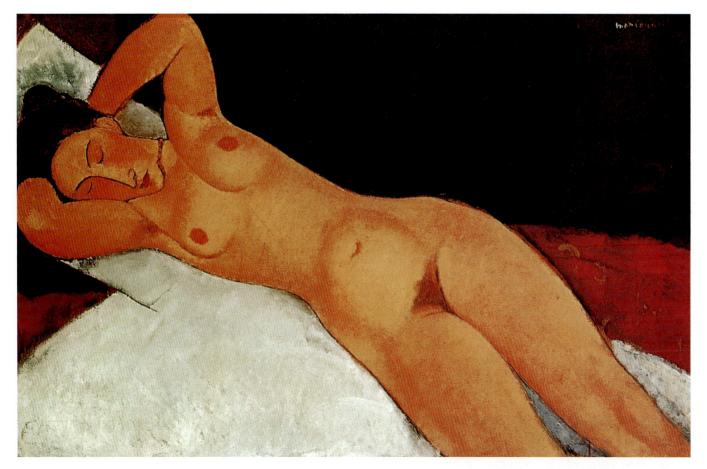

11.1 Amedeo Modigliani, *Nude*, 1917. Oil on canvas, 28¾ × 45¾" (73 × 116.2 cm). Solomon R. Guggenheim Museum, New York.

against a neutral background. His career was so short that it is difficult to speak of a stylistic development, although a gradual transition can be seen from work inspired by the Symbolist painters (see Ch. 3, pp. 50–53), in which the figure is securely integrated in the space of an interior, toward a pattern of linear or sculptural detachment. Modigliani knew Picasso and occasionally visited his studio, but he never really succumbed to the lure of Cubism.

Although all of his portraits resemble one another through their elegantly elongated features or their reference to forms deriving from **Archaic** art, the portraits of his friends, who included notable artists and critics of the early twentieth century, are sensitive records of specific personalities, eccentricities, and foibles. Modigliani also painted anonymous students or children—anyone who would pose for him without a fee. For his paintings of nudes, however, he frequently relied on professional models. Modigliani developed a fairly standard formula for his compositions of reclining nudes (fig. **11.1**). The attenuated figure is normally arranged along a diagonal and set within a narrow space, her legs eclipsed by the edge of the canvas. The figure is outlined with a flowing but precise line, while the full volumes are modeled with almost imperceptible gradations of flesh tones. The artist was fond of contrasting draped white sheets against deep Venetian red, as seen in this 1917 example. The influence here of Titian is unmistakable, particularly that of his *Venus of Urbino*, in the Uffizi, which Modigliani frequented during his student days in Florence. His friend and fellow Italian,

the Futurist Gino Severini, detected a "Tuscan elegance" in the work of Modigliani, who kept reproductions of Old Master paintings on the walls of his Paris studio. For his paintings of nudes, he frequently assumed a point of view above the figure, thus establishing a perspective that implies the subject's sexual availability to the artist and (presumably male) viewers. With their blatant sexuality and coy, flirtatious expressions, Modigliani's nudes present a modernized version of a long-standing genre of eroticized female nudes, a subject of particular interest to modern artists (see discussion in Ch. 2, pp. 34–35). In Modigliani's day, his paintings of nude women were deemed indecent enough to be confiscated from an exhibition by the police for their excessive exposure of pubic hair.

Soutine

Chaim Soutine (1894–1943), the tenth of eleven children from a poor Lithuanian-Jewish family, developed an early passion for painting and drawing. He managed to attend some classes in Minsk and Vilna (Vilnius), a center of Jewish cultural activity, and, through the help of a patron, arrived in Paris before the war's outbreak. He studied at the École des Beaux-Arts, but it was through the artists whom he met at an old tenement known as La Ruche (The Beehive), where Chagall also lived around this time, that he began to find his way. Modigliani in particular took the young artist under his wing. He showed him Italian paintings in the Louvre and helped refine Soutine's manners and

improve his French. "He gave me confidence in myself," Soutine said.

Soutine constantly destroyed or reworked his paintings, so it is difficult to trace his development from an early to a mature style. An early formative influence was Cézanne, an artist likewise greatly admired by Modigliani. Van Gogh also provided a crucial example, although the energy and vehemence of Soutine's brushstroke surpassed even that of the Dutch artist. The essence of Soutine's Expressionism lies in the intuitive power and the seemingly uncontrolled but immensely descriptive brush gesture (see fig. 11.2). In this quality he is closer than any artist of the early twentieth century to the Abstract Expressionists of the 1950s, especially De Kooning (see fig. 16.6), who greatly admired Soutine.

In Soutine's portraits and figure paintings of the 1920s there is frequently a predominant color—red, blue, or white—around which the rest of the work is built. In *Woman in Red* (fig. 11.2) the sitter is posed diagonally across an armchair over which her voluminous red dress flows. The red of the dress permeates her face and hands; it is picked up in her necklace and in the red-brown tonality of the ground. Only the deep blue-black of the hat stands out

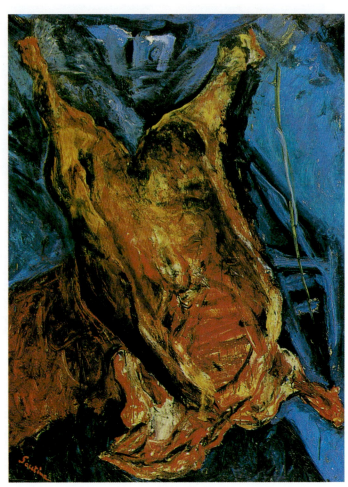

11.3 Chaim Soutine, *Carcass of Beef*, c. 1925. Oil on canvas, 55¼ × 42⅜″ (140.3 × 107.6 cm). Albright-Knox Art Gallery, Buffalo, New York.

against it. Soutine endows the static figure with tremendous vitality and movement, as the undulating surface rhythms swerve back and forth across the canvas. The hands are distorted as though from arthritis, and the features of the face are twisted into a slight grin. As in many of Soutine's portraits, the first impression is of a cruel caricature. Then one becomes aware of the sitter's highly individual, and in this case ambiguous, personality. *Woman in Red* appears at once comic, slightly mad, and knowingly shrewd.

Soutine's passion for **Rembrandt** (1606–69) was commemorated in a number of extraordinary paintings that were free adaptations of the Dutch master's compositions. In *Carcass of Beef* (fig. 11.3) Soutine transcribed Rembrandt's 1655 *Butchered Ox*, in the Louvre, with gruesome, bloody impact (fig. 11.4). Unlike Rembrandt, Soutine isolated his subject, stripped it of any anecdotal context, and pushed it up to the surface. The story of the painting is well known— Soutine poured blood from the butcher's shop to refurbish the rapidly decaying carcass while his assistant fanned away the flies, and nauseated neighbors clamored for the police. Oblivious to the stench, Soutine worked obsessively before his subject, recording every detail in vigorously applied, liquid color. In this and in many other paintings, Soutine demonstrated how close are the extremes of ugliness and beauty, a phenomenon that would intrigue his Surrealist peers.

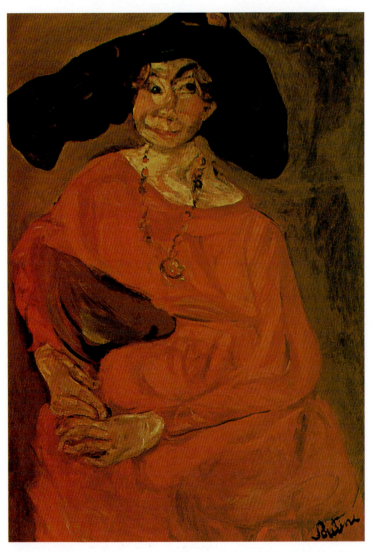

11.2 Chaim Soutine, *Woman in Red*, c. 1924–25. Oil on canvas, 36 × 25″ (91.4 × 63.5 cm). Private collection.

Utrillo

Maurice Utrillo (1883–1955) was the child of artist and model Suzanne Valadon, whose work belongs with that of the Post-Impressionists who hired her to model and also supported her turn to artmaking (see Ch. 3, pp. 68–69). Valadon's son provides perhaps the greatest paradox among *les maudits*. He was given the family name of the Spanish art critic Miguel Utrillo, who wished to help the boy. The identity of his actual father remains uncertain, and speculation regarding his paternity has typically focused on the more prominent artists for whom Valadon was regularly posing at the time of his birth: Puvis de Chavannes, Auguste Renoir, and Edgar Degas, as if to link his genetic ancestry to the aesthetic legacy evident in Utrillo's art. As a youngster, Utrillo began to drink heavily, was expelled from school, and by the age of eighteen was in a sanatorium for alcoholics. During his chaotic adolescence—probably through his mother's influence—he became interested in painting. Like his mother, he was self-trained, but his art is hardly reminiscent of hers. Although his painting was technically quite accomplished and reveals stylistic influences from the Impressionists and their successors, his work is closer to the purposely naive or primitive type of painting inspired by Henri Rousseau (see fig. 3.14).

The first paintings that survive are of the suburb of Montmagny where Utrillo grew up, and of Montmartre, where he moved. Painted between approximately 1903 and 1909, they have coarse brush texture and sober colors. In about 1910 Utrillo began to focus obsessively and almost exclusively on the familiar scenes of Montmartre, which he painted street by street. The view depicted in *La rue du Mont-Cenis* (fig. **11.5**) typifies paintings from this series. The street itself dominates the composition, rolling like a wave into the foreground as if beckoning the viewer to enter into the scene before it recedes again into the background. The pavement's almost tidal character suggests the dynamism of the neighborhood while the architectural repoussoir that frames the scene provides an anchorage for the viewer's gaze. Movement is further conveyed through bustling figures just

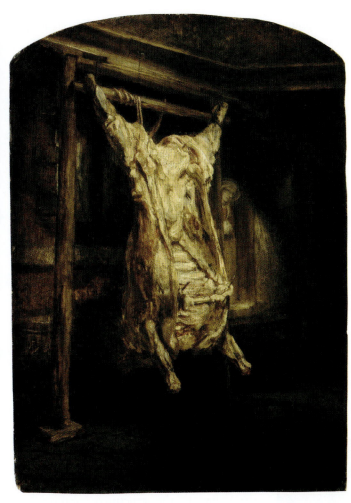

11.4 Rembrandt van Rijn, *Butchered Ox*, 1655. Oil on panel, 37 × 27" (94 × 69 cm). Louvre, Paris.

11.5 Maurice Utrillo, *La rue du Mont-Cenis*, 1915. Oil on canvas, 19¾ × 24" (50 × 61 cm). Musée National d'Art Moderne, Centre d'Art et de Culture Georges Pompidou, Paris.

visible in the distance. Utrillo's subordination of figures to the cityscape makes it clear that his real preoccupation is with the animate character of place and space: the street pulses with its history as with the life of its residents. His favorite scenes recur over and over again, his memory refreshed from postcards. Around the end of the war, fhis colors brightened and figures occurred more frequently. From 1930 until his death in 1955, Utrillo, now decorated with the Legion of Honor, lived at Le Vésinet outside Paris. During these twenty-five years of rectitude, he did little but repeat his earlier paintings.

Dedication to Color: Matisse's Later Career

The culmination of **Henri Matisse**'s (1869–1954) prewar exploration of color, which he first undertook during his Fauve period (see Ch. 5, pp. 91–98), may be seen in his 1911 painting *The Red Studio* (see fig. 5.24). When compared with works of a similar date by Braque and Picasso (see figs. 7.19, 7.20), which have the typically muted palette of Analytic Cubism, its reliance on the power of a single strong color is particularly striking. Just as the Cubists used multiple viewpoints to undermine the conventional illusionism of single-point perspective, Matisse placed objects in relation to each other in terms not of spatial recession but of color. As he said of *The Red Studio* (which in real life was an airy, white-walled room), "I find that all these things, flowers, furniture, the chest of drawers, only become what they are to me when I see them together with the color red."

Despite his very different approach to painting, and the fact that he was considerably older than most members of the Cubist circle (he was in his mid-forties at the outbreak of war in 1914 and so did not serve in the military), Matisse shared some of their concerns, including an enthusiasm for non-Western art. The influence of Cubism can be felt in his work during the war years, although subsequent phases of his career—from his "Rococo" decorative idiom of the 1920s to the sharply defined and supremely graceful simplicity of his late cut-outs—reassert the primacy of color.

The careers of Matisse and Picasso followed quite different courses through the mid-twentieth century. At the same time, the development of Matisse's art from around 1914 onward presents numerous points of comparison with Picasso's. Extending over decades of their long working lives, the more-or-less cordial rivalry between them fueled the popular view of these two great artists as "mighty opposites" in the history of modernism.

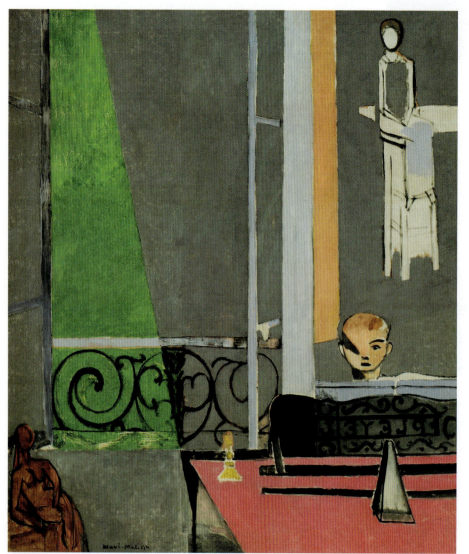

Response to Cubism, 1914–16

Being thoroughly immersed in the art of Cézanne, Matisse inevitably found himself responding to the structured interpretation of Cézanne's style realized by Braque and Picasso. One of Matisse's most austere interpretations of a Cubist mode is *Piano Lesson* of 1916 (fig. **11.6**). This work is a large, abstract arrangement of geometric color planes—grays and greens compressed by shots of orange and pink. A tilted foreground plane of rose pink constitutes the top of the piano, on which a gray metronome sits; its triangular shape is echoed in the angled green plane that falls across the window. The planes are accented by decorative curving patterns based on the iron grille of the balcony and the music stand of the piano. The environment is animated by the head of the child sculpturally modeled in line evoking Matisse's 1908 sculpture *Decorative Figure* (fig. **11.7**), which appears in so many of his paintings. Another of his works, the painting *Woman on a High Stool*, 1914, is schematically indicated in the upper right, but its nature, as a painting or a figure in the room, remains

11.6 Henri Matisse, *Piano Lesson*, late summer 1916. Oil on canvas, 8′ ½″ × 6′ 11¾″ (2.45 × 2.13 m). The Museum of Modern Art, New York.

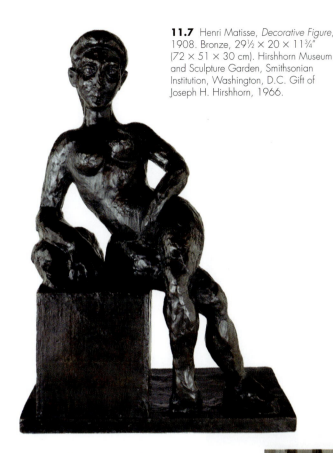

11.7 Henri Matisse, *Decorative Figure*, 1908. Bronze, 29½ × 20 × 11¾" (72 × 51 × 30 cm). Hirshhorn Museum and Sculpture Garden, Smithsonian Institution, Washington, D.C. Gift of Joseph H. Hirshhorn, 1966.

view. The artist implies his own presence through his open violin case on the piano, his painting on the wall in the upper right corner, and his sculpture, *Reclining Nude, I; Aurore* (see fig. 5.10), here enlarged and flesh-colored, which sits by the pond before a lush landscape. In the wake of *Piano Lesson*, Matisse replaced his previous Cubist austerity with a lush indulgence in color and decorative forms. The tranquil, orderly family scene holds at bay the destruction and privations still weighing on Western Europe. Indeed, little of Matisse's artistic production during or immediately after the war speaks directly to the conflict.

In late 1917 Matisse moved to Nice, in the south of France, where he spent much time thereafter. In spacious, seaside studios, he painted languorous models, often in the guise of exotic "odalisques," under the brilliant light of the Riviera. These women reveal little in the way of individual psychologies; they are objects of fantasy and visual gratification in a space seemingly sealed off from the rest of the world. Matisse, no doubt like many others living in Europe at this time, found such escapist fantasies far more appealing than either the shocking realism of New Objectivity or the nihilism of Dada. Throughout most of the 1920s, Matisse supplanted heroic abstraction with intimacy, charm, and a mood of sensual indulgence, all suffused with color as lavish

unclear, heightening the sense of spatial ambiguity. The stiff figure seems to preside over the piano lesson like a stern instructor. Here again, Matisse's interpretation of Cubism is intensely personal, with none of the shifting views and fractured forms that mark the main line of Picasso, Braque, and Juan Gris. Its frontality and its dominant uniform planes of geometric color areas show that Matisse could assimilate Cubism in order to achieve an abstract structure of space and color.

Renewal of Coloristic Idiom, 1917–c. 1930

In 1917 Matisse undertook another version of this theme with *Music Lesson* (fig. **11.8**), a painting almost identical in size to *Piano Lesson*, which depicts the same room in the artist's house at Issy-les-Moulineaux, southwest of Paris. Matisse has transformed that room into a pleasant domestic setting for a portrait of his family. The three children are in the foreground while Madame Matisse sews in the garden. Everyone is self-absorbed and takes little heed of the artist or the beautiful garden

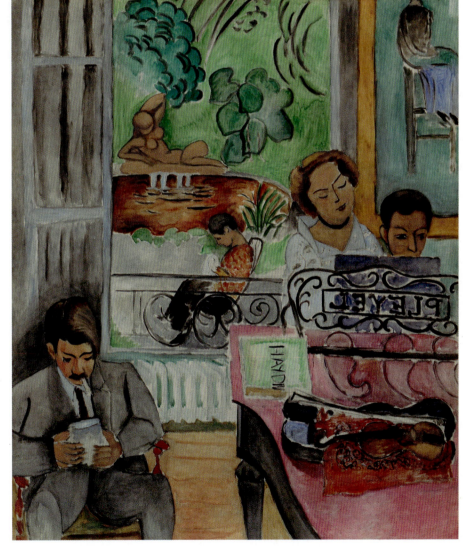

11.8 Henri Matisse, *Music Lesson*, 1917. Oil on canvas, 8' ⅛" × 6' 7" (2.4 × 2 m). The Barnes Foundation, Philadelphia, Pennsylvania.

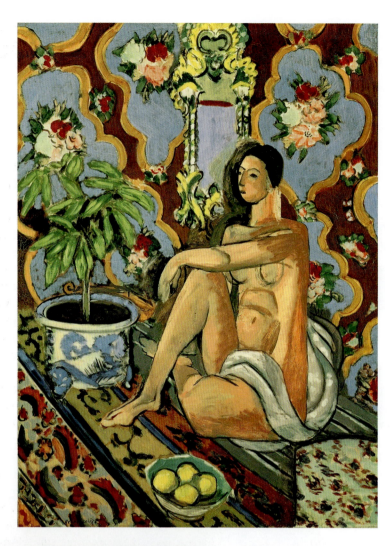

11.9 Henri Matisse, *Decorative Figure Against an Ornamental Background*, 1925–26. Oil on canvas, 51⅛ × 38½" (129.9 × 97.8 cm). Musée National d'Art Moderne, Centre d'Art et de Culture Georges Pompidou, Paris.

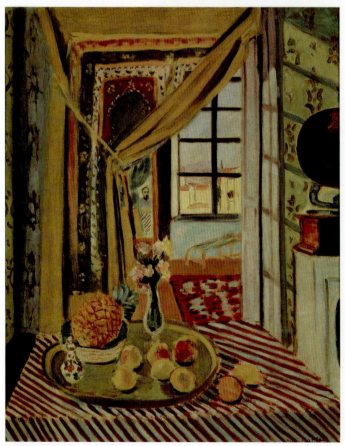

as an Oriental carpet and with a sense of line and pattern that owed much to Islamic art. Yet, even within this deceptively relaxed manner, the artist produced images and compositions of grand, even solemn magnificence. The *Decorative Figure Against an Ornamental Background* of 1925–26 (fig. **11.9**) epitomizes this most Rococo phase of Matisse's work. Through the highly sculptural quality of his model, he manages to set the figure off against the patterned Persian carpet, which visually merges with a background wall decorated with the repetitive floral motif of French baroque wallpaper and the elaborate **volutes** of a Venetian mirror. Such solidly modeled figures appear in his sculptures of this period and in lithographs.

During the 1920s Matisse revived his interest in the window theme, first observed in the 1905 Fauve *The Open Window* (see fig. 5.6) and often with a table, still life, or figure set before it. Through this subject, in fact, one may follow the changing focus of his attention from Fauve color to Cubist reductiveness and back to the coloristic, curvilinear style of the postwar years. In *Interior with a Phonograph* (fig. **11.10**), a painting of 1924, Matisse gave full play to his brilliant palette, while at the same time constructing a richly ambiguous space, created through layers of rectangular openings.

11.10 Henri Matisse, *Interior with a Phonograph*, 1924. Oil on canvas, 39¾ × 32" (101 × 81.3 cm). Private collection.

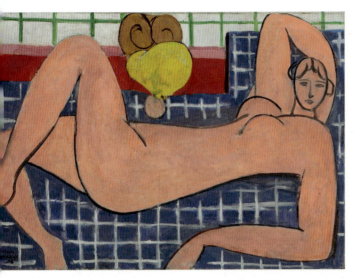

11.11 Henri Matisse, *Large Reclining Nude (The Pink Nude)*, 1935. Oil on canvas, 26 × 36½" (66 × 92.7 cm). The Baltimore Museum of Art. Cone Collection, ormed by Dr. Claribel Cone and Miss Etta Cone of Baltimore, Maryland, BMA 1950.258

⊙─┤Watch a video about Matisse on mysearchlab.com

An Art of Essentials, c. 1930–54

Matisse had once expressed (in 1908) his desire to create "an art of balance, of purity and serenity devoid of troubling or depressing subject matter, an art which would be … something like a good armchair in which to rest from physical fatigue." Indulgent as this may seem, Matisse was earnest in his self-effacing and unsparing search for the ideal. Thus, in the wake of his 1920s luxuriance, the sixty-six-year-old artist set out once again to renew his art by reducing it to essentials. The evidence of this prolonged and systematic exercise has survived in a telling series of photographs, made during the course of the work—state by state—that he carried out toward the ultimate realization of his famous *Large Reclining Nude* (formerly called *The Pink Nude*) of 1935 (fig. **11.11**). He progressively selected, simplified,

and reduced—not only form but also color, until the latter consisted of little more than rose, blue, black, and white. The odalisque thus rests within a pure, rhythmic flow of uninterrupted curves. While this cursive sweep evokes the simplified volumes of the figure, it also fixes them into the gridded support of the chaise longue. Here is the perfect antithetical companion to the Fauve *Blue Nude* of 1907 (see fig. 5.9), a sculptured image resolved by far less reductive means than those of the *Large Reclining Nude*.

Like artists in the grand French tradition of the decorative that preceded him—from Le Brun at Versailles through Boucher and Fragonard in the eighteenth century to Delacroix, Renoir, and Monet in the nineteenth—Matisse had ample opportunity to be overtly decorative when, in 1932, he began designing and illustrating special editions of great texts, the first of which was *Poésies* by Stéphane Mallarmé, published by Albert Skira. In the graphics for these volumes, Matisse so extended the aesthetic economy already seen in the *Large Reclining Nude* that, even when restricted to line and black and white, he could endow the image with a living sense of color and volume.

Matisse's most extraordinary decorative project during the 1930s was his design for a large triptych on the subject of dance (fig. **11.12**) commissioned by the American collector

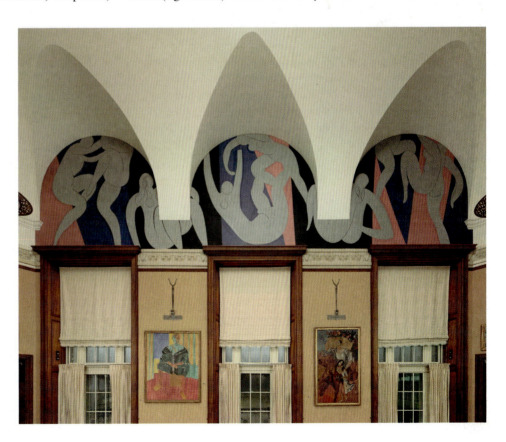

11.12 Henri Matisse, *Merion Dance Mural*, 1932–33. Oil on canvas:
left 11' 1¾" × 14' 5¾" (3.4 × 4.4 m),
center 11' 8⅛" × 16' 6⅛" (3.6 × 5 m),
right 11' 1¾" × 14' 5¾" (3.4 × 4.4 m).
The Barnes Foundation, Merion, Pennsylvania.

Matisse in Merion, Pennsylvania

Among the most dedicated American collectors of European avant-garde art was Albert C. Barnes, a chemist who amassed a fortune at the start of the twentieth century creating patent medicines. His interest in art led him first to collect Barbizon School paintings before the artist William Glackens, a childhood friend, advised him instead to pursue Impressionist and Post-Impressionist works. Barnes adopted this recommendation with gusto, compiling an enormous collection of works by artists such as Monet, Renoir, Degas, Van Gogh, Gauguin, and Cézanne. Through Gertrude and Leo Stein, Barnes became acquainted with Picasso and Matisse in 1912 and began collecting their work as well. His support for avant-garde artists continued to gain momentum. Relying increasingly on his own instincts, he was the first serious collector of paintings by Chaim Soutine.

Barnes's collection eventually comprised over 2,000 artworks, many by leading members of the European and American avant-garde. He assembled the collection in a limestone mansion outside Philadelphia in suburban Merion, Pennsylvania. Inspired by the educational theories of John Dewey, Barnes invited schoolchildren and laborers to the housemuseum, in which he had carefully arranged his collection to highlight formal correspondences. Intermingled with the avant-garde artworks were examples of African sculpture, folk art, and ironwork. Thus, a visitor might consider the design of an ornamental hinge alongside a painting by Seurat. Barnes felt his collection was more valuable to students and the working class than to members of the social elite, whom he regularly refused to admit. His will stipulated that the collection, held in trust by the Barnes Foundation, could never be rearranged or relocated even temporarily, thus preserving for decades after his death the eccentricity as well as the intimacy of his galleries. Barnes's experiment came to an end in 2004 when the Foundation's board successfully challenged the terms of his will, paving the way for the collection's relocation to Philadelphia where the new Barnes Art Education Center, a modernist structure designed by Tod Williams and Billie Tsien with galleries intended to evoke the scale and disposition of the original hanging, opened in 2012.

Albert C. Barnes, the man who had bought the works of Soutine (see *Matisse in Merion, Pennsylvania*, above). The triptych would occupy three lunettes in the Barnes Foundation at Merion, which already housed more works by Matisse than any museum. Matisse began to paint the murals in Nice, only to discover well into the project that he was using incorrect measurements. So he began anew. (In 1992, in an amazing discovery, this unfinished but splendid composition was found rolled up in Matisse's studio in Nice.) When he returned to work on the second version, he discovered that his usual technique of brushing in every color himself was enormously time-consuming. In order to expedite his experiments with form and color arrangements,

he cut large sheets of painted paper and pinned them to the canvas, shifting them, drawing on them, and, ultimately, discarding them once he decided on the final composition. This method of cutting paper became an artistic end in itself during the artist's later years.

For both compositions, Matisse turned to his own previous treatment of the dance theme (see fig. 5.22). In the final murals, the dancing figures are rendered in light gray, to harmonize with the limestone of the building, and are set against an abstract background consisting of broad, geometric bands of black, pink, and blue. The limbs of the figures are dramatically sliced by the curving edges of the canvas, which somehow enhance rather than inhibit their ecstatic movements. Matisse, of course, understood that his image had to be legible from a great distance, so the forms are boldly conceived, with no interior modeling to distract from their simplified contours. The result is one of the most successful mergings of architecture and painting in the twentieth century. Fortunately, Matisse felt the need to paint a third version of the murals, which now belongs, as does the first, to the Musée National d'Art Moderne in Paris.

Celebrating the Good Life: Dufy's Later Career

Raoul Dufy (1877–1953) joined Matisse in remaining true to the principles of Fauve color but, in the years following 1906 (see fig. 5.16), refined them into a sumptuous signature style. Even more than Matisse, he was a decorator with a connoisseur's taste for the hedonistic joys of the good life. During the 1920s and 30s, Dufy achieved such popularity—not only in paintings, watercolors, and drawings, but also in ceramics, textiles, illustrated books, and stage design—that his rainbow palette and stylish, insouciant drawing seem to embody the spirit of the period. *Indian Model in the Studio at L'Impasse Guelma* (fig. **11.13**) shows many of the characteristics of the artist's mature manner. The broad, clear area of light blue that covers the studio wall forms a background to the intricate pattern of rugs and paintings whose exotic focus is an elaborately draped Indian girl. The use of descriptive line and oil color laid on in thin washes is such that the painting—and this is true of most of Dufy's works—seems like a delicately colored ink drawing.

Dufy combined influences from Matisse, Rococo, Persian and Indian painting, and occasionally modern primitives such as Henri Rousseau, transforming all these into an intimate world of his own. The artist could take a panoramic view and suggest, in minuscule touches of color and nervous arabesques of line, the movement and excitement of his world—crowds of holidaymakers, horse races, boats in sun-filled harbors, the circus, and the concert hall.

Eclectic Mastery: Picasso's Career after the War

"I paint objects as I think them, not as I see them," said **Pablo Picasso** (1881–1973). This statement emphasizes

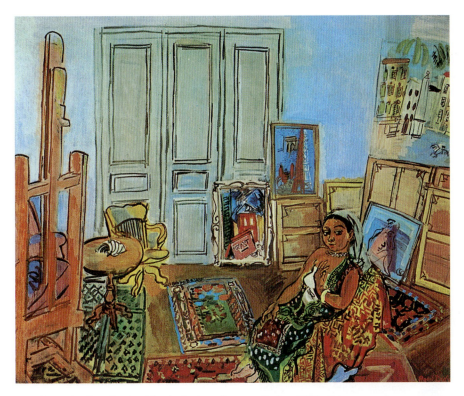

11.13 Raoul Dufy, *Indian Model in the Studio at L'Impasse Guelma*, 1928. Oil on canvas, 31⅞ × 39⅝" (81 × 100 cm). Private collection.

the strong conceptual element that lies behind both his life-long readiness to experiment with new kinds of visual language and his capacity to assimilate the essence of a diverse range of artistic styles and techniques. Unlike Matisse, whose "art of balance," like a comfortable armchair, sought to relax and refresh the viewer, Picasso came to see art as "an instrument of war against brutality and darkness." His work during the interwar years reflects intellectual currents of the times, from the classical "call to order" that followed the war to his involvement with Surrealism and communism, and the passionate political statement of *Guernica*.

In 1914, like other European avant-garde movements, Cubism had lost momentum as artists and writers, including Braque, Léger and Apollinaire, enlisted in the armed forces. As a foreigner, Picasso was able to remain in Paris, but he worked more now in isolation. After the period of discovery and experiment in Analytic Cubism, collage, and the beginning of Synthetic Cubism (1908–14), there was a pause during which the artist used Cubism for decorative ends (see figs. 7.25, 7.28). Then, suddenly, during a sojourn in Avignon in 1914, he began a series of realistic portrait drawings in a sensitive, scrupulous linear technique that recalls his longtime admiration for the drawings of Ingres. But works such as the portrait of Picasso's dealer, *Ambroise Vollard* (fig. **11.14**), were in the minority during 1915–16, when the artist was still experimenting with painting and constructions in a Synthetic Cubist vein.

Picasso produced several portraits of Vollard and his other dealer, Daniel-Henry Kahnweiler, giving some indication of their importance to the artist. Dealers played a crucial role in promoting modernism. The experimental nature of avant-garde art often kept mainstream patrons at bay,

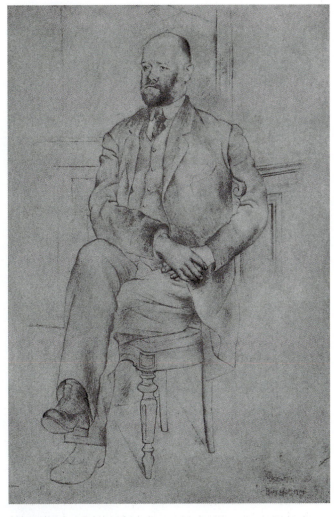

11.14 Pablo Picasso, *Ambroise Vollard*, 1915. Pencil on paper, 18⅜ × 12⁹⁄₁₆" (46.7 × 31.9 cm). The Metropolitan Museum of Art, New York.

making it difficult if not impossible for progressive artists without independent means to sustain their careers. The timely intervention of a supportive dealer could make all the difference not just in terms of professional success but in terms of survival. Of course, as supportive as they may have been of the avant-garde enterprise, dealers were in the business of turning a profit, and their methods could propel one career while hampering another. For instance, dealers often purchased the entire contents of an artist's studio, a transaction that immediately provided the artist with ready cash, enabling him or her to focus on creating more work. But such transactions meant that artists no longer had control over these pieces, and dealers might keep the works off the market and even in storage while awaiting (sometimes for years) an advantageous moment to promote and sell the

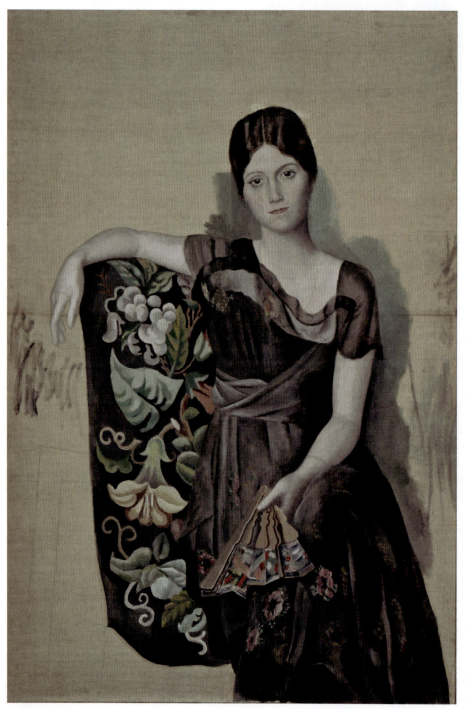

works, with the effect that meanwhile the artist's public profile was allowed to diminish. Picasso never suffered from such commercial invisibility: Vollard and Kahnweiler regularly exhibited his art in their galleries and kept up a steady flow of eager buyers, to Picasso's and their own advantage.

The war years and the early 1920s saw a return to forms of realism on the part of other French painters—Derain, Vlaminck, Dufy—originally associated with Fauvism or Cubism. In Picasso's case, however, the drawings and, subsequently, paintings in a realist mode contributed to a re-examination of the nature of Cubism. He obviously felt confident enough of his control of the Cubist vocabulary to attack reality from two widely divergent vantage points. With astonishing agility, he pursued Cubist experiments side by side with realistic and classical drawings and paintings in the early 1920s. Picasso's facility with an eclectic range of styles—in itself one of the most extraordinary phenomena of twentieth-century art—is interesting in several ways. It shows how the artist was able to take full advantage of the experimental freedoms that were an integral part of modernism. But at the same time it shows him moving away from modernist notions of authenticity (for example, Cubism's truth to the fragmented nature of visual perception as it is actually experienced) toward modes of parody or pastiche, strategies similarly exploited by the Dadaists.

Parade and Theatrical Themes

In 1917 Picasso agreed, somewhat reluctantly because he hated travel or disruption of his routine, to go to Rome as part of a group of artists, including the poet and dramatist Jean Cocteau, the composer Erik Satie, and the choreographer Léonide Massine, to design curtains, sets, and costumes for a new ballet, *Parade*, being prepared for Diaghilev's Ballets Russes (Russian Ballet Company). The stimulus of Italy, where Picasso stayed for two months visiting museums, churches, and ancient sites like Pompeii, contributed to

11.15 Pablo Picasso, *Olga Seated in an Armchair*, 1917. Oil on canvas, 51⅛ × 35″ (130 × 88.8 cm). Musée Picasso, Paris.

Diaghilev's Ballets Russes

Serge Diaghilev's Ballets Russes exemplify the profitable tension between traditional and avant-garde culture around World War I. Diaghilev was a Russian impresario who, in 1909, formed a touring troupe of dancers classically trained at the Imperial Ballet in St. Petersburg. By 1911, the successful Ballets Russes had settled in Paris, where Diaghilev invited avant-garde artists to collaborate with his director, composers, and dancers in designing innovative costumes and sets. One of the most infamous of Diaghilev's productions was the "realist ballet" *Parade* (see fig. 11.16). At its première in Paris the ballet provoked outrage. There was no single problem: Picasso's Cubist sets and costumes, Erik Satie's music (which included conventional instruments along with sounds produced by typewriters, a foghorn, and milk bottles), and Jean Cocteau's anti-capitalist story all had a share in eliciting the critics' gall. Diaghilev recognized that postwar tastes in culture were returning to reassuringly traditional forms. Subsequent productions by the Ballets Russes retreated from the avant-garde experimentation of *Parade* and instead pursued folk themes animated by more conventional instrumentation.

it that is reminiscent of his 1905 circus paintings (see fig. 7.4) in its tender, romantic imagery and Rose Period coloring. Like Satie's soothing prelude, it reassured the audience, which was expecting Futurist cacophony. But they were shocked out of their complacency once the curtain rose. When *Parade* was first performed in Paris on May 18, 1917, the audience included sympathetic viewers like Gris and Severini. Most of the theatergoers, however, were outraged members of the bourgeoisie. The reviews were devastating, and *Parade* became a *succès de scandale*, marking the beginning of many fruitful collaborations between Picasso, as well as other artists in France, with the ballet company (see *Diaghilev's Ballets Russes*, opposite).

During this period, Picasso's early love of the characters from the Italian *commedia dell'arte* and its descendant, the French circus, was renewed. Pierrots, Harlequins, and musicians again became a central theme. The world of the theater and music took on a fresh aspect that resulted in a number of brilliant portraits, such as that of the Russian composer Igor Stravinsky, and figure drawings done in delicately sparse outlines.

the resurgence of classical style and subject matter in his art. He also met and married a young dancer in the *corps de ballet*, Olga Koklova, who became the subject of many portraits in the ensuing years, including the Ingresesque *Olga Seated in an Armchair* (fig. 11.15). Even in its unfinished state, this portrait testifies to Picasso's interest in the classical tradition of French painting, a reassuring reminder of the capacity for cultures to endure even in the somber world of postwar Europe.

Picasso's contributions to *Parade*, however, reveal his enduring commitment to progressive art. *Parade* brought the artist back into the world of the theater, which, along with the circus, had been an early love and had provided him with subject matter for his Blue and Rose Periods (see Ch. 7, pp. 138–40). Dating back to the late eighteenth century, a traditional "parade" was a sideshow performance enacted outside a theater to entice the spectators inside. The ballet was built around the theme of conflict: on the one hand, the delicate humanity and harmony of the music and the dancers; on the other, the commercialized forces of the mechanist–Cubist managers (fig. 11.16) and the deafening noise of the sound effects. Cocteau, who saw the scenario as a dialog between illusion and reality, the commonplace and the fantastic, intended these real sounds—sirens, typewriters, or trains—as the aural equivalent of the literal elements in Cubist collages (see fig. 7.21). The mixture of reality and fantasy in *Parade* led Apollinaire in his program notes to refer to its *sur-réalisme*, one of the first recorded uses of this term to describe an art form. *Parade* involved elements of shock that the Dadaists were then exploiting in Zurich (see Ch. 10, pp. 214–18). Picasso designed a backdrop for

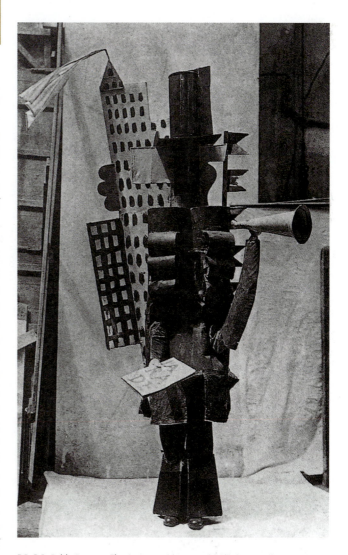

11.16 Pablo Picasso, *The American Manager*, 1917. Reconstruction. Realized by Kermit Love for The Museum of Modern Art, 1979. Paint on cardboard, fabric, paper, wood, leather, and metal, 11' 2¼" × 8' × 3' 8½" (3.4 × 2.4 × 1.1 m). The Museum of Modern Art, New York.

Postwar Classicism

In the early postwar period Picasso experimented with different attitudes toward Cubism and other modes of representation. One impulse driving Picasso's pictorial experiments of the 1920s was his preoccupation with a robust classicism that resulted in simplified, monumental figures placed in reassuringly elemental settings such as the seaside or next to a spring. He pursued this approach to classicism for the next four years in painting and then continued in sculpture in the early 1930s. The years of working with flat, tilted Cubist planes seemed to build up a need to go to the extreme of sculptural mass. The faces are simplified in the heavy, coarse manner of Roman rather than Greek sculpture, and when Picasso placed the figures before a landscape, he reduced the background to frontalized accents that tend to close rather than open the space. Thus, the effect of high sculptural relief is maintained throughout. Picasso's explorations in this vein gave rise to works evocative of the ideals associated with Athens in the fifth century BCE. One of the outstanding works of this phase is *The*

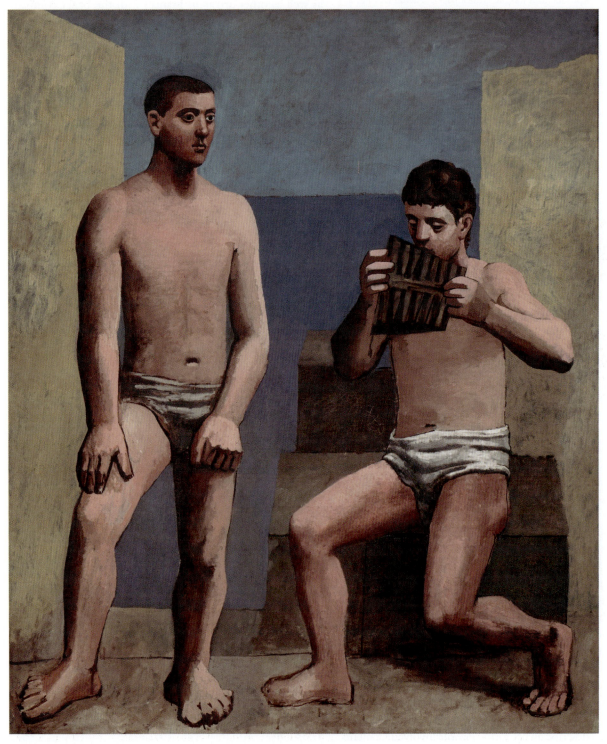

11.17 Pablo Picasso, *The Pipes of Pan*, 1923. Oil on canvas, 6′ 6½″ × 5′ 8½″ (2 × 1.74 m). Musée Picasso, Paris.

👁 Watch a video about postwar classicism on mysearchlab.com

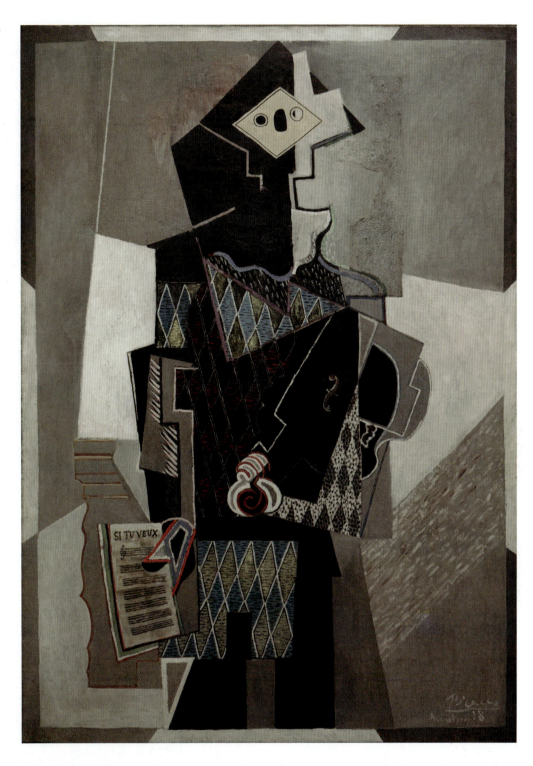

11.18 Pablo Picasso, *Harlequin with Violin (Si tu veux)*, 1918. Oil on canvas, 56 × 39½" (142.2 × 100.3 cm). The Cleveland Museum of Art. Purchase, Leonard C. Hanna, Jr. 1975.2.

Pipes of Pan (fig. **11.17**). The two youths are presented as massive yet graceful athletes, absorbed in their own remote and magical world. The rectilinear forms of the background deny any sense of spatial recession, turning the whole into a kind of Mediterranean stage set.

Cubism Continued

The remarkable aspect of Picasso's art during this ten-year period (1915–25) is that he was also producing major Cubist paintings. He explained this stylistic dichotomy in a 1923 interview: "If the subjects I have wanted to express have suggested different ways of expression I have never hesitated to adopt them." After the decorative enrichment of the

Cubist paintings around 1914–15 (see fig. 7.25), including Pointillist color and elaborate, applied textures, the artist moved back, in his Cubist paintings of 1916–18, to a greater austerity of more simplified flat patterns, frequently based on the figure (fig. **11.18**). Simultaneously, he made realistic versions of this subject, a favorite with him. From compositions involving figures, there gradually evolved the two versions of the *Three Musicians* (fig. **11.19**), both created in 1921. One version is in The Museum of Modern Art, New York; the other is in the Museum of Art, Philadelphia. The three figures in both versions are seated frontally in a row, against an enclosing back wall, and fixed by the restricted foreground, but the version in New York is simpler and

11.19 Pablo Picasso, *Three Musicians*, summer 1921. Oil on canvas, 6' 7" × 7' 3¾" (2 × 2.2 m). The Museum of Modern Art, New York.

👁 Watch a video about the *Three Musicians* on mysearchlab.com

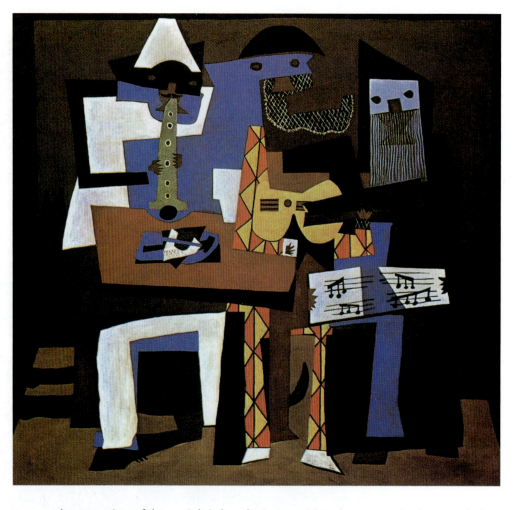

more somber. The paintings are a superb summation of the Synthetic Cubist style up to this point, but they also embody something new. The figures are suggestive not so much of exuberant musicians from the *commedia dell'arte* as of some mysterious tribunal. It has been persuasively argued that the three musicians represent covert portraits of Picasso's friends—the writer Max Jacob (the monk at the right), who had recently withdrawn from the world and taken up residence in a monastery, and Apollinaire (Pierrot, the "poet" at the left), who had died in 1918. Picasso portrays himself, as he often did, in the guise of Harlequin, situated in the middle between his friends. The somber, somewhat ominous mood of the painting is thus explained as the work becomes a memorial to these lost friends.

The other direction in which Picasso took Cubism involved sacrifice of the purity of its Analytic phase for the sake of new exploration of pictorial space. The result was, between 1924 and 1926, a series of the most colorful and spatially intricate still lifes in the history of Cubism. In some of these still lifes, Picasso introduced classical busts as motifs, suggesting the artist's simultaneous exploration of classic idealism and a more expressionist vision. In *Studio with Plaster Head* (fig. **11.20**), the Roman bust introduces a quality of mystery analogous to De Chirico's use of classical motifs (see fig. 9.3). While the trappings of classicism are here, the serenity of Picasso's earlier classical paintings has vanished. The work belongs to a tradition of still lifes representing the attributes of the arts (including the prominent architect's square at the

right), but the juxtapositions become so jarring as to imbue the composition with tremendous psychological tension. At the back of the still life, fragments of Picasso's small son's toy theater imply that the entire still life is an ancient Roman stage set. The head is almost a caricature, which Picasso manages to twist in space from a strict profile view at the right to a fully frontal one in the deep blue-gray shadow at the left. The broken plaster arm at the left grips a baton so intensely that it feels animated.

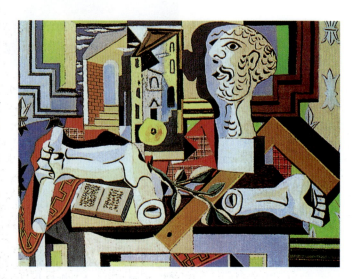

11.20 Pablo Picasso, *Studio with Plaster Head*, summer 1925. Oil on canvas, 38⅝ × 51⅝" (97.9 × 131.1 cm). The Museum of Modern Art, New York.

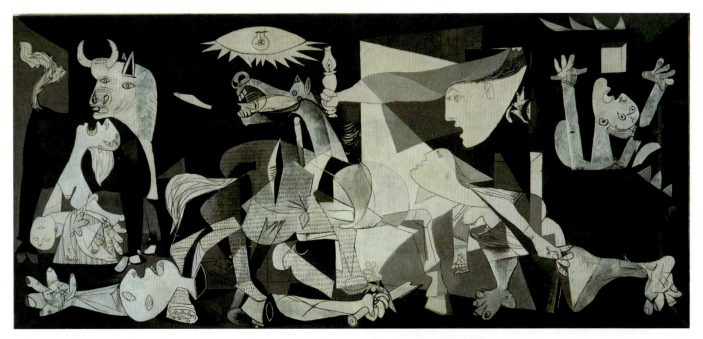

11.21 Pablo Picasso, *Guernica*, 1937. Oil on canvas, 11′ 6″ × 25′ 8″ (3.5 × 7.8 m). Museo Nacional Centro de Arte Reina Sofía, Madrid.

View the Closer Look for *Guernica* on mysearchlab.com

Guernica and Related Works

Picasso's major painting of the 1930s and one of the most recognizable works of the twentieth century is *Guernica* (fig. **11.21**). Executed in 1937, it was inspired by the atrocities of the Spanish Civil War—specifically, the destruction of the Basque town of Guernica by German bombers in the service of the Spanish fascists. In January 1937, Picasso, who supported the Republicans in their fight against the fascist General Francisco Franco, created two etchings, each composed of a number of episodes, and accompanied by a poem, *Dream and Lie of Franco*. General Franco is shown as a turnip-headed monster, and the bull as the symbol of resurgent Spain. The grief-stricken woman in the painting who shrieks over the body of her dead child first appeared in this etching. In May and June 1937 Picasso painted *Guernica* for the Spanish Republican Pavilion of the Paris World's Fair. It is a huge painting in black, white, and gray, a scene of terror and devastation. Although Picasso used motifs such as the screaming horse or agonized figures derived from his Surrealist distortions of the 1920s, the structure is based on the Cubist grid and returns to the more stringent palette of Analytic Cubism (see fig. 7.17). With the exception of the fallen warrior at the lower left, the human protagonists are women, but the central victim is the speared horse from *Minotauromachy*. *Guernica* is Picasso's most powerfully expressionist application of Cubism and one of the most searing indictments of war ever painted.

Although *Guernica* was created in response to current events, elements in the painting can be traced back to Picasso's work of the 1920s. The figure of the Minotaur first appeared in a collage of 1928. In 1933 he made a series of etchings, collectively known as the *Vollard Suite*, in which the Minotaur is a central character. During 1933 and 1934 Picasso also drew and painted bullfights of particular savagery. These explorations climaxed in the etching *Minotauromachy* of 1935 (fig. **11.22**). It presents a number of elements reminiscent of Picasso's life and his Spanish past, including: recollection of the prints of Goya; the women in the window; the Christ-like figure on the ladder; the little girl holding flowers and a candle (a symbol of innocence); the screaming, disemboweled horse (which becomes the central player in *Guernica*) carrying a dead woman (dressed as a toreador); and the Minotaur groping

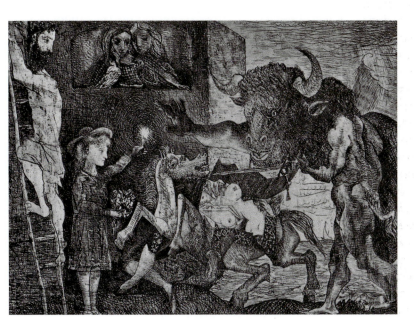

11.22 Pablo Picasso, *Minotauromachy*, March 23, 1935. Etching and engraving on copper plate, printed in black; plate 19½ × 27⅜″ (49.6 × 69.6 cm). The Museum of Modern Art, New York.

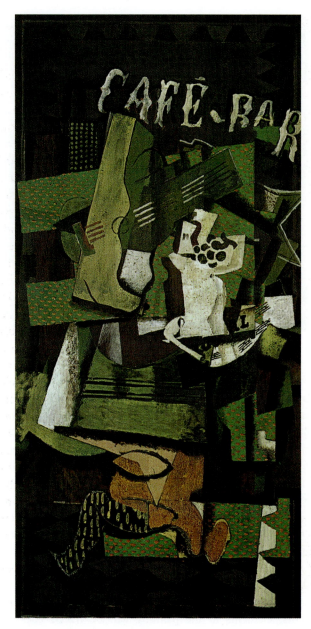

11.23 Georges Braque, *Café-Bar*, 1919. Oil on canvas, 63¼ × 31⅞″ (160.7 × 81 cm). Öffentliche Kunstsammlung, Kunstmuseum Basel.

his way. The place of the Minotaur (or the bull) in Picasso's iconography is ambiguous. It may be a symbol of insensate, brute force, sexual potency and aggression, a symbol of Spain, or of the artist himself.

Sensuous Analysis: Braque's Later Career

Georges Braque (1882–1963) and Picasso had parted company in 1914, never to regain the intimacy of the formative years of Cubism. After his war service and slow recovery from a serious wound, Braque returned to a changed Paris in the fall of 1917. Picasso was in Italy, and other pioneers of Cubism or Fauvism were widely scattered. However, Juan Gris and Henri Laurens (see Ch. 7, pp. 159–60) were still in Paris, working in a manner that impressed Braque and inspired him to find his own way once more. By 1918–19 a new and personal approach to Synthetic Cubism began to

be apparent in a series of paintings, of which *Café-Bar* (fig. **11.23**) is a document for Braque's style for the next twenty years. The painting is tall and relatively narrow, a shape which Braque had used during his first essays in Cubism (see fig. 7.16) and which he now began to utilize on a more monumental scale. The subject is a still life of guitar, pipe, journal, and miscellaneous objects piled vertically on a small, marble-topped pedestal table, or *guéridon*. This table was used many times in subsequent paintings. The suggested elements of the environment are held together by a pattern of horizontal green rectangles patterned with orange-yellow dots, placed like an architectural framework parallel to the picture plane.

Compared with Braque's prewar Cubist paintings, *Café-Bar* has more sense of illusionistic depth and actual environment. Also, although the colors are rich, and Braque's feeling for texture is more than ever apparent, the total effect recalls, more than Picasso's, the subdued, nearly monochrome tonalities that both artists worked with during their early collaboration (see figs. 7.19, 7.20). This is perhaps the key to the difference between their work in the years after their collaboration. Whereas the approach of Picasso was experimental and varied, that of Braque was conservative and intensive, continuing the first lessons of Cubism. Even when he made his most radical departures into his own form of classical figure painting during the 1920s, the color remained predominantly the grays, greens, browns, and ochers of Analytic Cubism. The principal characteristic of Braque's style emerging about 1919 was that of a textural sensuousness in which the angular geometry of earlier Cubism began to diffuse into an overall fluid pattern of organic shapes.

This style manifested itself in the early 1920s in figure paintings in which the artist seems to have deserted Cubism as completely as Picasso did in his classical figure paintings. The difference again lay in the painterliness of Braque's oils and drawings, as compared with Picasso's Ingres-like contour drawings and the sculptural massiveness of his classical paintings. In Braque's paintings and figure drawings of this period, the artist effected his personal escape from the rigidity of his earlier Cubism and prepared the way for his enriched approach to Cubist design of the later 1920s and 30s. The sobriety of Braque's palette and the purposefulness of his devotion to Cubism—the style that promised such formal liberty in the years between 1909 and 1914—must be reckoned at least in part a consequence of his wartime experiences.

The most dramatic variation on his steady, introspective progress occurred in the early 1930s when, under the influence of Greek vase painting, Braque created a series of line drawings and engravings with continuous contours. This flat, linear style also penetrated to his newly austere paintings of the period: scenes of artist and model or simply figures in the studio. These works exhibit some of the most varied effects of Braque's entire career. The dominant motif of *Woman with a Mandolin* (fig. **11.24**) is a tall, dark silhouette of a woman seated before a music stand. Behind her, a profusion of patterns on the wall recalls the wallpaper patterns of Braque's earlier *papiers collés*. Because the woman's

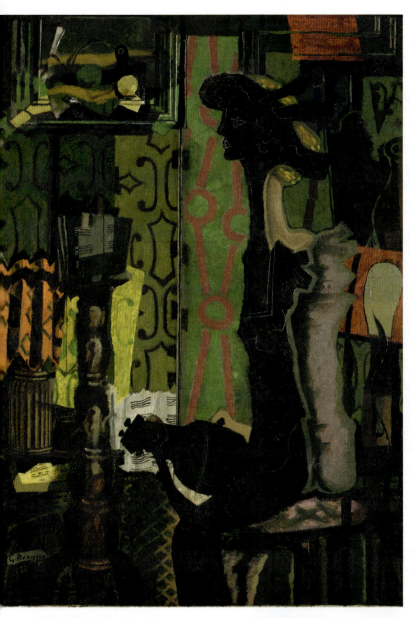

Austerity and Elegance: Léger, Le Corbusier, and Ozenfant

In his paintings of the 1920s and 30s, **Fernand Léger** (1881–1955) took part in the so-called "call to order" that characterized much French art after World War I, in which he had served. One of his major figure compositions from the postwar period is *Three Women* (*Le Grand Déjeuner*) (fig. **11.25**). The depersonalized figures, who stare fixedly and uniformly at the spectator, are machine-like volumes modeled out from the rigidly rectangular background. Léger labored over *Three Women*, the largest of three very similar versions of the same composition, and even repainted the figure at the right, who was originally the same marble-like gray color as her companions. He regarded the subject as timeless and eternal and said that his artistic sources were David, Ingres, Renoir, and Seurat. Although *Three Women* reflects Léger's engagement with classicism, it is also resolutely modern. In the abstract, rectilinear forms of the background one detects an awareness of the contemporary paintings of Mondrian, who was then living in Paris (see fig. 12.3). With its elements of austere, Art Deco elegance, Léger's art of this period also had much in common with the 1920s Purism (see p. 260) of Amédée Ozenfant and Le Corbusier (see figs. 11.27, 11.28). Léger remained very close to these artists after their initial meeting in 1920.

During the last twenty years of his life, Léger revisited a few basic themes through which he sought to sum up his experiences in the

11.24 Georges Braque, *Woman with a Mandolin*, 1937. Oil on canvas, 51¼ × 38¼″ (130.2 × 97.2 cm). The Museum of Modern Art, New York.

profile, very similar to ones in related compositions, is painted a deep black-brown, she becomes a shadow, less material than the other richly textured elements in the room. She plays the role of silent muse in this monumental painting, which represents Braque's meditation on art and music. It was probably inspired by Corot's treatment of the same subject, painted around 1860, which shows a young woman before an easel, holding a mandolin.

11.25 Fernand Léger, *Three Women* (*Le Grand Déjeuner*), 1921. Oil on canvas, 6′ ¼″ × 8′ 3″ (1.8 × 2.5 m). The Museum of Modern Art, New York.

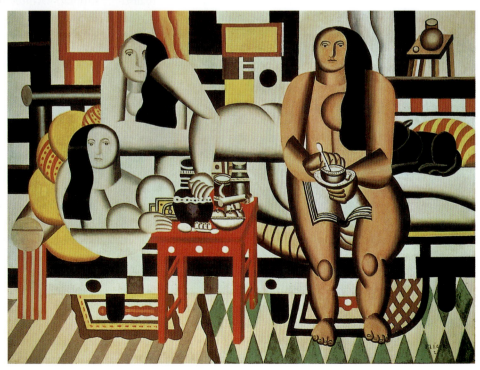

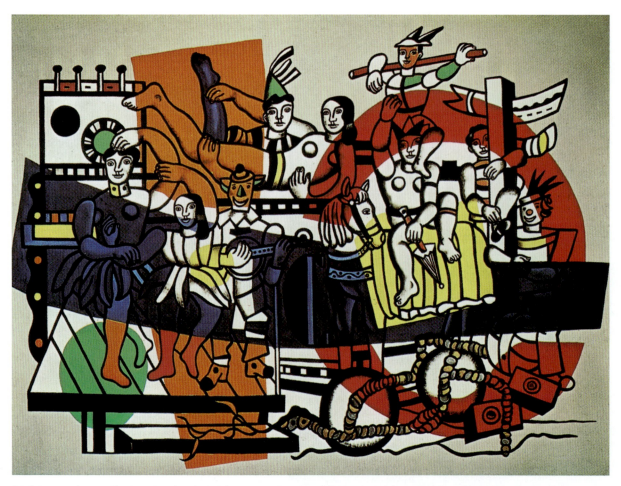

11.26 Fernand Léger, *The Great Parade*, 1954. Oil on canvas, 9' × 13' 1" (2.7 × 4 m). Solomon R. Guggenheim Museum, New York.

exploration of humanity and its place in a contemporary industrial society. It was a social as well as a visual investigation of his world as an artist, a final and culminating assessment of his plastic means for presenting it. In *The Great Parade* of 1954 (fig. **11.26**), Léger brought to culmination a series in which figure and environment are realistically drawn in heavy black outline on a white ground, over which float free shapes of transparent red, blue, orange, yellow, and green. This huge work also reflects a lifelong obsession with circus themes, as well as an interest in creating a modern mural art. Léger worked on the large canvas for two years. "In the first version," he recalled, "the color exactly fitted the forms. In the definitive version one can see what force, what vitality is achieved by using color on its own." Despite his increased interest in illustrative subject and social observation, these late works are remarkably consistent with Léger's early Cubist paintings based on machine forms (see fig. 7.39). The artist was one of a few who never really deserted Cubism but demonstrated, in every phase of his prolific output, its potential for continually fresh and varied expression.

The variant on Cubism called Purism was developed around 1918 by the architect and painter Charles-Édouard Jeanneret, who in 1920 began to use the pseudonym **Le Corbusier** (1887–1965), and the painter **Amédée Ozenfant** (1886–1966). Unlike Picasso and Braque, who were not theoretically inclined, many later Cubist-inspired artists were prone to theorizing, and they published their ideas in journals and manifestos. In their 1918 manifesto *After Cubism*, Ozenfant and Jeanneret attacked the then current state of Cubism as having degenerated into a form of elaborate decoration. In their painting they sought a simple, architectural structure and the elimination of decorative ornateness as well as illustrative or fantastic subjects. To them the machine became the perfect symbol for the kind of pure, functional painting they hoped to achieve—just as, in his early, minimal architecture, Le Corbusier thought of a house first as a machine for living. Purist principles are illustrated in two still-life paintings by Ozenfant (fig. **11.27**) and Le Corbusier (fig. **11.28**). Executed in 1920, the year that Purism reached its maturity, both feature frontally arranged objects, with colors subdued and shapes modeled in an illusion of projecting volumes. Symmetrical curves move across the rectangular grid with the antiseptic purity of a well-tended, brand-new machine. Le Corbusier continued to paint throughout his life, but his theories gained significant expression in the great architecture he produced (see Ch. 21, pp. 531–34). Ozenfant had enunciated his ideas of Purism in *L'Élan*, a magazine published from 1915 to 1917, before he met Le Corbusier, and in *L'Esprit nouveau*, published with Le Corbusier from 1920 to 1925. Ozenfant, who eventually settled in the United States, later turned to teaching and mural painting.

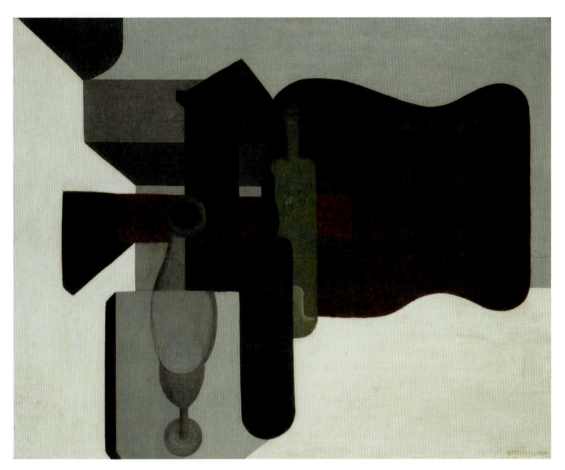

11.27 Amédée Ozenfant, *Guitar and Bottles*, 1920. Oil on canvas, 31⅞ × 39¼″ (81 × 99.7 cm). Solomon R. Guggenheim Museum, New York.

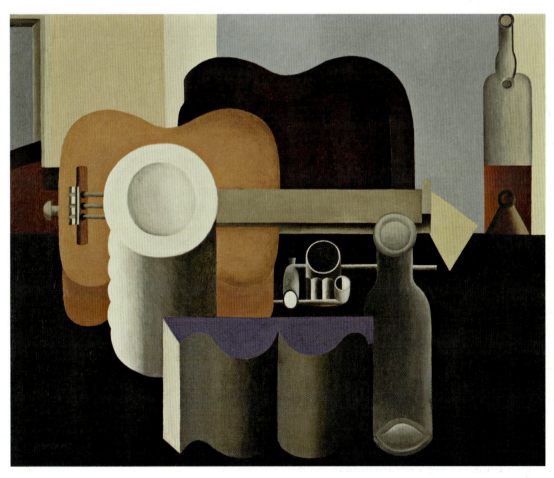

11.28 Le Corbusier (Charles-Édouard Jeanneret), *Still Life*, 1920. Oil on canvas, 31⅞ × 39¼″ (81 × 99.7 cm). The Museum of Modern Art, New York.

12
Clarity, Certainty, and Order: De Stijl and the Pursuit of Geometric Abstraction

As much of Europe girded itself for war, artists living in neutral countries like Switzerland and the Netherlands continued their work, largely unimpeded. It was thanks to Dutch neutrality in World War I that the movement called de Stijl ("the style") was able to take root in the 1910s. Led by Theo van Doesburg and Piet Mondrian, de Stijl embraced geometric abstraction and Constructivist ideas, free from the resurgence in classicism that led so many French avant-garde artists to retreat from abstraction. Constructivism in the hands of Western European artists like Van Doesburg and Mondrian must be understood as related but not identical to Russian Constructivism, which promoted a specific, Soviet-style socialism. Constructivism more generally can be understood as a movement in early twentieth-century modernism in which strong abstraction with a geometric basis is a defining element. Other characteristics of this more diffuse category of Constructivism include the avoidance of overt narrative and emotional content as well as a tendency to minimize facture. Facture—the evidence of an artist's manipulation of his or her medium through brushstrokes in the case of painting, or hand-modeling in clay sculpture—was suppressed by many Constructivists, who felt such traces to be vestiges of an outdated, even dangerous, Romantic sensibility. In the hands of artists like Van Doesburg and Mondrian, geometric abstraction was in part an attempt to create a scientifically based, universal language of the senses that would transcend the cultural, political, and economic divisions compounded by the war. Mainly Dutch but also including artists from Belgium and Hungary, the members of de Stijl sought a universal aesthetic that would unify all forms of visual art while also unifying humanity.

The de Stijl Idea

Theo van Doesburg was the leading spirit in the formation and promotion of the group and the creation of its influential journal, also called *de Stijl*, devoted to the art and theory of the group and published from 1917 to 1928, the dates by which the movement is generally bounded, though its influence persists even today (see *De Stijl "Manifesto 1,"* opposite). De Stijl was dedicated to the "absolute devaluation of

SOURCE

De Stijl "Manifesto 1"
(1918, published in *de Stijl* in 1922)

1. There is an old and a new consciousness of time.
 The old is connected with the individual.
 The new is connected with the universal.
 The struggle of the individual against the universal is revealing itself in the world war as well as in the art of the present day.

2. The war is destroying the old world and its contents: individual domination in every state.

3. The new art has brought forward what the new consciousness of time contains: a balance between the universal and the individual.

4. The new consciousness is prepared to realize the internal life as well as the external life.

5. Traditions, dogmas, and the domination of the individual are opposed to this realization.

6. The founders of the new plastic art, therefore, call upon all who believe in the reformation of art and culture to eradicate these obstacles to development, as in the new plastic art (by excluding natural form) they have eradicated that which blocks pure artistic expression, the ultimate consequence of all concepts of art.

7. The artists of today have been driven the whole world over by the same consciousness, and therefore have taken part from an intellectual point of view in this war against the domination of individual despotism. They therefore sympathize with all who work to establish international unity in life, art, culture, either intellectually or materially.

tradition ... the exposure of the whole swindle of lyricism and sentiment." The artists involved emphasized "the need for abstraction and simplification": mathematical structure as opposed to Impressionism and all "baroque" forms of art. They created art "for clarity, for certainty, and for order." Their works began to display these qualities, transmitted through the straight line, the rectangle, or the cube, and eventually through colors simplified to the primaries red, yellow, and blue and the neutrals black, white, and gray. For Van Doesburg these simplifications had symbolic significance based on Eastern philosophy and the mystical teachings of Theosophy, a popular spiritual movement that was known among de Stijl artists partly through Kandinsky's book *Concerning the Spiritual in Art* (see Ch. 6, p. 122). Despite Van Doesburg's efforts to present de Stijl as a unified and coherent entity, it included many individual talents who did not strictly adhere to a single style. Nevertheless, the artists, designers, and architects of the movement shared ideas about the social role of art in modern society, the integration of all the arts through the collaboration of artists and designers, and an abiding faith in the potential of technology and design to realize new utopian living environments based on abstract form. Together they developed an art based rigorously on theory, dedicated to formal purity, logic, balance, proportion, and rhythm.

The de Stijl artists were well aware of avant-garde developments in modern art in France, Germany, and Italy—Fauvism, Cubism, German Expressionism, and Italian Futurism. But they recognized as leaders only a few pioneers, such as Cézanne in painting and Frank Lloyd Wright and Hendrik Berlage in architecture. They had little or no knowledge of the Russian experiments in abstraction until the end of the war, when international communications were re-established. At that time, contact developed between the Dutch and Russian avant-garde, especially through El Lissitzky.

Mondrian: Seeking the Spiritual Through the Rational

In evaluating the course of geometric abstraction from its beginnings, in about 1911, to the present, an understanding of Piet Mondrian's role is of paramount importance and will, therefore, be treated at some length. He was the principal figure in the evolution of geometric abstraction during World War I, for the ideas of de Stijl and their logical development were primarily his achievement. Mondrian's influence extended not only to abstract painting and sculpture but also to the forms of the International Style in architecture. During the 1920s and 30s in Paris it was probably the presence and inspiration of Mondrian more than any other single person that enabled abstraction to survive and gradually to gain strength—in the face of the "call to order" and the 1920s return to figuration, as well as economic depression, threats of dictatorship, and war. Mondrian also played a central part in the rise of abstraction in American art during the 1940s and 50s.

Early Work

A transition from fairly conventional naturalistic paintings to a revolutionary modern style during and after World War I can be traced in the career of **Piet Mondrian** (1872–1944). Born Pieter Mondriaan, he was trained in the Amsterdam Rijksacademie and until 1904 worked primarily as a landscape painter. He then came under the influence of Jan Toorop and for a time painted in a Symbolist manner. His early work evinces a tendency to work in series—which proved central to the development of his abstract work—and to focus on a single scene or object, whether a windmill, a thicket of trees, a solitary tree, or an isolated chrysanthemum. Early landscapes adhered to a principle of frontality and, particularly in a series of scenes with windmills, to cutoff, close-up presentation. This phase of Mondrian's career also reveals his preoccupation with his own spirituality. Like many artists and intellectuals, Mondrian was drawn toward the **syncretic** and universalizing ideas of Theosophy. Like many of the spiritualist practices that emerged during the second half of the nineteenth century, Theosophy combined aspects of Christian and Jewish mysticism with Eastern practices, especially Hinduism and Buddhism. Adherents to Theosophical beliefs hold that a fundamental harmony unites all living things, and this essential unity manifests itself visually in certain shapes, especially simple geometric forms like squares and circles. For some artists attracted to Theosophy, like Mondrian, Vasily Kandinsky, and the architect Rudolf Steiner, pure abstraction could convey a sense of universality in a way that representational art could not.

By 1908 Mondrian was becoming aware of some of the innovations of modern art. His color blossomed in Fauve-inspired blues, yellows, pinks, and reds. In forest scenes he emphasized the linear undulation of saplings; in shore- and seascapes, the intense, flowing colors of sand dunes and water. For the next few years he painted motifs such as church façades presented frontally, in nearly abstract planes of arbitrary color or in patterns of loose red and yellow spots deriving from the Neo-Impressionists and the brushstrokes of Van Gogh. With any of his favorite subjects—the tree, the dunes and ocean, the church or windmill, all rooted in the familiar environment of the Netherlands—one can trace his progress from naturalism through Symbolism, Impressionism, Post-Impressionism, Fauvism, and Cubism to abstraction. In *Apple Tree* (fig. **12.1**), an image to which he devoted several paintings and drawings, Mondrian employed expressive, animated brushwork reminiscent of Van Gogh's, causing the whole scene to pulsate with energy.

In early 1912 Mondrian moved to Paris. Though he had seen early Cubist works by Picasso and Braque in Holland, he became fully conversant with the style in the French capital. It is in the wake of this experience that he emerges as a major figure in modern art. He himself came to regard the previous years as transitional. During his first years in Paris, Mondrian subordinated his colors to grays, blue-greens, and ochers under the influence of the Analytic

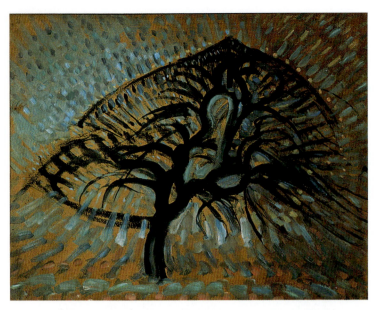

12.1 Piet Mondrian, *Apple Tree, Pointillist Version*, 1908–09. Oil on composition board, 22⅜ × 29½" (56.8 × 75 cm). A673. Dallas Museum of Art. Gift of the James H. and Lillian Clark Foundation. © 2012 Mondrian/Holtzman Trust c/o HCR International USA.

Cubism of Picasso and Braque (see figs. 7.19, 7.20). But he rarely attempted the tilted planes or sculptural projection that gave the works of the French Cubists their defined, if limited, sense of three-dimensional spatial existence; his most Cubist paintings still maintained an essential frontality. Mondrian was already moving beyond the tenets of Cubism to eliminate both subject and three-dimensional illusionistic depth.

As early as 1912 the tree had virtually disappeared into a linear grid that covered the surface of the canvas. Mondrian at this time favored centralized compositions, which involve greater density in the center with gradual loosening toward the edges. His occasional adoption of the oval canvas (inspired by the Cubists) allowed him to emphasize further the ideas of center and periphery. As his experiments continued, the linear structure of his paintings became more rectangular and abstract. By 1914 the artist had begun to experiment with a broader but still subtle range of colors, asserting their identity within a structure of horizontal and vertical lines.

In Paris Mondrian was profoundly affected by the example of Cubism, but he gradually began to feel that the style "did not accept the logical consequences of its own discoveries: it was not developing abstraction toward its ultimate goal, the expression of pure reality. I felt that this could only be established by pure plastics (plasticism)." In this statement, made in 1942, he emphasized the two words that summarize his lifelong quest—"plastic" and "reality." To him "plastic expression" referred to capacity of colors and forms to assert their presence, to affect the viewer. "Reality" or "the new reality" was the reality of plastic expression, or the reality of forms and colors in the painting. Thus, the new reality was the presence of the painting itself, as opposed to the painted imitation of nature or the romantic evocation of the artist's emotions.

Neoplasticism

Gradually, as the artist tells it, Mondrian became aware that "(a) in plastic art reality can be expressed only through the equilibrium of dynamic movements of form and color; (b) pure means afford the most effective way of attaining this." These ideas led him to develop a set of organizational principles in his art. Chief among them were the balance of unequal opposites, achieved through the right angle, and the simplification of color to the primary hues plus black and white. It is important to recall that Mondrian did not arrive at his final position solely through theoretical speculation, but through long and complex development.

In 1914 Mondrian returned to Holland to visit his ailing father; he was forced to stay when the war broke out. Between 1914 and 1916 he eliminated all vestiges of curved lines, so that the structure became predominantly vertical and horizontal. The paintings were still rooted in subject—a church façade, the ocean, and piers extending into the ocean—but these were now simplified to a pattern of short, straight lines, like plus and minus signs, through which the artist sought to suggest the underlying structure of nature. During 1917 and later he explored another variation (fig. **12.2**)—rectangles of flat color of varying sizes, suspended in a sometimes loose, sometimes precise rectangular arrangement. The color rectangles sometimes touch, sometimes float independently, and sometimes overlap. They appear positively as forms in front of the light background. Their interaction creates a surprising illusion of depth and movement, even though they are kept rigidly parallel to the surface of the canvas. It was in 1917 that Mondrian began contributing essays to *de Stijl*, embarking on a fertile association with Van Doesburg and the group's other members that would last until 1925. Mondrian's presence in Paris, where he lived again from 1919 until 1938, made him the *de facto* spokesman for de Stijl, a movement still largely unknown among French avant-garde artists until the early 1920s. Mondrian soon realized that these detached color planes created both a tangible sense of depth and a differentiation of foreground and background; this interfered with the pure reality he was seeking. This discovery led him during 1918 and 1919 to a series of works organized on a strict rectangular grid. In the so-called "checkerboards," rectangles of equal size and a few different colors are evenly distributed across the canvas. By controlling the strength and tone of his colors, Mondrian here neutralized any distinction between figure and ground, for the white and gray rectangles do not recede behind the colored ones or assume a subordinate role as support. Mondrian did not develop this compositional solution further, for he felt the modular grid was too prominent. Finally, therefore, he united the field of the canvas by thickening the dividing lines and running them through the rectangles to create a linear structure in tension with the color rectangles. In 1920, after returning to Paris, Mondrian came to the fulfillment of his Neoplastic artistic ideals. His paintings of this period express abstract, universal ideas: the dynamic balance of vertical and horizontal linear structure and simple,

fundamental color. Mondrian's ultimate aim was to express a visual unity through an "equivalence of opposites"; this in turn expressed the higher mystical unity of the universe.

In 1920, with his first full-fledged painting based on the principles of Neoplasticism (meaning roughly "new image" or "new form"), Mondrian had found his solution to a long unsolved problem—how to express universals through a dynamic and asymmetrical equilibrium of vertical and horizontal structure, with primary hues of color disposed in rectangular areas. These elements gave visual expression to Mondrian's beliefs about the dynamic opposition and balance between the dual forces of matter and spirit, theories that grew out of his exposure to Theosophy and the dialectical theories of the early nineteenth-century German philosopher Georg Wilhelm Friedrich Hegel. It was only

through the pure "plastic" expression of what Mondrian called the "inward" that humans could approach "the divine, the universal."

In his painting, Mondrian was disturbed by the fact that, up to this point, in most of his severely geometric paintings—including the floating color-plane compositions and the so-called "grid" or "checkerboard" paintings—the shapes of red, blue, or yellow seemed to function visually as foreground forms against a white and gray background (see fig. 12.2) and thus to interfere with total unity. The solution, he found, lay in making the forms independent of color, with heavy lines (which he never thought of as lines in the sense of edges) moving through the rectangles of color. By this device he was able to gain a mastery over color and space that he would not exhaust for the next twenty years.

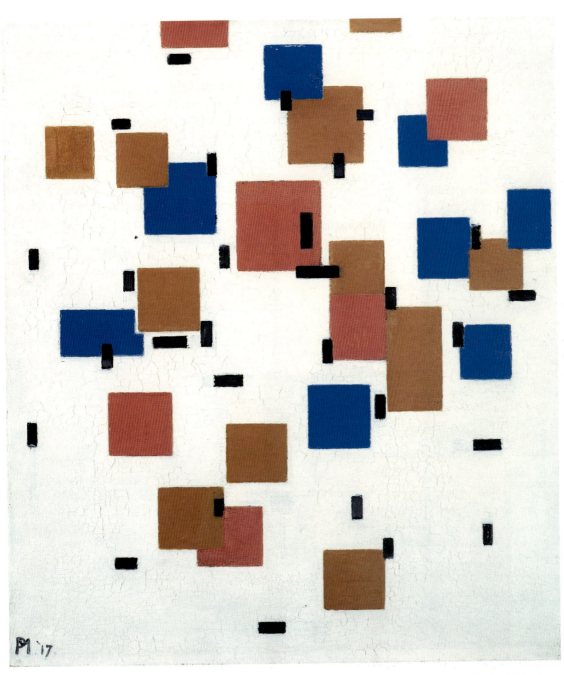

12.2 Piet Mondrian, *Composition in Color A*, 1917. Oil on canvas, 19⅞ × 17⅞" (50.3 × 45.3 cm). B84. Kröller-Müller Museum, Otterlo, the Netherlands. © 2012 Mondrian/Holtzman Trust c/o HCR International USA.

A mature example of Neoplasticism is seen in the *Tableau No. II 1921–25, with Red, Blue, Black, Yellow, and Gray* (fig. **12.3**). Here is the familiar palette of red, blue, yellow, black, and two shades of gray. The total structure is emphatic, not simply containing the color rectangles but functioning as a counterpoint to them. Both red and gray areas are divided into larger and smaller rectangles with black lines. The black rectangles, since they are transpositions of lines to planes, act as further unifying elements between line and color. The edges of the painting are left open. Along the top and in the lower left corner, the verticals do not quite go to the edge, with the consequence that the grays at these points surround the ends of the lines. Only in the lower right does the black come to the edge, and this is actually a black area through which the line moves slightly to the left of the edge. In all other parts a color, principally gray, but red and yellow at the upper left, forms the outer boundary. The result that Mondrian sought—an absolute but dynamic balance of vertical and horizontal structure, using primary hues and black and white—is thus achieved. Everything in the painting holds its place. By some purely visual phenomenon, caused by the structure and the subtle disposition of color areas, the grays are as assertive as the reds or yellows; they advance as well as recede. The painting is not flat. Everything is held firmly in place, but under great tension.

The open composition with emphasis on large white or light-gray areas predominated in Mondrian's production during the 1920s and, in fact, for the rest of his life. He usually worked on several pictures at once and often developed a single idea by working in series, devoting as many as eight paintings to variations on a single theme. He made several variations within a square format, including *Composition with Red, Blue, and Yellow* (1930), in which a large color square of red, upper right, is joined point to point with a small square of comparably intense blue by intersecting black lines. Surrounding them, equally defined by heavy black lines, are rectangles of off-white. In the lower right corner is one small rectangle of yellow. The white areas, combined with the subordinate blue and yellow, effectively control and balance the great red square. Although Mondrian did not ascribe symbolic meaning to colors in the way that, for example, Kandinsky did, he told a collector that his paintings with a predominant red were "more real" than paintings with little or no color, which he considered "more spiritual."

The Break with de Stijl

Mondrian resigned from de Stijl in 1925 after disagreements with Van Doesburg about the nature of de Stijl architecture (though the artists were reconciled in 1929). While Mondrian envisioned, like his de Stijl colleagues, the integration of all the arts, he fervently believed in the superiority of painting, another point of departure from a tenet of de Stijl. A prolific writer and theoretician, Mondrian fully formulated his mature ideas during the 1920s.

Despite this break with Van Doesburg, Mondrian continued working in the Constructivist vein commended by the de Stijl group. His studio in Paris was a spartan living space but a remarkable artistic

12.3 Piet Mondrian, *Tableau No. II, with Red, Blue, Black, Yellow, and Gray*, 1921–25. Oil on canvas, 29⅝ × 25⅝" (75 × 65 cm). B121/154. Private collection, Zurich. © 2012 Mondrian/Holtzman Trust c/o HCR International USA.

environment that was famous throughout the European art world. For his ideal Neoplastic environment, the artist created geometric compositions on the studio walls with arrangements of colored squares. The easel was more for viewing than working (he preferred to paint on a horizontal surface). In 1930 Mondrian was visited by Hilla Rebay, an artist and zealous supporter of abstract art who was to help found the Museum of Non-Objective Painting in New York, eventually to become the Solomon R. Guggenheim Museum. "He lives like a monk," she observed, "everything is white and empty, but for red, blue, and yellow painted squares that are spread all over the room of his white studio and bedroom. He also has a small record player with Negro music." Second only to painting was the artist's abiding passion for American jazz.

Lozenge Composition with Four Yellow Lines (fig. 12.4) is among Mondrian's most beautiful so-called "lozenge" or "diamond" paintings. In this format, first used by him in 1918, the square painting is turned onto its corner but the horizontal and vertical axes are maintained internally. The shape inspired some of Mondrian's most austere designs, in which his desire to transgress the frame, to express a sense of incompleteness, was given tangible expression. *Lozenge Composition with Four Yellow Lines* represents an ultimate

simplification in its design of four yellow lines, delicately adjusted in width and cutting across the angles of the diamond. Mondrian's fascination with the incomplete within the complete, the tension of lines cut off by the edge of the canvas that seek to continue on to an invisible point of juncture outside it, is nowhere better expressed than here. The viewer's desire to rejoin and complete the lines, to recover the square, is irresistible. The fascination of this magnificently serene painting also lies in another direction—the abandonment of black. Mondrian would fully develop this aspect in his very last works (see fig. 16.1). It is important to note that he also designed his own frames out of narrow strips of wood that he painted white or gray and set back from the canvas. He wished to emphasize the flat, nonillusionistic nature of his canvases, "to bring the painting forward from the frame … to a more real existence."

In 1932 Mondrian introduced a dramatic new element in one of his Neoplastic compositions when he divided a black horizontal into two thin lines. With this "double line" he set out to replace all vestiges of static form with a "dynamic equilibrium." This innovation brought a new, vibrant opticality to the work, with Mondrian multiplying the number of lines until, by the late 1930s, the paintings contained irregular grids of black lines with only one or a few planes

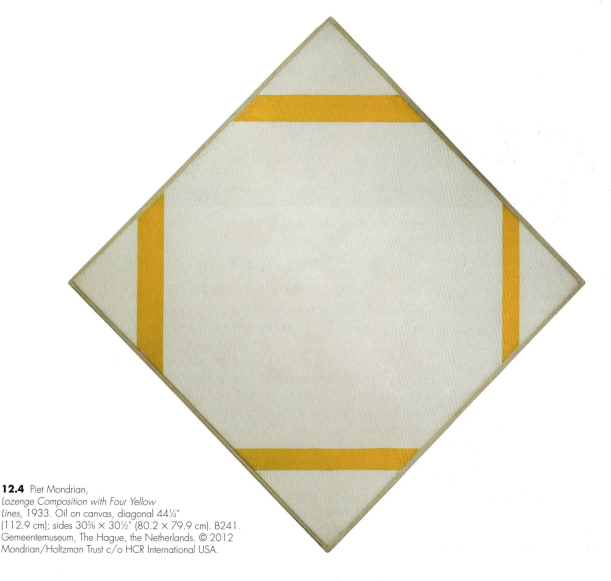

12.4 Piet Mondrian,
Lozenge Composition with Four Yellow Lines, 1933. Oil on canvas, diagonal 44¼"
(112.9 cm); sides 30⅝ × 30½" (80.2 × 79.9 cm). B241.
Gemeentemuseum, The Hague, the Netherlands. © 2012
Mondrian/Holtzman Trust c/o HCR International USA.

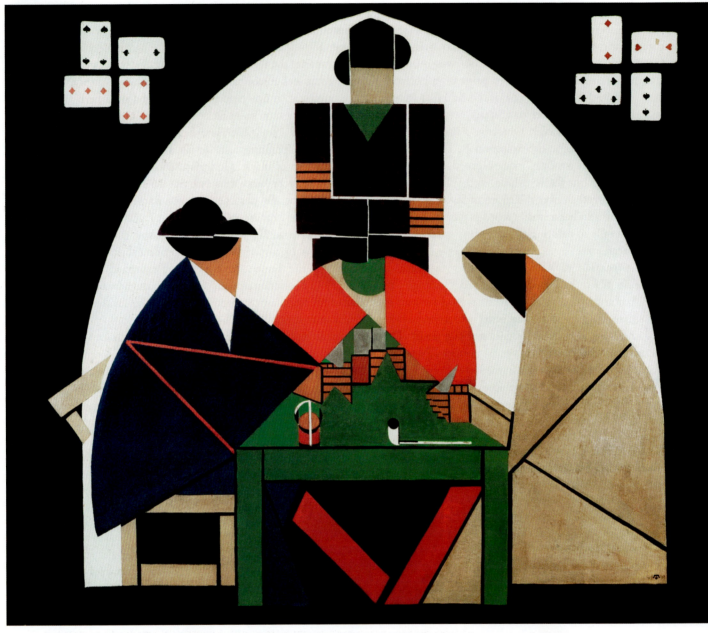

12.5 Theo van Doesburg, *Card Players*, 1916–17. Tempera on canvas, 46½ × 58" (118.1 × 147.3 cm). Private collection.

of color. A midway point in this development is *Composition in White, Black, and Red* of 1936, a structure of vertical and horizontal black lines on a white ground, with a small black rectangle in the upper left corner and a long red strip at the bottom. The lines, however, represent intricate proportions, both in the rectangles they define and in their own thickness and distribution. In the right lower corner, horizontal lines, varied subtly in width, create a grid in which the white spaces seem to expand and contract in a visual ambiguity.

Only the commencement of the bombing of Paris by the Germans in World War II persuaded Mondrian to abandon his studio and emigrate to the United States, where he had friends and collectors eager to help him. There he would join a diverse group of artists displaced from Europe by the war. These émigrés were to exert considerable influence on stylistic developments (see Ch. 16, pp. 377–83). Mondrian would also find an audience tentatively appreciative of avant-garde trends.

Van Doesburg, de Stijl, and Elementarism

As already noted, **Theo van Doesburg** (1883–1931) was the moving spirit in the formation and development of de Stijl, though Mondrian's greater celebrity in Paris and, especially, in New York made him a prominent symbol of the movement. During his two years of military service (1914–16) Van Doesburg studied the new experimental painting and sculpture and was particularly impressed by Kandinsky's essay, *Concerning the Spiritual in Art*. In 1916 he experimented with free abstraction in the manner of Kandinsky, as well as with Cubism, but was still searching for his own path. This he found in his composition *Card Players* (fig. **12.5**), based on a painting by Cézanne, but simplified to a complex of interacting shapes based on rectangles, the colors flat and reduced nearly to primaries. Fascinated by the mathematical implications of his new abstraction, Van

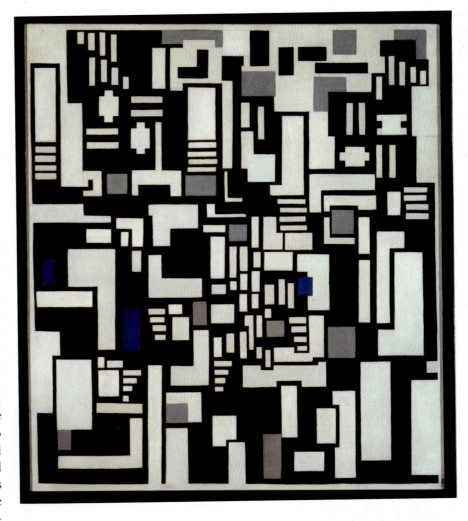

12.6 Theo van Doesburg, *Composition IX (Card Players)*, 1917. Oil on canvas, 45⅝ × 41¾" (115.9 × 106 cm). Gemeentemuseum, The Hague, the Netherlands.

Doesburg explored its possibilities in linear structures, as in a later version of *Card Players* (fig. **12.6**).

Even Mondrian was affected by the fertility of Van Doesburg's imagination. When artists work together as closely as the de Stijl painters did during 1917–19, it is extremely difficult and perhaps pointless to establish absolute priorities. Van Doesburg, Mondrian, and their colleague Bart van der Leck for a time were all nourished by one another. However, each went in his own direction in the 1920s, when Van Doesburg's attention turned toward architecture. He followed de Stijl principles until he published his *Fundamentals of the New Art* in 1924. He then began to abandon the rigid vertical–horizontal formula of Mondrian and de Stijl and to introduce diagonals. This heresy, as well as fundamental differences over the nature of Neoplastic architecture, contributed to Mondrian's resignation from de Stijl. Though by 1918 Mondrian himself made lozenge-shaped paintings with diagonal edges (see fig. 12.4), a development he discussed at length with Van Doesburg, the lines contained within his compositions always remained strictly horizontal and vertical.

In a 1926 manifesto in *de Stijl*, Van Doesburg named his new departure Elementarism, and argued that the inclined plane reintroduced surprise, instability, and dynamism. In his murals at the Café l'Aubette, Strasbourg (fig. 12.7)—decorated in collaboration with Jean Arp and Sophie Taeuber (see figs. 10.3–10.6)—Van Doesburg made his most monumental statement of Elementarist principles. He tilted his colored rectangles at forty-five-degree angles and framed them in uniform strips of color. The tilted rectangles were in part cut off by the ceiling and lower wall panels. Across the center ran a long balcony with steps at one end that added a horizontal and diagonal to the design. Incomplete rectangles emerged as triangles or irregular geometric shapes. In proper de Stijl fashion, Van Doesburg designed every detail of the interior, down to the ashtrays. Here he realized his ideals about an

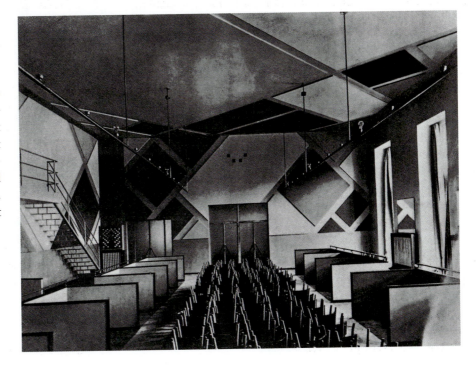

12.7 Theo van Doesburg, Sophie Taeuber, and Jean (Hans) Arp, Interior, Café l'Aubette, 1926–28, Strasbourg, destroyed 1940.

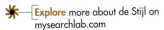
Explore more about de Stijl on mysearchlab.com

all-embracing, total work of abstract art, saying that his aim was "to place man within painting instead of in front of it and thereby enable him to participate in it."

In the richly diverse and international art world of the 1920s, Van Doesburg provided a point of contact between artists and movements in several countries. He even maintained a lively interest in Dada. His Dada activities included his short-lived magazine *Mecano*, his poems written under the pseudonym of I. K. Bonset, and a Dada cultural tour of Holland with his friend Kurt Schwitters.

Until his death in 1931, Van Doesburg promoted de Stijl abroad, traveling across Europe and seeking new adherents to the cause as older members defected. His efforts contributed to the establishment of de Stijl as a movement of international significance. With its belief in the integration of the fine and applied arts, the de Stijl experiment paralleled that of the Bauhaus in many ways. Van Doesburg was in Weimar in the early 1920s, lecturing and promoting de Stijl ideas at the Bauhaus, and fomenting dissent among the school's younger members. Although he was not a member of the faculty, he probably contributed to an increased emphasis at the Bauhaus on rational, machine-based design.

De Stijl Realized: Sculpture and Architecture

Although the most influential theorists of de Stijl—Van Doesburg and Mondrian—are known primarily for their painting, one of the central tenets of the movement was the assertion that artworks cannot be conceived of individually, as unconnected objects of aesthetic fascination. On the contrary, artistic production should be harnessed to a program of aesthetic and social integration. For this reason it is not surprising that some of the most convincing manifestations of de Stijl thinking appear in three-dimensional works such as architecture, interior design, and sculpture. Few de Stijl buildings remain standing. Their plans, though—and the ideas motivating them—were widely disseminated in the years immediately following the war, contributing significantly to the international development of modern architecture.

Formative influences on de Stijl architects were H. P. Berlage and Frank Lloyd Wright (see Ch. 8, pp. 172–76, 183–84). J. J. P. Oud, Robert van 't Hoff, and Gerrit Rietveld, three of its principal architects, were also acquainted with the early modernists in Germany and Austria—Behrens, Loos, Hoffmann, and Olbrich—but their association with Mondrian and Van Doesburg had considerable influence on the forms that their architecture would take. Another important influence were the writings of M. H. J. Schoenmaekers, which also provided a philosophical base for Mondrian's painting and theorizing before 1917. Schoenmaekers propounded a mystical cosmology based on the rectangle. Inspired by Theosophy, his *Elements of Expressive Mathematics* (1916) sought to uncover the hidden relationships between natural forms. From such ideas arose an architecture of flat roofs, with plain walls arranged according to definite systems that create a functional and harmonious interior space.

In their aesthetic, the architects and artists of de Stijl were much concerned with the place of the machine and its function in the creation of a new art and a new architecture. They shared this concern with the Italian Futurists, with whom Van Doesburg corresponded (Severini was a regular corresponding member of de Stijl), but they departed from the emotional exaltation of the machine in favor of enlisting its power to create a new collective order. From this approach arose their importance for subsequent experimental architecture. Van Doesburg called architecture the "synthesis of all the arts" and said that it would "spring from human function" rather than from historical building types developed in a time when the patterns of domestic life had little in common with modern lifestyles.

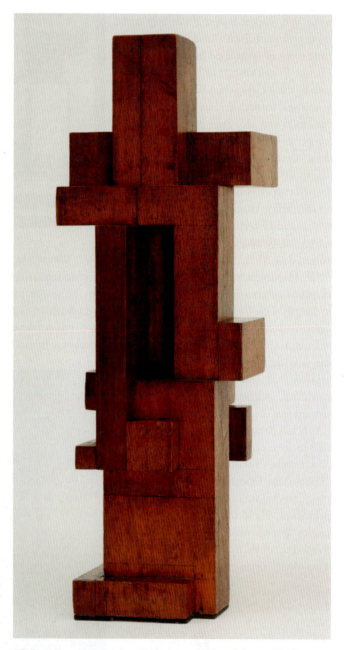

12.8 Georges Vantongerloo, *Construction of Volume Relations*, 1921. Mahogany, 16⅛ × 5⅝ × 5¾" (41 × 14.4 × 14.5 cm), including base. The Museum of Modern Art, New York.

👁 Watch a video about Vantongerloo on mysearchlab.com

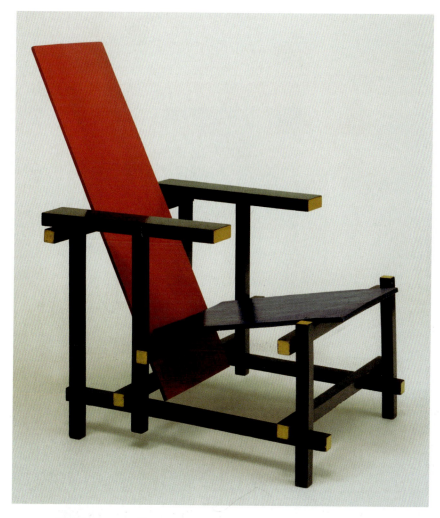

12.15 Gerrit Rietveld, *Red and Blue Chair*, 1917 (painted 1923). Painted wood, height 34½" (87.6 cm). The Museum of Modern Art, New York.

which, like all of Rietveld's furniture, eschews any sense of the luxurious or highly crafted object, for it was intended for mass production (which never took place). The tilted planes of the seat and back, which have parallels in the linear structures of some of Van Doesburg's paintings (see figs. 12.5, 12.6), convey less a sense of classical balance than of dynamic equilibrium. "The construction," the artist wrote, "is attuned to the parts to insure that no part dominates or is subordinate to the others. In this way the whole stands freely and clearly in space, and the form stands out from the material." Fundamental to de Stijl philosophy was this sense of the integral relationship between the whole and its constituent parts. Rietveld's influence was keenly felt at the Bauhaus art school, whose director Walter Gropius shared his commitment to aesthetic unity and pointed to his designs as exemplary models for students. Until his death in 1964, Rietveld remained one of the masters of Dutch architecture, receiving many major commissions, of which the last was the Van Gogh Museum in Amsterdam, begun posthumously in 1967.

Van Eesteren

Cornelis van Eesteren (1897–1988) collaborated with Van Doesburg on a number of architectural designs during the 1920s, including a project for a house that was one of the most monumental efforts in de Stijl domestic architecture attempted to that date. In contrast with Rietveld's approach, the palatial edifice of the projected Rosenberg House (fig. **12.16**) emphasized the pristine rectangular masses of the building, coordinated as a series of wings spreading out from a central core, defined by the strong vertical accent of the chimney pier in the mode of Wright. In the central mass they opened up the interior space with cantilevered terraces. Van Eesteren was also an influence on Gropius, who would likewise use cantilevered terraces in his design for the Bauhaus campus (see Ch. 13, pp. 278–79).

Trained as a cabinetmaker, Rietveld also designed furniture, which assumed a role much like functional sculpture within de Stijl interiors. His *Red and Blue Chair* (fig. **12.15**) is among the most succinct statements of de Stijl design. Rietveld first constructed the chair in plain wood in 1917, and painted it in 1923. The seat is blue, the back is red, and the sections of the frame are black with yellow ends. The simple, skeleton-like frame clearly discloses its structure,

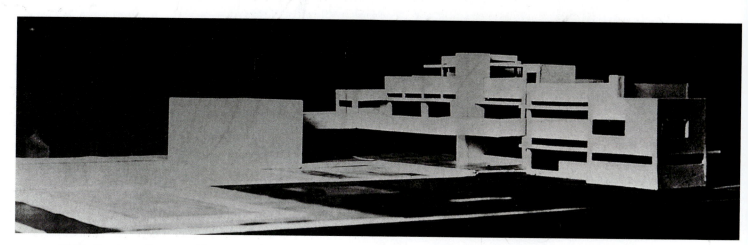

12.16 Cornelis van Eesteren and Theo van Doesburg, Project for the Rosenberg House, 1923. The Museum of Modern Art, New York.

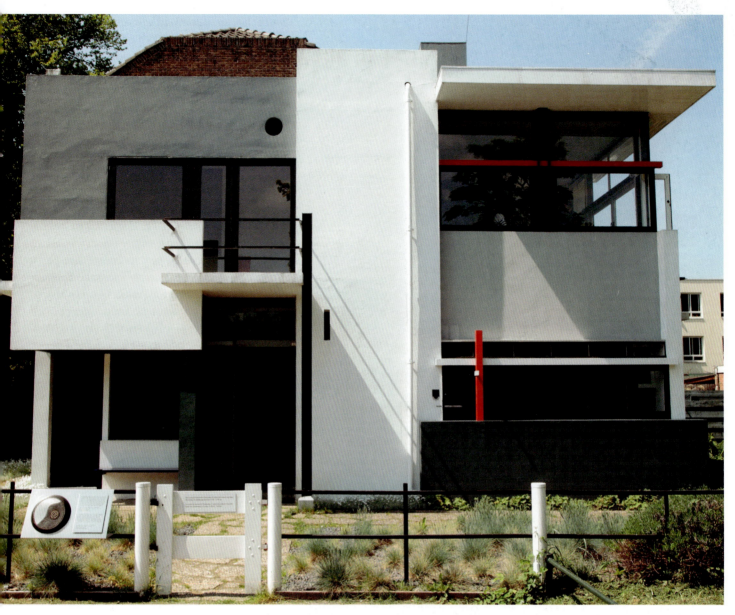

12.13 View of exterior of Schröder House, 1924.

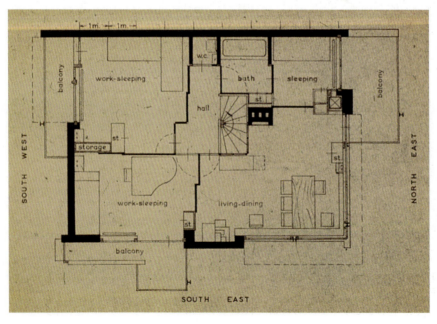

12.14 Plan of Schröder House.

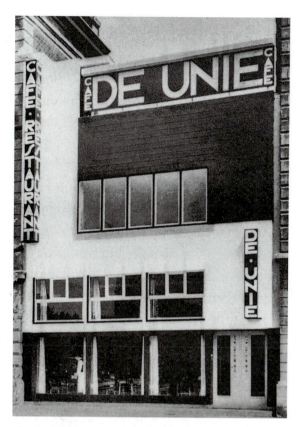

12.11 J. J. P. Oud, Café de Unie, 1925. Destroyed 1940. Rotterdam, the Netherlands.

low-cost housing. In the façade design of the Café de Unie in Rotterdam (fig. **12.11**), Oud almost literally translated a 1920s Mondrian painting into architectural terms, at the same time illustrating the possibilities of de Stijl for industrial, poster, and typographic design. The café was destroyed in the bombing of Rotterdam in 1940 during World War II.

Rietveld

The most complete statement of de Stijl architecture is the Schröder House (1924; fig. **12.12**), designed by **Gerrit Rietveld** (1888–1964) as a commission from Mrs. Truus Schröder-Schräder, who collaborated closely with Rietveld on its design. Mrs. Schröder lived in the house for sixty years and, toward the end of her life, initiated the Rietveld Schröder House Foundation, which oversaw its complete renovation between 1974 and 1987. Rietveld used detached interlocking planes of rectangular slabs, joined by unadorned piping, to break up the structure, giving the whole the appearance of a Constructivist sculpture (fig. **12.13**). The large corner and row windows give ample interior light; cantilevered roofs shelter the interior from the sun; and, according to Mrs. Schröder's requirements, sliding partitions created open-plan spaces for maximum flexibility of movement (fig. **12.14**). The rooms are light, airy, and cool, thus planned to create a close relationship between the interior spaces and exterior nature.

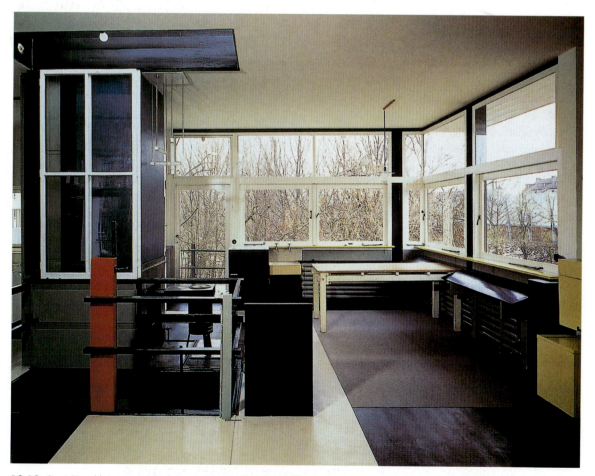

12.12 Gerrit Rietveld, Living and dining area, Schröder House, with furniture by Rietveld.

Watch a video about the Schröder House on mysearchlab.com

Vantongerloo

Free-standing sculpture, like architecture, guides a viewer's experience of space and time as well as of form and color. Sculpture refuses to divulge its content completely to a viewer who remains static. Experiments in sculpture by de Stijl artists generally engage many of the same principles and problems addressed by architecture. In sculpture the achievements of de Stijl were concentrated principally in the works of the Belgian **Georges Vantongerloo** (1886–1965). He was not only a sculptor but also a painter, architect, and theoretician. His first abstract sculptures (fig. **12.8**), executed in 1921, were conceived in the traditional sense as masses carved out of the block, rather than as constructions built up of separate elements. They constitute notable transformations of de Stijl painting into three-dimensional design. Later, Vantongerloo turned to open construction, sometimes in an architectural form and sometimes in free linear patterns. In his subsequent painting and sculpture he frequently deserted the straight line in favor of the curved, but throughout his career he maintained an interest in a mathematical basis for his art, to the point of deriving compositions from algebraic equations.

Van 't Hoff and Oud

The actual buildings created by these architects before 1921 were not numerous. A house built by **Robert van 't Hoff** (1852–1911) in Utrecht in 1916 (fig. **12.9**) antedated the formation of de Stijl and was almost entirely based on his firsthand observations of Wright's work in Chicago, as may be seen in the cantilevered cornices, the grouping of windows, the massing of corners, as well as the severe rectangularity of the whole. Van 't Hoff was an adventurous designer, at least in his theories. He was the first member of de Stijl to discover the Futurist architect Sant'Elia, about whose unfulfilled projects (see fig. 9.18) he wrote in *de*

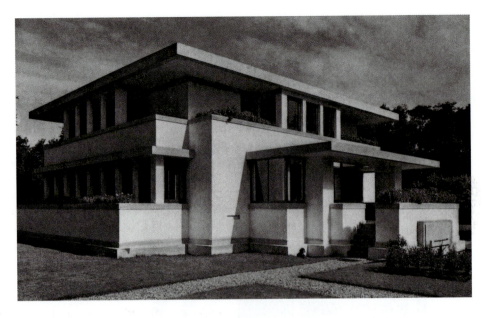

12.9 Robert van 't Hoff, Huis ter Heide, 1916. Utrecht, the Netherlands.

Stijl. The unrealized project that **J. J. P. Oud** (1890–1963) prepared for seaside housing on the Strand Boulevard at Scheveningen, the Netherlands, in 1917 displays the future International Style housing strategy in a flat-roofed, terraced row of repeated individual rectangular units. A 1919 project by Oud for a small factory was a combination of cubic masses alternating effectively with vertical chimney pylons and horizontal windows in the Wright manner. Instead of the typical early Wright pitched roof, however, these architects, almost from the beginning, opted for a flat roof, thus demonstrating a relationship to de Stijl painters. In the best-known and in many ways most influential of his early buildings, the 1924–27 housing project for workers at Hook of Holland (fig. **12.10**), Oud employed wraparound, curved corners on his façades and solidly expressed brickwork in a manner that suggested a direct line of influence from Berlage, despite the rectangularity and openness of the fenestration and the flat roofs. The workers' houses had an importance beyond their stylistic influence as an early example of enlightened planning for well-designed,

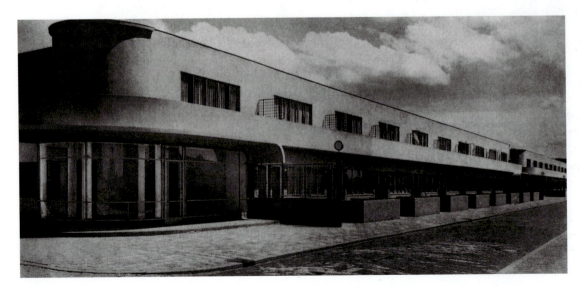

12.10 J. J. P. Oud, Workers' Housing Estate, 1924–27. Hook of Holland.

13
Bauhaus and the Teaching of Modernism

By 1918, progressive artists had introduced radical innovations to all areas of artistic production. Formal arts education, however, remained rooted in academic practices dating back to the seventeenth century. Since that time, specialization in a particular technique had been codified into the academic approach, a method that tended to maintain strict divisions between painting, sculpture, and architecture. Other forms of artistic production, including decorative or "applied" arts along with printmaking and photography, were typically excluded from academy programs, which taught only "fine art." By the late nineteenth century, modern artists increasingly eschewed these narrow categories, demonstrating an eagerness to explore diverse media and techniques. Paul Gauguin, for instance, employed painting, carving, and printmaking in an effort to give shape to his aesthetic aims. Such experimentation had only become more frequent in the early twentieth century.

Another convention maintained by arts academies was the focus on nature as model. Life classes, in which students draw a nude model posed in the studio, remained a staple in arts education, even though the history paintings and the heroic or mythological sculptural programs for which life drawing formerly prepared students were no longer in great demand. Many avant-garde artists, such as Matisse and Picasso, received prolonged academic training before turning to new influences such as African sculpture or popular prints in an effort to shake loose academic habits. At the other extreme, artists like Henri Rousseau or Theo van Doesburg were largely self-taught, thus less encumbered by academic conventions.

One of the earliest experiments in progressive arts education unfolded in Russia during the early years of the Soviet Union. Narkompros (the People's Commissariat for Enlightenment) initiated an arts education division in 1920 called Inkhuk (the Institute of Artistic Culture). Administered and staffed by some of the leading lights of the Russian avant-garde including Malevich, Lissitzky, and Kandinsky, Inkhuk was closely monitored by the Soviet government for doctrinal orthodoxy (see Ch. 9, p. 204). Such tight oversight as well as the diverse views of the artists involved made it difficult to establish and adhere to a coherent curriculum.

A more successful program for progressive arts education, the Bauhaus, opened in 1918 in Weimar, capital of an unsteady postwar Germany. The new art school encountered a challenging proving ground in the nascent Weimar Republic (1918–33). Traumatized by the war, beset by financial difficulties imposed by their victorious enemies, threatened by an influenza epidemic, and riven by political factions, Germans were confronting an uncertain future. The brutal suppression of socialist and Communist opposition to the new government signaled the regime's desperation. Growing popular resentment over the settlement of the peace and fear of accelerating economic privations soured much of the initial enthusiasm for a republican system of government. These conditions facilitated the rise of the National Socialist (Nazi) Party, whose leader Adolf Hitler assumed dictatorial powers in 1933. It was against this tumultuous backdrop that the Bauhaus transformed modern arts education, creating a system that endures today.

From its inception until 1928, the Bauhaus was under the direction of the architect Walter Gropius. Gropius provided the Bauhaus with the strong—some even felt autocratic—leadership and coherent vision missing from the Russian Constructivists' program at Inkhuk. It was Gropius's commitment to functionalism, his sympathy for Constructivist ideas, and his belief that art could improve society that launched this unparalleled institution. Any serious discussion of the Bauhaus must begin with a consideration of Gropius's work and career.

Audacious Lightness: The Architecture of Gropius

Many German artists who emerged from World War I resolved to place their art in the service of social betterment, to develop a new culture that would guide society toward political harmony and prosperity. **Walter Gropius** (1883–1969) not only epitomizes this attitude, but he put his beliefs into practice with a determination that few could match. This resoluteness emerged early in his career. Gropius was not naturally gifted at drafting. While many would have accepted this shortcoming as an insurmountable barrier to becoming a professional architect, Gropius turned the deficit

13.1 Walter Gropius and Adolph Meyer, Fagus Shoe Factory, 1911–25. Alfeld-an-der-Leine, Germany.

⊙─[**Watch** a video about Walter Gropius on mysearchlab.com

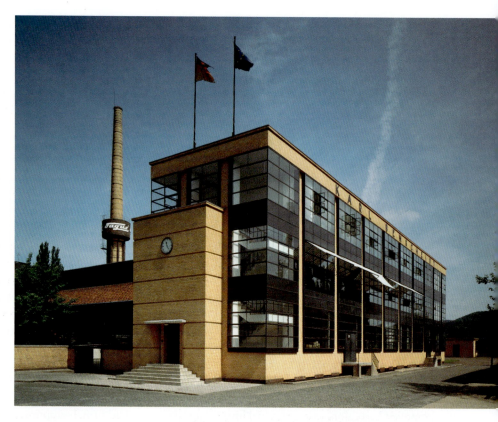

to his advantage. Throughout his career, he relied on draftsmen to render his designs, a practice that left him with more time for creative thinking and teaching. His training included two years (1908–10) in the office of Peter Behrens (see Ch. 8, pp. 180–81), where he adopted the view that industry and design could benefit through integration. Thanks to Behrens's influence, Gropius maintained an unwavering commitment to the belief that modern technologies and manufacturing practices could be used to serve aesthetic ends. During his time with Behrens, Gropius became acquainted with other young architects with whom he would maintain long associations, including **Adolph Meyer** (1881–1929) and Ludwig Mies van der Rohe.

Gropius left Behrens's firm in 1910 to establish a practice with Meyer in Berlin. The following year, they designed a factory for the Fagus Shoe Company at Alfeld-an-der-Leine (fig. **13.1**). The Fagus building represents a sensational innovation in its utilization of complete glass sheathing, even at the corners. In effect, Gropius here had invented the curtain wall that would play such a visible role in the form of subsequent large-scale twentieth-century architecture.

Gropius and Meyer were commissioned to build a model factory and office building in Cologne for the 1914 Werkbund Exhibition of arts and crafts and industrial objects (fig. **13.2**). Gropius felt that factories should possess the monumentality of ancient Egyptian temples. For one façade of their "modern machine factory," the architects combined massive brickwork with a long, horizontal expanse of open glass sheathing, the latter most effectively used to encase the exterior spiral staircases at the corners (clearly seen in the view reproduced here). The pavilions at either end have flat overhanging roofs derived from Frank Lloyd Wright (see fig. 8.7), whose work was known in Europe after 1910, and the entire building reveals the elegant and disciplined design that became a prototype for many subsequent modern buildings.

World War I temporarily prevented further collaborations between Gropius and Meyer. Accepting an officer's commission, Gropius served on the front lines. In 1915, he married Alma Mahler, whose intense affair with the Expressionist painter Oskar Kokoschka had recently ended. With the conclusion of the war in 1918, Gropius was called to revive and direct one of the many cultural institutions neglected during the war, including the School of Industrial Art (Kunstgewerbeschule Sachsen) that Henry van de Velde had organized in Weimar in 1908. The school had been

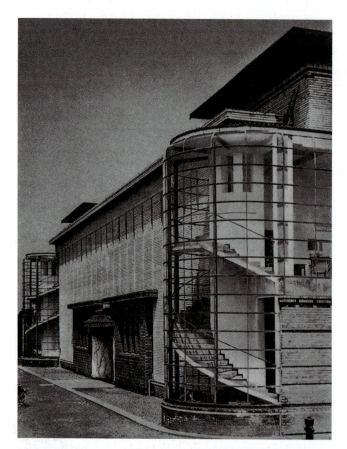

13.2 Walter Gropius and Adolph Meyer, Model Factory at the Werkbund Exhibition, 1914. Cologne.

The Building as Entity: The Bauhaus

Upon taking charge of the Weimar School of Industrial Art, Gropius immediately set about reorganization. The institution had become moribund due to the war and the resulting dismissal of Van de Velde, a Belgian and, therefore, subject to expulsion as a foreigner. As was the case with the Arts and Crafts and the Deutscher Werkbund traditions, which had informed Van de Velde's program of teaching in workshops rather than studios, Gropius was convinced of the need for the creations of architect, artist, and craftsman to form a unified whole. His program was innovative, not in its insistence that the architect, the painter, and the sculptor should work with the craftsperson, but in specifying that they should be craftspeople first of all. The concepts of learning by doing, of developing an aesthetic on the basis of sound craft skills, and of breaking down barriers between "fine art" and craft were fundamental to the Bauhaus philosophy, as was a reconciliation between craft and industry (see *Gropius, the Bauhaus Manifesto*, below).

As he wrote in 1923, "The Bauhaus believes the machine to be our modern medium of design and seeks to come to

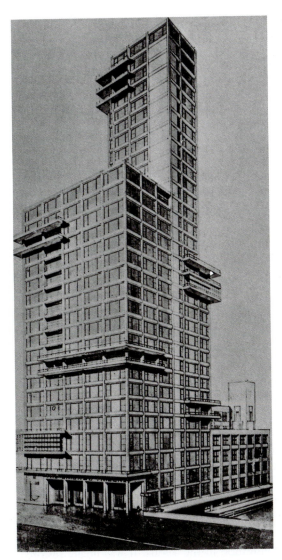

13.3 Walter Gropius and Adolph Meyer, Design for the Chicago Tribune Tower, 1922.

founded on Arts and Crafts principles of social utility and unity of the arts. Gropius shared these ideas, but would modify radically the curriculum and organization of the school, which he renamed Bauhaus.

During his years as director of the Bauhaus, Gropius continued his own architectural practice in collaboration with Meyer. One of their unfulfilled projects was the design for the Chicago Tribune Tower in 1922 (fig. **13.3**). The highly publicized competition for the design of this tower, with over 250 entries from architects worldwide, provides a cross-section of the eclectic architectural tendencies of the day, ranging from strictly historicist examples based on Renaissance towers to the modern styles emerging in Europe. The traditionalists won the battle with the neo-Gothic tower designed by the American architect Raymond Hood (probably in collaboration with John Mead Howells). The design of Gropius and Meyer, with the spare rectangularity of its forms, its emphasis on skeletal structure, and its wide tripartite windows, was based on the original skyscraper designs of Sullivan and the Chicago School (see figs. 8.2, 8.3) and also looked forward to the skyscrapers of the mid-twentieth century.

terms with it." This shift toward a machine aesthetic was no doubt due in part to the influence of Constructivism and the presence in Weimar by 1921 of the de Stijl artist Theo van Doesburg.

The first proclamation of the Bauhaus declared:

> Architects, painters, and sculptors must recognize anew the composite character of a building as an entity.... Art is not a "profession." There is no essential difference between the artist and the craftsman. The artist is an exalted craftsman.... Together let us conceive and create the new building of the future, which will embrace architecture and sculpture and painting in one unity and which will rise one day toward heaven from the hands of a million workers like the crystal symbol of a new faith.

This initial statement reflected a nostalgia for the medieval guild systems and collective community spirit that lay behind the building of the great Gothic cathedrals, as well as expressing the socialist idealism current in Germany during the infancy of the Weimar Republic, as it was throughout much of postwar Europe. But as Germany—and especially the conservative city of Weimar—grew more reactionary, suspicion of this political attitude caused antagonism toward the school, an antagonism that in 1925 drove the Bauhaus to its new home in Dessau.

Bauhaus Dessau

The growing industrial town of Dessau offered Gropius the perfect site for relocation. Not only would Dessau facilitate his desire to knit the aims of industry and art, but the region was also less conservative than the rerion around Weimar, thus more tolerant of the Bauhaus's socialist leanings. With the move to Dessau, Gropius closed his Weimar office in 1925, ending his partnership with Meyer. He could now focus his attention on giving full expression to his ideas through his design for the new campus at Dessau (fig. **13.4**). Here, Gropius was able to realize one of the clearest statements of functionalism. These buildings, finished in 1926, incorporated a complex of classrooms, studios, workshops, library, and living quarters for faculty and students. The workshops consisted of a glass box rising four stories and presenting the curtain wall, the glass sheath or skin, freely suspended from the structural steel elements. The form of the workshop wing suggests the uninterrupted spaces of its interior. On the other hand, in the dormitory wing, the balconies and smaller window units contrasting with clear expanses of wall surface imply the broken-up interiors of individual apartments.

The asymmetrical plan of the Bauhaus is roughly cruciform, with administrative offices concentrated in the broad, uninterrupted ferro-concrete span of the bridge linking workshops with classrooms and library. In every way, the architect sought the most efficient organization of interior space. At the same time he was sensitive to the abstract organization of the rectangular exterior—the relation of windows to walls, concrete to glass, verticals to horizontals, lights to darks. The Bauhaus combined functional organization and structure with a geometric, de Stijl-inspired design. Not only were the buildings revolutionary in their versatility and in the application of abstract principles of design based on the interaction of verticals and horizontals, but they also embodied a new concept of architectural space. The flat roof of the Bauhaus and the long, uninterrupted planes of white walls and continuous window voids create a lightness that opens up the space of the structure. The interior was furnished with designs by Bauhaus students and faculty, including Gunta Stölzl's tapestries and Marcel Breuer's tubular-steel furniture (see pp. 287–88). The building was seriously damaged in World War II and underwent limited renovation in the 1960s. It was finally restored to its original appearance in the 1970s. Since the reunification of Germany in 1990, this landmark building has become the focus of new studies and a site for historical exhibitions related to the Bauhaus.

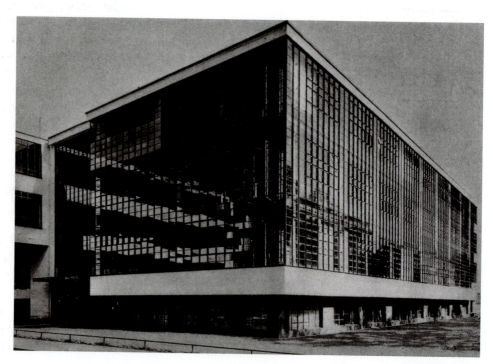

13.4 Walter Gropius, Workshop wing, Bauhaus, 1925–26. Dessau, Germany.

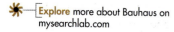
Explore more about Bauhaus on mysearchlab.com

The move to Dessau coincided with increased funding from the state and the elevation of some former Bauhaus students to positions as teachers. The latter helped to integrate the curriculum, bringing the school closer into line with Gropius's original plan. It was also in Dessau that the accent on craft declined, while the emphasis on architecture and industrial design substantially increased. The architecture students were expected to complete their training in engineering schools. Gropius said:

> We want to create a clear, organic architecture, whose inner logic will be radiant and naked, unencumbered by lying façades and trickeries; we want an architecture adapted to our world of machines, radios, and fast motor cars, an architecture whose function is clearly recognizable in the relation of its form.... [W]ith the increasing strength of the new materials—steel, concrete, glass—and with the new audacity of engineering, the ponderousness of the old methods of building is giving way to a new lightness and airiness.

Gropius's theories were disseminated in Bauhaus publications, including the influential *Bauhausbücher* (Bauhaus books). Designed in the school's advertising and typography studios, the Bauhaus books included essays and reproductions of artworks, helping to propagate the school's aesthetic and social principles. In addition to its theoretical publications, the Bauhaus produced catalogs of furniture and other household items for sale. Gropius was intent on bridging the divide between artisan and consumer that had undermined Morris and Co.'s attempt to bring finely crafted furnishings into middle- and working-class households in the previous century. With the adoption of mechanized production methods, Bauhaus products were generally more affordable than Morris and Co.'s.

The *Vorkurs*: Basis of the Bauhaus Curriculum

The Bauhaus curriculum was initially divided into two broad areas: problems of craft and problems of form. Each course had a "form" teacher and a "craft" teacher. This division was necessary because, during the school's early years in Weimar, it was not possible to assemble a faculty who were collectively capable of integrating the theory and practice of painting, sculpture, architecture, design, and crafts—although in practice several instructors taught both the *Vorkurs*, or foundation course, and workshop courses. The Swiss painter and textile artist Johannes Itten designed the *Vorkurs* as a six-month introduction to design principles as well as to a variety of media and techniques. Itten, like subsequent instructors of the foundation course, exerted a particularly strong influence on the program and students through the integration of design and social theory in the *Vorkurs*. Itten's personal emphasis on spirituality and on developing personal responses to design problems conflicted with Gropius's interest in subordinating individual

genius to a communal approach. After Itten left in 1923, the foundation course was given by László Moholy-Nagy and Josef Albers, each teaching in accordance with his own ideas. Paul Klee and Vasily Kandinsky also taught the course. Each of these artists left his mark on the Bauhaus curriculum, just as each influenced the development of modern art and pedagogy.

Moholy-Nagy

László Moholy-Nagy (1895–1946) was an important educator and advocate for abstract art, Constructivism, functional design, architecture, and, especially, experimental photography. A Hungarian trained in law, Moholy-Nagy was wounded on the Russian front during World War I, when Austria–Hungary fought—and was ultimately defeated—as part of the Central Powers. During his long convalescence, Moholy-Nagy became interested in painting. In the tumultuous years following the war, the political Left gained momentum in Hungary, resulting in a short-lived revolutionary government until 1919. By the end of that year, with the restoration of a counter-revolutionary regime intolerant of intellectual dissent, Moholy-Nagy left Budapest, first for Vienna, then for Berlin. He soon became a significant force in the remarkably diverse artistic environment of postwar Berlin, which during the 1920s was an international crossroads for members of the avant-garde. In Berlin, Moholy-Nagy met the de Stijl artist Theo van Doesburg, as well as the Dadaist Kurt Schwitters and other artists associated with Galerie Der Sturm. His encounter with the work of avant-garde Russian artists, including Malevich (see fig. 9.28) and El Lissitzky (see figs. 9.30–9.32), triggered an immediate response in his own work, as did his discovery of Naum Gabo's *Realistic Manifesto*, which had been published in a Hungarian communist journal (see Ch. 9, p. 212).

By 1921 Moholy-Nagy's interests had begun to focus on elements that dominated his creative expression for the rest of his life—light, space, and motion. He explored transparent and malleable materials, the possibilities of abstract photography, and the cinema. Beginning in 1922, Moholy-Nagy pioneered the creation of light-and-motion machines built from reflecting metals and transparent plastics. The first of these kinetic, motor-driven constructions, which he named "light–space modulators," was finally built in 1930 (fig. **13.5**). When the machines were set in motion, their reflective surfaces cast light on surrounding forms. During the 1920s, Moholy-Nagy was one of the chief progenitors of mechanized kinetic sculpture, but a number of his contemporaries, including Gabo, Tatlin (see fig. 9.35), and Rodchenko (see fig. 9.36), were also exploring movement in sculpture.

Moholy-Nagy met Gropius in 1922 at Galerie Der Sturm. He made such an impression that Gropius invited him to become a teacher at the Weimar Bauhaus. A student, the photographer Paul Citroën (see p. 289), described Moholy-Nagy's arrival: "Like a vigorous, eager dog, Moholy burst into the Bauhaus circle, ferreting out with unfailing scent the still unsolved, still tradition-bound problems in order

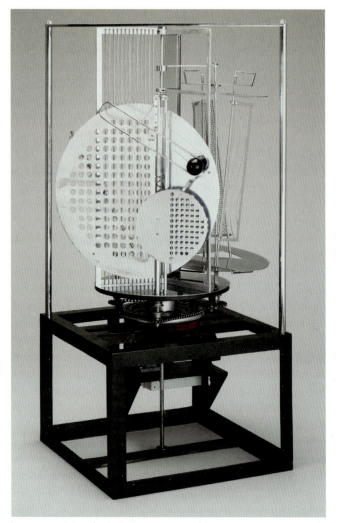

13.5 László Moholy-Nagy, *Light Prop for an Electric Stage* (*Light–Space Modulator*), 1922–30. Kinetic sculpture of steel, plastic, wood, and other materials with electric motor, 59½ × 27½ × 27½" (151.1 × 69.9 × 69.9 cm). Busch-Reisinger Museum, Harvard University Art Museums, Cambridge, MA.

👁—[Watch a video about Moholy-Nagy on mysearchlab.com

aesthetic and used the objects placed on light-sensitive paper as "light modulators"—materials for exercises in light. As in the example illustrated, the overlapping, dematerialized shapes of the photogram form abstract compositions that are set in motion purely by the manipulation of light. Moholy-Nagy regarded the camera as an instrument for extending vision and discovering forms otherwise unavailable to the naked eye. In the "new vision" of the world presented in his 1925 Bauhaus book *Malerei Fotografie Film* ("Painting Photography Film"), the artist included not only his own photographic works but also scientific, news, and aerial photographs, all of them presented as works of art. In addition to the abstract photograms, he made photomontages and practiced straight photography. Like Rodchenko (see fig. 9.38), he was partial to sharply angled, vertiginous views that bring to mind the dynamic compositions of Constructivist painting. About his 1928 aerial view taken from Berlin's Radio Tower (fig. 13.7), itself a symbol of new technology, Moholy-Nagy wrote: "The receding and advancing values of the black and white, grays and textures, are here reminiscent of the photogram." To him, the camera was a graphic tool equal to any as a means of rendering reality and disclosing its underlying purity of form. And so he wrote in a frequently quoted statement: "The illiterate of the future will be ignorant of camera and pen alike."

Moholy-Nagy was, until 1928, a principal theoretician in applying the Bauhaus concept of art to industry and architecture. Following Gropius's resignation that year, and

to attack them." In sharp contrast to the intuitive, mystical teaching methods of his predecessor Johannes Itten, Moholy-Nagy, a committed exponent of the Constructivist alliance of art and technology, stressed objectivity and scientific investigation in the classroom.

During his time at the Bauhaus Moholy-Nagy made abstract paintings, clearly influenced by El Lissitzky and Malevich, produced three-dimensional constructions, and worked in graphic design. Always alert to ways of exploring the potential of light for plastic expression, Moholy-Nagy also became an adventurous photographer. Apparently unaware of Man Ray's technically identical Rayograms, Moholy-Nagy developed his own cameraless images in 1922, just a few months after Ray. Both artists' discoveries attest to the highly experimental nature of photography in the 1920s. Moholy-Nagy and his wife Lucia, who collaborated with him until 1929, called their works "photograms" (fig. 13.6). However, unlike Man Ray, with his interest in the surreality of images discovered by automatic means, Moholy-Nagy remained true to his Constructivist

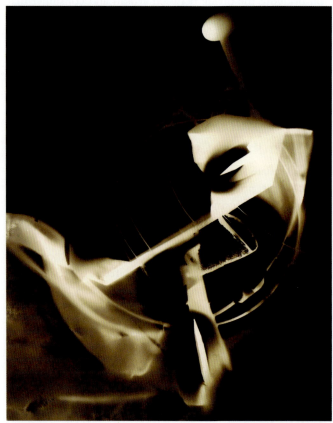

13.6 László Moholy-Nagy, *Untitled*, c. 1940. Photogram, silver bromide print, 20 × 16" (50 × 40 cm). The Art Institute of Chicago. Gift of George and Ruth Barford.

13.7 László Moholy-Nagy, *Untitled* (looking down from the Radio Tower, Berlin), c. 1928. Gelatin-silver print, 14¼ × 10" (36.2 × 25.6 cm). The Art Institute of Chicago, Julien Levy Collection.

the ensuing emphasis at the Bauhaus on practical training and industrial production over art and experimentation, Moholy-Nagy left the school.

Josef Albers

After studying widely in Germany, **Josef Albers** (1888–1976) entered the Bauhaus in 1920 as a student and, in 1923, was appointed to the faculty. While at the Bauhaus he met and married Anni Fleischmann, a gifted textile artist. In addition to his work in the foundation course, Albers taught furniture design and headed the glass workshop.

Albers's early apprenticeship in a stained-glass workshop contributed to his lifelong interest in problems of light and color within geometric formats. Returning to the medium of glass at the Bauhaus, Albers pointed to a means of making geometric abstraction part of a functional environment. Just as tapestry weaving or furniture crafting can be incorporated into an architectural work, so can colored glass windows. In his flashed glass pieces of the 1920s one can observe the transition from organic, free-form compositions of glass fragments to grid patterns, as in *City* (fig. **13.8**), in which the relations of each color strip to all the others are meticulously calculated. To create these compositions, Albers invented a painstaking technique of sand-blasting and painting thin layers of opaque glass, which he then baked in a kiln to achieve a hard, radiant surface. The title of this work highlights its resemblance to an International Style skyline. In fact, Albers adapted this composition in 1963 for a fifty-four-foot-wide (16.4 m) mural, which he called *Manhattan*, that was commissioned for New York's Pan Am Building (now the MetLife Building). Albers's time in the United States will be discussed later in this chapter.

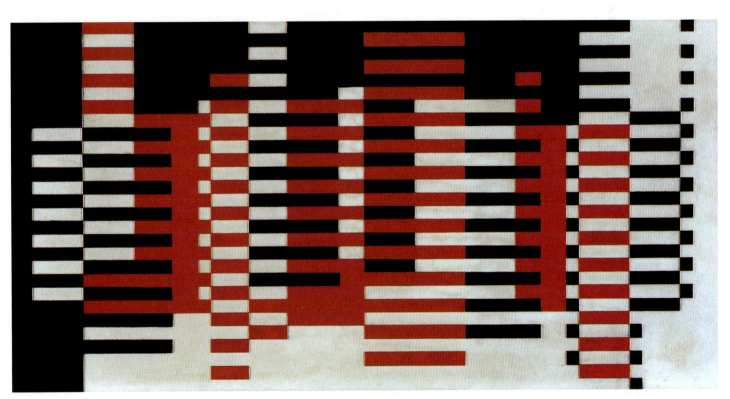

13.8 Josef Albers, *City*, 1928. Sand-blasted colored glass, 11 × 21⅝" (27.9 × 54.9 cm). Kunsthaus, Zurich.

Klee

First coming to attention when he participated in the Blaue Reiter exhibitions (see Ch. 6, pp. 128–29), **Paul Klee** (1879–1940) served in the German army in World War I immediately after the breakup of the group in 1914. In 1920 Gropius invited him to join the staff of the Bauhaus at Weimar, and he remained affiliated with the school from 1921 to 1931, an enormously productive period for him. Becoming a teacher prompted the artist to examine the tenets of his own painting. It also strengthened his resolve to discover and elaborate rational systems for the creation of pictorial form. He recorded his theories in his copious notes and in publications of great significance for modern art, including his 1925 Bauhaus book, *Pedagogical Sketchbook.*

Klee's art, as differentiated from that of Mondrian or even of Kandinsky in his later phase, was always rooted in nature and was seldom completely abstract. His abstract works mainly date from his Bauhaus years, when he was especially close to Kandinsky (whose Bauhaus years are discussed below) and to the traditions of Russian Suprematism and Constructivism and Dutch de Stijl. He drew upon his great storehouse of naturalistic observations as his raw material, but his paintings were never based on immediately observed nature except in his early works and sketchbook notations. Yet even his abstract paintings have a pulsating energy that appears organic rather than geometric, seemingly evolved through a natural process of dynamic growth and transformation.

In both his teaching and his art, Klee wanted to bring about a harmonious convergence of the **architectonic** and the poetic. With their heightened emphasis on geometric structure and abstract form, his paintings and drawings (he saw no need to distinguish between the two) from the Bauhaus years reveal formal influences from his Constructivist colleagues. Yet Klee was above all an individualist. However much he absorbed from the Bauhaus Constructivists, his poetic and intuitive inventions provided a counterweight to the more scientific and objective efforts at the school.

Like Mondrian and Kandinsky, Klee was concerned in his teachings and his painting with the geometric elements of the work of art—the point, the line, the plane, the solid. To him, however, these elements had a primary basis in nature and growth. It was the process of change from one to the other that fascinated him. To Klee, a painting continually grew and changed in time as well as in space. In the same way, color was neither a simple means of establishing harmonious relationships nor a method of creating space in the picture. Color was energy. It was emotion that established the mood of the painting within which the line established the action.

Klee saw the creative act as a magical experience in which the artist was enabled in moments of illumination to combine an inner vision with an outer experience of the world, to create an image that was parallel to and capable of illuminating the essence of nature. Although it grew out of the traditions of Romanticism and specifically of Symbolism (see Ch. 3, pp. 50–53), Klee's art represented a new departure. He believed that his inner truth, his inner vision, was revealed not only in the subject, the color, and the shapes as defined entities, but even more in the very process of creation. To start the creative process, Klee, a consummate draftsman, would begin to draw like a child; he said children, like the insane and "primitive" peoples, had the "power to see." He let the pencil or brush lead him until the image began to emerge. As it did, of course, his conscious experience and skills came back into play in order to carry the first intuitive image to a satisfactory conclusion. At this point, some other association, recollection, or fantasy would result in the poetic and often amusing titles that then became part of the total work. Because he placed such value on inner vision and the intuitive process of drawing, Klee's methods and theories had affinities with the **automatist** techniques of the Surrealists, who claimed him as a pioneer and included his work in their first exhibition in Paris in 1925 (see Ch. 14, p. 299). When two leading Surrealists, Masson and Miró, discovered Klee's art in 1922, they regarded the experience as one of great importance for their own work.

Klee discovered much of his iconography through teaching. As he used arrows to indicate lines of force for his students, these arrows began to creep into his work, where they are both formal elements and mysterious vectors of emotion. Color charts, perspective renderings, graphs, rapidly drawn heads, plant forms, linear patterns, checkerboards—elements of all descriptions became part of that reservoir of subconscious visual experience, which the artist then would transform into magical imagery. Usually working on a small scale in a deliberately naive rendition, Klee scattered or floated these elements in an ambiguous space composed of delicate and subtle harmonies of color and light that added mystery and strangeness to the concept.

During the 1920s, Klee produced a series of black pictures in which he used oils, sometimes combined with watercolor. Some of these were dark underwater scenes where fish swam through the depths of the ocean surrounded by exotic plants, abstract shapes, and sometimes strange little human figures. These works, including *Around the Fish* (fig. 13.9), embody an arrangement of irrelevant objects, some mathematical, some organic. Here the precisely delineated fish on the oval purple platter is surrounded by objects: some machine forms, some organic, some emblematic. A schematic head on the upper left grows on a long stem from a container that might be a machine and is startled to be met head-on by a red arrow attached to the fish by a thin line. A full and a crescent moon, a red dot, a green cross, and an exclamation point are scattered throughout the black sky—or ocean depth—in which all these disparate signs and objects float. This mysterious, nocturnal still life typifies Klee's personal language of hieroglyphs and his use of natural forms merely as a point of departure into a fantastic realm. "The object grows beyond its appearance through our knowledge of its inner being," he wrote, "through the knowledge that the thing is more than its outward aspect suggests."

Made during Klee's Bauhaus years, *In the Current Six Weirs* (fig. 13.10) is an arrangement of vertical and

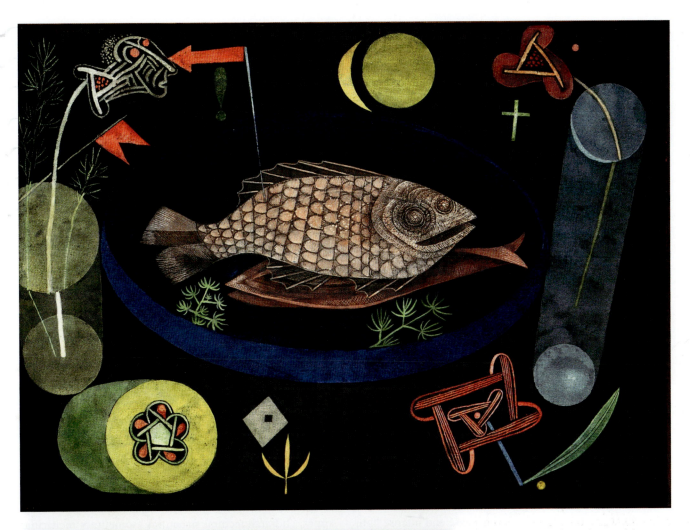

13.9 Paul Klee, *Um den Fisch* (*Around the Fish*), 1926. Oil and tempera on primed muslin on cardboard; original frame, 18⅜ × 25⅛" (46.7 × 63.8 cm). The Museum of Modern Art, New York. Abby Aldrich Rockefeller Fund.

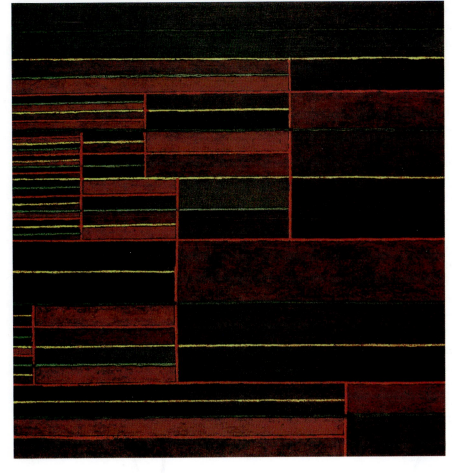

13.10 Paul Klee, *In der Strömung sechs Schwellen* (*In the Current Six Weirs*), 1929. Oil and tempera on canvas; original frame, 16⅗ × 16⅗" (42.2 × 42.2 cm). Solomon R. Guggenheim Museum, New York.

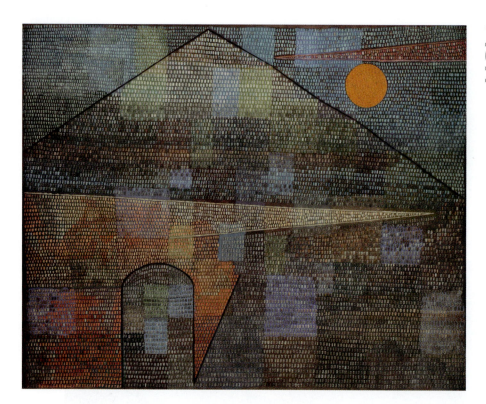

13.11 Paul Klee, *Ad Parnassum*, 1932. Oil and casein paint on canvas; original frame, 39⅜ × 49⅝" (100 × 126 cm). Kunstmuseum Bern, Dauerleihgabe des Vereins der Freunde des Kunstmuseums Bern (Society of Friends of Kunstmuseum Bern).

horizontal rectangles, in which gradations of deep color are contained within precisely ruled lines. Yet the total effect is organic rather than geometric, dynamic rather than static, with the bands continuing to divide as they move leftward. This and several similar abstract compositions of brilliantly colored strata were inspired by Klee's trip to Egypt in 1928–29 and are a response to the vast expanse and intense light of the desert landscape. Most of Klee's paintings were in combinations of ink and watercolor, media appropriate to the delicate quality of fluidity that he sought; but this particular work combines oil and tempera, media used to obtain effects of particular richness and density.

Desiring more time for his art and frustrated by the demands of teaching and the growing politicization within the Dessau Bauhaus, Klee left the school in 1931 and took a less demanding position at the Düsseldorf Academy. During the early 1930s, he applied his own variety of Neo-Impressionism in several compositions, culminating in a monumental painting from 1932, *Ad Parnassum* (fig. **13.11**). Klee covered the canvas with patterns of thick, brightly colored daubs of paint. These are marshaled into distinctive forms by way of a few strong lines that conjure up a pyramid beneath a powerful sun. Like Kandinsky, Klee believed that pictorial composition was analogous to music and that sound can "form a synthesis with the world of appearances." Both he and his wife were musicians, and he applied the principles of musical composition, with all its discipline and mathematical precision, to his paintings and to his teaching. The title of this majestic work derives from a famous eighteenth-century treatise on musical counterpoint called, in Latin, *Gradus ad Parnassum* ("Stairway to Parnassus"), Parnassus being a mountain sacred to the Greek god Apollo and the Muses. Klee orchestrated color and line in his painting according to his own system of pictorial polyphony, creating a luminous, harmonious vision aimed at elevating the viewer into a higher, Parnassian realm.

In 1933, the year Hitler assumed power in Germany, Klee was dismissed from his position at the Düsseldorf Academy and returned to his native Bern in Switzerland. Figures, faces (sometimes only great peering eyes), fantastic landscapes, and architectural structures (sometimes menacing)

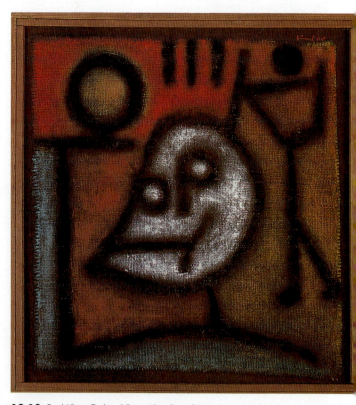

13.12 Paul Klee, *Tod und Feuer* (*Death and Fire*), 1940. Oil and colored paste on burlap; original frame, 18⅖ × 17½" (46.7 × 44.6 cm). Zentrum Paul Klee, Bern.

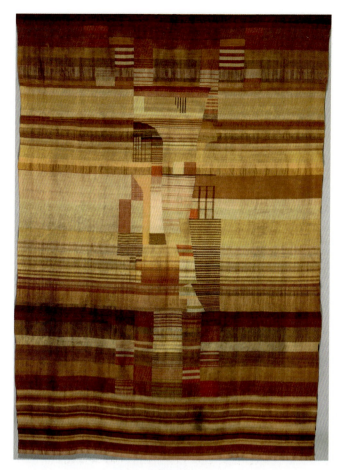

13.17 Gunta Stölzl, *Tapestry*, 1922–23. Cotton, wool, and linen, 8′ 4¹³⁄₁₆″ × 6′ 2″ (2.56 × 1.88 m). Busch-Reisinger Museum, Harvard University Art Museums, Cambridge, MA. Association Fund. BR49.669.

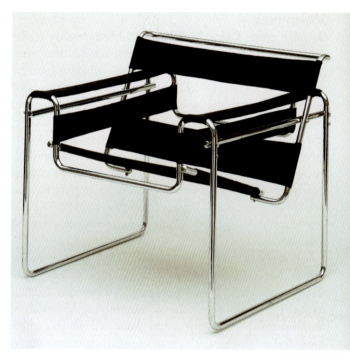

13.18 Marcel Breuer, Armchair, Model B3, Dessau, Germany. Late 1927 or early 1928. Chrome-plated tubular steel with canvas slings, 28⅛ × 30¼ × 27¾″ (71.4 × 76.8 × 70.5 cm). The Museum of Modern Art, New York.

❋—Explore more about Breuer on mysearchlab.com

13.19 Herbert Bayer, *Bauhaus Dessau*, 1926. Letterpress, 8½ × 5⅞″ (21.6 × 14.9 cm). The Museum of Modern Art, New York.

practice to accommodate industrial materials. The rhythmic play of bands of color enlivens her abstract pieces as they embody an aesthetic integrity perhaps unique to weaving: the rhythm of moving the shuttle back and forth finds its echo in the pattern woven into the tapestry (fig. **13.17**). In this way, tapestry weaving offers one of the clearest expressions of the unity between artisan and work that theorists such as William Morris, Aleksandr Rodchenko, and Theo van Doesburg had urged artists to pursue. Until her resignation in 1931, Stölzl was the only woman in charge of a Bauhaus workshop. Though initially women were to be given equal status at the Bauhaus, Gropius grew alarmed at the number of female applicants and restricted them primarily to weaving, a skill he deemed suitable for female students.

Breuer and Bayer

The greatest practical achievements at the Bauhaus were probably in interior, product, and graphic design. For example, **Marcel Breuer** (1902–81) created many furniture designs at the Bauhaus that have become classics, including the first tubular-steel chair (fig. **13.18**). He said that, unlike heavily upholstered furniture, his simple, machine-made chairs were "airy, penetrable," and easy to move. Through Breuer's influence, a new vocabulary of simple, functional shapes was established in metal design. The courses in display and typographic design under **Herbert Bayer** (1900–85), along with

Schlemmer

German artist **Oskar Schlemmer** (1888–1943) taught design, sculpture, and mural painting at the Bauhaus from 1920 to 1929. During his years there, Schlemmer's real passion was theater. In 1923 he was appointed director of theater activities at the school. When he moved to the new Dessau location in 1925 he set up the experimental theater workshop. Schlemmer's art—whether painting, sculpture, or the costumes he designed for his theatrical productions—was centered on the human body. While he applied the forms of the machine to the figure, he emphasized the need to strike a balance between humanist interests and the growing veneration at the Bauhaus for technology and the machine.

For his best-known production, *The Triadic Ballet*, Schlemmer encased the dancers in colored, geometric shapes made from wood, metal, and cardboard. Designed to limit the range of the dancers' movements, the costumes transformed the performers into abstracted, kinetic sculptures. Indeed, for exhibition purposes, Schlemmer mounted his "spatial–plastic" costumes as sculptures. As can be seen in his collage *Study for The Triadic Ballet* (fig. **13.15**), he

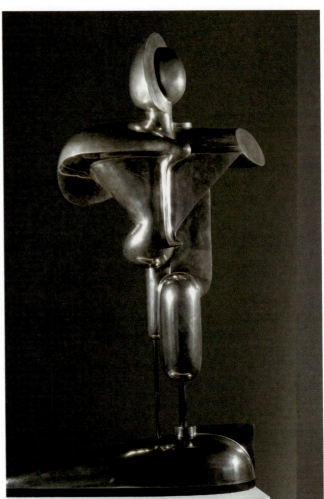

13.16 Oskar Schlemmer, *Abstract Figure*, 1923. Bronze (cast 1962 from original plaster), 42⅛ × 26⅜" (107 × 67 cm). Museum Moderner Kunst, Vienna.

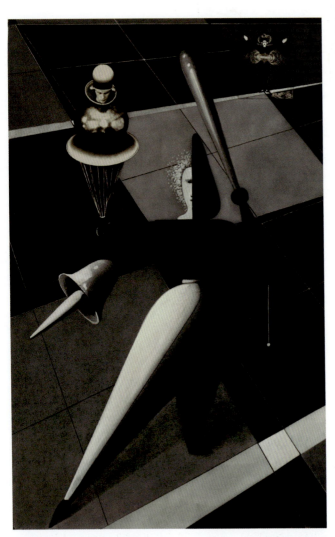

13.15 Oskar Schlemmer, *Study for The Triadic Ballet*, c. 1921–23. Gouache, brush and ink, incised enamel, and pasted photographs on paper, 22⅝ × 14⅝" (57.5 × 37.1 cm). The Museum of Modern Art, New York.

envisioned the stage as an abstract, gridded space through which the performers moved according to mathematically precise choreography. The deep-perspective space depicted here is similar to that of Schlemmer's paintings from this period. *The Triadic Ballet* was first performed in 1922 in the artist's native Stuttgart and was subsequently presented in several European cities.

Most of Schlemmer's sculptures were polychromed relief constructions, but in 1923 he made two free-standing sculptures, one of which was the original plaster for *Abstract Figure* (fig. **13.16**). For this large, imposing torso, Schlemmer sought the same clarity of form and geometric precision that he brought to his theatrical designs. With its gleaming surfaces and streamlined forms, the sculpture shines like the chassis of a new automobile.

Stölzl

The weaving workshop at the Bauhaus produced works that balanced perfectly the school's commitment to progressive design and utility. From 1925, the studio was directed by **Gunta Stölzl** (1897–1983), who had studied under Itten at the Bauhaus in Weimar. While Itten directed her to pursue a personal aesthetic vision through her weaving, she adapted to the functionalist vision of Gropius, expanding her

13.14 Vasily Kandinsky, *Several Circles, No. 323*, 1926. Oil on canvas, 55⅛ × 55⅛" (140 × 140 cm). Solomon R. Guggenheim Museum, New York.

Bauhaus teachers like Moholy-Nagy. "The contact of the acute angle of a triangle with a circle," he wrote, "is no less powerful in its effect than that of the finger of God with the finger of Adam in Michelangelo's [Creation of Man] painting." The circle, in particular, was filled with "inner potentialities" for the artist, and it took on a prominent role in his work of the 1920s. In *Several Circles, No. 323* (fig. **13.14**), the transparent color circles float serenely across one another above an indeterminate, gray-black ground, like planets orbiting through space. It is hardly surprising that the artist revered the circle as a "link with the cosmic" and as a form that "points most clearly to the fourth dimension."

In 1926 Kandinsky published, as a Bauhaus book, *Point and Line to Plane*, his textbook for a course in composition. As compared with Klee's *Pedagogical Sketchbook* of the previous year, Kandinsky's book attempts a more absolute definition of the elements of a work of art and their relations to one another and to the whole. Here the artist affirmed the spiritual basis of his art, and his correspondence of the time reveals a combination of the pragmatic and the mystical.

Kandinsky continued his association with the Bauhaus until the school was closed in 1933. At the end of that year he moved permanently to Paris, where he was soon involved in the Abstraction-Création group, organized in 1931 by artists hoping to promote the pursuit of pure abstraction. Through Abstraction-Création he became friendly with Miró, Arp, and Pevsner. This new environment heightened Kandinsky's awareness of the Surrealist activities of the 1920s, and one senses certain qualities akin to abstract Surrealism in the many works created after his move to France.

Die Werkmeistern: Craft Masters at the Bauhaus

Over the years the Bauhaus attracted one of the most remarkable art faculties in history. In addition to their duties teaching the *Vorkurs*, Klee and Kandinsky also taught painting, as did Lyonel Feininger and Georg Muche, among others. Herbert Bayer taught graphic arts, including advertising, typography, and book design. Oskar Schlemmer introduced students to innovations in stage design. Josef Albers ran the glass studio, and Gunta Stölzl directed the weaving workshop. The architect Marcel Breuer gave instruction in furniture design and fabrication. Pottery was taught by Gerhard Marcks, who was also a sculptor and graphic artist. In addition to the star-studded faculty, the Bauhaus frequently attracted distinguished foreign visitors, such as, in 1927, the Russian Suprematist painter Kazimir Malevich. As mentioned above, when the Bauhaus moved to Dessau, several former students joined the faculty, including Breuer and Bayer. These artist–teachers gained international renown for their innovative pedagogy as well as for their own creative production.

continued to appear in his art during the 1930s. Perhaps the principal characteristic of Klee's late works was his use of bold and free black linear patterns against a colored field. One of his last works, *Death and Fire* (fig. **13.12**), 1940, is executed with brutal simplicity, thinly painted on an irregular section of rough burlap. The rudimentary drawing, like the scrawl of a child, delineates a harrowing, spectral image, expressive perhaps of the burdens of artistic isolation, debilitating illness, and the imminent threats of war and totalitarianism. Klee died later that year.

Kandinsky

Vasily Kandinsky (1866–1944) renewed his friendship with Klee when he returned to Germany from Russia in 1921, and in 1922 he joined the Weimar Bauhaus. One of the school's most distinguished faculty members, he taught a course called Theory of Form and headed the workshop of mural painting (regarded as superior to traditional easel painting at the school). Kandinsky's style underwent significant changes during his tenure at the Bauhaus. While he still adhered to the mystical Theosophical beliefs expressed in his seminal book from 1911, *Concerning the Spiritual in Art*, he had come to value form over color as a vehicle for expression, and his paintings evolved toward a more objective formal vocabulary. Even before coming to the

Bauhaus, under the influence of Russian Suprematism and Constructivism, Kandinsky's painting had turned gradually from free Expressionism to a form of geometric abstraction. This evolution is evident in *White Line, No. 232* (see fig. 9.33), a painting he made in 1920 while still in Russia, which, despite expressive brushwork, contains clearly defined geometric and organic forms.

By 1923, in *Composition VIII* (fig. **13.13**), hard-edged shapes had taken over. Kandinsky regarded the works that he named *Compositions* as the fullest expression of his art (see Ch. 6, p. 123). Ten years had elapsed between *Composition VII*, 1913 (see fig. 6.16) and *Composition VIII*, and a comparison of the two paintings elucidates the changes that had taken place during this period. The deeply saturated colors and tumultuous collision of painterly forms in the 1913 picture are here replaced by clearly delineated shapes—circles, semicircles, open triangles, and straight lines—that float on a delicately modulated background of blue and creamy beige. The emotional climate of the later painting is far less heated than that of its predecessor, and its rationally ordered structure suggests that harmony has superseded the apocalyptic upheavals inhabiting the artist's prewar paintings.

Kandinsky fervently believed that abstract forms were invested with great significance and expressive power, and the spiritual basis of his abstract forms set him apart from

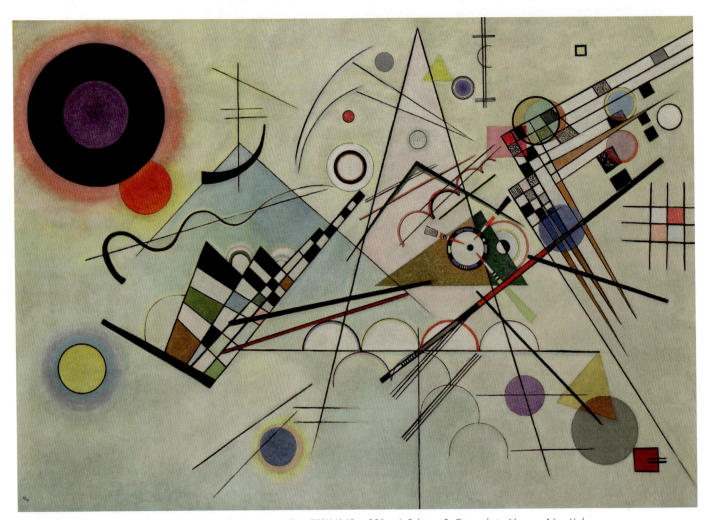

13.13 Vasily Kandinsky, *Composition VIII*, 1923. Oil on canvas, 55⅛ × 79⅛" (140 × 201 cm). Solomon R. Guggenheim Museum, New York.

Moholy-Nagy, Jan Tschichold, and others, revolutionized the field of type. Bayer developed a distinctive typography used in most Bauhaus publications (fig. **13.19**). Presented always in lower case, Bayer's sans-serif type became synonymous with mid-century modernism. Bauhaus designs have passed so completely into the visual language of the modern age that it is now difficult to appreciate how revolutionary they were on first appearance. Certain designs, such as Breuer's tubular chair and his basic table and cabinet designs, Gropius's designs for standard unit furniture, and designs by other faculty members and students for stools, stacking chairs, dinnerware, lighting fixtures, textiles, and typography so appealed to popular tastes that they are still manufactured today (see *Industry into Art into Industry*, below).

13.20 Paul Citroën, *Metropolis*, 1923. Collage, printed matter, and postcards, 30 × 23" (76.5 × 58.5 cm). Printroom of the University of Leiden, the Netherlands.

Industry into Art into Industry

The Bauhaus commitment to integrating art and industry led to as much technical as formal experimentation in the school's workshops. Materials that had been developed for purely industrial purposes—like steel tubing—were adopted for their aesthetic as well as functional properties. A familiar material through its use in bicycle handlebars, tubular steel is lightweight and durable. Both Ludwig Mies van der Rohe and Marcel Breuer perceived the potential for this material in furniture design and manufacturing (see fig. 13.18). Its strength meant that one or two slender runners could easily support a person's weight. And, once a prototype was made, infinite copies could be mechanically produced. Sand-blasting was taken from its commercial application and used by Josef Albers to incise designs into multicolored blocks of glass, which he made by flashing sheets of different colored glass together. Flashing involves heating two pieces of glass so that they fuse. Through this technique, Albers created a sandwich of two or three colored sheets of glass, which he then covered with a stencil before sand-blasting through the layers to achieve a design. László Moholy-Nagy literally transformed industrial machine parts into artworks: his *Light–Space Modulator* (see fig. 13.5) is composed of a variety of premachined parts intended originally for use in factory and kitchen equipment.

"The Core from which Everything Emanates": International Constructivism and the Bauhaus

The Bauhaus, as envisioned by Gropius, can be understood as a blend of three major influences: the Arts and Crafts Movement, with its integration of the arts and its insistence on the social role of art; the medieval guild system, which emphasized a collaborative, community-minded approach to artmaking over the Romantic emphasis on individual genius; and the aesthetic principles of Constructivism. Constructivist ideas reached the Bauhaus through a variety

of sources, principally de Stijl—in the form of Theo van Doesburg and the *de Stijl* magazine, the influence of teachers like Kandinsky, who had had firsthand experience with Russian Constructivism, and Moholy-Nagy. Students, such as **Paul Citroën** (1896–1983), made Constructivism central to their work, as evidenced by his iconic 1923 photomontage *Metropolis* (fig. **13.20**). Achieved by cutting and pasting, the image conveys the dynamism and chaos of modern urban life. Within the large format, Citroën crushed together such a towering mass of urban imagery that Moholy-Nagy called it "a gigantic sea of masonry," stabilized, however, by Constructivism's controlling principle of abstract design. Artists like Naum Gabo, Anton Pevsner, and Willi Baumeister, though neither students nor faculty members at the Bauhaus, nonetheless contributed to the school's engagement with Constructivism and, through associations with the Bauhaus faculty, helped to spread the school's ideas to an international audience.

Gabo

Following his departure from Russia in 1922, where the abstract art he had helped to evolve (see Ch. 9, pp. 211–212) proved incompatible with the utilitarian policies of the Soviet regime, **Naum Gabo** (1890–1977) lived in Germany until 1932, perfecting his Constructivist sculpture and contributing significantly, though indirectly, to Moholy-Nagy's

ideas on light, space, and movement at the Bauhaus. Though not a member of the Bauhaus faculty, Gabo lectured there in 1928, published an important article in *Bauhaus* magazine, and was in contact with several Bauhaus artists. In 1922 eight of his sculptures were included in a huge exhibition of Russian art that traveled to Berlin and Amsterdam, helping to bring his work and that of other Russian abstract artists to an international audience. Like Moholy-Nagy, Gabo was a major practitioner of Constructivism in many media. At the same time, both artists demonstrated how the formal aspects of Constructivism were assimilated in the West without its political associations with the early, idealistic phase of the Communist revolution. While Gabo sympathized with the initial aims of the revolution in Russia, he did not harness his art to specific ideas of collectivism and utilitarianism. Nevertheless, he shared Moholy-Nagy's utopian belief in the transformative powers of art. He encouraged modern artists to look to technology and the machine for forms and materials to express appropriately the aims of the new social order.

In Germany, Gabo continued the research he had begun in Russia. He explored the possibilities of new artistic media, particularly glass and recently developed plastic materials such as celluloid, to exploit a sense of planar transparency in his sculpture. For Diaghilev's 1927 ballet *La Chatte*, Gabo and his brother Anton Pevsner (see opposite) designed a set filled with large geometric sculptures in a transparent material that shone, in the words of one observer, with "quicksilver radiance." In 1931, Gabo took part in the international competition for the Palace of Soviets, a never-realized building that was to be a proud symbol in Moscow of the new Soviet Union. Several architects from the West also took part, including Le Corbusier and Gropius. Gabo, who had been searching for a form of architectural expression through his constructed sculpture, proposed a daring, winged structure of reinforced concrete.

In 1932, after Nazi stormtroopers came to his studio, Gabo left Germany for Paris, where he was active in the Abstraction-Création group, organized partly as an antidote to the influence of Surrealism (see Chapter 14). His next move was to England, where between 1936 and 1946 he was active in the circle of abstract artists centering on Herbert Read, Ben Nicholson, Barbara Hepworth (see fig. 17.40), and Henry Moore (see fig. 17.43). Thereafter Gabo lived in the United States until his death in 1977.

Gabo's principal innovation of the 1940s was a construction in which webs of taut nylon string were attached to interlocking sheets of lucite, a clear plastic (fig. **13.21**). Over many years, Gabo made several versions of *Linear Construction in Space, No. 1* on different scales. In these he attained a transparent delicacy and weightlessness unprecedented in sculpture. Like a drawing in space, the nylon filaments reflect light and gracefully articulate the void as positive form, transforming the space, according to Gabo, into a "malleable material element."

After emigrating to the United States in 1946, Gabo was able to realize his ambition to create large-scale public

13.21 Naum Gabo, *Linear Construction in Space, No. 1 (Variation)*. Lucite with nylon thread, 24½ × 24½" (62.2 × 62.2 cm). The Phillips Collection, Washington, D.C.

13.22 Naum Gabo, Construction for the Bijenkorf department store, 1956–57. Pre-stressed concrete, steel ribs, stainless steel, bronze wire, and marble, height 85' (25.9 m). Rotterdam, the Netherlands.

sculpture. His major architectural–sculptural commission was his 1956–57 monument for the new Bijenkorf department store in Rotterdam (fig. **13.22**), designed by the Bauhaus architect Marcel Breuer. The store was part of a massive postwar campaign to rebuild the city, which had been devastated by German bombs in 1940. Gabo's solution for the busy urban site was a soaring, open structure consisting of curving steel shafts that frame an inner abstract construction made of bronze wire and steel. Gabo likened the sculpture, with its tremendous weight anchored in the ground, to the form of a tree.

Pevsner

Unlike his younger brother Gabo, **Anton Pevsner** (1886–1962) never taught at the Bauhaus, although he did, like Gabo, work within the Constructivist tradition. Pevsner left Russia in 1923 and settled permanently in Paris, where he exhibited with his brother in 1924. At this time he began to work seriously in abstract constructed sculpture. Commissioned by the Société Anonyme in 1926 (see Ch. 10, p. 222), his *Portrait of Marcel Duchamp* is an open plastic construction with obvious connections to Gabo's *Constructed Head No. 1* of 1915. By the end of the 1920s, however, Pevsner had nearly abandoned construction in transparent plastics in favor of abstract sculpture in bronze or copper. In 1932 he joined the Abstraction-Création group in Paris and, like Gabo, contributed to their journal.

In his *Monde* (*World*) (fig. **13.23**), Pevsner realized his idea of "developable surface" or sculpture realized from a single, continuously curving plane.

13.23 Anton Pevsner, *Monde* (*World*), 1947. Bronze, 29½ × 23⅔ × 22¾″ (75 × 60 × 57 cm). Musée National d'Art Moderne, Centre d'Art et de Culture Georges Pompidou, Paris.

Monde is made of bronze, not cast but hammered out to machine precision. Despite the geometric precision of his work, Pevsner denied any mathematical basis in its organization. The structure of *Monde* invites viewing from multiple vantage points, carrying the eye of the spectator around the perimeter, while the dynamic, spiraling planes give the illusion of movement in a static design. This quality was explored in such Futurist sculptures as Boccioni's *Development of a Bottle in Space* (see fig. 9.15), but the elimination of all representation in Pevsner's work heightens the sense of dynamism.

Pevsner carried out several large architectural commissions. The *Dynamic Projection in the 30th Degree* at the University of Caracas, Venezuela, enlarged from a smaller bronze version, is more than eight feet (2.43 m) high. This sculpture centers around a sweeping diagonal form that thrusts out from the center at a thirty-degree angle from the compressed waist of the vertical, hourglass construction. In this form, Pevsner combines solidity of shape with the freedom of a vast pennant seemingly held rigid by the force of a tornado wind.

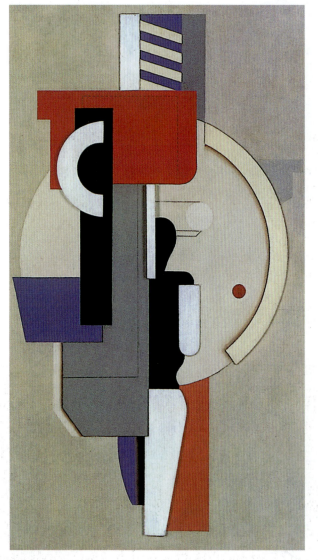

13.24 Willi Baumeister, *Wall Picture with Circle II*, 1923. Oil and wood on wood panel, 46½ × 27⅛" (118 × 69 cm). Kunsthalle, Hamburg.

Baumeister

Like Schlemmer, **Willi Baumeister** (1889–1955) was a pupil of Adolf Hoelzel at the Stuttgart Academy. He collaborated with both artists on a mural project in 1914 and frequently exhibited with Schlemmer in Germany. Throughout the interwar years, he was in contact with an international group of artists ranging from Le Corbusier and Léger to Malevich and Moholy-Nagy. He exhibited in Paris in the 1920s, and became a member of Cercle et Carré and Abstraction-Création during 1930 and 1931. Although he never served on the Bauhaus faculty, he associated with several artists at the school and contributed to its magazine.

Baumeister's mature work was affected by Cubism and Purism as well as by Schlemmer's machine-based figurative style. Following World War I, during which he served in the German army, Baumeister made a series of shallow relief constructions called *Mauerbilder* ("wall pictures"). In one example from 1923 (fig. **13.24**), geometric forms surround a highly schematized figure. While some of these forms are painted directly on the wooden support, others are sections of wood applied to the surface. A decade earlier, Archipenko, whose work was no doubt known to Baumeister, was experimenting with similar techniques in Paris (see fig. 7.29). By the early 1930s, organic shapes appeared among the artist's machine forms, evidence of his interest in Surrealism and the paintings of Paul Klee. In such works as *Stone Garden I*, Baumeister added a textural element by building up his surfaces sculpturally with sand and plaster. During the Nazi regime, when he was branded a "degenerate artist," Baumeister painted in secret, advancing his own ideas toward freer abstraction—**ideograms** with elusive suggestions of figures. These signs came from the artist's imagination, but were based on his studies of the art of ancient civilizations, such as Mesopotamia.

From Bauhaus Dessau to Bauhaus U.S.A.

Gropius resigned as director of the Bauhaus in 1928 to work full-time in his architectural practice. He was succeeded by Hannes Meyer, a Marxist who placed less emphasis on aesthetics and creativity than on rational, functional, and socially responsible design. Meyer increasingly politicized the curriculum at the Bauhaus and stressed practical, industrial training over artistic production. This trend eventually led to Schlemmer's resignation. Meyer was forced to leave the Bauhaus in 1930, and Ludwig Mies van der Rohe (Gropius's first choice in 1928) assumed the directorship.

Mies van der Rohe

The spare, refined architecture of **Ludwig Mies van der Rohe** (1886–1969), built on his edict that "Less is more," is synonymous with the modern movement and the International Style. He has arguably had a greater impact on the skylines of American cities than any other architect. His contribution lies in the ultimate refinement of the basic forms of the International Style, resulting in some of its

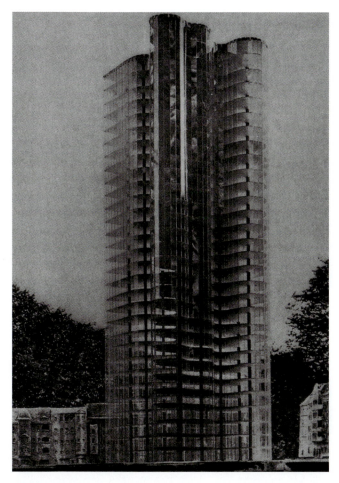

13.25 Ludwig Mies van der Rohe, Model for a glass skyscraper, 1922.

that began there, despite a certain rivalry, continued. Mies's style remained almost conventionally Neoclassical until after World War I. Then, in the midst of the financial and political turmoil of postwar Germany, he plunged into the varied and hectic experimentation that characterized the Berlin School.

In 1921 and 1922 Mies completed two designs for skyscrapers, which, although never built, established the basis of his reputation. The first was triangular in plan, the second a free-form plan of undulating curves (fig. **13.25**). In these he proposed the boldest use yet envisaged of a reflective, all-glass sheathing suspended on a central core. As Mies wrote:

> Only in the course of their construction do skyscrapers show their bold, structural character, and then the impression made by their soaring skeletal frames is overwhelming. On the other hand, when the façades are later covered with masonry, this impression is destroyed and the constructive character denied.... The structural principle of these buildings becomes clear when one uses glass to cover non-load-bearing walls. The use of glass forces us to new ways.

No comparably daring design for a skyscraper was to be envisaged for thirty or forty years. Because there was no real indication of either the structural system or the disposition of interior space, these projects still belonged in the realm of visionary architecture, but they were prophetic projections of the skyscraper.

Mies's other unrealized projects of the early 1920s included two designs for country houses, both in 1923, in brick (fig. **13.26**) and in concrete. The brick design so extended the open plan made famous by Frank Lloyd Wright that the free-standing walls no longer enclose rooms but instead create spaces flowing into one another. Mies fully integrated the interior and exterior spaces. The plan of this house, drawn with the utmost economy and elegance, and the abstract organization of planar slabs in the elevation exemplify Mies's debt to the principles of de Stijl (it has often been compared to the composition of a 1918 painting by Mies's friend Theo van Doesburg).

One of the last works executed by Mies in Europe was the German Pavilion for the Barcelona International Exposition

most famous examples. Some of the major influences on Mies were: his father, a master mason from whom he initially gained his respect for craft skills; Peter Behrens (see Ch. 8, pp. 180–81), in whose atelier he worked for three years; and Frank Lloyd Wright. From Wright, Mies gained his appreciation for the open, flowing plan and for the predominant horizontality of his earlier buildings. He was affected not only by Behrens's famous turbine factory (see fig. 8.17), but also by Gropius's 1911 Fagus Factory (see fig. 13.1), with its complete statement of the glass curtain wall. Gropius had worked in Behrens's office between 1907 and 1910, and the association between Gropius and Mies

13.26 Ludwig Mies van der Rohe, Elevation for brick country house, 1923.

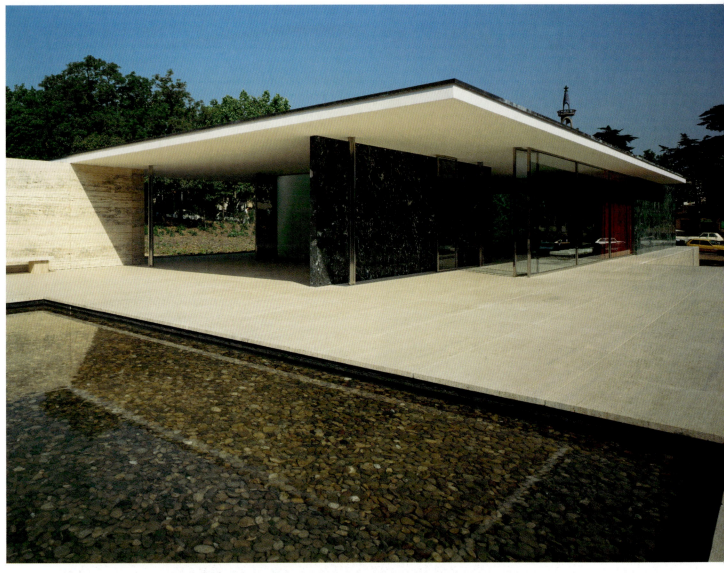

13.27 Ludwig Mies van der Rohe, German Pavilion, International Exposition, 1929. Barcelona, Spain. Reconstructed 1986.

✳ Explore more about Mies van der Rohe on mysearchlab.com

in 1929 (fig. **13.27**)—Mies was in charge of Germany's entire contribution. The Barcelona Pavilion, destroyed at the end of the exhibition, has become one of the classics of his career and is perhaps the pre-eminent example of the International Style. Here was the most complete statement to date of all the qualities of refinement, simplification, and elegance of scale and proportion that Mies, above all others, brought to modern architecture. In this building he contrasted the richness of highly polished marble wall slabs with the chrome-sheathed slender columns supporting the broad, overhanging flat roof. Thus, the walls are designed to define space rather than support the structure. In a realization of the open plan that he had designed for the brick country house, the marble and glass interior walls stood free, serving simply to define space (fig. **13.28**). But in contrast to the earlier work, the architect put limits on the space of pavilion and court by enclosing them in end walls. This definition of free-flowing interior space within a total rectangle was to become a signature style for Mies in his later career. The pavilion was furnished with chairs (the

"Barcelona chair"), stools, and glass tables also designed by Mies (fig. **13.29**). In the Barcelona Pavilion, he demonstrated that the International Style had come to a maturity permitting comparison with the great styles of the past. In 1986, to celebrate the centenary of the architect's birth, the pavilion was completely reconstructed in Barcelona according to the original plans.

Although Mies became director of the Bauhaus in 1930 he had little opportunity to advance its program. After moving from Dessau to Berlin in that year, the school suffered increasing pressure from the Nazis until it was finally closed in 1933. In 1937, with less and less opportunity to practice, Mies left for the United States, where in the last decades of his life he was able to fulfill, in a number of great projects, the promise apparent in the relatively few buildings he actually created in Europe (see Ch. 21, pp. 536–39).

At its best, the uncompromising rationalism of Mies's architecture could produce compelling examples of pristine, streamlined form. In lesser hands, as is apparent in skylines across the United States, his minimalist forms could

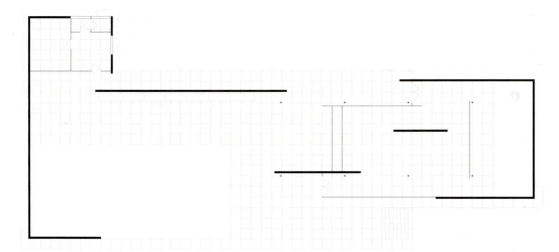

13.28 Ludwig Mies van der Rohe, German Pavilion, International Exposition, Barcelona, Spain. Floor plan, 1929

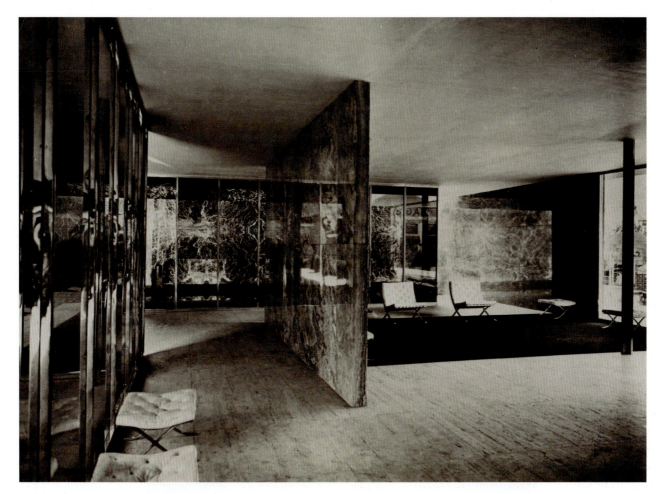

13.29 Ludwig Mies van der Rohe, German Pavilion, 1929. Interior view.

become impersonal glass and steel monuments to consumer capitalism or drab apartment dwellings. In the words of architecture critic Ada Louise Huxtable, "Mies' reductive theories, carried to their conceptual extreme, contained the stuff of both sublimity and failure, to which even he was not immune." By the early 1970s, the modern movement, and particularly the International Style as represented above all by Mies and Le Corbusier, would encounter a protracted backlash, opening the door to the era of Postmodernism (see Chapter 24).

Bauhaus U.S.A.

Mies was one of many artists associated with the Bauhaus to emigrate to the United States in the 1930s. These artists carried the Bauhaus curriculum and ethos with them, establishing throughout North America new art programs based on its model.

Walter Gropius continued to produce work deemed degenerate, leading to his expulsion from Germany by the Nazis in 1934. Initially he settled in Britain, but moved to the United States in 1937 upon accepting a position at Harvard

University's Graduate School of Design. Much of the work he produced between his departure from the Bauhaus and his arrival in the U.S.A. was low- or middle-cost housing. He would continue his efforts in this vein, developing, in a collaboration with Konrad Wachsmann, another German émigré architect, a system for producing inexpensive prefabricated housing. In his pioneering European and American works, Gropius helped provide the foundation of what would later be dubbed the International Style.

Josef Albers likewise emigrated, becoming one of the most important art teachers in the United States, first at the remarkable school of experimental education, Black Mountain College in North Carolina, and subsequently at Yale University. Throughout the 1940s, Albers developed his increasingly reductive vocabulary with remarkable assiduity, exploring issues of perception, illusionism, and the often ambiguous interaction of abstract pictorial elements. Beginning in 1950 he settled on the formula that he entitled *Homage to the Square*, where he relentlessly explored the relationships of color squares confined within squares, devoting his own studio practice to the lessons on color theory he taught so famously at Yale. For the next twenty-five years, in a seemingly endless number of harmonious color combinations, Albers employed the strict formula of *Homage to the Square* in paintings and prints of many sizes. Within this format, the full, innermost square is, in the words of one observer, "like a seed; the heart of the matter, the core from which everything emanates." As *Apparition*, a 1959 *Homage to the Square* subtitle, suggests (fig. **13.30**),

Albers's goal was to expose the "discrepancy between physical fact and psychic effect." The interior square is not centered, but rather positioned near the bottom of the canvas. According to a predetermined asymmetry, the size of the color bands at the bottom is doubled on each side of the square and tripled at the top. By restricting himself to this format, Albers sought to demonstrate the subtle perceptual ambiguities that occur when bands of pure color are juxtaposed. Colors may advance or recede according to their own intrinsic hue and in response to their neighbor, or they may even appear to mix optically with adjacent colors. And by the painted miter effect, seen here on the outermost corners, the artist creates a sense of illusionistic depth on a flat surface.

Marcel Breuer, principally active at the Bauhaus as a furniture designer, ultimately joined Gropius in 1937 on the faculty of Harvard University and practiced architecture with him. After Breuer left this partnership in 1941, his reputation steadily grew to a position of world renown (see figs. 21.27, 21.42). Moholy-Nagy, through his books *The New Vision* and *Vision in Motion* and his directorship of the New Bauhaus, founded in Chicago in 1937 (now the Institute of Design of the Illinois Institute of Technology), greatly influenced the teaching of design in the United States. He eventually resided in Amsterdam and London, painting, writing, and making art in all media. His stylistic autobiography, *Abstract of an Artist* (added to the English edition of *The New Vision*), is one of the clearest statements of the modern artist's search for a place in technology and industry.

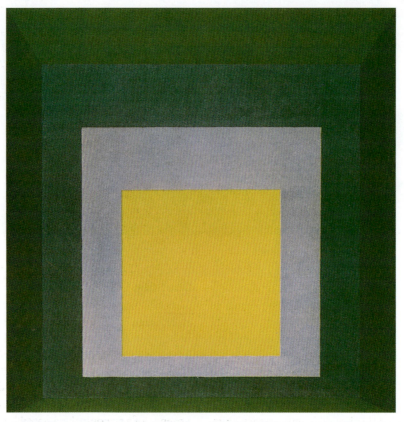

13.30 Josef Albers, *Homage to the Square: Apparition*, 1959. Oil on board, 47½ × 47½" (120.7 × 120.7 cm). Solomon R. Guggenheim Museum, New York.

14
Surrealism

Surrealism made visible a new, modern consciousness. Europe was changed by the time the armistice was signed in 1918. Feeling alienated, unable to imagine themselves as part of a society that had plunged more or less heedlessly into the catastrophe of World War I, artists responded in different ways. As seen in the previous chapters, some adopted the oppositional, anti-aesthetic of Dada while others affirmed Western cultural traditions by resuming the classicism of earlier generations. The aesthetic posture showing the greatest resilience and optimism was probably that staked out by Constructivists, such as those allied with the Bauhaus, who believed that Western civilization could redeem itself with the help of art. Surrealism charted a completely different tack. Neither rejecting entirely Western aesthetic traditions nor promising a cure for society's ills, Surrealism responded to this moment by reasserting the invincibility of artistic genius.

What Surrealists understood to be the source of artistic creativity departed from previous conceptions. Renaissance artists understood genius to be an innate capacity, a divine spark that animated only a very few. Academic artists of the eighteenth and nineteenth centuries conceived of genius in terms of emulation and intellectual attainment. Romantic artists reintroduced the idea of genius as something inborn but rare, a creative faculty that gave rise to originality. Surrealism shares the Romantic notion of genius as exceptional and marked by originality, but traces its source to the mind's unconscious. Artistic genius, for Surrealism, depends on the ability to tap into the raw impulses, desires, and fears that Freud claimed were seated in the unconscious. Only by giving form to the unconscious could an artist achieve the authenticity and originality essential for a work of aesthetic genius. This, like all conceptions of genius, privileged some individuals while rendering it virtually impossible for others to lay claim to it. Grounded in Freudian psychology, the Surrealist theory of genius endowed masculinity with particular creative resonance, contributing to the movement's dearth of female participants while affirming the modernist tendency to view the female body as a powerful catalyst for artistic experimentation. As strong as this impulse is in Surrealism, some women nevertheless seized upon Surrealism as a means of expressing their own aesthetic aims and psychic desires.

By 1920, Freud's ideas had become popularized throughout Europe and North America. Psychoanalysis promised to explain—maybe even cure—human aggression and deviance. The possibility of accounting for the irrational by rational, scientific means was especially appealing in the wake of the war. Central to Freudian psychoanalysis is the assertion that personalities develop in early childhood, largely in response to thwarted and repressed sexual desires. Freud's theories tend to address male subjects, leaving women to serve largely as triggers for unfulfilled erotic impulses or feelings of shame and inadequacy. The Surrealists' loose appropriation of psychoanalytic theory carried with it this perception of women as objects to desire or fear, reviving forcefully the *femme fatale* so prevalent in Symbolist art.

Surrealism, like Symbolism, began as a literary movement, widening to accommodate the visual arts. In 1917 French writer Guillaume Apollinaire referred to his own drama *Les Mamelles de Tirésias* (*The Breasts of Tiresias*), and also to the ballet *Parade* produced by Diaghilev, as "surrealist." The term was commonly used thereafter by the poets André Breton and Paul Éluard, as well as other contributors to the Paris journal *Littérature*. The concept of a literary and art movement formally designated as Surrealism, however, did not emerge until after the demise of Dada in Paris in the early 1920s.

Breton and the Background to Surrealism

In the years immediately after World War I, French writers had been trying to formulate an aesthetic of the nonrational stemming variously from the writings of Arthur Rimbaud, the Comte de Lautréamont (see p. 299), Alfred Jarry, and Apollinaire. By 1922 Breton was growing disillusioned with Dada on the ground that it was becoming institutionalized and academic, and led the revolt that broke up the Dada Congress of Paris. Together with Philippe Soupault, he explored the possibilities of automatic writing in his 1922 Surrealist texts called *The Magnetic Fields*. Pure psychic automatism, one of the fundamental precepts of Surrealism, was defined by Breton as "dictation of thought, in the absence of any control exercised by reason, and beyond any aesthetic or moral preoccupation." While this method of

Fetishism

Freudian psychoanalysis offered two theories especially appealing to Surrealist artists: dream work and fetishism. Both are described in terms of their sensory appeal: dreams as visual projections of the unconscious (see *The Interpretation of Dreams*, Ch. 4, p. 78) and fetishes as objects of particular tactile or optical interest. Fetishism, according to Freud, can arise during the process of psycho-sexual maturation, which begins at birth and continues into young adulthood. Traumatic experiences can affect the outcome of this process. For Freud, certain events were especially prone to trigger anxiety in children, who repress memories of such episodes, confining them to their unconscious. Sometimes the unconscious cannot retain difficult memories, allowing them to enter the conscious mind as unwanted (and seemingly groundless) phobias or desires. One event that Freud believed could tax the unconscious was a male child's recognition that women do not possess a penis. This revelation would be difficult to comprehend by a young boy, who naturally assumes that all humans are anatomically like him. The lack of a penis could only be accounted for by assuming the woman had somehow lost hers due to an injury or terrible punishment, raising the possibility that he might lose his penis, too. Typically, the "castration anxiety" caused by this event is minimized thanks to the child's ability to repress all memory of the event in his unconscious. But if repression is not entirely successful, the boy (and, later, the man) might employ a fetish to assuage the anxiety released by the unconscious. A fetish is typically an object linked by the unconscious to the traumatic event. Fetishes provide comfort by allowing the unconscious to revisit the trauma safely, with the security of an object that is a substitute for the thing lost or injured. Thus, in the case of castration anxiety, a shoe or stocking (something seen at the same time the boy realized that there was no penis where he expected to see one) compensates for the lack, providing pleasure by erasing anxiety. Although Freud's explanation of the source of fetishism precludes a female fetishist, some Surrealist artists like Claude Cahun explored fetishism in terms of feminine sexuality and pleasure.

One such game produced "The exquisite corpse will drink the young wine," hence the name. When this method was adapted for collective drawings (fig. **14.1**), the surprising results coincided with the Surrealist love of the unexpected. The elements of chance, randomness, and coincidence in the formation of a work of art had for years been explored by the Dadaists. Now it became the basis for intensive study for the Surrealists, whose experience of four years of war made them attach much importance to their isolation, their alienation from society and even from nature.

From the meetings between writers and painters emerged Breton's *Manifesto of Surrealism* in 1924, containing this definition:

> SURREALISM, noun, masc., pure psychic automatism by which it is intended to express, either verbally or in writing, the true function of thought. Thought dictated in the absence of all control exerted by reason, and outside all aesthetic or moral preoccupations. ENCYCL. Philos. Surrealism is based on the belief in the superior reality of certain forms of association heretofore neglected, in the omnipotence of the dream, and in the disinterested play of thought. It leads to the permanent destruction of all other psychic mechanisms and to its substitution for them in the solution of the principal problems of life.

This definition emphasizes words rather than plastic images, literature rather than painting or sculpture. Breton was a serious student and disciple of Freud, from whose teachings he derived the Surrealist position concerning the central significance of dreams and the unconscious, as well as the use of free association (allowing words or images to suggest other words or images without imposing rational connections or structures) to gain access to the unconscious.

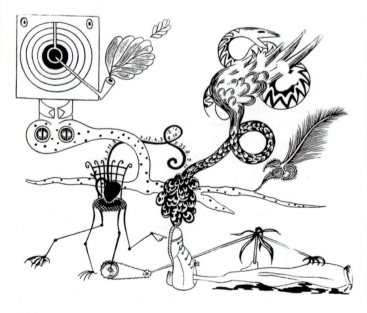

14.1 André Breton, Valentine Hugo, Greta Knutson, and Tristan Tzara, *Exquisite Corpse*, c. 1930. Ink on paper, 9¼ × 12¼" (23.5 × 31.1 cm). Morton G. Neumann Family Collection.

composing without any preconceived subject or structure was designed for writing, its principles were also applied by the Surrealists to drawing.

After 1922 Breton assumed the principal editorship of *Littérature* and gradually augmented his original band of writers with artists whose work and attitudes were closest to his own: Francis Picabia, Man Ray, and Max Ernst. One of the exercises in which the artists engaged during their gatherings was the so-called "exquisite corpse." The practice was based on an old parlor game in which one participant writes part of a sentence on a sheet of paper, folds the sheet to conceal part of the phrase, and passes it to the next player, who adds a word or phrase based on the preceding contribution. Once the paper makes it around the room in this manner, the provocative, often hilarious, sentence is read aloud.

Breton conceived of the Surreal condition as a moment of revelation in which are resolved the contradictions and oppositions of dreams and realities. In the second manifesto of Surrealism, issued in 1930, he said: "There is a certain point for the mind from which life and death, the real and the imaginary, the past and the future, the communicable and the incommunicable, the high and the low cease being perceived as contradictions."

Two nineteenth-century poets had irresistible appeal to the Surrealists: Isidore Ducasse, known as the Comte de Lautréamont (1846–70), and Arthur Rimbaud (1854–91). Unknown to each other, both lived almost in isolation, wandered from place to place, and died young; they wrote transformative poetry while still adolescents, tearing at the foundations of Romantic verse. The idea of revolt permeates Lautréamont's poetry: revolt against tradition, against the family, against society, and against God. The ideas of Rimbaud at seventeen years of age seemed to define for the Surrealists the nature of the poet and poetry. Rimbaud believed that the poet, like a Christian mystic, must attain a visionary state through rigid discipline—but here a discipline of alienation, monstrosities of love, suffering, and madness. Like the Surrealists later, Rimbaud was concerned with the implications of dreams, the unconscious, and chance.

An influential and charismatic figure, Breton was the self-appointed but generally acknowledged leader of Surrealism. He was ruthless in the role as he invited artists to join the group only to exclude them when they failed to toe the party line. As Breton formulated a dogma of Surrealist principles, schisms and heresies inevitably appeared, for few of its exponents practiced Surrealism with scrupulous literalness. In fact, the works of the major Surrealists have little stylistic similarity, aside from their departure from traditional content and their rejection of journalistic approaches to art. The first group exhibition of Surrealist artists was in 1925 at the Galerie Pierre. It included Arp, De Chirico, Ernst, Klee, Man Ray, Masson, Miró, and Picasso. In that year Yves Tanguy joined the group. A Surrealist gallery was opened in 1927 with an exhibition of these artists joined by Marcel Duchamp and Picabia. Except for René Magritte, who joined later that year, and Salvador Dalí, who did not visit Paris until 1929, this was the roster of the first Surrealist generation.

The Two Strands of Surrealism

From its inception, Surrealism in painting tended in two directions. The first, represented by Arp, Ernst, Miró, André Masson, and, later, Matta, is biomorphic or abstract Surrealism. In this tendency, automatism—"dictation of thought without control of the mind"—is predominant, and the results are generally close to abstraction, although some degree of recognizable imagery is normally present. Its origins were in the experiments in chance and automatism carried on by the Dadaists and the automatic writing of Surrealist poets. The other direction is associated with Salvador Dalí, Yves Tanguy, and René Magritte. It presents, in meticulous detail, recognizable scenes and objects that are taken out of natural context, distorted, and combined in fantastic ways as they might be in dreams. Its sources are the art of Henri Rousseau, Chagall, Ensor, De Chirico, and nineteenth-century Romantics. These artists attempted to use images of the unconscious, defined by Freud as uncontrolled by conscious reason (although Dalí, with his "paranoiac–critical methods," claimed to have control over his unconscious). Freud's theories of the unconscious and of the significance of dreams were, of course, fundamental to all aspects of Surrealism. To the popular imagination it was the naturalistic Surrealism associated with Dalí, Tanguy, and others of that group that signified Surrealism, even though it has had less influence historically than the abstract biomorphism of Miró, Masson, and Matta.

Both strands of Surrealism differed from Dada in their essentially Romantic emphasis on the unconscious (rather than the forms and rhythms of the machine). Like Dada, however, Surrealism delighted in the exploration of unconventional techniques and in discovering creative potential in areas that lay outside the conventional territory of art.

Political Context and Membership

Surrealism was a revolutionary movement not only in literature and art but also in politics. The Surrealist period in Europe was one of deepening political crisis, financial collapse, and the rise of fascism, provoking moral anxiety within the avant-garde. Under Breton's editorship (1925–29) the periodical *La Révolution surréaliste* maintained a steady Communist line during the 1920s. The Dadaists at the end of World War I were anarchists, and many future Surrealists joined them. Feeling that government systems guided by tradition and reason had led humankind into the bloodiest conflict in history, they insisted that government of any form was undesirable, and that the irrational was preferable to the rational in art and in all of life and civilization. The Russian Revolution and the spread of communism provided an alternative channel for Surrealist protests during the 1920s. Louis Aragon and, later, Paul Éluard joined the Communist Party, while Breton, after exposure to the reactionary bias of Soviet communism or Stalinism in art and literature (discussed in Chapter 9), took a Trotskyist position in the late 1930s (see *Trotsky and International Socialism between the Wars*, p. 300). Picasso, who made Surrealist work in the 1930s, became a Communist in protest against the fascism of Franco. By 1930, although schisms were occurring among the original Surrealists, new artists and poets were being recruited by Breton. Dalí joined in 1929, the sculptor Alberto Giacometti in 1931, and René Magritte in 1932. Other later recruits included Paul Delvaux, Henry Moore, Hans Bellmer, Oscar Dominguez, and Matta. The list of writers was considerably longer. Surrealist groups and exhibitions were organized in Britain, Czechoslovakia, Belgium, Egypt, Denmark, Japan, the Netherlands, Romania, and Hungary. Despite this substantial expansion, infighting resulted in continual resignations, dismissals, and reconciliations. In addition, artists such as Picasso were adopted by the Surrealists without joining officially.

Trotsky and International Socialism Between the Wars

Socialism attracted many adherents after World War I, with numerous artists and intellectuals among those drawn to the idea of a government managed for the economic benefit of all of its citizens. This was probably the only idea shared by the diverse organizations referred to as "socialist" that arose in Europe and North America during the 1910s and 20s. Labor unions were perhaps the most visible manifestation of socialism in Western Europe and North America between the wars. Strong unionists, or syndicalists, believed that workers needed to seize control (violently, if necessary) of production in order to alleviate economic disparity. The writings of Karl Marx and Friedrich Engels provided the basis for much socialist activity, most notably the Bolshevik Revolution in Russia. Far from monolithic, the Russian socialists directing the revolution held disparate views. Leon Trotsky, for instance, famously challenged Vladimir Lenin's and especially Joseph Stalin's advocacy of a powerful, central government controlled by intellectuals and bureaucrats drawn from the bourgeoisie. Trotsky's endorsement of a government managed by the working class itself was rejected, as was his adherence to the idea that socialism had to be an international phenomenon to succeed; he was eventually sent into exile by Stalin in 1924. Living first in Turkey, then France, Norway, and finally Mexico, Trotsky became a symbol of democratic communism and international workers' solidarity. Many artists and intellectuals, including most of the Surrealists, subscribed to Trotskyism. He was assassinated in Mexico by a Stalinist agent in 1940.

During the 1920s Arp's favorite material was wood, which he made into painted reliefs. He also produced paintings, some on cardboard with cut-out designs making a sort of reverse collage. Although Arp had experimented with geometric abstractions between 1915 and 1920 (see fig. 10.3), frequently collaborating with Sophie Taeuber, he abandoned geometric shapes after 1920. His art would increasingly depend on the invention of biomorphic, abstract forms, based on his conviction that "art is a fruit that grows in man, like a fruit on a plant, or a child in its mother's womb." Yet Arp championed the geometric work of Van Doesburg and Sophie Taeuber (see figs. 12.6, 10.4) and collaborated with these two artists in decorating ten rooms of the Café l'Aubette in his native city, Strasbourg (see fig. 12.7). His murals for the café (now destroyed) were the boldest, most free, and most simplified examples of his biomorphic abstraction. They utilized his favorite motifs: the navel and mushroom-shaped heads, sometimes sporting a mustache and round-dot eyes. *Rising Navel and Two Heads* was simply three flat, horizontal, scalloped bands of color, with two color shapes suggesting flat mushrooms floating across the center band. *Navel-Sun* was a loosely circular white shape floating on a blue background (though most of the actual color scheme is lost). There are no parallels for these large, boldly abstracted shapes until the so-termed Color Field painters of the 1950s and 60s.

Of particular interest among Arp's reliefs and collages of the late 1920s and early 30s were those entitled or subtitled *Objects Arranged According to the Laws of Chance*, or *Navels* (fig. **14.2**). These continued the 1916–17 experiment in *Collage Arranged According to the Laws of Chance* (see fig. 10.3), although most of the forms were now organic rather

During the 1930s the major publication of the Surrealists was the lavish journal *Minotaure*, founded in 1933 by Albert Skira and E. Tériade. The last issue appeared in 1939. Although emphasizing the role of the Surrealists, the editors drew into their orbit any of the established masters of modern art and letters who they felt had made significant contributions. These included artists as diverse as Matisse, Kandinsky, Laurens, and Derain.

"Art is a Fruit": Arp's Later Career

One of the original Zurich Dadaists (see Ch. 10, p. 214), **Jean (Hans) Arp** (1886–1966) was active in Paris Dada during its brief life, showing in the International Dada Exhibition of 1922 at the Galerie Montaigne, and contributing poems and drawings to Dada periodicals. When official Surrealism emerged in 1924, Arp was an active participant. At the same time, he remained in close contact with German and Dutch abstractionists and Constructivists. He also contributed to Theo van Doesburg's *de Stijl* and with El Lissitzky edited *The Isms of Art*. He and his wife and fellow artist Sophie Taeuber eventually made their home in Meudon, outside Paris.

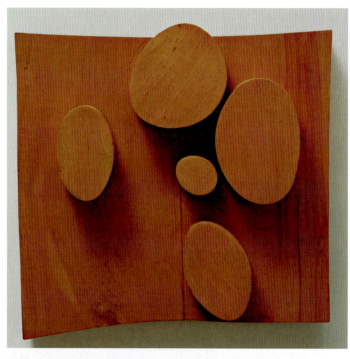

14.2 Jean (Hans) Arp, *Objects Arranged According to the Laws of Chance*, or *Navels*, 1930. Varnished wood relief, 10⅜ × 11⅛ × 2¼" (26.3 × 28.3 × 5.4 cm). The Museum of Modern Art, New York.

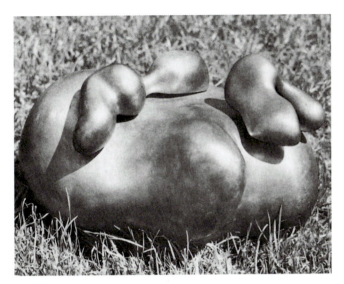

14.3 Jean (Hans) Arp, *Head with Three Annoying Objects*, 1930 (cast 1950). Bronze, 14⅛ × 10¼ × 7½" (35.9 × 26 × 19.1 cm). Estate of Jean Arp.

than geometric. Arp made several versions of this wooden relief in 1930–31; he often employed the oval shapes seen here, which were for him variations on a navel, his universal emblem of human life. He also produced string reliefs based on chance—loops of string dropped accidentally on a piece of paper and seemingly fixed there. It seems, however, that he may have given the laws of chance some assistance, for which he had a precedent in Duchamp's *3 Standard Stoppages* (see fig. 10.10).

Arp's great step forward in sculpture occurred at the beginning of the 1930s, when he began to work completely in the round, making clay and plaster models for later bronze or marble sculptures. Arp shared Brancusi's devotion to mass rather than space as the fundamental element of sculpture (see fig. 5.27). He thus stands at the opposite pole from the Constructivists Tatlin or Gabo (see figs. 9.34, 9.41). In developing the ideas of his painted reliefs, he had introduced seemingly haphazard detached forms that hovered around the matrix-like satellites. *Head with Three Annoying Objects* (fig. 14.3) was originally executed in plaster, Arp's preferred medium for his first sculptures in the round. On a large biomorphic mass rest three objects, identified as a mustache, a mandolin, and a fly. The three strange forms were named in Arp's earliest title for the work, derived from one of his stories in which he describes himself waking up with three "annoying objects" on his face. The objects were not secured to the "head," for Arp intended that they be moved around by the spectator, introducing yet another element of chance in his work. Arp applied titles to his works after he had made them, with the intention of inspiring associations between images and ideas or, as he said, "to ferret out the dream." Thus, the meaning of the work, like the arrangement of the forms themselves, was open-ended. Like many of Arp's plasters, *Head with Three Annoying Objects* was not cast in bronze until much later, in this case not until 1950.

To his biomorphic sculptural forms Arp applied the name "human concretion," for even forms that are not derived from nature, he said, can still be "as concrete and sensual

as a leaf or a stone." In 1930 Van Doesburg had proposed the name "concrete art" as a more accurate description for abstract art. He contended that the term "abstract" implied a taking away from, a diminution of, natural forms and therefore a degree of denigration. What could be more real, he asked, more concrete than the fundamental forms and colors of nonrepresentational or non-objective art? Although Van Doesburg's term did not gain universal recognition, Arp used it faithfully, and as "human concretions," it has gained a specific, descriptive connotation for his sculptures in the round. Arp said:

> Concretion signifies the natural process of condensation, hardening, coagulating, thickening, growing together. Concretion designates the solidification of a mass. Concretion designates curdling, the curdling of the earth and the heavenly bodies. Concretion designates solidification, the mass of the stone, the plant, the animal, the man. Concretion is something that has grown.

The art of Jean Arp took many different forms between 1930 and 1966, the year of his death. Abstract (or concrete) forms suggesting sirens, snakes, clouds, leaves, owls, crystals, shells, starfish, seeds, fruit, and flowers emerged continually, suggesting such notions as growth, metamorphosis, dreams, and silence. While developing his free-standing sculpture, Arp continued to make reliefs and collages. To make his new collages, Arp tore up his own work (fig. 14.4). In this

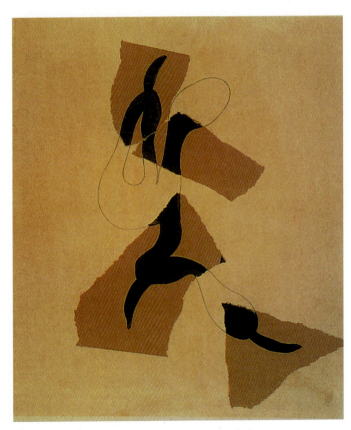

14.4 Jean (Hans) Arp, *Composition*, 1937. Collage of torn paper, India ink wash, and pencil, 11¾ × 9" (29.8 × 22.9 cm). Philadelphia Museum of Art.

example from 1937, he essentially recomposed the work by connecting the new forms with curvilinear lines drawn in pencil. This new collage technique, a liberating release from the immaculateness of the sculptures, was described by Arp:

> I began to tear my papers instead of curving them neatly with scissors. I tore up drawings and carelessly smeared paste over and under them. If the ink dissolved and ran, I was delighted.... I had accepted the transience, the dribbling away, the brevity, the impermanence, the fading, the withering, the spookishness of our existence.... These torn pictures, these *papiers déchirés* brought me closer to a faith other than earthly.

Many of these torn-paper collages found their way to the United States and offered a link between organic Surrealism and postwar American Abstract Expressionism.

Hybrid Menageries: Ernst's Surrealist Techniques

The career of **Max Ernst** (1891–1976) as a painter and sculptor, interrupted by four years in the German army, began when he moved to Paris from Cologne in 1922. At the end of 1921, the Dadaist Ernst had resumed painting

14.5 Max Ernst, *Two Children Are Threatened by a Nightingale*, 1924. Oil on wood with wood construction, 27½ × 22½ × 4½" (69.8 × 57.1 × 11.4 cm). The Museum of Modern Art, New York.

after having devoted himself to various collage techniques since 1919 (see fig. 10.25). The manner of *Celebes*, the chief painting of his pre-Paris period (see fig. 10.26), is combined with the technique of his Dada assemblages in *Two Children Are Threatened by a Nightingale* (fig. **14.5**), a 1924 dream landscape in which two girls—one collapsed on the ground, the other running and brandishing a knife—are frightened by a tiny bird. The fantasy is given peculiar emphasis by the elements attached to the panel—the house on the right and the open gate on the left. A figure on top of the house clutches a young girl and seems to reach for the actual wooden knob on the frame. Contrary to Ernst's usual method of working, the title of this enigmatic painting (inscribed in French on the frame) preceded the image. Ernst himself, speaking in the third person, noted:

> He never imposes a title on a painting. He waits until a title imposes itself. Here, however, the title existed before the picture was painted. A few days before, he had written a prose poem which began: *à la tombée de la nuit, à la lisière de la ville, deux enfants sont menacés par un rossignol* (as night falls, at the edge of town, two children are threatened by a nightingale).... He did not attempt to illustrate this poem, but that is the way it happened.

In 1925, Ernst became a full participant in the newly established Surrealist movement. That year he began to make drawings that he termed *frottage* ("rubbing"), in which he used the child's technique of placing a piece of paper on a textured surface and rubbing over it with a pencil. The resulting image was largely fortuitous, but Ernst consciously reorganized the transposed textures in new contexts, creating new and unforeseen associations. Not only did *frottage* provide the technical basis for a series of unorthodox drawings, it also intensified Ernst's perception of the textures in his environment—wood, cloth, leaves, plaster, and wallpaper.

Ernst applied this technique, combined with *grattage* ("scraping"), to his paintings of the late 1920s and the 30s. The 1927 canvas *The Horde* (fig. **14.6**) expresses the increasingly ominous mood of his paintings. The monstrous, tree-like figures are among the many frightening premonitions of the conflict that would overtake Europe in the next decade. In 1941, Ernst fled World War II in Europe and settled in New York City, where his presence, along with other Surrealist refugees, would have tremendous repercussions for American art. Ernst's antipathy toward the rise of fascism was given fullest expression in *Europe after the Rain* (fig. **14.7**), which has been aptly described as a requiem for the war-ravaged continent. In this large painting Ernst employed yet another technique, which he called "decalcomania." Invented by the Spanish Surrealist Oscar Dominguez, this technique involved placing paper or glass on a wet painted surface, then pulling it away to achieve surprising textural effects. It appealed to Ernst and other Surrealists for the startling automatic forms that could be created.

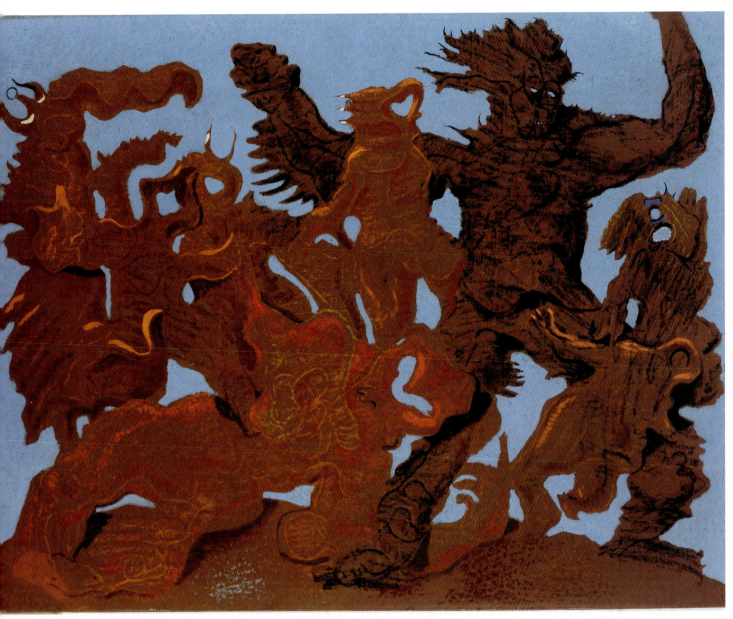

14.6 Max Ernst, *The Horde*, 1927. Oil on canvas, 44⅞ × 57½″ (114 × 146.1 cm). Stedelijk Museum, Amsterdam.

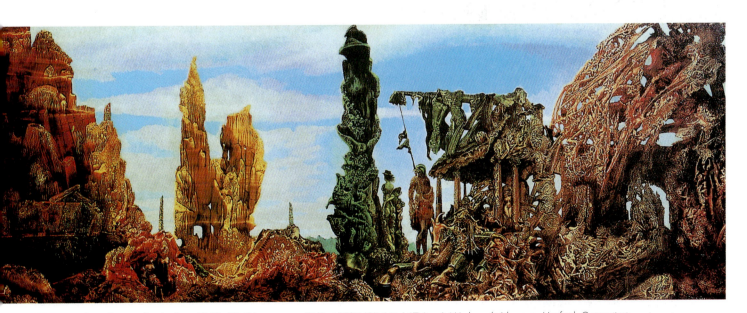

14.7 Max Ernst, *Europe after the Rain*, 1940–42. Oil on canvas, 21½ × 58⅛″ (54.6 × 147.6 cm). Wadsworth Atheneum, Hartford, Connecticut.

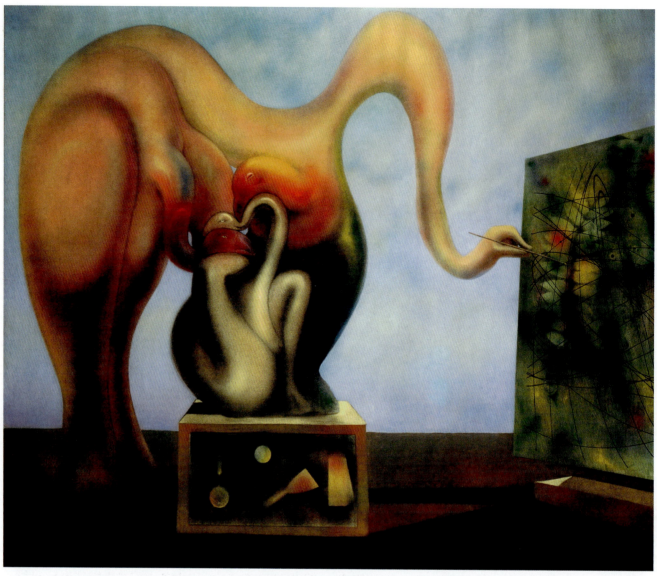

14.8 Max Ernst, *Surrealism and Painting*, 1942. Oil on canvas, 77 × 92" (1.95 × 2.3 m). Menil Collection, Houston, Texas.

Of all the menageries and hybrid creatures that Ernst invented, he most closely identified with the image of the bird, eventually adopting one of his inventions, named Loplop, as a kind of surrogate self-image. The 1942 painting *Surrealism and Painting* (fig. **14.8**), also the title of a book by Breton, shows a bird-like beast made of smoothly rounded sections of human anatomy, serpents, and birds' heads. The monster, painted in delicate hues, is composing an abstract painting, perhaps "automatically." In fact, Ernst engaged in a partially automatic process to create the painting—he swung paint over the canvas from a hole in a tin can. The full implications of this "drip" technique would be explored by Jackson Pollock to make his revolutionary, mural-sized abstract paintings in the late 1940s and the 1950s (see fig. 16.8).

"Night, Music, and Stars": Miró and Organic–Abstract Surrealism

Although active for many years in Paris, the Spanish artist **Joan Miró** (1893–1983) constantly returned to his native country, and his Catalan roots remained a consistent force in his art throughout his life. In art schools in Barcelona, where he was born, he was introduced to French art, and his first mature paintings, executed in 1915–16, show the influence of Cézanne. But he also admired more contemporary masters, especially Matisse and his fellow Spaniard Picasso. Though never a Cubist, he freely adapted aspects of the style to suit his own purposes.

Nude with Mirror (fig. **14.9**), begun in the spring of 1919, combines Cubist faceting, flat-color areas, and geometric pattern with a sculptural figure. Painted from a live model, the nude is set against a spare, terracotta-colored background that contrasts sharply with the highly decorative patterns of the stool and rug on which she sits. Despite the Cubist fracturing of certain parts of the anatomy, the figure has a strong three-dimensional presence of rounded volumes. In the monumental simplicity of *Nude with Mirror* there is evidence of Miró's admiration for Henri Rousseau (see fig. 3.14). A hint of the unreality to come in Miró's work emerges as we realize that the model gazes at herself in the mirror with nearly closed eyes.

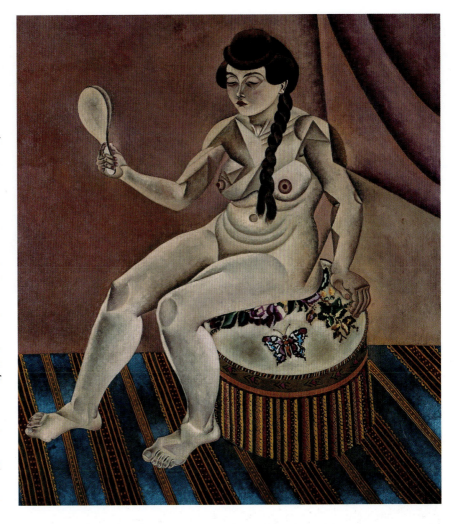

14.9 Joan Miró, *Nude with Mirror*, 1919. Oil on canvas, 44½ × 40⅛" (113 × 102 cm). Kunstsammlung Nordrhein-Westfalen, Düsseldorf.

In 1920 Miró began to spend winters in Paris and summers in Montroig, Spain. He was drawn to the work of the Dadaists as well as Paul Klee and, by 1923, was working from his imagination rather than from nature. He became friendly with Breton and the other poets in Paris who were soon to launch the Surrealist revolution. Yet these encounters, as well as Miró's natural inclination to fantasy, do not entirely account for the richly imaginative imagery that he said was "always born in a state of hallucination."

Carnival of Harlequin, 1924–25 (fig. **14.10**), is one of the first Surrealist pictures where Miró's playful sense of caprice has been given full rein. His space, the suggested confines of a grayish-beige room, teems with life of the strangest variety. At the left is a tall ladder to which an ear has been attached along with, at the very top, a tiny, disembodied eye. Animating the inanimate was a favorite Surrealist theme. To the right of the ladder is a man with a disk-shaped head who sports a long-stemmed pipe beneath a tendriled mustache and stares sadly at the spectator. At his side, an insect with blue and yellow wings pops out of a box. Surrounding this group is every sort of hybrid organism, all having a fine time. Miró's unreal world is painstakingly rendered and remarkably vivid; even his inanimate objects have an eager vitality. He derived his imagery from many sources beyond his own fertile imagination. While some are based on forms in nature, others may stem from medieval art or the paintings of his fellow Surrealists. As they float in the air or cavort on the ground, his creatures are spread equally across the entire surface of the painting, so our eyes do not alight in one central place. In this picture, as well as in a number of others around this time, Miró mapped out his compositional organization with red lines arranged in a diagonal grid that can still be detected through the paint layer.

The second half of the 1920s was an especially prolific period for Miró. His first solo show was held in Paris in 1925, and in November of that year he took part in the first exhibition of Surrealist painting, which included *Carnival of Harlequin*. Much of the work of this period is marked by a reduction of means, moving from the complexity of *Carnival of Harlequin* to the magic simplicity of a painting such as *Dog*

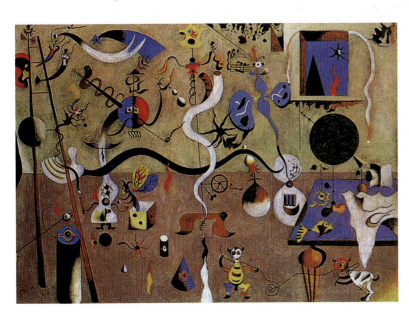

14.10 Joan Miró, *Carnival of Harlequin*, 1924–25. Oil on canvas, 26 × 36⅝" (66 × 93 cm). Albright-Knox Art Gallery, Buffalo, New York.

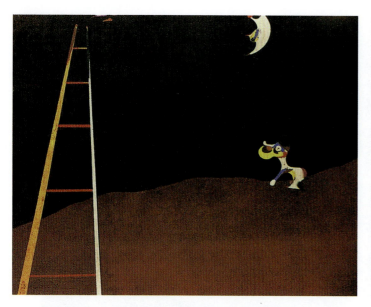

14.11 Joan Miró, *Dog Barking at the Moon*, 1926. Oil on canvas, 28¾ × 36¼" (73 × 92 cm). Philadelphia Museum of Art.

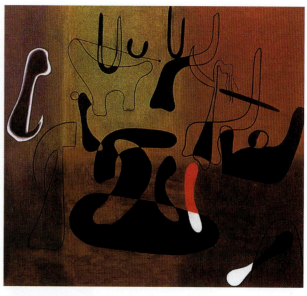

14.12 Joan Miró, *Painting*, 1933. Oil on canvas, 5' 8½" × 6' 5¼" (1.74 × 2 m). The Museum of Modern Art, New York.

Barking at the Moon (fig. **14.11**). Again we find the ladder, for Miró a symbol of transcendence and a bridge to another, unearthly realm. But it is now a player in a depopulated nocturnal landscape, a dark and alien place that resembles a scene from a dream.

In 1933 Miró made a remarkable group of eighteen paintings based on collages of realistic details torn from newspapers and pasted on cardboard. The motifs—tools, machines, furniture, and dishes—suggested to him organic–abstract shapes, sometimes with implied faces or figures. The predominantly abstract intent of these paintings is indicated by their neutral titles. One of the paintings that resulted from this process is *Painting* (fig. **14.12**). Although this work appears completely nonfigurative, many observers have found a resemblance between the mysterious forms and animals, such as a seated dog at the upper left. These organic–abstract shapes are perhaps closest to the biomorphic inventions of Arp.

A classic example of the Surrealist "object" that proliferated in the movement in the 1930s is Miró's sculpture that takes this very word for its title (fig. **14.13**). The object consists of a wood cylinder that holds in its cavity a high-heeled, doll-sized leg, the fetishistic nature of which typifies Surrealist eroticism. The cylinder is surrounded by other found objects, including a stuffed parrot from whose perch is suspended a little cork ball. The whole construction sits on a base made of a bowler hat; in its brim "swims" a red plastic fish. The Surrealist juxtaposition of disparate objects was meant to evoke surprise and trigger further associations in the mind of the viewer. The notion of found objects was introduced by Duchamp (see fig. 10.8), but Miró did not adopt that artist's attitude of aesthetic indifference in this whimsical, carefully composed object.

With the outbreak of World War II, Miró had to flee from his home in Normandy and go back to Spain, where a rightwing government under General Franco had been established in 1939 following Franco's victory, with

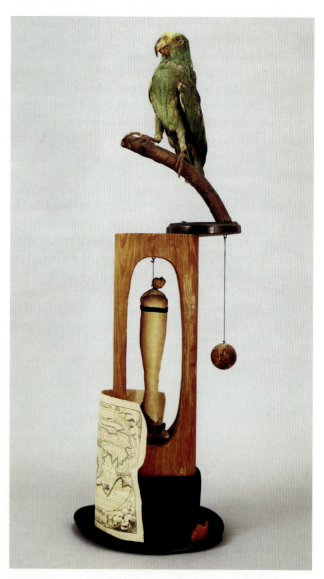

14.13 Joan Miró, *Object*, 1936. Assemblage: stuffed parrot on wooden perch, stuffed silk stocking with velvet garter and doll's paper shoe suspended in hollow wooden frame, derby hat, hanging cork ball, celluloid fish, and engraved map, 31⅞ × 11⅞ × 10¼" (81 × 30.1 × 26 cm). The Museum of Modern Art, New York.

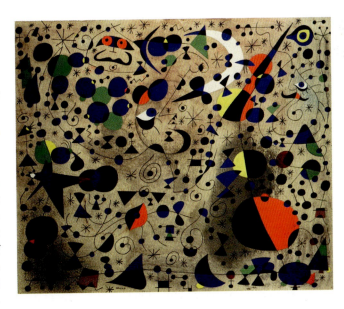

14.14 Joan Miró, *The Poetess* from the series *Constellations*, December 31, 1940. Gouache and oil wash on paper, 15 × 18" (38.1 × 45.7 cm). Private collection.

support from Nazi Germany, in the Spanish Civil War of 1936–39. The isolation of the war years and the need for contemplation and re-evaluation led Miró to read mystical literature and to listen to the music of Mozart and Bach. "The night, music, and stars," he said, "began to play a major role in suggesting my paintings." While fleeing from the Nazis in France to Franco's Spain, Miró, in contrast to his inclination—in response to the Spanish Civil War—to revisit representation, committed himself to an abstract art consistent with his evocative Surrealist compositions of the 1920s. Between January 1940 and September 1941 he worked on a series of twenty-three small gouaches entitled *Constellations* (fig. **14.14**), which are among his most intricate and lyrical creations. In the sparkling compositions the artist was concerned with ideas of flight and transformation as he contemplated the migration of birds, the seasonal renewal of butterfly hordes, and the flow of constellations and galaxies. Miró dispersed his imagery evenly across the surface. In 1945 the *Constellations* were shown at New York's Pierre Matisse Gallery, where they affected the emerging American Abstract Expressionist painters then seeking alternatives to Social Realism and Regionalism (see figs. 16.4, 16.27). As the leader of the organic–abstract tendency within Surrealism, Miró had a major impact on younger American painters.

Methodical Anarchy: André Masson

One of the Surrealist artists who would eventually emigrate from Paris to New York was **André Masson** (1896–1987). Among the first Surrealists, Masson was the most passionate revolutionary, a man of vehement convictions who had been deeply spiritually scarred by his experiences in World War I. Almost fatally injured, he was hospitalized for a long time, and after partially recovering, he continued to rage against the insanity of humankind and society until he was confined for a while to a mental hospital. Masson was by nature an anarchist, whose convictions were fortified by his experience. He joined the Surrealist movement in 1924, though his anticonformist temperament caused him to break with the controlling Breton. Masson first left the group in 1929, rejoined it in the 1930s, and left again in 1943.

Masson's paintings of the early 1920s reveal his debt to Cubism, particularly that of Juan Gris (see Ch. 7, pp. 160–61). In 1925 Masson was regularly contributing automatic drawings to *La Révolution surréaliste*. These works directly express his emotions and contain various images relating to the sadism of human beings and the brutality of all living things. *Battle of Fishes* (fig. **14.15**) is an example of Masson's sand painting, which he made by freely applying adhesive to the

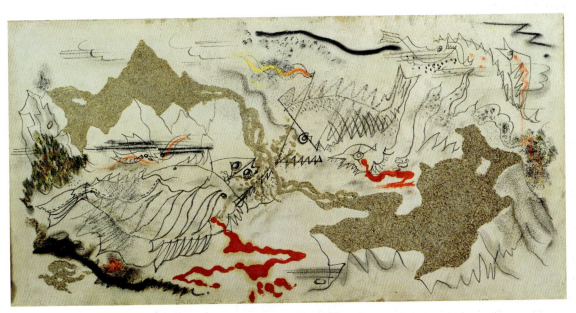

14.15 André Masson, *Battle of Fishes*, 1926. Sand, gesso, oil, pencil, and charcoal on canvas, 14¼ × 28¾" (36.2 × 73 cm). The Museum of Modern Art, New York.

canvas, then throwing sand over the surface and brushing away the excess. The layers of sand would suggest forms to the artist, "although almost always irrational ones," he said. He then added lines and small amounts of color, sometimes directly from the paint tube, to form a pictorial structure around the sand. Here the imagery is aquatic, though the artist described the fish as **anthropomorphic**. As in the *frottage* technique used by Ernst (see fig. 14.6), Masson here allows chance to help determine his composition, though his firm belief that art should be grounded in conscious, aesthetic decisions eventually led him away from this method.

In the late 1930s, after living principally in Spain for three years, Masson temporarily painted in a style closer to the more naturalistic wing of Surrealism. He painted monstrous, recognizable figures from mythological themes in a manner influenced by Picasso and possibly Dalí. To escape World War II, Masson lived for a time in the United States, where, he said, "Things came into focus for me." He exhibited regularly in New York, influencing some of the younger American painters, particularly Jackson Pollock. Masson would later say that Pollock carried automatism to an extreme that he himself "could not envision." Living in rural Connecticut, Masson reverted to a somewhat automatist, Expressionist approach in works such as *Pasiphaë* (fig. **14.16**). The classical myth of the Minotaur provided one of his recurrent themes in the 1930s and 40s. (It was he who named the Surrealist review after this part-man, part-bull beast from Greek mythology.) Because she displeased the sea god Poseidon, Pasiphaë was made to feel a passionate, carnal desire for a beautiful white bull. Following her union with the bull she gave birth to the monstrous

Minotaur. Masson said he wanted to represent the violent union of woman and beast in such a way that it is impossible to tell where one begins and the other ends. This subject, which had become a major theme in Picasso's work (see fig. 11.22), also appealed to the young Pollock, who made a painting of Pasiphaë in the same year as Masson.

Enigmatic Landscapes: Tanguy and Dalí

To capture the simultaneous familiarity and strangeness of dreams—believed to be a link to the unconscious—some Surrealists worked in a highly naturalistic style. Using the illusionism of Renaissance perspective along with intense colors and highly finished surfaces, artists like Yves Tanguy and Salvador Dalí attempted to picture the desires and fears contained in the unconscious, an endeavor that Freud would dismiss as both pointless and impossible.

Yves Tanguy (1900–55) had literary interests and close associations with the Surrealist writers Jacques Prévert and Marcel Duhamel in Paris after 1922. With Prévert he discovered the writings of Lautréamont and other prophets of Surrealism. In 1923, inspired by two De Chirico paintings in the window of the dealer Paul Guillaume, he decided to become a painter. Entirely self-taught, Tanguy painted in a naive manner until 1926, at which time he destroyed many of these canvases. After meeting André Breton, Tanguy began contributing to *La Révolution surréaliste* and was adopted into the Surrealist movement. His subsequent progress was remarkable, in both technique and fantastic imagination. *Mama, Papa Is Wounded!* (fig. **14.17**) was the

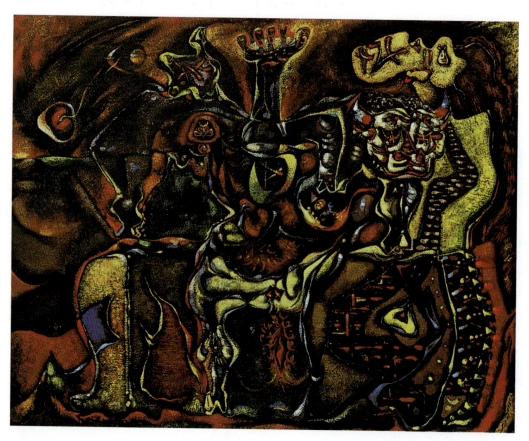

14.16 André Masson, *Pasiphaë*, 1943. Oil and tempera on canvas, 39¾ × 50" (101 × 127 cm). Private collection.

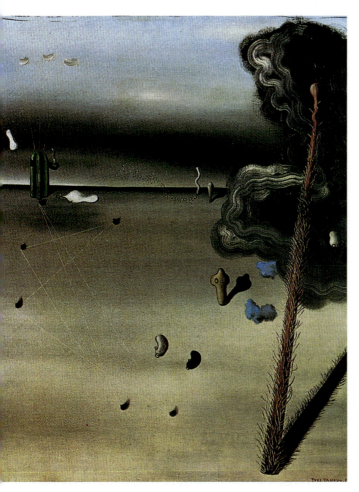

14.17 Yves Tanguy, *Maman, Papa est blessé!* (*Mama, Papa Is Wounded!*), 1927. Oil on canvas, 36¼ × 28¾" (92.1 × 73 cm). The Museum of Modern Art, New York.

A substantial part of the iconography of Dalí refers to real or imagined episodes from his childhood and adolescence. The landscape of these early years appears constantly in his paintings, which are marked by the violence of his temperament—ecstatic, filled with fantasy, terror, and megalomania. Dalí encountered Italian and French art, Impressionism, Neo-Impressionism, and Futurism before he went to Madrid's Academy of Fine Arts in 1921. He followed the normal academic training, developing a highly significant passion for nineteenth-century academicians and artists such as Millet (see fig. 1.13), Böcklin (see fig. 4.30), and particularly the meticulous narrative painter Ernest Meissonier. His discoveries in modern painting during the early 1920s were Picasso, De Chirico, Carrà, and the Italian Metaphysical School, whose works were reproduced in the periodical *Valori Plastici*. More important for his development was the discovery of Freud, whose writings on dreams and the subconscious seemed to answer the torments and erotic fantasies he had suffered since childhood. Between

SOURCE

Georges Bataille
from *The Cruel Practice of Art* (1949)

The philosopher Georges Bataille was, along with André Breton, a chief theoretician of Surrealism. By 1929, Breton's political intransigence led many artists and writers to form an alternative Surrealist group around Bataille.

The painter is condemned to please. By no means can he transform a painting into an object of aversion. The purpose of a scarecrow is to frighten birds from the field where it is planted, but the most terrifying painting is there to attract visitors. Actual torture can also be interesting, but in general that can't be considered its purpose. Torture takes place for a variety of reasons. In principle its purpose differs little from that of the scarecrow: unlike art, it is offered to sight in order to repel us from the horror it puts on display. The painted torture, conversely, does not attempt to reform us. Art never takes on itself the work of the judge. When horror is subject to the transfiguration of an authentic art, it becomes a pleasure, an intense pleasure, but a pleasure all the same....

The paradox of emotion is that it wants to have much more sense than it does have. Emotion that is not tied to the opening of a horizon but to some nearby object, emotion within the limits of reason only offers us a compressed life. Burdened by our lost truth, the cry of emotion rises out of disorder, such as it might be imagined by the child contrasting the window of his bedroom to the depths of the night. Art, no doubt, is not restricted to the representation of horror, but its movement puts art without harm at the height of the worst and, reciprocally, the painting of horror reveals the opening onto all possibility. That is why we must linger in the shadows which art acquires in the vicinity of death.

culmination of this first stage and exhibited all the obsessions that haunted him for the rest of his career. The first of these was an infinite-perspective depth, rendered simply by graded color and a sharp horizon line—a space that combines vast emptiness and intimate enclosure, where ambiguous organic shapes, reminiscent of Arp's biomorphic sculptures, float in a barren dreamscape.

Dalí

The artist who above all others symbolizes Surrealism in the public imagination is the Spaniard **Salvador Dalí** (1904–89). Not only his paintings, but his writings, his utterances, his actions, his appearance, his mustache, and his genius for publicity have made the word "Surrealism" a common noun in all languages, denoting an art that is irrational, erotic, mad—and fashionable. Dalí's life was itself so completely Surrealist as to appear contrived, leading some—including many Surrealists—to question his integrity along with his pictorial accomplishments. The primary evidence must be the paintings themselves, and no one can deny the technical facility, the power of imagination, or the intense conviction that they display.

Dalí was born at Figueras, near Barcelona. Like Picasso, Miró, and, before them, the architect Gaudí (see Ch. 4, pp. 80–81), he was a product of the rich Catalan culture.

1925 and 1927 he explored several styles and often worked in them simultaneously: the Cubism of Picasso and Gris, the Purism of Le Corbusier and Ozenfant, the Neoclassicism of Picasso, and a precise realism derived from the seventeenth-century Dutch master Vermeer.

In 1929 Dalí visited Paris for several weeks and, through his friend Miró, met the Surrealists. He moved to the French capital for a time the following year (though his main residence was Spain) to become an official member of the movement. Breton regarded the dynamic young Spaniard as a force for renewal in the group, which was plagued by endless ideological conflict (see *Bataille, The Cruel Practice of Art*, p. 309). Dalí became deeply involved with Gala Éluard, the wife of the Surrealist writer Paul Éluard, and he married her in 1934. He had by now formulated the theoretical basis of his painting, described as "paranoiac–critical": the creation of a visionary reality from elements of visions, dreams, memories, and psychological or pathological distortions.

Dalí developed a precise miniaturist technique, accompanied by a discordant but luminous color. His detailed *trompe l'oeil* technique was designed to make his dreamworld more tangibly real than observed nature (he referred to his paintings as "hand-painted dream photographs"). He frequently used familiar objects as a point of departure—watches, insects, pianos, telephones, old prints or photographs—imparting to them fetishistic significance. He declared his primary images to be blood, decay, and excrement. From the commonplace object Dalí set up a chain of metamorphoses that gradually or suddenly dissolved and transformed the object into a nightmare image, given conviction by the exacting technique. He was determined to paint as a madman—not in an occasional state of receptive somnambulism, but in a continuous frenzy of induced paranoia. In collaboration with Luis Buñuel, Dalí turned to the cinema and produced two classics of Surrealist film, *Un Chien andalou* (*An Andalusian Dog*) (1929) and *L'Age d'or* (*The Golden Age*) (1930). The cinematic medium held infinite possibilities for the Surrealists, in the creation of dissolves, metamorphoses, and double and quadruple images, and Dalí made brilliant use of these.

The microscopic brand of realism that Dalí skillfully deployed to objectify the dreamworld reached full maturity in a tiny painting from 1929, *Accommodations of Desire* (fig. **14.18**). The work is actually a collage, created using two illustrations of lions' heads that Dalí cut from a book and placed on what appear to be stones. These strange forms cast dark shadows in the desolate landscape and serve as backdrops to other imagery, including an army of ants. In one of the most disturbing images in *Un Chien andalou*, which had been made earlier the same year, ants swarm over a hand. They appear again, this time over a pocket watch, in one of Dalí's later paintings (see fig. 14.19). His own painted incarnations of a lion's head appear at the upper left of *Accommodations* and with the group of figures at the top of the composition. In his mostly fictional autobiography of 1942, *The Secret Life of Salvador Dalí*, the artist said that he undertook this painting during his courtship of Gala (who was then still married to Paul Éluard). The experience of intense sexual anxiety led him to paint this work, in which "desires were always represented by the terrorizing images of lions' heads."

In his book *La Femme visible* (*The Visible Woman*) (1930), Dalí wrote: "I believe the moment is at hand when, by a paranoiac and active advance of the mind, it will be possible (simultaneously with automatism and other passive states) to systematize confusion and thus to help discredit completely the world of reality." By 1930 Dalí had left De Chirico's type of metaphysical landscape for his own world

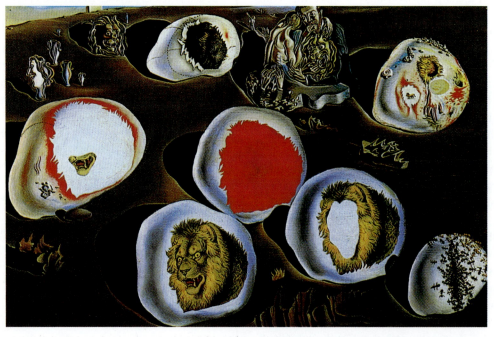

14.18 Salvador Dalí, *Accommodations of Desire*, 1929. Oil and collage on panel, 8⅝ × 13¾" (22 × 34.9 cm). The Metropolitan Museum of Art, Jacques and Natasha Gelman Collection, 1998 (1999.363.16).

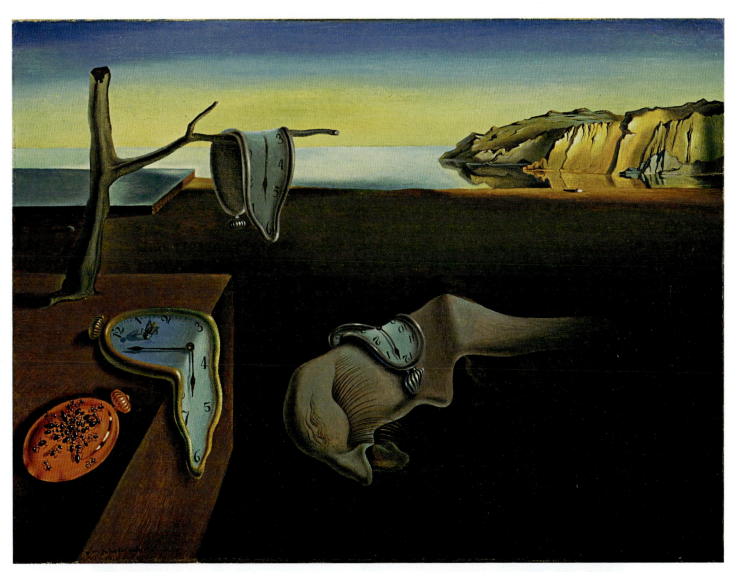

14.19 Salvador Dalí, *Persistance de la mémoire* (*The Persistence of Memory*), 1931. Oil on canvas, 9½ × 13″ (24.1 × 33 cm). The Museum of Modern Art, New York.

View the Closer Look for *The Persistence of Memory* on mysearchlab.com

of violence, blood, and decay. He sought to create in his art a specific documentation of Freudian theories applied to his own inner world. He started a painting with the first image that came into his mind and went on from one association to the next, multiplying images of persecution or megalomania like a true paranoiac. He defined his paranoiac–critical method as a "spontaneous method of irrational knowledge based upon the interpretative–critical association of delirious phenomena."

Dalí shared the Surrealist antagonism to art that defined itself in terms of formal qualities rather than content. *The Persistence of Memory* of 1931 (fig. **14.19**) is a denial of every twentieth-century experiment in abstract organization. Its miniaturist technique (the painting is only just over a foot wide) goes back to fifteenth-century Flemish art, and its sour greens and yellows recall nineteenth-century **chromolithographs**. The space is as infinite as Tanguy's (see fig. 14.17), and rendered with hard objectivity. The picture's fame comes largely from the presentation of recognizable objects—watches—in an unusual context, with unnatural

attributes, and on an unexpected scale. Throughout his career Dalí was obsessed with the morphology of hard and soft. Here, lying on the ground, is a large head in profile (which had appeared in several previous paintings) seemingly devoid of bone structure. Drooped over its surface, as on that of a tree and a shelf nearby, is a soft pocket watch. Dalí described these forms as "nothing more than the soft, extravagant, solitary, paranoic–critical Camembert cheese of space and time." He painted the work one night after dinner, when, after all the guests were gone, he contemplated the leftover Camembert cheese melting on the table. When he then looked at the landscape in progress in his studio—with shoreline cliffs and a branchless olive tree—the image of soft watches came to him as a means of representing the condition of softness. This pictorial metamorphosis, in which matter is transformed from one state into another, is a fundamental aspect of Surrealism.

Dalí's painting during the 1930s vacillated between outrageous fantasy and a strange atmosphere of quiet achieved less obviously. *Gala and the Angelus of Millet Immediately*

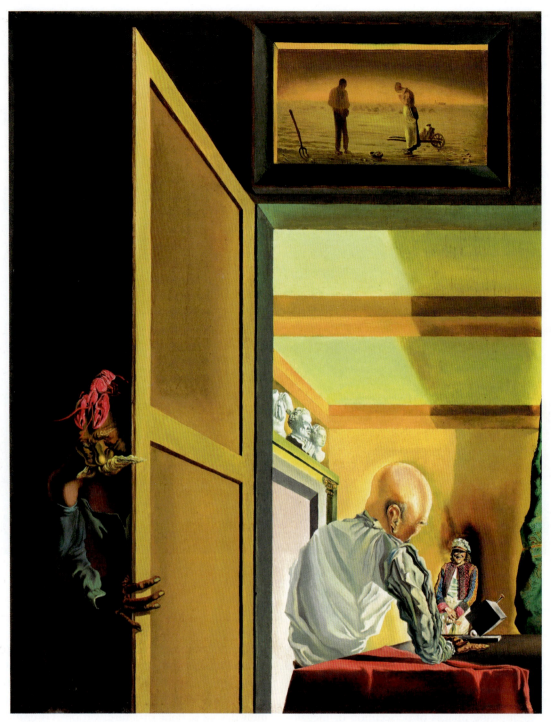

14.20 Salvador Dalí, *Gala and the Angelus of Millet Immediately Preceding the Arrival of the Conic Anamorphoses*, 1933. Oil on panel, 9⅜ × 7⅜" (23.8 × 18.7 cm). National Gallery of Canada, Ottawa.

Preceding the Arrival of the Conic Anamorphoses (fig. **14.20**) exemplifies the first aspect. In the back of a brilliantly lit room is Gala, grinning broadly, as though snapped by an amateur photographer; in the front sits an enigmatic male, actually a portrait of Vladimir Lenin. Over the open doorway is a print of Millet's *Angelus* (see fig. 1.13), a painting that, in Dalí's obsessive, Freudian reading, had become a scene about predatory female sexuality. Around the open door a monstrous comic figure (the Russian writer Maxim Gorky) emerges from the shadow, wearing a lobster on his head. There is no rational explanation for the juxtaposition of familiar and phantasmagoric, but the nightmarish effect is undeniable. Dalí painted *Soft Construction with Boiled Beans: Premonitions of Civil War* (fig. **14.21**) in Paris in 1936, on the eve of the Spanish Civil War. It is a horrific scene of psychological torment and physical suffering. A gargantuan figure with a grimacing face is pulled apart, or rather pulls itself apart ("in a delirium of auto-strangulation" said the artist), while other body parts are strewn among the excretory beans along the ground. Despite the anguish expressed in his painting, Dalí reacted to the civil war in his native country—as he did to fascism in general—with characteristic self-interest (he had quarreled bitterly with the Surrealists in 1934 over his refusal to condemn Hitler).

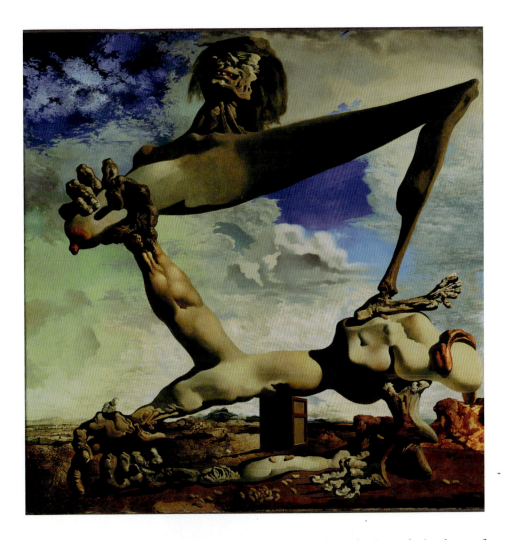

14.21 Salvador Dalí,
*Soft Construction with Boiled Beans:
Premonitions of Civil War*, 1936. Oil on
canvas, 39¼ × 39" (100 × 99 cm).
Philadelphia Museum of Art.

◄•—⎯ Listen to a podcast about Dalí on
mysearchlab.com

In 1940 Dalí, like so many of the Surrealists, moved to the United States where he painted society portraits and flourished in the role of Surrealist *agent provocateur*. His notoriety and fashionable acceptance reached their height with designs for the theater, jewelry, and *objets d'art*. In 1941 came a transition in his painting career. He announced his determination to "become Classic," to return to the High Renaissance of Raphael, though his paintings still contained a great deal of Surrealist imagery. He and Gala resettled permanently in Spain in 1948. After 1950 Dalí's principal works were devoted to Christian religious art, exalting the mystery of Christ and the Mass.

Surrealism beyond France and Spain: Magritte, Delvaux, Bellmer, Matta, and Lam

In contrast to Dalí, **René Magritte** (1898–1967) has been called the invisible man among the Surrealists. Thanks perhaps to the artist's comparatively low-key personality, due in part to Breton's lukewarm support of his art, the works of Magritte have had a gradual but powerful impact. In particular, his exploration of how we "read" visual images as part of a code, or system of signs, coincided with the linguistic and philosophical investigations that led to the modern field of **semiotics**.

After years of sporadic study at the Brussels Academy of Fine Arts, Magritte, like Tanguy, was shocked into realizing his destiny when in 1923 he saw a reproduction of De Chirico's 1914 painting *The Song of Love*. In 1926 he emerged as an individual artist with his first Surrealist paintings, inspired by the work of Ernst and De Chirico. Toward the end of that year, Magritte joined other Belgian writers, musicians, and artists in an informal group comparable to the Paris Surrealists. He moved to a Paris suburb in 1927, entering one of the most highly productive phases of his career, and participated for the next three years in Surrealist affairs. Wearying of the frenetic, polemical atmosphere of Paris after quarreling with the Surrealists, and finding himself without a regular Parisian dealer to promote his work, Magritte returned to Brussels in 1930 and lived there quietly for the rest of his life.

Because of this withdrawal from the art centers of the world, Magritte's paintings did not initially receive much attention. In Europe he was seen as a marginal figure among the Surrealists, and in the United States, in the heyday of painterly abstraction after World War II, his meticulous form of realism seemed irrelevant to many who were drawn instead to the work of Masson or Miró. But subsequent generations, such as that of the Pop artists, appreciated Magritte's capacity for irony, uncanny invention, and deadpan realism. The perfect symbol for his approach is the painting entitled *The Treachery (or Perfidy) of Images*

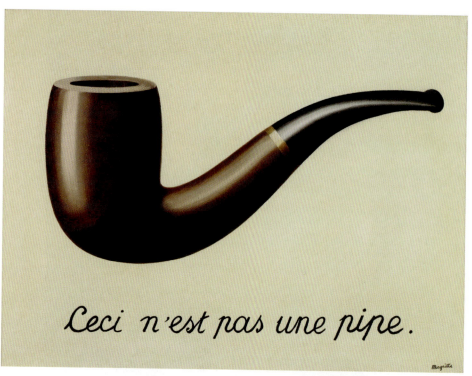

on illusion implies that the painting is less real than the landscape, when in fact both are painted fictions. The tree depicted here, as the artist explained (somewhat confusingly, in view of the illusory nature of the "real" landscape, as he defines it), exists for the spectator "both inside the room in the painting, and outside in the real landscape. Which is how we see the world: we see it as being outside ourselves even though it is only a mental representation of it that we experience inside ourselves."

Magritte drew freely on the Freudian repertoire of sexual anxiety, a constellation of psychological experiences that presupposes a heterosexual male consciousness confronted with the alluring yet dangerous "eternal feminine." As is often the case with works by male Surrealists, Magritte's exploration of

(fig. **14.22**). It portrays a briar pipe so meticulously that it might serve as a tobacconist's trademark. Beneath, rendered with comparable precision, is the legend *Ceci n'est pas une pipe* ("This is not a pipe"). This delightful work confounds pictorial reality and underscores Magritte's fascination with the relationship of language to the painted image. It undermines our natural tendency to speak of images as though they were actually the things they represent. A similar idea is embodied in *The Human Condition* (fig. **14.23**), where we encounter a pleasant landscape framed by a window. In front of this opening is a painting on an easel that "completes" the very landscape it blocks from view. The problem of real space versus spatial illusion is as old as painting itself, but it is imaginatively treated in this picture within a picture. Magritte's classic play

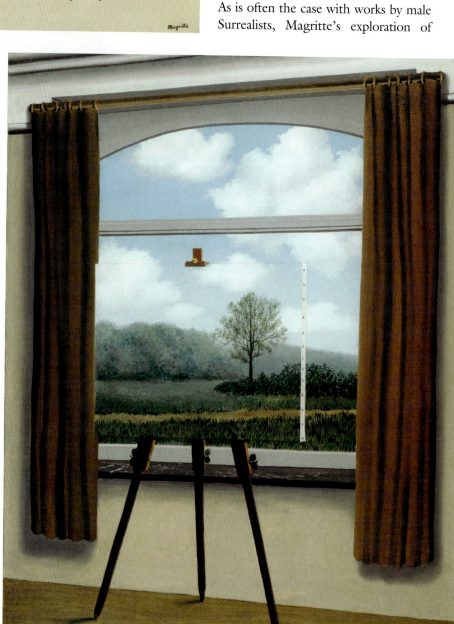

14.23 René Magritte, *The Human Condition*, 1933. Oil on canvas, 39⅜ × 31⅞" (100 × 81 cm). National Gallery of Art, Washington, D.C.

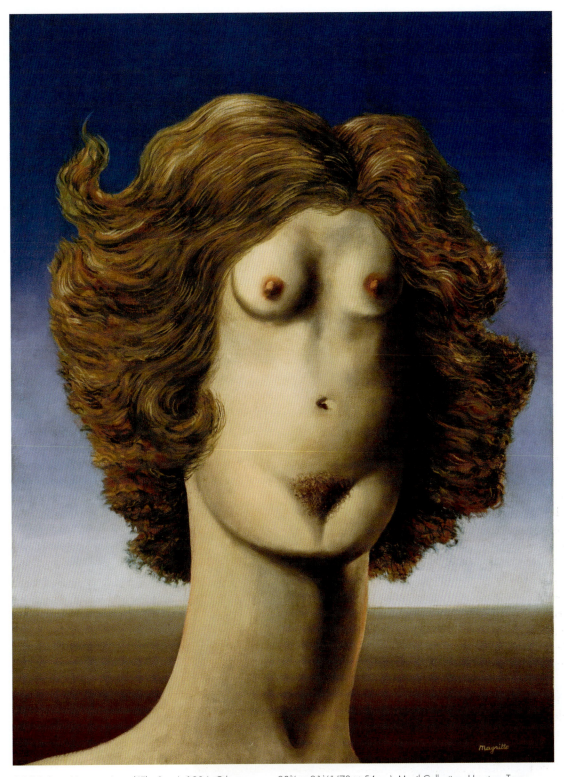

14.24 René Magritte, *Le viol* (*The Rape*), 1934. Oil on canvas, 28¾ × 21¼" (73 × 54 cm). Menil Collection, Houston, Texas.

unconscious drives posits a heterosexual male viewer confronted with an often violently distorted—even dismembered—female body. In the case of *The Rape* (*Le viol*) of 1934 (fig. **14.24**), the instability of the image causes disorientation as it vacillates between a woman's limbless nude torso and an androgynous face. As the breasts of the figure morph into eyes and the pubic area resolves into a mouth, the work becomes a lesson in the uncanny: the unsettling loss of confidence in one's ability to discern one form from another. In the case of *The Rape*, this disorientation becomes

threatening. The title announces sexual violence psychically if not literally committed against women. The image raises the specter of another sort of sexual violence, the unconscious fear of castration, signaled by the fusion of mouth with *mons veneris*, evoking the "vagina dentata" or toothed vagina that functioned, along with the praying mantis, as a common Surrealist symbol of the psychic threat posed by women. The absence of legs, arms, or a head also conjures associations with the famed *Venus de Milo*, inviting further consideration of the modernist association between art and

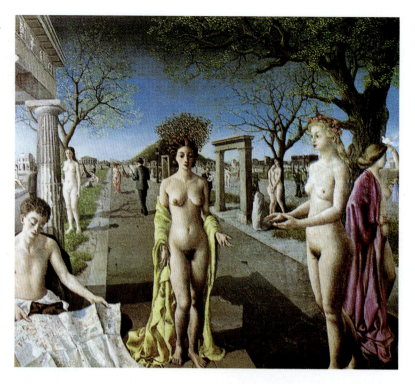

14.25 Paul Delvaux, *Entrance to the City*, 1940. Oil on canvas, 63 × 70⅞" (160 × 180 cm). Private collection.

sexuality as well as Western Europe's history of pillaging the artworks of other cultures. A kind of colonizing or fetishistic impulse seems to propel both the modernist treatment of the body and modern attitudes toward nation-building.

Paul Delvaux (1897–1994), like Magritte a longtime resident of Brussels, came to Surrealism slowly. Beginning in 1935, he painted women, usually nude but occasionally clothed in chaste, Victorian dress. Sometimes lovers appear, but normally the males are shabbily dressed scholars, strangely oblivious to the women. *Entrance to the City* (fig. **14.25**) gives the basic formula: a spacious landscape; nudes wandering about, each lost in her own dreams; clothed male figures, with here a partly disrobed young man studying a large plan; here also a pair of embracing female lovers and a bowler-hatted gentleman (reminiscent of Magritte) reading his newspaper while walking. The chief source seems to be fifteenth-century painting, translated into Delvaux's peculiar personal fantasy. Delvaux's dreamworld is filled with a nostalgic sadness that transforms even his erotic nudes into something elusive and unreal.

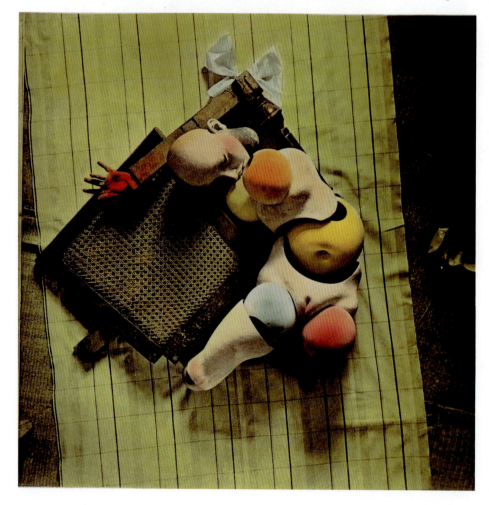

14.26 Hans Bellmer, *Doll*, 1935. Wood, metal, and *papier mâché*. Manoukian Collection, Paris.

Another artist who, like Delvaux, belonged to a later, second wave of Surrealism is **Hans Bellmer** (1902–75). In 1923–24 this Polish-born artist trained at the Berlin Technical School, studying drawing with George Grosz (see Ch. 10, pp. 235–36) and establishing contact with other figures related to German Dada. In the 1930s, he began assembling strange constructions called "dolls" (fig. **14.26**), adolescent female mannequins whose articulated and ball-jointed parts—heads, arms, trunks, legs, wigs, glass eyes—could be dismembered and reassembled in every manner of erotic or masochistic posture. The artist then photographed the fetishistic objects, whose implied sadism appealed to the Surrealists. This led to publication of Bellmer's photographs in a 1935 issue of *Minotaure*; a career for the artist in the Surrealist milieu of Paris; and a place for his camera-made images in the history of photography. Bellmer also expressed his rather Gothic imagination in a number of accomplished, if sometimes disturbing, drawings.

Matta and Lam

Surrealism in the 1940s was also enriched by the contributions of the Chilean artist Matta and the Cuban Wifredo Lam, both of whom traveled to Europe and participated in Parisian Surrealist circles before returning to the Americas. Their long careers provide links between the later phases of Surrealism and other art movements of the postwar period.

Born in Chile as Roberto Sebastiano Antonio Matta Echaurren, **Matta** (1911–2002) studied architecture in the Paris office of Le Corbusier until, in 1937, he showed some of his drawings to Breton, who immediately welcomed him into the Surrealist fold. When he emigrated to the United States in 1939 (on the same boat as Tanguy), Matta was relatively unknown, despite his association with the Surrealists in Paris. His 1940 one-man show at the Julien Levy Gallery, the most important commercial showcase for Surrealist art in New York, had a momentous impact on American experimental artists. Although Matta—the last painter, along with Arshile Gorky (see Ch. 16, pp. 380–82), claimed for Surrealism by

André Breton—was much younger than most of his better-known expatriate European colleagues, his paintings marked the step that American artists were seeking.

Over the next few years, together with the American painter Robert Motherwell, Matta, who unlike many émigré artists from Europe spoke English fluently, helped to forge a link between European Surrealism and the American movement to be called Abstract Expressionism. Matta's painting at that point is exemplified in the 1942 *Disasters of Mysticism* (fig. **14.27**). Although this has some roots in the work of Masson and Tanguy, it is a powerful excursion into uncharted territory. In its ambiguous, automatist flow, from brilliant flame-light into deepest shadow, it suggests the ever-changing universe of outer space.

Wifredo Lam (1902–82) brought a broad cultural background to his art and, once he arrived in Paris in 1938, to the Surrealist milieu. Born in Cuba to a Chinese father and a European–African mother, he studied art first in Havana and, in 1923, in Madrid. In Spain he fought on the side of the Republicans during the Civil War, a fact that endeared him to Picasso when he moved to Paris. Through Picasso, Lam was introduced to members of the Parisian Surrealist circle, including Breton. In his paintings he explored imagery that was heavily influenced by Picasso, Cubism, and a continuing interest in African art. Lam left Paris because of World War II, eventually traveling with Breton to Martinique, where they were joined by Masson. The Frenchmen moved on to New York while Lam returned to Cuba in 1942. His rediscovery of the rich culture of his homeland helped to foster the emergence of his mature style: "I responded always to the presence of factors that emanated from our history and our geography, tropical flowers, and black culture."

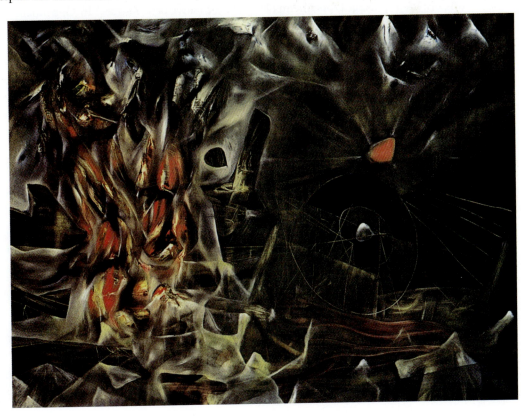

14.27 Matta, *Disasters of Mysticism*, 1942. Oil on canvas, 38¼ × 51¾" (101.6 × 152.4 cm). Private collection.

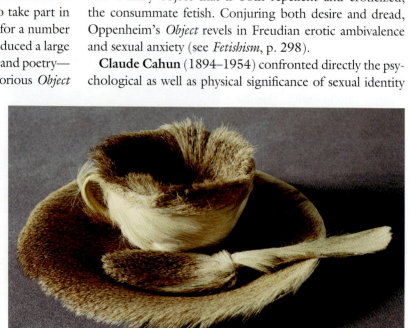

14.28 Wifredo Lam, *The Jungle*, 1943. Gouache on paper mounted on canvas, 7' 10¼" × 7' 6½" (2.4 × 2.3 m). The Museum of Modern Art, New York.

While in Cuba, Lam made the large, sumptuously colored painting *The Jungle* (fig. **14.28**). Based in part on the Cuban religion of Santería, which blends mystical and ritualistic traditions from Africa with old-world Catholicism, *The Jungle* presents a dense tropical landscape populated by odd, long-limbed creatures whose disjointed heads resemble African masks. These human–animal hybrids, who assemble in a lush dreamscape, give evidence of the artist's Surrealist background. Lam returned to France in 1952, though he continued to travel widely and visit Cuba. His art was especially important to postwar European and American artists, especially the CoBrA painters of northern Europe (see Ch. 17, pp. 431–33).

Women and Surrealism: Oppenheim, Cahun, Maar, Tanning, and Carrington

As a movement, Surrealism was not particularly hospitable to women, except as a terrain onto which male artists projected their erotic desires and psychic fears. Nevertheless, several women advanced decidedly innovative work in a Surrealist idiom. **Meret Oppenheim** (1913–85), a native of Berlin, arrived in Paris as an art student in 1932 when she was not yet twenty years old and was soon introduced to members of the Surrealist circle. She began to take part in the group's exhibitions in 1935 and modeled for a number of photographs by Man Ray. Although she produced a large body of work—paintings, drawings, sculpture, and poetry—Oppenheim was known primarily for her notorious *Object (Le Déjeuner en fourrure)* (*Luncheon in Fur*) (fig. **14.29**), a cup, plate, and spoon covered with the fur of a Chinese gazelle. The idea for this "fur-lined tea cup," which has become the very archetype of the Surrealist

object, germinated in a café conversation with Picasso about Oppenheim's designs for jewelry made of fur-lined metal tubing. When Picasso remarked that one could cover just about anything with fur, she quipped, "even this cup and saucer." In Oppenheim's hands, this emblem of domesticity and the niceties of social intercourse metamorphosed into a hairy object that is both repellent and eroticized, the consummate fetish. Conjuring both desire and dread, Oppenheim's *Object* revels in Freudian erotic ambivalence and sexual anxiety (see *Fetishism*, p. 298).

Claude Cahun (1894–1954) confronted directly the psychological as well as physical significance of sexual identity

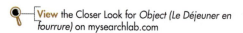

14.29 Meret Oppenheim, *Object (Le Déjeuner en fourrure)* (*Luncheon in Fur*), 1936. Fur-covered cup, diameter 4⅜" (10.9 cm); saucer, diameter 9⅜" (23.7 cm); spoon, length 8" (20.2 cm). Overall height 2⅞" (7.3 cm). The Museum of Modern Art, New York.

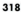 **View** the Closer Look for *Object (Le Déjeuner en fourrure)* on mysearchlab.com

in her photographs, many of which are self-portraits (fig. **14.30**). The nature of gender was of particular interest to Cahun, born Lucy Schwob, who adopted a gender-neutral name and made no secret of either her lesbianism or her romantic partnership with her stepsister and collaborator Suzanne Malherbe. Her self-portraits capture an uncannily androgynous figure, often sporting the costume and accoutrements of a decidedly masculine occupation: sailor, pilot, circus strongman, or dandy. Another series of self-images presents Cahun as a lifeless mannequin or doll, challenging the viewer to discern reality from representation. Cahun exhibited regularly with the Surrealists and shared their commitment to a politically engaged art. The depth of this commitment became clear during World War II, when Cahun and Malherbe were living on the German-occupied island of Jersey. They distributed anti-war tracts on thin tissue paper, which they stuffed into the pockets of German soldiers. In 1944, the pair were arrested and condemned to death, but the liberation prevented the sentence from being carried out. The Nazis repeatedly sacked her home and studio, though, destroying most of the work she had made before and during the war.

Like Cahun, **Dora Maar** (1907–97) found in photography a means of exploring and challenging visual perception. Maar became acquainted with the Surrealists in the 1930s, a connection that was strengthened by a 1936 romance with

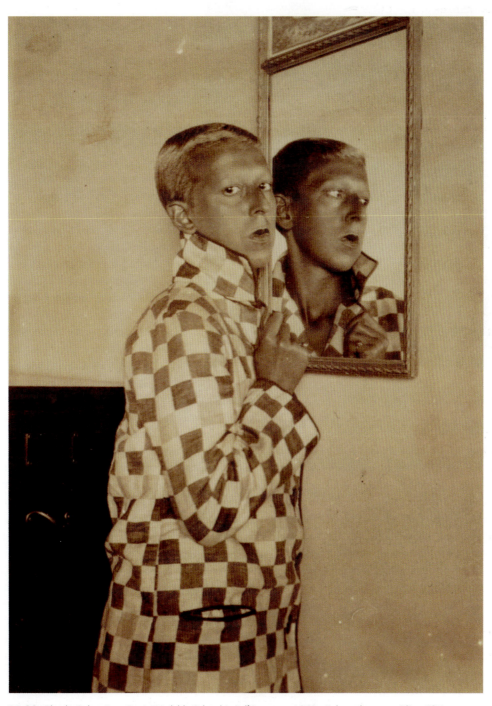

14.30 Claude Cahun (Lucy Renée Mathilde Schwob), *Self-Portrait*, c. 1928. Gelatin-silver print, 3⅝ × 2⅝″ (8.2 × 5.7 cm). San Francisco Museum of Modern Art.

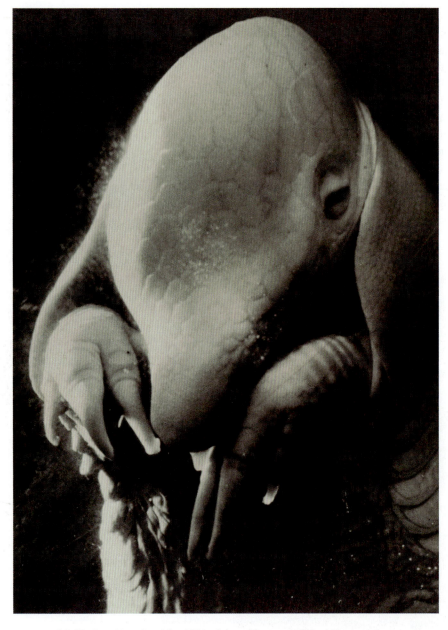

14.31 Dora Maar, *Père Ubu*, 1936. Gelatin-silver print, 15%⁄₁₆ × 11″ (39.6 × 28 cm). The Metropolitan Museum of Art, New York.

Père Ubu challenges the viewer to settle on a final understanding of the image. Oscillating between a recognizable figure and a collection of surely unrelated parts, Maar's photograph endows the phallus with the uncanny appearance so often accorded by Surrealists to women's genitalia.

The career of American artist **Dorothea Tanning** (1910–2012) was somewhat overshadowed by that of her husband, Max Ernst, whom she married in 1946. Tanning had met Ernst in New York, where she moved after her brief art studies in Chicago. Like so many American artists, she was deeply moved by the experience of the important exhibition Fantastic Art, Dada, and Surrealism, held at The Museum of Modern Art in 1936. She came into contact with Surrealist refugee artists from Paris, including Ernst and Breton. By the early 1940s, Tanning had produced her first mature paintings, and in 1944 she was given a solo exhibition at the Julien Levy Gallery. In 1946, she moved with Ernst to Sedona, Arizona, and later settled in France. Tanning's skills as a painter and her penchant for the bizarre are given rich expression in the 1952 still life *Some Roses and Their Phantoms* (fig. **14.32**). Across a table covered with strange, rose-hybrid formations and a tablecloth marked by grid-shaped folds, a monstrous creature raises its head. Tanning's meticulous style intensifies the hallucinatory quality of the scene. As she claimed, "It's necessary to paint the lie so great that it becomes the truth."

Slightly younger than Tanning was British-born **Leonora Carrington** (1917–2011), who distinguished herself both as a writer and a painter. Carrington scandalized her wealthy Catholic parents by moving to Paris with Max Ernst at the age of twenty and becoming an associate of the Surrealists. During the war, when Ernst was interned by the French as an enemy alien (and imprisoned for a time in a cell with Hans Bellmer), Carrington suffered a mental collapse, about which she wrote eloquently in the book *En bas* (*Down There*) of 1943. After living in New York for two years, she settled in Mexico in 1942. The enigmatic imagery that surrounds the artist in her *Self-Portrait (The White Horse Inn)* (fig. **14.33**) is closely tied to Celtic mythology and memories of her childhood. These are themes that she explored in her literary works: in two of her short stories the protagonists befriend, respectively, a hyena and a rocking horse, both of which have magical powers. Carrington, who apparently kept a rocking horse in her Paris apartment, created a lead character in one of the stories who is capable of transforming herself into a white horse. In the painting, Carrington, wearing her white jodhpurs, reaches out to a hyena-like creature heavy with milk, while at the same time a hobby-horse

Bataille. (She was one of Picasso's lovers, too.) Her photograph *Père Ubu* (fig. **14.31**) in fact exemplifies Bataille's concept of the *informe* ("formless"). The *informe* designates that which cannot be circumscribed by language, cannot be given physical structure, and cannot be accommodated by social practice. In other words, the *informe* exists prior to any sort of composition, whether linguistic, cultural, or social. It is instead a manifestation of the disorganized feelings, thoughts, and experiences that give rise to each moment of consciousness. Bataille's *informe* also evokes the abject: material that embodies the disgusting or disavowed immanence of death such as feces, saliva, and other excrescences. Attempts to represent the *informe* must overcome its fundamental resistance to composition and conceptual stability. Titled after the childish and tyrannical main character in Alfred Jarry's infamously scatalogical 1896 play *Ubu Roi* (the first line is "*Merdre*!" ("Shitter!"),

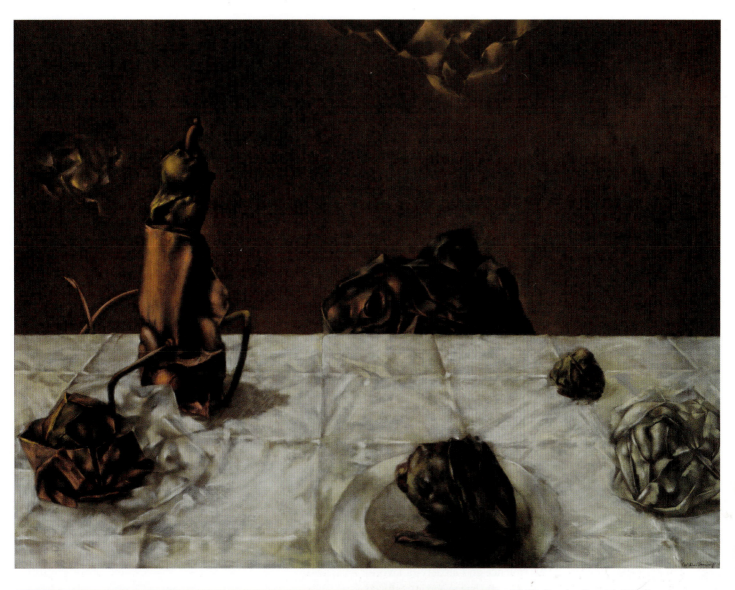

14.32 Dorothea Tanning, *Some Roses and Their Phantoms*, 1952. Oil on canvas, 29⅞ × 40" (75.9 × 101.6 cm). Tate, London. Gift of Robert Shapazian.

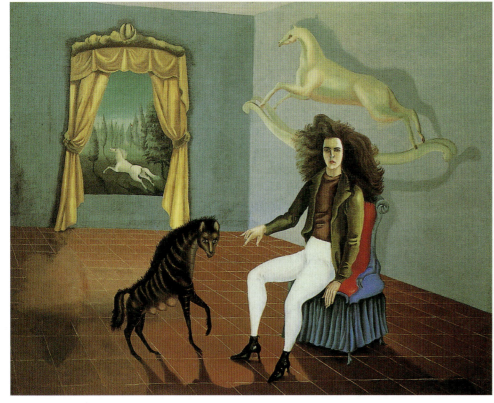

14.33 Leonora Carrington, *Self-Portrait (The White Horse Inn)*, 1936–37. Oil on canvas, 25½ × 32⅛" (65 × 81.5 cm). The Metropolitan Museum of Art, New York.

levitates inexplicably above her head. Given the subject of Carrington's own fable, the galloping white horse seen through the window becomes a kind of liberated surrogate self. In a larger context, this arresting painting abounds with classic Freudian dream imagery, in which horses are symbols of sexual desire. After she moved to Mexico, Carrington cast her mystical subjects of alchemy and the occult in imagery reminiscent of the late fifteenth-century Netherlandish painter Hieronymus Bosch.

Never Quite "One of Ours": Picasso and Surrealism

In 1925, André Breton claimed **Pablo Picasso** (1881–1973) as "one of ours," but sensibly exempted the great artist (at least for a time) from adopting a strict Surrealist regime. Picasso was never a true Surrealist. He did not share the group's obsession with the unconscious and the dreamworld, though his paintings could certainly plumb the depths of the psyche and express intense emotion. The powerful strain of eroticism and violence in Picasso's art also helped ally him to the Surrealist cause. He had considerable sympathy for the group, exhibiting with them and contributing drawings to the second number of *La Révolution surréaliste* (January 15, 1925). In the fourth number of the magazine (July 15, 1925) Breton, the editor, included an account of *Les Demoiselles d'Avignon* (see fig. 7.7) and reproduced collages and a new painting by Picasso.

Painting and Graphic Art, mid-1920s to 1930s

Studio with Plaster Head of 1925 (see fig. 11.20) showed how a new emotionalism was entering Picasso's work in the mid-1920s. Now, in 1929, violence and anxiety (a favorite emotional coupling of the Surrealists) have been introduced, permeating *Large Nude in Red Armchair* (fig. **14.34**). It is a timeless subject—a figure seated in a red chair draped in fabric and set against green flowered wallpaper (these saturated hues persisted in Picasso's work of the 1930s). But the woman's body is pulled apart as though made of rubber. With knobs for hands and feet and black sockets for eyes, she throws her head back not in sensuous abandon but in

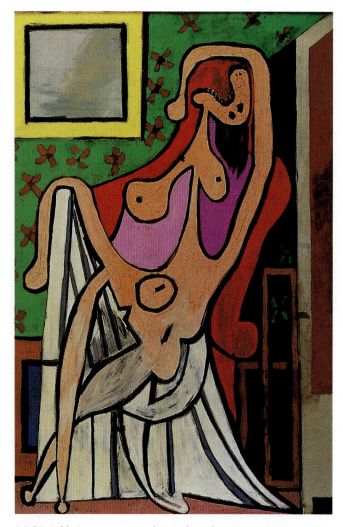

14.34 Pablo Picasso, *Large Nude in Red Armchair*, May 5, 1929. Oil on canvas, 6′ 4¾″ × 4′ 3¼″ (1.9 × 1.3 m). Musée Picasso, Paris.

a toothy wail, resulting in what Breton called "convulsive" beauty. While he did it to rather different effect, the photographer André Kertész subjected the female body to a similar kind of elasticity in the 1930s (see figs. 14.54, 14.55). In many ways, Picasso's paintings can be read as running commentaries on his relationships, and his paintings of the late 1920s, when his marriage was disintegrating, were filled with women as terrifying monsters. As the poet Paul Éluard observed, "He loves with intensity and kills what he loves."

One of Picasso's favorite subjects was the artist in his studio. He returned to it periodically throughout his career, often exploring the peculiarly voyeuristic nature of the painter's relationship to the model. His interest may have been aroused by a commission from the dealer Ambroise Vollard to provide drawings for an edition of Honoré de Balzac's novel *The Unknown Masterpiece*. The illustrated edition was published in 1931. This story concerns an obsessive painter who worked for ten years on a painting of a woman and

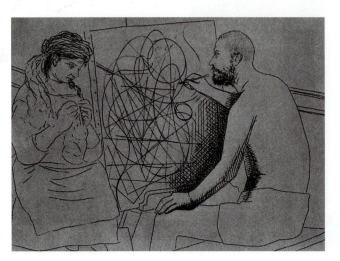

14.35 Pablo Picasso, *Painter and Model Knitting* (executed in 1927) from *Le Chef-d'oeuvre inconnu* (*The Unknown Masterpiece*), by Honoré de Balzac, Paris, Ambroise Vollard, 1931. Etching, printed in black, plate 7⁹⁄₁₆ × 10⅞″ (19.2 × 27.6 cm). The Museum of Modern Art, New York.

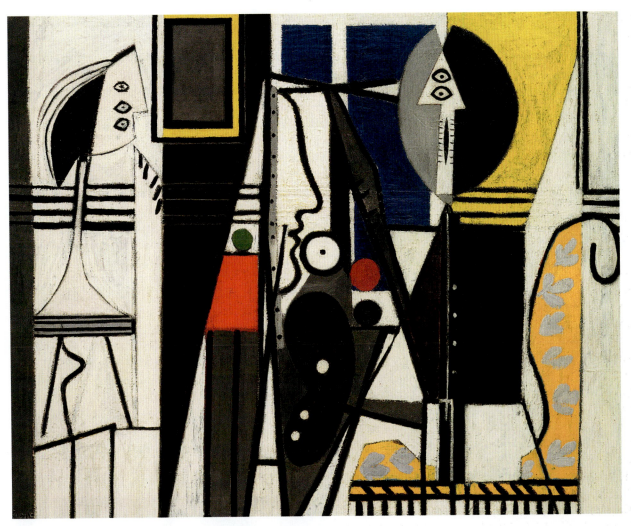

14.36 Pablo Picasso, *Painter and Model*, 1928. Oil on canvas, 51⅛ × 64¼″ (130 × 163.2 cm). The Museum of Modern Art, New York.

ended with a mass of incomprehensible scribbles, which the painter asserts is a nude of surpassing beauty, his crowning achievement. Picasso's interpretation (fig. **14.35**) may illustrate his mistrust in complete abstraction as a means of representing an ideal, for he had already warned against trying "to paint the invisible." In a highly geometric composition of 1928 (fig. **14.36**), reality and illusion as presented in the drawing are reversed. The painter and model are highly abstracted, Surrealist ciphers, while the "painted" portrait on the artist's canvas is a more "realistic" profile.

In 1928 Picasso made sketches of the figure compartmentalized into strange bone-like forms. Variations on these highly sexualized "bone figures" continued into the 1930s. One startling example is *Seated Bather* (fig. **14.37**), which is part skeleton, part petrified woman, and all monster, taking her ease in the Mediterranean sun. *Seated Bather* simultaneously has the nonchalance of a bathing beauty and the predatory countenance of a praying mantis, one of the Surrealists' favorite insect images. Because the female

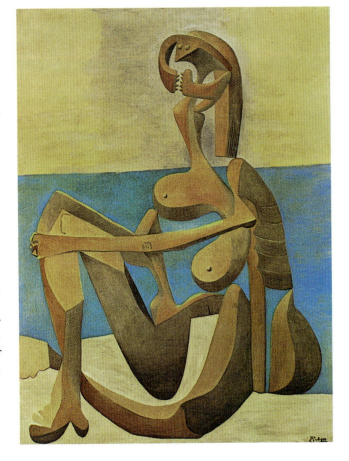

14.37 Pablo Picasso, *Seated Bather*, early 1930. Oil on canvas, 64¼ × 51″ (163.2 × 129.5 cm). The Museum of Modern Art, New York.

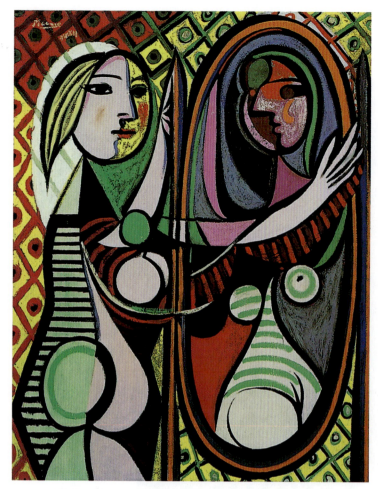

14.38 Pablo Picasso, *Girl Before a Mirror*, Boisgeloup, 1932. Oil on canvas, 64 × 51¼" (162.3 × 130.2 cm). The Museum of Modern Art, New York.

powerful example. With the technical help of his old friend Julio González (see pp. 325–26), a skilled metalworker, Picasso produced welded iron constructions that, together with González's similar creations of the period, marked the emergence of direct-metal sculpture as a major, modern medium. Picasso's *Woman in the Garden* (fig. **14.39**), a large, open construction in which the figure consists of curving lines and organic-shaped planes, is one of the most intricate and monumental examples of direct-metal sculpture produced to that date. The woman's face is a triangle with strands of windswept hair and the by now familiar gaping mouth. The bean-shaped form in the center stands for her stomach, while the disk below it is one of Picasso's familiar signs for female genitalia. The original version of this work was made of welded and painted iron. Picasso commissioned González to make a bronze replica.

Carried away by enthusiasm, Picasso modeled in clay or plaster until by 1933 his studio at Boisgeloup was full. His work included massive heads of women, reflecting his contemporaneous curvilinear style in painting and looking back in some degree to his Greco-Roman style; torsos transformed into anthropomorphic monsters; surprisingly representational animals including a cock and a heifer; and figures assembled from found objects organized with humor and delight. Of the found-object sculptures perhaps the most renowned is the *Bull's Head* of 1943

praying mantis sometimes devours the male after mating, it was seen as a particularly apt metaphor for the threatening feminine of Freudian theory. Picasso reveals some interest in the unconscious as a source of creativity and of truth in the 1932 painting *Girl Before a Mirror* (fig. **14.38**), for which his mistress Marie-Thérèse Walter served as model. Picasso here assimilates classical repose with Cubist space in a key painting of the 1930s. Such moments of summation for Picasso alternate with cycles of fertile and varied experiment. *Girl Before a Mirror* brings together brilliant color patterns and sensual curvilinear rhythms. Rapt in contemplation of her mirror image, the girl sees not merely a reversed reflection but some kind of mysterious alter ego. In the mirror her clear blonde features become a disquieting series of dark, abstracted forms, as though the woman is peering into the depths of her own soul.

Sculpture, late 1920s to 1940s

In 1928 Picasso's Surrealist bone paintings revived his interest in sculpture, which, except for a few sporadic assemblages, he had abandoned since 1914. In broader terms, sculpture can be seen to gain greater importance around 1930 as part of a movement away from modernism's earlier emphasis on individual, experimental inquiry toward more public forms of expression, of which *Guernica* is a

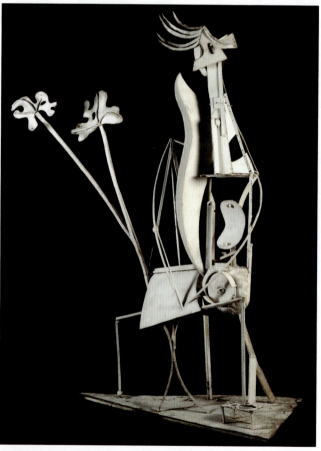

14.39 Pablo Picasso, *Woman in the Garden*, 1929–30. Bronze after welded and painted iron original, height 6' 10¾" (2.1 m). Musée Picasso, Paris.

welding, and by 1927 he was producing his first sculptures in iron. In the late 1920s he made a series of masks (fig. **14.41**) from sheets of flat metal. The sharp, geometric contours in the mask, as González's drawings make clear, are derived from the strong, angular shadows cast over faces in the hot sun. Their openwork construction had no real precedents in figural sculpture. In 1928, Picasso asked González for technical help in constructed sculpture, Picasso's new interest. It may be said that González began a new age of iron for sculpture, which he described in his most famous statement:

The age of iron began many centuries ago by producing very beautiful objects, unfortunately for a large part, arms. Today, it provides as well, bridges and railroads. It is time this metal ceased to be a murderer and the simple instrument of a super-mechanical science. Today the door is wide open for this material to be, at last, forged and hammered by the peaceful hands of an artist.

By 1931 González was working in direct, welded iron, with a completely open, linear construction in which the solids were

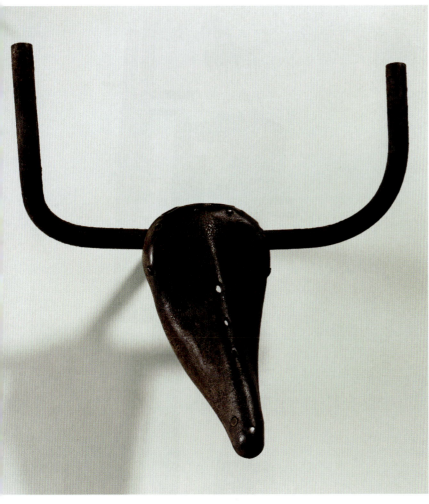

14.40 Pablo Picasso, *Bull's Head*, 1943. Bicycle saddle and handlebars, 13¼ × 17⅛ × 7½" (33.5 × 43.5 × 19 cm). Musée Picasso, Paris.

(fig. **14.40**), which consists of an old bicycle seat and handlebars—a wonderful example of the way Picasso remained alert to the formal and expressive potential of the most commonplace objects.

Pioneer of a New Iron Age: Julio González

Julio González (1876–1942), another son of Barcelona, had been trained in metalwork by his father, a goldsmith, but he practiced as a painter for many years. In Paris by 1900, he came to know Picasso and Brancusi, but after the death of his brother Jean in 1908, he lived in isolation for several months. In 1910 González began to make masks in a metal repoussé technique. In 1918, he learned the technique of oxyacetylene

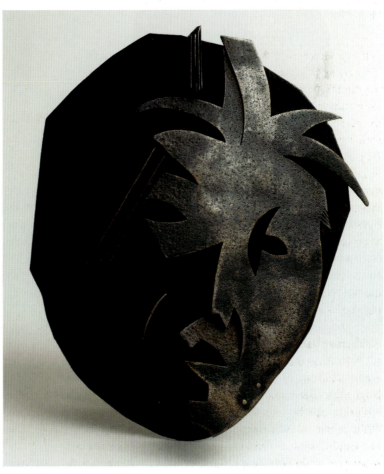

14.41 Julio González, *Mask of Roberta in the Sun*, c. 1929. Iron, height 7⅛" (18.1 cm). Collection Roberta González, Paris.

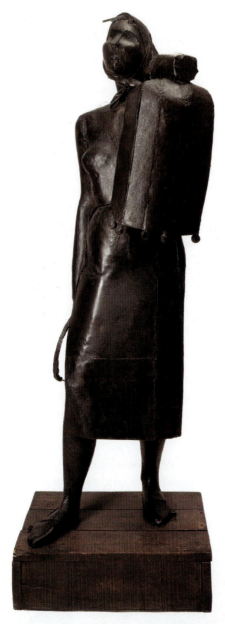

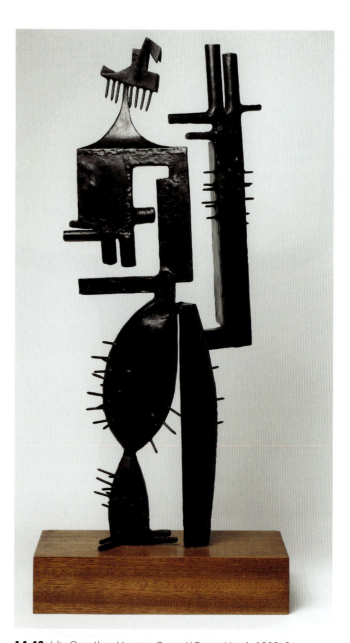

14.42 Julio González, *Montserrat*, 1937. Wrought iron, 65 × 18½ × 18½" (165 × 47 × 47 cm). Stedelijk Museum, Amsterdam.

14.43 Julio González, *Monsieur Cactus I* (*Cactus Man I*), 1939. Bronze (cast from original iron), height 26" (66 cm). Musée National d'Art Moderne, Centre d'Art et de Culture Georges Pompidou, Paris.

merely contours defining the voids. The difference between these constructions and the earlier ones of Gabo and the Russian Constructivists (see figs. 9.36, 9.41) lies not only in the technique—which was to have such far-reaching effects on younger sculptors—but also in the fact that, however abstract his conceptions, González was always involved with the figure. Side by side with these openwork, direct-metal constructions, González continued to produce naturalistic heads and figures, such as his large wrought-iron and welded *Montserrat* (fig. **14.42**), a heroic figure of a Spanish peasant woman, symbol of the resistance of the Spanish people against fascism. Montserrat is the name of the mountain range near Barcelona, epitomizing Catalonia. This work was commissioned by the Spanish Republic for the 1937 World's Fair in Paris, where it was shown with murals by Miró and Picasso's *Guernica*. Dating from 1939, *Monsieur Cactus I* (*Cactus Man I*) (fig. **14.43**), as the name implies, is

a bristly and aggressive individual, suggesting a new authority in the artist's work. The original version of this work was made of welded iron; it was then cast in bronze in an edition of eight. Scholars have posited that the angry, aggressive forms of *Monsieur Cactus I* may embody the artist's reactions to the recent fascist defeat of resistance forces in his beloved Barcelona, signaling the end of civil war in Spain.

Surrealism's Sculptural Language: Giacometti's Early Career

If González was the pioneer of a new iron age, in which the medium would be used to forge artworks instead of weapons, **Alberto Giacometti** (1901–66) inaugurated a bronze age that would give form to the human psyche in all its exultation and depravity. After studies in Geneva and a long stay with his father, a painter, in Italy, where he saturated

14.44 Alberto Giacometti, *Femme cuillère* (*Spoon Woman*), 1926 (cast 1954). Bronze, 56¾ × 20 × 9" (144.1 × 50.8 × 22.9 cm). Raymond and Patsy Nasher Collection, Dallas.

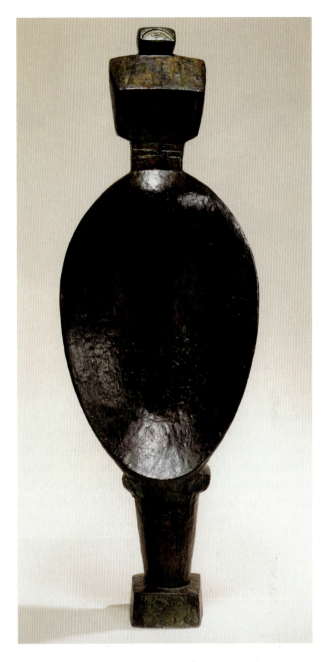

himself in Italo-Byzantine art and became acquainted with the Futurists, Giacometti moved to Paris in 1922. Here he studied with Émile-Antoine Bourdelle, who had been trained at the École des Beaux-Arts and by Rodin. After three years with Bourdelle, Giacometti set up a studio with his brother Diego, an accomplished technician who continued to be his assistant and model to the end of his life. His first independent sculptures reflected awareness of the Cubist sculptures of Lipchitz and Laurens and, more importantly, of African, Oceanic, and prehistoric art. Giacometti's *Femme cuillère* (*Spoon Woman*) of 1926 (fig. **14.44**) is a frontalized, Surrealist–primitive totem, probably inspired by a Dan spoon from West Africa that the artist saw in the Paris ethnographic museum. Evincing a spiritual if not a stylistic affinity with the work of Brancusi, *Femme cuillère* has the totemic presence of an ancient fertility figure.

At the end of the 1920s Giacometti was drawn into the orbit of the Paris Surrealists. For the next few years he made works that reflected their ideas, exhibiting with Miró and Arp at the Galerie Pierre until 1935 (when he was expelled by the movement). The pieces he produced during these years are among the masterworks of Surrealist sculpture. *No More Play* (fig. **14.45**) is an example of his tabletop compositions. Here the base becomes the actual sculpture on which movable parts are deployed like pieces in a board game (as the title implies). In two of the rounded depressions carved in the lunar-like surface are tiny male and female figurines in wood. Between them are three cavities, like coffins with movable lids. One of these contains an object resembling a skeleton. The viewer can interact with the work, moving aside the lids of the "tombs" to discover their contents and crossing over the usually inviolable space between object and viewer.

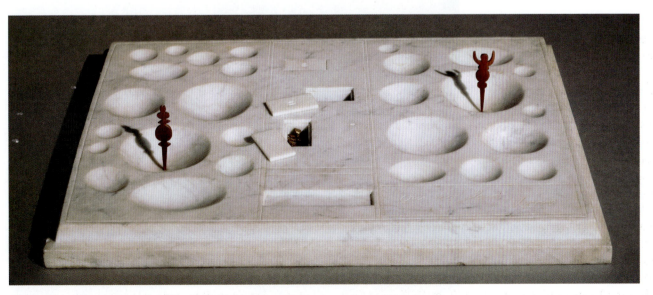

14.45 Alberto Giacometti, *No More Play*, 1931–32. Marble, wood, bronze, 1⅝ × 22⅞ × 17¾" (4.1 × 58 × 45.1 cm). National Gallery of Art, Washington, D.C.

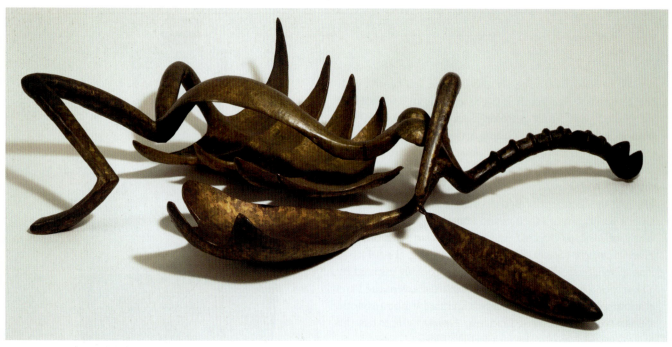

14.46 Alberto Giacometti, *Femme égorgée* (*Woman with Her Throat Cut*), 1932 (cast 1949). Bronze, 8 × 34½ × 25″ (20.3 × 87.6 × 63.5 cm). The Museum of Modern Art, New York.

Woman with Her Throat Cut (fig. **14.46**), a bronze construction of a dismembered female corpse, bears a family resemblance to Picasso's 1930 *Seated Bather* (see fig. 14.37). The spiked, crustacean form of the sculpture suggests the splayed and violated body of a woman. According to the artist, the work should be placed directly on the floor, without a base. From a high vantage point, looking down, the Surrealist preoccupation with sexual violence is undisguised. The avant-garde's focus on the female nude, always more than a mere formal concern, has moved well beyond Manet's modernization of the reclining Venus (see fig. 2.21) to investigate more troubling themes of sexual subjugation

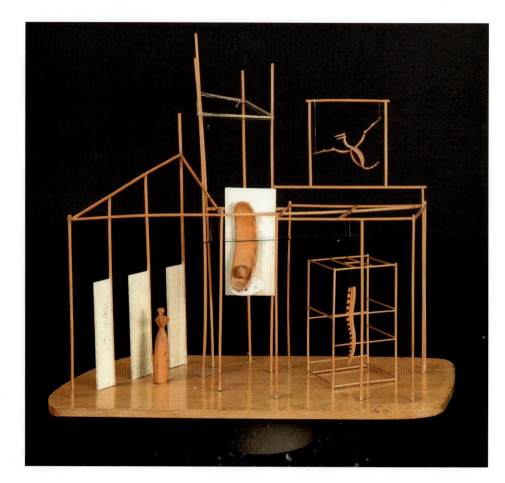

14.47 Alberto Giacometti, *The Palace at 4 a.m.*, 1932–33. Construction in wood, glass, wire, and string, 25 × 28¼ × 15¾″ (63.5 × 71.8 × 40 cm). The Museum of Modern Art, New York.

Watch a video about *The Palace at 4 a.m.* on mysearchlab.com

and fetishization. The fatal wound's rupture of the figure's phallic neck makes only too clear the Freudian displacement of castration fears onto the female body. The work's fetishistic quality is enhanced by its portability: it can, like *No More Play*, be moved by the viewer, though the phallic-shaped form should be placed in the leaf-like "hand" of the figure, for Giacometti related the sculpture to the common nightmare of being unable to move one's hand.

In a number of his Surrealist sculptures Giacometti experimented with the format of an open cage structure, a series that climaxed in *The Palace at 4 a.m.* of 1932–33 (fig. **14.47**), a structure of wooden rods defining the outlines of a house. At the left a woman in a long dress (the artist's recollection of his mother) stands before three tall rectangular panels. She seems to look toward a raised panel on which is fixed a long, oval spoon shape with a ball on it. To the right, within a rectangular cage, is suspended an object resembling a spinal column, and in the center of the edifice hangs a narrow panel of glass. Above, floating in a rectangle that might be a window, is a sort of pterodactyl—"the skeleton birds that flutter with cries of joy at four o'clock." This strange edifice was the product of a period in the artist's life that haunted him and about which he has written movingly:

> For six whole months hour after hour was passed in the company of a woman who, concentrating all life in herself, made every moment something marvelous for me. We used to construct a fantastic palace in the night (days and night were the same color as if everything had happened just before dawn; throughout this time I never saw the sun), a very fragile palace of matchsticks: at the slightest false move a whole part of the minuscule construction would collapse: we would always begin it again.

Whatever the associations and reminiscences involved, *The Palace at 4 a.m.* was primarily significant for its wonderful, haunting quality of mystery.

Invisible Object (Hands Holding the Void) of 1934 (fig. **14.48**) is one of Giacometti's last Surrealist sculptures. The elongated female personage half sits on a cage/chair structure that provides an environment and, when combined with the plank over her legs, pins her in space. With a hieratic gesture, she extends her hands to clasp an unseen object, as though participating in some mysterious ritual. The work has been connected to sources in Oceanic and ancient Egyptian art. The form of a single, vertical, attenuated figure is significant for Giacometti's later work (see Ch. 17, pp. 412–14).

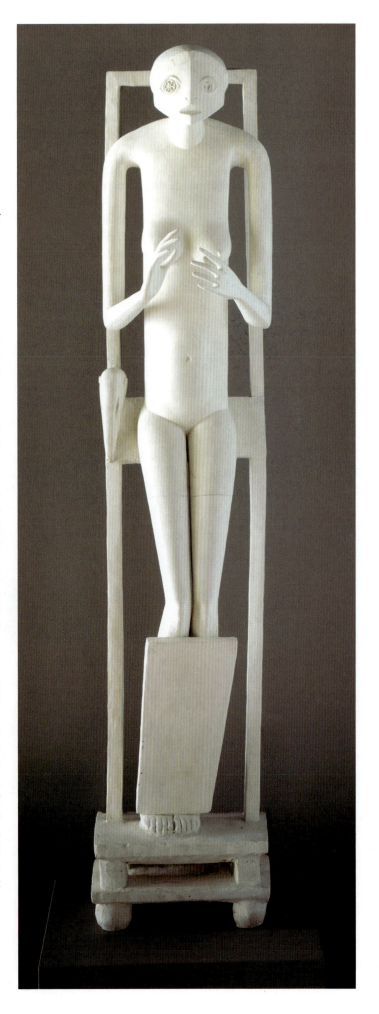

14.48 Alberto Giacometti, *Objet invisible (Mains Tenant le Vide)* *(Invisible Object/Hands Holding the Void)*, 1934. Plaster, height 61½" (156.2 cm). Yale University Art Gallery, New Haven. Anonymous gift.

Surrealist Sculpture in Britain: Moore

Although **Henry Moore** (1898–1986) did not begin to assume a genuinely international stature before 1945, he was already a mature artist by the early 1930s, in touch with the main lines of Surrealism and abstraction on the Continent, as well as all the new developments in sculpture, from Rodin through Brancusi to Picasso and Giacometti. By 1935, his work had already made original statements and he had arrived at many of the sculptural figurative concepts that he was to build on over the course of the rest of his career.

The son of a coal miner, Moore studied at the Royal College of Art in London from 1921 until 1925. The greatest immediate influence on him was the range of works he studied in English and European museums, particularly the classical, pre-classical, African, and pre-Columbian art he saw in the British Museum. He was also attracted to English medieval church sculpture and to artists in the Renaissance tradition—Masaccio, Michelangelo, Rodin, Maillol—who had a particular feeling for the monumental.

Between 1926 and 1930 the dominant influence on Moore was pre-Columbian art. The 1929 *Reclining Figure* (fig. **14.49**) is an example of the artist's mature sculpture, a piece that may owe its original inspiration to a chacmool (with overtones of Maillol). Chacmools are a distinctive type of stone sculpture, associated with the tenth–twelfth-century Toltec culture of central Mexico, that represents a reclining warrior holding an offering dish. The massive blockiness of Moore's figure stems from a passionate devotion to the principle of truth to materials; that is, the idea that stone should look like stone, not flesh. In this and other reclining figures, torsos, and mother-and-child groups of the late 1920s, Moore staked out basic themes that he then used throughout his life.

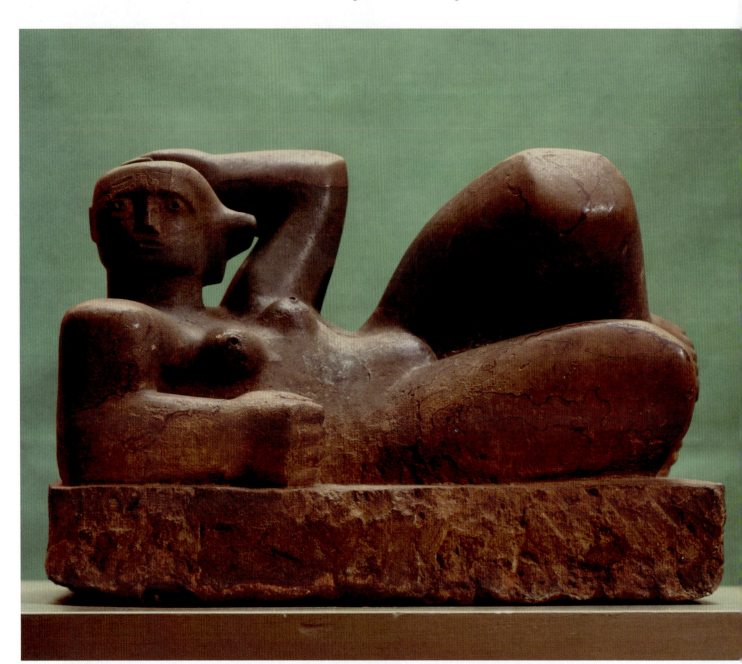

14.49 Henry Moore, *Reclining Figure*, 1929. Hornton stone, height 22½" (57.2 cm). Leeds City Art Galleries, England.

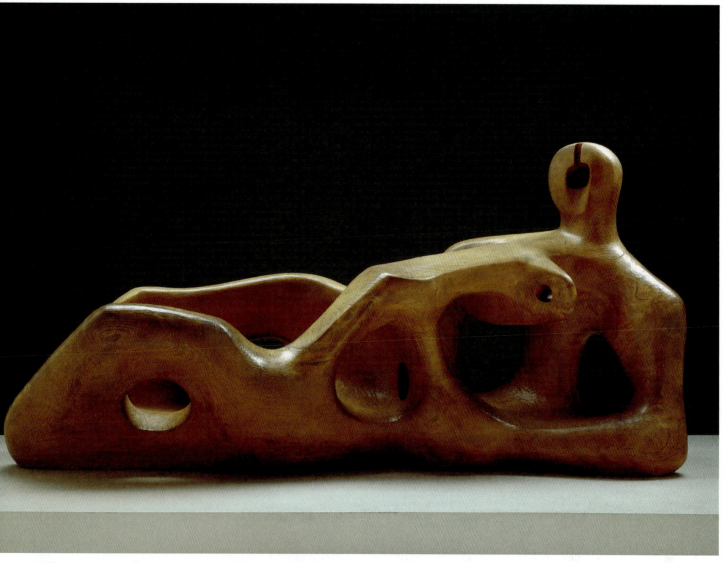

14.50 Henry Moore, *Reclining Figure*, 1939. Elm wood, 3′ 1″ × 6′ 7″ × 2′ 6″ (0.94 × 2 × 0.76 m). The Detroit Institute of Arts.

In the early 1930s, the influence of Surrealist sculpture, notably that of Picasso, became evident. Moore began to explore other materials, particularly bronze, and his figures took on a fluidity and sense of transparent surface appropriate to what was for him a new material. Similar effects were achieved in carved wood in which he followed the wood grain meticulously, as in *Reclining Figure* from 1939 (fig. **14.50**), his largest carved sculpture to date. Less angular than the 1929 figure, this sculpture consists of a series of holes piercing the undulating solids, transforming the body into a kind of landscape filled with caves and tunnels. A characteristic of the figures of the 1930s is this opening up of voids, frequently to the point where the solids function as space-enclosing frames.

In the mid-1930s Moore turned to abstract forms, and by opening up masses and creating dispersed groups, he studied various kinds of space relationships. This began a continuing concern with a sculpture of tensions between void and solid, of forms enclosed within other forms, which developed during and after World War II (see Ch. 17, p. 435). These experiments were then translated back into the figures. The interest in spatial problems led Moore during

the 1940s and 50s to an ever greater use of bronze and other metals in which he could enlarge the voids of the figures.

Bizarre Juxtapositions: Photography and Surrealism

Paris in the 1920s and 30s was especially fertile ground for photography. From many countries, several of the medium's greatest practitioners came together with painters and sculptors in an era of remarkably fruitful exchange among the arts. The 1920s, in particular, was a highly experimental period for photography that witnessed, among other related media, the explosion of cinema. The Surrealists valued photography for its ability to capture the bizarre juxtapositions that occur naturally in daily experience. The Surrealist sense of dislocation could be made even more shocking when documented in a photograph than in, for example, a literally rendered painting by Dalí. The Surrealists regularly featured photography, ranging from Bellmer's constructed "dolls" (see fig. 14.26) to vernacular snapshots by amateurs, in their various journals. Their embrace of the medium, however, was not unequivocal. Breton viewed photography

as a threat to what he regarded as the more important activity of painting, and mistrusted its emphasis on the external world rather than internal reality. Nevertheless, photography was even used by artists in the Surrealist movement who were not necessarily photographers. Max Ernst, for example, incorporated photographs into his collages; Bellmer's creations, as we have seen, were wholly dependent upon photography; and Magritte took photographs of his family and friends, quite separately from his paintings. Others, who were not card-carrying Surrealists but who shared a kindred vision with its official practitioners, were claimed by the movement. Its lasting legacy extended beyond still photography to film, and to other media, notably literature, that are outside the scope of this account.

Atget's Paris

By no means a practicing Surrealist, **Eugène Atget** (1857–1927) was one of the artists embraced by the group through Man Ray, who sensed that his vision lay as much in fantasy as in documentation. After having failed at the military and at acting, Atget taught himself photography and began a business providing photographs, on virtually any subject, for use by artists. By 1897, he had begun to specialize in images of Paris and conceived what a friend called "the ambition to create a collection of all that which both in Paris and its surroundings was artistic and picturesque. An immense subject." Over the next thirty years Atget labored to record the entire face of the French capital, especially those aspects

of it most threatened by "progress." Although he was often commissioned by various official agencies to supply visual material on Paris, Atget proceeded with a single-minded devotion to transform facts into art. His unforgettable images go beyond the merely descriptive to evoke a dream-like world that is also profoundly real, though infused with a mesmerized nostalgia for a lost and decaying classical past.

Among the approximately 10,000 pictures by Atget that survive—images of streets, buildings, historic monuments, architectural details, parks, peddlers, vehicles, trees, flowers, rivers, ponds, the interiors of palaces, bourgeois apartments, and ragpickers' hovels—are a series of shop fronts (fig. **14.51**) that, with their grinning dummies and superimposed reflections from across the street, would fascinate the Surrealists as "found" images of dislocated time and place. Man Ray was so taken with *Magasin* that he arranged for it to be reproduced in *La Révolution surréaliste* in 1926. The sense it evokes of a dreamworld, of a strange "reality," of threatened loss, could only have been enhanced by equipment and techniques that were already obsolescent when Atget adopted them, and all but anachronistic by the time of his death.

Man Ray, Kertész, Tabard, and the Manipulated Image

The photographer who was most enduringly liberated by Surrealism was the one-time New York Dadaist **Man Ray** (1890–1976) (see figs. 10.17, 10.18), who after 1921 lived

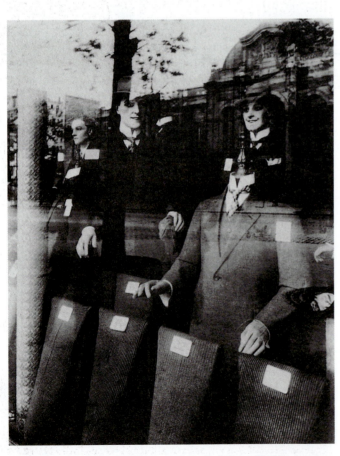

14.51 Eugène Atget, *Magasin, avenue des Gobelins*, 1925. Albumen-silver print, 9⅜ × 7″ (24 × 18 cm). The Museum of Modern Art, New York.

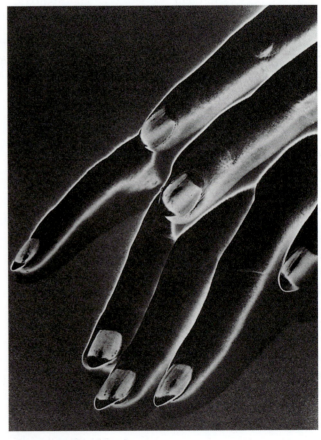

14.52 Man Ray, *Fingers*, 1930. Solarized gelatin-silver print from negative print, 11½ × 8¾″ (29.2 × 22.2 cm). The Museum of Modern Art, New York.

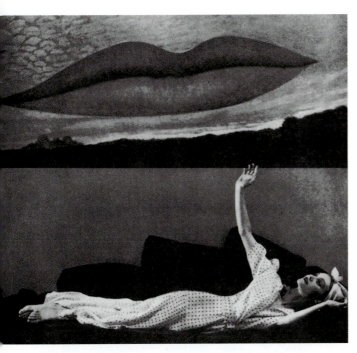

14.53 Man Ray, *Observatory Time—The Lovers*, 1936. Halftone reproduction. Published in *Harper's Bazaar*, November 1936

in Paris and became a force within the circle around André Breton. In the course of his long career, Man Ray worked not only in photography but also in painting, sculpture, collage, constructed objects, and film. Despite his preference for the art of painting, it was through photography and film that he found the most successful expression of his aesthetic goals. From 1924 through the 1930s he contributed his photographs regularly to the Surrealist journals as well as to books by Surrealist writers.

In Paris Man Ray continued to experiment with unorthodox methods in the darkroom. In his Sabattier prints (so named for the early inventor of the technique but generally known as "solarizations"), a developed but unfixed print is exposed to light and then developed again, producing a reversal of tones along the edges of forms and transforming the mundane into something otherworldly (fig. **14.52**). Regarding one of his most famous paintings, *Observatory Time—The Lovers*, executed in 1930–32, Man Ray wrote:

> One of these enlargements of a pair of lips haunted me like a dream remembered: I decided to paint the subject on a scale of superhuman proportions. If there had been a color process enabling me to make a photograph of such dimensions and showing the lips floating over a landscape, I would certainly have preferred to do it that way.

To support himself while carrying out such ambitious painting projects, Man Ray made fashion photographs and photographic portraits of his celebrated friends in art, literature, and society. For *Harper's Bazaar* in 1936 he posed a model wearing a couture beach robe against the backdrop of *Observatory Time—The Lovers* (fig. **14.53**), thereby grafting on to this elegant scene of high fashion a hallucinatory

image of eroticism and Freudian association so revered by the Surrealists.

A lyrical, life-affirming *joie de vivre*, tethered to a rigorous, original sense of form, characterizes the work of **André Kertész** (1894–1985), who was already a practicing photographer when he arrived in France from Budapest in 1925. It was in Paris, however, that he became a virtuoso of the 35mm camera, the famous Leica introduced in 1925, and emerged as a pioneer of modern photojournalism. Though the hand-held camera had been used for years by amateurs, the desire for spontaneity among professionals meant that, by the 1930s, the Leica became the preferred camera of photojournalists. In his personal work, Kertész used the flexible new equipment not so much for analytical description, which the large-format camera did better, as for capturing the odd, fleeting moment or elliptical view when life is most, because unexpectedly, revealed. Photographed in the studio of a sculptor friend, Kertész's image of a woman in a pose like a human pinwheel (fig. **14.54**) playfully mimics the truncated limbs of the nearby sculpture.

The kind of elastic distortion achieved by Picasso through sheer force of imagination opened a rich vein of possibilities for photography, equipped as this medium was with every sort of optical device. Kertész created his funhouse effects (what he called Distortions) by photographing nude

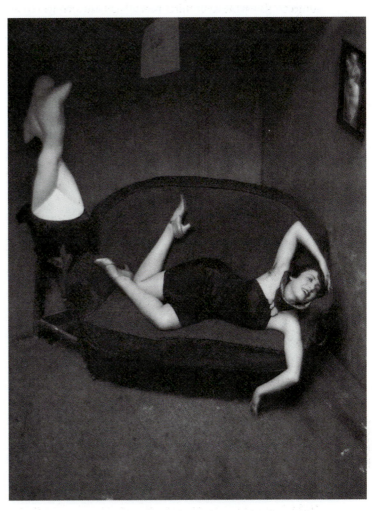

14.54 André Kertész, *Satiric Dancer*, Paris, 1926. Gelatin-silver print.

models reflected in a special mirror (fig. **14.55**). Despite the visual affinities with Surrealist-inspired imagery, Kertész never claimed any allegiance with the Surrealists and was not asked by Breton to enlist in their ranks. In 1936 he emigrated to America, where he freelanced for the leading illustrated magazines, with the exception of *Life*. The editors of that publication, one crucial to the development of American photography in the 1930s (see fig. 15.41), told him his photographs "spoke too much."

Maurice Tabard (1897–1984) was born in France but came to the United States in 1914. After studying at the New York Institute of Photography and establishing himself as a portrait photographer in Baltimore, Tabard returned to Paris in 1928 to make fashion photographs. He soon came to know photographers Man Ray, Henri Cartier-Bresson (see p. 336), and Kertész, as well as the painter Magritte, and became a well-known figure in Parisian avant-garde circles. Like Man Ray, he made solarized photographs and continued his creative photography alongside his more commercial fashion work. The methods by which Tabard obtained his Surrealistic imagery differed significantly from those of Kertész or Cartier-Bresson. While these artists found their images by chance or, in the case of Kertész's *Distortions*, a special mirror, Tabard engaged in the elaborate manipulation of his craft in the darkroom. His haunting photographs involve double exposures and negative printing, sometimes combining several techniques within the same image. In an

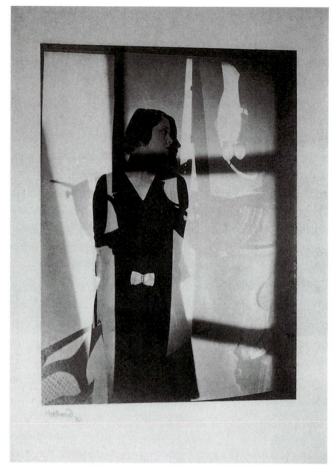

14.56 Maurice Tabard, *Untitled*, 1929. Gelatin-silver print. Collection Robert Shapazian, Fresno, California.

untitled work (fig. **14.56**), he locked the figure into place with a ladder-shaped shadow pattern slyly mimicking the frames that surround each exposure in a roll of film. Other superimposed imagery, including what appears to be the shadow of a tennis racket at the lower left, contributes to an overall sense of disorienting complexity.

The Development of Photojournalism: Brassaï, Bravo, Model, and Cartier-Bresson

Brassaï (Gyula Halász) (1899–1984) took his pseudonym from his native city, Brasso, in the Transylvanian region of Romania. Following his days as a painting student in Budapest and Berlin, Brassaï arrived in the French capital in 1924 and promptly fell in love with its streets, bars, and brothels, its artists, poets, and writers, even its graffiti. He sought out these subjects nightly and slept throughout the day. Once introduced to the small-format camera by his friend Kertész, Brassaï proceeded to record the whole of the Parisian human comedy, doing so as faithfully and objectively as possible (fig. **14.57**). That desire for objectivity prompted him to turn down an invitation from Breton to join the Surrealists, though he was on close terms with many artists associated with the movement, including Dora Maar, with whom he shared a studio. He watched for the moment when character seemed most naked and most rooted in time and place. Brassaï published the results of his nocturnal

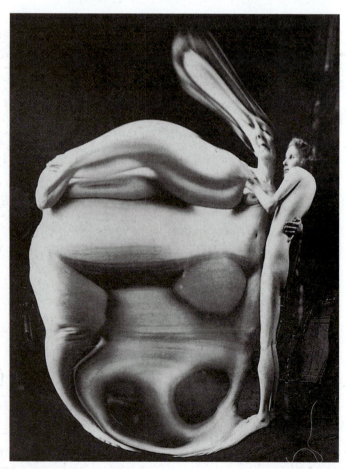

14.55 André Kertész, *Distortion No. 4*, 1933. Gelatin-silver print.

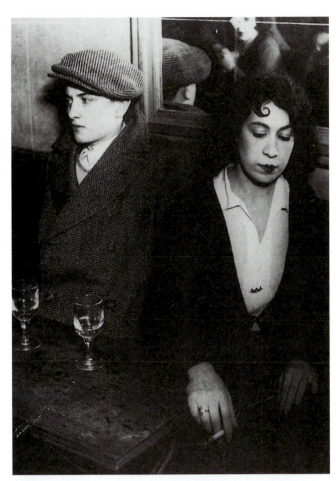

14.57 Brassaï, *Dance Hall*, 1932. Gelatin-silver print, 11½ × 9¼" (29.2 × 23.5 cm). The Museum of Modern Art, New York.

Parisian forays in the successful book *Paris de nuit* (*Paris by Night*, 1933). In a more Surrealist vein, he produced images of *sculptures involontaires* ("involuntary sculptures"), close-up photographs of the bizarre shapes formed by discarded tickets, cigarette ends, and other throwaway objects.

Born in Mexico City, **Manuel Álvarez Bravo** (1902–2002) was a self-taught photographer whose work contributed to the artistic renaissance flourishing in Mexico during the 1930s. He befriended many of Mexico's leading avant-garde artists during this period, including the muralists Diego Rivera, David Alfaro Siqueiros, and José Clemente Orozco (see Ch. 15, p. 364–67), whose work is often recorded in Álvarez Bravo's photographs. His work represents a distinctive blend of cultural influences, fusing imagery and traditions indigenous to Mexico with current ideas imported from Europe and America, including those of the Surrealists. His work was illustrated in the last issue of *Minotaure*. Like Cartier-Bresson, Álvarez Bravo's penchant for discovering the visual poetry inherent in the everyday world could result in delightful and mysterious found images. He happened upon a group of mannequins, which he captured in a photograph of an outdoor market from the early 1930s (fig. **14.58**). Mannequins were a favorite Surrealist subject thanks to their uncanny resemblance to human beings, a resemblance that can trigger momentary but dizzying disorientation. The smiling cardboard mannequins in Álvarez Bravo's image, themselves merely mounted photographs, repeat the same woman's face, which, unlike its real counterparts below, meets the viewer's gaze.

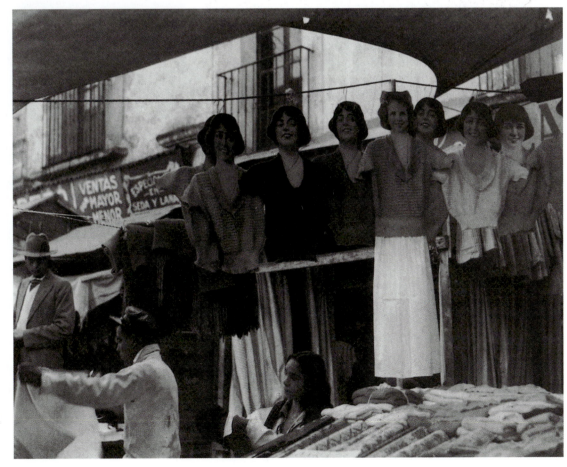

14.58 Manuel Álvarez Bravo, *Laughing Mannequins*, c. 1932. Gelatin-silver print, 7⁵⁄₁₆ × 9⁹⁄₁₆" (18.6 × 24.3 cm). The Art Institute of Chicago.

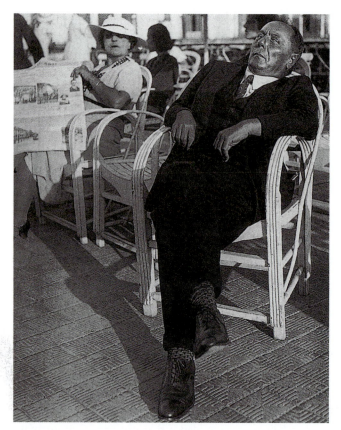

14.59 Lisette Model, *Promenade des Anglais*, 1934. Gelatin-silver print on paper, mounted on pasteboard, 13½ × 10⅞" (34.2 × 27.6 cm). The National Gallery of Canada, Ottawa.

Perhaps closer in spirit to the Austrian Expressionists than to the Surrealists is the work of **Lisette Model** (1901–83), a photographer born in turn-of-the-century Vienna to an affluent family of Jewish and Catholic descent. Model wanted first and foremost to become a concert pianist. In Vienna, she studied music with the composer Arnold Schoenberg and through his circle became aware of the activities of the Viennese avant-garde. In 1926, following the loss of the family's fortune during the war, she moved to France with her mother. It was in Paris, in 1933, that she decided to abandon music and become a professional photographer, learning the rudiments of the technique from her younger sister, her friend Florence Henri, and Rogi André, a photographer (and former wife of Kertész) who advised her to photograph only those things that passionately interested her. Model was, above all, interested in people. She regarded the world as a vast cast of characters from which she constructed her own narratives. With her twin-lens Rolleiflex in hand, during a visit to Nice to see her mother, she photographed wealthy vacationers soaking up the Riviera sun along that city's Promenade des Anglais (fig. **14.59**). Model wielded her camera like an invasive tool. Catching her wary subjects off-guard, she approached them closely, sometimes squatting to record their reactions at eye level. She then cropped her images in the darkroom, augmenting the confrontational nature of the close-up effect. In 1935 her photographs from Nice were published in the leftwing journal *Regards* as disparaging examples of a complacent middle class, "the most hideous specimens of

the human animal." While it is not clear whether Model intended this interpretation, she did allow the photographs to be published again in 1941 in the weekly *PM*, one of the American publications for which she worked after she settled in New York in 1938. *PM* used the photos to demonstrate the French characteristics that, in its opinion, led to the country's capitulation in World War II. This photograph was reproduced under the heading "Cynicism." By the 1950s Model had become an influential teacher; her students included the American photographer Diane Arbus.

With its power to record, heighten, or distort reality—a power vastly increased with the invention of the small, hand-held 35mm Leica—photography proved a natural medium for artists moved by the Surrealist spirit. One of the most remarkable was France's **Henri Cartier-Bresson** (1908–2004), who, after studying painting with the Cubist André Lhote, took up photography and worked as a photojournalist covering such epochal events as the Spanish Civil War (1936–39). His is a photojournalism broadly defined, however, for his magical images, especially those made before World War II, have little to do with a discernible narrative or straight reportage of visual fact. From a

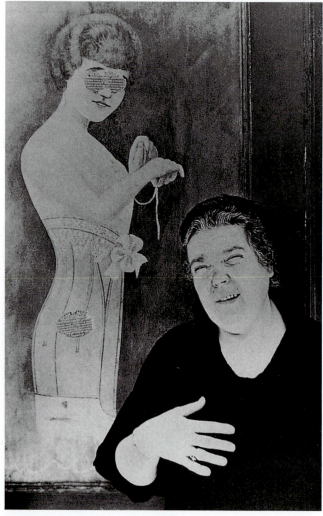

14.60 Henri Cartier-Bresson, *Córdoba, Spain*, 1933. Gelatin-silver print.

✳—⎡Explore⎤ more about Cartier-Bresson on mysearchlab.com

very young age Cartier-Bresson was powerfully influenced by the Surrealist theories of André Breton. He matured quickly as a photographer, and in the first half of the 1930s, in photographs made in France, Spain, Italy, and Mexico, he created some of the most memorable images of the twentieth century.

The photographer, freed from the encumbrance of a tripod, could exploit new opportunities, pursuing the action as it unfolded. Cartier-Bresson said of his practice:

> I prowled the streets all day feeling very strung up and ready to pounce, determined to "trap" life—to preserve life in the act of living. Above all, I craved to seize the whole essence, in the confines of a single photograph, of some situation that was in the process of unrolling itself before my eyes.

Citing Man Ray, Atget, and Kertész as his chief influences, Cartier-Bresson allowed his viewfinder to "discover" a composition within the world moving about him. Once this had been seized upon, the photographer printed the whole uncropped negative, an image that captured the subject in "the decisive moment" (the title of his 1952 book). *Córdoba, Spain* (fig. **14.60**) is a witty juxtaposition of art and life, as in the collages of his friend Max Ernst. A woman clasps a hand to her bosom, unconsciously repeating the gesture in the corset advertisement behind her. The woman squints into the photographer's lens while the eyes of the poster model are "blinded" by an advertisement pasted over them. In this deceptively simple image, the artist sets up a complex visual dialog between art and life, illusion and reality, youth and old age. Cartier-Bresson's pictures, with their momentary equipoise between form, expression, and content, served as models of achievement to photographers for well over half a century.

An English Perspective: Brandt

Although England's **Bill Brandt** (1904–83) was trained as a photographer in the late 1920s in Paris, where he worked in the studio of Man Ray, he made mostly documentary photographs in the 1930s, including a famous series on the coal miners in the North of England during the Depression. After World War II, he rediscovered his early days in Surrealist Paris and gave up documentation in favor of re-exploring the "poetry" of optical distortion, or what he called "something beyond reality." Between 1945 and 1960, he photographed nudes with a special Kodak camera that had an extremely

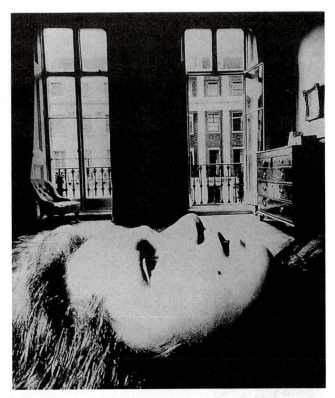

14.61 Bill Brandt, *Portrait of a Young Girl, Eaton Place, London*, 1955. Gelatin-silver print, 17 × 14¾" (43.2 × 37.5 cm).

wide-angle lens and a tiny aperture. The distortions transformed the nudes into Surreal dream landscapes. He exploits the same distorted perspective in *Portrait of a Young Girl, Eaton Place, London* from 1955 (fig. **14.61**). The dreamlike effect is enhanced by the artist's characteristically high-contrast printing style, where portions of the room disappear into blackness. Brandt also continued to make portraits after the war, recording the likenesses of luminaries in the world of literature and art, including leading Surrealists such as Magritte, Arp, Miró, and Picasso.

Surrealism provided a crucial platform for continuing avant-garde investigations into the sources and meanings of visual art. Among those who would feel its influence most intensely were contemporary American artists eager to explore for themselves the ideas generated by the European avant-garde. Although artists like Man Ray and Duchamp provided a link between the European Surrealists and progressive American artists during the 1930s, it would not be until the conclusion of World War II that Surrealist ideas entered fully into American avant-garde practice. Prewar art in America addressed itself to different concerns.

15
American Art Before World War II

In the years leading up to World War I, the American realist tradition was given new life within the ranks of the so-called "Ashcan School." The name was invented by critics in the 1930s to describe a group of artists active between 1905 and 1913 in New York who depicted commonplace subjects emphasizing the seedy aspects of daily urban life. Like all Americans, artists were adjusting to life in their burgeoning industrialized society. The vitality of the city provided many themes, with artists sometimes documenting the lives of urban inhabitants with a literalness that shocked viewers accustomed to the bland generalizations of academic art. Far from seeking through art a retreat from the world, the first wave of American modernism confronted society with an unblinking directness. In this way, American art of the first decades of the twentieth century exhibits a kinship with those Parisian artists drawn to bohemian quarters like Montmartre and Montparnasse. While European modernists had moved away from strict naturalism to explore Symbolism and various types of abstraction, an analogous avant-garde movement had not yet taken hold in the United States.

This is not to say that American artists were not affected by the European avant-garde. On the contrary, interest in modernist trends prompted many to travel to cultural capitals like Paris and Berlin in order to gain firsthand experience of works they were reading about in arts periodicals. The majority of American artists, however, had to rely on secondhand descriptions or reproductions of avant-garde works, retarding to some extent their response to innovations such as Synthetism, Fauvism, and Cubism. Access to European modernism increased significantly with the opening of venues dedicated to presenting new art to American audiences. Among the most influential of these were Alfred Stieglitz's 291 Gallery and the gigantic 1913 exhibition of modern art known as the Armory Show. Simultaneously, a cadre of ambitious American collectors became determined not only to bring avant-garde art and artists to the United States but to foster experiments with new trends at home.

While many American artists embraced modernism, audiences remained skeptical for the most part. This tendency ensured strong support for artworks that relied on familiar modes of representation, such as naturalism. Among the artists to benefit from this inclination were the so-called Regionalists, famous for presenting the rural life of the Midwest, and the more politically engaged Social Realists, who documented the consequences of extreme economic change.

American Artist as Cosmopolitan: Romaine Brooks

American painter **Romaine Brooks** (1874–1970) can be taken as exemplary of those progressive artists keen to engage with the European trends. The unconventionality of her New York City upbringing—she was abandoned by her wealthy mother when she was seven and taken in by the family laundress before being reconciled with her family—exposed her to a milieu normally hidden from members of the upper classes. A great deal of personal freedom accompanied her temporary dispossession, and Brooks pursued art studies in New York before returning to her natal city of Rome to further her artistic education. There, she pursued life drawing and developed an approach to portraiture that combined an intensely psychological character—her subjects often appear in a sort of distracted reverie—with a formal abstraction of the figure. Her sitters' heads and faces assume the simplified geometry of archaic sculpture, much like Picasso's portraits of the early 1900s (see figs. 7.3, 7.5). The affinity is not surprising: Brooks had settled in Paris in 1905 and was likewise interpreting the city's cultural milieu with an expatriate's acuity for visual condensation. Brooks's paintings, remarkably for a female artist at the time, included nudes, and were shown at the prestigious Parisian gallery Durand-Ruel in 1910.

In Paris, Brooks met American poet Natalie Clifford Barney, whose literary salon attracted such illustrious talents as Marcel Proust, Colette, and André Gide. Brooks conducted an open lesbian relationship with Barney and adopted a masculine manner of dress. In her arresting *Self-Portrait* (fig. **15.1**), shown at the 1923 Salon des Indépendants, she projects herself as a stark silhouette with deeply shadowed eyes against an urban backdrop. The striking contrast of the white collar and cuffs of her shirt against the pure black of her coat recalls Manet's use of unmixed color, while the muted background evokes the work of another American expatriate, James Whistler (see fig. 2.25). But the effect created by Brooks departs from

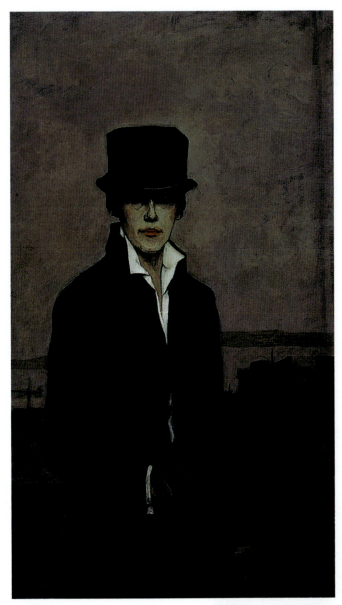

15.1 Romaine Brooks, *Self-Portrait*, 1923. Oil on canvas, 46¼ × 26⅞" (117.5 × 68.3 cm). National Museum of American Art, Washington, D.C.

The Truth about America: The Eight and Social Criticism

In response to the National Academy's rejection of their work for the 1907 spring exhibition, eight painters participated in a historic exhibition at the Macbeth Gallery in New York City in February 1908. The painter Robert Henri (1865–1929), who had moved to New York from Philadelphia in 1900, was the intellectual leader of this loosely constituted group, called The Eight. Since 1905, Henri had been a member of the Academy, but in 1907 he found himself so at odds with his colleagues there that he organized an alternative exhibition.

Henri was joined by four Philadelphia artists—John Sloan, Everett Shinn, William Glackens, and George Luks—all illustrators who provided on-the-spot pictorial sketches for newspapers, a practice soon to be superseded as the technology for reproducing newsprint photographs was developed. As a result of this vocation, they came to painting first as draftsmen who portrayed the transient and everyday realities of American life. Three other artists also joined the ranks—the landscape painters Ernest Lawson and Maurice Prendergast, and the Symbolist Arthur B. Davies—and The Eight was christened by a New York journalist.

The exhibition of The Eight was a milestone in the history of modern American painting. Although the participating artists represented diverse styles and varying points of view, they were united by their hostility to the Academy, with its rigid jury system, and by their conviction that artists had the right to paint subjects of their own choosing. The show received mixed reviews. Some criticized it for its "inappropriate" recording of the uglier aspects of the New York scene. Several of the exhibiting artists were to become leading members of the Ashcan School.

Sloan, Prendergast, and Bellows

Following the exhibition of The Eight, Henri established his own independent art school, becoming one of the most influential teachers in the early years of the century (see *Robert Henri, excerpts from The Art Spirit*, p. 341). Among those he mentored was **John Sloan** (1871–1951), a friend and protégé rather than a student in the conventional sense. Sloan was already a professional illustrator when Henri encouraged him to take up painting and portray what was most familiar to him—the streets and sidewalks of the American urban landscape. In fact, Sloan happened upon the scene depicted in *Hairdresser's Window* (fig. **15.2**) on his way to visit Henri at his New York studio. He was so taken with the spectacle of a crowd gathering beneath the window of a hairdresser's shop that he returned home to paint it from memory and, in his words, "without disguise." In the signs adorning the façade, Sloan introduced amusing puns such as one announcing the shop of "Madame Malcomb."

Although the terms The Eight and Ashcan School are often used interchangeably, not all of the participants in the 1908 Macbeth Gallery show qualify as Ashcan artists. A case in

their example. By articulating her form with such a strong contour line and intense, flattening contrast, she endows herself with an emphatic presence against an indistinct background. This is the closest modern artists have come to realizing a female *flâneur*—a *flâneuse*—a social idler who moves comfortably and confidently through any urban milieu. Baudelaire was the first to contend that the *flâneur* was the consummate modern artist. His essay "The Painter of Modern Life" (1863) linked artmaking with masculine sociability and sexuality, a presumption that has informed the discourse of modernism since its inception. Brooks's self-presentation as a *flâneur* testifies to conscious manipulation (and rejection) of gender stereotypes.

Brooks's decision to relocate to Europe illustrates one way in which American artists could engage with modernism. For the great majority who remained in the United States, other means of advancing a personal, even "American," mode of modern art began to emerge at the start of the twentieth century.

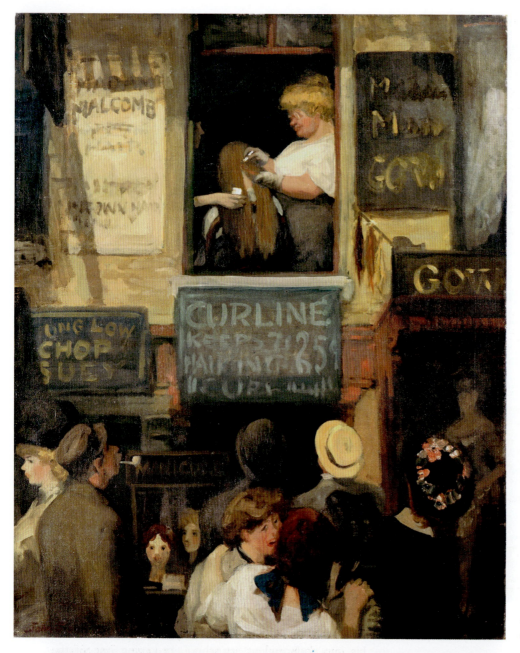

15.2 John Sloan, *Hairdresser's Window*, 1907. Oil on canvas, 31⅞ × 26" (81 × 66 cm). Wadsworth Atheneum, Hartford, Connecticut.

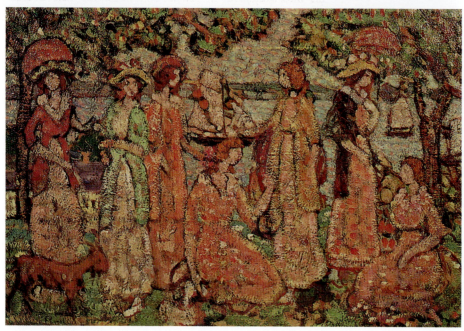

15.3 Maurice Prendergast, *The Idlers*, c. 1918–20. Oil on canvas, 21 × 23" (53.3 × 58.4 cm). Maier Museum of Art, Randolph-Macon Women's College, Lynchburg, Virginia.

point is the Boston artist **Maurice Prendergast** (1858–1924), who had trained in Paris in the 1890s and closely followed the developments of the French avant-garde. Prendergast chronicled the lighter side of contemporary life—the pageantry of holiday crowds, city parks, or seaside resorts (fig. **15.3**). He recorded these scenes in a distinctive, highly decorative style consisting of brightly colored patches of paint, reflecting his interest in Japanese prints and the French Nabis painters (see Ch. 3, pp. 64–67).

George Bellows (1882–1925), one of Henri's most accomplished students and an exemplar of the Ashcan School, developed a bold, energetic painting style that he deployed for subjects ranging from inner city street scenes to tense, ringside views of boxing matches, or socialites at leisure. His *Cliff Dwellers*, 1913 (fig. **15.4**), is a classic Ashcan depiction of daily life in Manhattan's Lower East Side. Forced from their apartments by stifling summer heat, the residents carry on their lives on stoops and sidewalks, seemingly trapped within the walls of the tenement walk-ups. Bellows published

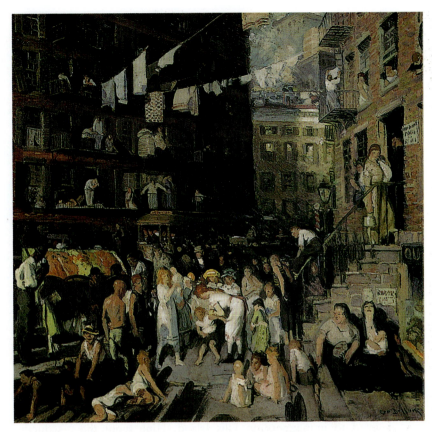

15.4 George Bellows, *Cliff Dwellers*, 1913. Oil on canvas, 39½ × 41½" (100.3 × 105.4 cm). Los Angeles County Museum of Art.

a preparatory drawing for this work in *The Masses*, a radical socialist magazine for which Sloan also worked, and assigned it a satirical caption, "Why don't they all go to the country for vacation?"

Two Photographers: Riis and Hine

The social criticism inherent in Ashcan School art was even more explicit in the photographic work of **Jacob August Riis** (1849–1914), a Danish immigrant who took his camera into alleys and tenements on the Lower East Side to document the wretched conditions he found there in order to report them in the progressive *Tribune* newspaper (fig. **15.5**). Many of his photographs were taken at night or in dark spaces, so the self-taught Riis used a flash in order to document the scene. This technique results in images with tremendous immediacy and candor. His role as a police reporter led Riis to say of his camera, "I had use for it and beyond that I never went." To the dismay of New York society, he used his pictures to expose the poverty and starvation that he felt were direct results of the Industrial Revolution. His book *How the Other Half Lives: Studies Among the Tenements of New York*, published in 1890, became a classic reference for subsequent social documentary photographers (see figs. 19.57, 19.58).

Likewise employing photography as an instrument of social reform was **Lewis W. Hine** (1874–1940). His approach to the project and the resulting photographs differ profoundly from those of Riis. Like Riis, Hine was self-taught, but he studied the medium carefully and exploited

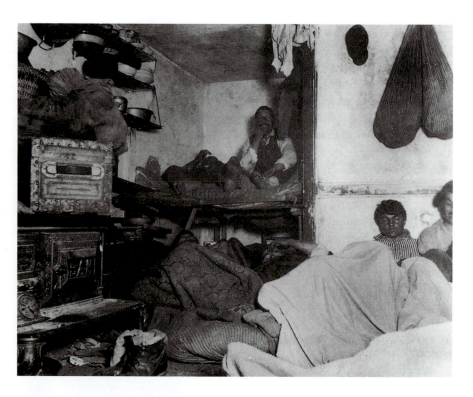

photography's aesthetic as well as documentary capacities in order to create a persuasive image. After an initial series devoted to immigrants on Ellis Island, Hine spent the years 1908–16 as the staff photographer for the National Child Labor Committee visiting factories to photograph and expose child-labor abuses (fig. **15.6**). Like Riis, Hine used the camera to produce "incontrovertible evidence" that helped win passage of laws protecting children against industrial exploitation. Hine, like his predecessor Mathew Brady in his Civil War images (see fig. 2.11), often directed his subjects and skillfully composed his images the better to make his case. With Hine, however, the careful management of lighting, pose, and setting can result in images of

such alluring aesthetic character that the grim realities of the labor practices he aims to expose recede into the overall seductiveness of the photograph.

A Rallying Place for Modernism: 291 Gallery and the Stieglitz Circle

In 1905, at the Little Galleries of the Photo-Secession at 291 Fifth Avenue in New York, the photographers **Alfred Stieglitz** (1864–1946) and Edward Steichen began to hold exhibitions of photography, and shortly thereafter of modern European paintings and sculpture, as well as African art. The artists whose work was exhibited at the gallery known as 291 were more cosmopolitan than the Henri group: they were in closer contact with current events and artists in Europe, and less chauvinistic about Americanism in art. Moreover, Stieglitz and Steichen were in touch with avant-garde leaders in Paris.

The 291 Gallery would serve as a rallying place for American pioneers of international modernism. The gallery was a focal point for the New York Dada movement (see Ch. 10, pp. 218–27), and *291* was also the title of a short-lived Dada magazine. Between 1908 and 1917, works by many of the greatest European modernists were exhibited there, among them Cézanne, Toulouse-Lautrec, Brancusi, Matisse, and Braque, as well as members of the American avant-garde, including John Marin, Charles Sheeler, Charles Demuth, Georgia O'Keeffe, and Elie Nadelman. At the same time, Stieglitz edited an important quarterly magazine on photography called *Camera Work*.

After 291 closed in 1917, Stieglitz continued to sponsor exhibitions at various New York galleries. In 1925 he opened the Intimate Gallery, which was succeeded by An American Place in 1929. Stieglitz directed this gallery until his death in 1946, featuring exhibitions by

15.6 Lewis W. Hine, *Child in Carolina Cotton Mill*, 1908. Gelatin-silver print on masonite, 10½ × 13½" (26.7 × 34.3 cm). The Museum of Modern Art, New York.

America's leading modernists. The impact of Stieglitz and his exhibitions at 291 was enormous. The miscellaneous group of Americans shown by him constituted the core of experimental art in the United States in the first half of the twentieth century.

Stieglitz and Steichen

Well before he became a central figure in the American avant-garde, Stieglitz lived in Berlin. Here he began his long and distinguished career as a photographer and launched his crusade to establish photography as a fine art. He was an ardent advocate of Pictorialism in photography. The Pictorialists deplored the utilitarian banality of sharp-focus, documentary photography, as well as the academic pretension of Rejlander and Robinson (see figs. 2.2, 2.4). Instead, they insisted upon the artistic possibilities of camera-made imagery, but held that these could be realized only when art and science had been combined to serve both truth and beauty (see fig. 15.8). Many Pictorialists tried to emulate painting and prints through soft-focus or darkroom manipulation. Too often, however, these attempts to create a heightened sense of poetry resulted in murky, sentimentalized facsimiles of etchings or lithographs.

Because Stieglitz maintained a strict "truth to materials" position, creating highly expressive images without the aid of darkroom enhancement, he was an important forerunner of so-called "straight" photography. The straight photographer exploits the intrinsic properties of the camera to make photographs that look like photographs instead of imitations of paintings or fine-art prints. Stieglitz joined the Pictorialists in maintaining that their works should be presented and received with the same kind of regard accorded other artistic media. In pursuit of this goal, progressive photographers initiated an international secession movement that provided spaces for meetings and exhibitions, stimulated enlightened critical commentary, and published catalogs and periodicals devoted to photography. The most distinguished and far-reaching in its impact was New York's Photo-Secession group, established by Stieglitz in 1902 to promote "the serious recognition of photography as an additional medium of pictorial expression."

Stieglitz achieved his pictorial goals through his choice of subject, light, and atmosphere in the world about him, allowing natural conditions and commonplace subjects to produce the desired thematic and compositional effects. In 1907, during a voyage to Europe, Stieglitz discovered little of social or visual interest among his fellow first-class passengers and wandered over to steerage, where the cheapest accommodation was located. As he later explained, he was struck by the combination of forms he witnessed among the crowds on deck—"a round straw hat, the funnel leaning left, the stairway leaning right, the white drawbridge with its railings made of circular chains, white suspenders crossing on the back of a man." Stieglitz fetched his camera and took what he came to regard as one of his most successful photographs, *The Steerage* (fig. 15.7). Avoiding even the slightest Pictorialist sentiment or anecdote, Stieglitz provided a straight document of the scene, which he said was not merely a crowd of immigrants but "a study in mathematical lines ... in a pattern of light and shade."

15.7 Alfred Stieglitz, *The Steerage*, 1907. Gelatin-silver print, 4⁵⁄₁₆ × 3⅜" (11 × 9.2 cm). The Art Institute of Chicago. Alfred Stieglitz Collection, 1949.

15.8 Edward Steichen, *Balzac, The Silhouette—4 a.m.*, 1908. Gum bichromate print, 14¹⁵⁄₁₆ × 18⅛″ (37.9 × 46 cm). The Metropolitan Museum of Art, New York.

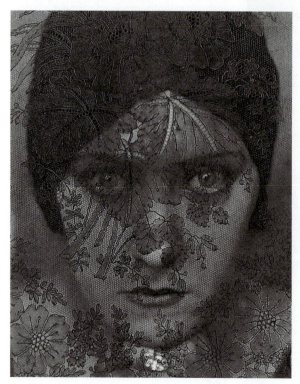

15.9 Edward Steichen, *Gloria Swanson*, 1924. Gelatin-silver print, 16¹⁄₁₆ × 13½″ (42.1 × 34.2 cm). The Museum of Modern Art, New York.

Stieglitz's longtime associate in New York's Photo-Secession group, 291 Gallery, and *Camera Work* magazine was **Edward Steichen** (1879–1973), whom Rodin commissioned in 1908 to photograph the original plaster cast of his Balzac (fig. **15.8**). Rodin proposed that Steichen try working by moonlight. Not only did this technique avoid the flattening effect that direct sunlight would have had on the white material, but the long exposure that the dim light required invested the pictures with a sense of timelessness totally unlike the stop-action instantaneity normally associated with the camera. The resulting photograph summarizes the aesthetic aims of Pictorialism. After World War I, during which he worked as an aerial photographer, Steichen abandoned his soft-focus Pictorialism to practice and promote straight, unmanipulated photography. Steichen became chief photographer for *Vogue* and *Vanity Fair*, publications in which his celebrity portraits and fashion photos, both revealing the artist's acute sensitivity to abstract pattern and composition, appeared regularly from 1923 to 1938, exerting tremendous influence on photographers on both sides of the Atlantic (fig. **15.9**). In 1947 Steichen was appointed director of the Department of Photography at New York's Museum of Modern Art, a position he held until his retirement in 1962. In this capacity, he continued to exert enormous influence on the American reception of avant-garde art.

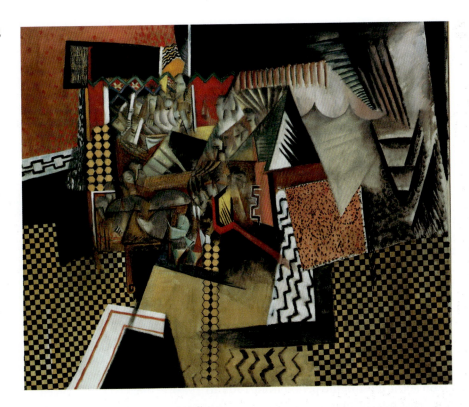

15.10 Max Weber, *Chinese Restaurant*, 1915. Oil on canvas, 40 × 48" (101.6 × 121.9 cm). Whitney Museum of American Art, New York.

Weber, Hartley, Marin, and Dove

In a 1910 group show at 291, Stieglitz included works by **Max Weber** (1881–1961), a painter who had recently returned from three years in Paris. For an American, Weber was unusually knowledgeable about recent developments in French art and, by the time of Stieglitz's show, had begun to develop his own highly individual Cubist style. The 1915 *Chinese Restaurant* (fig. **15.10**) is his response to a friend's suggestion that he make a painting about the conversations they had had over dinners in New York City's Chinatown. The wealth of colorful patterns suggests fragments of curtains, tile floors, and figures—colliding visual recollections of a bustling, urban interior and analogs for the rapid exchange of new ideas. Toward the end of World War I, the artist abandoned Cubism for a form of expressionist figuration related to that of Chagall and Soutine.

American painter **Marsden Hartley** (1877–1943) came to Stieglitz's attention with the Post-Impressionist landscapes he made in Maine in 1907–09. His works were shown for the first time at 291 in 1909. From 1912 to 1915, Hartley lived abroad, first in Paris and then in Berlin. In Germany he was drawn to the mystically based art of Der Blaue Reiter (see Ch. 6, pp. 121–30), and the first works he made there are clearly inspired by Kandinsky. Among the Blaue Reiter group, Hartley found enthusiastic supporters, notably Franz Marc, who helped him locate venues to exhibit his work, and he quickly came to regard Berlin, the capital of imperial Germany, as the most vital urban center in Europe. In 1914–15 he made a series of paintings in which the imagery is derived from German flags, military insignia, and all the regalia of the imperial court. The works were not a celebration of German nationalism but rather Hartley's response to the lively pageantry of the city. *Portrait of a German Officer* (fig. **15.11**) contains coded

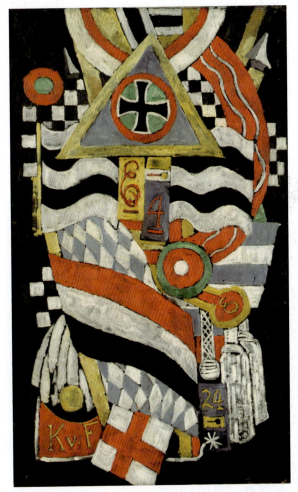

15.11 Marsden Hartley, *Portrait of a German Officer*, 1914. Oil on canvas, 68¼ × 41⅜" (173.3 × 105.1 cm). The Metropolitan Museum of Art, New York.

View the Closer Look for *Portrait of a German Officer* on mysearchlab.com

15.12 John Marin, *Lower Manhattan (Composition Derived from Top of Woolworth Building)*, 1922. Watercolor and charcoal with paper cut-out attached with thread on paper, 21⅝ × 26⅞" (54.9 × 68.3 cm). The Museum of Modern Art, New York.

references to Hartley's friend and probable lover Karl von Freyburg, a German officer who was killed on the Western Front. Along with the initials "K v. F" in the lower left, the painting features a number 4, which was Freyburg's regiment. The checkerboard pattern evokes his love of chess. Like Weber, Hartley began with motifs from the visible world, broke them up, and reorganized them into a largely abstract composition. The exuberant energy, brilliant colors, and bold arrangement of forms are evidence of his interest in the Orphist paintings of Delaunay (see fig. 7.40). In 1916, as war raged in Europe, Hartley's German works were shown at 291, where they were regarded by some reviewers as treacherously pro-German.

Among the artists that Stieglitz promoted, **John Marin** (1870–1953) is known for his superb skill as a watercolorist. Following his art studies in Philadelphia and New York, Marin spent most of the period from 1905 to 1910 in Europe. His introduction to Stieglitz in 1909 marked the beginning of a long and fruitful relationship. The late watercolors of Cézanne were an important source of inspiration for him, and Cubist structure remained a controlling force in the cityscapes and landscapes he painted throughout his life.

During the 1920s and 30s he carried his interpretations of New York close to a form of expressionist abstraction in which his subject is almost always discernible. In the 1922 *Lower Manhattan (Composition Derived from Top of Woolworth Building)* (fig. **15.12**), an explosion of buildings

erupts from a black circular form containing a sunburst center, a cut-out form that Marin attached to the paper with thread. He reinforced the transparent, angular strokes of the watercolor with charcoal, creating a work of graphic force that vibrates with the clamor and speed of the city.

Arthur G. Dove (1880–1946) temporarily abandoned a career as an illustrator to go to Paris in 1907 with hopes of becoming a full-time painter. With astonishing speed, he seems to have absorbed much of the course of European modernism. The group of pastels that he exhibited at 291 in 1912 were even closer to non-objectivity than contemporaneous paintings by Kandinsky, whose work Dove knew, and were probably the earliest and most advanced statements in abstract art by an American artist (fig. **15.13**). Throughout

15.13 Arthur G. Dove, *Nature Symbolized No. 2*, c. 1911. Pastel on paper, 17⅞ × 21½" (45.8 × 55 cm). The Art Institute of Chicago. Alfred Stieglitz Collection, 1949. 533.

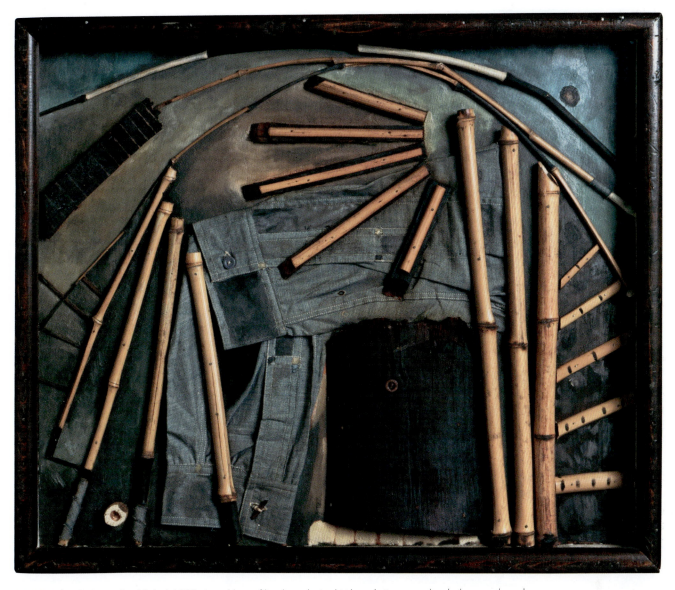

15.14 Arthur G. Dove, *Goin' Fishin'*, 1925. Assemblage of bamboo, denim shirtsleeve buttons, wood and oil on wood panel, 19½ × 24" (49.5 × 61 cm). The Phillips Collection, Washington, D.C.

his life, Dove was concerned more with the spiritual forces of nature than its external forms, and the curving shapes of his pastels were inspired by the natural world. He later called his group of abstract pastels *The Ten Commandments*, as if together they constituted his spiritual and artistic credo.

Between 1924 and 1930, Dove produced a remarkable group of multimedia assemblages, including *Goin' Fishin'* (fig. **15.14**), composed of fragmented fishing poles and denim shirtsleeves. The artist was aware of the evolution of Cubist collage, but his own efforts have more in common with nineteenth-century American folk art, *trompe l'oeil* painting, and Dada collage, though Dove never adopted the subversive, antiart stance of the first Dadaists. His own collages range from landscapes made up literally of their natural ingredients—sand, shells, twigs, and leaves—to delicate and magical *papiers collés*. During the 1930s, Dove continued to paint highly abstracted landscapes in which concentric bands of radiating color and active brushwork express both a quality of intense light and the artist's sense of spiritual energy in nature.

O'Keeffe

The last exhibition at 291, held in 1917, was the first solo show by **Georgia O'Keeffe** (1887–1986). Marsden Hartley said that O'Keeffe was "modern by instinct," although she had been exposed, especially through exhibitions at 291, to the work of the major European modernists. The biomorphic, Kandinsky-like abstractions in charcoal that she made in 1915–16 so impressed Stieglitz that he soon gave her an exhibition. The two artists married in 1924. Before he put away his camera for good in 1937, Stieglitz made more than 300 photographs of O'Keeffe (fig. **15.15**), contributing to her almost cult status in the art of the twentieth century.

Whether her subjects were New York skyscrapers, enormously enlarged details of flowers, bleached cow skulls, or adobe churches, they have become icons of American art. Her paintings involve such economy of detail and such skillful distillation of her subject that, however naturalistically precise, they somehow become works of abstraction. Alternatively, her abstractions have such tangible presence that they suggest forms in nature. *Music—Pink and Blue,*

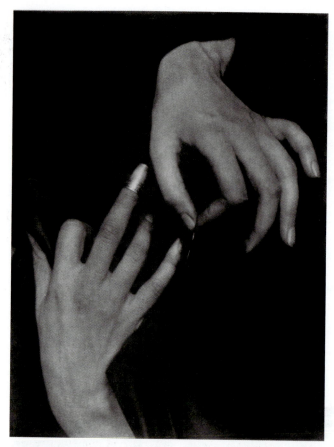

II (fig. **15.16**) is a breathtaking study in chromatic relationships and organic form. The title suggests the lingering influence of Kandinsky's equation of color with music and, ultimately, with emotion. Typically ambivalent, the forms resemble an enlarged close-up of the flowers that O'Keeffe painted in the 1920s, although some have interpreted them as implicitly sexual. The persistence of interpretations linking O'Keeffe's abstractions to female genitalia or sexuality speaks to the distinctions critics and art historians have drawn between O'Keeffe's work and that of her male contemporaries, whose works are rarely subjected to such biological essentialism. The artist rejected such readings of her imagery, and, partly in response to such interpretations, her work became more overtly representational in the 1920s, as in her tightly rendered views of New York skyscrapers made from the window of her Manhattan apartment. In 1929 O'Keeffe visited New Mexico for the first time and thereafter divided her time between New York and the Southwest, settling permanently in New Mexico in 1949. The desert motifs that she painted there are among her best-known images (fig. **15.17**). Despite the variety of her strategies for exploring abstraction, O'Keeffe remains best known for the colorful paintings suggestive of flowers, and critics still tend

15.15 Alfred Stieglitz, *O'Keeffe Hands and Thimble*, 1919, printed 1947 by Lakeside Press, Chicago. Photomechanical (halftone) reproduction, 7¾ × 6" (19.7 × 15.3 cm). George Eastman House, Rochester, New York.

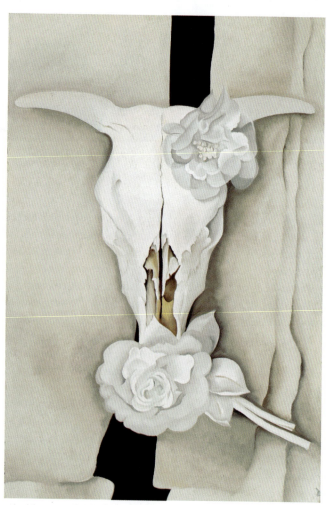

15.16 Georgia O'Keeffe, *Music—Pink and Blue, II*, 1919. Oil on canvas, 35½ × 29" (90.2 × 73.7 cm). Whitney Museum of American Art, New York.

15.17 Georgia O'Keeffe, *Cow's Skull with Calico Roses*, 1931. Oil on canvas, 35⅞ × 24" (91.2 × 61 cm). The Art Institute of Chicago. Alfred Stieglitz Collection, Gift of Georgia O'Keeffe, 1947.712.

to focus on their supposed sexual connotations as opposed to the enormous influence O'Keeffe exerted on the first wave of American abstract artists. She, perhaps more than any of her contemporaries, pointed the way to a distinctively American approach to abstraction.

Straight Photography: Strand, Cunningham, and Adams

Three important American photographers associated, like O'Keeffe, with the West are Paul Strand, Imogen Cunningham, and Ansel Adams. Photographer and filmmaker **Paul Strand** (1890–1976) studied in his native New York City with Lewis Hine. He officially entered the Stieglitz circle in 1916, when his photographs were reproduced in *Camera Work* and he exhibited at 291 for the first time. By now Strand had abandoned the Pictorialism of his early work and was making photographs directly inspired by Cubist painting. In 1917 he contributed an essay to the last issue of *Camera Work* in which he called for photography as an objective art "without tricks of process or manipulation." In 1930–32 Strand worked in New Mexico and photographed the same church that his friends O'Keeffe and Adams had already depicted (fig. **15.18**). All three artists were drawn to the desert sun's ability to accentuate the abstract qualities and dignified monumentality of the adobe structure.

From her origins in soft-focus Pictorialism, **Imogen Cunningham** (1883–1976), like Strand, shifted to straight photography, producing a series of plant studies (fig. **15.19**), in which blown-up details and immaculate lighting yield an image analogous to the near-abstract flower paintings of Georgia O'Keeffe. In 1932, along with Ansel Adams, Edward Weston, and other photographers in the San Francisco Bay area, Cunningham helped found Group f.64, a loosely knit organization devoted to "straight" photography as an art form. Their name refers to the smallest aperture on a large-format camera, producing sharp focus and great depth of field.

Ansel Adams (1902–84) discovered his passion for nature at the age of fourteen during a visit to California's Yosemite Valley, but it was his initial meeting with Paul Strand in 1930 that decided his career in photography. Three years later he met and engaged the support of Alfred Stieglitz. A masterful technician, Adams revealed himself to be an authentic disciple of Stieglitz when he wrote:

A great photograph is a full expression in the deepest sense, and is, thereby, a true expression of what one feels about life in its entirety. And the expression of what one feels should be set forth in terms of simple devotion to the medium—a statement of the utmost clarity and perfection possible under the conditions of creation and production.

Adams's art is synonymous with spectacular unspoiled vistas of the West. An image taken in the Sequoia National Park, California, in 1932 (fig. **15.20**) shows the wintry

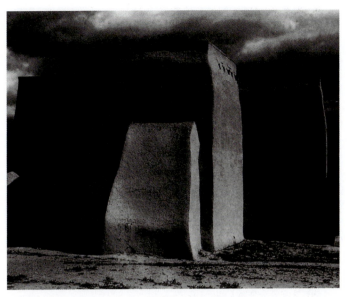

15.18 Paul Strand, *Ranchos de Taos Church, New Mexico*, 1931. Gelatin-silver print.

landscape from a close-up angle, so that it fills the frame to reveal the textures of the earth. An experienced mountaineer and dedicated conservationist, Adams was an active member of the Sierra Club by the late 1920s. He helped establish the Department of Photography at New York's Museum of Modern Art in 1940 and the Center for Creative Photography at the University of Arizona, Tucson, in 1975.

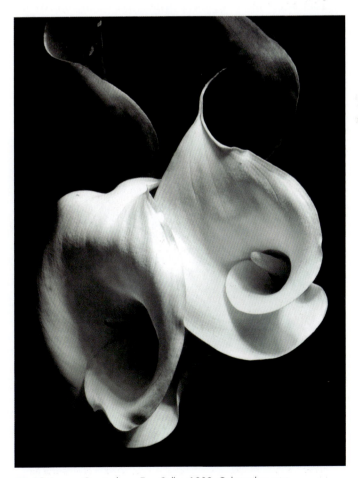

15.19 Imogen Cunningham, *Two Callas*, 1929. Gelatin-silver print.

15.20 Ansel Adams, *Frozen Lakes and Cliffs, The Sierra Nevada, Sequoia National Park, California*, 1932. Gelatin-silver print.

Coming to America: The Armory Show

In the early part of the twentieth century, an important catalyst affecting the subsequent history of American art was the International Exhibition of Modern Art, held in New York at the 69th Regiment Armory on Lexington Avenue at 25th Street between February 17 and March 15, 1913. Known simply as the Armory Show, it was organized by the Association of American Painters and Sculptors, who aimed to show a large number of European and American artists and to compete with the regular exhibitions of the National Academy of Design. Arthur B. Davies, a member of The Eight respected by both the Academy and the independents and highly knowledgeable in the international art field, was chosen as chairman and, with the painter Walt Kuhn, did much of the selection. They were assisted in several European cities by the painter and critic Walter Pach. William Glackens, another member of The Eight, oversaw the choice of American works. The Armory Show proved to be a monumental though uneven exhibition focusing on the nineteenth- and early twentieth-century painting and sculpture of Europe (fig. **15.21**). The artists shown ranged from Goya and Delacroix to Daumier, Courbet, Manet, the Impressionists, Van Gogh, Gauguin, Cézanne, Redon, the Nabis, and Seurat and his followers. Matisse and the Fauves were represented, as were Picasso, Braque, and the Cubists. German Expressionists were slighted, while the Orphic Cubists and the Italian Futurists withdrew. Stieglitz purchased the only Kandinsky in the show. Among sculptors, the Europeans Rodin, Maillol, Brancusi, Nadelman, and Lehmbruck, as well as the American Gaston Lachaise, were included, although sculpture was generally far less well represented than painting. American painting of all varieties and quality dominated the show in sheer numbers, but failed in its impact relative to that of the exotic imports from Europe.

The Armory Show created a sensation, and while the popular press covered it extensively (at first with praise), it was savagely attacked by critics and American artists. Matisse was singled out for abuse, as were the Cubists, while Duchamp's *Nude Descending a Staircase* (see fig. 7.46) enjoyed a *succès de scandale* and was likened to an "explosion in a shingle factory" (see Ch. 7, p. 168).

As a result of the controversy, an estimated 75,000 people attended the exhibition in New York. At Chicago's Art Institute, where the European section and approximately

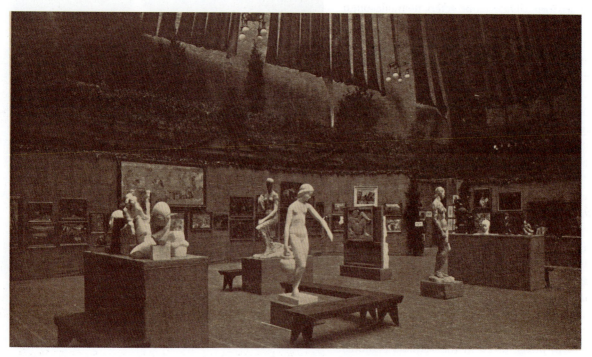

15.21 Postcard showing the Armory Show, 1913. The Museum of Modern Art Archives, New York.

half the American section were shown, nearly 200,000 visitors crowded the galleries. Here the students of the Art Institute's school, egged on by members of their faculty, threatened to burn Matisse and Brancusi in effigy. In Boston, where some 250 examples of the European section were displayed at Copley Hall, the reaction was more tepid.

The Armory Show, an unprecedented achievement in America, was a powerful impetus for the advancement of modernism there. Almost immediately, there was evidence of change in American art and collecting. New galleries dealing in modern painting and sculpture began to appear. Although communications were soon to be interrupted by World War I, more American artists than ever were inspired to go to Europe to study. American museums began to buy and to show modern French masters, and a small but influential new class of collectors, which included Dr. Albert Barnes, Arthur Jerome Eddy, Walter Arensberg, Lillie P. Bliss, Katherine Dreier, and Duncan Phillips, arose. From their holdings would come the nuclei of the great American public collections of modern art.

Sharpening the Focus on Color and Form: Synchromism and Precisionism

Synchromism

In the year of the Armory Show, two Americans living in Paris, **Stanton Macdonald-Wright** (1890–1973) and **Morgan Russell** (1886–1953), launched their own movement, which they called Synchromism. The complicated theoretical basis of Synchromism began with the principles of French color theorists such as Chevreul, Rood, and Blanc (see Ch. 3, p. 43). The color abstractions, or Synchromies, that resulted were close to the works of Delaunay, although the ever-competitive Americans vehemently differentiated their work from his. Their 1913 exhibitions in Munich and Paris were accompanied by brash manifestos, followed by a show the next year in New York. Macdonald-Wright, whose *Abstraction on Spectrum (Organization, 5)* (fig. **15.22**) clearly owes much to Delaunay's earlier *Disk* paintings (see fig. 7.42), wrote in 1916, "I strive to divest my art of all anecdote and illustration and to purify it to the point where the emotions of the spectator will be wholly aesthetic, as when listening to good music." Macdonald-Wright returned to the United States in 1916 and showed his work at 291 the following year. He moved to California in 1918, the year that more or less witnessed the end of Synchromism; although he largely returned to figuration after 1920, his subsequent work was still informed by his early Synchromist experiments.

Russell, on the other hand, spent most of his life in France after 1909. His most important Synchromist work is the monumental *Synchromy in Orange: To Form* (fig. **15.23**), which was included in the 1914 Salon des Indépendants in Paris. Although the densely packed, curving planes of

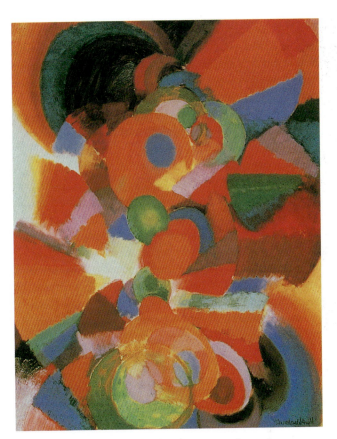

15.22 Stanton Macdonald-Wright, *Abstraction on Spectrum (Organization, 5)*, c. 1914. Oil on canvas, 30⅛ × 24³⁄₁₆" (76.5 × 61.4 cm). Des Moines Art Center, Iowa.

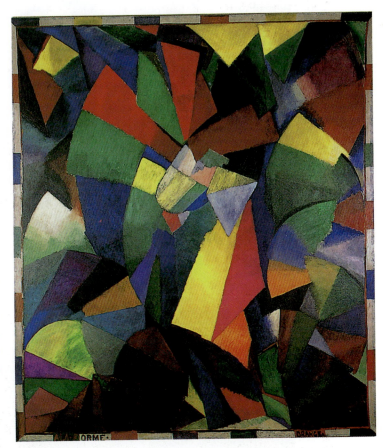

15.23 Morgan Russell, *Synchromy in Orange: To Form*, 1913–14. Oil on canvas with painted frame, 11′ 3″ × 10′ 3″ (3.4 × 3.1 m). Albright-Knox Art Gallery, Buffalo, New York.

brilliant color seem to construct a wholly abstract composition, the central planes actually contain the forms of a man, possibly Michelangelo's *Dying Slave* in the Louvre, after which Russell—always interested in sculpture—had made drawings. By virtue of juxtaposed advancing and receding colors, the painting has a distinctive sculptural appearance, an aspect that sets his work apart from that of Delaunay.

Precisionism

A major manifestation of a new spirit in American art was the movement called Precisionism, which originated during the 1920s, though the term was not itself coined until the 1940s. Never organized into a coherent group with a common platform, the artists involved have also been labeled Cubo-Realists and even the Immaculates. All these terms refer to an art that is basically descriptive, but guided by geometric simplification stemming partly from Cubism. Precisionist paintings tend to be stripped of detail and are often based on sharp-focus photographs. The movement is in some ways the American equivalent of Neue Sachlichkeit or New Objectivity, the realist style practiced in Germany after the war (see Ch. 10, pp. 233–41). The Germans, who had witnessed the horrors of war firsthand, tended to focus on politically charged images of the human figure, while the Americans preferred the more neutral subjects of still life, architecture, and the machine. Given their hard-edge style and urban theme, Georgia O'Keeffe's New York views of the 1920s could be considered Precisionist, but Charles Demuth and, especially, Charles Sheeler were the key formulators of the style.

Charles Sheeler (1883–1965), a Philadelphia-born and -trained artist, began working as a professional photographer around 1910, making records of new houses and buildings for architectural firms. In 1919 he moved to New York, where he had already befriended Stieglitz and Strand, and continued to participate in the salons organized by the collectors Walter and Louise Arensberg. There he met Duchamp, Man Ray, Picabia, and other artists associated with New York Dada. Sheeler photographed skyscrapers— double exposing, tilting his camera, and then transferring these special effects and the patterns they produced to his paintings. In 1920 he collaborated with Strand on a six-minute film entitled *Manhatta*, which celebrated the dizzying effect of life surrounded by a dense forest of skyscrapers. Sheeler's 1920 painting *Church Street El* (fig. **15.24**), representing a view looking down from a tall building in

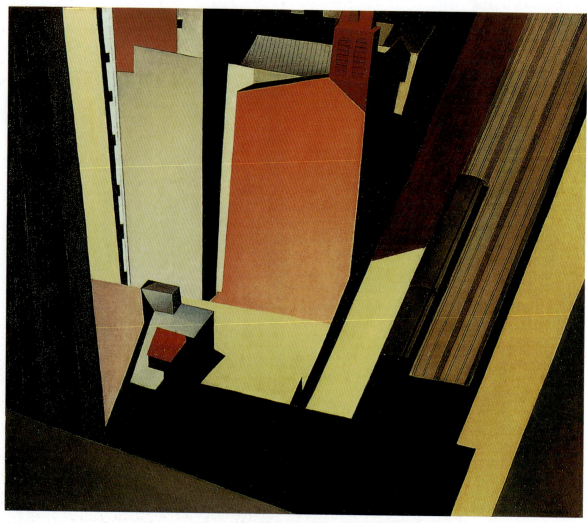

15.24 Charles Sheeler, *Church Street El*, 1920. Oil on canvas, 16 × 19⅛" (40.6 × 48.6 cm). Cleveland Museum of Art. Mr. and Mrs. William H. Marlatt Fund, 1977.43.

15.25 Charles Sheeler, *Rolling Power*, 1939. Oil on canvas, 15 × 30" (38.1 × 76.2 cm). Smith College Museum of Art, Northampton, MA.

Lower Manhattan, was based on a still from the film. In its severe planarity and elimination of details, *Church Street El* is closer to geometric abstraction than to the shifting viewpoints of Cubist painting. By cropping the photographic image, Sheeler could be highly selective in his record of the details provided by reality, thus creating arbitrary patterns of light and shadow and flat color that transform themselves into abstract relationships. At the right in *Church Street El*, amidst the deep shadows and bright, geometric patches of sun, an elevated train moves along its tracks.

The relationship between Sheeler's camera work (he stopped making strictly commercial photographs in the early 1930s) and his canvases seems to have been virtually symbiotic, as can be seen in the painting known as *Rolling Power*, which is based on a photograph taken by the artist as a preparatory study for the work (fig. **15.25**). At first glance, the work in oil comes across as an almost literal transcription of a photograph. But Sheeler altered the composition and suppressed such details as the grease on the engine's piston

box, all in keeping with Precisionism's love of immaculate surfaces and purified machine imagery. Sheeler made this painting for *Fortune* magazine as part of a commissioned series called *Power*, consisting of six "portraits" of power-generating machines. Much of Sheeler's work in the 1930s and 40s was a celebration of the modern industrial age, with majestic views of factories, power plants, and machines.

Charles Demuth (1883–1935), also a Pennsylvanian, was the other major figure of Precisionism. He completed his studies at the Pennsylvania Academy in 1910 and, during a trip to Paris in 1912, befriended Hartley, who became an important mentor. Demuth's first mature works were book illustrations and imaginative studies of dancers, acrobats, and flowers, free and organic in treatment, and seemingly at the other extreme from a Precisionist style. The work of Cézanne was an important guiding force during these years. Like Marin, Demuth was a consummate watercolorist, but where Marin used the medium for great drama and expressive purpose, Demuth applied his delicate washes of color with restraint. "John Marin and I drew our inspiration from the same sources," he once said. "He brought his up in buckets and spilled much along the way. I dipped mine out with a teaspoon but I never spilled a drop." Beginning in 1917, Demuth began producing landscapes executed in watercolor, using interpenetrating and shifting planes and suggestions of multiple views (fig. **15.26**). With these works, Demuth began his experiments with abstract lines of force, comparable to those used by the Futurists.

In the 1920s, Demuth produced a series of emblematic portraits of American artists. Made up of images, words, and letters, these "posters," as he called them, were related to some of the Dadaists' symbolic portraits, including Picabia's (see fig. 10.15). They led to *The Figure 5 in Gold*

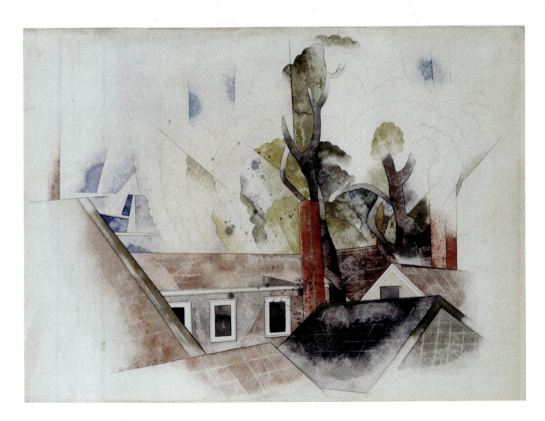

15.26 Charles Demuth, *Rooftops and Trees*, 1918. Watercolor and graphite on paper, 10 × 14" (25.4 × 35.6 cm). Corcoran Gallery of Art, Washington, D.C. Bequest of George Biddle.

(fig. **15.27**). The work, a tribute to his friend the poet William Carlos Williams, is based on *The Great Figure*, a poem Williams wrote after seeing a roaring red fire engine emblazoned with a golden number 5:

> Among the rain
> and lights
> I saw the figure 5
> in gold
> on a red
> fire truck
> moving
> tense
> unheeded
> to gong clangs
> siren howls
> and wheels rumbling
> through the dark city.

Like other artists in the postwar era, Demuth was searching for intrinsically American subjects and became interested in the advertising signs on buildings and along highways, not as blemishes on the American landscape but as images

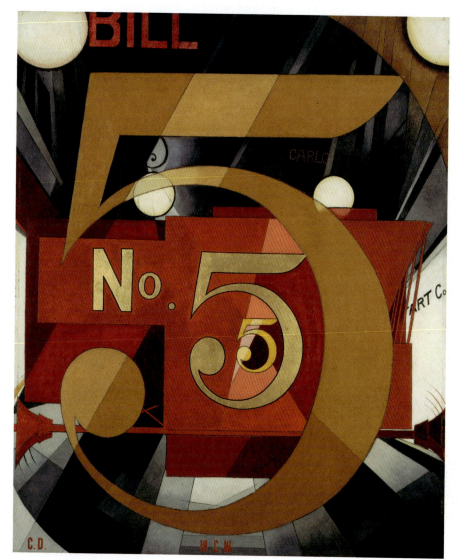

with a certain abstract beauty of their own. Demuth's work influenced that of somewhat younger artists, such as Stuart Davis, who avowed his debt to the older artist, as well as that of future generations, including Jasper Johns and, quite specifically, Robert Indiana (see fig. 19.43).

The Harlem Renaissance

In the 1920s in the Harlem neighborhood of New York City arose the first overtly race-conscious cultural movement in America. The Harlem Renaissance grew out of the ideas of thinkers like W. E. B. du Bois, who helped to found the New Negro movement earlier in the century. Fundamental to the movement was the insistence that any conception of "the negro" had to be formulated by blacks themselves; the characterizations of African-Americans by whites, which often relied on denigrating stereotypes, had to be eliminated from black consciousness and replaced with a positive self-image. The Harlem Renaissance saw an explosion of cultural responses to the ideas put forth by the concept of the New Negro: the poetry of Langston Hughes, the blues of Bessie Smith, the philosophy and art criticism of Alain Locke, the novels and stories of Nella Larsen, to name just a few. The influence of the Harlem Renaissance was felt throughout the twentieth century, particularly during the Civil Rights Movement. But its energy was curtailed in 1929 when the stock-market crash of that year brought a close to the so-called Jazz Age in the United States.

There was no particular style associated with the Harlem Renaissance, whether in music, literature, or the visual arts. Some artists, like **Palmer Hayden** (1890–1964), worked in a strongly naturalistic and sometimes satirical mode. Hayden studied at Cooper Union in New York City, later spending time in Paris where he made contact with members of the European avant-garde. His painting *A Janitor Who Paints* (fig. **15.28**) exemplifies his powers of observation and expression as well as his frustration with narrow-minded perceptions of African-Americans. The painting depicts his friend and fellow artist Cloyde Boykin, who, like Hayden, often picked up odd jobs to support himself. Hayden represents the artist at work in his small apartment, executing a portrait of a woman and her baby. A trashcan rests near the painter, its lid echoing the shape of Boykin's palette, linking him to the labor he needs to perform in order to survive.

15.27 Charles Demuth, *The Figure 5 in Gold*, 1928. Oil on composition board, 36 × 29¾" (91.4 × 75.6 cm). The Metropolitan Museum of Art, New York.

View the Closer Look for *The Figure 5 in Gold* on mysearchlab.com

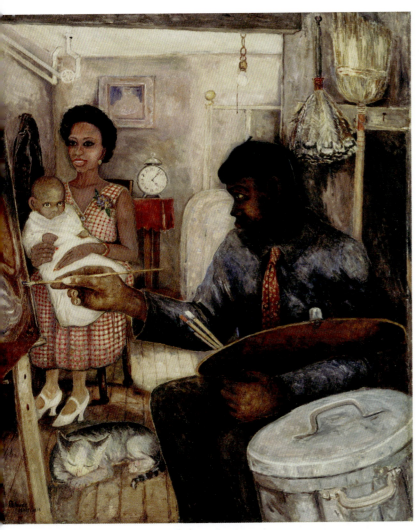

15.28 Palmer Hayden, *A Janitor Who Paints*, c. 1930. Oil on canvas, 39⅛ × 32⅞" (99.3 × 83.6 cm). Smithsonian American Art Museum, Washington, D.C.

15.29 James Van Der Zee, *Harlem Billiard Room*, n.d. Gelatin-silver print, 11 × 14" (27.9 × 35.6 cm). Curtis Galleries, Minneapolis.

Hayden said of the work, "I painted it because no one called Cloyde a painter; they called him a janitor," echoing the ideas of Du Bois and other champions of the New Negro movement who recognized that stereotypes and the perceptions of others function as insidious, invisible bonds.

While earning his living as a portrait photographer, **James Van Der Zee** (1886–1983) created a visual portrait of Harlem at the time (fig. **15.29**), documenting places and events such as weddings, funerals, anniversaries, and graduations. With his background in art and music, Van Der Zee took occasion to manipulate his photographs, even to the point of painting his own studio backdrops and retouching his prints. During a period of mass migration of African-Americans from the rural south to northern industrial centers, Van Der Zee's studio portraits captured the aspirational dreams of his sitters, striking a balance between rich fantasy and confident modernity.

Painting the American Scene: Regionalists and Social Realists

The 1930s, the decade that opened after the Wall Street crash of 1929 and closed with the onset of war in Europe, was a period of economic depression and political liberalism in the United States. Reflecting the spirit of isolationism that dominated so much of American thought and action after World War I, art became socially conscious, nationalist, and regionalist. One of the seminal books of the decade was John Steinbeck's *The Grapes of Wrath* (1939), a Pulitzer Prize-winning novel celebrating the quiet heroism of Oklahoma Dust Bowl victims during their migration to California. The so-called American Scene refers to those artists who, like Steinbeck, turned their attention to naturalistic depictions of contemporary American life. For the most part, these painters became the guardians of conservatism, fighting a rearguard battle against modernist abstraction. They concentrated on intrinsically "American" themes in their painting, whether chauvinistic praise of the virtues of an actually declining agrarian America, or bitter attacks on the political and economic system that had produced the sufferings of the Great Depression. The term American Scene is an umbrella one, covering a wide range of realist painting, from the more reactionary and nationalistic Regionalists to the generally leftwing Social Realists. Divergent as their sociopolitical concerns may have been, the factions merged in

their common preference for illustrational styles and their contempt for "highbrow" European formalism.

A crucial event of this decade—indeed, a catalyst for the development of American art transcending even the 1913 Armory Show—was the establishment in 1935, by the United States government, of a Federal Art Project, a subdivision of the WPA (Works Progress Administration). Just as the WPA provided jobs for the unemployed, the Art Project enabled many of the major American painters to survive during these difficult times. A large percentage of the younger artists who created a new art in America after World War II might never have had a chance to develop had it not been for the government-sponsored program of mural and easel painting.

The decade, however, witnessed little of an abstract tendency in American art. There were many artists of talent, and many interesting directions in American art, some of them remarkably advanced. Those who claimed the most attention throughout the era were, however, the painters of the American Scene. Having some common ground with them were two artists who are referred to as Primitives: Grandma Moses and Horace Pippin (see *American Primitives*, opposite).

Benton, Wood, and Hopper

Dominant among the American Scene artists were the Regionalists such as **Thomas Hart Benton** (1889–1975) and Grant Wood. Of these artists, Missouri-born Benton was the most ambitious, vocal, and ultimately influential. Benton moved in modernist circles in New York in the 1910s and 20s, and even made abstract paintings based on his experiments with Synchromism in Paris. By 1934, however, when his fame was such that his self-portrait was reproduced on the cover of *Time* magazine, the artist had vehemently rejected modernism. "I wallowed," he once said, "in every cockeyed ism that came along, and it took me ten years to get all that modernist dirt out of my system." Benton was the darling of the rightwing critic Thomas Craven, who promoted the Regionalists as the great exemplars of artistic nationalism, while he was an object of scorn among leftist artists such as Stieglitz.

In 1930 Benton executed a cycle of murals on the theme of modern technology for the New School for Social Research in New York. Called *America Today*, the series presents a cross-section of working America through images based on the artist's travel sketches. Benton presented his vast subject by means of compositional montage, as in *City Building* (fig. **15.30**), where heroic workers are seen against a backdrop of New York construction sites. Benton turned to the sixteenth-century art of Michelangelo and El Greco for the sinewy anatomies and mannered poses of his figures.

Although he studied in Paris for a time in 1923, the Iowan **Grant Wood** (1892–1942) was never tempted by European modernist styles as was Benton. More formative was his trip in 1928 to Munich, where he discovered the art of the fifteenth-century Flemish and German primitives. The art from this historical period was also experiencing a

American Primitives

As movements like the Ashcan School, Precisionism, and American Scene painting asserted new possibilities for visualizing American identity, a compelling riposte arose from practitioners of folk art. Traditional handicrafts such as needlework, silhouettes, *Scherenschnitte* (paper-cut shapes), and basketry, along with sculpture, painting, and furniture making, had been used to demarcate distinctly American visual idioms since colonial times. A certain defiance of European forms has often inflected this practice, as in the preference for homespun cloth on the part of American Revolutionary "Patriots" intent on establishing an economy as well as a culture apart from Britain. A similar impulse toward cultural separatism emerged during the 1920s and 1930s. Propelled by political isolationism after World War I, by the commercial dominance of machine-made goods, and by a wariness toward puzzling or even decadent-seeming European artistic movements, there arose a widespread craze for American Primitives. Two self-taught artists whose portrayals of American life, albeit from very different perspectives, satisfied this yearning for authentic cultural expression were Anna Mary Robertson Moses, known as Grandma Moses (1860–1961), and Horace Pippin (1888–1946). Grandma Moses made pictures in yarn before graduating to oil painting because of arthritis. In 1939, she was included in the exhibition Contemporary Unknown American Painters at The Museum of Modern Art. Pippin, a black artist from West Chester, Pennsylvania, worked in isolation until his naive, frank-seeming paintings were first exhibited in the late 1930s. His range of subjects included portraits, landscapes, genre themes, and a series on the life of the abolitionist John Brown. He also painted scenes based on his experiences as an infantryman in World War I.

resurgence of interest among some German painters, whose work had much in common with Wood's. Adapting this stylistic prototype to the Regionalist concerns he shared with Benton, Wood produced his most celebrated painting, *American Gothic* (fig. **15.31**), which soon became a national icon. Wood was initially drawn to the nineteenth-century Carpenter Gothic house that is depicted in the portrait's background. The models for the farmer couple (not husband and wife but two unrelated individuals) were actually Wood's sister and an Iowan dentist. The marriage of a miniaturist, deliberately archaizing style with contemporary, homespun, Puritan content drew immediate attention to the painting, though many wondered if Wood intended to satirize his subject. The artist, who was certainly capable of pictorial satire, said the subjects were painted out of affection rather than ridicule.

By contrast with the Midwestern Regionalists, **Edward Hopper** (1882–1967) was a mainly urban, New York artist. He rejected any association with Benton and his fellow Regionalists, who, he said, caricatured America in their paintings. Hopper, a student of Henri, made several long

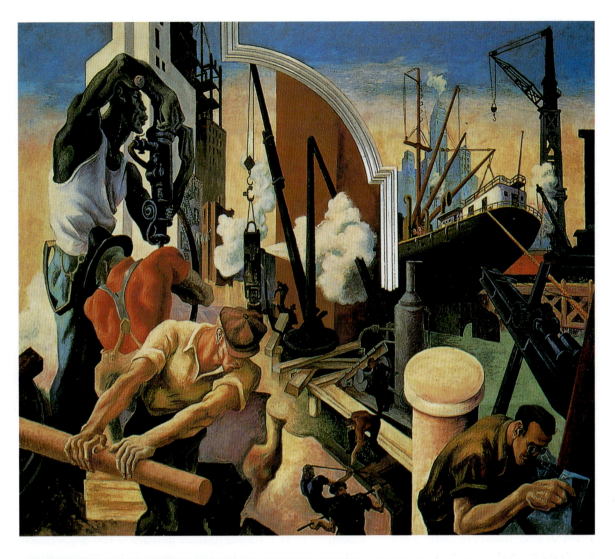

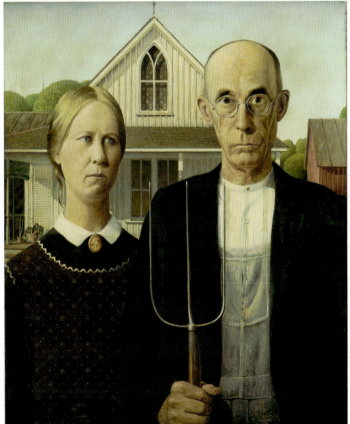

15.30 Thomas Hart Benton, *City Building*, from the mural series *America Today*, 1930. Distemper and egg tempera on gessoed linen with oil glaze, 7′ 8″ × 9′ 9″ (2.3 × 3 m). Originally in the New School for Social Research, New York. Relocated in 1984. Collection the Equitable Life Assurance Society of the United States. Art © T.H. Benton and R.P. Benton Testamentary Trusts/UMB Bank Trustee/Licensed by VAGA, New York, NY.

15.31 Grant Wood, *American Gothic*, 1930. Oil on beaverboard, 29⅞ × 24⅞″ (75.9 × 63.2 cm). The Art Institute of Chicago. Friends of American Art Collection. Art © Figge Art Museum, successors to the Estate of Nan Wood Graham/Licensed by VAGA, New York, NY.

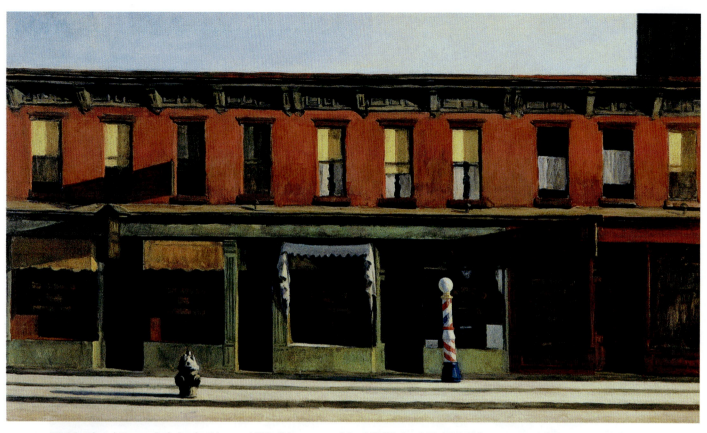

15.32 Edward Hopper, *Early Sunday Morning*, 1930. Oil on canvas, 35 × 60" (88.9 × 152.4 cm). Whitney Museum of American Art, New York.

visits to France between 1906 and 1910, at the time of the Fauve explosion and the beginnings of Cubism. Seemingly unaffected by either movement, Hopper early on established his basic themes of hotels, restaurants, or theaters, as well as their lonely inhabitants.

Much of the effect of Hopper's paintings is derived from his sensitive handling of light—the light of early morning or of twilight; the dreary light filtered into a hotel room or office; or the garish light of a lunch counter isolated within the surrounding darkness. He could even endow a favorite landscape motif—the lighthouses of Cape Cod or Maine—with a quiet eeriness. One of his finest works, *Early Sunday Morning* (fig. **15.32**), depicts a row of buildings on a deserted Seventh Avenue in New York, where a sharp, raking light casts deep shadows and a strange stillness over the whole. The flat façade and dramatic lighting have been linked to Hopper's interest in stage-set design.

Despite his reputation as one of America's premier realist painters, Hopper brought a rigorous sense of abstract design to his compositions. In a late work from 1955, *Carolina Morning* (fig. **15.33**), a woman in a red dress and hat stands in a shaft of intense light. Beyond her the seemingly endless landscape is described with great economy in almost geometric terms. The mood of introspective isolation

that pervades many of Hopper's works has affinities with European Surrealist art.

Likewise drawn to urban scenes was the African-American painter **Romare Bearden** (1914–88), who was born in North Carolina but grew up in the thriving artistic milieu of the Harlem Renaissance. In a 1934 essay, "The Negro Artist and Modern Art," Bearden called on fellow African-American artists to create art based on their own unique cultural experiences. He became involved with the 306 Group, an informal association of African-American artists and writers who met in studios at 306 West 141st Street. In 1936 he studied for a

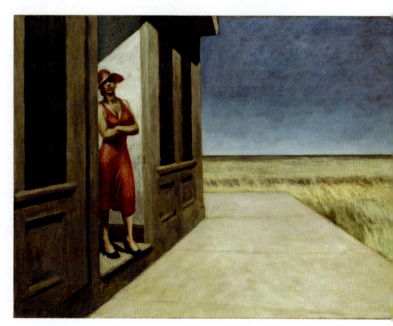

15.33 Edward Hopper, *Carolina Morning*, 1955. Oil on canvas, 30 × 40⅛" (76.2 × 102 cm). Whitney Museum of American Art, New York. Given in memory of Otto L. Spaeth by his family.

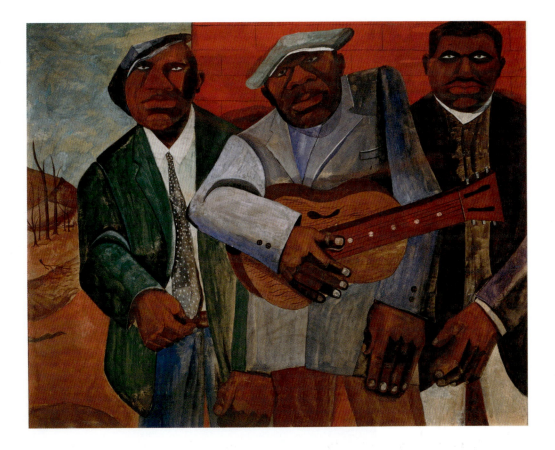

15.34 Romare Bearden, *Folk Musicians*, c. 1941–42. Gouache and casein on Kraft paper, 35½ × 45½" (90 × 114 cm). Bearden Foundation. Art © Romare Bearden Foundation/Licensed by VAGA, New York, NY.

Watch a video about Bearden on mysearchlab.com

time with the German artist George Grosz (see figs. 10.30–10.32) at the city's Art Students League, no doubt drawn to the artist's reputation as a political satirist. *Folk Musicians* (fig. **15.34**) is characteristic of Bearden's early work. With its simple modeling and consciously "folk" manner, the painting coincides with the prevailing Social Realist trends. The sophistication of Bearden's approach is nevertheless conveyed by his manipulation of space. The loosely modeled figures appear flattened against the wall behind them, while the juxtaposition of strong complementary colors creates a sense of spatial expansion and movement. The spatial dynamism is further enhanced through Bearden's competing backgrounds: the brick wall suggestive of urban life gives way to reveal an expansive, rural landscape. This juxtaposition suggests the interchange between urban and rural in the lives and culture of African-Americans, many of whom left their small southern hometowns in the late nineteenth and early twentieth centuries to seek opportunities in northern cities.

Like Bearden, **Jacob Lawrence** (1917–2000) took the African-American experience as his subject, but with a preference for recounting black history through narrative series. In 1940–41 he made sixty panels on the theme of the migration by black men and women from the rural South to the industrial North during and after World War I (fig. **15.35**). Lawrence thoroughly researched his subject and attached his own texts to each of the paintings, outlining the causes for the migration and the difficulties encountered by the workers in the new labor force as they headed for steel mills and railroads in cities like Chicago, Pittsburgh, and New York. Lawrence visually unified his

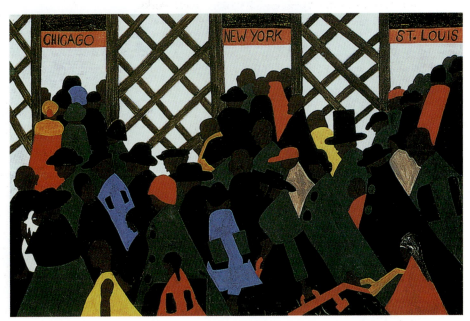

15.35 Jacob Lawrence, *The Migration* series, *Panel No. 1: During World War I there was a great migration north by Southern African Americans*, 1940–41. Casein tempera on hardboard, 12 × 18" (30.5 × 45.7 cm). The Phillips Collection, Washington, D.C.

Listen to a podcast about Lawrence on mysearchlab.com

panels by establishing a common color chord of red, green, yellow, and black and a style of boldly delineated silhouettes. The year after its creation, Lawrence's epic cycle went on a national museum tour organized by The Museum of Modern Art. By 1967, when he made a series on the life of black abolitionist Harriet Tubman, Lawrence had earned an international reputation and had begun a distinguished university career in teaching.

Bishop, Shahn, and Blume

Also active in American Scene painting were such confirmed urban realists as **Isabel Bishop** (1902–88), who portrayed and dignified Depression-wracked New York and its unemployed or overworked and underpaid masses. Bishop, who had studied at the Art Students League while still a teenager, worked for a time on the Federal Art Project, which employed many women artists. She made keenly observed sketches of secretaries and stenographers relaxing during their breaks in Union Square, which she worked into paintings in her studio. Through a technically complex method of oil and tempera, which she built up layer upon layer, she brought to her humble subjects the mood and gravity of a Holy Family by Rembrandt (fig. **15.36**). Bishop's words of tribute to her friend the painter Reginald Marsh could easily apply to her own work. She said he portrayed "little people, in unheroic situations" that are "modeled in the grand manner."

Foremost among the Social Realist painters of the 1930s was **Ben Shahn** (1898–1969), whose work as an artist was inextricably tied to his social activism and who was, in his day, one of the most popular of all American painters. His paintings, murals, and posters inveighed against fascism, social injustice, and the hardships endured by the working-class poor. An accomplished photographer, Shahn often based his paintings on his own photographs, although the mat, thinly brushed tempera surfaces of his canvases have little to do with the photographic realism of Sheeler, for example. Shahn gained recognition in the early 1930s through his paintings on the notorious case of Sacco and Vanzetti (see *The Sacco and Vanzetti Trial*, opposite). These were bitter denunciations of the American legal system, which

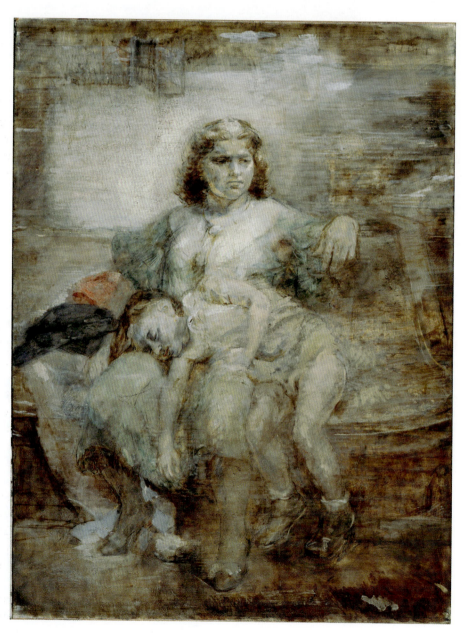

15.36 Isabel Bishop, *Waiting*, 1938. Oil and tempera on gesso panel, 29 × 22½″ (73.7 × 57.2 cm). Newark Museum, New Jersey.

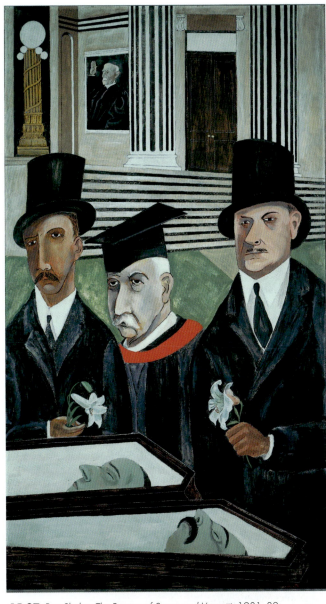

15.37 Ben Shahn, *The Passion of Sacco and Vanzetti*, 1931–32. Tempera on canvas, 7' ½" × 4' (2.1 × 1.2 m). Whitney Museum of American Art, New York. Art © Estate of Ben Shahn/Licensed by VAGA, New York, NY.

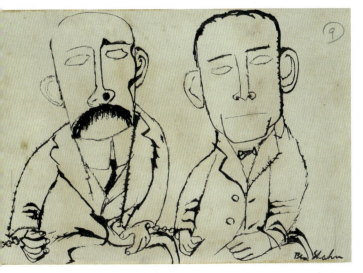

15.38 Ben Shahn, *The Passion of Sacco and Vanzetti*, 1952. Drawing for poster. Fogg Art Museum, Cambridge, MA. Art © Estate of Ben Shahn/Licensed by VAGA, New York, NY.

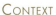

The Sacco and Vanzetti Trial

In the spring of 1920, two employees of a Boston shoe factory were murdered during a robbery of the company's payroll. A couple of weeks later, two Italian immigrants active in anarchist politics, Nicola Sacco and Bartolomeo Vanzetti, were arrested for the crime. They were convicted in a jury trial and sentenced to death. The pair's conviction quickly galvanized supporters who believed that Sacco and Vanzetti had been arrested simply because of their political sympathies. The evidence that led to the conviction was weak enough to prompt the governor of Massachusetts to assemble an advisory council to review the case, but the recommendation was to retain the verdict. At the time, many laborers as well as artists, intellectuals, and professionals embraced leftist or socialist ideas (see *Trotsky and International Socialism between the Wars*, Ch. 14, p. 300), and Sacco and Vanzetti were seen as symbols of the government's suppression of political opposition. Demonstrations—even riots and bombings—occurred around the country. Despite this, the pair were executed in 1927.

had condemned these two men to death in 1927 despite official doubts about their guilt (fig. **15.37**). With the title *The Passion of Sacco and Vanzetti*, Shahn obviously meant to draw a connection to Christian martyrdom. Addressing the theme again around twenty years later but in a different medium—Shahn often explored the same subject through multiple media—the artist uses a poster to appeal to the economic but powerful visual language of street protest (fig. **15.38**).

Documents of an Era: American Photographers Between the Wars

The stalled economy, as well as the failed banks and crops, catalyzed American documentary photographers, many of whom were sponsored by the Federal Farm Security Administration (FSA). Established in 1935, the FSA aimed to educate the population at large about the drastic toll that the Great Depression had taken upon the country's farmers and migrant workers. The moving force behind the project was the economist Roy Stryker, who hired photographers, including Ben Shahn, Dorothea Lange, and Walker Evans, to travel to the hard-pressed areas and document the lives of the residents.

Following studies at Columbia University under Clarence H. White, **Dorothea Lange** (1895–1965) opened a photographic studio for portraiture in San Francisco. However, she found her most vital themes in the life of the streets, and this prepared her for the horrors of the Depression, which she encountered firsthand when she joined Stryker's FSA project. With empathy and respect toward her subjects, Lange photographed a tired, anxious, but stalwart

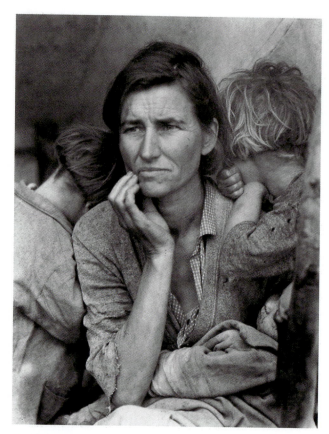

15.39 Dorothea Lange, *Migrant Mother*, 1936. Gelatin-silver print. Library of Congress, Washington, D.C.

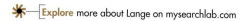
Explore more about Lange on mysearchlab.com

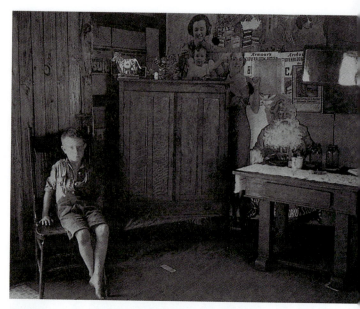

15.40 Walker Evans, *Miner's Home, West Virginia*, 1935. Gelatin-silver print, 7⁹⁄₁₆ × 9½" (19.2 × 24.1 cm). National Gallery of Art, Washington, D.C.

Another student of Clarence H. White and a hard-driven professional was **Margaret Bourke-White** (1904–71). As fellow photographer Alfred Eisenstaedt wrote, she "would get up at daybreak to photograph a bread crumb." Really a photojournalist, Bourke-White was the first staff photographer recruited for Henry Luce's *Fortune* magazine, and

mother with three of her children in a migrant worker camp (fig. **15.39**). This unforgettable and often-reproduced image has been called the Madonna of the Depression. Considered the first "documentary" photographer, Lange redefined the term by saying, "a documentary photograph is not a factual photograph per se … it carries with it another thing, a quality [in the subject] that the artist responds to." In fact, Lange often staged her images, which allowed her to convey with force and clarity a scene of contemporary American life that may not have been captured had she relied only on chance encounters.

Walker Evans (1903–75) studied in Paris, albeit literature rather than art, and like Lange, was hired by the FSA, making work, he later said, "against salon photography, against beauty photography, against art photography." In the summer of 1936 he and the writer James Agee lived in Alabama with sharecropper families. The result, a 1941 book called *Let Us Now Praise Famous Men*, containing Evans's photographs and Agee's writings, is one of the most moving documents in the history of photography. The straightest of straight photographers, Evans brought such passion to his work that in his images the simple, direct statement ends up being almost infinitely complex—as metaphor, irony, and compelling form. His portrait of a West Virginia miner's home tells volumes about the life of its inhabitants. The cheerful middle-class homemakers and the smiling Santa that cover the walls are sadly incongruent in this stark environment (fig. **15.40**).

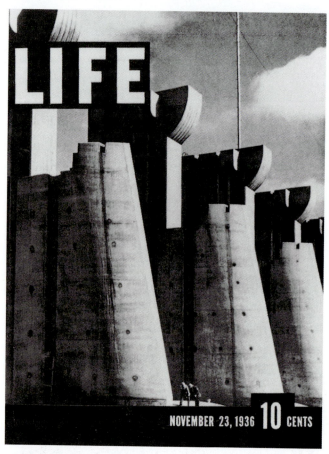

15.41 Margaret Bourke-White, *Fort Peck Dam, Montana*, Photograph for the first cover of *Life* magazine, November 23, 1936. *Life* magazine.

when the same publisher launched *Life* in 1936, Bourke-White's photograph of Fort Peck Dam appeared on the cover of the first issue (fig. **15.41**), for which she also wrote the lead article. As this image indicates, Bourke-White favored the monumental in her boldly simplified compositions of colossal, mainly industrial, structures. While emphasizing the accomplishments of the country in a time of faltering confidence—her first major body of work documented the construction of the New York City skyscrapers in the early 1930s as the Depression began—she also focused her camera on human subjects. Some of her most compelling images depict farmers in the drought-stricken Midwest during the Depression; soldiers in the war zones and prison camps of the early 1940s; and black South Africans in the 1950s.

The German-born **Alfred Eisenstaedt** (1898–1995) was one of the first four staff photographers hired for *Life* magazine and another pioneer in the field of pictorial journalism. His photograph of the hazing of a West Point cadet appeared on the cover of the second issue of the magazine. He began his career as an Associated Press photographer in Germany but emigrated to the United States in 1935 when prewar politics made it difficult to publish his frank pictures. Though he produced many pictorial narratives, he was a firm believer in the single image that presented the distillation, the essential statement, of an event. This photograph of a sailor kissing a nurse in New York City's Times Square on Victory Day, 1945 (fig. **15.42**), sums up all the feelings of joy and relief at the end of World War II; but there is some controversy as to whether or not this image was staged.

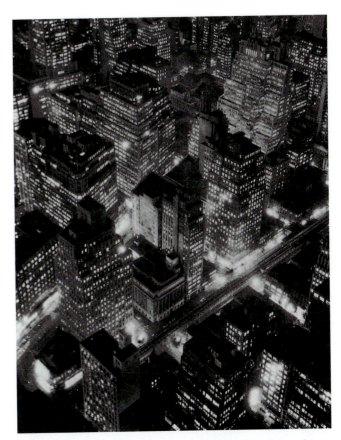

15.43 Berenice Abbott, *New York at Night*, 1933. Gelatin-silver print on masonite, 10½ × 12¾″ (26.7 × 32.4 cm). The Museum of Modern Art, New York.

Berenice Abbott (1898–1991) returned to New York in 1929 from Paris, where she had learned photography as an assistant to Man Ray. One of the first to appreciate the genius of Atget (see fig. 14.51), and the only photographer ever to make portrait studies of the aged French photographer, Abbott fell in love with Manhattan upon her rediscovery of the city, much as Atget had with Paris. First working alone and then for the WPA, she set herself the task of capturing the inner spirit and driving force of the metropolis, as well as its outward aspect. Though utterly straight in her methods, Abbott, thanks to her years among the Parisian avant-garde, inevitably saw her subject in modernist, abstract terms (fig. **15.43**).

Weegee (b. Arthur Fellig) (1899–1968), another advocate of straight photography, exploited the voyeuristic side of taking pictures. He worked primarily as a freelance newspaper photographer and published his sensational and satiric images of criminal arrests, murder victims, and social events in the tabloids of the day. Like Lisette Model (see fig. 14.59), with whom he worked at *PM* magazine, he captured events by surprising his subjects, often through the use of startling flash. *The Critic* (fig. **15.44**) is an ironic image of two women going to the opera. They stare at the camera and are in turn stared at by the woman to the right who ogles their jewelry, flowers, and furs, all in marked contrast to her own disheveled appearance. In 1945, Weegee published *Naked City*, a book containing many images of New York's underworld.

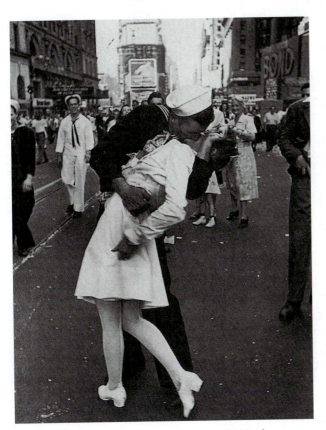

15.42 Alfred Eisenstaedt, *The Kiss (Times Square)*, 1945. *Life* magazine.

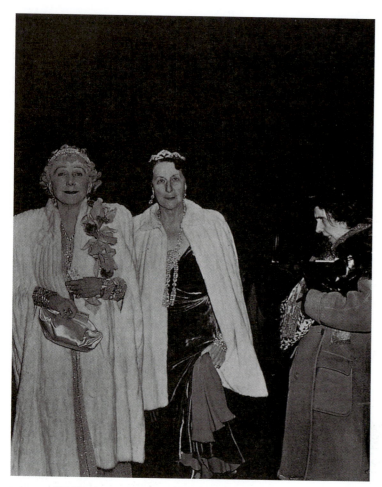

15.44 Weegee, *The Critic*, 1943. Gelatin-silver print, 10⅝ × 13³⁄₁₆″ (27 × 33.5 cm). The Art Institute of Chicago.

Social Protest and Personal Pain: Mexican Artists

While many artists in the United States were looking to indigenous traditions and subject matter between the two world wars, a number of like-minded artists in Mexico turned to their own history and artistic heritage, contributing to a veritable renaissance of Mexican painting. The years 1910–20 were a time of armed revolution in Mexico. This was the era of Emiliano Zapata and Pancho Villa, which began with the ousting of the longtime president Porfirio Díaz and ended with a new constitution that swept in major land and labor reforms. Beginning in the 1920s and continuing to mid-century, Mexican artists covered the walls of the country's schools, ministerial buildings, churches, and museums with vast murals, depicting subjects drawn from ancient and modern Mexico that celebrated a new cultural nationalism. The leading muralists were Diego Rivera, José Orozco, and David Siqueiros. Each of these also worked in the United States, where their work inspired American artists to turn away from European modernism and helped them, through the reintroduction of mural art, to rekindle the social dimensions of art. This was partially because they utilized the classical tradition of fresco painting and partially because theirs was an art of social protest with an obvious appeal to the left wing, a dominant force in American

cultural life throughout the Depression decade. The muralists were enormously influential throughout Latin America as well as the United States.

Rivera

Following his artistic education in Mexico City, **Diego Rivera** (1886–1957) studied and lived in Europe between 1907 and 1921. There he met many of the leading avant-garde artists, including Picasso and Gris, and was developing his own Cubist style by 1913. He went to Italy near the end of his European sojourn and was particularly impressed by Renaissance murals. Upon his return to his native country, Rivera began to receive important commissions for monumental frescoes from the Mexican government. He attempted to create a national style reflecting both the history of Mexico and the socialist spirit of the Mexican revolution. In the murals, Rivera turned away from the abstracting forms of Cubism to develop a modern Neoclassical style consisting of simple, monumental forms and bold areas of color. This style can also be seen in his occasional easel paintings, such as *Flower Day*, 1925 (fig. **15.45**). While the subject of this work relates to an enormous mural project that Rivera undertook for the Ministry of Education in Mexico City, the massive figures and classically balanced composition derive from Italian art, as well as the Aztec and Mayan art that he consciously emulated.

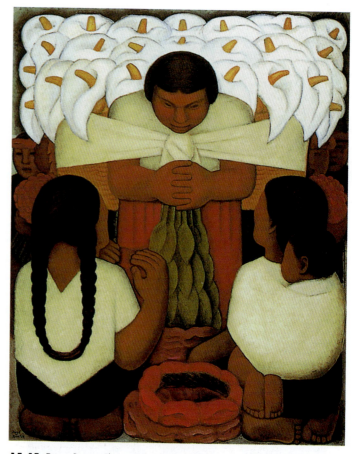

15.45 Diego Rivera, *Flower Day*, 1925. Oil on canvas, 58 × 47½″ (147.4 × 120.6 cm). Los Angeles County Museum of Art.

👁 ▬[**Watch** a video about Rivera on mysearchlab.com

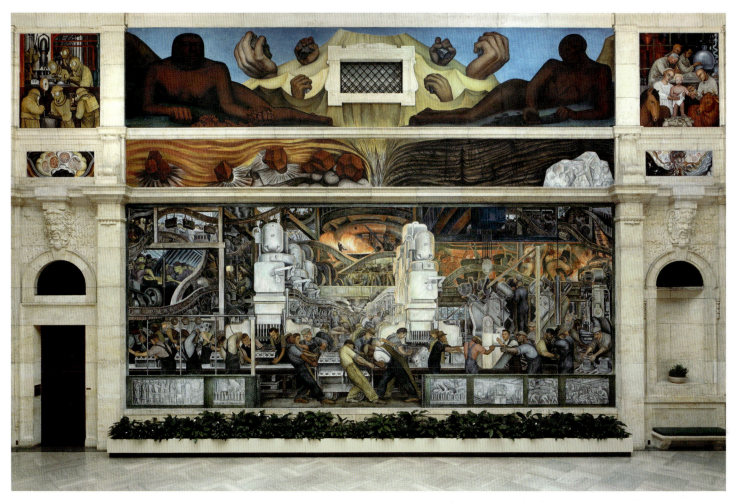

15.46 Diego Rivera, *Detroit Industry*, 1932–33. Fresco, north wall. The Detroit Institute of Arts.

View the Closer Look for *Detroit Industry* on mysearchlab.com

In 1930 Rivera, a committed Communist, came to the United States, where he carried out several major commissions that were, ironically, made possible by capitalist industry. Political differences between artist and patrons did lead to problems, however. Most notably, in 1931, Rivera's mural at Rockefeller Center, New York, was destroyed as a result of the inclusion of the Soviet leader Lenin in a scene celebrating the achievements of humanity. Rivera had invited the exiled Communist leader Leon Trotsky to live with him during his exile (see *Trotsky and International Socialism between the Wars*, Ch. 14, p. 300). Foremost among his surviving works in the United States is a narrative fresco cycle for the Detroit Institute of Arts on the theme of the evolution of technology, culminating in automobile manufacture (fig. **15.46**). Rivera toured the Ford motor plants for months, observing the workers and making preparatory sketches for his murals. The result is a *tour de force* of mural painting in which Rivera orchestrated man and machine into one great painted symphony. "The steel industry itself," he said, "has tremendous plastic beauty … it is as beautiful as the early Aztec or Mayan sculptures." In Rivera's vision, there is no sign of the unemployment or economic depression then crippling the country, nor the violent labor strikes at Ford that had just preceded his arrival in Detroit. At the same time, Rivera reveals criticism of capitalism's potential

effects. Even though he portrays the workers with dignity, it is important to note that they are rendered in a dehumanized fashion.

Orozco

José Clemente Orozco (1883–1949), like Rivera and Siqueiros, received his training in Mexico City, at the Academy of San Carlos. Orozco lived in the United States between 1927 and 1934, when he also gained important fresco commissions, notably from Dartmouth College in Hanover, New Hampshire. There, in the Baker Library, he created a panorama of the history of the Americas. Orozco was not a proselytizer in the same vein as Rivera, and he hardly shared his compatriot's faith in modern progress and technology. In his complex of murals for Dartmouth, Orozco showed the viewer the human propensity for greed, deception, or violence. The murals begin with the Aztec story of the deity Quetzalcoatl, continue with the coming of the Spaniards and the Catholic Church, and conclude with the self-destruction of the machine age, climaxing in a great Byzantine figure of a flayed Christ, who, upon arriving in the modern world before piles of guns and tanks, destroys his own cross (fig. **15.47**). All of this is rendered in Orozco's fiery, expressionist style, with characteristically long, striated brushstrokes and brilliant color.

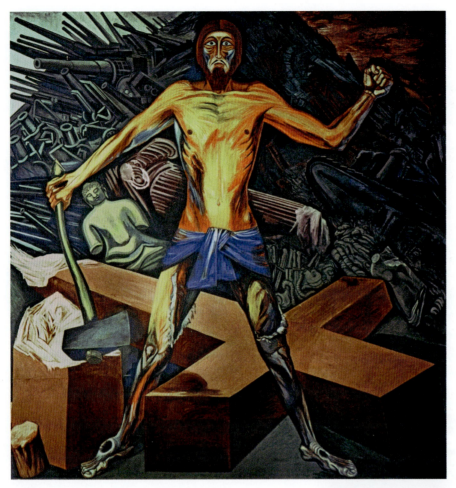

15.47 José Orozco, *The Epic of American Civilization: Modern Migration of the Spirit*, 1932–34. Mural, fourteenth panel. Baker Library, Dartmouth College, Hanover, New Hampshire.

Siqueiros

The third member of the Mexican triumvirate of muralists, **David Alfaro Siqueiros** (1896–1974), executed fewer public murals throughout the 1930s than his countrymen, partly because his radical political activities kept him on the move. Siqueiros maintained a lifelong interest in adopting the means of modern technology for art. In 1932 he came to the United States, to experience a "technological civilization," and taught at a Los Angeles art school where he executed murals using innovative materials and methods. Siqueiros's first major mural project came in 1939 for the Electricians' Syndicate Building in Mexico City.

The 1937 *Echo of a Scream* (fig. **15.48**), painted the year that Siqueiros joined the antifascist Republican Army in the Spanish Civil War, illustrates his vigorous pictorial attack. Beginning with an actual news photograph of a child in the aftermath of a bombing in the contemporaneous Sino–Japanese war, Siqueiros portrayed the "echo" of the child's cries as an enormous disembodied head above a field of ruins, creating a wrenching image of despair.

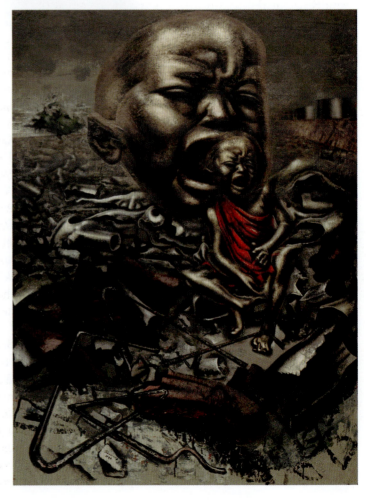

15.48 David Siqueiros, *Echo of a Scream*, 1937. Enamel on wood, 48 × 36″ (121.9 × 91.4 cm). The Museum of Modern Art, New York.

In 1936 Siqueiros established an experimental workshop in New York that attracted young artists from Latin America and the United States (including Jackson Pollock). The workshop was dedicated to modernizing the methods and materials of art production and to promoting the aims of the Communist Party of the United States. One participant described the use of new industrial paints in the workshop:

We sprayed [it] through stencils and ... embedded wood, metal, sand, and paper. We used it in thin glazes or built up into thick gobs. We poured it, dripped it, splattered it, hurled it at the picture surface.... What emerged was an endless variety of accidental effects.

Using such experimental methods, Siqueiros hoped to establish bold new ways of creating modern propagandistic murals. In general, the tradition of mural painting in the 1930s, of both the Mexicans and WPA artists like Benton, was crucial for the coming of age of Abstract Expressionist artists during the ensuing decades.

Kahlo

In the life of Mexican painter **Frida Kahlo** (1907–54), the defining moment came in 1925, when her spine, pelvis, and foot were crushed in a bus accident. During a year of painful convalescence, Kahlo, already a victim of childhood polio, took up painting. Through photographer Tina Modotti she met Diego Rivera, whom she married in 1929. She was with Rivera in Detroit when he painted the murals at the Institute of Arts, but Kahlo never adopted the monumental scale or public themes of mural art. She found her way outside the dominant, masculine mode, which in her circle was mural painting, by turning instead to the creation of

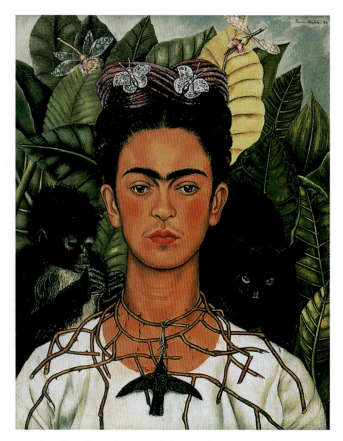

15.50 Frida Kahlo, *Self-Portrait with Thorn Necklace*, 1940. Oil on canvas, 24 × 18¾" (61 × 47.6 cm). Art Collection, Harry Ransom Humanities Research Center, University of Texas, Austin.

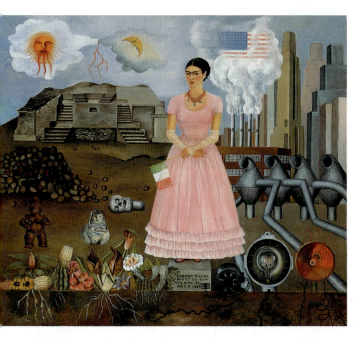

15.49 Frida Kahlo, *Self-Portrait on the Border Between Mexico and the United States*, 1932. Oil on sheet metal, 12¼ × 13¾" (31.1 × 34.9 cm). Private collection.

⭒ Explore more about Kahlo on mysearchlab.com

an intimate autobiography through an astonishing series of self-portraits. In an early example (fig. **15.49**), she envisions herself in a long pink dress surrounded at the left by the cultural artifacts of Mexico and, at the right, the industrial trappings of the North. The hieratic and miniaturist technique she employs in this small painting on metal is in the folk tradition of Mexican votive paintings, which depict religious figures often surrounded by fantastic attributes.

When André Breton visited Kahlo and Rivera in Mexico in 1938, he claimed Kahlo as a Surrealist and arranged for her work to be shown, with considerable success, in New York. Breton also promised Kahlo a Paris show, which opened in 1939 thanks to Duchamp's intervention. Soon thereafter she and Rivera divorced (they remarried a year later), and Kahlo made several self-portraits documenting her grief. In *Self-Portrait with Thorn Necklace* (fig. **15.50**) she assumes the role of martyr, impaled by her necklace from which a dead hummingbird (worn by the lovelorn) hangs.

Tamayo

Rufino Tamayo (1899–1991), a native of Oaxaca of Zapotec Indian descent, was another Mexican artist who came to prominence around the 1930s. He lived in New York in the late 1920s and again from 1936 to 1948, teaching and working for a time for the WPA, until the government banned foreign artists from the program. Although he occasionally received mural commissions, Tamayo differed from the three leading Mexican muralists in that his aim was

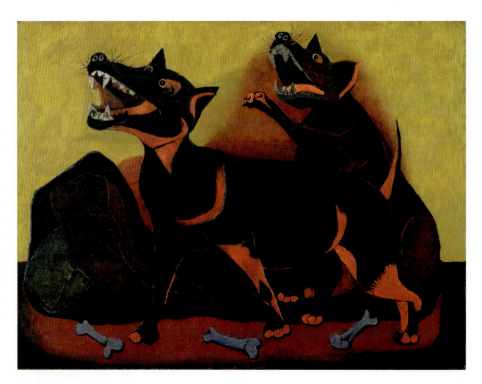

never to create a public art based on political ideologies: instead, he preferred themes of a more universal nature. His style was informed both by modernist modes, such as Cubism and Surrealism, and by Mexico's pre-Hispanic art. In the early 1940s, he made a series of animal paintings (fig. **15.51**), whose forms were inspired by popular Mexican art, but whose implied violence seems to register the traumas of war.

Modotti's Photography in Mexico

Closely associated with the artist-reformers of Mexico was Italian-born photographer **Tina Modotti** (1896–1942), who, with her longtime companion the photographer Edward Weston, arrived in Mexico in the early 1920s. She joined the Communist Party in 1927 and worked in Mexico until her expulsion in 1930 for political activism. She was commissioned by the muralists to document their works in photographs that were circulated internationally and contributed to their celebrity. Her sharp-focus, unmanipulated images, such as her elegant close-ups of plants, bear the influence of Weston. But Modotti used her camera largely for socially relevant subjects, as when she photographed the hands and marionettes of a friend who used his craft for

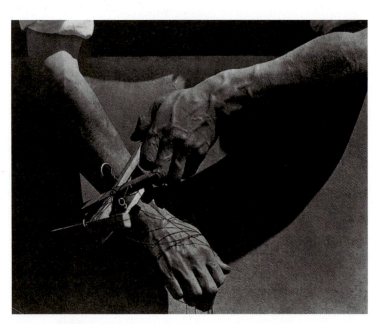

15.52 Tina Modotti, *Number 29: Hands of Marionette Player*, n.d. Gelatin-silver print, 7½ × 9½" (19.1 × 24.1 cm). The Museum of Modern Art, New York.

political ends (fig. **15.52**). With a sure eye for the telling image, Modotti built a remarkable corpus of photographs until she gave up the profession to live a nomadic existence in pursuit of her political goals. After periods in Moscow and Spain, she returned to Mexico, where she died in suspicious circumstances in 1942.

The Avant-Garde Advances: Toward American Abstract Art

As we have seen in both the United States and Mexico, during the 1930s modernism, particularly Cubism and abstraction, seemed to have been driven underground. Nevertheless, while figuration and representation found wide public appeal, artists, many supported by the Federal Art Project, were laying the groundwork for a revival of abstract art. Thus the seeds were sown that would germinate, after World War II, in the transformation of the United States from the position of a provincial follower to that of a full partner in the creation of new art and architecture.

Exhibitions and Contact with Europe

A number of other events and developments of the 1920s and 30s also helped to strengthen the presence of avant-garde art in New York. Katherine Dreier, the painter and collector advised by Marcel Duchamp, had organized the Société Anonyme in 1920 for the purpose of buying and exhibiting examples of the most advanced European and American art and holding lectures and symposia on related topics (see Chapter 10). In 1927 A. E. Gallatin, another painter-collector, put his personal collection of modern art on display at New York University as the Gallery of Living Art. It remained on exhibition for fifteen years. This collection, now at the Philadelphia Museum together with that of Walter C. Arensberg, includes examples by Brancusi,

Braque, Cézanne, Kandinsky, Klee, Léger, Matisse, Miró, Mondrian, and many others.

The Gallery of Living Art was, in effect, the first museum with a permanent collection of exclusively modern art to be established in New York City. Shortly afterward came the opening of The Museum of Modern Art in 1929, which followed its initial series of exhibitions by modern masters with the historic shows Cubism and Abstract Art and Fantastic Art, Dada, Surrealism, both in 1936. In 1935 the Whitney Museum held its first exhibition of American abstract art, and in 1936 the American Abstract Artists (AAA) group was organized. By 1939 Solomon R. Guggenheim had founded the Museum of Non-Objective Painting, which would eventually be housed in the great Frank Lloyd Wright building on Fifth Avenue (see fig. 21.5).

During the 1930s, a few progressive European artists began to visit or emigrate to the United States. Léger made three visits before settling at the outbreak of World War II. Duchamp, Ozenfant, Moholy-Nagy, Josef Albers, and Hans Hofmann were all living in the United States before 1940. The last four were particularly influential as teachers. The group as a whole represented the earliest influx of European artists who spent the war years in the United States and who helped to transform the face of American art. Conversely, younger American painters continued to visit and study in Paris during the 1930s. Throughout the late 1930s and the 40s, the AAA held annual exhibitions dedicated to the promotion of every form of abstraction, but with particular emphasis on experiments related to the Constructivist and Neoplasticist abstraction being propagated in Paris by the Cercle et Carré and Abstraction-Création groups. These close contacts with the European modernists were of great importance for the subsequent course of modern American art.

Davis

The professional career of **Stuart Davis** (1894–1964) encompassed five decades of modern art in the United States. Although Davis was deeply committed to socialist reforms, unlike his Mexican contemporaries or Americans like Ben Shahn he did not exploit painting as a public platform for his political beliefs. Davis was committed to art with a broad, popular appeal, and he negotiated the vast territory between pure abstraction and the conservative realism of the Regionalists. After leaving Robert Henri's School of Art, Davis exhibited five watercolors in the 1913 Armory Show and was converted to modernism as a result of seeing the European work on display. Davis's collages and paintings of the early 1920s are explorations of consumer-product packaging as subject matter, and demonstrated his assimilation of Synthetic Cubism as well as his recollection of nineteenth-century American *trompe l'oeil* painting. But his emphatically two-dimensional, deadpan treatment of imagery borrowed from popular culture, as well as his use of modern commercial lettering in his paintings, made Davis an important forerunner of 1960s Pop art.

In his *Egg Beater* series of 1927–28, Davis attempted to rid himself of the last illusionistic vestiges of nature, painting an egg beater, an electric fan, and a rubber glove again and again until they had ceased to exist in his eyes and mind except as color, line, and shape relations (fig. **15.53**). Throughout the 1930s, Davis continued the interplay of clearly defined, if fragmented, objects with geometric abstract organization. His color became more brilliant, and he intensified the tempo, the sense of movement, the gaiety, and the rhythmic beat of his works through an increasing complication of smaller, more irregular, and more contrasted color shapes.

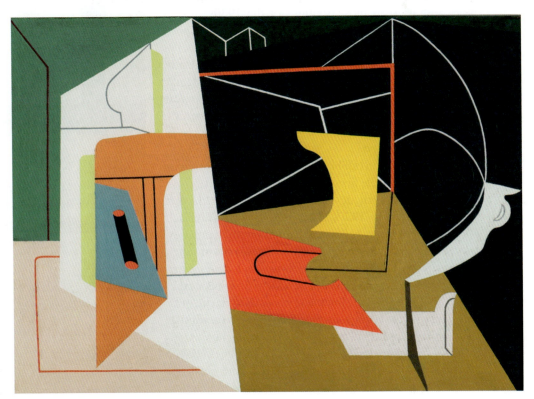

15.53 Stuart Davis, *Egg Beater #4*, 1928. Oil on canvas, 27 × 38¼" (68.6 × 97.2 cm). The Phillips Collection, Washington, D.C. Art © Estate of Stuart Davis/Licensed by VAGA, New York, NY.

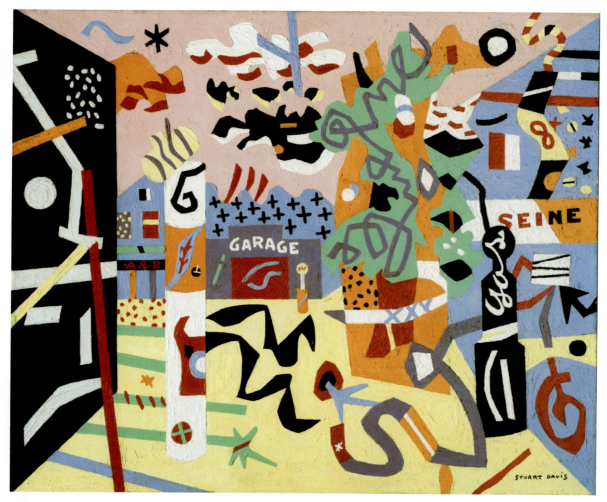

15.54 Stuart Davis, *Report from Rockport*, 1940. Oil on canvas, 24 × 30" (61 × 76.2 cm). The Metropolitan Museum of Art, New York. Art © Estate of Stuart Davis/Licensed by VAGA, New York, NY.

The culmination of these experiments may be seen in a 1940 work, *Report from Rockport* (fig. **15.54**). Although more abstract than most paintings of the 1930s, *Report from Rockport*, inspired by the main square of Rockport, Massachusetts, includes recognizable features such as buildings and gas pumps. There is a suggestion of depth, achieved by a schematic linear perspective, but the graphic shapes that twist and vibrate across the surface, with no clear representational role to play, reaffirm the picture plane.

Diller and Pereira

One of the artists who exhibited with the AAA was **Burgoyne Diller** (1906–65), the first American to develop an abstract style based on Dutch de Stijl. Once enrolled at the Art Students League in 1929, Diller very rapidly assimilated influences from Cubism, German Expressionism, Kandinsky, and Suprematism, much of which he knew only through reproductions in such imported journals as *Cahiers d'art*. Finally, toward the end of 1933, he had his first direct experience of a painting by Mondrian, whose **Neoplastic** principles became the main source of Diller's interests. But far from servile in his dependence on Neoplasticism, he went his own way by integrating color and line, so that lines became overlapping color planes (fig. **15.55**). Thus he created a complex sense of space differing from that of Mondrian.

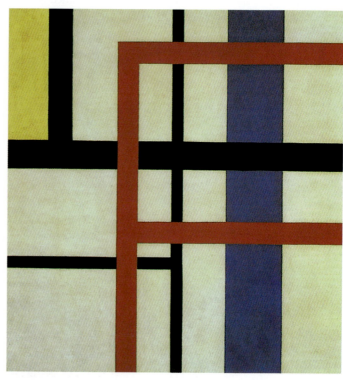

15.55 Burgoyne Diller, *Second Theme*, 1937–40. Oil on canvas, 30⅛ × 30" (76.5 × 76.2 cm). The Metropolitan Museum of Art, New York. George A. Hearn Fund, 1963. Art © Estate of Burgoyne Diller//Licensed by VAGA, New York, NY.

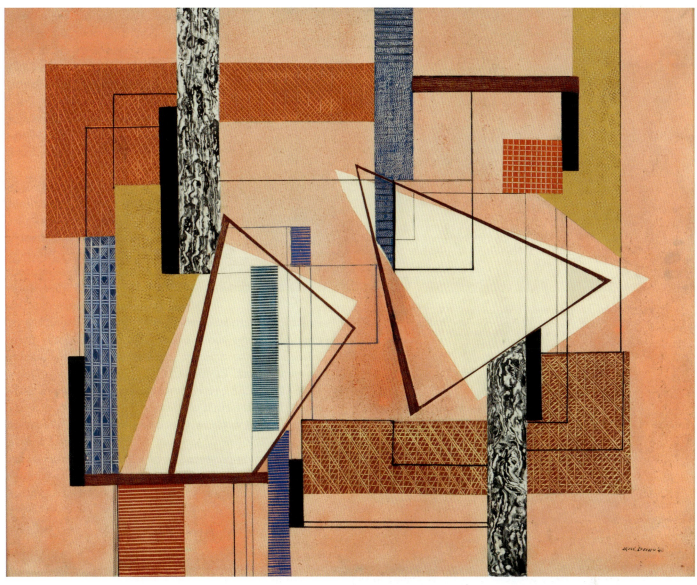

15.56 Irene Rice Pereira, *Abstraction*, 1940. Oil on canvas, 30 × 38" (76.2 × 96.5 cm). Honolulu Academy of Arts.

Irene Rice Pereira (1907–71) was another pioneer American abstractionist to appear in the 1930s. Taking her inspiration primarily from the Bauhaus, Pereira sought to fuse art and science, or technology, in a new kind of visionary image grounded in abstract geometry, but aspiring, like the Suprematist art of Malevich, toward an even more rarefied realm of experience. Boston-born and professionally active in New York, Pereira developed a seasoned style compounded of sharply rectilinear hard-edge and crystalline planes, often rendered as if floated or suspended one in front of the other, with transparent tissues giving visual access to the textured, opaque surfaces lying below (fig. **15.56**). The resulting effect is that of a complex, many-layered field of color and light.

Avery and Tack

Born and schooled in Hartford, Connecticut, **Milton Avery** (1885–1965) moved to New York in 1925. He characteristically worked in broad, simplified planes of thinly applied color deriving from Matisse but involving an altogether personal poetry. His subjects were his family and friends, often relaxing on holiday, as in his 1945 canvas *Swimmers and Sunbathers* (fig. **15.57**). In his later years he turned more to landscape, which, though always recognizable, became more and more abstract in organization. Avery was a major source for the American Color Field painters of the 1950s and 60s, such as Mark Rothko (see figs. 16.18, 16.19). In a memorial service for his friend, Rothko said, "Avery had that inner power which can be achieved only by those gifted with magical means, by those born to sing."

Augustus Vincent Tack (1870–1949) may have been the most maverick and removed of all the progressive American painters between the wars. He alone managed to integrate modernism's non-objective and figural modes into organic, sublimely evocative, wall-size abstractions. His work formed a unique bridge between an older pantheistic tradition of landscape painting, last seen in the work of Ryder (see fig. 2.45), and its new, brilliant flowering in the heroic abstractions of the postwar New York School, especially in the paintings of Clyfford Still (see fig. 16.24). Duncan Phillips, Tack's faithful patron throughout the 1920s and 30s, foresaw it all when he declared, in commenting on one of Tack's

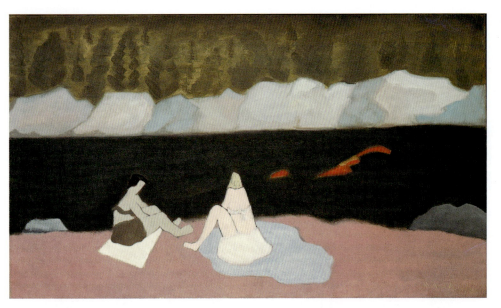

15.57 Milton Avery, *Swimmers and Sunbathers*, 1945. Oil on canvas, 28 × 48⅛" (71.1 × 122.2 cm). The Metropolitan Museum of Art, New York.

paintings: "We behold the majesty of omnipotent purpose emerging in awe-inspiring symmetry out of thundering chaos…. It is a symbol of a new world in the making, of turbulence stilled after tempest by a universal God." Such an interpretation undoubtedly pleased Tack whose painting was informed by his deeply held Catholicism.

Tack was trained in the 1890s by the American Impressionist John Twachtman, and his early work consisted largely of landscapes in the style of late nineteenth-century American symbolism. In 1920, when he made his first paintings of the Rocky Mountains, Tack discovered in the majestic Western landscape motifs capable of expressing his mystical feelings about nature. These he gradually transformed into the dramatic, nature-inspired abstractions of his mature work. Paintings such as *Night, Amargosa Desert*, 1935 (fig. 15.58), represent American Romanticism in the most advanced form it would take during the period, a view of the material world examined so intensely that it dissolved into pure emblem or icon, an aesthetic surrogate for the divine, ordering presence sensed within the disorder of raw nature. Tack's paintings exhibit uncanny affinities with the allover abstractions of the New York School of the 1950s.

Sculpture in America Between the Wars

American sculpture during the first four decades of the twentieth century lagged behind painting in quantity, quality, and originality. Throughout this period the academicians predominated, and such modernist developments in sculpture as Cubism or Constructivism were hardly visible. Archipenko, who had lived in the United States since 1923 and who had taught at various universities, finally opened his own school in New York City in 1939. Alexander Calder was the best-known American sculptor before World War II, but largely in a European context, since he had worked in Paris since 1926. His influence grew in America in the following years. During the 1930s, in sculpture as in painting, despite the predominance of the academicians and the isolation of the progressive artists, a number of sculptors were emerging who helped to change the face of American sculpture at the end of World War II.

Lachaise and Nadelman

Among the first generation of modern American sculptors, two important practitioners were Europeans, trained in Europe, who emigrated to the United States early in their careers. These were **Gaston Lachaise** (1882–1935) and Elie Nadelman. Lachaise was born in Paris and trained at the École des Beaux-Arts. By 1910 he had begun to

15.58 Augustus Vincent Tack, *Night, Amargosa Desert*, 1935. Oil on canvas mounted on plywood panel, 7' × 4' (2.1 × 1.2 m). The Phillips Collection, Washington, D.C.

experiment with the image that was to obsess him during the rest of his career, that of a female nude with enormous breasts and thighs and delicately tapering arms and legs (fig. **15.59**). This form derives from Maillol (see fig. 5.5), but in Lachaise's versions it received a range of expression from pneumatic elegance to powerfully primitivizing works that recall the ancient sculpture of India, as well as prehistoric female fertility figures.

Elie Nadelman (1882–1946) received his European academic training at the Warsaw Art Academy. Around 1909

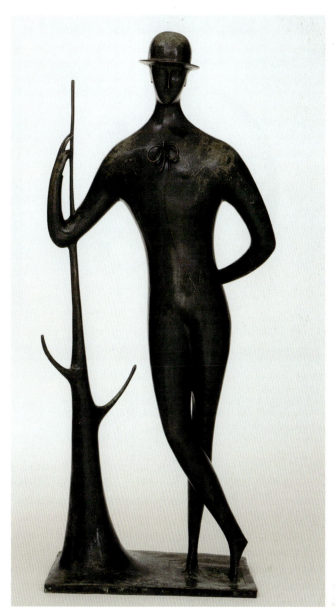

15.60 Elie Nadelman, *Man in the Open Air*, c. 1915. Bronze, 54½" (138.4 cm) high; at base 11¾ × 21½" (29.9 × 54.6 cm). The Museum of Modern Art, New York.

in Paris, where he made the acquaintance of artists including Picasso and Brancusi, Nadelman was reducing the sculpted human figure to almost abstract curvilinear patterns. After his move to the United States in 1914, he was given an exhibition by Stieglitz at 291 Gallery. He progressively developed a style that might be described as a form of sophisticated primitivism (he was an avid collector of folk art), marked by simplified surfaces employed in the service of a witty and amusing commentary on contemporary life. His *Man in the Open Air* (fig. **15.60**) is an early example of his work in this manner.

Roszak

Although in the minority, sculpture in a Constructivist vein thrived in the hands of a few American artists in the 1930s, among them Polish-born Theodore Roszak (1907–81). Having arrived in Chicago with his family as a young child, Roszak was trained as a conventional painter at that city's

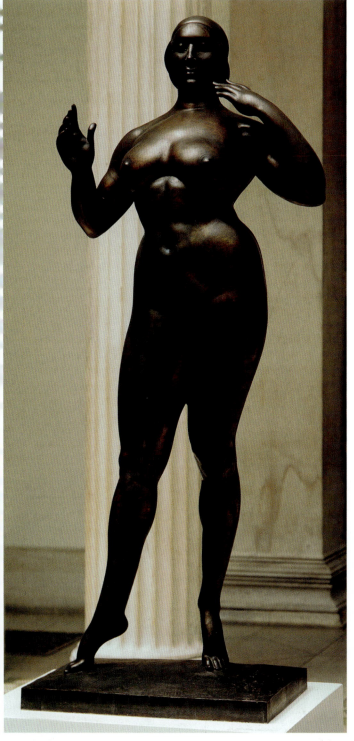

15.59 Gaston Lachaise, *Standing Woman*, 1912–27. Bronze, height 70" (177.8 cm). Albright-Knox Art Gallery, Buffalo, NY.

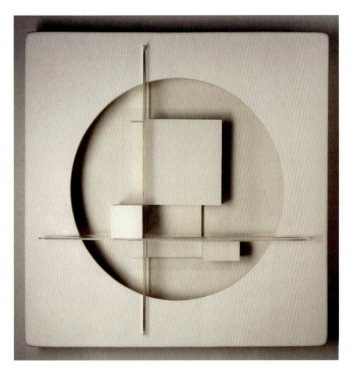

15.61 Theodore Roszak, *Construction in White*, 1937. Wood, masonite, plastic, acrylic, and Plexiglas, 80¼ × 80⅛ × 18¼" (203.8 × 203.6 × 46.4 cm). Smithsonian American Art Museum, Washington, DC. Gift of the artist. Art © Estate of Theodore Roszak/ Licensed by VAGA, New York, NY.

school of the Art Institute, but underwent a change in his outlook during a trip to Europe from 1929 to 1931. Upon returning to the United States he settled in New York, working eventually for the WPA. He made De Chiricoesque figure paintings with Cubist overtones in the early 1930s and, at the same time, began making Cubist sculptures and reliefs. By the middle of the decade, he was experimenting with abstract constructed sculpture as a result of his interest in machines and industrial design. *Construction in White* (fig. 15.61) is a whitewashed plywood box in which Roszak cut a circle and inserted intersecting sheets of plastic and wooden blocks. He said he wanted such works to stand as utopian symbols for perfection. Critical to him were the teachings of the Bauhaus, particularly those of Moholy-Nagy, who had come to Chicago in 1937 to head the New Bauhaus. In the aftermath of World War II, Roszak became disenchanted with technology and began to make welded sculpture in steel. The rough surfaces and aggressive forms of these works reflected the violence and terror of war, situating his work in the arena of Abstract Expressionism (see Chapter 16).

Calder

It was a formative encounter with Mondrian's art in 1930 that prompted American **Alexander Calder** (1898–1976) to become an abstract artist. Born in Philadelphia, Calder was the son and grandson of

sculptors. After studying engineering, a training that would have direct consequences for his art, he was gradually drawn into the field of art, studying painting at New York's Art Students League and working as an illustrator. Calder's early paintings of circus or sports scenes reflect the styles of his teachers, such as John Sloan (see fig. 15.2). By the time of his first visit to Paris in 1926, Calder had begun to make sculptures in wire and wood. In the French capital he eventually attracted the attention of avant-garde artists and writers (especially the Surrealists) with his *Circus*, a full-fledged, activated environment made up of tiny animals and performers that he assembled from wire and found materials and then set into motion (fig. **15.62**). The whimsical mood of Calder's *Circus* breathed new life into a theme that had preoccupied modern artists since the nineteenth century. Peripatetic entertainers who are viewed with alternating suspicion and wonder, circus performers embody the idea of the artist as an alienated yet alluring presence on the edge of society. Picasso captured the melancholy of this notion of the artist (see fig. 7.4); Calder instead seized on the theme's comic absurdity, casting the artist as empowered ring master rather than struggling *saltimbanque*. At the same time he made wooden sculptures and portraits and caricatures constructed from wire. The wire sculptures are early demonstrations of Calder's marvelous technical ingenuity and playful humor. They could be quite large, such as the ten-foot (3-m) *Romulus and Remus* of 1928 (fig. **15.63**). Here Calder bent and twisted wire into a composition of such economy that the entire "torso" of the she-wolf is one continuous stretch of wire. The whole is like a three-dimensional line drawing (Calder made drawings related to the wire sculpture at the same time).

In 1930, during a subsequent sojourn in Paris, Calder visited Mondrian's rigorously composed studio, which deeply impressed him. "This one visit gave me a shock that started things," he said. "Though I had heard the word 'modern' before, I did not consciously know or feel the term 'abstract.' So now, at thirty-two, I wanted to paint and work in the abstract." He began to experiment with abstract

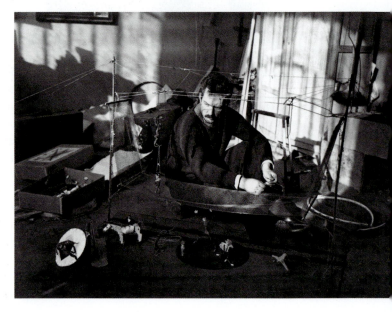

15.62 André Kertész, *Alexander Calder with his Circus ("Cirque Calder")*, 1929. Portrait Gallery, Smithsonian Institution, Washington, D.C.

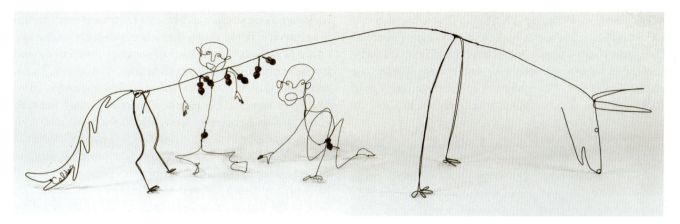

15.63 Alexander Calder, *Romulus and Remus*, 1928. Wire and wood, 30½ × 124½ × 26" (77.5 × 316.2 × 66 cm). Solomon R. Guggenheim Museum, New York.

painting and, more significantly, abstract wire constructions that illustrated an immediate mastery of constructed space sculpture. These early abstract sculptures, which were exhibited in a 1931 solo exhibition in Paris, consisted of predominantly austere, geometric forms like open spheres; but they also contained a suggestion of subject—constellations and universes.

In 1931, at Arp's suggestion, Calder joined Abstraction-Création and began to introduce motion into his constructions. At first he induced movement by hand cranks or small motors, but eventually the sculptures were driven merely by currents of air and Calder's carefully calibrated systems of weights and balances. There were precedents for this kineticism in sculpture, as we have seen, in the work of Gabo, Rodchenko, and Moholy-Nagy, but no artist developed the concept as fully or ingeniously as Calder. His first group of hand and motor **mobiles** was exhibited in 1932 at the Galerie Vignon, where they were so christened by Marcel Duchamp. When Arp heard the name "mobile," he asked, "What were those things you did last year—stabiles?" Thus was also born the word that technically might apply to any sculpture that does not move but that has become specifically associated with Calder's works.

Calder's characteristic works of the 1930s and 40s are wind-generated mobiles, either standing or hanging, made of plates of metal or other materials suspended on strings or wires, in a state of delicate balance. The earliest mobiles were relatively simple structures in which a variety of objects, cut-out metal or balls and other forms in wood moved slowly in the breeze. A far greater variety of motion was possible than in the mechanically driven mobiles. For one thing, the element of chance played an important role. Motion varied from slow, stately rotation to a rapid staccato beat. In the more complex examples, shapes rotated, soared, changed tempo, and, in certain instances, emitted alarming sounds. In *Object with Red Disks (Calderberry Bush)* (fig. **15.64**), a standing mobile from 1931 (the second title, by which the work is best known, was not Calder's), the artist counterbalanced five flat red disks with wooden balls and perched the whole on a wire pyramidal base. When set in motion by the wind or a viewer's hand, this abstract

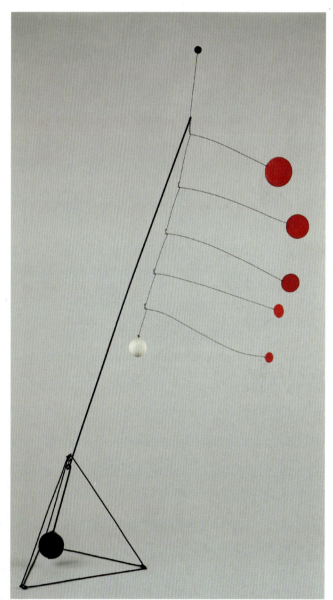

15.64 Alexander Calder, *Object with Red Disks (Calderberry Bush)*, 1931. Painted steel rod, wire, wood, and sheet aluminum, 88½ × 33 × 47½" (224.8 × 83.8 × 120.7 cm). Whitney Museum of American Art, New York.

construction moves through space in preplanned yet not entirely predictable ways.

Among Calder's motorized mobiles were also reliefs, with the moving parts on a plane of wooden boards or within a rectangular frame. One of the earliest on a large scale is *The*

White Frame of 1934 (fig. **15.65**). In this, a few elements are set against a plain, flat background: a large, suspended disk at the right, a spiral wire at the left, and between them, suspended on wires, a white ring and two small balls, one red and one black. Put into motion, the large disk swings back and forth as a pendulum, the spiral rotates, and the balls drop unexpectedly and bounce from their wire springs. Whereas *The White Frame* (with the exception of the spiral) still reflects Mondrian, geometric abstraction, and Constructivism, Calder also used free, biomorphic forms reflecting the work of his friends Miró and Arp. From this point onward, his production moved easily between geometric or Neoplastic forms and those associated with organic Surrealism.

By the end of the 1930s, Calder's mobiles had become extremely sophisticated and could be made to loop and swirl up and down, as well as around or back and forth. One of the largest hanging mobiles of the 1930s is *Lobster Trap and Fish Tail* (fig. **15.66**), a work commissioned for The Museum of Modern Art. Although it is quite abstract, the subject association of the Surrealist-inspired, biomorphic forms is irresistible. The torpedo-shaped element at top could be a lobster cautiously approaching the trap, represented by a delicate wire cage balancing at one end of a bent rod. Dangling from the other end is a cluster of fan-shaped metal plates suggestive of a school of fish. The delicacy of the elements somewhat disguises the actual size, some nine and a half feet (2.9 m) in diameter. After World War II, Calder would pursue an international career, expanding the abstract art he had already formulated in the 1930s to an architectural scale of unprecedented grandeur.

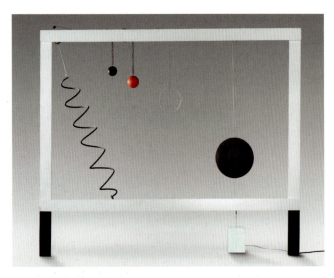

15.65 Alexander Calder, *The White Frame*, 1934. Painted wood, sheet metal, wire, 7′ 5″ × 9′ (2.1 × 2.7 m). Moderna Museet, Stockholm.

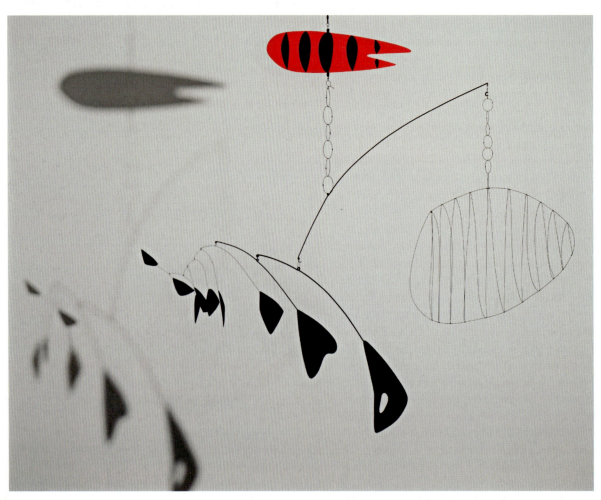

15.66 Alexander Calder, *Lobster Trap and Fish Tail*, 1939. Hanging mobile: painted steel wire and sheet aluminum, approximately 8′ 6″ high × 9′ 6″ diameter (2.6 × 2.9 m). The Museum of Modern Art, New York.

Conclusion

In 1942, immediately after the United States' entry into World War II, the dominant styles of painting were still Social Realism and Regionalism (see Ch. 15, pp. 355–61). These styles—conservative in their naturalism, unapologetic in their nationalism and nostalgia—were seen by many progressive artists as insufficient for registering the outrage and desperation provoked by World War II. The scale of the war's many fronts along with the unprecedented role played by technology (the firebombings of London, Dresden, and Tokyo, for instance, and the introduction of nuclear warfare) left even citizens of the victorious United States struggling to imagine a safe, peaceful future. The almost immediate mobilization of the Soviet Union's war industry only compounded the confusion and wariness.

This ferment contributed to the creation of Abstract Expressionism, or, as it is more generically called, the New York School. Attitudes conditioned by the war—a sense of alienation and a loss of faith in old systems and old forms of expression—led artists to explore a broad range of intellectual thought, from existentialism to the theories of Sigmund Freud and Carl Jung. Existentialism, with its insistence that an individual's consciousness alone constitutes a sufficient framework for moral or ethical behavior, was especially compelling after the profound failure of established social institutions to protect human life and dignity. Expressionism, Cubism, Constructivism, and Surrealism served as guideposts for new aesthetic explorations.

Social and economic conditions following the war also contributed to the ability of American artists to respond as immediately and radically as they did (see *Artists and Cultural Activism*, opposite). The devastation of Europe's cultural centers by the second major war in three decades crippled established arts institutions. Many major European dealers and collectors of avant-garde art had been killed, their collections stolen and dispersed; museums and galleries were struggling to regain financial support and social relevancy. It was at this point that New York City assumed a new cultural prominence. By the early twentieth century, the city had become a refuge for progressive American artists as well as recent émigrés.

CONTEXT

Artists and Cultural Activism

As academies grew less and less relevant for American artists working in the 1930s and 40s, new organizations appeared to take their place. In 1936, several of Hans Hofmann's students helped to establish American Abstract Artists (AAA), an organization dedicated to promoting the progressive art of its members through exhibitions, lectures, and publications. The group rejected European Expressionism and Surrealism along with the Social Realism of their contemporaries, supporting instead the geometric abstraction associated with artists like Mondrian. Early members of AAA included Willem de Kooning, Krasner, Diller, Reinhardt, and Smith. Also convened in 1936 was the American Artists' Congress, whose aims and membership (which included Stuart Davis, along with many Ashcan and Social Realist artists) differed from that of the AAA. The Congress was Communist in its orientation, advocating, for social justice and government, arts programs such as the Federal Art Project, of which the Works Progress Administration (WPA) was one branch. Support for communism receded during World War II, and the Congress disbanded in 1943. The Artists Equity Association, established in 1947, promoted American art and artists without regard to style or ideology. The group, led by painter Yasuo Kuniyoshi, adopted the model of a labor union, an approach that had succeeded during the Depression when the Artists' Union (founded 1934) demonstrated that picket lines could influence hiring practices and legislation. The conditions faced by artists in the postwar years differed from those of the 1930s, though. With the closure of the FAP in 1943, an economy geared toward industrial rather than cultural expansion, and a population much less sympathetic to socialist-seeming ideas, many artists found themselves in difficult straits. Artists Equity proved successful in increasing government patronage for the arts and finding other financial, legal, and even medical assistance for some unemployed artists.

Mondrian in New York: The Tempo of the Metropolis

In 1938, with the war approaching, **Piet Mondrian** (1872–1944) left Paris, first for London then New York, where he spent his final four years. Manhattan became the last great love of his life, perhaps because of the Neoplastic effect created by skyscrapers rising from the narrow canyons of the streets and the rigid grid of its plan. As early as 1917 Mondrian had said, "The truly modern artist sees the metropolis as abstract life given form: it is closer to him than nature and it will more easily stir aesthetic emotions in him." A major stimulus to the artist was that of lights at night, when the skyscrapers were transformed into a brilliant pattern of light and shadow, blinking and changing. Mondrian also loved the tempo, the dynamism, of the city—the traffic,

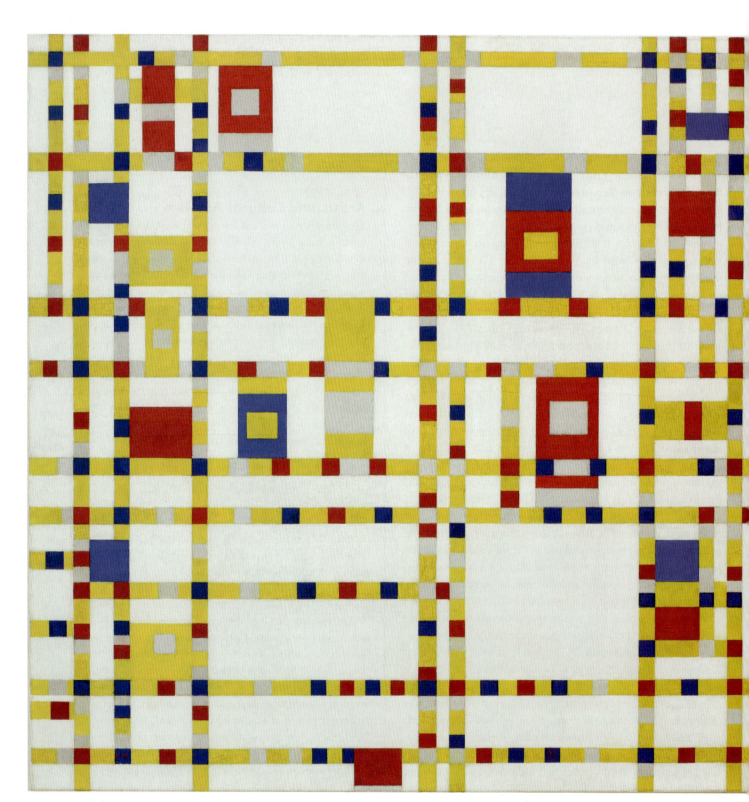

C.1 Piet Mondrian, *Broadway Boogie Woogie*, 1942–43. Oil on canvas, 50 × 50″ (127 × 127 cm). B323. The Museum of Modern Art, New York. Anonymous gift. © 2012 Mondrian/Holtzman Trust c/o HCR International USA.

the dance halls, the jazz bands, the excitement of movement and change. He felt driven to translate these rhythms into his late paintings, where the earlier grid of black lines (see fig. 12.3) is replaced by a complex weave of colored lines.

The impact of the city and music is most evident in *Broadway Boogie Woogie*, painted in 1942–43 (fig. **C.1**). Here the artist departed radically from the formula that had occupied him for more than twenty years. There is still the rectangular grid, but the black, linear structure balanced against color areas is gone. In fact, the process is reversed: the grid itself is the color, with the lines consisting of little blocks of red, yellow, blue, and gray. The ground is a single plane of off-white, and against it vibrate the varicolored lines as well as larger color rectangles. Mondrian was a legendary figure in the United States, inspiring not only the geometric abstractionists, who had been carrying on a minority battle against Social Realism and Regionalism, but also a number of younger artists who were to create a major revolution in American art. Almost without exception, the emerging Abstract Expressionists of the early 1940s had great respect for Mondrian, even though their painting took directions that would seem diametrically opposed to everything he believed in.

Entering a New Arena: Modes of Abstract Expressionism

The diverse group of artists involved were opposed to all forms of Social Realism and any art form that smacked of nationalism. Much as they admired Mondrian, they also rejected as trivial the pure geometric abstraction, promoted within the ranks of the American Abstract Artists (AAA), that his art had engendered in America. On the other hand, the relationship of the new movement to the European Surrealists, some of whom also sought refuge from the war in New York, was critical. The Americans were particularly drawn to the organic, abstract, automatist Surrealism of Matta, Miró, and Masson (see Ch. 14, pp. 304–8, 317). Matta, who was in New York from 1939 to 1948, helped introduce the idea of psychic automatism to the Abstract Expressionists. The Americans were less concerned with the new method as a means of tapping into the unconscious than as a liberating procedure that could lead to the exploration of new forms.

Although Abstract Expressionism is as diverse as the artists involved, in a very broad sense two main tendencies may be noted. The first is that of the so-called gestural painters, concerned in different ways with the spontaneous and unique touch of the artist, his or her "handwriting," and the emphatic texture of the paint. It included such major artists as Pollock, Willem de Kooning, and Franz Kline. The other group consisted of the Color Field painters, concerned with an abstract statement in terms of a large, unified color shape or area, as in the work of Mark Rothko. Some of the ideas associated with Color Field painting were presented in a short manifesto co-authored by Rothko (along with the artists Barnett Newman and Adolph Gottlieb) and published as an open letter in *The New York Times* in 1943, which

stated, among other things: "There is no such thing as a good painting about nothing." "We assert that the subject is crucial," they wrote, "and only that subject matter is valid which is tragic and timeless."

The Picture as Event: Experiments in Gestural Painting

In 1952 Harold Rosenberg coined the name Action Painting to describe the process by which the spontaneous gesture was enacted on the canvas. He wrote:

> At a certain moment, the canvas began to appear to one American painter after another as an arena in which to act—rather than as a space in which to reproduce, re-design, analyze or "express" an object, actual or imagined. What was to go on the canvas was not a picture but an event.

What the term Action Painting failed to account for was the balance that these artists struck between forethought and spontaneity; between control and the unexpected.

Hofmann

The career of **Hans Hofmann** (1880–1966) encompassed two worlds and two generations. Born in Bavaria, Hofmann lived and studied in Paris between 1903 and 1914, experiencing the range of new movements from Neo-Impressionism to Fauvism and Cubism. He returned to Bavaria to open his first school in Munich in 1915. In 1932, as cultural and political conditions deteriorated in Germany under growing Nazi influence, he relocated permanently to the United States to teach, first at the University of California, Berkeley, then at New York's Art Students League, and finally at his own Hans Hofmann School of Fine Arts in New York and in Provincetown, Massachusetts. Hofmann's greatest concern as a painter, teacher, and theoretician lay in his concepts of pictorial structure, which were based on architectonic principles rooted in Cubism and Constructivism. His admiration for Mondrian's painting led him to point out that to "move a line one millimeter to the right or the left and the whole picture collapses into decoration." To understand composition, Hofmann occasionally took recourse to automatism. Unlike the Surrealists, who relied on automatism as a means of drawing on the creative potential of unconscious drives or anxieties, Hofmann experimented with automatic painting and drawing as a way of conjuring new forms. A number of works executed in the mid-1940s, although on a small scale, preceded Pollock's drip paintings (fig. **C.2**). Hofmann also found pedagogical value in automatism. One technique he used to convey the importance of structure to students was to tear up a student's drawing into several pieces, then reassemble it using tape or tacks. In this way, Hofmann enabled his students to see how planes, figures, and space relate to one another, to find pictorial coherence by examining form from a different perspective. Like his fellow German émigré Josef Albers, Hofmann was one of the

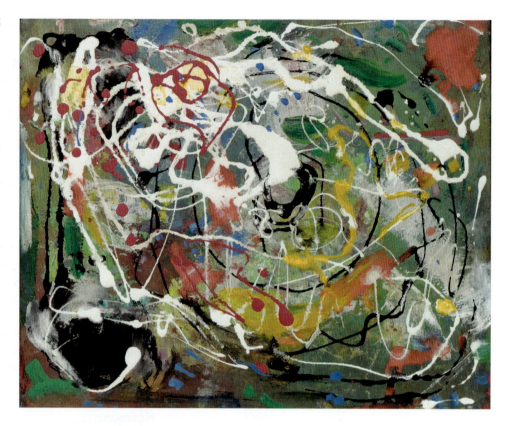

C.2 Hans Hofmann, *Spring*, 1944–45 (dated 1940 on reverse). Oil on wood, 11¼ × 14⅛" (28.5 × 35.7 cm). The Museum of Modern Art, New York.

premier art educators and theoreticians in the United States, and his influence on a generation of younger artists such as Lee Krasner (see fig. C.8) and critics including Clement Greenberg was enormous.

Gorky

Armenian-born **Arshile Gorky** (1905–48) was a largely self-taught artist whose work constituted a critical link between European Surrealism and American Abstract Expressionism. Gorky arrived in the United States in 1920, a refugee from the Turkish campaign of genocide against the Armenians, which gave him firsthand experience of the brutality of which militarized, nationalist regimes are capable. His work often addresses—literally or metaphorically—these experiences. His early experiments with both figuration and abstraction were deeply influenced by Cézanne and then Picasso and Miró. By the early 1940s, Gorky was evolving his mature style, a highly original mode of expression that combined strange hybrid forms with rich, fluid color. One of his most ambitious paintings, *The Liver is the Cock's Comb*, 1944 (fig. C.3), is a large composition that resembles both a wild and vast landscape and a microscopically detailed internal anatomy. Gorky combined veiled but recognizable shapes, such as claws or feathers, with overtly sexual forms, creating an erotically charged atmosphere filled with softly brushed, effulgent color. His biomorphic imagery owed much to Kandinsky (see fig. 13.14) and Miró (see fig. 14.12), whose works he knew well, and to the Surrealist automatism of Masson (see fig. 14.15) and Matta (see fig. 14.27), who were both in New York in the 1940s. The year he made this painting, Gorky met André Breton, the self-appointed leader of the Surrealists, who took a strong interest in his work and arranged for it to be shown at a New York gallery in 1945.

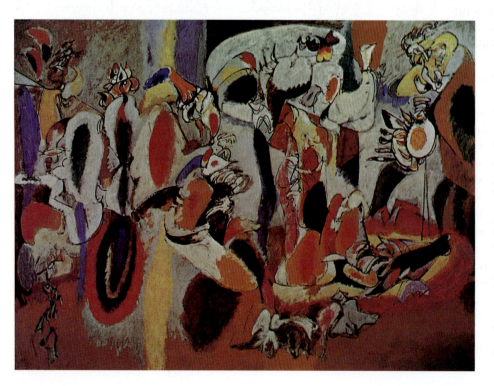

C.3 Arshile Gorky, *The Liver is the Cock's Comb*, 1944. Oil on canvas, 6' 1¼" × 8' 2" (1.9 × 2.5 m). Albright-Knox Art Gallery, Buffalo, New York.

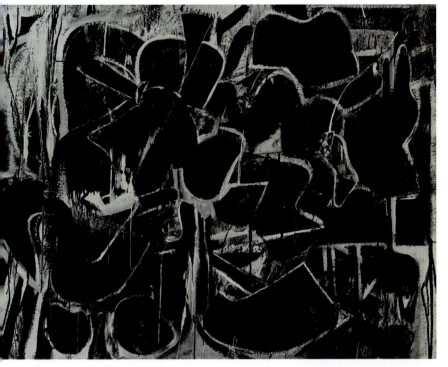

C.4 Willem de Kooning, *Painting*, 1948. Enamel and oil on canvas, 42⅝ × 56⅛" (108.3 × 142.5 cm). The Museum of Modern Art, New York.

Willem de Kooning

Willem de Kooning (1904–97) was a central figure of Abstract Expressionism, even though he was not one of the first to emerge in the public eye during the 1940s. Born in the Netherlands, De Kooning underwent rigorous artistic training at the Rotterdam Academy. He came to the United States in 1926, where, throughout the 1930s, he slowly made the transition from house painter, commercial designer, and Sunday painter to full-time artist. Of the utmost importance was his early encounter with Stuart Davis (see fig. 15.53), Gorky, and the influential Russian-born painter John Graham, "the three smartest guys on the scene," according to De Kooning. They were his frequent companions on visits to The Metropolitan Museum of Art, where it was possible to see examples of ancient and Old Master art. Although he did not exhibit until 1948, De Kooning was an underground force among younger experimental painters by the early 1940s.

One of the most remarkable aspects of De Kooning's talent was his ability to shift between representational and abstract modes, which he never held to be mutually exclusive. He continued to make paintings of figures into the 1970s,

but even many of his most abstract compositions contain remnants of, or allusions to, the figure. "Even abstract shapes must have a likeness," he said. In the late 1940s he made a bold group of black-and-white abstractions in which he had fully assimilated the tenets of Cubism, which he made over into a dynamic, painterly idiom (fig. **C.4**). While he was making his black-and-white compositions, De Kooning was also working on large paintings of women (fig. **C.5**). With this project, he embarked on a direct dialog with modernist predecessors like Manet, Matisse, Picasso, Kirchner, and many of the Surrealists, who made representations of the female body the locus of aesthetic experimentation. Long characterized as a sort of homage to female beauty or a natural desire to explore the "eternal feminine," De Kooning's approach to the theme reveals the uncomfortable

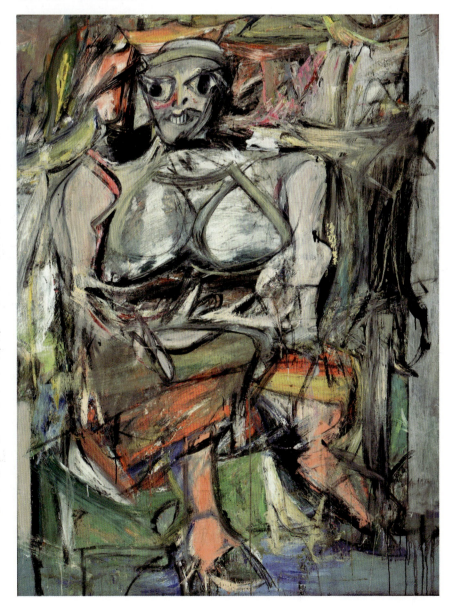

C.5 Willem de Kooning, *Woman I*, 1950–52. Oil on canvas, 6' 3⅞" × 4' 10" (1.9 × 1.47 m). The Museum of Modern Art, New York.

admixture of impulses that propelled this preoccupation. One current that De Kooning makes visible is the violence of such intense aesthetic scrutiny, his slashing strokes simultaneously evoking the work of a dispassionate anatomist as well as a frenzied attacker. The banal and the shocking coexist in *Woman I*, creating a striking aesthetic tension. A monumental image of a seated woman in a sundress is his repellent and arresting evocation of woman as sex symbol and fertility goddess. At the same time, the strip of silver metallic paint along the right edge of the canvas insists on a decidedly quotidian setting—the aluminum edge of a screen door, perhaps, or other structure redolent of middle-class comfort—and anchors the sitter in the everyday world. Although the vigorous paint application appears entirely improvisatory, the artist labored over the painting for eighteen months, scraping the canvas down, revising it, and, along the way, making countless drawings—he was a consummate draftsman—of the subject. When his paintings of women were exhibited in 1953, De Kooning, who once said his work was "wrapped in the melodrama of vulgarity," was dismayed when critics failed to see the humor in them, reading them instead as misogynist. Akin to the Surrealists, De Kooning perceived a relationship between the comic and the terrifying, a relationship he, like the Surrealists, projected onto the female body.

Pollock

According to De Kooning, it was **Jackson Pollock** (1912–56), with the radical "drip" paintings he began to make in the late 1940s, who "broke the ice." Hailing from the West, Pollock became a huge force on the New York art scene, until his alcoholism led to a fatal car wreck. His identity as a Westerner—a sort of cowboy, even—was cultivated by the artist and his admirers, who saw in his work a uniquely American self-reliance and independence. Pollock embodied an American expression of the alienated, misunderstood, and tragic Romantic genius. He achieved a stature of mythic proportions. By the 1950s, he was an international symbol of the new American painting and remains an icon of the post-World War II artist. Pollock came to New York from Cody, Wyoming, by way of Arizona and California. Until 1932 he studied at the Art Students League with Thomas Hart Benton (see fig. 15.30), who represented, Pollock said, "something against which to react very strongly, later on." Nevertheless, there is a relation between Pollock's abstract arabesques and Benton's rhythmical figurative patterns. The landscapes of Ryder (see fig. 2.45) as well as the work of the Mexican muralists (see figs. 15.46, 15.47) were important sources for Pollock's violently expressive early paintings, as were the automatic methods of Masson and Miró. In 1939 The Museum of Modern Art mounted a large

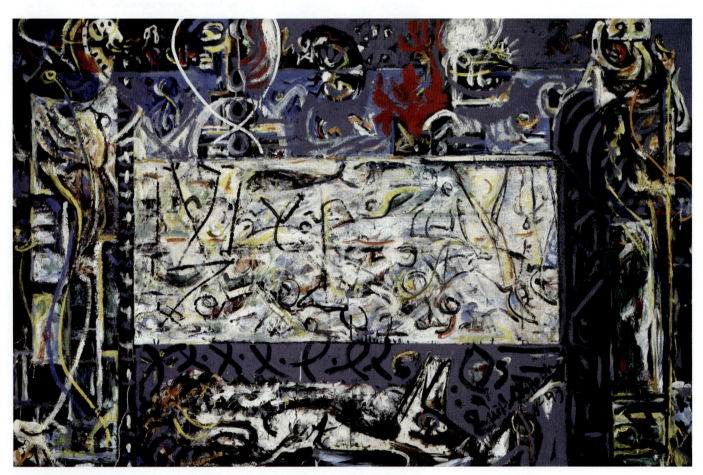

C.6 Jackson Pollock, *Guardians of the Secret*, 1943. Oil on canvas, 4′ ¾″ × 6′ 3″ (1.2 × 1.9 m). San Francisco Museum of Modern Art. Albert M. Bender Bequest Fund. Purchase.

View the Closer Look for another of Pollock's paintings on mysearchlab.com

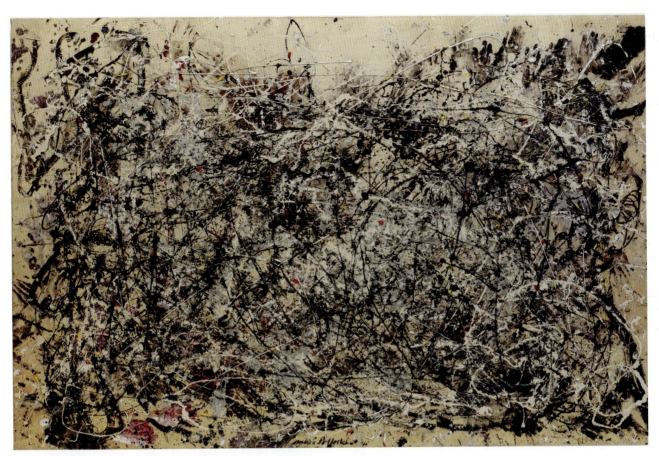

C.7 Jackson Pollock, *Number 1A, 1948*, 1948. Oil and enamel paint on canvas, 5′ 8″ × 8′ 8″ (1.73 × 2.64 m). The Museum of Modern Art, New York.

Watch a video about Pollock on mysearchlab.com

Picasso exhibition, a catalyst for artists like De Kooning and Pollock, who were then struggling to come to terms with his work, learn from his example, and forge their own independent styles out of Cubism.

Pollock's paintings of the mid-1940s, usually involving some degree of actual or implied figuration, were coarse and heavy, suggestive of Picasso, but filled with a nervous, brutal energy all their own. In *Guardians of the Secret*, 1943 (fig. **C.6**), schematic figures stand ceremonially at either end of a large rectangle, perhaps a table, an altar, or a funeral bier. A profound transformation in his approach took place by 1947. Pollock had begun to experiment with **"allover painting,"** a labyrinthine network of lines, splatters, and paint drips from which emerged the great drip or poured paintings of the next few years. While Hans Hofmann had employed similar techniques for applying pigment to a support, Pollock transformed the older artist's intimate technical experiments into monumental statements on the aesthetic and psychological power of large-scale abstract painting. *Number 1A, 1948* (fig. **C.7**) is an early realization of his distinctive approach to drip painting. Its intricate web of oil colors mixed with black enamel and aluminum paint asserts and then subverts the viewer's attempt to interpret the image as a sequence of overlapping webs or as a sort of veil obscuring an underlying subject. Thin lines of dripped pigment commingle with broader strokes and even handprints in the upper right quadrant, while smudges of red-pink punctuate the lower

left portion of the composition, asserting the possibility of a distinct foreground before dissolving into the play of colors across the plane of the canvas.

In Pollock's *Number 1A, 1948* one can trace the movements of the artist's arm, swift and assured, as he deployed sticks or dried-out brushes to drip paint onto the surface. His lines are divorced from any descriptive function and range from string-like thinness to coagulated puddles, all merging into a hazy, luminous whole that seems to hover above the picture plane rather than illusionistically behind it. These paintings, generally executed on a large canvas laid out on the floor, are popularly associated with so-called Action Painting. It was never the intention of the critic Harold Rosenberg, in coining this term, to imply that Action Painting was limited to a kind of athletic exercise, but rather that the process of painting was as important as the completed picture (see *Harold Rosenberg's The American Action Painters*, p. 385). Despite the furious and seemingly haphazard nature of his methods, Pollock's painting was not a completely uncontrolled, intuitive act. There is no question that, in his paintings and those of other Abstract Expressionists, the elements of intuition and accident play a significant part—this was indeed one of the principal contributions of Abstract Expressionism, which had found its own inspiration in Surrealism's psychic automatism. The presence of bits of studio detritus—cigarette butts, ashes, pastry wrapping, even insects whose struggle left frantic marks—

embedded in his paintings (deliberately or by accident is impossible to know) suggests that Pollock was giving form to the unconscious, with its capacity for sublime longing as well as abject fear. At the same time, however, Pollock's works are informed by skills honed by years of practice and reflection, just as the improvisatory talents of jazz musicians are paradoxically enhanced by regimented training.

Krasner

Brooklyn-born **Lee Krasner** (1908–84) received academic training at several New York art schools before joining the Mural Division of the WPA in 1935. From 1937 to 1940 she was a student of Hans Hofmann, from whom she said she "learned the rudiments of Cubism." Subsequently, she joined the AAA, devoted to non-objective art in the tradition of Mondrian, and exhibited Cubist abstractions in their group shows. Krasner became acquainted with Pollock in 1942, when John Graham included their work in a show of young artists he felt showed promise. Krasner and Pollock began to share a studio in 1942, married in 1945, and relocated to Long Island. Unlike Pollock, Krasner felt a general antipathy toward the Surrealists and their automatic methods, due in part to the fundamentally misogynist attitudes of the European Surrealist émigrés (compounded by the general marginalization of women within Abstract Expressionist circles). Throughout the 1940s and 50s, she gradually moved away from Cubist-based forms to a concern for spontaneous gesture and large-scale allover compositions, while remaining committed to a Mondrianesque sense of structure. A painting from 1949 (fig. **C.8**) shows a web of elusive forms whose vertical organization suggests a deliberate, readable order, leading the viewer to anticipate decoding the marks as some form of language. The promised linguistic coherence fails to materialize, though, and the forms maintain their manic mystery. The rhythm of colors and lines endows the piece with a dynamism as the figures appear to struggle against the grid underlying the composition.

The prominence of Krasner today as a major contributor to the development of modern art in America is a consequence of critical acuity and historical sensitivity. Beginning in the 1970s, critics and art historians began to emphasize Krasner's importance not just in relation to her more famous husband, but in terms of the significance of her independent aesthetic vision. During the 1950s and 60s, however, Krasner's work received comparatively little attention from critics, curators, and collectors, who tended to view Abstract Expressionism as a distinctly masculine movement that manifested alternately heroic or neurotic impulses. Thus, even with the international reputations of such American artists as Mary Cassatt and Romaine Brooks (see figs. 2.24, 15.1), who spent much of their careers in Europe, women seeking careers as painters, sculptors, or architects in the United States faced prejudices redoubled by postwar anxieties about the changing economic, political, and cultural roles being claimed by women.

Kline

Franz Kline (1910–62) was as fascinated with the details and tempo of contemporary America as was Mondrian, and he was also deeply immersed in the tradition of Western painting, from Rembrandt to Goya. Kline studied art at academies in Boston and London and, throughout the 1940s, painted figures and urban scenes tinged with Social Realism. A passion for drawing manifested itself during the 1940s, particularly in his habit of making little black-and-white sketches, fragments in which he studied single motifs, structure, or space relations. One day in 1949, according to the painter and critic Elaine de Kooning, Kline was looking

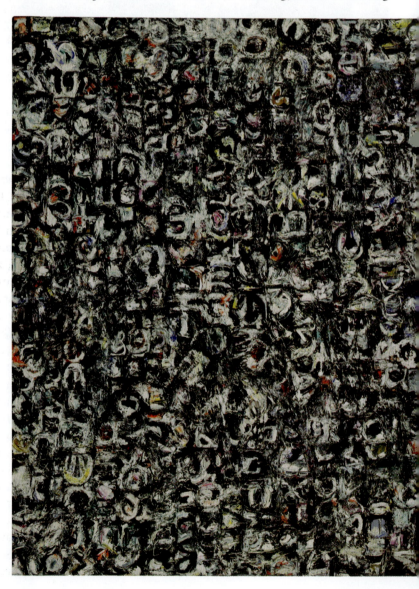

C.8 Lee Krasner, *Untitled*, 1949. Oil on composition board, 48 × 37″ (121.9 × 93.9 cm). The Museum of Modern Art, New York.

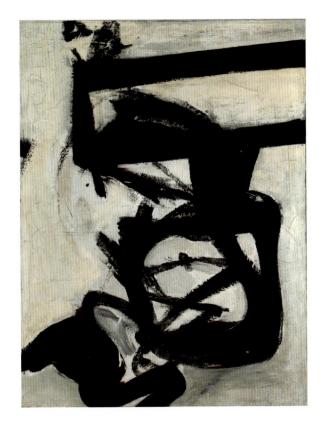

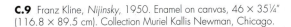
C.9 Franz Kline, *Nijinsky*, 1950. Enamel on canvas, 46 × 35¼"
(116.8 × 89.5 cm). Collection Muriel Kallis Newman, Chicago.

at some of these sketches enlarged through an opaque pro-jector and saw their implications as large-scale, free abstract images. Although this moment of revelation has no doubt been exaggerated, and although Kline's mastery of abstrac-tion was gradual rather than instantaneous, he did formulate his new Abstract Expressionist vocabulary with astonishing speed. Even the first works in his new mode have nothing tentative about them.

In 1950, when he made his first large-scale black-and-white abstractions, Kline was well aware of the experiments of the pioneer Abstract Expressionists, although he never shared Pollock's interest in myth or Rothko's interest in the sublime, and he tended to gamble less with spontane-ous gesture than his friend Willem de Kooning. Instead he worked out his compositions in advance, with preliminary sketches, usually on pages torn from the telephone book. *Nijinsky* (fig. **C.9**) is an abstract meditation on his own figu-rative representations of the subject, based on a photograph of the great Russian dancer as Petrushka in Stravinsky's bal-let of the same name. Despite the almost academic approach that Kline employed in working up paintings after numer-ous studies, the final works exhibit the gestural freedom and immediacy so valued by critics like Harold Rosenberg. Of course, what Kline's method makes clear is that Abstract Expressionism is not a form of automatism, a point that Hans Hofmann had demonstrated earlier to students like Lee Krasner, who would help to define the movement.

Guston

Philip Guston (1913–80) was expelled from Manual Arts High School in Los Angeles along with his classmate Jackson Pollock for lampooning the conservative English department in their own broadside. Pollock was read-mitted, but Guston set off on his own, working at odd jobs, attending art school briefly as well as meetings of the Marxist John Reed Club. He followed Pollock to New York and, in 1936, signed up for the mural section of the WPA. By the mid-1940s, drawing on his diverse studies of Cubism, the Italian Renaissance, and the paintings of De Chirico and Beckmann, he was painting mysterious scenes of figures in compressed spaces, works that earned him a national reputation.

Guston taught painting for a time in Iowa City and St. Louis and, in the late 1940s, began to experiment with loosely geometric abstractions. After many painful inter-vals of doubt, he made his first abstract gestural paint-ings in 1951. These contained densely woven networks of short strokes in vertical and horizontal configurations (fig. **C.10**) that reveal an admiration for Mondrian. The heavy impasto, serene mood, and subtle, fluctuating light in his muted reds, pinks, and grays caused some to see these works as lyrical landscapes, earning Guston the label

SOURCE

Harold Rosenberg
from *The American Action Painters*
(first published in 1952)

With a few important exceptions, most of the artists of this vanguard found their way to their present work by being cut in two. Their type is not a young painter but a reborn one. The man may be over forty, the painter around seven. The diagonal of a grand crisis separates him from his personal and artistic past.

Many of the painters were "Marxists" (WPA unions, art-ists' congresses); they had been trying to paint Society. Others had been trying to paint Art (Cubism, Post-Impressionism)—it amounts to the same thing.

The big moment came when it was decided to paint … just to PAINT. The gesture on the canvas was a gesture of libera-tion, from Value—political, aesthetic, moral.

If the war and the decline of radicalism in America had any-thing to do with this sudden impatience, there is no evidence of it. About the effects of large issues upon their emotions, Amer-icans tend to be either reticent or unconscious. The French artist thinks of himself as a battleground of history; here one hears only of private Dark Nights. Yet it is strange how many segregated individuals came to a dead stop within the past ten years and abandoned, even physically destroyed, the work they had been doing. A far-off watcher unable to realize that these events were taking place in silence might have assumed they were being directed by a single voice.

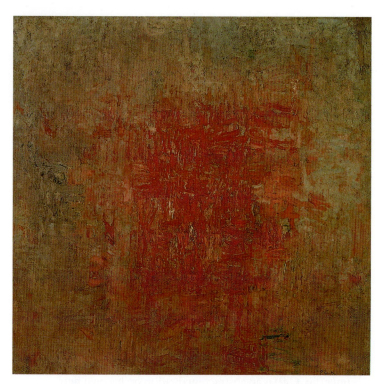

C.10 Philip Guston, *Zone*, 1953–54. Oil on canvas, 46 × 48" (116.8 × 122.2 cm). The Edward R. Broida Trust, Los Angeles.

Abstract Impressionist. But Guston, who had negligible interest in the Impressionists, explained, "I think of painting more in terms of the drama of this process than I do of 'natural forces.'"

Throughout the 1950s, Guston employed larger and more emphatic gestures in his abstractions, with a tendency to concentrate centralized color masses within a light and fluid environment. In 1962 the Guggenheim Museum mounted a major Guston retrospective, as did New York's Jewish Museum in 1966. But despite these external successes, Guston was experiencing a crisis in his art, with concerns about abstraction's limited potential for expressing the full gamut of human experience. In the late 1960s, he returned to recognizable imagery, astonishing the art world with intensely personal, sometimes nightmarish, images in a crude, cartoonish style. "I got sick and tired of all that purity," he said, "and wanted to tell stories."

Elaine de Kooning

Elaine de Kooning (1918–89) is probably best known for the figurative paintings she made in the 1950s. However, at her death a group of abstractions from the 1940s was discovered among her belongings that reveals her early experiments within an Abstract Expressionist mode. She spent the summer of 1948 at Black Mountain College in North Carolina with her husband, Willem de Kooning (they had married in 1943). At the invitation of Josef Albers, Willem had joined the distinguished faculty at the experimental school as a visiting artist. Elaine de Kooning always acknowledged the importance of her husband's paintings as well as those of their friend Arshile Gorky to her own work: "Their reverence and knowledge of their materials, their constant

attention to art of the past and to everything around them simultaneously, established for me the whole level of consciousness as the way an artist should be." Following the summer at Black Mountain, De Kooning began to write on contemporary art for *ARTnews*. Her keen perceptions, as well as her vantage point as a practicing artist who knew her subject firsthand, endowed her writing with authority. In the 1950s and 60s, De Kooning displayed expressive tendencies in a group of male portraits (including several of John F. Kennedy). Her portrayal of art critic Harold Rosenberg (fig. **C.11**), one of the champions of Abstract Expressionism, shows how she brought the gesturalism of the New York School to bear on figurative subjects. With her depiction of Rosenberg, De Kooning participates in a tradition of portraying critics that goes back at least as far as Édouard Manet's painting of Émile Zola (see fig. 2.22). The fraught relationship between artist and critic involves mutual dependence and vulnerability: a sympathetic critic can further an artist's career, and a successful artist can confirm a critic's perspicacity and prestige. In this way, portraits of critics are as much about art world relationships as they are about individuals. Portraits of critics can also provide an opportunity for a statement of aesthetic commitments. Here, De Kooning depicts Rosenberg using precisely the approach he had championed in *The American Action Painters*: "It is to be taken for granted that in the final effect, the image, whatever be or be not in it, will be a tension." Indeed, the oil paint applied in broad strokes to the canvas competes with and ultimately conquers the ostensible subject of the canvas. Rosenberg appears placid, enervated by the energized passages of color around him.

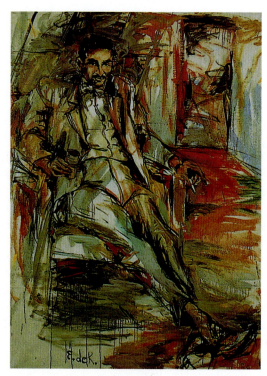

C.11 Elaine de Kooning, *Harold Rosenberg #3*, 1956. Oil on canvas, 6' 8" × 4' 10⅞" (2 × 1.5 m). National Portrait Gallery, Smithsonian Institution, Washington, D.C.

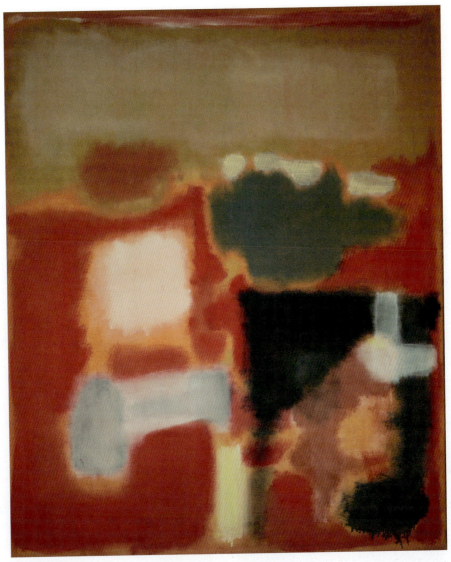

C.12 Mark Rothko, *No. 1 (No. 18, 1948)*, 1948–49. Oil on canvas, 67¹¹⁄₁₆ × 55⅞" (170.8 × 141.9 cm). The Frances Lehman Loeb Art Center, Vassar College, Poughkeepsie, New York.

Complex Simplicities: The Emergence of Color Field Painting

Although the divisions between gestural and Color Field painting are somewhat artificial, there were both formal and conceptual differences between artists such as Kline and De Kooning on the one hand and Mark Rothko and Barnett Newman on the other. In 1943 Rothko and Newman were among the signatories of an open letter published in *The New York Times*, which announced their self-conscious pursuit of a particular aesthetic: "We favor the simple expression of the complex thought. We are for the large shape because it has the impact of the unequivocal. We wish to reassert the picture plane. We are for flat forms because they destroy illusion and reveal truth." These artists, whose works were described by Clement Greenberg as "allover" or Color Field Painting, were not afraid of polemic: "It is our function as artists to make the viewer see the world our way—not his way." That, presumably, had been the standard before the war. But now, after Auschwitz, allowing the viewer such self-indulgence (and self delusion) could no longer be tolerated.

Rothko

Mark Rothko (1903–70) emigrated to the United States with his Russian-Jewish family in 1913 and moved ten years later to New York, where he studied with Max Weber at the Art Students League. Throughout the 1930s he made figurative paintings on mostly urban themes and in 1935 formed an independent artists' group called The Ten. In 1940, in search of more profound and universal themes and impressed by his readings of Nietzsche and Jung, Rothko began to engage with ancient myths as a source of "eternal symbols." In their letter to *The New York Times*, Rothko, Barnett Newman, and Adolph Gottlieb proclaimed their "spiritual kinship with primitive and archaic art." Rothko first made compositions based on classical myths and then, by the mid-1940s, painted biomorphic, Surrealist-inspired, hybrid creatures floating in primordial waters. These forms began to coalesce at the end of the decade into floating color shapes with loose, undefined edges within larger expanses of color (fig. **C.12**). By 1949 Rothko had refined and simplified his shapes to the point where they consisted of color rectangles floating on a color ground. He applied thin washes of oil

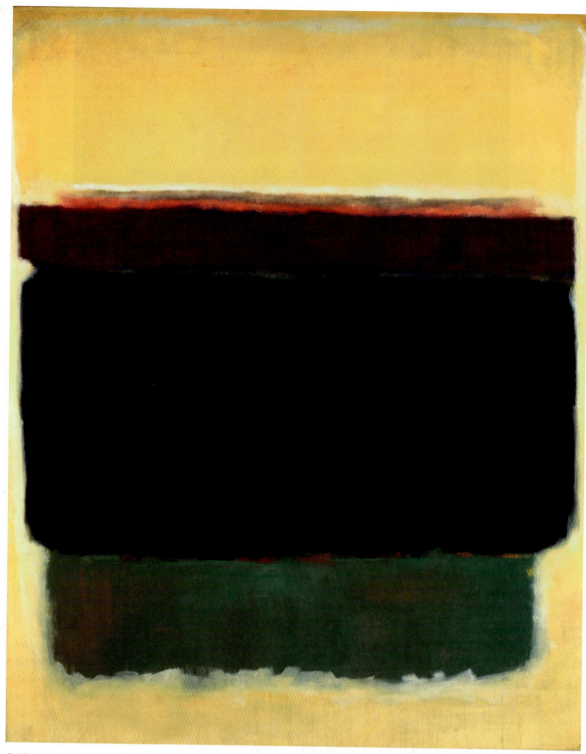

C.13 Mark Rothko, *Untitled (Rothko number 5068.49)*, 1949. Oil on canvas, 6' 9⅜" × 5' 6⅜" (2.1 × 1.7 m). National Gallery of Art, Washington, D.C.

paint containing considerable tonal variation and blurred the edges of the rectangles to create luminous color effects and a shifting, ambiguous space (fig. **C.13**). Over the next twenty years, he explored this basic compositional type with infinite and subtle variation. By the sheer sensuousness of their color areas and the sense of indefinite outward expansion without any central focus, the paintings are designed to absorb and engulf the spectator. Eventually, Rothko was painting on a huge scale, something that contributed to the effect of enclosing, encompassing color.

The simplified, architectonic forms that seem to hover in Rothko's canvases have prompted speculation about the significance of these works. Some critics have argued that Rothko's paintings are essentially landscapes, with their insistent horizontal bands demarking the horizon and blocks of color indicating receding planes of earth. According to this interpretation, Rothko's paintings engage the polarity between earth and sky, thus participating in a dualistic cosmology that dates back thousands of years. A variation on this interpretation sees instead cityscapes defined by

rectilinear forms competing for prominence, thereby finding in Rothko's painting the long-standing modernist critique of urban life. Others insist that Rothko's works are abstract recapitulations of medieval Christian altarpieces, an interpretation that accords with the spiritual character that the artist allowed a central to his project. For his part, though, the artist always refuted assertions that his paintings represent some*thing*. Rothko instead stated that he was striving for "the elimination of all obstacles between the painter and the idea, and between the idea and the observer."

Newman

Like Rothko, **Barnett Newman** (1905–70) studied at the Art Students League in the 1920s, but his artistic career did not begin in earnest until 1944, when he resumed painting after a long hiatus and after he had destroyed his early work. By the mid-1950s, he had received nowhere near the attention that Pollock, De Kooning, or Rothko had attracted, although it could be argued that, in the end, his work had the greatest impact on future generations. His mature work, in its radical reductiveness and its denial of painterly surface,

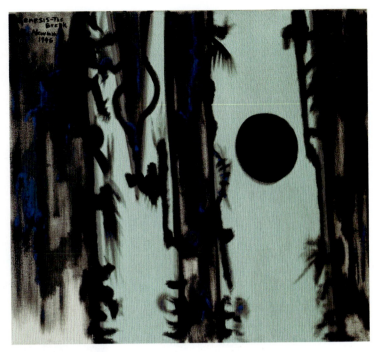

C.14 Barnett Newman, *Genesis—The Break*, 1946. Oil on canvas, 24 × 27" (61 × 68.6 cm). Collection DIA Center for the Arts, New York.

Watch a video about Newman on mysearchlab.com

differed from that of the Abstract Expressionists discussed so far. As the group's most thoughtful and most polemical theorist, Newman produced an important body of critical writing on the work of his contemporaries as well as on subjects such as pre-Columbian art.

In his early mythic paintings Newman, who had studied botany and ornithology, explored cosmic themes of birth and creation, of primal forms taking shape. Those works share many traits with Rothko's biomorphic paintings. By 1946, however, in canvases such as *Genesis—The Break* (fig. **C.14**), the forms become more abstract and begin to shed their biological associations, although the round shape here is a recurring seed form. Thomas Hess, a leading champion of the Abstract Expressionists, said that this painting (as the title implies) was about "the division between heaven and earth." In 1948 Newman made *Onement, I* (fig. **C.15**), which he regarded as the breakthrough picture that established his basic formula: a unified color field interrupted by a vertical line—a Zip as he called it—or, rather, a narrow, vertical contrasting color space that runs the length of the canvas. The nature of the Zip varied widely, from irregular hand-brushed bands to uninflected, straight edges made possible with the use of masking tape, but the impression is usually of an opening in the picture plane rather than simply a line on the surface. While Newman did not seek out the atmospheric effects that Rothko achieved in his mature works, he was capable of brushed surfaces of tremendous beauty and nuance.

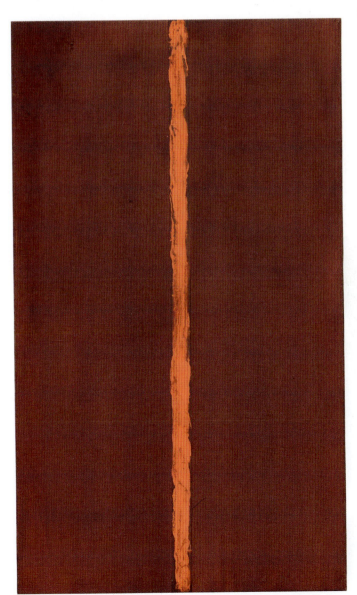

C.15 Barnett Newman, *Onement, I*, 1948. Oil on canvas and oil on masking tape on canvas, 27¼ × 16¼" (69.2 × 41.2 cm). The Museum of Modern Art, New York.

Motherwell

Robert Motherwell (1915–91) received his early training in literature, art history, and philosophy at Stanford, Harvard, and Columbia. Motherwell's erudition made him a leading theorist of modern art. Motherwell provided American artists with their most thorough introduction to Dada in the 1951 collection of essays *The Dada Painters and Poets*, still an essential sourcebook for Dada writing. As a painter, he was largely self-trained, with the exception of some formal study as a young man in California and later with the Surrealist Kurt Seligmann in New York. The aspect of Surrealism that most intrigued him was automatism, the concept of the intuitive, the irrational, and the accidental in the creation of a work of art. In 1943, Motherwell began to experiment with collage, introducing automatist techniques using roughly torn pieces of paper. One of the earliest examples is *Pancho Villa, Dead and Alive*, 1943 (fig. **C.16**). Motherwell, who had traveled to Mexico with the Surrealist Matta, had been struck by a photograph of the revolutionary figure, dead and covered with blood. The stick figures representing Villa relate directly to a painting by Picasso from the 1920s, but other forms in the collage were to become signature Motherwell images, such as the ovoid shapes held in tension between vertical, architectural elements.

In 1948 Motherwell made the first work of his great series of abstract paintings entitled *Elegy to the Spanish Republic,*

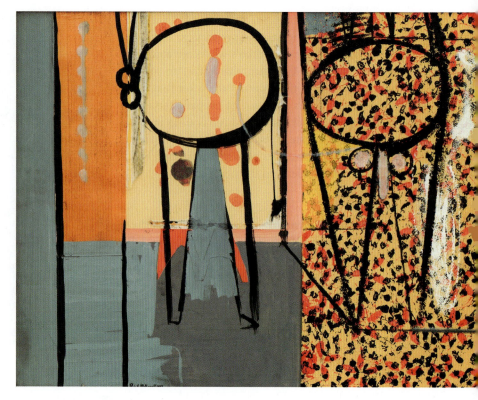

C.16 Robert Motherwell, *Pancho Villa, Dead and Alive*, 1943. Gouache and oil with cut-and-pasted papers on cardboard, 28 × 35⅞" (71.7 × 91.1 cm). The Museum of Modern Art, New York. Art © Dedalus Foundation, Inc./Licensed by VAGA, New York, NY.

No. 34 (fig. **C.17**), inspired by his profound reaction to its defeat by fascist forces in early 1939. Until his death in 1991, he painted more than 150 variants of the *Elegy* theme. These works stand in contrast to his brilliantly coloristic collages and paintings created during the same period, for they were executed predominantly in stark black and white. "Black is death; white is life," the artist said. It is no coincidence that Picasso's monumental painting of protest against the Spanish Civil War, *Guernica* (see fig. 11.21), was black, white, and gray. The *Elegies* consisted for the most part of a few large, simple forms, vertical rectangles holding ovoid shapes in suspension. The scale increased as the series progressed, with some works on a mural scale. While the loosely brushed, organic shapes have been read literally by some, who have suggested that they might represent male genitalia with reference to Spanish bullfights, Motherwell said he invented the forms as emblems for universal tragedy.

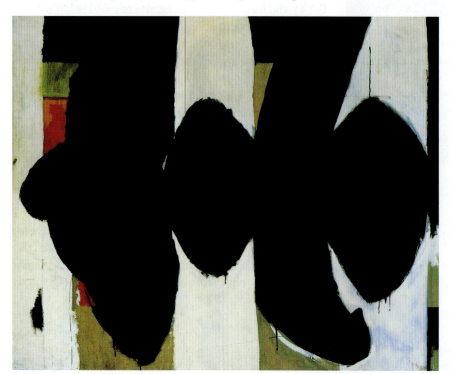

C.17 Robert Motherwell, *Elegy to the Spanish Republic, No. 34*, 1953–54. Oil on canvas, 6' 8" × 8' 4" (2 × 2.5 m). Albright-Knox Art Gallery, Buffalo, New York. Art © Dedalus Foundation, Inc./Licensed by VAGA, New York, NY.

Drawing in Steel: Constructed Sculpture

Constructed sculpture—as contrasted with sculpture cast in bronze or modeled in stone—and, particularly, welded metal sculpture, constituted a major direction taken by American artists after World War II.

Smith and Dehner

David Smith (1906–65), a pioneer sculptor of his generation working in welded steel, said of his medium: "The material called iron or steel I hold in high respect.... The metal itself possesses little art history. What associations it possesses are those of this century: power, structure, movement, progress, suspension, brutality." Smith was born in Decatur, Illinois, and between 1926 and 1932 he studied painting, initially with John Sloan (see fig. 15.2), at the Art Students League in New York (he was never formally trained as a sculptor). In the early 1930s, intrigued by reproductions of Picasso's welded-steel sculptures of 1929–30 (see fig. 14.39) as well as the works of Julio González (see fig. 14.41) that he saw in John Graham's collection, Smith began to experiment with constructed metal sculpture. He first learned to weld in an automobile plant in the summer of 1925, and in 1933 he established a studio in Brooklyn at Terminal Iron Works, a commercial welding shop. During World War II he worked in a locomotive factory, where he advanced his technical experience in handling metals, and the sheer scale of locomotives suggested to him possibilities for the monumental development of his metal sculpture. Moreover, these experiences established the kinship that he felt with skilled industrial laborers.

During the 1930s and 40s, Smith endowed his sculpture with a Surrealist quality, derived from Picasso, González, and Giacometti. His works of the early 1950s are like steel drawings in space, as in *The Letter* (fig. **C.18**). Yet even when the sculptures were composed two-dimensionally, the natural setting, seen through the open spaces, introduced ever-changing suggestions of depth, color, and movement.

Toward the end of the war, Smith established a studio in Bolton Landing in upstate New York. The studio was a complete machine shop, and during the 1950s and 60s he populated the surrounding fields with his sculptures, which were becoming more monumental in scale and conception. During much of his career Smith worked on sculpture in series, with different sequences sometimes overlapping chronologically and individual sculptures within series varying widely in form. The *Agricola* (Latin for "farmer") constructions (1952–59) continued the open, linear approach (with obvious agrarian overtones), while the *Sentinels* (1956–61) were usually monolithic, figurative sculptures, at times employing elements from farm or industrial machinery. *Sentinel I* (fig. **C.19**), for example, includes a tire rod and industrial steel step, while the "head" of the sculpture resembles street signs. In contrast with most sculptors who used found objects in the 1960s, Smith integrated such objects in the whole structure so that their original function

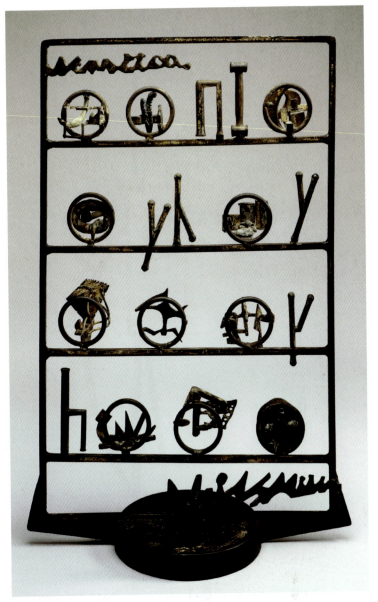

C.18 David Smith, *The Letter*, 1950. Welded steel, 37⅝ × 22⅞ × 9¼" (95.6 × 58.1 × 23.5 cm). Munson-Williams-Proctor Institute Museum of Art, Utica, New York. Art © Estate of David Smith/Licensed by VAGA, New York, NY.

✳—[Explore more about Smith on mysearchlab.com

was subordinated to the totality of the new design. This was Constructivist sculpture in the original sense of Naum Gabo's Realistic Manifesto (see Ch. 9, p. 212), in which voids do not merely surround mass but are articulated by form. Significant for future developments in sculpture is the fact that *Sentinel I* is not isolated on a pedestal but occupies the viewer's actual space.

Dorothy Dehner (1901–94) was overshadowed as an artist by her famous husband, Smith, yet for nearly forty years she produced a distinguished body of sculpture whose origins should be considered within the Abstract Expressionist milieu. She met Smith while studying painting at the Art Students League in 1926 and later became acquainted with Davis, Gorky, and Avery. Dehner worked in various figurative styles until the late 1940s, when she also began to exhibit her work publicly. Although many

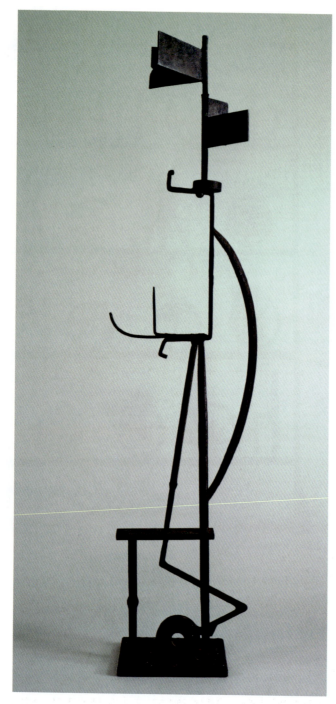

C.19 David Smith, *Sentinel I*, 1956. Painted steel, 89⅝ × 16⅞ × 22⅝" (227.6 × 42.9 × 57.5 cm). National Gallery of Art, Washington, D.C. Art © Estate of David Smith/Licensed by VAGA, New York, NY.

Such tampering with the past is central not only to Dehner's approach to sculpture but to the project of modernism generally. Avant-garde artists, even those whose works struck their first audiences as highly, indeed disturbingly, original, understood their practice in terms of its history. Some, like Édouard Manet, confronted the legacy of past art directly, attempting to create works that insisted upon affording the aesthetic character of modernity the same worth as that of classical antiquity or the Italian Renaissance (see fig. 2.19). Others, such as Picasso, reveal an intriguing ambivalence toward tradition (see fig. 7.7). His *Les Demoiselles d'Avignon* is simultaneously an assault on centuries-old conventions for easel painting as it is a restatement of the centrality of one of the most enduring themes in Western visual culture: the eroticized female nude. Mondrian's mature works might be seen as a total rejection of traditional expectations for painting in pursuit of originality (see fig. C.1). Yet Mondrian's project—as radical as it was—accepts the basic premise of easel painting as pigment arranged on a support that can be easily presented on the wall of a residence, gallery, or museum. The question facing modern artists, then, is not one merely of originality or conventionality, but rather one of how to express truth through visual representation. Is history to be transcended in pursuit of an ideal aesthetic or social experience as was the case with the de Stijl group? Is history to be empirically confronted, dissected, and analyzed according to Cubist principles or perhaps via Socialist Realism? The history of modern art, then, is a history of attempts to give visual form to the experience of life as it is shaped by industrialization, urbanization, and capitalism. The first part of that history unfolds mostly in Europe and North America; with the expansion of these conditions around the world, the later history of modern art reveals its global reach.

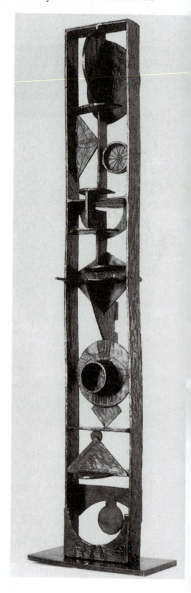

C.20 Dorothy Dehner, *Nubian Queen*, 1960. Bronze, 56 × 14 × 8" (142.2 × 35.6 × 20.3 cm). Richard L. Eagan Fine Arts, New York.

of her early abstract paintings and drawings demonstrate a sculptor's sensibility with their depiction of forms that seem to unfold and turn in space, Dehner did not start making sculpture until 1955, five years after she and Smith had separated. *Nubian Queen* (fig. **C.20**), a bronze from 1960, is an open-frame, totemic construction containing mysterious, pictographic signs. Like her contemporaries in the New York School, Dehner sought to develop a private language with universal implications, and, like them, as her title implies, she liked to tap the art of ancient civilizations for forms and meaning. "I am an archeologist of sorts," she said. "I tamper with the past."

Glossary

Abstract art The term has two main applications: 1. Art that is non-representational, purely autonomous and makes no reference to an exterior world, e.g. Suprematism, Abstract Expressionism (known as "strong" abstraction); 2. Art that "abstracts" its images from the visible world, e.g. Cubism (referred to as "weak" abstraction).

academicism Term referring to a conservative artistic mindset that believes works should only be created according to a prescribed aesthetic established by great masters of the past and codified into a doctrine by an official organization, or academy, of artists. In the nineteenth century it was used primarily to describe the milieu of the official French Academy, and in the twentieth century it was often used to describe the work of artists working in what were considered traditional and outmoded styles.

airbrush A device that uses compressed air to spray fine droplets of paint, producing a smooth, even surface. Most often associated with commercial art but also employed by Hard Edge abstract painters. Airbrush effects do not show brushmarks or other evidence of the artist's touch.

aleatory The use of chance or random elements (from the Latin *aleatorius*, a dicer).

allover painting Painting that treats the whole surface of the canvas in a uniform manner, in contrast to suggesting a compositional center or main focal point. The term is applied to the work of Jackson Pollock and the Color Field painters.

altarpiece A devotional painting or sculpture placed on, above, or behind an altar. Many depict multiple scenes and are on several panels (*see* **triptych**), hinged so that they can be concealed or revealed as required.

anthropomorphic refers to an animal or object that has been given human characteristics.

apse Vaulted semicircular termination of a building, usually a church.

arabesque Intricate surface decoration of plant forms, spirals, knots, etc. without human figures.

arcadian refers to a mythical land of rustic peace and plenty, which is frequently evoked in classical, Renaissance, and later art and literature.

Archaic refers to an artistic style of ancient Greek sculpture of c. 600–480 ABD that has come to be considered in modern times to have an admirable simplicity of form.

architectonic Term used to refer to art that has architectural qualities—usually works that seem to have been constructed or built up from basic forms.

armature Framework on which sculpture in clay is supported.

assemblage An artwork composed of three-dimensional objects, either natural or manufactured, often junk.

atelier French term for a studio or workshop. In nineteenth-century France "ateliers libres" provided non-academic, studio-based teaching.

atmospheric perspective A technique for indicating spatial recession on a two-dimensional surface by making crisp and clear those objects intended to be perceived close to the viewer, while objects meant to be understood as further away are represented as hazy or less distinct.

automatism An artistic approach in which the artist relinquishes conscious, rational control, enabling unconscious impulses to direct the form of the work. Automatism is most closely associated with the Surrealists and Abstract Expressionists.

avant-garde Literally, the vanguard; more loosely, those in advance or ahead of their time—or thought to be so.

balustrade A series of balusters (short posts or pillars) supporting a rail.

barrel vault The simplest type of vault, formed of a continuous semicircular or pointed section.

basilica An ancient Roman colonnaded hall for public use, later adopted as a building type for Early Christian churches. The Christian basilica had acquired its essential characteristics by the fourth century: oblong plan, longitudinal axis, timber roof either open or concealed by a flat ceiling, and a termination either rectangular or apsidal. It is usually divided into a **nave** and two or more aisles, the former higher and wider than the latter, lit by clerestory windows and with or without a gallery.

bas-relief *see* **relief**.

biomorphic A type of abstract art in which—as in much of Arp's work—the forms relate to organic shapes (in contrast to geometric abstraction).

canon A list of works that sets the standard for artistic achievement. In the late twentieth century the concept of the canon came increasingly to be challenged on the basis that it represents a relatively narrow spectrum of Western art and is defined as much by what it excludes as by the works that are included.

cantilever A horizontally-projecting architectural element such as a beam or canopy that has no external bracing and appears to be self-supporting. Such an element is, in fact, anchored at one end by the structure from which it projects. Closely associated with the designs of Frank Lloyd Wright.

caricature A type of literary or visual portraiture in which the subject is distorted for comic, often satirical, effect.

chiaroscuro In painting, the manipulation of light and shade to give the effect of modeling.

chromolithography A type of lithography in which color prints are produced by printing each color using a different stone or plate.

collage A composition made by gluing pieces of paper, cloth, etc. on a canvas or other ground.

combination printing A photographic technique in which the final print is created by combining two or more negatives.

commedia dell'arte Type of semi-improvisational Italian comic theatre that became established as a distinct theatrical tradition from the sixteenth century onwards. It often drew its subjects from topics of the day, treating them with biting satire through a set of stock characters, such as the clowns Harlequin, Columbine and Pierrot. Through the centuries these *commedia dell'arte* characters have often been the subject of painting and sculpture.

contrapposto A pose developed in classical antiquity. The figure is shown resting his or her weight on one leg, allowing the other leg to bend slightly and the hip to drop. This gives the figure a slight S-curve, and suggests a moment of repose between actions.

curtain wall The outer enclosing wall of a medieval castle or, especially with reference to twentieth-century architecture, a non-load-bearing wall applied to the exterior of a structure.

cyanotype An early photographic technique that uses iron salts to produce a deep blue image.

daguerreotype Photographic process invented by L.-J.-M. Daguerre and patented in 1839 for fixing positive images on silver-coated metal plates; widely used, especially for portraits, until the 1860s. Each daguerreotype is unique and the process was superseded by developments from the calotype process by which numerous prints may be made from a single negative.

Divisionism The technique of painting with small areas of unmixed pigments juxtaposed so that they combine optically when seen from a certain distance. Another term for this technique is **Pointillism**.

drypoint Technique of **print**making by which the copper plate is scratched with a sharply pointed tool, which creates a soft, feathery line when printed. Drypoint is often used in combination with other methods of **engraving** and **etching**.

empiricism A theory of knowledge that maintains that truth can only be found in what can be sensorially perceived in the world around us. In art, it is used to describe an approach that considers that artworks should only show what can be seen with the eye.

etching A print from a metal plate on which the design has been etched or eaten away by acid.

façade The architecturally-emphasized front or face of a building.

facture Manner in which an artwork is made.

ferro-concrete A modern development of concrete reinforced by the insertion of steel mesh or rods. Also called **reinforced concrete**.

formalist An approach to art analysis that emphasizes qualities of visual form, color, and composition above other aspects of the work of art, such as narrative meaning, or biographical, social, and political context.

found images, materials or **objects** Those found in an everyday environment and **appropriated** for artworks, especially **assemblages**.

fresco Wall and ceiling painting on fresh (*fresco*) moist lime plaster with pigments ground in water so that they are absorbed into the plaster. Pigments added after the plaster has dried are said to be applied *a secco*.

frieze The middle division of an entablature, also loosely any sculptured or decorated horizontal band.

functionalism The theory that a building, piece of furniture or other object should be designed primarily to fulfill its material purpose and use and that its form should be determined exclusively by its function.

genre painting A picture of everyday life.

genres The various categories of painting, e.g. history, landscape, portrait, **still life**, etc.

history painting In European academic theory a **figurative** painting of a scene from classical mythology, the Bible, the lives of saints, or a historical event.

iconography The meaning of visual images whether conveyed directly or by symbols, allegories, etc. Often used to refer to a standard set of imagery identified with a particular subject or genre.

ideogram A written character or symbol that represents a thing itself, rather than a word or sound.

impasto Thickly applied **oil paint**.

kinetic art An artwork that moves, usually by a mechanism; or an artwork whose purpose is to convey a sense of movement.

Land art *see* **Earthwork**.

linear perspective A technique for indicating spatial recession on a two-dimensional surface in which literal or implied lines converge at one or two points in the distance.

lithography A process of **print**making from a drawing in oily crayon on stone. Invented c. 1798.

medium (pl. media) refers to the materials and/or techniques with which an artwork is made. For example, the medium of marble or the medium of sculpture.

mimesis the action of imitation or mimicry.

mobile A three-dimensional artwork, parts of which can be moved by a current of air, as distinct from **kinetic sculpture** with mechanically controlled movement.

monochrome A painting in tones of a single color.

monotype A print made from an image painted (not **engraved**) on a metal or glass plate. As the plate must be partly repainted each time it is used, each of the prints made from it is unique.

mosaic A pictorial composition made of small colored stones (*pebble mosaic*) or cubes of stone, glass, etc., set in plaster.

naturalism An approach to art that emphasizes likeness to observable nature. Like "realism" it is used in a non-specific sense of representational art that achieves lifelike effects. Neither naturalism nor realism should be confused with the term Realism (with a capital R), which has specific connotations. Nineteenth-century French Realism, for example, combined an unidealized view of actual people and places with a strong element of social commentary that can be found later in the work of American Social Realist painters of the Depression era of the 1930s.

nave The congregational area of a church, flanked by **aisles**.

Neoclassical Art-historical term referring to styles from the eighteenth century onwards—and particularly those in architecture—that looked back to the styles of the classical period of ancient Greece and Rome.

Neoplastic refers to the concepts of Neoplasticism, which are a set of organizational principles for art developed by Piet Mondrian in the early twentieth century. In essence these principles aim to achieve the balance of unequal opposites through the right angle, and to limit the use of color to the primary hues plus black and white.

odalisque A female slave or concubine in a harem. Odalisques frequently appear, both nude and clothed, as a subject of Western painting from Ingres to Matisse.

oil paint Pigment mixed with an oil (usually linseed) which hardens when dry into a transparent film. Oil paint is normally applied opaquely but it can be used as a colored translucent or semi-translucent film over opaque ground colors. Its use was developed in the fifteenth century in Flanders and Italy and it was soon taken up for easel paintings throughout Europe.

Old Master A non-specific term for any great European painter or painting of pre-nineteenth-century date.

panchromatic refers to a substance that is sensitive to all colours of the spectrum. Almost all colour photographic film is panchromatic.

papier collé A **collage** composed of pieces of variously colored paper glued to a ground.

Performance art A live-action piece in which the artist is typically present, either directing or participating in the event.

photomontage A term coined in Berlin c. 1918 for a **collage** composed of fragments of photographs, newsprint, etc., but later used also for a composite picture made by printing from several negatives on a single sheet.

planarity Having the quality of a flat plane.

plastic Term used to describe a material that can be molded, sculpted or carved. Also used to describe a flexible and sinuous shape.

plein-air **painting** A painting executed out of doors rather than in a studio.

Pointillism *see* **Divisionism**.

Positivism a philosophy that rejects metaphysical considerations in favor of a strictly empirical approach to understanding all forms of human experience.

primitivism Tendency of Western artists to emulate motifs or techniques associated with so-called "primitive" cultures. Artists such as Paul Gauguin believed that non-Western and pre-industrial cultures were more authentic than industrialized Europe and North America.

reinforced concrete *see* **ferro-concrete**.

relief Sculpture with forms projecting from a ground, called *high relief* when they are at least half in the round; less than that they are known as *low relief* or **bas-relief**.

Rococo Art-historical term for an artistic style prevalent in Europe during the eighteenth century. In architecture and the decorative arts, it is characterized by gently curving and ornate surfaces; in painting by softly textured garden scenes of courting lovers.

Romanesque refers generally to medieval European culture produced roughly between 1000 BD and 1250 BD. More specifically, Romanesque denotes a style of medieval architecture that immediately preceded the Gothic, characterized by monumental scale along with the use of **barrel vaults** and rounded arches.

Romanticism Beginning in the late eighteenth century and continuing throughout much of the nineteenth century, this was a movement in music, literature, and the visual arts that exalted in humanity's capacity for emotion.

Salon The French word *salon* means a formal room like the Salon Carré (square room) in the Louvre Palace (Paris). Exhibitions of work by members of the French Royal Academy of painters and sculptors were held in the Salon Carré; "Salon" became shorthand for official displays of works by living artists. Later in the nineteenth and twentieth centuries it was also co-opted for "unofficial" exhibitions put on by avant garde movements outside the artistic mainstream.

secularism philosophy that maintains that morality should be based on what contributes to the well-being of human life, and not on belief in what a deity (or deities) prescribes.

semiotics The study of signs, in particular the analysis of language as a system of signs proposed by the Swiss pioneer of modern linguistics, Ferdinand de Saussure. Semiotic interpretation has been extended to other cultural arenas such as mythology and clothing.

sfumato A soft, misty effect attained in **oil painting** mainly by the use of glazes to create delicate transitions of color and tone.

simultaneity 1. Term used by Robert Delaunay to describe the way he conveyed light through color in his painting. 2. The instance of two events happening at the same time—represented in art particularly by the Futurists.

spiritism Based on the mid-nineteenth-century writings of Hypolite Léon Denizard Rivail (pseud. Allan Kardec), this is a system of religious beliefs united in their conviction that the spirit survives death, inhabits an invisible spirit world, and communicates with the world of the living.

still life A representation of such inanimate objects as flowers, fruit, dead animals, or household articles.

stucco Various types of plaster used as a protective and decorative covering for walls. A mixture including lime and powdered marble has been extensively used for **relief** decorations on ceilings and interior walls since the sixteenth century in Europe.

syncretic refers to the union of diverse beliefs, practices, and systems.

Synthetism Term used by Paul Gauguin to describe the anti-Realist approach in his art in which he attempted to synthesize subject and idea with form and color.

tenebrism Painting with a dominant dark tonality.

Theosophy A metaphysical formulation established by Helena Petrovna Blavatsky and expounded from the Theosophical Society she founded in New York in 1875. It combines elements of Eastern religions, especially Buddhism and Hinduism, with mysticism and an esoteric belief in the pursuit of spiritual knowledge.

triptych A painting on three panels.

trompe l'oeil An illusionistic painting intended to "deceive the eye."

volute a decorative element shaped in a spiral scroll.

woodcut A **print** made from a block of wood from the surface of which all areas not intended to carry ink have been cut away. The block is cut from a smoothed plank of fairly soft wood with the grain running parallel to the surface. A print made from a block of very hard wood cut across the grain and worked with a graving tool is called a *wood engraving*.

Bibliography

Art and architectural surveys reflect a wide range of critical discourse. Their bibliographies are, by necessity, selective. These suggestions for further reading strive for balance between canonical texts and recent scholarship published both as monographs and exhibition catalogues. Comprehensive research will benefit from a review of current periodical literature, but no attempt has been made to incorporate this vast and rapidly changing body of work here.

The bibliography is organized as follows:

I. General

A. Surveys, Theory, and Methodology
B. Dictionaries and Encyclopedias
C. Architecture, Engineering, and Design
D. Photography, Prints, and Drawings
E. Painting and Sculpture

II. Further Readings, Arranged by Chapter

Books and exhibition catalogs without discernible author(s) are listed alphabetically by title.

Abbreviations

HMSG Hirshhorn Museum and Sculpture Garden, Washington, D.C.
LACMA Los Angeles County Museum of Art
MMA The Metropolitan Museum of Art, New York
MOCA Museum of Contemporary Art, Los Angeles
MOFA Museum of Fine Arts, Boston
MOMA The Museum of Modern Art, New York
SFMOMA San Francisco Museum of Modern Art
SMH Studio Museum in Harlem, New York
SRGM Solomon R. Guggenheim Museum, New York
WMAA Whitney Museum of American Art, New York

Works cited here are in English, except for selected important sources, catalogues, and documents.

This bibliography was compiled by Mary Clare Altenhofen and revised by Rachel Federman.

I. General

A. Surveys, Theory, and Methodology

Adams, Laurie Schneider. *The Methodologies of Art: An Introduction.* 2nd ed. Boulder, Colo.: Westview Press, 2010.

Adamson, Walter L. *Embattled Avant-Gardes: Modernism's Resistance to Commodity Culture in Europe.* Berkeley, Calif.: University of California Press, 2007.

Altshuler, Bruce. *Salon to Biennial: Exhibitions that Made Art History; Volume 1, 1863–1959.* London: Phaidon, 2009.

Arnheim, Rudolf. *Art and Visual Perception: A Psychology of the Creative Eye.* Enl. and rev. ed. Berkeley and Los Angeles, Calif.: University of California Press, 1974.

———. *To the Rescue of Art: Twenty-six Essays.* Berkeley, Calif.: University of California Press, 1992.

Art and Power: Europe Under the Dictators, 1930–45. Comp. D. Ades, et al. London: Hayward Gallery, 1995.

Art of the Twentieth Century. Trans. Antony Shugaar. 5 vols. Vol. 1. *1900–1919: The Avant-Garde Movements;* Vol. 2. *1920–1945: The Artistic Culture Between the Wars;* Vol. 3. *1946–1968: The Birth of Contemporary Art;* Vol.4. *1968–1999:*

Neo-Avant-Gardes: Postmodern and Global art; Vol. 5. *2000 and Beyond: Contemporary Tendencies.* Milan: Skira; New York: Distr. Rizzoli, 2006.

Ashton, Dore. *Out of the Whirlwind: Three Decades of Arts Commentary.* Ann Arbor, Mich.: UMI Research Press, 1987.

Baigell, Matthew. *A Concise History of American Painting and Sculpture.* Rev. ed. New York: Icon Editions, 1996.

Barasch, Moshe. *Modern Theories of Art.* 2 vols. New York: New York University Press, 1990–98.

Barr, Jr., Alfred H. *Cubism and Abstract Art: Painting, Sculpture, Constructions, Photography, Architecture, Industrial Arts, Theatre, Films, Posters, Typography.* Cambridge, Mass.: Belknap Press of Harvard University Press, 1986.

———. *Defining Modern Art: Selected Writings of Alfred H. Barr.* Eds. I. Sandler and A. Newman. New York: H.N. Abrams, 1986.

Baudelaire, Charles. *Painter of Modern Life and Other Essays.* Trans. and ed. J. Mayne. 2nd ed. London: Phaidon, 1995.

Bearden, Romare. *A History of African American Artists: From 1792 to the Present.* New York: Pantheon Books, 1993.

Berger, John. *About Looking.* New York: Vintage International, 1991.

Bindman, David, and Chris Stephens, eds. *The History of British Art, Volume 3: 1870–Now.* New Haven: Yale University Press, 2008.

———, and Henry Louis Gates, Jr., eds. *The Image of the Black in Western Art, Vol. IV: From the American Revolution to World War I.* Cambridge, Mass.: Belknap Press of Harvard University Press in collaboration with the W.E.B. DuBois Institute for African and African American Research, 2012.

Bjelajac, David. *American Art: A Cultural History.* 2nd ed. Upper Saddle River, N.J.: Prentice Hall, 2005.

Boime, Albert. *The Academy and French Painting in the Nineteenth Century.* With new pref. and suppl. bibliography. New Haven, Conn.: Yale University Press, 1986.

Bois, Yve-Alain. *Painting as Model.* Cambridge, Mass.: MIT Press, 1991.

Bowness, Alan. *Modern European Art.* New York: Thames & Hudson, 1972.

Brown, Milton W. *American Art: Painting, Sculpture, Architecture, Decorative Arts, Photography.* New York: H.N. Abrams, 1979.

Bryson, Norman. *Calligram: Essays in New Art History from France.* New York: Cambridge University Press, 1988.

———, ed. *Vision and Painting: The Logic of the Gaze.* New Haven, Conn.: Yale University Press, 1983.

———, et al., eds. *Visual Theory: Painting and Interpretation.* New York: Cambridge University Press, 1991.

Bürger, Peter. *Theory of the Avant-Garde.* Trans. M. Shaw. Minneapolis, Minn.: University of Minnesota Press, 1984.

Butler, Cornelia, and Alexandra Schwartz, eds. *Modern Women: Women Artists at the Museum of Modern Art.* New York: MOMA, 2010.

Cahn, Steven M., and Aaron Meskin, eds. *Aesthetics: a Comprehensive Anthology.* Malden, Mass.: Blackwell Publishers, 2008.

Canaday, John. *Mainstreams of Modern Art.* 2nd ed. New York: Holt, Rinehart and Winston, 1981.

Caws, Mary Ann. *The Eye in the Text: Essays on Perception, Mannerist to Modern.* Princeton, N.J.: Princeton University Press, 1981.

Celant, Germano, ed. *Architecture & Arts, 1900/2004: A Century of Creative Projects in Building, Design, Cinema, Painting, Sculpture.* 1st ed. Milan: Skira; New York: Distr. Rizzoli, 2004.

Cerutti, Toni, ed. *Ruskin and the Twentieth Century: The Modernity of Ruskinism.* Vercelli: Edizioni Mercurio, 2000.

Chadwick, Whitney. *Women, Art and Society.* 4th ed. New York: Thames & Hudson, 2007.

Cheetham, Mark, et al. *The Subjects of Art History: Historical Objects in Contemporary Perspectives.* Cambridge, England; New York: Cambridge University Press, 1998.

Chu, Petra ten-Doesschate. *Nineteenth-Century European Art.* 3rd ed. Upper Saddle River, N.J.: Prentice Hall, 2012.

Clark, Kenneth. *Ruskin Today.* London: J. Murray, 1964.

Collingwood, R. G. *Essays in the Philosophy of Art.* Bloomington, Ind.: Indiana University Press, 1964.

Compton, Susan, ed. *British Art in the 20th Century: The Modern Movement.* Munich: Prestel, 1986.

Cone, Michèle. *The Roots and Routes of Art in the 20th Century.* New York: Horizon Press, 1975.

Crary, Jonathan. *Techniques of the Observer: On Vision and Modernity in the 19th Century.* Cambridge, Mass.: MIT Press, 1990.

Craven, Wayne. *American Art: History and Culture.* Madison, Wis.: Brown and Benchmark, 1994.

Crow, Thomas E. *Modern Art in the Common Culture.* New Haven, Conn.: Yale University Press, 1996.

———. *The Intelligence of Art.* Chapel Hill, N.C.: University of North Carolina Press, 1998.

Danto, Arthur C. *The Philosophical Disenfranchisement of Art.* New York: Columbia University Press, 2005.

———. *The Transfiguration of the Commonplace: A Philosophy of Art.* Cambridge, Mass.: Harvard University Press, 1981.

———. *Unnatural Wonders: Essays From the Gap Between Art and Life.* New York: Farrar, Straus and Giroux, 2005.

Davis, Whitney. *A General Theory of Visual Culture.* Princeton, N.J.: Princeton University Press, 2011.

Dempsey, Amy. *Art in the Modern Era: A Guide to Styles, Schools, Movements, 1860 to the Present.* New York: H.N. Abrams, 2002.

Eisenmann, Stephen. *Nineteenth Century Art: A Critical History.* 4th ed. New York: Thames & Hudson, 2011.

Ferrier, Jean Louis, ed. *Art of Our Century: The Chronicle of Western Art, 1900 to the Present.* New York: Prentice Hall, 1989.

Fletcher, Valerie. *Dreams and Nightmares: Utopian Visions in Modern Art.* Washington, D.C.: HMSG, 1983.

Focillon, Henry. *The Life of Forms in Art.* New York: Zone Books, 1989.

Foster, Hal. *Return of the Real: The Avant-Garde at the End of the Century.* Cambridge, Mass.: MIT Press, 1996.

———, et al. *Art Since 1900: Modernism, Antimodernism, Postmodernism.* 2 vols. New York: Thames & Hudson, 2004.

Frank, Patrick, ed. *Readings in Latin American Modern Art.* New Haven, Conn.: Yale University Press, 2004.

Frascina, Francis, et. al. *Modernity and Modernism: French Painting in the Nineteenth Century.* New Haven, Conn.: Yale University Press in assoc. with the Open University, 1993.

———. *Modern Art Culture: A Reader.* London: Routledge, 2009.

———, and Jonathan Harris, eds. *Art in Modern Culture: An Anthology of Critical Texts.* New York: Harper & Row, 1992.

———, and Charles Harrison, eds. *Modern Art and Modernism: A Critical Anthology.* New York: Harper & Row, 1982.

Fry, Roger. *Last Lectures.* Cambridge, England: The University Press, 1939.

———. *A Roger Fry Reader.* Ed. with introd. essays by Christopher Reed. Chicago: University of Chicago Press, 1996.

———. *Vision and Design.* Reprint. New York: Oxford University Press, 1981.

Gablik, Suzy. *Has Modernism Failed?* 2nd ed. New York: Thames & Hudson, 2004.

Gage, John. *Color and Culture: Practice and Meaning from Antiquity to Abstraction.* Boston: Little, Brown, 1993.

Gaiger, Jason, and Paul Wood, eds. *Art of the Twentieth Century: A Reader.* New Haven, Conn.: Yale University Press in assoc. with the Open University, 2003.

Goddard, Donald. *American Painting.* New York: MacMillan, 1990.

Goldwater, Robert. *Primitivism in Modern Art.* Enl. ed. Cambridge, Mass.: Harvard University Press, 1986.

Gombrich, Ernst H. *The Sense of Order: A Study in the Psychology of Decorative Art.* 2nd ed. Oxford: Phaidon, 1984.

Gordon, Donald. *Expressionism: Art and Idea.* New Haven, Conn.: Yale University Press, 1987.

Green, Christopher, ed. *Art Made Modern: Roger Fry's Vision of Art.* London: Merrell Holberton Publishers in assoc. with the Courtauld Gallery, Courtauld Institute of Art, 1999.

Greenberg, Clement. *Clement Greenberg: The Collected Essays and Criticism.* 4 vols. Chicago: University of Chicago Press, 1986–93.

Groys, Boris. *The Total Art of Stalinism: Avant-Garde, Aesthetic Dictatorship, and Beyond.* Trans. C. Rougle. Princeton, N.J.: Princeton University Press, 1992.

Harris, Jonathan. *Writing Back to Modern Art: After Greenberg, Fried, and Clark.* London; New York: Routledge, 2005.

Harrison, Charles, and Paul Wood, eds. *Art in Theory, 1900–1990: An Anthology of Changing Ideas.* New ed. Malden, Mass.: Blackwell Publishers, 2003.

Hauser, Arnold. *The Social History of Art.* With an introd. by Jonathan Harris. 3rd ed. London; New York: Routledge, 1999.

Heller, Nancy G. *Women Artists: An Illustrated History.* 4th ed. New York: Abbeville Press, 2003.

Herbert, Robert L. *From Millet to Léger: Essays in Social Art History.* New Haven, Conn.: Yale University Press, 2002.

————, ed. *The Art Criticism of John Ruskin.* Garden City, N.Y.: Anchor Books, 1964.

Hertz, Richard, and Norman Klein, eds. *Twentieth-Century Art Theory: Urbanism, Politics, and Mass Culture.* Englewood Cliffs, N.J.: Prentice Hall, 1990.

Hildebrand, Adolf von. *The Problem of Form in Painting and Sculpture.* Ann Arbor, Mich.: University Microfilms, 1979.

Hunter, Sam, and John Jacobus. *Modern Art: Painting, Sculpture, Architecture.* 3rd ed., rev. and expanded. Upper Saddle River, N.J.: Prentice Hall, 2004.

Joachimides, Christos. *American Art in the 20th Century: Painting and Sculpture 1913–1933.* London and Munich: Royal Academy of Arts and Prestel, 1993.

————, et al. *German Art in the 20th Century: Painting and Sculpture 1905–1985.* London: Royal Academy of Arts and Weidenfeld & Nicholson, 1985.

————, ed. *The Age of Modernism: Art in the 20th Century.* Ostfildern-Ruit, Germany: Hatje Cantz; New York: Distr. D.A.P./Distributed Art Publishing, 1997.

Johnston, Patricia, ed. *Seeing High & Low: Representing Social Conflict in American Visual Culture.* Berkeley, Calif.: University of California Press, 2006.

Kemp, Martin. *The Science of Art: Optical Themes in Western Art from Brunelleschi to Seurat.* New Haven, Conn.: Yale University Press, 1990.

————. *Seen/Unseen: Art, Science, and Intuition From Leonardo to the Hubble Telescope.* Oxford, England; New York: Oxford University Press, 2006.

Kern, Stephen. *The Culture of Time and Space: 1880–1918.* Cambridge, Mass.: Harvard University Press, 1980.

Kleinbauer, W. Eugene. *Modern Perspectives in Western Art History: An Anthology of Twentieth-Century Writings on the Visual Arts.* Reprint of the 1971 ed. Toronto: University of Toronto Press, 1989.

Kozloff, Max. *Renderings: Critical Essays on a Century of Modern Art.* London: Studio Vista, 1968.

Krauss, Rosalind. *The Optical Unconscious.* Cambridge, Mass.: MIT Press, 1993.

————. *The Originality of the Avant-Garde and Other Modernist Myths.* Cambridge, Mass.: MIT Press, 1986.

Kuh, Katharine. *The Artist's Voice.* New York: Harper & Row, 1962.

Kultermann, Udo. *The History of Art History.* New York: Abaris Books, 1993.

Kuspit, Donald B. *The Critic as Artist: The Intentionality of Art.* Ann Arbor, Mich.: UMI Research Press, 1984.

————. *The Cult of the Avant-Garde Artist.* New York: Cambridge University Press, 1993.

The Latin American Spirit: Art and Artists in the United States, 1920–1970. Essays by Luis R. Cancel, et al. New York: Bronx Museum of the Arts in association with H.N. Abrams, 1988.

Lewis, M, T., ed. *Critical Readings in Impressionism and Post-Impressionism: An Anthology.* Berkeley, Calif.: University of California Press, 2007.

Lewis, Samella S. *African American Art and Artists.* Foreword by F. Coleman; new introd. by M. J. Hewitt. 3rd. ed., rev. and expanded. Berkeley, Calif.: University of California Press, 2003.

Liberman, Alexander. *The Artist in His Studio.* Rev. ed. New York: Random House, 1988.

Lucie-Smith, Edward. *Latin American Art of the 20th Century.* 2nd ed. World or Art. New York: Thames & Hudson, 2004.

Lynton, Norbert. *The Story of Modern Art.* 2nd ed. Oxford: Phaidon, 1989.

McCoubrey, John. *American Art, 1700–1960: Sources and Documents.* Englewood Cliffs, N.J.: Prentice Hall, 1965.

Meecham, Pam and Julie Sheldon. *Modern Art: A Critical Introduction.* 2nd ed. London; New York: Routledge, 2005.

Michalski, Sergiusz. *Public Monuments: Art in Political Bondage, 1870–1997.* London: Reaktion Books, 1998.

Miller, Angela L., et al. *American Encounters: Art, History and Cultural Identity.* Upper Saddle River, N.J.: Pearson Education, Inc., 2008.

Millon, Henry A., and Linda Nochlin, eds. *Art and Architecture in the Service of Politics.* Cambridge, Mass.: MIT Press, 1978.

Mitchell, W. J. T. *Picture Theory: Essays on Verbal and Visual Representation.* Chicago: University of Chicago Press, 1994.

Nelson, Robert, and Richard Shiff, eds. *Critical Terms for Art History.* 2nd ed. Chicago: University of Chicago Press, 2003.

Nochlin, Linda. *The Body in Pieces: The Fragment as a Metaphor of Modernity.* New York: Thames & Hudson, 1995.

————. *The Politics of Vision: Essays on Nineteenth-Century Art and Society.* New York: Harper & Row, 1989.

————. *Women, Art, and Power: and Other Essays.* New York: Harper & Row, 1988.

Osborne, Harold, ed. *Oxford Companion to Twentieth-Century Art.* New York: Oxford University Press, 1981.

Parker, Rozsika, and Griselda Pollock. *Old Mistresses: Women, Art, and Ideology.* New York: Pantheon, 1981.

Podro, Michael. *The Critical Historians of Art.* New Haven, Conn.: Yale University Press, 1982.

Pohl, Frances K. *Framing America: A Social History of American Art.* 2nd ed, New York: Thames & Hudson, 2008.

Poggioli, Renato. *The Theory of the Avant-Garde.* Trans. G. Fitzgerald. Cambridge, Mass.: Belknap Press of Harvard University Press, 1968.

Pollock, Griselda. *Vision and Difference: Femininity, Feminism, and the Histories of Art.* With a new introd. London; New York: Routledge, 2003.

Powell, Richard. *Black Art: a Cultural History.* 2nd ed. London: Thames & Hudson, 2003.

————. *The Blues Aesthetic: Black Culture and Modernism.* Washington, D.C.: Washington Project for the Arts, 1989.

Preziosi, Donald. *Rethinking Art History: Meditations on a Coy Science.* New Haven, Conn.: Yale University Press, 1989.

————, ed. *The Art of Art History: A Critical Anthology.* Oxford; New York: Oxford University Press, 1998.

Prown, Jules, and Barbara Rose. *American Painting: From the Colonial Period to the Present.* New ed. New York: Rizzoli, 1977.

————, et al. *Discovered Lands, Invented Pasts: Transforming Visions of the American West.* New Haven, Conn.: Yale University Press, 1992.

Rasmussen, Waldo, ed. *Latin American Artists of the Twentieth Century.* New York: MOMA, 1993.

Rees, A. L., and Frances Borzello. *The New Art History.* London: Camden Press, 1986.

Rose, Barbara. *Readings in American Art Since 1900: A Documentary Survey.* New York: Praeger, 1968.

Rosen, Charles, and Henri Zerner. *Romanticism and Realism: The Mythology of Nineteenth-Century Art.* New York: Viking, 1984.

Rosenberg, Harold. *The Tradition of the New.* New York: Horizon Press, 1959.

Rosenblum, Robert. *On Modern American Art: Selected Essays.* New York: H.N. Abrams, 1999.

Rubin, William, ed. *"Primitivism" in 20th-Century Art: Affinity of the Tribal and the Modern.* 2 vols. New York: MOMA, 1984.

Schapiro, Meyer. *Theory and Philosophy of Art: Style, Artist, and Society.* New York: G. Braziller, 1994.

Sims, Lowery Stokes. *Challenge of the Modern: African-American Artists 1925–1945.* New York: SMH, 2003.

Stangos, Nikos, ed. *Concepts of Modern Art: From Fauvism to Postmodernism.* 3rd ed. New York: Thames & Hudson, 1994.

Stiles, Kristine, and Peter Selz. *Theories and Documents of Contemporary Art: A Sourcebook of Artist's Writings.* Berkeley and Los Angeles, Calif.: University of California Press, 1996.

Storr, Robert. *Modern Art Despite Modernism.* New York: MOMA: Distr. H.N. Abrams, 2000.

Summers, David. *Real Spaces: World Art History and the Rise of Western Modernism.* London; New York: Phaidon, 2003.

Sylvester, David. *Interviews with American Artists.* New Haven, Conn.: Yale University Press, 2001.

Tagg, John. *Grounds of Dispute: Art History, Cultural Politics and the Discursive Field.* Minneapolis, Minn.: University of Minnesota Press, 1992.

Taylor, Joshua, ed. *Nineteenth-Century Theories of Art.* Berkeley, Calif.: University of California Press, 1991.

Tuchman, Maurice. *The Spiritual in Art: Abstract Painting, 1890–1985.* New York: Abbeville Press, 1986.

Varnedoe, Kirk, and Adam Gopnik. *High and Low: Modern Art and Popular Culture.* New York: MOMA, 1990.

————, eds. *Modern Art and Popular Culture: Readings in High and Low.* New York: H.N. Abrams, 1990. With essays by J.E. Bowlt, et al.

Walther, Ingo F., ed. *Art of the 20th Century.* 2 vols in 1. New York: Taschen, 2000.

Weiss, Jeffrey S. *The Popular Culture of Modern Art: Picasso, Duchamp, and Avant-Gardism.* New Haven, Conn.: Yale University Press, 1994.

Whiting, Cécile. *Antifascism in American Art.* New Haven, Conn.: Yale University Press, 1989.

Wilkins, David G., Bernard Schultz, and Katheryn M. Linduff. *Art Past/Art Present.* 5th ed. Upper Saddle River, N.J.: Pearson Prentice Hall, 2005.

Wilmerding, John. *American Views: Essays on American Art.* Princeton, N.J.: Princeton University Press, 1991.

Witzling, Mara, ed. *Voicing Our Visions: Writings by Women Artists.* New York: Universe Books, 1991.

Wollheim, Richard. *Art and Its Objects.* With six suppl. essays. 2nd ed. Cambridge, England; New York: Cambridge University Press, 1992, 1980.

————. *Painting as an Art.* Princeton, N.J.: Princeton University Press, 1987.

Zegher, Catherine de, ed. *Inside the Visible: An Elliptical Traverse of 20th Century Art in of and From the Feminine.* Cambridge, Mass.: MIT Press, 1996.

B. Dictionaries and Encyclopedias

Benezit, Emmanuel. *Dictionary of Artists.* 14 vols. Paris: Gründ, 2006.

Chilvers, Ian, ed. *The Concise Oxford Dictionary of Art and Artists.* 3rd ed. Oxford, England; New York: Oxford University Press, 2003. Also available as an electronic database by subscription.

————. *A Dictionary of Twentieth-Century Art.* Oxford, England; New York: Oxford University Press, 1998. Also available as an electronic database by subscription.

Curl, James Stevens. *A Dictionary of Architecture and Landscape Architecture.* 2nd ed. Oxford, England; New York: Oxford University Press, 2006.

Dunford, Penny. *Biographical Dictionary of Women Artists in Europe and America Since 1850.* Philadelphia: University of Pennsylvania Press, 1990.

Encyclopedia of World Art. 17 vols. New York: McGraw-Hill, 1959–87.

Fleming, John. *The Penguin Dictionary of Architecture.* 4th ed. London; New York: Penguin Books, 1991.

Govignon, Brigitte. *The Abrams Encyclopedia of Photography.* New York: H.N. Abrams, 2004.

Hannavy, John, ed. *Encyclopedia of Nineteenth-Century Photography*. New York: Routledge, Taylor & Francis Group, 2007.

Heller, Jules, and Nancy Heller. *North American Women Artists of the Twentieth Century: A Biographical Dictionary*. New York: Garland, 1995.

Huyghe, Rene, ed. *Larousse Encyclopedia of Modern Art from 1800 to the Present Day*. Updated ed. New York: Excalibur, 1981.

Jervis, Simon. *The Penguin Dictionary of Design and Designers*. London: A. Lane, 1984.

Jones, Lois Swan. *Art Information and the Internet: How to Find It, How to Use It*. Chicago; London: Fitzroy Dearborn, 1999.

———. *Art Information: Research Methods and Resources*. 3rd ed. Dubuque, Iowa: Kendall/Hunt, 1990.

Julier, Guy. *The Thames & Hudson Dictionary of Design Since 1900*. 2nd ed. London; New York: Thames & Hudson, 2005.

Kort, Carol, and Liz Sonneborn. *A to Z of American Women in the Visual Arts*. New York: Facts on File, 2002.

Lucie-Smith, Edward. *Lives of the Great Twentieth-Century Artists*. New York: Thames & Hudson, 1999.

Maillard, Robert, ed. *New Dictionary of Modern Sculpture*. New York: Tudor, 1970.

Morgan, Ann Lee. *The Oxford Dictionary of American Art and Artists*. Oxford, England; New York: Oxford University Press, 2007. Also available as an electronic database by subscription.

Norman, Geraldine. *Nineteenth-Century Painters and Painting: A Dictionary*. Berkeley, Calif.: University of California Press, 1977.

Osborne, Harold. *The Oxford Companion to Twentieth-Century Art*. Oxford, England: Oxford University Press, 1981.

Pehnt, Wolfgang, ed. *Encyclopedia of Modern Architecture*. New York: H.N. Abrams, 1964.

Phaidon Dictionary of Twentieth-Century Art. Oxford, England: Phaidon, 1973.

The Prestel Dictionary of Art and Artists in the 20th Century. Munich, Germany; New York: Prestel, 2000.

Sennott, R. Stephen. ed. *Encyclopedia of 20th Century Architecture*. 3 vols. New York: Fitzroy Dearborn, 2004.

Spalding, Frances. *20th Century Painters and Sculptors*. Woodbridge, England: Antique Collector's Club, 1990.

Turner, Jane, ed. *The Dictionary of Art*. New York: Grove's Dictionaries, 1996. Also available as an electronic database by subscription.

Walker, John. *Glossary of Art, Architecture and Design Since 1945*. 3rd ed. Boston: G.K. Hall, 1992.

Warren, Lynne. *Encyclopedia of Twentieth-Century Photography*. New York: Routledge, 2006.

Woodham, Jonathan M. *A Dictionary of Modern Design*. Oxford, England; New York: Oxford University Press, 2004.

C. Architecture, Engineering, and Design

Arnheim, Rudolph. *The Dynamics of Architectural Form*. Berkeley and Los Angeles, Calif.: University of California Press, 1977.

Banham, R. *Theory and Design in the First Machine Age*. 2nd ed. New York: Praeger, 1960.

Behrendt, Walter. *Modern Building: Its Nature, Problems and Forms*. London: M. Kopkins, 1936.

Benevelo, Leonardo. *History of Modern Architecture*. 2 vols. Trans. H.J. Landry. Cambridge, Mass.: MIT Press, 1971.

Benton, Charlotte, et al. *Art Deco 1910–1939*. New York: Bulfinch Press, 2003.

Blake, Peter. *The Master Builders: Le Corbusier, Mies van der Rohe, Frank Lloyd Wright*. New York: Norton, 1996.

———. *No Place Like Utopia: Modern Architecture and the Company We Kept*. New York: Knopf, 1993.

Bouillon, Jean Paul. *Art Deco, 1903–1940*. New York: Rizzoli, 1989.

Brooks, H. Allen. *The Prairie School: Frank Lloyd Wright and His Mid-West Contemporaries*. Toronto: University of Toronto Press, 1972.

Coleman, Nathaniel. *Utopias and Architecture*. New York: Routledge, 2005.

Crook, J. Mordant. *The Dilemma of Style: Architectural Ideas from the Picturesque to the Post Modern*. Chicago: University of Chicago Press, 1987.

Curtis, William. *Modern Architecture Since 1900*. 3rd ed. Upper Saddle River, N.J.: Prentice Hall, 1996.

Dal Co, Francesco. *Figures of Architecture and Thought: German Architectural Culture, 1890–1920*. New York: Rizzoli, 1986.

———. *Transformations in Modern Architecture*. Greenwich, Conn.: New York Graphic Society, 1980.

Dean, Andrea Oppenheimer, ed. *Bruno Zevi on Modern Architecture*. New York: Rizzoli, 1983.

Drexler, Arthur. *Transformations in Modern Architecture*. New York: MOMA, 1979.

Fitch, James. *American Building: The Historical Forces That Shaped It*. 2 vols. 2nd ed. Boston: Houghton Mifflin, 1966–72.

Frampton, Kenneth. *Modern Architecture: A Critical History*. World of Art. 4th ed. London; New York: Thames & Hudson, 2007.

Giedion, Sigfried. *Space, Time, and Architecture: The Growth of a New Tradition*. 5th ed., rev. and enl. Cambridge, Mass.: Harvard University Press, 1967.

Goode, Patrick, ed. *The Oxford Companion to Architecture*. New York: Oxford University Press, 2010.

Gössel, Peter. *Architecture in the Twentieth Century*. Köln, Germany; London: Taschen, 2001.

Heyer, Paul. *Architects on Architecture*. New York: Van Nostrand Reinhold, 1993.

Hitchcock, Henry-Russell. *Architecture: Nineteenth and Twentieth Centuries*. 4th ed., rev. Yale Univesity Press Pelican History of Art. Harmondsworth: Penguin, 1987, 1977.

Jencks, Charles. *Modern Movements in Architecture*. 2nd. ed. New York: Penguin, 1985.

Kostof, Spiro. *History of Architecture: Settings and Rituals*. 2nd ed. New York: Oxford University Press, 1995.

Kultermann, Udo. *Architecture in the Twentieth Century*. New York: Van Nostrand Reinhold, 1993.

Lampugnani, Vittorio. *Encyclopedia of Twentieth-Century Architecture*. New York: H.N. Abrams, 1986.

Leach, Neil. *Rethinking Architecture: A Reader in Cultural Theory*. New York: Routledge, 1996.

Le Corbusier (Charles-Édouard Jeanneret). *Toward an Architecture*. Introd. by J.-L. Cohen; trans. by J. Goodman. Los Angeles, Calif.: Getty Research Institute, 2007.

Lemaire, Sylvie, ed. *Looking at European Architecture: A Critical View*. Brussels: CIVA, 2008.

Loyer, François. *Architecture of the Industrial Age*. New York: Skira, 1983.

Maddex, Diane, ed. *Master Builders: A Guide to Famous American Architects*. Washington, D.C.: Preservation Press, 1985.

Meeks, Carol. *The Railroad Station: An Architectural History*. New Haven, Conn.: Yale University Press, 1995.

Middleton, Robin, and David Watkin. *Neoclassical and 19th-Century Architecture*. 2 vols. History of World Architecture. New York: Electa/Rizzoli, 1987.

Mignot, Claude. *Architecture of the Nineteenth Century in Europe*. New York: Rizzoli, 1984.

Mumford, Lewis. *The Culture of Cities*. Reprint of the 1940 ed. London: Routledge/Thoemmes, 1997.

———. *Technics and Civilization*. New York: Routledge, 1934.

Nelson, George. *Building a New Europe: Portraits of Modern Architects: Essays by George Nelson, 1935–1936*. New Haven, Conn.: Yale University Press, 2007.

Pehnt, Wolfgang. *Expressionist Architecture*. London: Thames & Hudson, 1973.

Peter, John. *The Oral History of Modern Architecture: Interviews With the Greatest Architects of the Twentieth Century*. New York: H.N. Abrams, 1994.

Pevsner, Nikolaus. *Pioneers of Modern Design: From William Morris to Walter Gropius*. 4th ed. New Haven, Conn.; London: Yale University Press, 2005.

———. *The Sources of Modern Architecture and Design*. World of Art. New York: Thames & Hudson, 1985, 1968.

Pierson, William, and William H. Jordy. *American Buildings and Their Architects*. 4 vols. New York: Oxford University Press, 1986.

Pommer, Richard, ed. "Revising Modernist History: The Architecture of the 1920s and 1930s." *Art Journal* (Summer 1983) special issue.

Read, Herbert. *Art and Industry*. 5th ed. London: Faber, 1966.

Richards, J. M., ed. *The Anti-Rationalists and the Rationalists*. Oxford, England; Boston: Architectural Press, 2000.

Riesebero, Bill. *Modern Architecture and Design: An Alternative History*. Cambridge, Mass.: MIT Press, 1983.

———. *The Story of Western Architecture*. 3rd ed. Cambridge, Mass.: MIT Press, 2001.

Roth, Leland. *American Architecture: A History*. Boulder, Colo.: Westview Press, 2001.

———. *Understanding Architecture: Its Elements, History and Meaning*. New York: Harper & Row, 1993.

Rudofsky, Bernard. *Architecture Without Architects: An Introduction to Non-Pedigreed Architecture*. New York: MOMA, 1964.

Schafter, Debra, *The Order of Ornament, the Structure of Style: Theoretical Foundations of Modern Art and Architecture*. Cambridge, England; New York: Cambridge University Press, 2003.

Scully, Vincent. *American Architecture and Urbanism*. Rev. ed. New York: H. Holy, 1988.

———. *Modern Architecture and Other Essays*. Princeton, N.J.: Princeton University Press, 2003.

———. *Modern Architecture: The Architecture of Democracy*. Rev. ed. New York: G. Braziller, 1974.

Sharp, Dennis, ed. *Twentieth-Century Architecture: A Visual History*. Millennial ed. Mulgrave, Victoria, Australia: Images Publishing, 2002.

Silver, Nathan. *Lost New York*. Exp. and updated ed. Boston: Houghton Mifflin, 2000.

Tafuri, Manfredo. *Modern Architecture*. 2 vols. History of World Architecture. New York: Electa/Rizzoli, 1986.

Trachtenberg, Marvin, and Isabelle Hyman. *Architecture: From Pre-history to Post-Modernity*. 2nd ed. New York: H.N. Abrams, 2002.

Troy, Nancy. *Modernism and the Decorative Arts in France: Art Nouveau to Le Corbusier*. New Haven, Conn.: Yale University Press, 1991.

Tunnard, Christopher, and Boris Pushkarev. *Man-Made America: Chaos or Control?* New Haven, Conn.: Yale University Press, 1963.

Vidler, Anthony. *The Architectural Uncanny: Essays in the Modern Unhomely*. Cambridge, Mass.: MIT Press, 1992.

———. *Histories of the Immediate Present: Inventing Architectural Modernism*. Cambridge, Mass.: MIT Press, 2008.

Wright, Gwendolyn. *USA: Modern Architectures in History*. London: Reaktion, 2008

D. Photography, Prints, and Drawing

Adams, Clinton. *American Lithographs, 1900–1960: The Artists and Their Prints*. Albuquerque, N.Mex.: University of New Mexico Press, 1983.

Adams, Robert. *Beauty in Photography: Essays in Defense of Traditional Values*. 2nd ed. New York: Aperture, 1989.

Ades, Dawn. *Photomontage*. World of Art. Rev. and enl. ed. London: Thames & Hudson, 1986.

Badger, Gerry. *Collecting Photography*. London: Mitchell Beazley, 2003.

Barthes, Roland. *Camera Lucida, Reflections on Photography*. Trans. R. Howard. London: Vintage, 1993, 1981.

Batchen, Geoffrey, ed. *Photography Degree Zero: Reflections on Roland Barthes's "Camera Lucida"*. Cambridge, Mass.: MIT Press, 2009.

Benjamin, Walter. *The Work of Art in the Age of Its Technological Reproducibility, and Other Writings on Media*. Ed. M.W. Jennings, et al. Trans. E. Jephcott, et al. Cambridge, Mass.: Belknap Press of Harvard University Press, 2008.

Bolton, Richard, ed. *The Contest of Meaning: Critical Histories of Photography*. Cambridge, Mass.: MIT Press, 1989.

Bretell, Richard, et al. *Paper and Light: The Calotype in Great Britain and France 1839–1870*. Boston: D.R. Godine, 1984.

Buerger, Janet E. *The Era of the French Calotype*. Rochester, N.Y.: International Museum of Photography at George Eastman House, 1982.

———. *French Daguerreotypes*. Chicago: University of Chicago Press, 1989.

Bunnell, Peter C. *Inside the Photograph: Writings on Twentieth-Century Photography*. New York: Aperture Foundation; Distr. D.A.P., 2006

———, ed. *A Photographic Vision: Pictorial Photography, 1889–1923*. Salt Lake City: Peregrine Smith, 1980.

Burgin, Victor. *Thinking Photography*. London: MacMillan, 1990.

Campany, David, ed. *Art and Photography*. Themes and Movements. London: Phaidon, 2003.

Castleman, Riva. *Modern Art in Prints*. New York: MOMA, 1973.

———. *Modern Artists as Illustrators*. New York: MOMA, 1981.

———. *Prints from Blocks: From Gauguin to Now*. New York: MOMA, 1983.

———. *Prints of the Twentieth Century*. London: Thames & Hudson, 1988.

Clarke, Graham. *The Photograph*. Oxford, England; New York: Oxford University Press, 1997.

Coe, Brian. *Colour Photography: The First Hundred Years, 1840–1940*. London: Ash & Grant, 1978.

———, and Paul Gates. *The Snapshot Photograph: The Rise of Popular Photography, 1888–1939*. London: Ash & Grant, 1977.

Coke, Van Deren. *One Hundred Years of Photographic History: Essays in Honor of Beaumont Newhall*. Albuquerque, N.Mex.: University of New Mexico Press, 1975.

Daval, Jean-Luc. *Photography: History of an Art*. New York: Rizzoli, 1982.

Davis, Keith F. *Hallmark Photographic Collection: An American Century of Photography: from Dry-plate to Digital: the Hallmark Photographic Collection*. 2nd ed., rev. and enl. Kansas City, Mo: Hallmark Cards in association with H.N. Abrams, 1999.

Doty, Robert, ed. *Photography in America*. New York: WMAA, 1974.

Edwards, Steve. *Photography: A Very Short Introduction*. Oxford, England; New York: Oxford University Press, 2006.

Fabian, Rainer, and Hans-Christian Adam. *Masters of Early Travel Photography*. New York: Vendome Press, 1983.

Fleischhauer, Carl, ed. *Documenting America, 1935–1943*. Berkeley, Calif.: University of California Press in association with the Library of Congress, 1988.

Freund, Gisele. *Photography & Society*. Boston: D.R. Godine, 1980.

Frizot, Michel. *A New History of Photography*. Köln, Germany: Könemann, 1998.

Galassi, Peter. *American Photography, 1890–1965, from the Museum of Modern Art, New York*. New York: MOMA: Distr. H.N. Abrams, 1995.

Galassi, Peter. *Before Photography: Painting and the Invention of Photography*. New York: MOMA, 1981.

Gernsheim, Helmut, *The History of Photography: From the Camera Obscura to the Beginning of the Modern Era*. 2 vols. 3rd rev. ed. London; New York: Thames & Hudson, 1982–88.

Gidal, Tim N. *Modern Photojournalism: Origin and Evolution: 1910–1933*. New York: Collier, 1972.

Gilmour, Pat, ed. *Lasting Impressions: Lithography as Art*. London: Alexandria Press, 1988.

Goldberg, Vicki, ed. *Photography in Print: Writings from 1816 to the Present*. New York: Simon and Schuster, 1981.

Golden, Reuel, comp. *Photojournalism, 1855 to the Present: Editor's Choice*. New York: Abbeville Press, 2006.

Goldschmidt, Lucien. *The Truthful Lens: A Survey of the Photographically Illustrated Book, 1844–1914*. New York: Grolier Club, 1980.

Gover, C. Jane. *The Positive Image: Women Photographers in Turn of the Century America*. Albany, N.Y.: SUNY Press, 1988.

Green, Jonathan. *Camera Work: A Critical Anthology*. Millerton, N.Y.: Aperture, 1973.

———, ed. *The Snapshot*. Millerton, N.Y.: Aperture, 1974.

Greenough, Sarah, et al. *On the Art of Fixing a Shadow: One Hundred and Fifty Years of Photography*. Chicago: Art Institute of Chicago, 1989.

Hambourg, Maria Morris, et al. *The Waking Dream: Photography's First Century*. New York: MMA, 1993.

Harker, Margaret. *The Linked Ring: The Secession Movement in Photography in Britain, 1892–1910*. London: Heinemann, 1979.

Harnsberger, R. Scott. *Four Artists of the Stieglitz Circle: A Sourcebook on Arthur Dove, Marsden Hartley, John Marin, and Max Weber*. Westport, Conn.: Greenwood Press, 2002.

Hartmann, Sadakichi. *The Valiant Knights of Daguerre: Selected Critical Essays on Photography and Profiles of Photographic Pioneers*. Ed. H. W. Lawton and G. Knox. Berkeley, Calif.: University of California Press, 1978.

Hirsch, Robert. *Seizing the Light: A Social History of Photography*. New York: McGraw-Hill Higher Education, 2009.

Hobgen, Carol, and Rowan Watson, eds. *From Manet to Hockney: Modern Artists' Illustrated Books*. London: Victoria and Albert Museum, 1985.

Homer, William I. *Stieglitz and the Photo-Secession, 1902*. Ed. by C. Johnson. New York: Viking Studio, 2002.

Jammes, André, and Eugenia Janis. *The Art of French Calotype*. Princeton, N.J.: Princeton University Press, 1983.

Jeffrey, Ian. *Photography: A Concise History*. London: Thames & Hudson, 1981.

Johnson, William. *Nineteenth-Century Photography: An Annotated Bibliography, 1839–1879*. Boston: G.K. Hall, 1990.

Koetzle, Hans-Michael. *Photo Icons: The Story Behind the Pictures*. 2 vols. Köln, Germany; New York: Taschen, 2002.

Kozloff, Max. *Photography and Fascination: Essays*. Danbury, N.H.: Addison House, 1979.

———. *The Privileged Eye: Essays on Photography*. Albuquerque, N.Mex.: University of New Mexico Press, 1987.

———. *The Theatre of the Face: Portrait Photography Since 1900*. London; New York: Phaidon, 2007.

Lavin, Maud, et al. *Montage and Modern Life, 1919–1942*. Cambridge, Mass. and Boston: MIT Press and Institute of Contemporary Art, 1992.

Lenman, Robin, ed. *The Oxford Companion to the Photograph*. Oxford; New York: Oxford University Press, 2005.

Lewinski, Jorge. *The Camera at War*. London: W. H. Allen, 1978.

Long, J. J., Andrea Noble, and Edward Welch, eds. *Photography: Theoretical Snapshots*. New York: Routledge, 2009.

Lynes, Barbara Buhler, and Jonathan Weinberg, eds. *Shared Intelligence: American Painting and the Photograph*. Berkeley, C.A.: University of California Press; Santa Fe, N.M.: the Georgia O'Keeffe Museum, 2011.

Marien, Mary Warner. *Photography: A Cultural History*. 3rd ed. Upper Saddle River, N.J.: Pearson Prentice Hall, 2011.

Mayor, A. Hyatt. *Prints and People: A Social History of Printed Pictures*. Rev. and updated. Princeton, N.J.: Princeton University Press, 1980, 1971.

Mellor, David, ed. *Germany: The New Photography, 1927–33*. London: Arts Council of Great Britain, 1978.

Morris, Rosalind C., and Nicholas Thomas, eds. *Photographies East: The Camera and Its Histories in East and Southeast Asia*. Durham, N.C.: Duke University Press Books, 2009.

Naef, Weston. *Fifty Pioneers of Modern Photography: The Collection of Alfred Stieglitz*. New York: MMA, 1978.

Newhall, Beaumont. *The History of Photography from 1839 to the Present*. Completely rev. and enl. 5th ed. New York: MOMA; Boston: Distr. Bulfinch Press/Little, Brown and Company, 1999.

———, ed. *Photography: Essays and Images*. New York: MOMA, 1980.

Orvell, Miles. *American Photography*. Oxford, England; New York: Oxford University Press, 2003.

Osborne, Peter D. *Travelling Light: Photography, Travel and Visual Culture*. Manchester, England; New York: Manchester University Press; Distr. in the U.S. by St. Martin's Press, 2000.

Petherbridge, Deanna. *The Primacy of Drawing: Histories and Theories of Practice*. New Haven, Conn.: Yale University Press, 2010.

Petruck, Peninah, ed. *The Camera Viewed: Writings on Twentieth-Century Photography*. 2 vols. New York: Dutton, 1979.

Phillips, Christopher, ed. *Photography in the Modern Era: European Documents and Critical Writings, 1913–1940*. New York: MMA, 1989.

Pyne, Kathleen A. *Modernism and the Feminine Voice: O'Keeffe and the Women of the Stieglitz Circle*. Berkeley, Calif.: University of California Press, 2007.

Roberts, Pam. *A Century of Colour Photography: From the Autochrome to the Digital Age*. London: Andre Deutsch, 2007.

Rosenblum, Naomi. *A World History of Photography*. 4th ed. New York: Abbeville Press, 2007.

Rosenblum, Naomi. *A History of Women Photographers*. 3rd ed. New York: Abbeville Press, 2010.

Sandler, Martin W. *Against the Odds: Women Pioneers in the First Hundred Years of Photography*. New York: Rizzoli, 2002.

Sobieszek, Robert A. *The Art of Persuasion: A History of Advertising Photography*. New York: H.N. Abrams, 1988.

Solomon-Godeau, Abigail. *Photography at the Dock*. Minneapolis, Minn.: University of Minnesota Press, 1991.

Sontag, Susan. *On Photography*. New York: Farrar, Straus and Giroux, 1973.

Stieglitz, Alfred. *Stieglitz on Photography: His Selected Essays and Notes*. Comp.and annotated by Richard Whelan. New York: Aperture, 2000.

———, ed. *Camera Work: A Photographic Quarterly*. Reprint. New York: A. Stieglitz, 1969.

Stott, William. *Documentary Expression and Thirties America*. Reprint. Chicago: University of Chicago Press, 1986.

Szarkowski, John. *The Photographer's Eye*. New York: MOMA and Doubleday, 1977.

———. *Photography Until Now*. New York: MOMA, 1989.

Tagg, John. *The Burden of Representation: Essays on Photographies and Histories*. Amherst, Mass.: University of Massachusetts Press, 1988.

Trachtenberg, Allan, ed. *Classic Essays on Photography*. New Haven, Conn.: Leeter's Island Books, 1980.

———. *Reading American Photographs: Images as History: Mathew Brady to Walker Evans*. New York: Hill and Wang, 1989.

Watrous, James. *American Printmaking: A Century of American Printmaking, 1880–1980*. Madison, Wis.: University of Wisconsin Press, 1984.

Weaver, Mike, ed. *The Art of Photography, 1839–1989*. New Haven, Conn.: Yale University Press, 1989.

Wells, Liz, ed. *Photography: A Critical Introduction*. 4th ed. New York: Routledge, 2009.

E. Painting and Sculpture

Auping, Michael, ed. *Abstraction, Geometry, Painting*. New York: H.N. Abrams, 1989.

Barron, Stephanie, and Sabine Eckmann. *Exiles + Emigrés: The Flight of European Artists from Hitler*. With contributions by Matthew Affron, et al. Los Angeles: LOCMA; New York: Abrams, 1997.

Braun, Emily, ed. *Italian Art in the 20th Century: Painting and Sculpture, 1900–1988*. Munich: Prestel, 1989.

Clement, Russell T. *A Sourcebook of Gauguin's Symbolist Followers: Les Nabis, Pont-Aven, Rose + Croix*. Westport, CT: Praeger, 2004.

Curtis, Penelope. *Sculpture 1900-1945: After Rodin*. Oxford; New York: Oxford University Press, 1999.

Eitner, Lorenz. *An Outline of Nineteenth Century European Painting: From David to Cézanne*. Rev. ed. Boulder, Colo.: Westview Press, 2002.

Fink, Lois Marie, and Joshua C. Taylor. *Academy: The Academic Tradition in American Art*. Chicago: University of Chicago Press, 1978.

Gaiger, Jason. *Aesthetics and Painting*. London; New York: Continuum Press, 2008.

Hamilton, George H. *Painting and Sculpture in Europe, 1880–1940*. 6th ed. with a revised bibliography by R. Cork. New Haven, Conn.: Yale University Press, 1993.

Hammacher, A. M. *Modern Sculpture: Tradition and Innovation*. Enl. ed. New York: H.N. Abrams, 1988.

Hughes, Robert. *Shock of the New*. 2nd ed. New York: McGraw-Hill, 1991.

Hunter, Sam, and John Jacobus. *Modern Art: Painting, Sculpture, Architecture*. 2nd ed. Englewood Cliffs, N.J.: Prentice Hall, 1985.

Janson, H. W. *Nineteenth-Century Sculpture*. New York: H.N. Abrams, 1985.

Joachimides, Christos, et al., eds. *German Art in the Twentieth Century: Painting and Sculpture, 1905–1985*. London: Royal Academy of Arts, 1985.

Lane, John, and Susan Larsen, eds. *Abstract Painting and Sculpture in America: 1927–1944*. Pittsburgh: Museum of Art, Carnegie Institute, 1983.

Le Normand-Romain, Antoinette, et al. *Sculpture: The Adventure of Modern Sculpture in the Nineteenth and Twentieth Centuries*. New York: Rizzoli, 1986.

Lieberman, William S. *Painters in Paris, 1895–1950*. New York: MMA: Distr. H.N. Abrams, 2000.

———, ed. *Modern Masters: Manet to Matisse*. New York: MOMA, 1975.

Lynton, Norbert. *The Story of Modern Art*. 2nd ed. Oxford, England: Phaidon, 1989.

Modern Sculpture Reader. Ed. Jon Wood, et al. Leeds, England: Henry Moore Institute, 2007.

Novak, Barbara. *American Painting in the Nineteenth Century: Realism, Idealism, and the American Experience*. 3rd ed. Oxford, England; New York: Oxford University Press, 2007.

———. *Nature and Culture: American Landscape and Painting, 1825–1875*. 3rd ed., with a new preface. New York: Oxford University Press, 2007.

Painting and Sculpture in the Museum of Modern Art: Catalog of the Collection: With Selected Works on Paper to January 1988. Ed. by Alicia Legg with Mary Beth Smalley. New York: The Museum, 1989, 1988.

Penny, Nicholas. *The Materials of Sculpture*. New Haven, Conn.: Yale University Press, 1993.

Potts, Alex. *The Sculptural Imagination: Figurative, Modernist, Minimalist*. New Haven, Conn.: Yale University Press, 2000.

Reynolds, Donald M. *Masters of American Sculpture: the Figurative Tradition from the American Renaissance to the Millennium.* New York: Abbeville Press, 1993.

The Rise of Modern Japanese Art. Greenwich, CT: Shorewood Fine Art Books, 1999.

Rosenblum, Robert. *Modern Painting and the Northern Romantic Tradition: Friedrich to Rothko.* New York: Harper & Row, 1975.

———, and H. W. Janson. *Nineteenth-Century Art.* Rev. and updated ed. Upper Saddle River, N.J.: Pearson Prentice Hall, 2005.

Russell, John. *The Meanings of Modern Art.* Rev. ed. New York: MOMA and HarperCollins, 1991.

Schapiro, Meyer. *Modern Art: 19th and 20th Centuries: Selected Papers.* New York: G. Braziller, 1978.

Selz, Jean. *Art in Our Times: A Pictorial History, 1890–1980.* New York: H.N. Abrams, 1981.

Shone, Richard. *The Art of Bloomsbury: Roger Fry, Vanessa Bell, and Duncan Grant.* London: Tate, 1999.

Sidlauskas, Susan. *Body, Place, and Self in Nineteenth-Century Painting.* Cambridge; New York: Cambridge University Press, 2000.

Spalding, Frances. *British Art Since 1900.* London: Thames & Hudson, 1986.

Steinberg, Leo. *Other Criteria: Confrontations with Twentieth-Century Art.* New York: Oxford University Press, 1972.

Swiss Made: Precision and Madness: Swiss Art from Hodler to Hirschhorn. Texts by Markus Brüderlin, et al. Ostfildern-Ruit, Germany: Hatje Cantz, 2007.

Tomkins, Calvin. *The Bride and the Bachelors: Five Masters of the Avant-Garde.* Exp. ed. Harmondsworth, England; New York: Penguin, 1976.

Tuchman, Maurice. *The Spiritual in Art: Abstract Painting 1890–1985.* Los Angeles: LACMA, 1986.

Varnedoe, Kirk. *Northern Light: Realism and Symbolism in Scandinavian Painting 1880–1910.* New York: Brooklyn Museum, 1982.

Waldman, Diane. *Collage, Assemblage, and the Found Object.* New York: H.N. Abrams, 1992.

II. Further Readings, Arranged by Chapter

1. The Origins of Modern Art

Adams, Steven. *The Barbizon School and the Origins of Impressionism.* London: Phaidon, 1994.

Ashton, Dore. *Rosa Bonheur: A Life and a Legend.* New York: Viking, 1981.

Baudelaire, Charles. *Eugène Delacroix: His Life and Work.* Trans. J. Bernstein. New York: Lear Publishers, 1947.

Boime, Albert. *Art in an Age of Civil Struggle, 1848–1871. A Social History of Modern Art*; vol. 4. Chicago: University of Chicago Press, 2007.

———. *Art in an Age of Counterrevolution, 1815–1848. A Social History of Modern Art*; vol. 3. Chicago: University of Chicago Press, 2004.

Bordes, Philippe. *Jacques-Louis David: Empire to Exile.* New Haven, Conn.: Yale University Press, 2005.

Bowness, Alan. *Gustave Courbet: 1819–1877.* London: Arts Council of Great Britain, 1978.

Brettell, Richard R. *Modern Art, 1851–1929: Capitalism and Representation.* Oxford, England; New York: Oxford University Press, 1999.

Brookner, Anita. *Jacques-Louis David.* London: Oxford University Press, 1980.

Bryson, Norman. *Tradition and Desire: From David to Delacroix.* Cambridge and New York: Cambridge University Press, 1984.

Chu, Petra T. D., ed. *Courbet in Perspective.* Englewood Cliffs, N.J.: Prentice Hall, 1977.

Clark, Timothy J. *Image of the People: Gustave Courbet and the 1848 Revolution.* Berkeley, Calif.: University of California Press, 1999.

Crow, Thomas. *Emulation: Making Artists for Revolutionary France.* New Haven, Conn.: Yale University Press, 1995.

[Delacroix] *Eugène Delacroix (1798–1863): Paintings, Drawings, and Prints from North American Collections.* New York: MMA, 1991.

[Delacroix] *The Journal of Eugène Delacroix.* New York: Garland Pub., 1972. Introd. by R. Motherwell.

Faunce, Sarah, ed. *Courbet Reconsidered.* New Haven, Conn.: Yale University Press, 1988.

Fermigier, André. *Jean-François Millet.* London: Hayward Gallery, 1976.

Fried, Michael. *Courbet's Realism.* Chicago: University of Chicago Press, 1990.

———. *Menzel's Realism: Art and Embodiment in Nineteenth-Century Berlin.* New Haven, Conn.: Yale University Press, 2002.

Hargrove, June, ed. *The French Academy: Classicism and Its Antagonists.* Newark, N.J.: University of Delaware Press, 1990.

Hoozee, Robert, ed. *British Vision: Observation and Imagination in British Art, 1750–1950.* With introd. essays by John Gage and Timothy Hyman. Brussels: Mercatorfonds; Ghent: Museum voor Schone Kunsten; Distr. Cornell University Press, 2007.

Jansen, Leo. *Vincent Van Gogh: Painted with Words: the Letters to Émile Bernard.* New York: Rizzoli, in assoc. with the Morgan Library & Museum and the Van Gogh Museum, Amsterdam, 2007.

Johnson, Dorothy. *David to Delacroix: the Rise of Romantic Mythology.* Chapel Hill, N.C.: University of North Carolina Press, 2011.

Johnson, Lee. *The Paintings of Eugène Delacroix: A Critical Catalogue, 1816–1831.* 2 vols. Oxford: Clarendon Press, 1981.

Joll, Evelyn, et al. *The Oxford Companion to J.M.W Turner.* Oxford, England: Oxford University Press, 2001.

Landow, George P. *William Holman Hunt and Typological Symbolism.* New Haven, Conn.: Paul Mellon Centre for Studies in British Art, 1979.

Licht, Fred. *Goya.* Rev. ed. New York: Abbeville Press, 2001.

———, ed. *Goya in Perspective.* Englewood Cliffs, N.J.: Prentice Hall, 1973.

Murphy, Alexandra R. *Jean-François Millet.* Boston: MOFA, 1984.

Prettejohn, Elizabeth. *Art for Art's Sake: Aestheticism in Victorian Painting.* New Haven, Conn.: Yale University Press in association with Paul Mellon Centre for Studies in British Art, 2007.

Rosenblum, Robert. *Jean-Auguste-Dominique Ingres.* New York: H.N. Abrams, 1990.

Schnapper, Antoine. *David.* New York: Alpine Fine Arts Collection, 1980.

Siegfried, Susan L. *Ingres: Painting Reimagined.* New Haven, Conn.: Yale University Press, 2009.

Stanton, Theodore, ed. *Reminiscences of Rosa Bonheur.* New York: Hacker Art Books, 1976.

Vigne, George. *Ingres.* Trans. J. Goodman. New York: Abbeville Press, 1995.

2. The Search for Truth: Early Photography, Realism, and Impressionism

Adler, Kathleen. *Manet.* Oxford, England: Phaidon, 1986.

———, and Tamar Garb. *Berthe Morisot.* Ithaca, N.Y.: Cornell University Press, 1987.

Barger, Susan M., and William B. White. *The Daguerreotype: Nineteenth-Century Technology and Modern Science.* Washington, D.C.: Smithsonian Institution Press, 1991.

Belloli, Andrea. *A Day in the Country: Impressionism and the French Landscape.* Los Angeles: LACMA, 1984.

Boggs, Jean Sutherland. *Degas.* Chicago: Art Institute of Chicago, 1996.

Boime, Albert. *The Art of the Macchia and the Risorgimento.* Chicago: University of Chicago Press, 1993.

Breeskin, Adelyn Dohme. *Mary Cassatt: A Catalogue Raisonné of the Oils, Pastels, Watercolors, and Drawings.* 2nd rev. ed. Washington, D.C.: Smithsonian Institution Press, 1979.

Brettell, Richard R. *Impression: Painting Quickly in France, 1860–1890.* New Haven, Conn.: Yale University Press in assoc. with the Sterling and Francine Clark Art Institute, Williamstown, Mass., 2000.

———, and Joachim Pissarro. *The Impressionist and the City: Pissarro's Series Paintings.* New Haven, Conn.: Yale University Press, 1992.

Broude, Norma. *Edgar Degas.* New York: Rizzoli, 1993.

———. *Impressionism: A Feminist Reading.* New York: Rizzoli, 1991.

Buckland, Gail. *Fox Talbot and the Invention of Photography.* Boston: D.R. Godine, 1980.

Callen, Anthea. *The Spectacular Body: Science, Method, and Meaning in the Work of Degas.* New Haven, Conn.: Yale University Press, 1995.

Casteras, Susan, et al. *John Ruskin and the Victorian Eye.* New York: H.N. Abrams, 1993.

Cikovsky, Jr., Nicolai, and Franklin Kelly. *Winslow Homer.* Washington: National Gallery of Art; New Haven, Conn.: Yale University Press, 1995.

Clark, T. J. *The Absolute Bourgeois: Artists and Politics in France, 1848–1851.* Reprint of the 1973 ed. Berkeley, Calif.: University of California Press, 1999.

———. *The Painting of Modern Life: Paris in the Art of Manet and His Followers.* New York: Knopf, 1985.

Clarke, Michael. *Corot and the Art of Landscape.* London: British Museum Press, 1991.

Clayson, Hollis. *Paris in Despair: Art and Everyday Life Under Siege (1870–71).* Chicago: University of Chicago Press, 2002.

Cooper, Suzanne F. *Pre-Raphaelite Art in the Victoria and Albert Museum.* London: V&A Publications; New York: Distr. H.N. Abrams, 2003.

Cox, Julian. *Julia Margaret Cameron: The Complete Photographs.* Contrib. Joanne Lukitsh and Philippa Wright. Los Angeles: Getty Publications in association with the National Museum of Photography, Film & Television, Bradford, England, 2003.

Cumming, Elizabeth, and Wendy Caplan. *Arts and Crafts Movement.* World of Art. New York: Thames & Hudson, 1991.

[Degas] *Pastels.* New York: G. Braziller, 1992. Texts by J. S. Boggs and A. Maheux.

Denvir, Bernard, ed. *The Thames & Hudson Encyclopedia of Impressionism.* World of Art. New York: Thames & Hudson, 1990.

Distel, Anne. *Renoir.* New York: Abbeville Press, 2010.

Dorment, Richard. *James McNeill Whistler.* New York: H.N. Abrams, 1995.

Fried, Michael. *Manet's Modernism, or, the Face of Painting in the 1860s.* Chicago: University of Chicago Press, 1996.

Gernsheim, Helmut. *Julia Margaret Cameron: Pioneer of Photography.* 2nd ed. London and New York: Aperture, 1975.

———, and Alison Gernsheim. *L. J. M. Daguerre: The History of the Diorama and the Daguerreotype.* Reprint. New York: Dover Publications, 1968.

Getlein, Frank. *Mary Cassatt: Paintings and Prints.* New York: Abbeville Press, 1980.

Goodrich, Lloyd. *Thomas Eakins.* 2 vols. Cambridge, Mass.: Harvard University Press, 1982.

Gordon, Robert, and Andrew Forge. *Monet.* New York: H.N. Abrams, 1983.

Gosling, Nigel. *Nadar.* New York: Knopf, 1976.

Gotz, Adriani. *Renoir.* Cologne: Dumont; Distr. Yale University Press, 1999.

Gray, Michael, et al. *First Photographs: William Henry Fox Talbot and the Birth of Photography.* New York: PowerHouse Books in assoc. with the Museum of Photographic Arts, San Diego, 2002.

Griffin, Randall C. *Winslow Homer: An American Vision.* London; New York: Phaidon, 2006.

Haas, Robert B. *Muybridge: Man in Motion.* Berkeley and Los Angeles, Calif.: University of California Press, 1976.

Hambourg, Maria Morris. *Nadar.* New York: MMA; Distr. H.N. Abrams, 1995.

Hamilton, George. *Manet and His Critics.* Reprint of the 1954 ed. New Haven, Conn.: Yale University Press, 1986.

Hanson, Anne Coffin. *Manet and the Modern Tradition.* 2nd ed. New Haven, Conn.: Yale University Press, 1979.

Herbert, Richard. *Impressionism: Art, Leisure and Parisian Society.* New Haven, Conn.: Yale University Press, 1988.

Higonnet, Anne. *Berthe Morisot.* New York: Harper & Row, 1990.

———. *Berthe Morisot's Images of Women.* Cambridge, Mass.: Harvard University Press, 1992.

Hills, Patricia. *John Singer Sargent.* New York: WMAA, 1986. Texts by L. Ayres, A. Boime, W. H. Gerdts, S. Olson, G. A. Reynolds.

Hilton, Timothy. *The Pre-Raphaelites.* World of Art. Reprint of the 1970 ed. London: Thames & Hudson, 1985.

Hofmann, Werner. *Degas: A Dialogue of Difference.* London; New York: Thames & Hudson, 2007.

House, John. *Monet: Nature into Art.* New Haven, Conn.: Yale University Press, 1986.

Jenkyns, Richard. *Dignity and Decadence: Victorian Art and the Classical Inheritance.* Cambridge, Mass.: Harvard University Press, 1992.

Johns, Elizabeth. *Thomas Eakins and the Heroism of Modern Life.* Princeton, N.J.: Princeton University Press, 1984.

———. *Winslow Homer: The Nature of Observation.* Berkeley, Calif.: University of California Press, 2002.

Kendall, Richard, and Griselda Pollock, eds. *Dealing with Degas: Representations of Women and the Politics of Vision*. New York: Universe Books, 1992.

Leja, Michael. *Looking Askance: Skepticism and American Art from Eakins to Duchamp*. Berkeley, Calif.: University of California Press, 2004.

Lemoine, Serge. *Paintings in the Musée d'Orsay*. Trans. T. Ballas. New York: H.N. Abrams, 2004.

Lewis, Mary Tompkins, ed. *Critical Readings in Impressionism and Post-Impressionism: An Anthology*. Berkeley, Calif.: University of California Press, 2007.

Lipton, Eunice. *Looking into Degas*. Berkeley, Calif.: University of California Press, 1986.

Livingstone, Karen, and Linda Parry, eds. *International Arts and Crafts*. London: Victoria and Albert; New York: Distr. H.N. Abrams, 2005.

Lochnan, Katharine A., and Carol Jacobi, eds. *Holman Hunt and the Pre-Raphaelite Vision*. Toronto and New Haven: Art Gallery of Ontario in association with Yale University Press, 2009.

Manet, Édouard. *Manet by Himself: Correspondence & Conversation, Paintings, Pastels, Prints & Drawings*. Ed. by J. Wilson-Bareau. Boston: Little, Brown, 1991.

[Manet] *Manet: 1832–1883*. New York: MMA, 1983.

Marley, Anna O., ed. *Henry Ossawa Tanner: Modern Spirit*. A George Gund Foundation Book in African American Studies. Berkeley, Calif. and Philadelphia, Pa.: University of California Press and Pennsylvania Academy of Fine Arts, 2012.

Marsh, Jan. *The Pre-Raphaelite Circle*. London: National Portrait Gallery, 2005.

Mathews, Nancy M. *Mary Cassatt: A Life*. New York: Villard Books, 1994.

Mary Cassatt, Modern Woman. Org. Judith A. Barter; Contrib. Erica E. Hirshler, et al. New York: Art Institute of Chicago in assoc. with H.N. Abrams, 1998.

Miller, David, ed. *American Iconology: New Approaches to Nineteenth-Century Art and Literature*. New Haven, Conn.: Yale University Press, 1993.

Moffett, Charles S. *The New Painting: Impressionism, 1874–1886*. San Francisco: Fine Arts Museums, 1986.

Mosby, Dewey, and Darrel Sewell. *Henry Ossawa Tanner*. Philadelphia and New York: Philadelphia Museum of Art and Rizzoli, 1991.

Needham, Gerald. *19th-Century Realist Art*. New York: Harper & Row, 1988.

Nochlin, Linda. *Impressionism and Post-Impressionism, 1874–1904: Sources and Documents*. Englewood Cliffs, N.J.: Prentice Hall, 1976.

———. *Realism*. Harmondsworth: Penguin, 1972.

———. *Realism and Tradition in Art, 1848–1900: Sources and Documents*. Englewood Cliffs, N.J.: Prentice Hall, 1966.

———. *Representing Women*. New York: Thames & Hudson, 1999.

Ormond, Richard. *John Singer Sargent: Complete Paintings*. 4 vols. New Haven, Conn.: Published for the Paul Mellon Centre for Studies in British Art by Yale University Press, 1998–2006.

Orienti, Sandra. *Manet, Edouard. The Complete Paintings of Manet*. Intro. by P. Pool. New York: H.N. Abrams, 1985, 1967.

Pollock, Griselda. *Mary Cassatt: Painter of Modern Women*. New York: Thames & Hudson, 1998.

———. *Mary Cassatt*. London: Chaucer, 2005.

Parris, Leslie, ed. *The Pre-Raphaelites*. Reprinted with corrections. London: Tate, 1994, 1984.

Prettejohn, Elizabeth. *The Art of the Pre-Raphaelites*. Princeton, N.J.: Princeton University Press, 2000.

Prodger, Phillip. *Time Stands Still: Muybridge and the Instantaneous Photography Movement*. Stanford, Calif.: The Iris & B. Gerald Cantor Center for Visual Arts in assoc. with Oxford University Press, 2003.

Ratcliff, Carter. *John Singer Sargent*. New York: Abbeville Press, 1982.

Reff, Theodore. *Manet and Modern Paris*. Washington, D.C.: National Gallery of Art, 1982.

Renoir. Texts by J. House, A. Distel, L. Gowing. London: Hayward Gallery, 1985.

Renoir, Jean. *Renoir: My Father*. Introd. by Robert Herbert. New York: New York Review Books, 2001.

Rewald, John. *The History of Impressionism*. 4th rev. ed. New York: MOMA, 1973.

———. *Degas's Complete Sculpture: Catalogue Raisonné*. New ed. San Francisco: Alan Wofsy Fine Arts, 1990.

Rilke, Rainer Maria. *Auguste Rodin*. Trans. Daniel Slager. Introd. by William Gass. New York: Archipelago Books, 2004.

———, and Frances Weitzenhoffer, eds. *Aspects of Monet: A Symposium on the Artist's Life and Times*. New York: H.N. Abrams, 1984.

Reynolds, Graham. *Victorian Painting*. Rev. ed. New York: Harper & Row, 1987.

Rosenblum, Robert. *Paintings in the Musée d'Orsay*. New York: Stewart, Tabori and Chang, 1989.

Rothkopf, Katherine, et al. *Pissarro: Creating the Impressionist Landscape*. Baltimore: Baltimore Museum of Art; London: Philip Wilson, 2006.

Rouart, Denis. *Renoir*. New York: Skira/Rizzoli, 1985.

Schaaf, Larry J. *Out of the Shadows: Herschel, Talbot and the Invention of Photography*. New Haven, Conn.: Yale University Press, 1992.

———. *The Photographic Art of William Henry Fox Talbot*. Princeton, N.J.: Princeton University Press, 2000.

Sewell, Darrel. *Thomas Eakins*. Essays by Kathleen A. Foster, et al. Philadelphia: Philadelphia Museum of Art in assoc. with Yale University Press, 2001.

Sheldon, James L. *Motion and Document, Sequence and Time: Eadweard Muybridge and Contemporary American Photography*. Andover, Mass.: Addison Gallery of American Art, 1991.

Spate, Virginia. *Claude Monet: Life and Work*. New York: Rizzoli, 1992.

Stuckey, Charles F. *Claude Monet, 1840–1926*. Chicago: Art Institute, 1995.

———, and William P. Scott. *Berthe Morisot, Impressionist*. New York: Hudson Hills Press, 1987.

Sutton, Denys. *Edgar Degas: Life and Work*. New York: Rizzoli, 1986.

Tinterow, Gary, and Henri Loyrette. *Origins of Impressionism*. New York: MMA, 1994.

Tucker, Paul. *Claude Monet: Life and Art*. New Haven, Conn.: Yale University Press, 1995.

———. *The Impressionists at Argenteuil*. Paul Hayes Tucker. Washington, D.C.: National Gallery of Art; Hartford, Conn.: Wadsworth Atheneum, 2000.

———. *Monet in the '90s: The Series Paintings*. New Haven, Conn.: Yale University Press, 1989.

———. *Monet in the 20th Century*. London: Royal Academy of Arts: New Haven, Conn.: Published in assoc. with Yale University Press, 1998.

Wadley, Nicholas. *Renoir: A Retrospective*. New York: Hugh Lauter Levin Assoc., 1987.

Waggoner, Diane, ed. *The Pre-Raphaelite Lens: British Photography and Painting, 1848–1875*. Washington, D.C. and Aldershot, UK: Lund Humphries in association with National Gallery of Art, 2010.

Weisberg, Gabriel. *Beyond Impressionism: The Naturalist Impulse*. New York: H.N. Abrams, 1992.

———, ed. *The Orient Expressed: Japan's Influence on Western Art, 1854-1918*. Jackson, Miss.: Mississippi Museum of Art; Seattle, Wash.: in association with University of Washington Press, 2011.

———. *The Realist Tradition: French Painting and Drawing, 1830–1900*. Cleveland: Cleveland Museum of Art, 1981.

White, Barbara Ehrlich. *Renoir: His Life, Art, and Letters*. New York: H.N. Abrams, 1984.

Wood, Christopher. *The Pre-Raphaelites*. New York: Viking, 1981.

3. Post-Impressionism

Adriani, Gotz. *Cézanne: A Biography*. New York: H.N. Abrams, 1990.

———. *Toulouse-Lautrec: Complete Graphic Works*. London: Thames & Hudson, 1988.

Bocquillon-Ferretti, Marina, et al. *Signac, 1863–1935*. New York: MMA; New Haven, Conn.: Yale University Press, 2001.

Brettell, Richard, et al. *The Art of Paul Gauguin*. Washington, D.C.: National Gallery of Art, 1988.

Broude, Norma. *Georges Seurat*. New York: Rizzoli, 1992.

Cachin, Françoise. *Cézanne*. Philadelphia: Philadelphia Museum of Art, 1996.

Denvir, Bernard. *Post-Impressionism*. World of Art. New York: Thames & Hudson, 1992.

Druick, Douglas W., et al. *Odilon Redon: Prince of Dreams, 1840–1916*. New York: H.N. Abrams, 1994.

Easton, Elizabeth, ed. *Snapshot: Painters and Photography, Bonnard to Vuillard*. New Haven, Conn.: Yale University Press, 2011.

Elsen, Albert, ed. *Rodin Rediscovered*. Washington, D.C.: National Gallery of Art, 1981.

———. *Rodin's Art: The Rodin Collection of the Iris & B. Gerald Cantor Center for Visual Arts at Stanford University*. Palo Alto, Calif.: The Iris & B. Gerald Cantor Center for Visual Arts at Stanford University in assoc. with Oxford University Press, 2003.

Facos, Michelle. *Symbolist Art in Context*. Berkeley, Calif.; Los Angeles: University of California Press, 2009.

Frèches-Thory, Clair. *The Nabis: Bonnard, Vuillard and Their Circle*. New York: H.N. Abrams, 1991.

Frey, Julia Bloch. *Toulouse-Lautrec: A Life*. London: Weidenfeld and Nicolson, 1994.

Fry, Roger. *Seurat*. 3rd ed. London: Phaidon, 1965.

Gauguin, Paul. *Gauguin By Himself*. Ed. by Belinda Thomson. Boston: Little, Brown, 1993.

Gauguin, Paul. *The Intimate Journals of Paul Gauguin*. Boston: KPI, 1985.

———. *Noa Noa: The Tahiti Journal of Paul Gauguin*. Trans. O. F. Theis. 1994 Océanie ed. San Francisco: Chronicle Books, 2005.

Gerhardus, Maly, and Dietfried Gerhardus. *Symbolism and Art Nouveau*. Trans. A. Bailey. Oxford: Phaidon, 1979.

Gogh, Vincent van. *The Complete Letters of Vincent van Gogh: With Reproductions of All the Drawings in the Correspondence*. 2nd ed. Boston: Little, Brown, 1978.

Goldwater, Robert. *Paul Gauguin*. New York: H.N. Abrams, 1984.

———. *Symbolism*. New York: Harper & Row, 1979.

Gotz, Adriani. *Henri Rousseau*. Trans. S. Kleager and J. Marsh. New Haven, Conn.: Yale University Press, 2001.

———. *Cézanne Paintings*. Trans. R. Stockman. Cologne: Dumont; New York: H.N. Abrams, 1995.

Gowing, Lawrence. *Cézanne, the Early Years, 1859–1872*. New York: H.N. Abrams, 1988.

Herbert, Robert L. *Georges Seurat, 1859–1891*. New York: MMA, 1991.

———. *Seurat and the Making of La Grande Jatte*. With an essay by Neil Harris, et al. Chicago: Art Institute of Chicago in assoc. with the University of California Press, 2004.

———. *Seurat, Drawings and Paintings*. New Haven, Conn.: Yale University Press, 2001.

Hulsker, Jan. *The New Complete Van Gogh: Paintings, Drawings, Sketches*. Rev. enl. ed. Amsterdam: J.M. Meulenhoff; Philadelphia: Distr. John Benjamins, 1996.

Jensen, Robert. *Marketing Modernism in Fin de Siècle Europe*. Princeton, N.J.: Princeton University Press, 1994.

Leighton, John, et al. *Seurat and the Bathers*. London: National Gallery Publications: Distr. Yale University Press, 1997.

Lemoine, Serge. *Toward Modern Art: From Puvis de Chavannes to Matisse and Picasso*. New York: Rizzoli, 2002.

Lewis, Mary Tompkins. *Cézanne's Early Imagery*. Berkeley, Calif.: University of California Press, 1989.

Lorquin, Bertrand. *Aristide Maillol*. Trans. Michael Taylor. London; New York: Skira in association with Thames & Hudson, 1995, 1994.

Murray, Gale B. *Toulouse-Lautrec: A Retrospective*. New York: Hugh Lauter Levin Assoc., 1992.

Pierre Bonnard: The Work of Art, Suspending Time: Musée d'art Moderne de la Ville de Paris, 2 February–7 May 2006. Paris: Paris Musées; Gand: Ludion, 2006.

Rapetti, Rodolphe. *Symbolism*. Trans. D. Dusinberre. Paris: Flammarion; Distr. Rizzoli, 2005.

Rewald, John. *Paul Cézanne: The Watercolors, A Catalogue Raisonné*. Boston: Little, Brown, 1983.

———. *The Paintings of Paul Cézanne: A Catalogue Raisonné*. New York: H.N. Abrams, 1996.

———. *Post-Impressionism: From Van Gogh to Gauguin*. 3rd ed. rev. New York: MOMA, 1978.

———. *Seurat: A Biography*. New York: H.N. Abrams, 1990.

Rubin, William, ed. *Cézanne: The Late Work*. New York: MOMA, 1977.

Schwartz, Dieter, ed. *Medardo Rosso, 1858–1928*. Düsseldorf: Richter Verlag, 2004.

Solana, Guillermo, ed. *Gauguin and the Origins of Symbolism*. London: Philip Wilson Publishers in assoc. with Museo Thyssen-Bornemisza and Fundación Caja Madrid, 2004.

Schapiro, Meyer. *Paul Cézanne*. Concise ed. New York: H.N. Abrams, 1988.

———. *Van Gogh*. Rev. ed. New York: H.N. Abrams, 1982.

Shiff, Richard. *Cézanne and the End of Impressionism: A Study of the Theory, Technique, and Critical Evaluation of Modern Art*. Chicago: University of Chicago Press, 1984.

———. *Toulouse-Lautrec*. World of Art. New York: Thames & Hudson, 1991.

Studies in Post-Impressionism. Texts by J. House, A. Distel, L. Gowing. New York: H.N. Abrams, 1986.

Théberge, Pierre, and Jean Clair. *Lost Paradise, Symbolist Europe.* Montreal: Montreal Museum of Fine Arts, 1995.

Thomson, Belinda. *Gauguin.* World of Art. New York: Thames & Hudson, 1987.

Thomson, Richard. *Toulouse-Lautrec and Montmartre.* Richard Thomson, et al. Washington, D.C.: National Gallery of Art; Princeton, N.J.: In association with Princeton University Press, 2005.

Turner, Elizabeth H. *Pierre Bonnard: Early and Late.* Contrib. Nancy Colman Wolsk, et al. London: Philip Wilson Publishers in collaboration with the Phillips Collection, Washington, D.C., 2002.

Verdi, Richard. *Cézanne.* World of Art. New York: Thames & Hudson, 1992.

Walther, Ingo F., and Rainer Metzger. *Van Gogh: The Complete Paintings.* Cologne: Taschen, 1993.

4. Arts and Crafts, Art Nouveau, and the Beginnings of Expressionism

Artigas, Isabel. *Antoni Gaudí: Complete Works.* Köln, Germany: Evergreen, 2007.

Arwas, Victor. *Art Deco.* Rev. ed. New York: H.N. Abrams, 1992.

———. *Art Nouveau: From Mackintosh to Liberty: The Birth of a Style.* London: Andreas Papadakis, 2000.

Brandstätter, Christian. *Wonderful Wiener Werkstätte: Design in Vienna, 1903–1932.* London: Thames & Hudson, 2003.

———, ed. *Vienna 1900: Art, Life & Culture.* New York: Vendome Press, 2006.

Calloway, Stephen. *Aubrey Beardsley.* New York: H.N. Abrams, 1998.

Colquhoun, Kate. *"The Busiest Man in England": A Life of Joseph Paxton, Gardener, Architect & Victorian Visionary.* Boston: David R. Godine, 2006.

Crawford, Alan. *Charles Rennie Mackintosh.* New York: Thames & Hudson, 1995.

Duncan, Alastair. *Art Nouveau.* World of Art. New York: Thames & Hudson, 1994.

Eggum, Arne. *Edvard Munch: Paintings, Sketches, and Studies.* New York: C. N. Potter, 1985.

Escritt, Stephen. *Art Nouveau.* Art & Ideas. London: Phaidon, 2000.

Frehner, Matthias, et al. *Ferdinand Hodler.* Ostfildern-Ruit, Germany: Hatje Cantz, 2008.

Heller, Reinhold. *Munch: His Life and Work.* Chicago: University of Chicago Press, 1984.

Howarth, Thomas. *Charles Rennie Mackintosh and the Modern Movement.* 2nd ed. London: Routledge and Kegan Paul, 1977.

Kaplan, Wendy, ed. *Charles Rennie Mackintosh.* New York: Abbeville Press, 1996.

Kirk, Sheila. *Philip Webb: Pioneer of Arts & Crafts Architecture.* Photography by Martin Charles. Chichester, England; Hoboken, N.J.: Wiley-Academy, 2005.

Kallir, Jane. *Viennese Design and the Wiener Werkstätte.* New York: G. Braziller, 1986.

Lahuerta, Juan José. *Antoni Gaudí, 1852–1926: Architecture, Ideology, and Politics.* Milan, Italy: Electa Architecture; London: Phaidon, 2003.

Lemoine, Serge. *Vienna 1900: Klimt, Schiele, Moser, Kokoschka.* Paris: Editions de la Réunion des Musées Nationaux in association with Lund Humphries, 2005.

McShine, Kynaston, ed. *Edvard Munch: The Modern Life of the Soul.* Essays by Reinhold Heller, et al. New York: MOMA, 2006.

[Munch] *Munch in His Own Words.* Ed. by Poul Erik Tøjner. Munich; New York: Prestel Verlag, 2001.

The Origins of L'Art Nouveau: The Bing Empire. Ed. by Gabriel P. Weisberg, et al. Amsterdam: Van Gogh Museum; Paris: Musée des Arts Décoratifs; Antwerp: Mercatorfonds; Ithaca, N.Y.: Distr. Cornell University Press, 2004.

Partsch, Suzanna. *Klimt: Life and Work.* London: Bracken, 1993.

Permanyer, Lluis. *Barcelona Art Nouveau = Paseo por la Barcelona Modernista.* Trans. Richard Rees. New York: Rizzoli, 1999.

Pfeiffer, Ingrid, and Max Hollein. *James Ensor.* Texts by Sabine Bown-Taevernier, et al. Ostfildern-Ruit, Germany: Hatje Cantz, 2005.

Price, Renée, ed. *Egon Schiele: The Ronald S. Lauder and Serge Sabarsky Collections.* Contrib. Alessandra Comini, et al. Munich; New York: Prestel, 2005.

———. *Gustav Klimt: The Ronald S. Lauder and Serge Sabarsky Collections.* Contrib. Ronald S. Lauder, et al. New York: Neue Galerie, New York; Munich; New York: Prestel Verlag, 2007.

Prideaux, Sue. *Edvard Munch: Behind the Scream.* New Haven, Conn.: Yale University Press, 2005.

Reade, Brian. *Aubrey Beardsley.* Rev. ed. Suffolk, England.: Antique Collectors's Club, 1998, 1987.

Rennhofer, Maria. *Koloman Moser: Master of Viennese Modernism.* London; New York: Thames & Hudson, 2002.

Riquer, Borja de, et al. *Modernismo: Architecture and Design in Catalonia.* New York: Monacelli Press, 2003.

Schmutzler, Robert. *Art Nouveau.* Abridged ed. Trans. E. Rodotti. London: Thames & Hudson, 1978.

Schorske, Carl. *Fin-de-Siècle Vienna: Politics and Culture.* New York: Vintage Books, 1980.

Selz, Peter, and Mildred Constantine, eds. *Art Nouveau: Art and Design at the Turn of the Century.* Rev. ed. New York: MOMA, 1974.

Silverman, Deborah. *Art Nouveau in Fin-de-Siècle France.* Berkeley, Calif.: University of California Press, 1989.

Stansky, Peter. *Redesigning the World: William Morris, the 1880s, and the Arts and Crafts.* Princeton, N.J.: Princeton University Press, 1985.

Sweeney, James J., and Joseph L. Sert. *Gaudí.* Rev. ed. New York: Praeger, 1970, 1960.

Swinbourne, Anna. *James Ensor.* New York: MOMA, 2009.

Varnedoe, Kirk. *Vienna 1900: Art, Architecture, and Design.* New York: MOMA, 1986.

———, and Elizabeth Streicher. *Graphic Work of Max Klinger.* New York: Dover Publications, 1977.

Vergo, Peter. *Art in Vienna, 1898–1918: Klimt, Kokoschka, Schiele and Their Contemporaries.* 3rd ed. London: Phaidon, 1993.

Weidinger, Alfred, ed. *Gustav Klimt.* With texts by Marian Bisanz-Prakken, et al. Munich; New York: Prestel, 2007.

Weisberg, Gabriel P. *Art Nouveau: a Research Guide for Design Reform in France, Belgium, England, and the United States.* New York: Garland Pub., 1998.

Whitford, Frank. *Klimt.* World of Art. London: Thames & Hudson, 1990.

Woll, Gerd. *Edvard Munch: Complete Paintings, Catalogue Raisonné.* 4 vols. V. 1. 1880-1897; V. 2. 1898-1908; V. 3. 1909-1920; V. 4. 1921-1944. London: Thames & Hudson, 2009.

Yearning for Beauty: The Wiener Werkstätte and the Stoclet House. Ed. by Peter Noever, et al. Vienna: MAK; Ostfildern-Ruit, Germany: Hatje Cantz; New York: Distr. D.A.P./Distributed Art Publishers, 2006.

5. The New Century: Experiments in Color and Form

Art of the Twentieth Century. Trans. Antony Shugaar. 5 vols. Vol. 1. *1900–1919: The Avant-Garde Movements*, Vol. 2. *1920–1945: The Artistic Culture Between the Wars*, Vol. 3. *1946–1968: The Birth of Contemporary Art*; Vol. 4. *1968–1999: Neo-Avant-Gardes: Postmodern and Global art*; Vol. 5. *2000 and Beyond: Contemporary Tendencies.* Milan: Skira; New York: Distr. Rizzoli International Publications, 2006.

Barr, Jr., Alfred H. *Matisse: His Art and His Public.* New York: MOMA, 1951.

Brodskaia, Natalia. *The Fauves: the Hermitage, St. Petersburg: the Pushkin Museum of Fine Arts, Moscow.* Trans. Paul Williams. Bournemouth, England: Parkstone; St. Petersburg: Aurora, 1995.

Clement, Russell T. *Les Fauves: A Sourcebook.* Westport, Conn.: Greenwood Press, 1994.

Cowling, Elizabeth. *Matisse Picasso.* London: Tate Publishing, 2002.

Elderfield, John. *Henri Matisse, A Retrospective.* New York: MOMA, 1992.

———. *The "Wild Beasts": Fauvism and Its Affinities.* New York: MOMA, 1976.

Ferrier, Jean Louis. *The Fauves: The Reign of Colour: Matisse, Derain, Vlaminck, Marquet, Camoin, Manguin, Van Dongen, Friesz, Braque, Dufy.* Paris: Terrail, 1995.

Flam, Jack D. *Matisse: The Man and His Art, 1869–1918.* London: Thames & Hudson, 1986.

———, ed. *Matisse: A Retrospective.* New York: Park Lane, 1990.

———, ed. *Matisse On Art.* Berkeley, Calif.: University of California Press, 1994.

———, ed. *Primitivism and Twentieth-Century Art: A Documentary History.* Berkeley, Calif.: University of California Press, 2003.

Flora, Holly, and Soo Yun Kang. *George Rouault's Miserere et Guerre: This Anguished World of Shadows.* New York: Museum of Biblical Art, 2006.

Freeman, Judi. *The Fauve Landscape.* New York: Abbeville Press, 1990.

———. *Fauves.* Sydney: Art Gallery of New South Wales; London: Distr. Thames & Hudson, 1995.

Herbert, James D. *Fauve Painting: The Making of Cultural Politics.* New Haven, Conn.: Yale University Press, 1992.

Kosinski, Dorothy M., et al. *Matisse: Painter as Sculptor.* Baltimore, Md.: Baltimore Museum of Art; Dallas, Tex.: Dallas Museum of Art: Nasher Sculpture Center; New Haven, Conn.: Yale University Press, 2007.

Lee, Jane. *Derain.* Oxford, England: Phaidon; New York: Universe, 1990.

Leymarie, Jean. *Fauves and Fauvism.* Enl. ed. New York: Skira Rizzoli, 1987.

Masters of Colour: Derain to Kandinsky: Masterpieces From the Merzbacher Collection. London: Royal Academy of Arts; New York: Distr. in U.S. by H.N. Abrams, 2002.

Monod-Fontaine, Isabelle. *André Derain: An Outsider in French art.* Contrib. Sibylle Pieyre de Mandiargues, et al. Copenhagen, Denmark: Statens Museum for Kunst, 2007.

Muller-Tamm, Pia, ed. *Henri Matisse: Figure, Color, Space.* Texts by Gottfried Boehm, et al. Ostfildern-Ruit, Germany: Hatje Cantz, 2005.

Rouault, Georges. *Miserere.* New and enl. ed. Paris: Le Léopard d'or; Tokyo: Zauho Press, 1991.

Venturi, Lionello. *Rouault: Biographical and Critical Study.* Trans. J. Emmons. Paris: Skira, 1959.

Whitfield, Sarah. *Fauvism.* New York: Thames & Hudson, 1996.

Wright, Alastair. *Matisse and the Subject of Modernism.* Princeton, N.J.: Princeton University Press, 2004.

6. Expressionism in Germany and Austria

Art of the Twentieth Century. Trans. Antony Shugaar. Vol. 1. *1900–1919: The Avant-Garde Movements.* Milan: Skira; New York: Distr. Rizzoli International Publications, 2006.

Bach, Friedrich Teja. *Constantin Brancusi, 1876–1957.* Philadelphia, Pa.: Philadelphia Museum of Art; Cambridge, Mass.: MIT Press, 1995.

Barnett, Vivian Endicott, and Josef Helfenstein. *The Blue Four: Feininger, Jawlensky, Kandinsky, and Klee in the New World.* Cologne: Dumont; New Haven, Conn.: Distr. Yale University Press, 1997.

Barron, Stephanie, ed. *"Degenerate Art": The Fate of the Avant-Garde in Nazi Germany.* Los Angeles: LACMA, 1991.

———, and Wolf-Dieter Dube, eds. *German Expressionism: Art and Society.* New York: Rizzoli, 1997.

Behr, Shulamith. *Expressionism.* Movements in Modern Art. Cambridge, England: Cambridge University Press, 1999.

Benson, Timothy. *Expressionist Utopias: Paradise, Metropolis, Architectural Fantasy.* Los Angeles: LACMA, 1993.

Carey, Frances. *The Print in Germany, 1880–1933: The Age of Expressionism: Prints from the Department of Prints and Drawings in the British Museum.* With a section of illustrated books from the British Library by D. Paisey. 2nd ed. London: British Museum Press, 1993, 1984.

Chave, Anna. *Constantin Brancusi: Shifting the Bases of Art.* New Haven, Conn.: Yale University Press, 1993.

Dabrowski, Magdalena. *Kandinsky Compositions.* New York: MOMA. 1995.

Expressionism: A German Intuition. New York: SRGM, 1980.

Figura, Starr, ed. *German Expressionism: The Graphic Impulse.* New York: MOMA, 2011.

Fischer, Hartwig, and Sean Rainbird, eds. *Kandinsky: The Path to Abstraction.* Essays by Shulamith Behr, et al. London: Tate; New York: Distr. in U.S. and Canada by H.N. Abrams, 2006.

Geist, Sydney. *Brancusi: A Study of the Sculpture.* Rev. and enl. ed. New York: Hacker Art Books, 1983.

Gordon, Donald. *Expressionism: Art and Idea.* New Haven, Conn.: Yale University Press, 1987.

———. *Oskar Kokoschka and the Visionary Tradition.* Bonn: Bouvier, 1981.

Helfenstein, Josef, and Elizabeth Hutton Turner, eds. *Klee and America.* Houston, Tex.: Menil Collection: Ostfildern-Ruit, Germany: Hatje Cantz, 2006.

Heller, Reinhold. *The Art of Wilhelm Lehmbruck.* Washington, D.C.: National Gallery of Art, 1972.

Hinz, Renate, ed. *Käthe Kollwitz: Graphics, Posters, Drawings.* Foreword by Lucy R. Lippard. Trans. Rita and Robert Kimber. New York: Pantheon Books, 1982.

Hoberg, Annegret, and Isabelle Jansen. *Franz Marc: The Complete Works*. 2 vols. in 3. London: Philip Wilson; New York: Distr. in the U.S. by Palgrave Macmillan, 2004–05.

Holst, Christian von. *Franz Marc, Horses*. Essays by Karin von Maur, et al. Trans. Elizabeth Clegg. Cambridge, Mass.: Harvard University Art Museums; Ostfildern-Ruit, Germany: Hatje Cantz, 2000.

Hultén, Pontus. *Brancusi*. New York: H.N. Abrams, 1987.

Jawlensky, Maria. *Alexej von Jawlensky: Catalogue Raisonné of the Oil Paintings*. London: Sotheby's Publications, 1991–98.

Jordan, Jim. *Paul Klee and Cubism*. Princeton, N.J.: Princeton University Press, 1984.

Kallir, Jane. *Egon Schiele*. With an essay by Alessandra Comini. New York: H.N. Abrams; Alexandria, Va.: Art Services International, 1994.

[Kandinsky] *Kandinsky in Munich: 1896–1914*. New York: SRGM, 1982.

Klee, Felix, ed. *The Diaries of Paul Klee: 1898–1918*. Berkeley and Los Angeles, Calif.: University of California Press, 1964.

Klipstein, August. *The Graphic Work of Käthe Kollwitz: Complete Illustrated Catalogue*. Reprint. Mansfield Center, Conn.: M. Martino, 1996, 1955.

Knesebeck, Alexandra von dem. *Käthe Kollwitz: Werkverzeichnis der Graphik*. Neubearb. des Verzeichnisses von A. Klipstein, 2 vols. + 1 CD-ROM with English translation of the text. Bern: Kornfeld, 2002.

Kokoschka: A Retrospective Exhibition of Paintings, Drawings, Lithographs, Stage Design and Books. London: Tate, 1962. Texts by E. H. Gombrich, F. Novotny, H. M. Wingler, et al.

[Kokoschka] *Oskar Kokoschka, 1886–1980*. New York: SRGM, 1986.

Kollwitz, Hans, ed. *The Diary and Letters of Käthe Kollwitz*. Evanston, Ill.: Northwestern University Press, 1988.

Lanchner, Carolyn, ed. *Paul Klee, His Life and Work*. Rev. ed. New York: MOMA; Ostfildern-Ruit, Germany: Hatje Cantz; New York,: Distr. D.A.P./Distributed Art Publishers, 2001.

Levine, Frederick S. *The Apocalyptic Vision: The Art of Franz Marc as German Expressionism*. New York: Harper & Row, 1979.

Lincoln, Louise. *German Realism of the Twenties: The Artist as Social Critic*. Minneapolis: Minneapolis Institute of Arts, 1980.

Lindsay, Kenneth, and Peter Vergo. *Kandinsky: Complete Writings on Art*. 2 vols. Boston: G. K. Hall, 1982.

Lloyd, Jill. *German Expressionism: Primitivism and Modernity*. New Haven, Conn.: Yale University Press, 1991.

———, and Magdalena M. Moeller, eds. *Ernst Ludwig Kirchner: The Dresden and Berlin Years*. London: Royal Academy of Arts, 2003.

———, and Michael Peppiatt, eds. *Van Gogh and Expressionism*. Ostfildern-Ruit, Germany: Hatje Cantz, 2007.

Long, Rose-Carol Washton, ed. *German Expressionism: Documents from the End of the Wilhelmine Empire to the Rise of National Socialism. Documents of Twentieth Century Art*. New York: G. K. Hall, 1993.

Lorenz, Ulrike, and Norbert Wolf, eds. *Brücke*. Köln, Germany: Taschen, 2008.

Luckhardt, Ulrich. *Lyonel Feininger*. Munich: Prestel; New York: Distrib. in the U.S. and Canada by Te Neues, 1989.

Michalski, Sergiusz. *New Objectivity: Painting, Graphic Art and Photography in Weimar Germany, 1919–1933*. Köln, Germany: Taschen, 1994.

Miller, Sanda. *Constantin Brancusi: A Survey of His Work*. Oxford, England: Clarendon, 1995.

Modersohn-Becker, Paula. *Paula Modersohn-Becker, the Letters and Journals*. Ed. by Günther Busch and Liselotte von Reinken, et al. New York: Taplinger Pub. Co., 1983.

Perry, Gillian. *Paula Modersohn-Becker: Her Life and Work*. New York: Harper & Row, 1979.

Prelinger, Elizabeth. *Käthe Kollwitz*. Washington, D.C.: National Gallery of Art, 1992.

Price, Renée, ed. *Egon Schiele: The Ronald S. Lauder and Serge Sabarsky Collections*. Contrib. Alessandra Comini, et al. Munich; New York: Prestel, 2005.

Rewald, Sabine. *Glitter and Doom: German Portraits from the 1920s*. New York: MMA; New Haven: Yale University Press, 2006.

Richard, Lionel. *Phaidon Encyclopedia of Expressionism*. Trans. S. Tint. Oxford: Phaidon, 1978.

Roethel, Hans. *The Blue Rider*. New York: Praeger, 1971.

———, and Jean Benjamin. *Kandinsky. Catalogue Raisonné of the Oil Paintings*. 2 vols. Ithaca, N.Y.: Cornell University Press, 1982.

Sabarsky, Serge. *Egon Schiele*. New York: Rizzoli, 1985.

Schvey, Henry. *Oskar Kokoschka, the Painter as Playwright*. Detroit: Wayne State University Press, 1982.

Shanes, Eric. *Constantin Brancusi*. New York: Abbeville Press, 1989.

Urban, Martin. *Emil Nolde: Catalogue Raisonné of the Oil Paintings*. 2 vols. London: Sotheby's Publications, 1987–90.

Vergo, Peter. *Art in Vienna, 1898–1918: Klimt, Kokoschka, Schiele, and Their Contemporaries*. London: Phaidon, 1975.

Vogt, Paul. *Erich Heckel*. Recklinghausen, Germany: Bongers, 1965.

———. *Expressionism: German Painting, 1905–1920*. Trans. A. Vivus. New York: H.N. Abrams, 1980.

Voices of German Expressionism, Comp, and ed. by Victor H. Miesel. London: Tate; New York: Distr. in North America by H.N. Abrams, 2003, 1970.

Weikop, Christian, ed. *New Perspectives on Brücke Expressionism: Bridging History*. Farnham, Surrey, England; Burlington, VT: Ashgate ; c2011.

Whitford, Frank. *Expressionist Portraits*. New York: Abbeville Press, 1987.

Zweite, Armin. *The Blue Rider in the Lenbachhaus, Munich: Masterpieces by Franz Marc, Vassily Kandinsky, Gabriele Münter, Alexei Jawlensky, August Macke, Paul Klee, Armin Zweite*. Commentaries and biographies by Annegret Hoberg. Munich: Prestel; New York: Distr. in the U.S. and Canada by Neues Publishing Co., 1989.

7. Cubism

Apollinaire, Guillaume. *The Cubist Painters*. Trans. with commentary by Peter Read. Berkeley, Calif.: University of California Press, 2004.

Arnason, H. H. *Jacques Lipchitz: Sketches in Bronze*. New York: Praeger, 1969.

Art of the Twentieth Century. Trans. Antony Shugaar. Vol. 1. *1900–1919: The Avant-Garde Movements*. Milan: Skira; New York: Distr. Rizzoli International Publications, 2006.

Barr, Jr., Alfred H. *Cubism and Abstract Art: Painting, Sculpture, Constructions, Photography, Architecture, Industrial Art, Theatre, Films, Posters, Typography*. Reprint of the 1939 ed. Cambridge, Mass.: Belknap Press of Harvard University Press, 1986.

Bois, Yve-Alain. *Painting as Model*. Cambridge, Mass.: MIT Press, 1990.

Brooke, Peter. *Albert Gleizes: For and Against the Twentieth Century*. New Haven, Conn.: Yale University Press, 2001.

Brunhammer, Yvonne. *Fernand Léger: The Monumental Art*. Milan, Italy: 5 Continents, 2005.

Cogniat, Raymond. *Georges Braque: Rétrospective*. Saint-Paul: Foundation Maeght, 1994.

Clement, Russell T. *Georges Braque: A Bio-bibliography*. Westport, Conn.: Greenwood Press, 1994.

Cooper, Douglas. *The Cubist Epoch*. New York and London: LACMA, MMA, and Phaidon, 1970.

———, and Gary Tinterow. *Essential Cubism: Braque, Picasso and Their Friends, 1907–1920*. London: Tate, 1983.

———, ed. *Letters of Juan Gris (1913–1927)*. London: Lund Humphries, 1956.

Cottington, David. *Cubism and Its Histories*. Manchester, England; New York: Manchester University Press, 2004.

Cowling, Elizabeth, and John Golding. *Picasso: Sculptor/Painter*. London: Tate, 1994.

———. *Visiting Picasso: The Notebooks and Letters of Roland Penrose*. New York: Thames & Hudson, 2006.

Esteban Leal, Paloma. *Juan Gris: Paintings and Drawings, 1910–1927*. Madrid: Museo Nacional Centro de Arte Reina Sofía, 2005.

FitzGerald, Michael C. *Picasso and American Art*. With a chronology by Julia May Boddewyn. New York: WMAA; New Haven, Conn.: Yale University Press, 2006.

Flam, Jack, ed. *Primitivism and Twentieth-Century Art: A Documentary History*. Berkeley, Calif.: University of California Press, 2003.

Ganteführer-Trier, Anne, and Ute Grosenick. *Cubism*. Köln, Germany; Los Angeles: Taschen, 2004.

Golding, John. *Braque, the Late Works*. New Haven, Conn.: Yale University Press, 1997.

———. *Cubism: A History and an Analysis, 1907–1914*. 3rd ed. Cambridge, Mass.: Belknap Press of Harvard University Press, 1988.

Green, Christopher. *Cubism and Its Enemies*. New Haven, Conn.: Yale University Press, 1987.

———. *Juan Gris*. New Haven, Conn.: Yale University Press, 1992.

———. *Léger and the Avant-Garde*. New Haven, Conn.: Yale University Press.

———. *Picasso: Architecture and Vertigo*. New Haven: Yale University Press, 2005.

Harrison, Charles, Francis Frascina, and Gill Perry. *Primitivism, Cubism, Abstraction: The Early Twentieth Century*. New Haven, Conn.: Yale University Press, 1993.

Hicken, Adrian. *Apollinaire, Cubism and Orphism*. Aldershot, England; Burlington, Vt: Ashgate, 2002.

Hofmann, Werner, and Daniel-Henry Kahnweiler. *The Sculpture of Henri Laurens*. New York: H.N. Abrams, 1970.

Kahnweiler, Daniel-Henry. *My Galleries and Painters*. With Francis Crémieux. Trans. by Helen Weaver; new material trans. by Karl Orend. ArtWorks. Boston, Mass.: MFA Publications, 2003.

Karmel, Pepe. *Picasso and the Invention of Cubism*. New Haven, Conn.: Yale University Press, 2003.

Krauss, Rosalind E. *The Picasso Papers*. New York: Farrar, Straus, and Giroux, 1998.

Lanchner, Carolyn, et al. *Fernand Léger*. New York: MOMA: Distr. H.N. Abrams, 1998.

Leighten, Patricia. *Re-Ordering the Universe: Picasso and Anarchism, 1897–1914*. Princeton, N.J.: Princeton University Press, 1989.

Les Desmoiselles d'Avignon. 2 vols. Paris: Musée Picasso, 1988.

Leshko, Jaroslaw. *Alexander Archipenko: Vision and Continuity*. New York: The Ukrainian Museum, 2005.

Lipchitz, Jacques. *My Life in Sculpture*. With H. H. Arnason. *The Documents of 20th-Century Art*. New York: Viking Press, 1972.

Michaelsen, Katherine J. *Alexander Archipenko, a Centennial Tribute*. Washington, D.C.: National Gallery of Art; Tel Aviv: Tel Aviv Museum; New York: Distr. Universe Books, 1986.

Monod-Fontaine, Isabelle, and E. A. Carmean, Jr. *Braque: The Papiers Collés*. Text by A. Martin. Washington, D.C.: National Gallery, 1982.

Nash, Steven A., and Robert Rosenblum, eds. *Picasso and the War Years, 1937–1945*. Contrib. Brigitte Baer, et al. New York: Thames & Hudson; San Francisco: Fine Arts Museums of San Francisco, 1998.

[Picasso] *Cubist Picasso: Musée National Picasso, Paris, September 19, 2007–January 7, 2008*. Curator, Anne Baldassari. Paris: Flammarion; Réunion des Musées Nationaux; New York: Distr. Rizzoli, 2007.

Picasso: Sixty Years of Graphic Works; Aquatints, Dry Points, Engravings, Etchings, Linoleum Cuts, Lithographs, Woodcuts. Los Angeles: LACMA, 1966.

Picasso's Paintings, Watercolors, Drawings and Sculpture: A Comprehensive Illustrated Catalogue, 1885–1973. 17 vols. San Francisco: Alan Wofsy Fine Arts, 1995–2008.

Robinson, William H., et al. *Barcelona and Modernity: Picasso, Gaudí, Miró, Dalí*. Cleveland, OH: Cleveland Museum of Art in assoc. with Yale University Press, 2006.

Rosenblum, Robert. *Cubism and Twentieth-Century Art*. New York: H.N. Abrams, 2001, 1976.

Rubin, William. *Les Demoiselles d'Avignon: Special Issue*. New York: MOMA; Distr. H.N. Abrams, 1994.

———, ed. *Pablo Picasso: A Retrospective*. New York: MOMA, 1980.

———, ed. *Picasso and Braque: Pioneering Cubism*. New York: MOMA, 1989.

———, ed. *"Primitivism" in 20th-Century Art: Affinity of the Tribal and the Modern*. 2 vols. New York: MOMA, 1984.

Schapiro, Meyer. *The Unity of Picasso's Art*. New York: George Braziller, 2000.

Shoemaker, Innis H. *Jacques Villon and his Cubist Prints*. Philadelphia, Pa.: Philadelphia Museum of Art; New York: Distr. D.A.P., 2001.

Spate, Virginia. *Orphism: The Evolution of Non-Figurative Painting in Paris: 1910–1914*. Oxford; New York: Clarendon Press and Oxford University Press, 1979.

Steinberg, Leo. "The Philosophical Brothel." *October* 44 (Spring 1988): 7–74.

———. "The Polemical Part." *Art in America* 67:2 (March–April 1979): 114–127.

———. "Resisting Cézanne: Picasso's 'Three Women.'" *Art in America* (November–December 1978): 114–133.

Švestka, Jiří, and Tomáš Vlček, eds. *Czech Cubism 1909–1925: Art, Architecture, Design*. Trans. Derek Paton, et al. Prague, Czech Republic: i3 CZ: Modernista, 2006.

Wallen, Burr, and Donna Stein. *The Cubist Print*. Santa Barbara, Calif.: University of California Art Museum, 1981.

Wight, Frederick. *Jacques Lipchitz: A Retrospective Selected by the Artist*. Los Angeles: UCLA Art Galleries, 1963.

Wilkin, Karen. *Georges Braque*. New York: Abbeville Press, 1991.

Wilkinson, Alan G. *Jacques Lipchitz: A Life in Sculpture*. Toronto: Art Gallery of Ontario, 1989.

Zelevansky, Lynn, ed. *Picasso and Braque, A Symposium*. New York: MOMA, 1992.

Zurcher, Bernard. *Georges Braque: Life and Work*. Trans. S. Nye. New York: Rizzoli, 1988.

8. Early Modern Architecture

Anderson, Stanford. *Peter Behrens and a New Architecture for the Twentieth Century*. Cambridge, Mass.: MIT Press, 2000.

Barthes, Roland. *The Eiffel Tower, and Other Mythologies*. Trans. Richard Howard. Berkeley, Calif.: University of California Press, 1997.

Bock, Ralf. *Adolf Loos: Works and Projects*. Trans. Lorenzo Sanguedolce. Milan, Italy: Skira, 2007.

Britton, Karla Marie Cavarra. *Auguste Perret*. London: Phaidon, 2001.

Charenbhak, Wichit. *Chicago School Architects and Their Critics*. Ann Arbor, Mich.: UMI Research Press, 1984.

Floyd, Margaret Henderson. *Henry Hobson Richardson, a Genius for Architecture*. Photographs by Paul Rocheleau. New York: Monacelli Press, 1997.

Gebhard, David. *Schindler*. Preface by Henry-Russell Hitchcock. 3rd ed. San Francisco: William Stout, 1997.

Gold, John Robert. *The Experience of Modernism: Modern Architects and the Future City 1928–53*. London; New York: E & FN Spon, 1997.

Haiko, Peter, ed. *Architecture of the Early XX Century*. Trans. G. Clough. New York: Rizzoli, 1989.

Hitchcock, Henry-Russell. *The Architecture of H.H. Richardson and His Times*. New ed. Cambridge, Mass.; London: The M.I.T. Press, 1966.

———. *In the Nature of Materials: The Buildings of Frank Lloyd Wright, 1887–1941*. New foreword and bibliography by the author. New York: Da Capo Press, 1975, 1942.

Hudson, Hugh D. *Blueprints and Blood: the Stalinization of Soviet Architecture, 1917–1937*. Princeton, N.J.: Princeton University Press, 1994.

Larkin, David, and Bruce Brooks Pfeiffer. *Frank Lloyd Wright: The Masterworks*. New York: Rizzoli, 1993.

Lethaby, William R. *Philip Webb and His Work*. New ed. London: Raven Oaks Press, 1979.

Loyrette, Henri. *Gustave Eiffel*. New York: Rizzoli, 1985.

Mallgrave, Harry Francis. *Otto Wagner: Reflections on the Raiment of Modernity*. Santa Monica, Calif.: Getty Center for the History of Art and the Humanities, 1993.

Manieri-Elia, Mario. *Louis Henry Sullivan, 1856–1924*. Trans. A. Shuggar with C. Creen. New York: Princeton Architectural Press, 1996.

McCarter, Robert, ed. *On and by Frank Lloyd Wright: A Primer of Architectural Principles*. London; New York: Phaidon, 2005.

McKean, John. *Crystal Palace: Joseph Paxton and Charles Fox. Architecture in Detail*. London: Phaidon, 1994.

Mead, Christopher Curtis. *Charles Garnier's Paris Opera: Architectural Empathy and the Renaissance of French Classicism*. Cambridge, Mass.: MIT Press, 1991.

Meyer, Esther da Costa. *The Work of Antonio Sant'Elia: Retreat into the Future*. New Haven, Conn.: Yale University Press, 1995.

Morrison, Hugh. *Louis Sullivan, Prophet of Modern Architecture*. Introd. and revised list of buildings by T. J. Samuelson. New York: W. W. Norton & Co., 1998.

Oechslin, Werner. *Otto Wagner, Adolf Loos, and the Road to Modern Architecture*. Trans. Lynette Widder. Cambridge, England; New York: Cambridge University Press, 2002.

O'Gorman, James F. *Three American Architects: Richardson, Sullivan, and Wright, 1865–1915*. Chicago: University of Chicago Press, 1991.

Pfammatter, Ulrich. *Building the Future: Building Technology and Cultural History from the Industrial Revolution Until Today*. Munich; New York: Prestel, 2008.

Pfeiffer, Bruce Brooks. *Frank Lloyd Wright Designs: the Sketches, Plans, and Drawings*. New York: Rizzoli, 2011.

Riley, Terrence, and Peter Redd, eds. *Frank Lloyd Wright, Architect*. New York: MOMA, 1994.

Sarnitz, August. *Otto Wagner, 1841–1918: Forerunner of Modern Architecture*. Köln, Germany; Los Angeles: Taschen, 2005.

Schezen, Roberto, and Peter Haiko. *Vienna 1850–1930, Architecture*. Trans. Edward Vance Humphrey. New York: Rizzoli, 1992.

———. *Modern Architecture and Other Essays*. Selected, with introductions by Neil Levine. Princeton, N.J.: Princeton University Press, 2003.

Scully, Vincent. *Frank Lloyd Wright*. New York: G. Braziller, 1960.

———. *Modern Architecture and Other Essays*. Selected, with introductions by Neil Levine. Princeton, N.J.: Princeton University Press, 2003.

Sullivan, Louis H. *Kindergarten Chats and Other Writings*. New York: Dover Publications, 1979.

Szarkowski, John. *The Idea of Louis Sullivan*. Introd. by Terence Riley. New ed. Boston: Bulfinch Press/Little, Brown and Co., 2000.

Taverne, Ed, et al. *J.J.P. Oud, 1890–1963: Poetic Functionalist; The Complete Works*. Rotterdam: NAi Publishers, 2001.

Tournikiotis, Panayotis. *Adolf Loos*. New York: Princeton Architectural Press, 1994.

Twombley, Robert, ed. *Louis Sullivan, the Public Papers*. Chicago: University of Chicago Press, 1988.

———, ed. *Frank Lloyd Wright: Essential Texts*. New York: W.W. Norton, 2009.

Wright, Frank Lloyd. *The Essential Frank Lloyd Wright: Critical Writings on Architecture*. Ed. by Bruce B. Pfeiffer. Princeton; Oxford, England: Princeton University Press, 2008.

———. *Collected Writings*. Ed. Bruce B. Pfeiffer. 5 vols. New York: Rizzoli, 1992–95.

Zevi, Bruno. *Erich Mendelsohn: The Complete Works*. Trans. Lucinda Byatt. Basel, Switzerland; Boston: Birkhäuser, 1999.

9. European Art after Cubism

Apollonio, Umbro, ed. *Futurist Manifestos*. Trans. Robert Brain, et al. With a new afterword by Richard Humphreys. Boston, Mass.: MFA Publications, 2001.

Art into Life: Russian Constructivism, 1914–32. New York: Rizzoli, 1990.

Art of the Twentieth Century. Trans. Antony Shugaar. Vol. 1. *1900–1919: The Avant-Garde Movements*. Milan, Italy: Skira; New York: Distr. Rizzoli International Publications, 2006.

Baal-Teshuva, Jacob, ed. *Chagall, a Retrospective*. New York: Hugh Lauter Levin Assoc., 1995.

———. *Marc Chagall, 1887–1985*. Köln, Germany; New York: Taschen, 1998.

Baldacci, Paolo. *De Chirico: The Metaphysical Period, 1888–1919*. Trans. Jeffrey Jennings. Boston: Little, Brown, 1997.

Barron, Stephanie, and Maurice Tuchman. *The Avant-Garde in Russia, 1910–1930: New Perspectives*. Los Angeles: LACMA, 1980.

Basner, Elena, et al. *Natalia Goncharova: The Russian Years*. Trans. Kenneth MacInnes. St. Petersburg, Russia: State Russian Museum, Palace Editions, 2002.

Black, Jonathan, et al. *Blasting the Future!: Vorticism in Britain 1910–1920*. London: Philip Wilson; New York: Distr. Palgrave Macmillan, 2004.

Botar, Oliver A. I. *Technical Detours: The Early Moholy-Nagy Reconsidered*. New York: Art Gallery of the Graduate Center, the City University of New York: Salgo Trust for Education, 2006.

Bowlt, John E, and Matthew Drutt, eds. *Amazons of the Avant-Garde: Alexandra Exter, Natalia Goncharova, Liubov Popova, Olga Rozanova, Varvara Stepanova, and Nadezhda Udaltsova*. New York: SRGM: Distr. H.N. Abrams, 2000.

Bowlt, John, ed. and trans. *Russian Art of the Avant-Garde: Theory and Criticism, 1902–1934*. Rev. and enl. ed. New York: Thames & Hudson, 1988.

———, and Rose-Carol Washton Long, eds. *The Life of Vasilii Kandinsky in Russian Art: A Study of "On the Spiritual in Art."* Trans. J. Bowlt. Newtonville, Mass.: Oriental Research Partners, 1980.

Bown, Matthew Cullerne. *Socialist Realist Painting*. New Haven, Conn.: Yale University Press, 1998.

Bruni, Claudio, and Maria Drudi Gambillo, eds. *After Boccioni, Futurist Paintings and Documents from 1915 to 1919*. Trans. H. G. Heath. Rome: Studio d'arte contemporanea, La Medusa, 1961.

Cardullo, Bert, and Robert Knopf, eds. *Theater of the Avant-Garde, 1890–1950: A Critical Anthology*. New Haven, Conn.: Yale University Press, 2001.

Chagall, Marc. *My Life*. New York: Da Capo Press, 1994, 1960.

Coen, Ester. *Umberto Boccioni*. New York: MMA, 1988.

Cork, Richard. *Vorticism and Abstract Art in the First Machine Age*. Berkeley, Calif.: University of California Press, 1976.

Dabrowski, Magdalena, et al. *Aleksandr Rodchenko*. New York: MOMA: Distr. H.N. Abrams, 1998.

Dabrowski, Magdalena. *Contrasts of Form: Geometric Abstract Art, 1910–1980*. New York: MOMA, 1985.

———. *Liubov Popova*. New York: MOMA, 1991.

D'Andrea, Jean. *Kazimir Malevich, 1878–1935*. Los Angeles: Armand Hammer Museum of Art, 1990.

Drutt, Matthew, ed. *Kazimir Malevich: Suprematism*. New York: SRGM; Distr. H.N. Abrams, 2003.

Edwards, Paul, ed. *Blast: Vorticism: 1914–1918*. Aldershot, England; Burlington, VT: Ashgate, 2000.

Elliott, David. *New Worlds: Russian Art and Society: 1900–1935*. London: Thames & Hudson, 1986.

———, ed. *Photography in Russia, 1840–1940*. London: Thames & Hudson, 1992.

Etlin, Richard A. *Modernism in Italian Architecture, 1890–1940*. Cambridge, Mass.: MIT Press, 1991.

Fagiolo del'Arco, Maurizio, et al. *De Chirico: Essays*. Ed. by William Rubin. New York: MMA, 1982.

Gauss, Ulrike, et al. *Marc Chagall, The Lithographs: La Collection Sorlier*. Ostfildern-Ruit, Germany: Hatje Cantz, 1998.

Gough, Maria. *The Artist as Producer: Russian Constructivism in Revolution*. Berkeley, Calif.: University of California Press, 2005.

Gray, Camilla, and Marian Burleigh-Motley. *Russian Experiment in Art: 1863–1922*. Rev. ed. London; New York: Thames & Hudson, 1986.

The Great Utopia: The Russian and Soviet Avant-Garde. New York: SRGM, 1992.

Groys, Boris, and Max Hollein, eds. *Dream Factory Communism: The Visual Culture of the Stalin Era = Traumfabrik Kommunismus: die visuelle Kultur der Stalinzeit*. Frankfurt, Germany: Schirn Kunsthalle; Ostfildern-Ruit, Germany: Hatje Cantz; New York: D.A.P./Distributed Art Publishers, 2003.

Guerman, Mikhail, ed. *Art of the October Revolution*. Trans. W. Freeman, D. Saunders, and C. Binns. New York: H.N. Abrams, 1979.

Haftmann, Werner. *Chagall*. Trans. H. Baumann and A. Brown. New York: Abradale Press, H.N. Abrams, 1998, 1973

———. *Marc Chagall: Gouaches, Drawings, Watercolors*. Trans. R. E. Wolf. New York: H.N. Abrams, 1984.

Hahl-Koch, Jelena. *Kandinsky*. New York: Rizzoli, 1993.

Hanson, Anne Coffin, ed. *The Futurist Imagination: Word + Image in Italian Futurist Painting, Drawing, Collage, and Free-word Poetry*. New Haven, Conn.: Yale University Art Gallery 1983.

———. *Severini Futurista, 1912–1917*. New Haven, Conn.: Yale University Art Gallery, 1995.

Harshav, Benjamin. *Marc Chagall and the Lost Jewish World: The Nature of Chagall's Art and Iconography*. New York: Rizzoli, 2006.

Hoffman, Katherine, ed. *Collage: Critical Views*. Ann Arbor, Mich.: UMI Research Press, 1989.

Hulten, Pontus. *Futurism and Futurisms*. New York: Abbeville Press, 1986.

Humphreys, Richard. *Futurism. Movements in Modern Art*. Cambridge, England; New York: Cambridge University Press, 1999.

Kandinsky, Vasily. *Complete Writings on Art*. Ed. K. Lindsay and P. Vergo. Documents of Twentieth-Century Art. 2 vols. Boston: G. K. Hall, 1982.

———. *Concerning the Spiritual in Art*. Original trans. Michael T. H. Sadler. With a new introd. by Adrian Glew and previously unpublished letters and poems by the author. Boston: MFA Publications, 2006.

Karasik, Irina, et al. *In Malevich's Circle: Confederates, Students, Followers in Russia, 1920s–1950s*. Moscow: The State Russian Museum; Palace Editions, 2000.

Khan-Magomedov, Selim. *Rodchenko: The Complete Work*. Cambridge, Mass.: MIT Press, 1986.

Lavrentiev, Alexander. *Aleksander Rodchenko: Photography is an Art*. Trans. Kate Cook. Mosdow: Interros, 2006.

Lissitzky, El, and Sophie Lissitzky-Küppers. *El Lissitzky: Life, Letters, Texts*. Introd. by Herbert Read; trans. Helene Aldwinckle and Mary Whittall, New York: Thames & Hudson, 1992.

Lista, Giovanni. *Balla*. Modena, Italy: Galleria Fonte d'Abisso, 1982.

———. *Futurism & Photography*. London: Merrell in assoc. with the Estorick Collection of Modern Italian Art, 2001.

Lodder, Christina. *Constructive Strands in Russian Art, 1914–1937*. London: Pindar Press, 2005.

———. *Russian Constructivism*. New Haven, Conn.: Yale University Press, 1983.

Malevich, Kazimir Severinovich. *Essays on Art*. Trans. X. Glowacki-Prus and A. McMillin; ed. by Troels Andersen. 4 vols. Copenhagen: Borgen, 1968–78.

———. *Malevich on Suprematism: Six Essays 1915 to 1926*. Edited and introd. by Patricia Railing. Iowa City, Iowa: Museum of Art, The University of Iowa, 1999.

Mansbach, Steven A. *Modern Art in Eastern Europe: From the Baltic to the Balkans, ca. 1890–1939*. Cambridge, England; New York: Cambridge University Press, 1999.

———. *Visions of Totality: László Moholy-Nagy, Theo van Doesberg, and El Lissitzky*. Ann Arbor, Mich.: UMI Research Press, 1980.

Margolin, Victor. *The Struggle for Utopia: Rodchenko, Lissitzky, Moholy-Nagy: 1917-1946*. Chicago: University of Chicago Press, 1997.

Martin, Marianne, and Anne Coffin Hanson, eds. "Futurism." *Art Journal* (Winter 1981) special issue.

Martin, Sylvia, and Uta Grosenick. *Futurism*. Köln, Germany; Los Angeles: Taschen, 2005.

Milner, John. *Kazimir Malevich and the Art of Geometry*. New Haven, Conn.: Yale University Press, 1996.

———. *A Slap in the Face!: Futurists in Russia*. Exhib. organized by Estorick Collection of Modern Italian Art. London: Philip Wilson Publishers, 2007.

———. *Vladmir Tatlin and the Russian Avant-Garde*. New Haven, Conn.: Yale University Press, 1983.

Monferini, Augusta, Carrà, Carlo, 1881–1966. Milano: Electa, 1994.

Nakov, Andrei B. *Kazimir Malewicz: Catalogue Raisonné*. Paris: A. Biro, 2002.

Ocheretianski, Aleksandr. *Literature and Art of Avant-Garde Russia (1890–1930): Bibliographical Index*. Newtonville, Mass.: Oriental Research Partners, 1989.

Petrova, Yevgenia, and Jean-Claude Marcadâe, eds. *The Avant-Garde: Before and After*. Trans. Kenneth MacInnes. St. Petersburg, Russia: State Russian Museum, 2005.

Poggi, Christine. *In Defiance of Painting: Cubism, Futurism and the Invention of Collage*. Yale Publications in the History of Art. New Haven, Conn.: Yale University Press, 1992.

———. *Inventing Futurism: the Art and Politics of Artificial Optimism*. Princeton, N.J.: Princeton University Press, 2009.

Rodchenko, Aleksandr Mikhalovich. *The Future is Our Only Goal*. Ed. by Peter Noever; essays by Aleksandr N. Lavrentiev and Angela Völker; trans. Mathew Frost, et al. Munich: Prestel; New York: Distr. Te Neues, 1991.

Rossi, Laura Mottioli. *Boccioni's Materia: A Futurist Masterpiece and the Avant-Garde in Milan and Paris*. New York: The Solomon R. Guggenheim Foundation, 2004.

Rotzler, Willy. *Constructive Concepts: A History of Constructive Art from Cubism to the Present*. New ed. New York: Rizzoli, 1989.

Rowell, Margit. *The Planar Dimension: Europe 1912–1932*. New York: SRGM, 1979.

Rowell, Margit, et al. *The Russian Avant-Garde Book, 1910–1934*. New York: MOMA: Distr. H.N. Abrams, 2002

———, and Angelika Z. Rudenstine. *Art of the Avant-Garde in Russia: Selections from the George Costakis Collection*. New York: SRGM, 1981.

Schmied, Wieland. *Giorgio de Chirico: The Endless Journey*. Trans. Michael Robinson. Munich; New York: Prestel, 2002.

Taylor, Brandon. *Collage: The Making of Modern Art*. London: Thames & Hudson, 2004.

Tisdall, Caroline, and Angelo Bozzolla. *Futurism*. New York: Oxford University Press, 1978, 1977.

Tolstoy, Vladimir, et al. *Street Art of the Revolution: Festivals and Celebrations in Russia, 1918–33*. London: Thames & Hudson, 1990.

Zhadova, Larissa A. *Malevich: Suprematism and Revolution in Russian Art*. Trans. A. Lieven. London: Thames & Hudson, 1982.

———, ed. *Tatlin*. New York: Rizzoli, 1988.

10. Picturing the Wasteland: Western Europe during World War I

Ades, Dawn, ed. *The Dada Reader: A Critical Anthology*. London: Tate, 2006.

———, et al., eds. *In the Mind's Eye: Dada and Surrealism*. New York: Abbeville Press, 1986.

———. *Surrealist Art: The Lindy and Edwin Bergman Collection at the Art Institute of Chicago*. Chicago: Art Institute of Chicago; New York: Thames & Hudson, 1997.

Afuhs, Eva. *Sophie Taeuber-Arp: Gestalterin, Architektin, Tänzerin = Designer, Dancer, Architect*. Zürich: Scheidegger & Spiess, 2007.

Andreotti, Margherita. *The Early Sculpture of Jean Arp*. Ann Arbor, Mich.: UMI Research Press, 1989.

Arp, Hans. *On My Way: Poetry and Essays, 1912–1947*. New York: Wittenborn, Schultz, 1948.

Art of the Twentieth Century. Trans. Antony Shugaar. Vol. 1. *1900–1919: The Avant-Garde Movements*. Milan: Skira; New York: Distr. Rizzoli International Publications, 2006.

Baker, George T. *The Artwork Caught by the Tail: Francis Picabia and Dada in Paris*. George Baker. Cambridge, Mass.: The MIT Press, 2007.

Barr, Jr., Alfred H., ed. *Fantastic Art, Dada, Surrealism*. Essays by Georges Hugnet. 3rd ed. New York: MOMA, 1947.

Borràs, Maria Lluïsa. *Picabia*. London: Thames & Hudson, 1985.

Bowers, Maggie Ann. *Magic(al) Realism*. London; New York: Routledge, 2004.

Camfield, William A. *Francis Picabia: His Art, Life, and Times*. Princeton, N.J.: Princeton University Press, 1979.

———. *Max Ernst: Dada and the Dawn of Surrealism*. New York: MOMA, 1993.

Caws, Mary Ann, et al. *Surrealism and Women*. Cambridge, Mass.: MIT Press, 1990.

Clair, Jean. *Marcel Duchamp: Catalogue Raisonné*. Paris: Musée National d'Art Moderne, Centre Georges Pompidou, 1977.

Compère-Morel, Thomas, et al. *Otto Dix: The War = der Krieg*. Milan: 5 Continents; Péronne: Historial de la Grande Guerre, 2003.

Dachy, Marc. *The Dada Movement, 1915–1923*. New York: Skira/Rizzoli, 1990.

———. *Dada: The Revolt of Art*. Trans. Liz Nash. New York: H.N. Abrams, 2006.

Dickerman, Leah. *The Dada Seminars*. Washington, D.C.: National Gallery of Art in assoc. with D.A.P./Distributed Art Publishers, 2005.

———. *Dada: Zurich, Berlin, Hannover, Cologne, New York, Paris*. Washington, D.C.: National Gallery of Art in association with D.A.P./Distributed Art Publishers, New York, 2005.

Dietrich, Dorothea. *The Collages of Kurt Schwitters: Tradition and Innovation*. New York: Cambridge University Press, 1993.

[Dix] *Otto Dix, 1891–1969*. London: Tate, 1992.

Duchamp, Marcel. *Marcel Duchamp, Notes*. Trans. P. Matisse. *Documents of Twentieth-Century Art*. Boston: G. K. Hall, 1983.

Dückers, Alexander. *George Grosz: das druckgraphische Werk = The Graphic Work*. Trans. Steven Connell. San Francisco: A. Wofsy Fine Arts, 1996.

Eberle, Matthias. *World War I and the Weimar Artists: Dix, Grosz, Beckmann, Schlemmer*. New Haven, Conn.: Yale University Press, 1985.

Elderfield, John. *Kurt Schwitters*. New York: MOMA and Thames & Hudson, 1985.

[Ernst] *Max Ernst: Life and Work: An Autobiographical Collage*. Ed. Werner Spies. New York: Thames & Hudson, in assoc. with Dumont, 2006.

Foresta, Merry. *Man Ray, 1890–1976: His Complete Works*. Düsseldorf: Edition Stemmle, 1989.

———, et al. *Perpetual Motif: The Art of Man Ray*. Washington, D.C.: National Museum of American Art, 1988.

Grosz, George. *George Grosz: An Autobiography*. Trans. Nora Hodges; foreword by Barbara McCloskey. Berkeley, Calif.: University of California Press, 1998.

Hancock, Jane H, and Stefanie Poley. *Arp: 1886–1966*. Minneapolis: Minneapolis Institute of Arts, 1987.

Hannah Höch: Museo Nacional Centro de Arte Reina Sofía, Madrid. Madrid: Aldeasa; Museo Nacional Centro de Arte Reina Sofía, 2004.

Hemus, Ruth. Dada's Women. New Haven, Conn.: Yale University Press, 2009.

Hess, Hans. *George Grosz*. New Haven, Conn.: Yale University Press, 1985, 1974.

Hopkins, David. *Dada and Surrealism: A Very Short Introduction*. Oxford, England; New York: Oxford University Press, 2004.

———. *Dada's Boys: Masculinity after Duchamp*. New Haven, Conn.: Yale University Press, 2007.

Jones, Amelia. *Postmodernism and the En-Gendering of Marcel Duchamp*. Cambridge, England and New York: Cambridge University Press, 1994.

Kachur, Lewis. *Displaying the Marvelous: Marcel Duchamp, Salvador Dali, and Surrealist Exhibition Installations*. Cambridge, Mass.: MIT Press, 2001.

Krauss, Rosalind. *Bachelors*. Cambridge, Mass: MIT Press, 1999.

Kuenzli, Rudolf, ed. *Dada*. London; New York: Phaidon, 2006.

———. *Dada and Surrealist Film*. Cambridge, Mass.: The MIT Press, 1996.

———, and Francis M. Naumann. *Marcel Duchamp: Artist of the Century*. Cambridge, Mass.: MIT Press, 1989.

Kuthy, Sandor. *Sophie Taeuber–Hans Arp*. Bern: Kunstmuseum Bern, 1988.

Lanchner, Carolyn. *Sophie Taeuber-Arp*. New York: MOMA, 1981.

Lavin, Maud. *Cut with the Kitchen Knife: The Weimar Photomontages of Hannah Höch*. New Haven, Conn.: Yale University Press, 1993.

Lewis, Beth Irwin. *George Grosz: Art and Politics in the Weimar Republic*. Rev. ed. Princeton, N.J.: Princeton University Press, 1991.

Makela, Maria. *The Photomontages of Hannah Höch*. Minneapolis: Walker Art Center, 1996.

Masheck, Joseph, ed. *Marcel Duchamp in Perspective*. Cambridge, Mass.: Da Capo Press, 2002.

Molderings, Herbert. *Duchamp and the Aesthetics of Chance: Art as Experiment*. New York: Columbia University Press, 2010.

Motherwell, Robert, ed. *The Dada Painters and Poets: An Anthology*. 2nd ed. Cambridge, Mass.: Belknap Press of Harvard University Press, 1989.

Müller-Alsbach, Annja, and Heinz Stahlhut, eds. *Kurt Schwitters: MERZ, a Total Vision of the World*. Bern: Benteli, 2004.

Mundy, Jennifer, ed. *Duchamp, Man Ray, Picabia*. London: Tate, 2008.

Naumann, Francis M. *Conversion to Modernism: The Early Work of Man Ray*. With an essay by Gail Stavitsky. New Brunswick, N. J.: Rutgers University Press; Montclair, N. J.: Montclair Art Museum, 2003.

Neue Sachlichkeit: New Objectivity in Weimar Germany New York: Ubu Gallery, 2004.

Orchard, Karin, and Isabel Schulz. *Kurt Schwitters, Catalogue Raisonné*. 3 vols. Ostfildern-Ruit, Germany: Hatje Cantz, 2000–06.

Penrose, Roland. *Man Ray*. New York: Thames & Hudson: 1989, 1975.

Rau, Bernd. *Jean Arp: The Reliefs, Catalogue of Complete Works*. New York: Rizzoli, 1981.

Richter, Hans. *Dada, Art, and Anti-Art*. New York: Thames & Hudson, 1997, 1965.

Robertson, Eric. *Arp: Painter, Poet, Sculptor*. New Haven, Conn.: Yale University Press, 2006.

Rubin, William. *Dada, Surrealism, and Their Heritage*. New York: MOMA, 1968.

[Sander] *August Sander: Photographer of an Epoch, 1904–1959*. Millerton, N.Y.: Aperture, 1980.

Schulz-Hoffmann, Carla, and Judith Weiss. *Max Beckmann: Retrospective*. St. Louis and Munich: St. Louis Art Museum and Prestel, 1984.

Schwarz, Arturo, ed. *The Complete Works of Marcel Duchamp*. 3rd rev. and expanded ed. New York: Delano Greenridge Editions, 1997.

Selz, Peter. *Max Beckmann*. Modern Masters. New York: Abbeville Press, 1996.

Silver, Kenneth. *Chaos & Classicism: Art in France, Italy, and Germany 1918-1936*. New York: SRGM, 2010.

Tatar, Maria. *Lustmord: Sexual Murder in Weimar Germany*. Princeton, N.J.: Princeton University Press, 1995.

Tzara, Tristan. *Seven Dada Manifestos and Lampisteries*. Trans. Barbara Wright. Illus. by Francis Picabia. New York: Riverrun Press, 1981.

Vögele, Christoph, ed. *Sophie Taeuber-Arp: Variations: Arbeiten auf Papier = Works on Paper*. Heidelberg: Kehrer, 2002.

Whitford, Frank, et al. *The Berlin of George Grosz: Drawings, Watercolours, and Prints, 1912–1930*. London: Royal Academy of Arts; New Haven, Conn: Yale University Press, 1997.

Wood, Ghislaine, ed. *Surreal Things: Surrealism and Design*. London: V&A Publications; New York: Distr. H.N. Abrams, 2007.

11. Art in France after World War I

Art of the Twentieth Century. Trans. Antony Shugaar. Vol. 2. *1920–1945: The Artistic Culture Between the Wars*. Milan: Skira; New York: Distr. Rizzoli International Publications, 2006.

Buffalo, Audreen, ed. *Explorations in the City of Light: African-American Artists in Paris, 1945–1965.* New York: SMH, 1996.

Golding, John, et al. *Braque, the Late Works.* New Haven, Conn.: Yale University Press, 1997.

Greenough, Sarah, et al. *André Kertész.* Washington: National Gallery of Art; Princeton: Princeton Univercity Press, 2005.

Kleeblatt, Norman L., and Kennesth E. Silver. *An Expressionist in Paris: The Paintings of Chaim Soutine.* Contrib. Romy Golan, et al. New York: Jewish Museum, 1998.

Klein, Mason, ed. *Modigliani: Beyond the Myth.* With essays by Maurice Berger, et al. New York: Jewish Museum; New Haven, Conn.: Yale University Press, 2004.

Mann, Carol. *Modigliani.* World of Art. New York: Oxford University Press, 1980.

———. *Paris Between the Wars.* New York: Vendome Press, 1996.

Musée Utrillo-Valadon. *Maurice Utrillo, Suzanne Valadon: Catalogue du Musée.* Sannois: Musée Utrillo-Valadon, 2006.

Nacenta, Raymond. *School of Paris: The Painters and the Artistic Climate of Paris Since 1910.* New York: Alpine Fine Arts Collection, 1981.

Perez-Tibi, Dora. *Dufy.* Trans. S. Whiteside. London: Thames & Hudson, 1989.

Rose, June. *Modigliani, the Pure Bohemian.* London: Constable, 1990.

Sayag, Alain, et al. *Brassaï: The Monograph.* Trans. J. Brenton and H. Mason. Boston: Little, Brown and Company, 2000.

———. *Brassaï: "No Ordinary Eyes."* Trans. J. Brenton and H. Mason. London: Thames & Hudson, 2000.

Silver, Kenneth. *Esprit de Corps: The Art of the Parisian Avant-Garde and the First World War, 1914–1925.* Princeton, N.J.: Princeton University Press, 1989.

Turner, Elizabeth Hutton. *Americans in Paris (1921–1931) Man Ray, Gerald Murphy, Stuart Davis, Alexander Calder.* With essays by Elizabeth Garrity Ellis, and Guy Davenport. Washington, D.C.: Counterpoint, 1996.

Werner, Alfred. *Amedeo Modigliani.* New York: H.N. Abrams, 1985.

———. *Chaim Soutine.* New York: H.N. Abrams, 1977.

———. *Maurice Utrillo.* Commentaries by Alfred Werner and Sabine Rewald. New York: H.N. Abrams, 1981.

12. Clarity, Certainty, and Order: de Stijl and the Pursuit of Geometric Abstraction

Art of the Twentieth Century. Trans. Antony Shugaar. Vol. 2. *1920–1945: The Artistic Culture Between the Wars.* Milan: Skira; New York: Distr. Rizzoli International Publications, 2006.

Bax, Marty. *Complete Mondrian.* Aldershot, England; Burlington, VT: Lund Humphries, 2001.

Blokhuis, Marleen, et al. *Theo van Doesburg, Oeuvre Catalogue.* Ed. by Els Hoek. Utrecht: Centraal Museum; Otterlo: Kröller-Müller Museum, 2000.

Blotkamp, Carel. *Mondrian: The Art of Destruction.* New York: H.N. Abrams, 1995.

Bulhof, Francis, ed. *Nijhoff, Van Ostaijen, "De Stijl": Modernism in the Netherlands and Belgium in the First Quarter of the Twentieth Century.* The Hague, the Netherlands: Nijhoff, 1976.

Dettingmeijer, Rob, Marie-Thérèse van Thoor, and Ida van Zijl, eds. *Rietveld's Universe.* Rotterdam: NAi Publishers, 2010.

Doesburg, Theo van. *New Movement in Painting.* Delft: J. Waltman, 1971.

Jaffé, Hans Ludwig C. *De Stijl, 1917–1931: the Dutch Contribution to Modern Art.* Cambridge, Mass.: Belknap Press of Harvard University Press, 1986.

Langmead, Donald. *The Artists of De Stijl: A Guide to the Literature.* Westport, Conn.: Greenwood Press, 2000.

Mondrian, Piet. *The Complete Writings.* Ed. and trans. H. Holtzmann and M. James. *Documents of Twentieth-Century Art.* Boston: G. K. Hall, 1986.

Overy, Paul. *De Stijl.* World of Art. New York: Thames & Hudson, 1991.

Rudenstine, Angelika Z., ed. *Piet Mondrian, 1872–1944.* Boston: Little, Brown, 1994.

Straaten, Evert van. *Theo van Doesburg: Painter and Architect.* The Hague, the Netherlands: SDU, 1988.

Troy, Nancy. *The De Stijl Environment.* Cambridge, Mass.: MIT Press, 1983.

Warncke, Carsten-Peter. *The Ideal as Art: De Stijl, 1917–1931.* Köln, Germany: Taschen, 1991

White, Michael. *De Stijl and Dutch Modernism.* Manchester; New York: Manchester University Press, 2003.

13. Bauhaus and the Teaching of Modernism

Albers, Josef. *Interaction of Color.* Rev. and expanded ed. New Haven, Conn.: Yale University Press, 2006.

———. *Interaction of Color.* Computer file. Edition: Interactive CD-ROM ed., New Haven, Conn.: Yale University Press, 1994.

Art of the Twentieth Century. Trans. Antony Shugaar. Vol. 2. *1920–1945: The Artistic Culture Between the Wars.* Milan: Skira; New York: Distr. Rizzoli International Publications, 2006.

Bärmann, Matthias, et al. *Paul Klee: Death and Fire: Fulfillment in the Late Work.* German/English ed. Wabern/Bern: Benteli, 2003.

Bauhaus Photography. Cambridge, Mass.: MIT Press, 1985.

Baumann, Kirsten. *Bauhaus Dessau: Architecture, Design, Concept = Architektur, Gestaltung, Idee.* Berlin: Jovis, 2007.

Bayer, Herbert, Walter Gropius, and Ise Gropius. *Bauhaus, 1919–1928.* New York: MOMA, 1975.

Bergdoll, Barry, and Leah Dickerman. *Bauhaus 1919–1933: Workshops for Modernity.* New York: MOMA; London: Thames & Hudson, 2009.

Borchardt-Hume, Achim, ed. *Albers and Moholy-Nagy: From the Bauhaus to the New World.* New Haven, Conn.: Yale University Press, 2006.

Botar, Oliver A. I. *Technical Detours: The Early Moholy-Nagy Reconsidered.* New York: Art Gallery of the Graduate Center, the City University of New York; Salgo Trust for Education, 2006.

Curtis, Penelope. *Kandinsky in Paris: 1934–1944.* Text by V. E. Barnett. New York: SRGM, 1985.

Droste, Magdalena. *Bauhaus, 1919–1933.* Trans. Karen Williams. Köln, Germany: Taschen, 1998.

Fiedler, Jeannine, ed. *Photography at the Bauhaus.* Cambridge, Mass.: MIT Press, 1990.

———, and Hattula Moholy-Nagy. *László Moholy-Nagy: Color in Transparency: Photographic Experiments in Color, 1934–1946.* Göttingen: Steidl; Berlin: Bauhaus-Archiv, 2006.

Gabo, Naum. *Of Diverse Arts.* New York: Pantheon Books, 1962.

Gauss, Ulrike. *Willi Baumeister: Zeichnungen, Gouachen, Collagen.* German/English ed. Stuttgart: Edition Cantz, 1989.

Gropius, Walter. *The New Architecture and the Bauhaus.* Trans. P. Morton Shand, with an introd. by Frank Pick. Cambridge, Mass: M.I.T. Press, 1965.

Hammer, Martin, and Christina Lodder. *Constructing Modernity: The Art & Career of Naum Gabo.* New Haven, Conn.: Yale University Press, 2000.

Hight, Eleanor. *Picturing Modernism: Moholy-Nagy and Photography in Weimar Germany.* Cambridge, Mass.: MIT Press, 1995.

Hochman, Elaine S. *Bauhaus: Crucible of Modernism.* Foreword by Dore Ashton. New York: Fromm International, 1997.

Isaacs, Reginald R. *Gropius: An Illustrated Biography of the Creator of the Bauhaus.* Boston: Little, Brown, 1991.

Itten, Johannes. *The Elements of Color; A Treatise on the Color System of Johannes Itten, based on his book The Arts of Color.* New York: John Wiley & Sons, 2001.

———. *Design and Form: The Basic Course at the Bauhaus and Later.* Rev. ed. New York: John Wiley & Sons, 2006.

Josef Albers, A Retrospective. New York: SRGM, 1988.

Kandinsky: Russian and Bauhaus Years, 1915–1933. New York: SRGM, 1983.

Kaplan, Louis. *László Moholy-Nagy: Biographical Writings.* Durham: Duke University Press, 1995.

Kentgens-Craig, Margret. *The Bauhaus and America: First Contacts, 1919–1936.* Cambridge, Mass.: MIT Press, 1999.

[Klee] *Paul Klee Notebooks.* Ed. by Jürg Spiller. 2 vols. Woodstock, N.Y.: Overlook Press, 1992.

———. *The Diaries of Paul Klee, 1898–1918.* Ed, with introd. by Felix Klee. Berkeley, Calif.: University of California Press, 1968, 1964.

Kudielka, Robert. *Paul Klee: The Nature of Creation: Works 1914–1940.* London: Hayward Gallery in assoc. with Lund Humphries, 2002.

Lane, Barbara Miller. *Architecture and Politics in Germany 1918–1945.* New ed. Cambridge, Mass.: Harvard University Press, 1985.

Lehman, Arnold, and Brenda Richardson, eds. *Oskar Schlemmer.* Baltimore, Md.: Baltimore Museum of Art, 1986.

Long, Rose-Carol Washton. *Kandinsky: The Development of an Abstract Style.* Oxford Studies in the History of Art and Architecture. Oxford, England and New York: Clarendon Press and Oxford University Press, 1980.

Lupfer, Gilbert. *Walter Gropius, 1883–1969: The Promoter of a New Form.* Köln, Germany: Taschen, 2004.

Maciuika, John V. *Before the Bauhaus: Architecture, Politics and the German State, 1890–1919.* New York: Cambridge University Press, 2005.

Michalski, Sergiusz. *New Objectivity: Painting, Graphic Art and Photography in Weimar Germany, 1919–1933.* Trans. Michael Claridge. Köln, Germany: Taschen, 1994.

Moholy-Nagy, László. *The New Vision, and 1928: Abstract of an Artist.* 3rd rev. ed. New York: Wittenborn Schultz, 1949.

———. *Vision in Motion.* Chicago: P. Theobald, 1947.

Müller, Ulrike. *Bauhaus Women.* Paris: Editions Flammarion; New York: Rizzoli, 2009.

Nash, Steven, and Jörn Merkert, eds. *Naum Gabo: Sixty Years of Constructivism.* Munich and New York: Prestel, 1985.

Passuth, Krisztina. *Moholy-Nagy.* New York: Thames & Hudson, 1985, 1982.

Roskill, Mark. *Klee, Kandinsky, and the Thought of their Time: A Critical Perspective.* Urbana, Ill.: University of Illinois Press, 1992.

Schlemmer, Oskar. *The Theatre of the Bauhaus: László Moholy-Nagy, and Farkas Molnár.* Ed. by Walter Gropius. Trans. Arthur S. Wensinger. Baltimore, Md.: Johns Hopkins University Press, 1996.

Thöner, Wolfgang. *The Bauhaus Life: Life and Work in the Masters' Houses Estate in Dessau.* Leipzig: Seemann, 2003.

Verdi, Richard. *Klee and Nature.* New York: Rizzoli, 1985.

Whitford, Frank, ed. *The Bauhaus: Masters & Students by Themselves.* With additional research by Julia Engelhardt. London: Conran Octopus, 1992.

Wingler, Hans Maria. *The Bauhaus: Weimar, Dessau, Berlin, Chicago.* With additions and bibliographical suppl. Cambridge, Mass.: MIT Press, 1978, 1969.

Willett, John. *Art and Politics in the Weimar Period: The New Sobriety, 1917–1933.* New York: Da Capo Press, 1996.

14. Surrealism

Abadie, Daniel, ed. *Magritte.* New York: Distr. Art Publishers, 2003.

Abbott, Berenice. *The World of Atget.* New York: Horizon Press, 1979.

Arbaïzar, Philippe, et al. *Henri Cartier-Bresson: The Man, the Image and the World: A Retrospective.* London; New York, N.Y.: Thames & Hudson, 2003.

Assouline, Pierre. *Henri Cartier-Bresson: A Biography.* New York: Thames & Hudson, 2005.

Ades, Dawn, and Simon Baker. *Undercover Surrealism: Georges Bataille and 'Documents.'* Cambridge, Mass.: MIT Press, 2006.

Ades, Dawn, et al., eds. *In the Mind's Eye: Dada and Surrealism.* New York: Abbeville Press, 1986.

Alix, Josefina, et al. *André Masson, 1896–1987.* Madrid: Museo Nacional Centro de Arte Reina Sofía, 2004.

Art of the Twentieth Century. Trans. Antony Shugaar. Vol. 2. *1920–1945: The Artistic Culture Between the Wars.* Milan: Skira; New York: Distr. Rizzoli International Publications, 2006.

Barr, Jr., Alfred H., ed. *Fantastic Art, Dada, Surrealism.* Essays by Georges Hugnet. 3rd ed. New York: MOMA, 1947.

Blanc, Giulio V., et al. *Wifredo Lam and His Contemporaries.* New York: SMH, 1992.

Bonnefoy, Yves. *Giacometti.* New York: Flammarion/Abbeville Press, 1991.

Breton, André. *Manifestoes of Surrealism.* Ann Arbor, Mich.: University of Michigan Press, 1969.

———. *Surrealism and Painting.* Trans. Simon Watson Taylor; introd. by Mark Polizzotti. Boston, Mass.: MFA Publications; New York: D.A.P./Distributed Art Publishers, 2002, 1965.

———. *What Is Surrealism? Selected Writings.* Ed. and introd. by Franklin Rosemont. New York: Pathfinder, 2001, 1978.

Camfield, William. *Max Ernst: Dada and the Dawn of Surrealism.* Houston and Munich: The Menil Collection and Prestel, 1993.

Carter, Curtis L., et al. *Wifredo Lam in North America.* Milwaukee, Wis.: Patrick and Beatrice Haggerty Museum of Art, Marquette University, 2007.

Caws, Mary Ann, ed. *Surrealism*. London; New York: Phaidon, 2004.

Chadwick, Whitney, ed. *Mirror Images: Women, Surrealism, and Self-Representation*. Essays by Dawn Ades, et al. Cambridge, Mass.: MIT Press, 1998.

———. *Women Artists and the Surrealist Movement*. London: Thames & Hudson, 1985.

Christensen, Hans Dam, et al. *Rethinking Art between the Wars: New Perspectives in Art History*. Copenhagen: Museum Tusculanum Press: University of Copenhagen, 2001.

Dalí, Salvador. *The Collected Writings of Salvador Dalí*. Ed. and trans. by H. Finkelstein. Cambridge, England; New York: Cambridge University Press, 1998.

———. *The Secret Life of Salvador Dalí*. Trans. H. M. Chevalier. New York: Dover, 1993.

De Bock, Paul Aloïse. *Paul Delvaux*. Hamburg: J. Asmus, 1965.

Dervaux, Isabelle. *Surrealism USA*. Contrib. Michael Duncan, et al. New York: National Academy Museum: Ostfildern-Ruit, Germany: Hatje Cantz, 2004.

Descharnes, Robert. *Salvador Dalí, 1904–1989*. Trans. Michael Hulse. Köln, Germany; London: Taschen, 1997.

———. *Salvador Dali: The Work, The Man*. New York: H.N. Abrams, 1997.

Diane Arbus: Revelations: San Francisco Museum of Modern Art. New York: Random House, 2003.

Durozoi, Gérard. *History of the Surrealist Movement*. Trans. Alison Anderson. Chicago: University of Chicago Press, 2002.

Ernst, Max. *Beyond Painting, and Other Writings by the Artist and His Friends*. New York: Wittenborn, Schultz, 1948.

Fanés, Fèlix. *Salvador Dalí: The Construction of the Image*. New Haven, Conn.: Yale University Press, 2007.

Fer, Briony. *Realism, Rationalism, Surrealism: Art Between the Wars*. New Haven, Conn.: Yale University Press, 1993.

———, et al. *Transmission: The Art of Matta and Gordon Matta-Clark*. San Diego, Calif.: San Diego Museum of Art, 2006.

Foster, Hal. *Compulsive Beauty*. Cambridge, Mass.: MIT Press, 1993.

Foucault, Michel. *This is Not a Pipe*. With illus. and letters by René Magritte; trans. and ed. by James Harkness. 25th anniversary ed. Berkeley, Calif.; London: University of California Press, 2008.

Gablik, Suzy. *Magritte*. World of Art. Reprint. New York: Thames & Hudson, 1985.

Grant, Kim. *Surrealism and the Visual Arts: Theory and Reception*. Cambridge, England; New York: Cambridge University Press, 2005.

Hohl, Reinhold. *Alberto Giacometti: A Retrospective Exhibition*. New York: SRGM, 1974.

Hopkins, David. *Dada and Surrealism: A Very Short Introduction*. Oxford, England; New York: Oxford University Press, 2004.

Klemm, Christian, et al. *Alberto Giacometti*. Zürich: Kunsthaus Zürich; New York: Distr. H.N. Abrams, 2001.

Krauss, Rosalind. *L'amour fou: Photography and Surrealism*. New York: Abbeville Press, 1985.

Kuenzli, Rudolf E., ed. *Dada and Surrealist Film*. Cambridge, Mass.: MIT Press, 1996.

Lanchner, Carolyn. *Joan Miró*. New York: MOMA, 1993.

Lewis, Helena. *The Politics of Surrealism*. New York: Paragon, 1988.

Lippard, Lucy R., ed. *Surrealists on Art*. Englewood Cliffs, N.J.: Prentice Hall, 1970.

Lord, James. *Giacometti, A Biography*. New York: Farrar, Straus and Giroux, 1985.

———. *Mythic Giacometti*. New York: Farrar, Straus and Giroux, 2004.

Magritte, René. *Magritte, the True Art of Painting*. Harry Torczyner, with the collaboration of Bella Bessard. Trans. R. Miller. New York: H.N. Abrams: distrib. by New American Library, 1985, 1979.

Maur, Karin von. *Yves Tanguy and Surrealism*. With essays by Susan Davidson. Trans. John Brownjohn and John S. Southard. Ostfildern-Ruit, Germany: Hatje Cantz; New York: Distr. D.A.P./Distributed Art Publishers, 2001.

Miró, Joan. *Joan Miró: Selected Writings and Interviews*. Ed. M. Rowell. Documents of Twentieth-Century Art. Boston: G. K. Hall, 1986.

Mundy, Jennifer, ed. *Surrealism: Desire Unbound*. Consultant ed., Dawn Ades; special adviser, Vincent Gille. Princeton, N.J.: Princeton University Press, 2001.

Nadeau, Maurice. *History of Surrealism*. Cambridge, Mass.: Harvard University Press, 1989.

Nesbit, Molly. *Atget's Seven Albums*. New Haven, Conn.: Yale University Press, 1992.

Ollinger-Zinque, Gisèle, et al. *Magritte, 1898–1967*. Ghent: Ludion Press; New York: Distr. H.N. Abrams, 1998.

———. *Paul Delvaux, 1897–1994: Royal Museums of Fine Arts of Belgium, Brussels*. Wommelgem: Blondé, 1997.

Roegiers, Patrick. *Magritte and Photography*. Trans. Mark Polizzotti. Aldershot, England: Lund Humphries; New York: D.A.P./Distributed Art Publishers, 2005.

Rowell, Margit. *Julio González: A Retrospective*. New York: SRGM, 1983.

Rubin, William S. *Dada, Surrealism, and Their Heritage*. New York: MOMA, 1968.

———. *Matta*. New York: MOMA, 1957.

Rubin, William S., and Carolyn Lanchner. *Andre Masson*. New York: MOMA, 1976.

Sims, Lowery Stokes. *Wifredo Lam and the International Avant-Garde, 1923–1982*. Austin, Tex.: University of Texas Press, 2002.

Spies, Werner. *Max Ernst: Life and Work: An Autobiographical Collage*. New York: Thames & Hudson, in assoc. with Dumont, 2006.

———, ed. *Max Ernst, Oeuvre-Katalog*. 7 vols. Houston, Tex.: Menil Foundation; Köln: M. DuMont Schauberg, 1975.

Spies, Werner, and Sabine Rewald, eds. *Max Ernst: A Retrospective*. New York: MMA; New Haven: Yale University Press, 2005.

Spiteri, Raymond, and Donald LaCoss, eds. *Surrealism, Politics and Culture*. Aldershot, England; Burlington, VT: Ashgate, 2003.

Stich, Sidra. *Anxious Visions: Surrealist Art*. New York: Abbeville Press, 1990.

The Surrealists Look at Art: Eluard, Aragon, Soupault, Breton, Tzara. Introd. by Pontus Hulten. Venice, Calif.: Lapis Press, 1990.

Sylvester, David. *Magritte: The Silence of the World*. New York: H.N. Abrams, 1994.

Szarkowski, John. *Atget. John Szarkowski*. New York: MOMA: Calloway, 2000.

———, and Maria Hambourg. *The Work of Atget*. 4 vols. New York: MOMA, 1981–84.

Walker, Ian. *City Gorged with Dreams: Surrealism and Documentary Photography in Interwar Paris*. Manchester, England; New York: Manchester University Press; New York: Distr. Palgrave, 2002.

Wilson, Laurie. *Alberto Giacometti: Myth, Magic, and the Man*. New Haven, Conn.: Yale University Press, 2003.

Worswick, Clark. *Berenice Abbott, Eugene Atget*. Santa Fe, N.Mex: Arena Editions, 2002.

15. American Art Before World War II

Abbott, Brett. *Edward Weston Photographs From the J. Paul Getty Museum*. Los Angeles: J. Paul Getty Museum, 2005.

Abstract Painting and Sculpture in America: 1927–1944. New York: H.N Abrams, 1984.

[Adams] *Ansel Adams: Images 1924–1974*. Boston: New York Graphic Society, 1974.

Adams, Henry. *Thomas Hart Benton: An American Original*. New York: Alfred A. Knopf, 1989.

———. *Thomas Hart Benton: Drawing from Life*. New York: Abbeville Press, 1990.

Alinder, Mary Street. *Ansel Adams, a Biography*. New York: H. Holt, 1996.

Argenteri, Letizia. *Modotti Between Art and Revolution*. New Haven: Yale University Press, 2003.

Arnason, H. H., and Ugo Mulas, eds. *Calder*. New York: Viking Press, 1971.

Art of the Twentieth Century. Trans. Antony Shugaar. Vol. 2. *1920–1945: The Artistic Culture Between the Wars*. Milan: Skira; New York: Distr. Rizzoli International Publications, 2006.

Baigell, Matthew. *The American Scene: American Painting of the 1930s*. New York: Praeger, 1974.

Balken, Debra Bricker, et al. *Arthur Dove: A Retrospective*. Andover, Mass.: Addison Gallery of American Art; Cambridge, Mass.: MIT Press, in assoc. with the Phillips Collection, Washington, D.C., 1997.

Baker, Houston A., Jr. *Modernism and the Harlem Renaissance*. Chicago: Chicago University Press, 1987.

Bochner, Jay. *An American Lens: Scenes From Alfred Stieglitz's New York Secession*. Cambridge, Mass.: MIT Press, 2005.

Brandow, Todd, and William A. Ewing. *Edward Steichen: Lives in Photography*. New York: W.W. Norton & Company, 2008.

Brock, Charles. *Charles Sheeler Across Media*. Washington, D.C.: National Gallery of Art; Berkeley, Calif.: In assoc. with University of California Press, 2006.

Brown, Milton. *Story of the Armory Show: The 1913 Exhibition that Changed American Art*. 2nd ed. New York: Abbeville Press, 1988.

Calo, Mary Ann. *Distinction and Denial: Race, Nation, and the Critical Construction of the African American Artist, 1920–40*. Ann Arbor, Mich.: University of Michigan Press, 2007.

Carr, Carolyn Kinder. *Gaston Lachaise, Portrait Sculpture*. Washington, D.C.: National Portrait Gallery, Smithsonian Institution in assoc. with the Smithsonian Institution Press, 1985.

Cohen, Stuart. *The Likes of Us: America in the Eyes of the Farm Security Administration*. Boston: David R. Godine, 2009.

Conde, Teresa del, ed. *Tamayo*. Trans. Andrew Long and Luisa Panichi. Boston: Little, Brown, 2000.

Corn, Wanda. *Grant Wood: The Regionalist Vision*. New York: WMAA, 1983.

———. *The Great American Thing: Modern Art and National Identity, 1915–1935*. Berkeley, Calif.: University of California Press, 1999.

Craven, David. *Diego Rivera as Epic Modernist*. New York: G.K. Hall; London: Prentice Hall International, 1997.

Curtis, James. *Mind's Eye, Mind's Truth: FSA Photography Reconsidered*. Philadelphia: Temple University Press, 1989.

Danly, Susan. *Georgia O'Keeffe and the Camera the Art of Identity*. With an introd. by Barbara Buhler Lynes. New Haven, Conn.: Yale University Press; Portland, Me.: In assoc. with the Portland Museum of Art, 2008.

Davidson, Abraham. *Early American Modernist Painting: 1910–1935*. New York: Harper & Row, 1981.

Diego Rivera: A Retrospective. New York: Founders Society, Detroit Institute of Arts, in association with W.W. Norton, 1986.

Drohojowska-Philp, Hunter. *Full Bloom: The Art and Life of Georgia O'Keeffe*. New York: W.W. Norton, 2004.

du Pont, Diana, ed. *Tamayo: A Modern Icon Reinterpreted*. Santa Barbara, Calif. Santa Barbara Museum of Art, 2007.

Dwight, Edward. *Armory Show 50th Anniversary Exhibition 1913–1963*. Utica, N.Y.: Munson-Williams-Proctor Institute, 1963.

Eldredge, Charles C. *American Imagination and Symbolist Painting*. New York: Grey Gallery, New York University, 1980.

———. *Georgia O'Keeffe*. Library of American Art. New York: H.N. Abrams, 1991.

———. *Georgia O'Keeffe: American and Modern*. New Haven, Conn.: Yale University Press, 1993.

Fahlman, Betsy. *Chimneys and Towers: Charles Demuth's Late Paintings of Lancaster*. Fort Worth, Tex.: Amon Carter Museum; Philadelphia: Distr. The University of Pennsylvania Press, 2007.

Fávela, Ramón. *Diego Rivera: The Cubist Years*. Phoenix: Phoenix Art Museum, 1984.

Fine, Elsa. *John Marin*. New York and Washington, D.C.: Abbeville Press and National Gallery of Art, 1990.

Fine, Ruth. *The Art of Romare Bearden*. Contrib. Mary Lee Corlett, et al. Washington National Gallery of Art in assoc. with H.N. Abrams, 2003.

Folgarait, Leonard. *So Far From Heaven: David Alfaro Siqueiros' "The March of Humanity" and Mexican Revolutionary Politics*. New York: Cambridge University Press, 1987.

Frank, Robin Jaffee. *Charles Demuth: Poster Portraits, 1923–1929*. New Haven, Conn.: Yale University Art Gallery, 1994.

Frida Kahlo, 1907–2007. Trans. Gregory Dechant. Mexico: D.F. Instituto Nacional de Bellas Artes Editorial RM, 2008.

Furth, Leslie. *Augustus Vincent Tack: Landscape of the Spirit*. With essays by Elizabeth V. Chew and David W. Scott. Washington, D.C.: Phillips Collection, 1993.

Gaston Lachaise: Sculpture. Essay by Barbara Rose. New York: Salander-O'Reilly Galleries; Houston, Tex.: Meredith Long & Co., 1991.

Giménez, Carmen, and Alexander S.C. Rower. *Calder: Gravity and Grace*. London; New York: Phaidon, 2004.

Glackens, Ira. *William Glackens and the Eight: The Artists who Freed American Art*. Rev. ed. New York: Horizon Press, 1984.

Goldberg, Vicki. *Margaret Bourke-White: A Biography*. New York: Harper & Row, 1986.

Greenough, Sarah. *Paul Strand: An American Vision.* New York: Aperture Foundation in assoc. with the National Gallery of Art, Washington, 1990.

Greenough, Sarah, and Juan Hamilton. *Alfred Stieglitz, Photographs and Writings.* Washington, D.C.: National Gallery of Art, 1983.

Haaften, Julia van, ed. *Berenice Abbott, Photographer: A Modern Vision: A Selection of Photographs and Essays.* New York: New York Public Library, 1989.

Hambourg, Maria Morris, et al. *Walker Evans.* New York: MMA in assoc. with Princeton University Press, Princeton, 2000.

Hammond, Anne. *Ansel Adams: Divine Performance.* New Haven, Conn.; London: Yale University Press, 2002.

Harnsberger, R. Scott. *Four Artists of the Stieglitz Circle: A Sourcebook on Arthur Dove, Marsden Hartley, John Marin, and Max Weber.* Westport, Conn.: Greenwood Press, 2002.

Harris, Jonathan. *Federal Art and National Culture: The Politics of Identity in New Deal America.* Cambridge, England; New York: Cambridge University Press, 1995.

Haskell, Barbara. *The American Century Art and Culture, 1900–1950.* New York: WMAA in assoc. with W.W. Norton, 1999.

———. *Burgoyne Diller.* New York: WMAA, 1990.

———. *Charles Demuth.* New York: WMAA; H.N. Abrams, 1987.

———. *Elie Nadelman: Sculptor of Modern Life.* New York: WMAA; Distr. H.N. Abrams, 2003.

———. *Joseph Stella.* New York: WMAA, 1994.

Herrera, Hayden. *Frida Kahlo: The Paintings.* New York: HarperCollins, 1991.

Heyman, Therese, et al. *Dorothea Lange: American Photographs.* San Francisco: SFMOMA and Chronicle Books, 1994.

Hobbs, Robert Carleton. *Milton Avery.* Introd. by Hilton Kramer. New York: Hudson Hills Press: Distr. Rizzoli, 1990.

Hole, Heather. *Marsden Hartley and the West: The Search for an American Modernism.* New Haven, Conn.: Yale University Press; Santa Fe, N.Mex.: Georgia O'Keeffe Museum, 2007.

Hunter, Sam. *Lachaise.* New York: Cross River Press, a division of Abbeville Press, 1993.

Hurlburt, Laurence P. *The Mexican Muralists in the United States.* Foreword by David W. Scott. Albuquerque: University of New Mexico Press, 1989.

Johnson, Diane. *American Symbolist Art: Nineteenth-Century "Poets in Paint": Washington Allston, John La Farge, William Rimmer, George Inness, and Albert Pinkham Ryder.* Lewiston, N.Y.: Edwin Mellen Press, 2004.

Karlstrom, Paul J. *Turning the Tide: Early Los Angeles Modernists, 1920–1956.* Santa Barbara, Calif.: Santa Barbara Museum of Art, 1990.

Kornhauser, Elizabeth Mankin, ed. *Marsden Hartley.* Hartford, Conn.: Wadsworth Atheneum Museum of Art, in assoc. with Yale University Press, 2002.

Lane, John R., and Susan C. Larsen. *Abstract Painting and Sculpture in America 1927–1944.* Pittsburgh: Museum of Art, Carnegie Institute, 1984.

Levin, Gail. *Edward Hopper: A Catalogue Raisonné.* New York: WMAA, 1995.

———. *Edward Hopper: An Intimate Biography.* Updated and expanded ed. New York: Rizzoli, 2007.

———. *Synchromism and American Color Abstraction: 1910–1925.* New York: WMAA, 1978.

Lipman, Jean. *Calder's Universe.* New York: Viking Press and WMAA, 1977.

Longwell, Dennis. *Steichen: The Master Prints, 1895–1914.* New York: MOMA, 1978.

Lorenz, Richard. *Imogen Cunningham: Flora/Photographs.* Boston: Little, Brown, 1996.

Lorquin, Bertrand. *Maillol.* London: Thames & Hudson, 1995.

Lowe, Sarah M. *Tina Modotti: Photographs.* Philadelphia and New York: Philadelphia Museum of Art and H.N. Abrams, 1995.

Lozano, Luis-Martín, et al. *Diego Rivera Art & Revolution.* Mexico City: Instituto Nacional de Bellas Artes; Landucci Editores, 1999.

Lucic, Karen. *Charles Sheeler and the Cult of the Machine.* Cambridge, Mass.: Harvard University Press, 1991.

Lyden, Anne M. *Paul Strand: Photographs from the J. Paul Getty Museum.* Los Angeles: Getty Publications, 2005.

Lynes, Barbara Buhler. *Georgia O'Keeffe Museum Collections.* New York: H.N. Abrams, 2007.

———. *Georgia O'Keeffe and the Calla Lily in American Art, 1860–1940.* With essays by Charles C. Eldredge and James Moore. New Haven, Conn.: Yale University Press in assoc. with the Georgia O'Keeffe Museum, 2002.

Lynes, Barbara Buhler. *O'Keeffe, Stieglitz, and the Critics, 1916–1929.* Chicago: University of Chicago Press, 1991, 1989.

Lyons, Deborah, et al. *Edward Hopper and the American Imagination.* New York: WMAA in assoc. with W.W. Norton, 1995.

Maillol and America. New York: Marlborough Gallery, 2004.

Marter, Joan. *Alexander Calder.* Cambridge, England: Cambridge University Press, 1991.

———. *Beyond the Plane: American Constructions 1930–1965.* Trenton, N.J.: New Jersey State Museum, 1983.

Mellow, James R. *Walker Evans.* New York: Basic Books, 1999.

Meltzer, Milton. *Dorothea Lange: A Photographer's Life.* With a foreword by Naomi Rosenblum. Syracuse, N.Y.: Syracuse University Press, 2000.

Messinger, Lisa Mintz, et al. *African-American Artists, 1929–1945: Prints, Drawings, and Paintings in the Metropolitan Museum of Art.* New York: MMA; New Haven, Conn.: Yale University Press, 2003.

———, ed. *Stieglitz and his Artists: Matisse to O'Keeffe: the Alfred Stieglitz Collection in the Metropolitan Museum of Art.* New York: MMA, 2011.

Milosch, Jane C., ed. *Grant Wood's Studio Birthplace of American Gothic.* Contrib. Wanda C. Corn, et al. Munich; New York: Prestel, 2005.

Mora, Gilles, ed. *Edward Weston: Forms of Passion.* New York: H.N. Abrams, 1995.

Morgan, Ann Lee. *Arthur Dove, Life and Work with a Catalogue Raisonné.* Newark: University of Delaware Press; London: Associated University Presses, 1984.

Nasgaard, Roald. *The Mystic North: Symbolist Landscape Painting in Northern Europe and North America, 1890–1940.* Toronto; Buffalo: Published in assoc. with the Art Gallery of Ontario by University of Toronto Press, 1984.

Newhall, Nancy. *Ansel Adams: The Eloquent Light.* Millerton, N.Y.: Aperture, 1980.

———. *From Adams to Stieglitz: Pioneers of Modern Photography.* Introd. by Beaumont Newhall. New York: Aperture, 1989.

———, ed. *The Daybooks of Edward Weston.* Foreword by Beaumont Newhall. 2nd ed. New York: Aperture, 1990.

Niven, Penelope. *Steichen: A Biography.* New York: Clarkson Potter, 1997.

Paul Strand: A Retrospective Monograph, the Years 1915–1968. 2 vols. Millerton, N.Y.: Aperture, 1971.

Peeler, David P. *The Illuminating Mind in American Photography: Stieglitz, Strand, Weston, Adams.* Rochester, N.Y.: University of Rochester Press, 2001.

Phillips, Stephen Bennett. *Margaret Bourke-White: The Photography of Design, 1927–1936.* Washington D.C.: The Phillips Collection in assoc. with Rizzoli, New York, 2003.

Photographs: Berenice Abbott. Foreword, Muriel Rukeyser; introd., David Vestal. Washington, D.C.: Smithsonian Institution Press, 1990.

Porter, James A. *Modern Negro Art.* With new introd. by David C. Driskell. Washington, D.C. Howard University Press, 1992, 1943.

Portrait of a Decade: David Alfaro Siqueiros, 1930–1940. Trans. Lorna Scott Fox. Mexico City: Instituto Nacional de Bellas Artes, 1997.

Powell, Richard J., and David A. Bailey. *Rhapsodies in Black Art of the Harlem Renaissance.* London: Hayward Gallery; Institute of International Visual Arts, Berkeley, Calif.: University of California Press, 1997.

Prather, Marla, et al. *Alexander Calder, 1898–1976.* Washington: National Gallery of Art; New Haven, Conn.: Yale University Press, 1998.

Rathbone, Belinda. *Walker Evans: A Biography.* Boston: Houghton Mifflin, 1995.

Roberts, Brady, et al. *Grant Wood: An American Master Revealed.* Davenport, Iowa and San Francisco: Davenport Museum of Art and Pomegranate Art Books, 1995.

Robertson, Bruce. *Marsden Hartley.* Library of American Art. New York: Abrams in assoc. with the National Museum of American Art, Smithsonian Institution, 1994.

Rosenblum, Walter, et al. *America and Lewis Hine: Photographs, 1904–1940.* Millerton, N.Y.: Aperture, 1977.

Rosenthal, Mark. *The Surreal Calder.* With a chronology by Alexander S. C. Rower. Houston, Tex.: Menil Collection; New Haven, Conn.; London: Distr. Yale University Press, 2005.

Rubin, Susan Goldman. *Margaret Bourke-White: Her Pictures Were Her Life.* New York: H.N. Abrams, 1999.

Rylands, Phillip. *Stuart Davis.* Milan: Electa, 1997.

Schmidt Campbell, Mary. *Memory and Metaphor: The Art of Romare Bearden, 1940–1987.* New York: Oxford University Press, 1991.

Simpson, Marc, ed. *Like Breath on Glass: Whistler, Inness, and the Art of Painting Softly.* With essays by Wanda M. Corn, et al. New Haven, Conn.: Yale University Press, 2008.

Sims, Lowery Stokes. *Stuart Davis: American Painter.* New York: MMA, 1991.

Smith, Joel. *Edward Steichen: The Early Years.* Princeton, N.J.: Princeton University Press in assoc. with the MMA, 1999.

Smith, Terry. *Making the Modern: Industry, Art, and Design in America.* Chicago: University of Chicago Press, 1993.

Snyder, Jill. *Against the Stream: Milton Avery, Adolph Gottlieb, and Mark Rothko in the 1930s.* Katonah, N.Y.: Katonah Museum of Art, 1994.

South, Will. *Color, Myth, and Music: Stanton Macdonald-Wright and Synchromism.* Contrib. William C. Agee, et al. Raleigh, N.C.: North Carolina Museum of Art, 2001.

Spirn, Anne Whiston. *Daring to Look: Dorothea Lange's Photographs and Reports From the Field.* Chicago: University of Chicago Press, 2008.

Stebbins, Jr., Theodore E. *Weston's Westons: Portraits and Nudes.* Boston: MOFA, 1994, 1989.

———, and Karen Quinn. *Edward Weston, Photography and Modernism.* Boston: MOFA Bulfinch Press/Little, Brown, 1999.

———. *Weston's Westons: California and the West.* Boston: MOFA, 1994.

Stein, Judith E. *I Tell My Heart: The Art of Horace Pippin.* Philadelphia: Pennsylvania Academy of Fine Arts, 1994.

Steinorth, Karl, et al. *Lewis Hine: Passionate Journey, Photographs, 1905–1937.* Zurich: Edition Stemmle, 1996.

[Tamayo] *Rufino Tamayo: Myth and Magic.* New York: SRGM, 1979.

Troyen, Carol, and Erica Hirschler. *Charles Sheeler: Paintings and Drawings.* Boston: MOFA, 1987.

Troyen, Carol, et al. *Edward Hopper.* Boston: MFA Publications; New York: D.A.P./Distributed Art Publishers, 2007.

Wagner, Anne. *Three Artists (Three Women): Modernism and the Art of Hesse, Krasner, and O'Keeffe.* Berkeley, Calif.: University of California Press, 1996.

Wagstaff, Sheena, ed. *Edward Hopper.* Contrib. David Anfam, et. al. London: Tate, 2004.

Wheat, Ellen Harkins. *Jacob Lawrence, American Painter.* Contrib. Patricia Hills. Seattle: University of Washington Press in assoc. with the Seattle Art Museum, 1986.

Yglesias, Helen. *Isabel Bishop.* New York: Rizzoli, 1989.

Yochelson, Bonnie, and Daniel Czitrom. *Rediscovering Jacob Riis: Exposure Journalism and Photography in Turn-of-the-Century New York.* New York: New Press; Distr. W.W. Norton, 2007.

Zurier, Rebecca. *Picturing the City: Urban Vision and the Ashcan School.* Berkeley, Calif.: University of California Press, 2006.

Index

Credits

The author and publisher wish to thank the libraries, museums, galleries, and private collectors named in the picture captions for permitting the reproduction of works of art in their collections and for supplying the necessary photographs. Photographs from other sources are gratefully acknowledged below. Numbers listed before the sources refer to figure numbers.

Key

ADAGP = Société des auteurs dans les arts graphiques et plastiques, Paris
AR = Art Resource, New York
ARS = Artists Rights Society, New York
LACMA = Los Angeles County Museum of Art
MET = The Metropolitan Museum of Art, New York
MoMA = The Museum of Modern Art, New York
RMN = Réunion des musées nationaux, Paris
Scala = Scala, Florence
SI = Smithsonian Institution

Cover: The Sidney and Harriet Janis Collection 644.1967 © 2012 Digital image, MoMA/Scala. © 2012 Estate of Pablo Picasso/ARS

Frontispiece: The Alfred Stieglitz Collection, 1949 (49.70.42) © 2012 Image copyright MET/AR/Scala

Chapter 1: 1.1 Gift of Dexter M. Ferry, Jr.,The Detroit Institute of Arts; 1.2 Gift of Cornelius Vanderbilt, 1887 © Photo Josse, Paris; 1.3, 1.9 © Tate, London 2012; 1.4 © The Trustees of the British Museum; 1.5 © RMN/Thierry Le Mage; 1.6 1943.859. Imaging Department © President and Fellows of Harvard College; 1.7 Courtesy of The Hispanic Society of America, New York; 1.8 Potter Palmer Collection, 1922.404. Photography © The Art Institute of Chicago; 1.10 Presented by Henry Vaughan, 1886 (5387) © The National Gallery, London/Scala; 1.11 © The Cleveland Museum of Art; 1.12, 1.13 © RMN/Herve Lewandowski

Chapter 2: 2.2, 2.3, 2.4 Science and Society Picture Library; 2.5 Photograph © 2012 The Detroit Institute of Arts; 2.6 Photo © Bayerisches Nationalmuseum; 2.7 Gift of Warner Communications, Inc., 531.1981 © 2012 Digital image, MoMA/Scala; 2.8 Bibliotheque Nationale de France, Paris; 2.9, 2.30 Courtesy of George Eastman House, International Museum of Photography and Film; 2.12 Photo National Portrait Gallery, Smithsonian Institution, Washington, D.C/AR/Scala; 2.13 © Albertina, Vienna; 2.14 © RMN (Musée d'Orsay)/Gérard Blot/Hervé Lewandowski; 2.15 H. O. Havemayer Collection. Bequest of Mrs. H. O. Havemayer, 29.100.122. © 2012 Image copyright MET/AR/Scala; 2.16 © RMN (Musée d'Orsay)/Michel

Urtado; 2.19 © RMN (Musée d'Orsay)/Hervé Lewandowski; 2.20 Rogers Fund 1919 (19.74.1) © 2012 Image copyright MET/AR/Scala; 2.21, 2.22, 2.28, 2.31, 2.35 © RMN (Musée d'Orsay)/ Hervé Lewandowski; 2.23 Gift of Anna Ferris, 30.1478.89; 2.24, 2.26 © 2012 Image copyright MET/AR/Scala; 2.25 © Tate, London 2012; 2.27 Musee Marmottan Monet, Paris, France/Giraudon/ The Bridgeman Art Library ; 2.29 Purchase: The Kenneth A. and Helen F. Spencer Foundation Acquisition Fund F72-35. Photo: Jamison Miller; 2.32 Philadelphia Museum of Art. W. P. Wilstach Fund, W1921-1-2; 2.34 Image courtesy of The National Gallery of Art, Washington; 2.36 Stickney Fund, 1924.127. Photography © The Art Institute of Chicago; 2.37 Musee de l›Orangerie, Paris, France/Giraudon/The Bridgeman Art Library ; 2.38 Arthur Hoppock Hearn Fund, 1916 (16.53) © 2012 Image copyright MET/AR/Scala; 2.39 Gift of Mrs. Hermine M. Turner © 2012 Digital image, MoMA/Scala ; 2.40 Gift of Mrs. Frank B. Porter, 1922 (22.207) © 2012 Image copyright MET/AR/Scala; 2.41 Mr. and Mrs. Martin A. Ryerson Collection, 1933.1235. Photography © The Art Institute of Chicago; 2.42 Purchase, Alfred N. Punnett Endowment Fund and George D. Pratt Gift, 1934 (34.92) © 2012 Image copyright MET/ AR/Scala; 2.43 Gift of the Alumni Association to Jefferson Medical College in 1878 and purchased by the Pennsylvania Academy of the Fine Arts and the Philadelphia Museum of Art in 2007 with the generous support of some 3,600 donors. 2007-1-1 © 2012 Photo: The Philadelphia Museum of Art/ AR/Scala; 2.45 34.55 © 2012 Image copyright MET/AR/Scala; 2.47 Harvard University Art Museums/Fogg Museum, Cambridge, MA. Gift of William Gray from the Collection of Francis Calley Gray, G1098. Imaging Department © President and Fellows of Harvard College.

Chapter 3: 3.1 Helen Birch Bartlett Memorial Collection, 1926.224. Photography © The Art Institute of Chicago; 3.2 © The Trustees of the British Museum; 3.3 © Albright-Knox Gallery/AR/Scala; 3.4 Fractional gift to MoMA, from a private collector 85.1991© 2012 Digital image, MoMA/Scala ; 3.5 Image courtesy of The National Gallery of Art, Washington; 3.6 Mr. and Mrs. Martin A. Ryerson Collection, 1933.1116. Photography © The Art Institute of Chicago; 3.7 Helen Birch-Bartlett Memorial Collection, 1926.252. Photography © The Art Institute of Chicago; 3.9 Wilstach Collection © Photo The Philadelphia Museum of Art/AR/Scala; 3.10 Harvard University Art Museums/Fogg Museum, Cambridge, MA, Grenville L. Winthrop Bequest 1943.268. Imaging Department © President and Fellows of Harvard College; 3.11 © The Cleveland Museum of Art; 3.12 Gift of Larry Aldrich, 4.1964 © 2012. Digital image, MoMA/Scala ; 3.13

Louis E. Stern Collection 1963 © Photo The Philadelphia Museum of Art/AR/Scala; 3.14 Gift of Mrs. Simon Guggenheim 646.1939 © 2012 Digital image, MoMA/Scala; 3.15 The Minneapolis Institute of Art. John R. Van Derlip Fund 54.1; 3.16 © RMN/Musée d'Orsay, Paris; 3.17 © RMN/ Musée d'Orsay, Paris/René-Gabriel Ojeda; 3.18 Gift of Joseph H Hirshhorn, 1966. Photography by Lee Stalsworth; 3.19 60.235. Photograph © 2012 Museum of Fine Arts, Boston; 3.20 © RMN/Musée Rodin, Paris; 3.21 Mrs Wendell T. Bush Fund 614.195 © 2012 Digital image, MoMA/Scala; 3.23 Arthur Tracy Cabot Fund 57.582. Photograph © 2012 Museum of Fine Arts, Boston; 3.24 © Musée d'Orsay, Paris, Dist. RMN/Patrice Schmidt ; 3.25 36.270. Photograph © 2012 Museum of Fine Arts, Boston; 3.26 1961.18.34 © 2012 Yale University Art Gallery/AR/Scala; 3.27 1951.65. Imaging Department © President and Fellows of Harvard College; 3.28 Acquired through the Lillie P. Bliss Bequest 472.1941 © 2012 Digital image, MoMA/Scala; 3.30 © Culture & Sport Glasgow (Museums); 3.31 81.1949 a-d © 2012 Digital image, MoMA/Scala. © 2012 ARS/ADAGP; 3.32 © Royal Museums of Fine Arts of Belgium, Brussels. © 2012 ARS/ADAGP; 3.33 Solomon R. Guggenheim Founding Collection, By gift 38.432. © 2012 ARS/ADAGP; 3.34 Photograph © 2012 The Barnes Foundation; 3.35 © Victoria and Albert Museum, London; 3.36 AKG Images; 3.37 © Centre Pompidou, MNAM-CCI, Dist. RMN/ Jacqueline Hyde.

Chapter 4: 4.1 © V&A Images, Victoria and Albert Museum; 4.2 AKG Images/AF Kersting; 4.4 Mark Fiennes/Arcaid; 4.5 Edifice Photo Library; 4.6 © Tate, London 2012; 4.7 Aubrey Beardsley Collection No. 97.; 4.8 John Tsantes, Freer Gallery of Art, SI, Washington DC; 4.9 Museum für Kunst und Gewerbe, Hamburg; 4.10 Mucha Trust/The Bridgeman Art Library ; 4.11 Foto Studio Minders, Ghent; 4.12 This acquisition made available in part through the generosity of the heirs of the Estates of Ferdinand and Adele Bloch-Bauer; 4.13 AKG Images/ Erich Lessing; 4.15 © Inigo Bujedo Aguirre, Barcelona; 4.17 © Reiner Lautwein/ Artur Images ; 4.18 © Bildarchiv Foto Marburg; 4.19 Andrea Jemolo/Corbis; 4.20 © Bildarchiv Foto Marburg, Marburg/Lahn; 4.21 © Jochen Helle/Artur Images ; 4.22 © 2012 Photo Scala. © 2012 The Munch Museum/The Munch-Ellingsen Group/ARS; 4.23 J. Lathion, Nasjonalgalleriet, Oslo; 4.24, 4.25 Nasjonalgalleriet, Oslo. © 2012 The Munch Museum/The Munch-Ellingsen Group/ARS; 4.25 Nasjonalgalleriet, Oslo. © 2012 The Munch Museum/The Munch-Ellingsen Group/ARS; 4.26 © 2012 Photo Scala. © 2012 The Munch Museum/The Munch-Ellingsen Group/ARS; 4.28 Menard Art Museum, Aichi, Japan. James Ensor, © 2012 ARS/SABAM,

Duchamp; 7.47 Science and Society Picture Library; 7.48 Image courtesy of The National Gallery of Art, Washington. © 2012 ARS/ADAGP

Chapter 8: 8.3 Thomas A. Heinz/Corbis; 8.4 © Bettmann/Corbis; 8.5, 8.8 Artifice, Inc./ Artifice Images. © 2012 Frank Lloyd Wright Foundation, Scottsdale, AZ/ARS; 8.6 Frank Lloyd Wright Collection. © 2012 Frank Lloyd Wright Foundation, Scottsdale, AZ/ARS; 8.7 © 2012 Andrea Jemolo/Scala. © 2012 Frank Lloyd Wright Foundation, Scottsdale, AZ/ARS; 8.9 Archive Photos/ Getty Images. Frank Lloyd Wright Preservation Trust. © 2012 Frank Lloyd Wright Foundation, Scottsdale, AZ/ARS; 8.10 Buffalo and Erie County Historical Society. © 2012 Frank Lloyd Wright Foundation, Scottsdale, AZ/ARS; 8.11 Hulton Archive/ Getty Images. © 2012 Frank Lloyd Wright Foundation, Scottsdale, AZ/ARS; 8.13 © Rudy Sulgan/Corbis; 8.14 © Paul M. R. Maeyaert. © 2012 ARS/VBK, Vienna; 8.15 b © Bildarchiv Monheim GmbH/Alamy. © 2012 ARS/ VBK, Vienna; 8.16 © Klaus Frahm/Artur Images ; 8.17 AKG Images; 8.20, 8.23 AKG Images/ Bildarchiv Monheim; 8.21 Thomas Dix/Arcaid/ Corbis; 8.22 Jan Derwig, Amsterdam /Doeser Photos; 8.24 AKG Images/Schutze/Rodemann; 8.25 © F.R. Yerbury/Architectural Association Photo Library

Chapter 9: 9.1, 9.39 © 2012 ARS/ADAGP; 9.2 © The Solomon R. Guggenheim Foundation, New York. Solomon R. Guggenheim Founding Collection, By gift 37.438. © 2012 ARS/ADAGP; 9.3 © 2012 Photo The Philadelphia Museum of Art/AR/Scala. © 2012 ARS/SIAE, Rome; 9.4 © 2012 ARS/SIAE, Rome; 9.5 © 2012 Digital image, MoMA/Scala; 9.6 Hillman Periodicals Fund 7.1954 © 2012 Digital image, MoMA/Scala. © 2012 ARS/SIAE, Rome; 9.7 © 2012 Albright Knox Art Gallery/AR/Scala. © 2012 ARS/SIAE, Rome; 9.8 Courtesy Sotheby›s Inc., NY. © 2012 ARS/SIAE, Rome; 9.9 Acquired through the Lillie P. Bliss Bequest 288.1949 © 2012 Digital image, MoMA/Scala. © 2012 ARS/ADAGP; 9.10 © The Solomon R. Guggenheim Foundation, New York. Solomon R. Guggenheim Founding Collection, 44.944. © 2012 ARS/ADAGP; 9.11 © 2012 Photo Scala. Courtesy of Ministero Beni e Attività Culturali. © 2012 ARS/ADAGP; 9.12 © Photo Scala. © 2012 ARS/SIAE, Rome; 9.13 © Bildarchiv Foto Marburg. © 2012 ARS/SIAE, Rome; 9.14 Mrs. Simon Guggenheim Fund 507.1951 © 2012 Digital image, MoMA/Scala; 9.15, 9.17, 9.29 © 2012 Digital image, MoMA/Scala; 9.19 Private Collection/The Stapleton Collection © The Wyndham Lewis Memorial Trust/The Bridgeman Art Library ; 9.20 © Tate, London 2012; 9.21 AKG Images; 9.22 Alfred H. Barr, Jr., NY/Bridgeman Art Library. © 2012 ARS/ADAGP; 9.23 © Tate, London 2012. © 2012 ARS/ADAGP; 9.24 State Tretyakov Gallery, Moscow/Bridgeman Art Library. © 2012 ARS/ADAGP; 9.25 The Riklis Collection of the McCrory Corporation 1059.1983 © 2012 Digital image, MoMA/Scala; 9.26 Tretyakov Gallery, Moscow, Russia/ The Bridgeman Art Library; 9.27 52.1327; 9.30 Gift of the Collection Société Anonyme 1941.548 © 2012 Yale University Art Gallery/AR/Scala. © 2012 ARS; 9.31, 9.32 Photo by Peter Cox, Eindhoven, the Netherlands. © 2012 ARS; 9.33 © 2012 ARS/ADAGP; 9.36 Alfred H. Barr, Jr., NY. ; 9.38 Mr. and Mrs. John Spencer Fund 55.1970 © 2012 Digital image, MoMA/

Scala.; 9.40 Costakis/Art Co.; 9.41 55.1429. Photograph by David Heald © The Solomon R. Guggenheim Foundation, New York. The work of Naum Gabo © Nina & Graham Williams

Chapter 10: 10.1 Photograph © CNAC/MNAM, Distr. RMN. © 2012 ARS/ADAGP; 10.2 © 2012 Kunsthaus Zürich. All rights reserved; 10.3 © 2012 Digital image, MoMA/Scala. © 2012 ARS/VG Bild-Kunst, Bonn; 10.4 © 2012 Kunsthaus Zürich. All rights reserved. © 2012 ARS/VG Bild-Kunst, Bonn; 10.5 Private Collection/ Giraudon/ The Bridgeman Art Library. © 2012 ARS/VG Bild-Kunst, Bonn; 10.6 © 2012 ARS/VG Bild-Kunst, Bonn; 10.7 Purchase 174.1945 © 2012 Digital image, MoMA/Scala. © 2012 ARS/ADAGP/ Succession Marcel Duchamp; 10.8 © 2012 ARS/ ADAGP/Succession Marcel Duchamp; 10.9 The Sidney and Harriet Janis Collection © 2012 Digital image, MoMA/Scala. © 2012 ARS/ADAGP/ Succession Marcel Duchamp; 10.10 Katherine S. Dreier Bequest © 2012 Digital image, MoMA/ Scala. © 2012 ARS/ADAGP/Succession Marcel Duchamp; 10.11 1953.6.4 © 2012 Yale University Art Gallery/AR/Scala. © 2012 ARS/ADAGP/ Succession Marcel Duchamp; 10.12 Bequest of Katherine S. Dreier, 1952 © Photo The Philadelphia Museum of Art/AR/Scala. © 2012 ARS/ADAGP/ Succession Marcel Duchamp; 10.13 © 2012 Photo The Philadelphia Museum of Art/AR/Scala. © 2012 ARS/ADAGP/Succession Marcel Duchamp; 10.14 a, b Gift of the Cassandra Foundation 1969. © 2012 Photo The Philadelphia Museum of Art/ AR/Scala . © 2012 ARS/ADAGP/Succession Marcel Duchamp; 10.15 Alfred Stieglitz Collection 49.70.14 © 2012 Image copyright MET/AR/Scala. © 2012 ARS/ADAGP; 10.16 Joseph H. Hirshhorn Purchase Fund and Museum Purchase, 1987, Lee Stalsworth. © 2012 Man Ray Trust/ARS/ADAGP; 10.17 © 2012 Digital image, MoMA/Scala. © 2012 Man Ray Trust/ARS/ADAGP; 10.18 Gift of James Thrall Soby © 2012 Digital image, MoMA/ Scala. © 2012 Man Ray Trust/ARS/ADAGP; 10.19 © RMN/Musée National d'Art Moderne, Centre d'Art et de Culture Georges Pompidou, Paris. © 2012 ARS/ADAGP; 10.20 Acc no. NG 57/61 Photo: Jörg P. Anders © 2012 Photo Scala/BPK, Bildagentur für Kunst, Kultur und Geschichte, Berlin. © 2012 ARS/VG Bild-Kunst, Bonn; 10.21 The Horace W. Goldsmith Foundation Gift through Joyce and Robert Menschel, 1987 © 2012 Image copyright MET/AR/Scala. © 2012 ARS/ VG Bild-Kunst, Bonn; 10.22 Purchase 18.1950 © 2012 Digital image, MoMA/Scala. © 2012 ARS/VG Bild-Kunst, Bonn; 10.23 © 2012 ARS/ VG Bild-Kunst, Bonn; 10.24 Photo: Wilhelm Redemann. Kurt Schwitters Archive, Sprengel Museum, Hanover (Reproduction: Aline Gwose/ Michael Herling) © 2012 ARS/VG Bild-Kunst, Bonn; 10.25 © 2012 ARS/ADAGP; 10.26 © Tate, London 2012. © 2012 ARS/ADAGP; 10.27 © Bildarchiv Foto Marburg. © 2012 ARS/VG Bild-Kunst, Bonn; 10.28 Kupferstich-Kabinett, Staatliche Kunstsammlungen, Dresden. © 2012 ARS/VG Bild-Kunst, Bonn; 10.29 Gift of Joseph H. Hirshhorn, 1996. Photography by Lee Stalsworth. © 2012 ARS/VG Bild-Kunst, Bonn; 10.31 A. Conger Goodyear Fund 234.1947 © 2012 Digital image, MoMA/Scala; 10.32 Advisory Committee Fund 120.1946 © 2012 Digital image, MoMA/Scala; 10.33 Acc. No. FNG 74/95 Property of the Association of Friends of the Nationalgalerie. Photo: Jörg P. Anders ©

2012 Photo Scala/BPK, Bildagentur für Kunst, Kultur und Geschichte, Berlin. © 2012 ARS/ VG Bild-Kunst, Bonn; 10.34 Gift of Abby Aldrich Rockefeller. N. Inv.159.1934.16 © 2012. Digital image, MoMA/Scala. © 2012 ARS/VG Bild-Kunst, Bonn; 10.35 © 2012. Digital image, MoMA/ Scala © 2012 ARS/VG Bild-Kunst, Bonn; 10.36 Gift of the photographer 400.1953. © 2012 Die Photographische Sammlung/SK Stiftung Kultur - August Sander Archiv, Cologne/ARS; 10.37 © 2012 Albert Renger-Patzsch Archiv/Ann u. Jürgen Wilde, Zülpich/ARS; 10.38 © 2012 Photo Scala/ BPK, Berlin. © 2012 ARS/VG Bild-Kunst, Bonn; 10.39 Association Fund, BR41.37. Photo: Imaging Department © President and Fellows of Harvard College. © 2012 ARS/VG Bild-Kunst, Bonn; 10.40 Dr. Marie-Andreas von Lüttichau; 10.41 Given anonymously (by exchange) 6.1942.a-c © 2012 Digital image, MoMA/Scala. © 2012 ARS/VG Bild-Kunst, Bonn

Chapter 11: 11.1 © The Solomon R. Guggenheim Foundation, New York. Solomon R. Guggenheim Founding Collection, By gift 41.535; 11.2 Edward Cornachio. © 2012 ARS/ADAGP; 11.3 Room of Contemporary Art Fund, 1939 © Albright-Knox Art Gallery/AR/Scala. © 2012 ARS/ADAGP; 11.4 © RMN/Rene-Gabriel Ojeda; 11.5 © Centre Pompidou, MNAM-CCI, Dist. RMN-GP. © 2012 ARS/ADAGP; 11.6 Mrs. Simon Guggenheim Fund © 2012 Digital image, MoMA/Scala. © 2012 Succession H. Matisse/ARS; 11.7 Gift of Joseph H. Hirshhorn, 1966. © 2012 Succession H. Matisse/ ARS; 11.8 Photograph © 2012 The Barrnes Foundation. © 2012 Succession H. Matisse/ARS; 11.9 © RMN. © 2012 Succession H. Matisse/ ARS; 11.10 © 2012 Succession H. Matisse/ARS; 11.11 Photo by Mitro Hood. © 2012 Succession H. Matisse/ARS; 11.12 Photograph © 2012 The Barnes Foundation. © 2012 Succession H. Matisse/ ARS; 11.13 Photo Josse/Leemage/Lebrecht Music & Arts © 2012 ARS/ADAGP; 11.14 Elisha Whittelsey Collection, The Elisha Whittelsey Fund, 1947 (47.14) © 2012 Image copyright MET/AR/ Scala. © 2012 Estate of Pablo Picasso/ARS; 11.15 © RMN/Rene-Gabriel Ojeda. © 2012 Estate of Pablo Picasso/ARS; 11.16 PA209 © 2012 Digital image, MoMA/Scala. © 2012 Estate of Pablo Picasso/ARS; 11.17 © RMN/Jean-Gilles Berizzi. © 2012 Estate of Pablo Picasso/ARS; 11.18 © The Cleveland Museum of Art. © 2012 Estate of Pablo Picasso/ARS; 11.19 Mrs. Simon Guggenheim Fund 55.1949 © 2012 Digital image, MoMA/ Scala. © 2012 Estate of Pablo Picasso/ARS; 11.20 Purchase 116.1964 © 2012 Digital image, MoMA/ Scala. © 2012 Estate of Pablo Picasso/ARS; 11.21 © 2012 Estate of Pablo Picasso/ARS; 11.22 Abby Aldrich Rockefeller Fund 20.1947 © 2012 Digital image, MoMA/Scala. © 2012 Estate of Pablo Picasso/ARS; 11.23 Hans Hinz, Base. © 2012 ARS/ADAGP; 11.24 Mrs. Simon Guggenheim Fund 2.1948 © 2012 Digital image, MoMA/ Scala. © 2012 ARS/ADAGP; 11.25 Mrs. Simon Guggenheim Fund 189.1942 © 2012 Digital image, MoMA/Scala. © 2012 ARS/ADAGP; 11.26 62.1619. © 2012 ARS/ADAGP; 11.27 © The Solomon R. Guggenheim Foundation, New York. © 2012 ARS/ADAGP; 11.28 Van Gogh Purchase Fund 261.1937 © 2012 Digital image, MoMA/ Scala. © 2012 ARS/ADAGP/F.L.C.

Chapter 12: 12.5 AKG Images/André Held; 12.7 Taeuber Arp and Arp only: © 2012 ARS/VG Bild-

Kunst, Bonn; 12.8 Gift of Sylvia Pizitz 509.1953 © 2012 Digital image, MoMA/Scala. © 2012 ARS/ProLitteris, Zürich; 12.9 Doeser Fotos, Lauren; 12.10 Foto van Ojen, The Hague. © 2012 ARS/c/o Pictoright Amsterdam; 12.11 Fototechnischer Dienst, Rotterdam. © 2012 ARS/c/o Pictoright Amsterdam; 12.12 Janne Linders. © 2012 Digital image, MoMA/Scala. © 2012 ARS; 12.13 © EggImages/Alamy; 12.14 Rietveld Schröder Archief/Centraal Museum, Utrecht. © 2012 ARS; 12.15 Gift of Philip Johnson 487.1953 © 2012 Digital image, MoMA/Scala. © 2012 ARS

Chapter 13: 13.1 AKG Images/Bildarchiv Monheim. Gropius only: © 2012 ARS/VG Bild-Kunst, Bonn; 13.2, 13.3, 13.4 Gropius only: © 2012 ARS/VG Bild-Kunst, Bonn; 13.5 Gift of Sibyl Moholy-Nagy. BR56.5. Photograph by Junius Beebe © President and Fellows of Harvard College. © 2012 ARS/VG Bild-Kunst, Bonn; 13.6 1968.264 Photography © The Art Institute of Chicago. © 2012 ARS/VG Bild-Kunst, Bonn; 13.7 Special Photography Acquisition Fund, 1979.84. Photography © The Art Institute of Chicago. © 2012 ARS/VG Bild-Kunst, Bonn; 13.8 © 2012 Kunsthaus Zürich. All rights reserved. © 2012 The Josef and Anni Albers Foundation/ARS; 13.9 271.1939 © 2012 Digital image, MoMA/Scala. © 2012 ARS; 13.10 67.1842. © 2012 ARS; 13.11 Inv. Nr. G 1427. © 2012 ARS; 13.12 © 2012 ARS; 13.13 © The Solomon R. Guggenheim Foundation, New York. Solomon R. Guggenheim Founding Collection, By gift 37.262. © 2012 ARS/ADAGP; 13.14 © The Solomon R. Guggenheim Foundation, New York. Solomon R. Guggenheim Founding Collection, By gift 41.283. © 2012 ARS/ADAGP; 13.15 © 20012 Digital image, MoMA/Scala. © 2012 Estate Oskar Schlemmer, Munich; 13.16 © Erich Lessing Archive. © 2012 Estate Oskar Schlemmer, Munich; 13.17 Photo: Imaging Department © President and Fellows of Harvard College. © 2012 ARS/VG Bild-Kunst, Bonn; 13.18 Gift of Herbert Bayer 229.1934 © 2012 Digital image, MoMA/Scala; 13.19 Jan Tschichold Collection, Gift of Philip Johnson 518.1999 © 2012 Digital image, MoMA/Scala. © 2012 ARS/VG Bild-Kunst, Bonn; 13.20 © 2012 ARS/c/o Pictoright Amsterdam; 13.21 The work of Naum Gabo © Nina & Graham Williams; 13.22 L.W. Schmidt, Rotterdam; 13.23 © Centre Pompidou, MNAM-CCI, Dist. RMN/Adam Rzepka. © 2012 ARS/ADAGP; 13.24 Acc no. 200, 504th Photo: Elke Walford © 2012 Photo Scala/BPK, Bildagentur für Kunst, Kultur und Geschichte, Berlin. © 2012 ARS/VG Bild-Kunst, Bonn; 13.25, 13.26 © 2012 ARS/VG Bild-Kunst, Bonn; 13.27 AKG Images/ Erich Lessing. © 2012 ARS/VG Bild-Kunst, Bonn; 13.28 © 2012 ARS/VG Bild-Kunst, Bonn; 13.29 © Hedrich Blessing Studio/VIEW Pictures. © 2012 ARS/VG Bild-Kunst, Bonn; 13.30 61.1590 © 2012 The Josef and Anni Albers Foundation/ARS

Chapter 14: 14.1 Image courtesy of National Gallery of Art Washington © 2012 ARS/ADAGP; 14.2 Acc no. 79.1936. © 2012 Digital image, MoMA/Scala. © 2012 ARS/VG Bild-Kunst, Bonn; 14.3 Etienne Bertrand Weill, Paris. © 2012 ARS/VG Bild-Kunst, Bonn; 14.4 A.E. Gallatin Collection © 2012 Photo The Philadelphia Museum of Art/AR/Scala. © 2012 ARS/VG Bild-Kunst, Bonn; 14.5 Purchase 00256.37 © 2012 Digital image, MoMA/Scala. © 2012 ARS/ADAGP; 14.6 © 2012

ARS/ADAGP; 14.7 The Ella Gallup Sumner and Mary Catlin Sumner Collection Fund (1942.281) © 2012 Wadsworth Atheneum Museum of Art/AR/Scala. © 2012 ARS/ADAGP; 14.8 © 2012 ARS/ADAGP; 14.9 © 2012 Successió Miró/ARS/ADAGP; 14.10 Room of Contemporary Art Fund, 1940 © 2012 Photo The Philadelphia Museum of Art/AR/Scala. © 2012 Successió Miró/ARS/ADAGP; 14.11 A. E. Gallatin Collection © Photo The Philadelphia Museum of Art/AR/Scala. © 2012 Successió Miró/ARS/ADAGP; 14.12 Loula D. Lasker Bequest (by exchange) 229.1937 © 2012 Digital image, MoMA/Scala. © 2012 Successió Miró/ARS/ADAGP; 14.13 Courtesy Successió Miró © 2012 Successió Miró/ARS/ADAGP; 14.14 Private collection/Bridgeman Art Library. © 2012 Successió Miró/ARS/ADAGP; 14.15 Purchase 260.1937 © 2012 Digital image, MoMA/Scala. © 2012 ARS/ADAGP; 14.16 Richard Nickel. © 2012 ARS/ADAGP; 14.17 Purchase 78.1936 © 2012 Digital image, MoMA/Scala. © 2012 Estate of Yves Tanguy/ARS; 14.18 Jacques and Natasha Gelman Collection, 1998 (1999.363.16) © 2012 Image copyright MET/AR/Scala. © Salvador Dalí, Fundació Gala-Salvador Dalí, ARS 2012; 14.19 Given anonymously 162.1934 © 2012 Digital image, MoMA/Scala. © Salvador Dalí, Fundació Gala-Salvador Dalí, ARS 2012; 14.20 © Salvador Dalí, Fundació Gala-Salvador Dalí, ARS 2012; 14.21 Louise and Walter Arensberg Collection 1950 © Photo The Philadelphia Museum of Art/AR/Scala. © Salvador Dalí, Fundació Gala-Salvador Dalí, ARS 2012; 14.22 Photograph © 2012 Digital Image Museum Associates/LACMA/AR NY/Scala. © 2012 C. Herscovici, London/ARS; 14.23 Image courtesy of The National Gallery of Art, Washington. © 2012 C. Herscovici, London/ARS; 14.24 © 2012 C. Herscovici, London/ARS; 14.25 © 2012 ARS/SABAM, Brussels; 14.26 Courtesy of George Eastman House, International Museum of Photography and Film. © 2012 ARS/ADAGP; 14.27 © 2012 ARS/ADAGP; 14.28 Inter-American Fund 140.1945 © 2012 Digital image, MoMA/Scala. © 2012 ARS/ADAGP; 14.29 Purchase 130.1946 a-c © 2012 Digital image, MoMA/Scala. © 2012 ARS/ProLitteris, Zürich; 14.30 Gift of Robert Shapazian; 14.31 Gift of Ford Motor Company and John C. Waddell, by exchange, 2005 (2005.100.443) © 2012. Image copyright MET/AR/Scala. © 2012 ARS/ADAGP; 14.32 © Tate, London 2012. © 2012 ARS/ADAGP; 14.33 The Pierre and Maria-Gaetana Matisse Collection, 2002 (2002.456.1). Image copyright MET/AR/Scala. © 2012 Leonora Carrington/ARS; 14.34 © RMN. © 2012 Estate of Pablo Picasso/ARS; 14.35 Louis E. Stern Collection 967.1964.12 © 2012 Digital image, MoMA/Scala. © 2012 Estate of Pablo Picasso/ARS; 14.36 The Sidney and Harriet Janis Collection 644.1967 © 2012 Digital image, MoMA/Scala. © 2012 Estate of Pablo Picasso/ARS; 14.37 Mrs. Simon Guggenheim Fund 82.1950 © 2012 Digital image, MoMA/Scala. © 2012 Estate of Pablo Picasso/ARS; 14.38 Gift of Mrs. Simon Guggenheim 2.1938 © 2012 Digital image, MoMA/Scala. © 2012 Estate of Pablo Picasso/ARS; 14.39 © RMN. © 2012 Estate of Pablo Picasso/ARS; 14.40 © RMN/ Beatrice Hatala. © 2012 Estate of Pablo Picasso/ARS; 14.41, 14.43 © Centre Pompidou, MNAC-CCI, Dist. RMN/Philippe Migeat. © 2012 ARS/ADAGP; 14.42 © 2012 ARS/ADAGP; 14.44 Nasher Sculpture Center, Dallas, Texas. Photograph by David Heald. © 2012 Succession

Alberto Giacometti (Fondation Alberto et Annette Giacometti, Paris)/ADAGP; 14.45 Image courtesy of The National Gallery of Art, Washington 1991.40.1. © 2012 Succession Alberto Giacometti (Fondation Alberto et Annette Giacometti, Paris)/ADAGP; 14.46 Purchase 696.1949 © 2012 Digital image, MoMA/Scala. © 2012 Succession Alberto Giacometti (Fondation Alberto et Annette Giacometti, Paris)/ADAGP; 14.47 Purchase 90.1936 © 2012 Digital image, MoMA/Scala. © 2012 Succession Alberto Giacometti (Fondation Alberto et Annette Giacometti, Paris)/ADAGP; 14.48 1950.730 © 2012 Yale University Art Gallery/AR/Scala. © 2012 Succession Alberto Giacometti (Fondation Alberto et Annette Giacometti, Paris)/ADAGP; 14.49 © Henry Moore Foundation/ The Bridgeman Art Library. © 2012 The Henry Moore Foundation. All Rights Reserved./ARS/DACS, London; 14.50 Founders Society Purchase © Henry Moore Foundation/ The Bridgeman Art Library. © 2012 The Henry Moore Foundation. All Rights Reserved./ARS/DACS, London; 14.51 Abbott-Levy Collection. Partial Gift of Shirley C. Burden 1.1969.1544 © 2012 Digital image, MoMA/Scala; 14.52 Gift of James Thrall Soby 162.1941 © 2012 Digital image, MoMA/Scala. © 2012 Man Ray Trust/ARS/ADAGP; 14.53 New York Public Library. © 2012 Man Ray Trust/ARS/ADAGP. Courtesy Harper's Bazaar; 14.54, 14.55 © Estate of André Kertész/Higher Pictures; 14.57 David H. McAlpin Fund 2523.1967 © 2012 Digital image, MoMA/Scala. © Estate Brassaï – RMN; 14.58 Julien Levy Collection, Gift of Jean Levy and the Estate of Julien Levy 1988.157.8. Photography © The Art Institute of Chicago; 14.59 © Lisette Model Foundation; 14.60 © Henri Cartier-Bresson/Magnum Photos; 14.61 © Bill Brandt/Bill Brandt Archive Ltd.

Chapter 15: 15.1 © 2012 Smithsonian American Art Museum/AR/Scala; 15.2 The Ella Gallup Sumner and Mary Catlin Sumner Collection Fund 1947.240 © 2012 Wadsworth Atheneum Museum of Art/AR/Scala; 15.4 Los Angeles County Fund (16.4) © 2012 Digital Image Museum Associates/LACMA/AR/Scala; 15.5 Gift of the Museum of the City of New York 338.1964 © 2012 Digital image, MoMA/Scala; 15.6 Purchase 48.1974 © 2012 Digital image, MoMA/Scala; 15.7 Alfred Stieglitz Collection, 1949.705. Photography © The Art Institute of Chicago. © 2012 Georgia O›Keeffe Museum/ARS; 15.8 Alfred Stieglitz Collection 33.43.36 © 2012. Image copyright MET/AR/Scala; 15.9 Gift of the photographer 219.1961 © 2012 Digital image, MoMA/Scala; 15.10 Whitney Museum of American Art, New York. Purchase 31.382; 15.11 The Alfred Stieglitz Collection, 1949 (49.70.42) © 2012 Image copyright MET/AR/Scala; 15.12 Acquired through the Lillie P. Bliss Bequest 1945 © 2012 Digital image, MoMA/Scala. © 2012 Estate of John Marin/ARS; 15.13 Photography © The Art Institute of Chicago; 15.15 Courtesy of George Eastman House, International Museum of Photography and Film; 15.16 Gift of Emily Fisher Landau in honor of Tom Armstrong 91.90. © 2012 Georgia O'Keeffe Museum/ARS; 15.17 Alfred Stieglitz Collection, Gift of Georgia O'Keeffe, 1947.712. Photography © The Art Institute of Chicago; 15.18 © Aperture Foundation, Inc., Paul Strand Archive; 15.19 © 1929, 2012 The Imogen Cunningham Trust ; 15.20 Photograph by Ansel Adams. Used with permission of The